P9-DVZ-389

CONTEMPORARY SCULPTURE. PROJECTS IN MÜNSTER 1997.

Edited by
Klaus Bußmann Kasper König Florian Matzner

Verlag Gerd Hatje

Greeting Kulturstiftung Deutsche Bank

Ever since its foundation, the Kultur-Stiftung der Deutschen Bank has endeavored to foster new developments and to help wherever it is important to waken interest in supporting creativity. For these reasons, we participated in saving the *Donaueschinger Musiktage*, and were involved in the foundation of the *Institut für Neue Medien* in Frankfurt. Now we are pleased to support this international exhibition for contemporary sculpture in Münster. Where else but in the public sphere could dialog with modern art be more vital? Where could it be more intensive than in such a project, the aim of which is to bring together young as well as experienced artists from many different countries? We would especially like to support public dialog by sponsoring the publication of the catalog and the tour guide. Our hope is that with our involvement, once again the *Skulptur. Projekte in Münster 1997* will achieve the overwhelming success it has had in the previous years.

Dr. Brigitte Seebacher-Brandt
Kulturstiftung der Deutschen Bank

KULTUR-STIFTUNG

Deutsche Bank Gruppe ☑

Contents

Preface

Skulptur. Projekte in Münster 1997 represents the third attempt, after 1977 and 1987, to explore the possibilities of "art in public space". Already following the last sculpture exhibition, Münster city council had declared itself in favor of continuing the experiment ten years later (a very Westphalian rhythm); still, the exhibition directors harbored considerable doubt as to whether such a continuation would be sensible or even possible. Münster isn't Kassel, with its established tradition of *documenta,* and it certainly isn't Venice, where the ambience of the city makes up for even the worst Biennale. Münster has to live up to its self-imposed task, though admittedly under ideal conditions: an urbanized, central European small-big city with a historical infrastructure, great willingness to cooperate on the part of all involved (city, state, university, regional association, private persons), and a sufficient financial base, which for 1997 could even be doubled through substantial sponsorships from business, banking, finance, industry, and trade. Rather, the concerns were of a more fundamental nature: today, in the age of media and dissolving communicative structures, is there still even a need to address the issue of communal public space? Will artists still be interested and willing to take on this challenge? After all, aren't cities like Münster, in the final phases of reconstruction, so thoroughly designed and perfectly equipped that no space is left for artistic intervention? And in any case, hasn't contemporary art lost interest for the most part in the sculpture and avantgarde of the twentieth century? Precisely these concerns, however, also served as an impetus to continue the approach from 1987, quite apart from the latent expectations on the part of the city and the international art scene. The

provisions were the same, allowing the invited artists the greatest possible freedom in developing their projects with respect to both subject and (up to a certain point) financing. The sole, and not merely pragmatic, limitation in contrast to 1987 was the request to stay as much as possible in the area of the old city inside the so-called Promenade ring. The renovated Landesmuseum of 1907 on the cathedral square in the heart of the city was also made available as a "temporary public space", in an effort to stimulate a dialog between the museum "interior" and the urban "exterior".

Of course the concentration on the central area had practical reasons as well: though a city of only moderate size, the urban area of Münster extends over a diameter of more than 20 km, threatening to turn the exhibition into a kind of Easter-egg hunt for out-of-town visitors if works were distributed over the entire area. A more important reason, however, was the desire to call attention to the central area's qualities as an urban center and place of historical identification. Already in 1987, the critical dialog between the artists and the experience of historical traces was one of the most exciting discoveries of the potentialities latent in so-called "artistic interventions" – from Ludger Gerde's *Gestrandetes Schiff* (Stranded Ship), to Lothar Baumgarten's discreet reminder of the fate of the Anabaptists in the cages on the Lamberti-Kirche, to Rebecca Horn's conjuring of history in the old Zwinger. Since 1977, the specific character of the Münster experiment had consisted not only in the "site specific", the work in situ with qualities developing out of the interplay of place and artistic intervention, but even more so – above all in the works of Joseph Beuys and Ulrich Rückriem, as well as in the large-scale project by Claes

Oldenburg – in the reference to a specific local historical situation. Without this background – which, moreover, presupposes a detailed familiarity not always available to the newcomer – the works lose an essential layer of their meaning.

Important works from the exhibition in 1987 have remained in Münster, some acquired by the city, others by the Landesmuseum. Regrettably, several works of central importance have disappeared, including the masterful sculpture by Sol LeWitt in front of the Schloß, *Dedicated to the Missing Jews*, one of the few credible and authentic monuments to the nearly unanswerable question of whether an artistic response to the horrors of the Holocaust is possible at all. The unfortunate discussion on this theme in Berlin reveals the current state of aporia.

The high, often naive expectations placed on art and its ability to address deficits of all kinds must necessarily be disappointed. Still, the discourse intended by the exhibition is not a purely art-immanent one, but rather constitutes the attempt at a dialog between artists, the local public, and the international art scene.

Without the enthusiastic involvement of the small but concentrated team in the Landesmuseum – Ulrike Groos (director of the exhibition office), Claudia Büttner, Barbara Engelbach, and Martina Ward (exhibition office) as well as Markus Müller (press and public relations) – the exhibition and catalog would not have been possible in this form. The editorial office in Cologne fed all three sculpture projects into the "Net", thus producing a unique, world-wide Internet databank for modern sculpture.

The realization of over 60 projects in the city of Münster, their temporary installation for the 100 days of the exhibition or their permanent acquisition, together with the renovation of nearly 30 already existing works from the two preceding exhibitions was a feat in which all the staff of the responsible municipal offices participated, along with various departments of district government and the university. More than once, "great solutions" were arrived at through "official channels".

The immense quantity of visual and textual material found in this handbook to the exhibition – material assembled in large part by the artists themselves – was put into printable and reader-friendly form by the publishing house Verlag Gerd Hatje with Bernd Barde, Gerhard Brunner, Regina Dorneich and Annette Kulenkampff, who under tremendous time pressure demonstrated their usual poise and great imagination.

Above all, however, we want to thank the artists – over 70 of them from 25 countries around the world – who let themselves in for the experiment, in some cases spending weeks in Münster doing intensive research on the city and its urban, historical, architectural, and social structures in order to develop a project here. Success and failure often went hand in hand during the two years or more of preparation; "public space", after all, is neither as rigid nor as alterable as the traditional exhibition space of a museum or a gallery. A few projects did fail because of practical difficulties; others, however, remained unrealized because those in positions of authority in the city made use of their right of veto, as in the case of Ayşe Erkmen or Tobias Rehberger. Still, the generally positive and open-minded attitude above all on the part of the population of Münster helped make it possible for us to realize more than we had hoped for in the beginning – and for this

reason, too, the third edition of the *Skulptur Projekte* is an exhibition above all for the city of Münster and its citizens.

Klaus Bußman
Kasper König
Florian Matzner

Art and the City

WALTER GRASSKAMP

With no location has modern art maintained such a close relationship as with the city. It is a relationship that has intensified apace from the sixteenth century on. After the monasteries of the Middle Ages, the palaces of the Renaissance and the chateaux of the Baroque, the profane space of the city became art's location, and this on many levels at once: as its motif, its venue, its market and its storehouse. This post-Renaissance symbiosis can be clearly seen emerging in *veduta* painting, which brought the city prospect out of the background of a scene to become the pictorial subject in its own right. Now neither the setting for a Life of Christ, nor an ideal city, it was as the context of everyday life that formed the central feature in a painting about space, space that was urban. It was to become a capital subject for modern art. From the Dutch city prospects of the seventeenth century, Canaletto's canal views or Robert Hubert's *veduti* of bridges, on to the idylls of the Biedermeier period and the Impressionists' detail views and into the pictorial tumult of Futurism and the Expressionists' icons of crisis, not to mention the entire later genres of the panorama and photography, the repertoire developed, drawing on the stock of urban reality unfolding as an experience central to the modern age.

What the city gave art was more than a motif. It has also stood it in good stead as a *market*; art in the modern era having become urban not just in subject-matter, but also in the channels through which it is conveyed. Even where art held up to the city its opposite image, for example in the landscapes of the German Romantics, it was the city that provided the public that bought the art; in fact, the very demand for subjects that looked to nature betrayed the cultural dominance of those who dwelt in the city. Art marketing gave rise to galleries specifically for exhibitions, where modern art proceeded to success as an art produced purely for exhibition. The city as the site of modernism was also the site of modern art. In the midst of this location rose the storehouse in which such exhibition art, having run its course through the stages of the market, the art exhibition association (the German institution of the *Kunstverein*), the gallery and the private collection, landed at its final and ultimately intended location, the museum. Long tainted with a reputation for being un-modern and given to a backward-looking antiquarianism, the museum has emerged today as perhaps modernism's most characteristic amenity: not only has it helped to mold the modernist historical consciousness; it has also given modern art's sense of autonomy the institutional framework it needed.

When urban space became artistic subject-matter, it had already for some time been art's venue. The works of sculptors had found their places in niches on the façades of churches and subsequently those of the city palaces and patricians' houses, and been erected free-standing in central squares or sited in public parks. Art discovered urban locations at an accelerating rate: sites where it seemed to integrate itself organically whilst it thereby defined the very look of the place. To furnish a site with sculptures and reliefs, frescoes and mosaics was no matter of decoration alone. It was to turn the city into a vast narrative space.

The City as a Narrative Space

To begin with, the narrative that dominated the medieval townscape was one consistent tale: the Life and Sufferings of Christ as orches-

trated on the façades of cathedrals, by wayside crosses and images of the saints, in processions and parish fêtes. The churches were not only buildings of stone, but welcomed their congregation into an edifice of meaning, an endowment of sense: so, too, the city was a topography set on an ideal foundation, significance. But, as a space for narrative, it was vulnerable to some fateful crises. One of the first came with the Reformation and put paid to the unity of the salvation narrative. That the sculptures that recited it were dispatched along with the tale, as they were in Münster during the regime of the Anabaptists, betrays the lack of insight into the ways in which a work of art and its meanings are distinguishable, and how intensely art was identified with its narrative substance. In the Counter-Reformation and the later coexistence of faiths, the salvation story did recover its place in urban narrative space, but as a religious aspect sharing that space with political and local, historical, mythological and, ultimately, even anecdotal subject-matter. Now the once unified narrative space spoke in several voices. It had become profane.

Victor Hugo dated the first crisis of the urban narrative space at a point some decades earlier. In his novel, *Notre-Dame de Paris. 1482*, it is the invention of book printing that he blames for making the architectural narrative redundant. When he has a contemporary of that media revolution comment that "the book will be the death of the building", he is not saying that the advent of the printing press meant that the script in architectural sculpture would no longer be intelligible; he is saying that architectural sculpture must lose its readership. With the advantage of technical reproducibility, the book had indeed come to claim all narrative traditions, both oral and sculptural, of setting and of ritual, and would dominate them from that time on. The distinguishing feature in Hugo's diagnosis, however, is that it was meant to describe the end of the Middle Ages but was written at the beginning of the modern age. The theme of the changes in urban perception is a processing not only of the revolution of the printing press, but, closer to home, of the mass-media innovations which Hugo experienced first-hand in newspaper publishing, the invention of lithography, the poster – if not indeed the photograph. The Middle Ages in Hugo's novel are a foil for industrial modernism. Just as the book had once overtaken the pictorial, allegorical narrative space of the city, so in Hugo's lifetime the visual media – the illustrated journal and photography – began to outdo the alphabetical narrative space of the book. Soon after him they would be joined by cinema. These were all media of yet more urban potential than painting or the book. With its romantic lament for the demise of the urban narrative space, Hugo's novel, published in 1831, certainly struck a chord with the mood of the time. In the nineteenth century, art, too, rose in a last act of defiance against the competing media of the book, the newspaper and photography, and took to architectural sculpture and the monument as hardly any age had done since the end of classical antiquity. Now the bourgeoisie aspired to a prominent share in the narrative filling out of city space: it was not by chance that a society like the *Kunstverein für die Rheinlande und Westfalen*, the Art Association for the Rhinelands and Westphalia, was founded in 1829 with the declared aim not only of holding exhibitions at its premises, but also of erecting public monuments.

Thus did the city inflate itself once more as a narrative space. War memorials, political monuments, triumphal arches, obelisks taken as trophies, scenes of city history and cultural heroes raised upon pedestals permeated the picture of the reorganized and expanding cities. They cor-

responded to the plaster cast company of classical mythology that now took up position so prominently across the façades of the town houses of the wealthy. Having become a consort of several voices, the narrative space now rang to a host in polyphony.

In this space, the architectural sculpture and ornamental façades of theatres, opera houses, art galleries and museums was molded upon the cultural model of ancient Greece and Rome. On these façades, all the stops could once more be pulled out for a cultural narrative that had begun to enthrall the bourgeoisie of the nineteenth century and which it would pass on to the century following. It was the lore of *the Artist as hero*. No matter which example is cited, whether it be the Thorvaldsen Museum in Copenhagen, the original part of the Hamburg Kunsthalle or the Academy of Fine Arts in Düsseldorf – the decoration of the façade was a celebration of the last great urban cultural narrative to which architecture was amenable – before it suddenly withdrew its co-operation. The buildings of the innovators of the early twentieth century dispensed with narrative architectural decoration at a stroke. This summary dismissal must amount to the first successful coup of radical modernism. In one stroke it brought upon the urban narrative space the greatest crisis in its existence, for the fusion of the urban setting with façade sculptures, frescoes and narrative monumental sculpture was lost, to survive only in the historical examples. After this strike was declared, new buildings, even churches, art academies and museums, came unadorned.

The façade narrative was not the most trenchant loss, however, compared to the forgoing of architecture's innate storytelling potential – no longer to design buildings as "architecture parlante", nor to order urban terrain as a visually meaningful, associative entity and with such configurations, to define a place. One need not be familiar with the cities built and understood as cosmological models from ancient times and into the Renaissance, before one can picture what was lost with this graphic approach. Early modern planners and architects still had the vision to see, in so radically new a challenge as the railway station, a motif as traditional as the city gate, and they designed it accordingly. Harking back to elements from the triumphal arch, in the orientation of lines of sight and access and in the style and register of the architectural ornament, welcome and farewell were fêted, and, in their allocation in the greater town plan, set to vie unashamedly with other structures of status such as museums or churches. The winged locomotive wheel now marked the mythical confluence of Classical antiquity and the modern age in the cast iron capital.

In the hands of radical modernists, however, it was not long before railway stations looked like check-in foyers. The airport seemed to be their example, and it was one of the first types of modern construction that could no longer become a visual, architectural embodiment of an idea. Nor could the military and housing barracks that had preceded it; nor the television towers and atomic power stations that followed, which remained at best insignia for their thoroughly un-visual, intangible purposes. If that was so, then how much more the highrises that housed political and commercial offices advanced the abstraction of the city's face. Lettering was the only medium that could possibly still convey the information which the architectural façade henceforth refused. Thus, out of the legible city emerged the city inscribed.

The twentieth century matured to see even art unable to compensate for the city's loss of visual sense. "Art in Architecture", under the Ger-

man post-War scheme, *Kunst am Bau*, meant placement at the foot of functional buildings and could be no substitute for what the building no longer articulated, the less so given that art itself was increasingly abandoning its figurative attributes. The stylization and abstraction of outdoor sculptures in their own way betokened the end of narratives as voices of consensus. As monuments to lost messages, they became the targets of a critique aimed at something they did, in fact, embody, but had not caused. The notorious criticism of *art in public spaces* as making no sense also did for the cultural narrative of the artist as hero. It led into a popular esthetics of the trite in which artists have played a guilty part ever since.

The Internalization of the Media

It did not follow from the loss of narrative meaning in architecture and outdoor sculpture in modernism, of course, that the production of images dwindled. It rose, exploding, from the easel painting right through to film; but the most conspicuous turn in this development was that the images moved indoors. In response to the dissolution of the city as a narrative space, there was an internalization of both images and narratives. The book found its place in the domestic context; for paintings, first the collector's home, then the museum became an abode. Dramatized and ritual narratives found their home in the theater, its structure also adopted by the most revolutionary of media, cinema (the "movie theater"), until this, too, found its way into the private household via the television set.

The art market had also followed the trend towards internalization. In the late eighteenth century, the shop premises became established which soon acquired renown as galleries; conversely, the open air picture markets that had been the custom in the Netherlands of the seventeenth century up to the fairs of the nineteenth, became incompatible with the esteem of an art now offered for sale in respectable exhibition establishments, in the academies, salons and associations for the promotion of art and on the premises of the artist leagues and their secessions. As cultural end sites, the museums reinforced the demand for the high degree of protection which art now demanded; they brought indoors even such sculptures as had been made for open-air sites, but which were no longer safe there. Religious architectural sculptures were protected in this way, at first from the vandalism of revolutions, then from secularization and economic exploitation, and later from the aerial pollutants of industry. The museum doubled as a bunker and a parade-ground for works of art which, left outside its walls, would have been in danger.

In the selections the museum of art made, it now shaped a *hierarchy of pictures* that was to be fateful indeed, and remain as good as unchallenged until the triumph of Pop Art. Pictures collected by a museum would enjoy unparalleled cultural respect, whilst typical pictorial products of industrialized modernism such as posters and photographs, films and illustrations, were not thus privileged; what circulated in public spaces was seen as trivia. Thus the walls of the museum became a cultural divide, separating two classes of pictures – those possessed of aura remaining stored in the archives even when no longer fit for the display collection, and the banal left to the fate of rapid wear and tear, with oblivion quick to follow.

By so polarising the domains of culture, the museums of modern art made possible an unusual development which could not have taken place but for this institutional context. Internalization promoted not only art's special position in the world of pictures, but an increasing radicality in the forms art took. As an institu-

tion of a bourgeois elite, the museum, flanked by influential art journalism and later augmented by the teaching of art and the understanding of art, not least in museum education departments, was able to rely on an esthetically informed public which was capable of discerning the artistic quality even in bolder innovations – or at least, one that was willing to try.

At the same time, the stories art had yet to tell depended increasingly upon its audience's being conversant with the history of modern art. Conflicts were inevitable when modern art, in the advanced state it had attained in its autonomous and elite reservation, was brought back with hardly an introduction into the public arena. The exchange between museum art and the urban space made a differentiation within the cultural milieu tangible to a degree which no other society is likely to have experienced before modernism. In this conflict-laden area, the public sphere, once the place for a common cultural narrative, became the venue of increasing cultural incoherence.

When modern art relinquishes the museum for the public sphere, it is inescapable that damage and destruction – let alone hostility – have to be reckoned with. In the public sphere the privileges the museum has won for art, and constantly defended, do not apply: outside its walls, modern art must expiate its enormous dependence on the museum – in the public space.

Where exactly is "public space"?

The term is as popular as it is vague. The questions so often asked, whether swimming pools, public transport, museums, or even holiday parks, constitute public space, or whether mass media or the Internet expand or perhaps obviate public space, betray a sense of uncertainty. This tends to be obscured when the term is nonchalantly applied in the field of visual art. English and French do not have the same lin-

guistic problem that we have in German: with such terms as "art public", "public art", "urban art", "art in public sphere". Yet the problem is essentially the same.

To speak of public *space* proves unexpectedly precise when it is considered in its most literal sense, referring to areas left blank in the landscape of town housing, or bounded by architecture. It would be meaningless, by comparison, to describe a wood as public space – be it state-owned, freely accessible, and thronged by walkers on high days and holidays. Anything beyond the busy settlements, especially the city, can count only as landscape. Any country road might constitute space of equal public use to an urban street, but this would hardly distinguish it as a public space.

When seeking criteria for a meaningful definition of public space, its *use* by many people would be too trivial a qualification – It is similar with *accessibility*, in the sense of one's being at liberty to join those many people at any time. Really, the distinctive criterion is the superimposition and concentration of various forms of use. The metropolitan street is distinct from the country road, as public space: it may be sauntered along, it can be and is frequented by all manner of transport. Time can be taken, or one can hurry along it. So many different points cross – the schoolchildren's short journeys with the long distances of the postmen, the meandering way of the pickpocket and the waggly path of the dog and its master. One can shop along the urban street, live on it, display goods in shop windows and make music on its pavements, ride a bike or distribute flyers, sit in street cafés or on benches, erect billboards or put up artworks. The road outside town is just for traffic.

Public space is, therefore, a *condition* – one of *intensifying and ramifying functions*. It is traditionally at its most vital in the town center, los-

ing its intensity in the outskirts and suburbs. Here, of course, smaller centers can also be cultivated, in the villages. As a condition, public space is not dependent on the shape of development alone. The calendar is also a factor. The "dead" village highway, the dormitory-town cul-de-sac choked with parked vehicles and the inner city expressway can undergo sudden transformation when for a few hours a public festival creates a lively space filled with a multiplicity of functions.

Antonio Negri recently witnessed the possibilities revealed by rediscovered public space when French transport workers called a general strike. The urban landscape had long been taken for granted as a backdrop for passing through, or even for traveling underneath on the metro. Now it became clear how far the means of transport had marginalised a whole physical dimension. The modern concept of spatial distance learned from the transport medium was destroyed; confronted, as it were, by the archaic, which sprang from the city and its challenging walking distances – reposing in its buildings almost provocatively. The political hopes which Negri linked to this mass experience, with its spontaneous forms of organisation and self-help, need not be shared in order to see its far-reaching implications. Public space no longer obscured by daily routine is once again palpable with social possibilities and all their ramifications – a situation where artists could only envy the strikers for having brought it about. The failure of one service spectacularly intensified the perception of metropolitan space.

If public space is to be more than a mere planning cliché, then, it must be fed constantly with a supply of collective energy in all its manifestations – political, economic, social, theatrical as well as artistic. The *fourth dimension* of public space is its utilization. Conversely, public space is the *user-surface of the town*. Errant town planning can impede this energy flow, whereas the right planning may facilitate but perhaps never guarantee it.

In the *Draft Urban Development Plan for the Public Domain*, conceived by a Berlin project group, public space becomes a "cohesive primary system, pervading the urban environment", a "basic urban structure accessible to all", "a cohesive urban multi-purpose space, for the free use of the widest general public". This should not only be the case in relation to leisure or recreation, but also to city orientation and the way it may be experienced or interpreted. With this structurally orientated concept, the authors consciously depart from the more decorative school of urban design that sees in public spaces an enclave, a playground for ambitious design. Sometimes fine spaces "lack the structural requirements to make them suitable for public space", while "some unsightly place, in urgent need of improvement" might "possess elements basic to support public space". The plan, therefore, begins with the premise of public space as an aesthetically neutral structure.

Nevertheless, public space is regarded neither as a mere "by-product of urban planning" nor as "space resulting between two buildings – or left-over space"; with which the theme of planning comes into play again. It is in fact the counterpart to utilization: if the social characteristic of public space lies in its mixing of many functions, then in terms of urban planning, it must have its own clear quality: be an identifiable entity. It is not enough to be able to discern only that a space has been separated out in some way from a settlement's structure. The wasteland of the bomb-sites that punctuated so many devastated cities after the Second World War offered the opportunity for a mixture of social uses by children at play,

courting couples, tramps, pet owners; they formed local parks for recreation, and black-market places. But they were not manifesting as public space. Unlike the sleepiest piazza in a little Italian town, the role of which as public space is architectonically articulated.

The planning of public space must be regarded, therefore, not as a phenomenon of omission, but as an independently articulated sphere. Then the attention given to design, whether conscious or otherwise, forms a reliable gauge of the vitality of that space and the regard given it. The façades which front a public space betray, in the quality of their design, an attitude to those who use the public space, to passers-by, and to those who sojourn there. In modern times respect has been rather scant. Indicators of the complexion of public space are also the mostly questionable accoutrements of *street furniture* with which local authorities decorate it, to the hilt. Robust bollards which bar motorists from double-parking, rubbish bins gracing nostalgic street lamps, crudely designed benches or elegant shelters, designer advertising-vitrines and archaic boundary stones, decorative paving designs, and plant tubs are amongst the arsenal of factory-produced homeliness from which Wolfgang Ullrich has correctly inferred the attempt to superimpose on the long-neglected public sphere an internalised aesthetic absorbed from the domestic sphere.

The most reliable indicator of how seriously a community takes its public space is probably shown in the horticultural sphere, where time and money are invested in nature, in the middle of the city. Ornamental trees, regularly trimmed, well-replenished borders, and a plethora of colourful annuals are distinctive features of the degree to which public space may be articulated, way beyond architectonic limits, while hardy ground-cover in large concrete tubs

makes the weakest statement. The slightest investment in design, however, distinguishes public space from mere *residual areas* which result from disorganised planning – empty spaces in the middle of towns, which remain barely noticed.

Thus, there are two axes between which public space can be located: that it has a *mixture of functions* and an *urban distinctness*. The latter is the answer to what is *spatial* about public space, the former to what is *public* about it. Their interaction brings about a wide variation in the degree of intensity. Thus there is public space with a high degree of mixed activity and much design, as in a prize piazza in the inner city; while a cemetery may display a similar density of ambitious design, but very little functional mixture. Then again, arterial roads can be multifunctional, though unslightly and vacant sites forgotten by the inner city's planners are mere negatives of public space.

Performance

User frequency, access, functional mix, the vividness and clarity of the impression public space leaves and the quality and extent of design put into it, however, are not criteria which can explain the aesthetic and political *virulence* attached to public space, which it derives chiefly from its characteristic as a *space for play* in a double sense. It offers scope for many different modes of behaviour, and it even appears that the denser the mixture of functions, the greater is this social scope. Every aggressive monoculture, such as that of a shopping zone calculated purely on a commercial basis, is a threat to diversity of behaviour, which must from that point on appear deviant, no matter whether embodied by the homeless or punks, by political agitation or busking, by children playing or pensioners standing still a moment on their slow walks about town.

Mixed function must therefore be combined with a wide social spread. Only then can public space realize its considerable part in a city's appeal, which it does even in cities whose face and structure otherwise offend all the rules of urbanity. Then the space becomes the playground of self-portrayal for the individual in public exchange in which the fashions worn by the current mainstream and the iconography of body-emblems sported in the radical subcultures can make for an impression of social colorfulness, but one which does not communicate so well for the individuals in their homes and at work. Urbanism may often go no deeper than these amorphous parades on the catwalks of the shopping malls and squares – but it does so in a thoroughly fascinating way.

Evidently, how public space is perceived also changes with the seasons and the circumstances in which it is used, with the moods of the passers-by and their experiences as eager-to-buy bargain hunters or as an unemployed looker-on at the consumer scene; as the participant in distracted erotic attentions, or as the victim of a night-time attack in a city-center devoid of people. The urban sphere is one of peculiar unreality in any event, even when it is busy with people, because it is above all a space for transit.

Its passers-by accelerate, unwittingly compelled by the speed of the same traffic that damages their microclimate. The environment has the design of a stage-set. The ostensibly identity-creating "islands of local-historical tradition" all have the effect of having been freshly varnished for the tourist-camera perspective; and even the great effort of self-representation in clothing, jewellery, body markings and movement can seem like thin whitewash over a base of isolation and separation; like the dogged parading of the "Lonely Crowd" (David Riesman).

One only needs to become aware of a long-term resident of the public domain *within* that mass to be disabused of any remnant of urbanist euphoria one might still have cherished: a homeless person. His is the most public life of all, for he has suffered the total loss of that privacy that traditionally defines the opposite domain of the public. Forced to make a home with privacy's movable wreckage in the open, he must lead in it the most private life of all – of complete isolation in his need. Without the protection of established privacy, his existence is inescapably public. He is as vulnerable to molestation by the police as to crime, exposed to the weather and to nature in general, and is stuck in a thoroughly inhospitable cleft between the private and public domain which only becomes visible by his being there, and which nobody wants to see.

An unwelcome element almost anywhere, the homeless are the best indicators for how "public" a given space is. This has been amply demonstrated by proprietors of inner city boutiques, if only in the way they have sought to be rid of the undesirable highway folk. They attempted, totally inconspicuously, to buy up a narrow strip of the public pedestrian zone in front of their premises, so that they could then take advantage of their domiciliary rights to have the police remove the mobile residents outside their shop-window frontages. In waiting rooms or in shopping arcades, to be sent off in this way is nothing unusual for the ragged figures, in the haze of their smell and slurred speech. To witness just once such act of dislocation in a railway station, for example, is enough for any hitherto intact, let alone social-romantic notion of the public sphere to come out markedly chipped.

The fact is that public space is both a definition and a *figment*, the latter for the benefit of all those users who can cross the invisible access

barriers so unhindered that it never strikes them that barriers are precisely what they are. Thus the privileged can enter a station – as Yutaka Sone says, "a very public space" – sure in the knowledge that they can move as freely here as in a department store or a park. But even where admission is free, it can be subject to restrictions which only become visible in the event of a conflict. Thus, access is nothing like as trivial a premise of public space as user frequency; there may be public spaces which are much frequented, but by no means accessible to all.

Thus, German investors have come to grasp the advantages of the North American system of drawing a line around inner-city consumer promenades to keep out the surrounding city space and its potential for conflict. The internalising process is finally extending to the experience of shopping itself. In a multi-storey architectural hybrid of the arcade type and the department store, high-rise buildings on an atrium plan and accessed via galleries, gather a host of shops in a single building. The owner's domiciliary rights make it possible, if so desired, to have undesired lookers-on become gate-crashers such as the homeless and buskers removed; and as easily, to prohibit the distribution of political flyers and any expression of religious opinion. In shopping centers in the US, this kind of single-function centre has become so widespread that it could be taken for a conveniently covered version of a public space, and is often perceived as such, as likely as without any awareness of the social and political limits it sets. Already, films like David Byrne's *True Stories* (1980) or *Scenes from a Mall* (1990), starring Woody Allen and Bette Midler, have made use of the pseudo-public surroundings of such consumer reservations as the backdrop for their mini urban dramas.

In Germany, too, there are instances of the trend to move such centers to the urban periphery or the land between almost abutting towns – not now as formerly, when the plain, lack-lustre consumer marts were sited in commercial estates on the city limits, but as would-be urban attractions. The inner cities of the future are being planned on the urban periphery – whether successfully, remains to be seen. This displacement and internalizing of once typically inner-city functions is very likely to bring with it a de-urbanization of the urban domain. The culminaton of such a development would be the social and esthetic pauperization of the former centers. In the evacuation of classical inner-city functions to the periphery, public space would be retained in its literal spatial meaning, but it would lose a historical locality with which it has been vitally associated through history, at least in Europe – the city center.

Politics

Apart from the right of assembly, demonstration and expression, the public domain in modern times has a political aspect at a more basic level – in that its *planning and design* is taken to be a matter of relevance to all. To the bourgeoisie of the nineteenth century, the shape of a city was still a matter of esthetic concern, as expressed not least in the affection in which the historic cities of Italy were held. In Jakob Burckhardt's Florence and John Ruskin's Venice, the educated public had before their mind's eye the paradox of the organically developed ideal city. The esthetic ideals of the bourgeoisie were unable to hold their ground against the competing economic interests of the same class. Real estate speculation and increasingly and determinedly economic husbandry at home contributed no less to draining traditional ways of life and esthetic utopias of meaning than did

industrialization, the segregation of spheres of function, and the growth of both inner-city traffic and anonymity.

The civil state did take up the initial impulse, introducing esthetic criteria for the issuing of building permits; but this was not enough to prevent modernization from stripping many towns of their lustre, so that Alexander Mitscherlich might speak of the "inhospitality of our cities", and Wolf Jobst Siedler of the "murdered city". It is a development that provokes emotional phrases and early on drew the opposition of an anti-modern critique of civilization. The credibility of that argument was not enhanced, however, by the fact that the examples it was able to quote were all of cities either unaffected by the problems of modern life, that is, pre-industrial communities which had grown at their own slow pace and had had no great population influx, or of cities dating from the nineteenth century, but which in these instances omitted all but the zones of the privileged – the patrician residential quarters, shops and walks. Even with better examples, this critique would not have held out against the anthropological hardness of hearing of a modernism which regarded the city as the parade-ground for its myth of a self-sanctioning functionality. It was only when the destruction wrought by the bombers' war had literally cleared the way for the construction of these modern utopias, that practical life quickly showed how limited the human image underlying this kind of urban planning was. In a blink, the utopias turned into incriminating evidence for the case against modernism. Modern is ugly, the verdict ran, and at that, far uglier than its critics had ever foretold. The judgement may not apply to famous modernist buildings and model housing developments, and there are persuasive instances which would deserve the respect even of anti-modernists to the present day. But

what the rationalized shape of the modernist city could well have done without is the notorious narrowing of the esthetic concept of functionality to mean economic expediency.

At any rate, one can only wonder, in retrospect, that the twentieth-century debate on the form of the city took place at all without much involving those affected. The public sphere, after all, is political patently because it is a *negotiable* space – but, evidently, far too little is, in fact, negotiated. Apart from the fights for unoccupied housing that were fought by those lacking it over the past decades, apart from the campaigns for the listing of inner-city precincts ruined according to plan, apart from protest action against the price-rises in public transport, the active interest of the populace in the shaping of its urban environment in the postwar era was surprisingly modest. The city was perceived as a fate, not as a workable space with scope.

In contrast, the citizens' voices rise in sudden accord to have their say as soon as modern art is erected in the urban outdoors. This is an old story often told, and the inevitable conclusion is that nothing scandalizes a public space like a work of art; no political demonstration, no unsightly high-rise, no increase in street crime and no ubiquitous dog-turds nor any evening rush-hour jam can enrage citizens and weld them into mutual solidarity as can a sculpture by Henry Moore in a small town in postwar Germany, or a monumental house of steel cards by Richard Serra on the station square of an industrial town like Bochum.

If art scandalizes public space so radically, then in doing so it also makes that space conscious for the first time in the minds of many who otherwise use it unquestioningly and who appear neither to perceive nor to want to consider the changes occurring so rapidly and comprehensively within it. Then, caught up in this mass-mobilization of emotional responses, they dis-

cover the city as their common property in need of defence against the infiltrators. In the process public space becomes territory to identify with, this also in an archaic reflex which functions via *exclusion* and so strives to play down the degree of complexity of modern life. In her book, *The Human Condition*, published in 1958, Hannah Arendt described the modern situation with exemplary accuracy. She offers a remarkable definition of the public arena, which she perceives in a more comprehensive sense than only the urban. For her, "The reality of the public sphere is born of the simultaneous presence of countless aspects and perspectives, in which things in common become manifest, and for which there can never be a common criterion and no common denominator. For, however the common world may put at our disposal the venue common to all, all who convene here will take up a different place in it, each his own, and the position of the one can no more coincide with that of another as with the position of two objects."

If the step of exclusion is an archaic reflex action of political identification, then the dispute about art in public spaces sees another such reflex come into play. Opponents of public art frequently suppose that they have a direct control over the public space just beyond their front door, in their quarter or in their home town. Whereas the *Draft Urban Development Plan for the Public Domain* asserts drily that, "In principle, the local resident has no prior rights over those of passers-by where the public space beyond his front door is concerned." It is only this understanding of public space that makes it a democratic space, in which privileges of origin, length of stay and ownership do not apply, but the processes of political and administrative decision-making do.

Between Kitsch and Refusal

This said, the art-in-public-places dispute so eagerly fuelled by the media and the local press in particular, is not nearly as representative as the participants would like it to be. The image of art in public places as presented in the much-attended scandals is a false one, and these scandals should not blind us to the wholly different circumstances which are the rule. In the meantime, a number of German towns have published surveys listing the works distributed within their city limits after 1945. The outcome is rather sobering: rather jolly, soundly crafted sculptures with easily identifiable subject-matter predominate, moderately modern pieces of decor placed less in the centers than in the adjoining districts and suburban communities. If these findings and one's own visual experience are extrapolated, then the decoration of Western Germany's small and large towns poured solid sculptures in great numbers into school playgrounds and the gardens in front of municipal authorities, into zoos and sports grounds, in front of hospitals and schools, homes for the elderly and administrative buildings, into new housing estates and parks and lawns – not to mention the diminutive fountains and fauna in bronze contributed to the *basso continuo* of figurative kitsch by the local branches of savings banks or inner-city retail associations. The most conspicuous feature of such figures consists in their inconspicuousness. Bland echoes to the taste of the passer-by, they merge almost completely with their surroundings as pieces of decor. No matter how generous they may be in their storytelling, they cannot do what was once demanded of outdoor sculpture, in the nineteenth century – that it should be fragments from a greater narrative. As for scandal, the only sense in which such pieces might qualify is that nobody appears in the least ruffled by them.

Although it is likely that the sculptures erected in public spaces are more often figurative and conventionally crafted than radical or abstract, the resistance from duped residents and passers-by has lent the abstract the high profile that has made it representative of the debate. These works seemed to confirm that modern society is unable to bear a contemporary image of its modernism. But the impression one could be forgiven for having often enough, that is, that modern works of art draw animosity as scapegoats for modernism as such, cannot stand as a general hypothesis. There is no **simple** grammar for such conflict, especially since it can be ignited just as readily by figurative works.

The issue in this kind of conflict is more than the form and symbolic potential of art, in any case. It is always also about the presumption with which an artist dares to make an enduring subjective statement in a public space. In so doing, s/he is given a dominance in terms of representation which grates on the passer-by's democratic sense of equality. The aspiration of the esthetic elites, to enhance the urban space with works of art, does not even need to affect the passers-by in their freedom of decision-making, movement and action, still they feel wronged by trespass on the realm with which they identify. The dispute that inevitably ensues is in most cases the second round, the first having been played out behind the scenes, between local politicians and local authority department heads and the elite concerned with aesthetic function, bent on conquering areas of free articulation for the artists who are the *genuinely* competent party. So the public realm is also a patchwork of areas of competence, in other words, a *bureaucratic space.*

Conflicts of this kind must lead into an aporetic situation: in a democracy, everyone wants to see her/his esthetic tastes represented, but no-one would want to tolerate the esthetic chaos that would be the only possible consequence. Since all are convinced they speak for the majority or that they are qualified to speak in matters of art, however, there seem to be only two alternatives for dealing with the dilemma. Either the greatest common factor of the greatest conceivable majority is taken as the guiding principle, which would ultimately imply decking out cities with heavyweight trinketry (already adopted as standard practice by some cities), or it is assumed that in the modern age, art has become both an unreasonable demand on the average beholder and never ceased to be a matter for the experts, in which case a few experts are commissioned with indeed entrusting such a challenge to the interest of the citizens, whereupon these again resolve that they, too, have some understanding of art.

The Federal Republic of Germany had, for decades, a method for getting out of this stalemate, and that was to quote a higher maxim: since postwar Germans were regarded as backward equally in questions of democracy and art, reeducation could become the postulates of a democratic arts policy. With the exercise of democracy and a tolerant approach to art placed under a common proviso, the traditional German notion of the arts as *Kultur* and *Kultur als Bildung* – as education and good breeding – was able to acquire meaning once more, and to unite politics and culture under a common denominator. But the concept of *Bildung* in its culturally emphatic form has long ceased to hold as a key factor in society's self-definition.

Instead, a new maxim has been emerging with which the esthetic elites can assert their aspirations. The deliberate featuring of urbanity has become for many cities a means of enhancing the qualities of their locality and their standing in a wider than regional geographic context. This

trend was given the fittingly catchword of "festivalisation" by two sociologists, Hartmut Häussermann and Walter Siebel, in their volume entitled *Festivalisierung der Stadtpolitik* in 1993. Contemporary art is, in fact, given a warmer welcome in public spaces than it was just a few decades ago, because it can become the subject of sophisticated conversation, raise the urban environment to a status of international presentability and make it a vitalising factor in the region. At the same time, the years of indispensable provocation in art seem to have come to an end; many artists willingly oblige these instrumentalising interests, at any rate, and this plays its part in weakening the definitive significance of a conflict-based theory of outdoor art.

Its esthetic version remains virulent: the thesis that art, also the outdoor kind, is *in duty to refuse ("Verweigerungspflicht"),* as Martin Warnke phrased it in the title of an essay dedicated to the modern separation of art and the public sphere. This could pass readily as the motto of an esthetic opposition aspiring to assert and extend Theodor W. Adorno's esthetics into outdoor spaces. But it would be a flaw in such demands that they were developed for an art beholden to a great extent to internalization and so to the reserves of the elite, visited voluntarily. Art outdoors, however, is the sole genre of modernism besides architecture to have to take an *involuntary viewer* into account. Thus it, more than any other, has the double nature defined by Adorno, of being both a "fait social" and autonomous; a state of affairs the political significance of which it is easy to underestimate. The involuntary viewer of the outdoor environment was long the cheap target of artistic provocation and the reliable guarantor of its unbroken power to irritate, but cannot be placed under esthetic tutelage.

An art under obligation to refuse in the public arena would result in a cultural paradox as well as the democratic aporia described: Is a city conceivable that would have outdoor sculptures deny its very quality as a space for living in? To stage urbanity has been one of art's traditional jobs, even in cities which were no less problematic politically and economically than their modern counterparts. Can art therefore lend itself to the enacting of urbanity in the present day, irrespective of the many discrepancies in this form of settlement? Or are the sculptures which "work" best in an outdoor situation still those which scandalize it? Should modern art, as at its birth, seek conflict with the bystander and beholder to avoid being abused as a charmingly novel backdrop for consumer life? Might it even be its duty to make the urban alienation visible and so open up the public field as a space for political action? Or is a contemporary art thinkable which respects the passer-by without underestimating him or her as an addressee – which does justice to its venue without pandering to it, or which even enhances that venue without functioning only as decoration? And would modern art be capable of setting up a narrative again, of reciting in public space more than the report of its internal, art-historical position readings? Or would it then become a picturesque sop to a problematic form of settlement, in other words, something akin to street furniture?

Example: Münster

In 1977, the Westphalian city of Münster began a long-term experiment in this field, the results of which, including the present exhibition, can be discussed in terms of the three campaigns to date. Far from local history or even parochial chauvinism, the issue is the linking of a provincial venue with art of international standing in a way that marks out only one other German town, Kassel. Completely destroyed in the Second World War and, in its wake, left rather

stranded at the frontier of the Western Zone, Kassel is host to what has become today's most important exhibition of contemporary art worldwide. The *documenta* regularly turns the provincial town into a paradox, temporary metropolis. No attempt to vie with this world exhibition has succeeded to date, even in major cities. Only the sculpture exhibitions in Münster, in 1977 and 1987, were discussed in such terms at the time, the more so because they were concurrent with the *documenta 6* and *documenta 8* shows respectively.

However one might perceive the competition between the *documenta*, mounted every five years, and the sculpture exhibition in Münster, mounted every ten, it is conspicuous that it matches two provincial German towns which in fact have something in common. Both were picturesque provincial capitals of decidedly romantic flavour before their complete destruction in the Second World War. Kassel, in Hessen, was a town of striking timbered architecture; Münster, in Westphalia, a dignified university town redolent of history. Though there was not much to choose between the destruction each suffered in the War, the motives for it differed: Kassel was home to the Henschel works, a centre of the Third Reich's armaments industry; Münster, with its historic cathedral, was destroyed in response to the German air raids on the British city of Coventry. The consequences of the destruction were very different, too. Kassel was planned without regard for the former layout of the town to become now a model of postwar modernity, car-oriented and functional, unsentimental and egalitarian; Münster, on the other hand, its center reconstructed somewhat loosely historically, but in exemplary fashion, has become the model of a reconstruction striving to reestablish historical connections.

So, too, the circumstances which led to the two exhibition concepts, both to become interna-

tional successes later, were different; but they had in common the initial diagnosis of a backlog to make good. In Kassel, the goal was to rehabilitate the modern art which the Nazis had banned. In 1955, the blueprint of an event was created that would later prove particularly suited to give regular reports on the state of contemporary art. In Münster, on the other hand, the irritations that led to the exhibition series initiated in 1977 were quite different. In the 1960s, the city had rejected the generous gift of an outdoor sculpture by Henry Moore, who had become a sculptor much in demand in other large West German towns after the War, and was also a regular guest at the *documenta*. In the mid-1970s, the debate around this missed opportunity led to Münster's purchase of a kinetic outdoor sculpture by George Rickey – but its erection on a public site ignited a chain of protest.

To bridge the obvious lack of information discernible in Münster's traditionally conservative population, the Landesmuseum set about preparing a comprehensive exhibition on the history of modern sculpture, that curator Klaus Bußmann originally conceived purely as a museum show. Yet a crucial addition to the exhibition was elaborated together with Kasper König, born near Münster, but who was then living in New York. The exhibition would be extended, with projects taking place outside the Museum. Nine contemporary artists were invited to submit ideas. They were Carl Andre, Michael Asher, Joseph Beuys, Donald Judd, Richard Long, Bruce Nauman, Ulrich Rückriem and Richard Serra.

In Kassel the same year, *documenta 6* had opened the grounds of Karlsaue Park to sculpture for the first time. The organisers of the former *documenta*s had made astonishingly little use of it in the past. In *documenta 2* (1959), there had been an architectural stand installed for outdoor sculpture in the ruins of the orang-

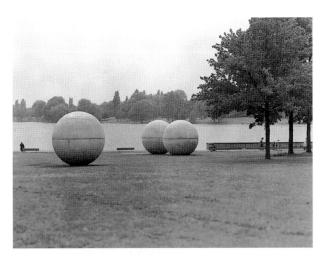

Claes Oldenburg: *Projekt für Münster II*, contribution to *Skulptur Ausstellung in Münster 1977*, location: Aasee terraces, south of Adenauerallee, concrete, three balls with diameter of 3.5 m, permanent installation, acquired by city of Münster

bound square. Claes Oldenburg installed an invasion of concrete billiard balls that dwarfed visitors. Bruce Nauman planned a *Square Depression* in the ground for a university campus, Michael Asher made a caravan appear at various points in the city. Joseph Beuys made a cast in wax and tallow of a space beneath a pedestrian ramp. Finally, Ulrich Rückriem set nine wedge-formed dolomite blocks on an inner-city way. Two further pieces were placed in a more park-like situation by the nearby Aasee. They were Donald Judd's two concentric concrete rings and a Richard Long stone circle.

The Search for Location 1977

It was of course, no longer new, in 1977 to place contemporary sculpture in the city space. In her dissertation on the history of such campaigns, Claudia Büttner cites as the first example in 1931 an event at the Kunsthaus in Zürich entitled *Plastik* (Sculpture). She examines relevant events in Spoleto, Italy in 1962, New York in 1967, Southampton in 1968, at Grand Rapids in 1973, Monschau in 1970 and Saint Paul in 1970. In 1971, there was the exhibition *Sonsbeek buiten de perken*, with which Wim Beeren attempted a bold revision of the conventional link between park and art. Amongst the precursive events significant for the Skulptur Projekte curators, was the *Umwelt-Akzente* exhibition (Accents of Environment) organized in Monschau by Klaus Honnef in 1970. Indeed, the American artists, for their part were already of equivalent standing to the bold native discussions and campaigns.

In divergence from the preceding exhibitions, some new precepts developed in Münster, which became typical for *Skulptur Projekte*. From the outset, the conventional procedure was avoided – where sculpture conceived in the studio would be placed in an optimal open air situation, there to await the museological

ery. And this remained the gravitational center for outdoor sculpture in following exhibitions, as though there were a reluctance to trust sculpture to the far reaches of the parklands. This shyness was the more puzzling, considering the fact that parks had long been deemed worthy surroundings in which to erect modern sculpture. From 1949 on, in Sonsbeek near Arnhem in Holland, and in Middelheim near Antwerp in Belgium, there had been frequent exhibitions which attempted to integrate modern art and nature, as there were in Battersea Park in London, shortly before, and later, in Louisiana near Copenhagen. But it was not until 1977, under the direction of Manfred Schneckenburger, that the Karlsaue site was used expansively by the *documenta*. The town itself, however, was not used.

This was in the end to the advantage of the exhibition in Münster 1977. Six of the eight invited artists related their works to municipal situations. Richard Serra positioned two corresponding double-yards of steel on a traffic-

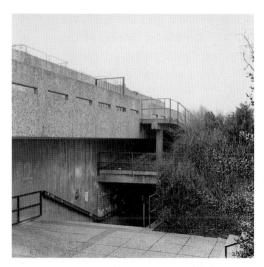

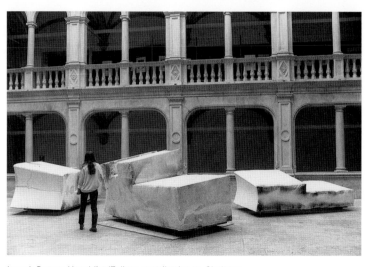

Joseph Beuys: Hollow space between pedestrian ramp of lecture hall and pedestrian tunnel at Hindenburgplatz, model for cast of *Unschlitt/Tallow*

Joseph Beuys: *Unschlitt/Tallow*, contribution to *Skulptur Ausstellung in Münster 1977*, location: atrium of old section of Westfälisches Landesmuseum, temporary warmth sculpture, tallow, Chromel-Alumel thermo-elements with compensating circuit, digital millivoltmeter, alternating current transformer, wedge 9.55x3.06x1.95 m

attention, which, frankly it would rarely earn. This way of searching for space was satirized by *Claes Oldenburg* in his Münster submission. He superimposed an invasion of over life-size billiard balls onto postcard views of Münster. This raiding party presented a caricature of the fantasies of artistic disposal which tend to beckon during public space projects. It is also a metaphor for the skill necessary in the placing of a billiard ball, or an art-work, to achieve the best effect. Three of the balls finally ended up on the embankment of the Aasee, not far from the city center, have become there something of a city emblem.

Alternatively, *Joseph Beuys* developed a complicated game of reference from Oldenburg's ironic search for public space. For his angle, he chose the scruffy cavity that opened out under a pedestrian ramp above a subway, on the outskirts of inner city. The resulting bizarrely proportioned space, just a concrete hole where "natural integration" takes the shape of the dirt that finds its way in, Beuys had reproduced in wax and tallow original size, with the intention of dividing the *Unschlitt* (Tallow) negative form into blocks which could be exhibited during the exhibition in the airwell of Münster's Landesmuseum. In fact, the *Unschlitt* form took so long to cool that it could not be divided and shown in the Landesmuseum until after the exhibition had finished. Yet even in this way Beuys was able to demonstrate that the scope of artistic construction offered by public space does not exclude ugly, marginal areas. This distinctive local reference has been lost in the course of the works subsequent and continuing reception. The work, which Beuys – together with the collector Erich Marx – unsuccessfully offered as a gift to the Landesmuseum's director of the time, is now a prized object in the

Marx collection in Berlin. The space from which it was formed has now sunk back into the twilight zone of the indifference of passers-by.

Beuys had, for the short term, brought together two polarities of public space which, in levels of esteem and perception could hardly have been further apart: a *black hole* of haphazard planning, and the most highly regarded public institution, the museum. Although both are connected with public space, they fall outside the realms of its definition. Left-over space is the far, rough side of esthetic public space. The museum is a powerful institution of bourgeois public space – but it is a public *building*. Beuys's double transference of a hollow to a sculpture and into the interior of a museum linked public space with its two extremes, forming a trenchant example of the supremely keen perceptive power of this artist.

The same words would also describe the contribution by *Michael Asher*. During the campaign a caravan would appear, parked at definitely planned times in various locations in Münster. These were carefully chosen, although they appeared incidental. The discrete confrontation of the nomadic and the sedentary, of motorized independence and the ties of permanent dwelling, unspectacularly skirted the exhibition's premise, to create spectacular monuments. In 1977 this was perhaps the dryest of the project's works. It has since become a personal narrative of the city, one of growing profundity. In 1987, and 1997 he suggested a repetition of the action, only to discover how quickly the shape of a city can change, even Münster, with its conservative mind-set. Some of the spaces which existed in 1977 and 1987 were no longer available in similarly usable form.

In his unfinished book, *La Mémoire Collective*, the French sociologist, Maurice Halbwachs, who was murdered in 1945 in Buchenwald, describes public space as the memory of a town, because here all its historically developed structures remain. Considered in this sense Asher's interventions mark alterations barely picked up by everyday perception, and by which

Michael Asher: *Installation Münster*, contribution to *Skulptur Ausstellung in Münster 1977* and to *Skulptur Projekte in Münster 1987*, caravan in changing locations, 19 different sites in and around Münster, parking position of 1st week

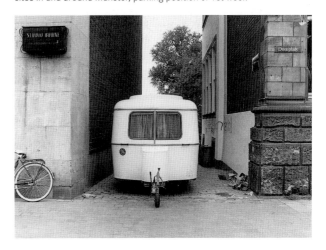

a city *loses* its memory. They are legible of course, only to the citizens and organizers of the exhibition, yet their "local speciality" links them with an all-embracing contemporary theme – the complaint of Baudelaire (and Walter Benjamin) about the unreliability of the town, which has no regard for the image held in the memory of its citizens finds a subtle and distant echo in Asher's caravan action.

Donald Judd, too, showed great precision in his choice of place. His search brought him to a gently sloping meadow by a path on the embankment of the Aasee as the place for his two concentric concrete rings. The outer one was planned to follow the incline of a slope,

and the inner to follow the horizontal. The abstract contrast between the inclined and the horizontal rings thus appeared to emphasize, as a poetic transposition, the contrast informing the landscape – the slope and the lake surface. Judd stated later in his catalogue text that the sculpture was neutral to environment, and could be placed in any chosen spot. However, it was its proximity to the lake which endowed it with a site specific surplus from which it clearly profited.

Judd's work was purchased after the campaign, thus marking another exceptional feature of the *Skulptur Projekte* as a model characteristic of the new approach to outdoor sculpture. Until now campaigns had either involved works being returned to studios and museums after the exhibition, or work was placed successively in the urban space, intended for permanent display. Such a successive positioning of works took place in Hannover in the early seventies in the much noted experiment, S*traßenkunst* (Street Art). In Münster, different objectives were set. In fact, in order that the individual projects might be realized, the organizers shouldered the production costs. However there was no commitment to purchase, or to provide permanent exhibition space when the event had finished.

If it could already be seen in 1977 in the works of Asher, Judd, Oldenburg, and above all, in Beuys's transformation that a site specific approach emerged that international discussion of external sculpture would be determined

Michael Asher: *Installation Münster*, contribution to *Skulptur Ausstellung in Münster 1977* and to *Skulptur Projekte in Münster 1987*, caravan in changing locations, 19 different sites in and around Münster, parking position of 4th week

of, perhaps *Ulrich Rückriem's* contribution might be cited as the most remarkable. He cut nine rough pieces of dolomite into wedge forms, and placed them along a path, thereby conveying the hint of a passage between an adjacent church and the stones. It was a work which received as much emnity *en place* as it was highly esteemed nationwide. The path between the Jesuit church and an adjoining meadow, had been spatially indeterminate. On one side, the long façade of the church formed a high and dramatic spatial border. On the other, a meadow seemed to lose itself. Between these extremes, apart from its surfacing, the path lacked any spatial articulation of its own. In the formal abstraction, and very immediate nature of the material of his sculpture, combined with the ambivalent spatial situation, Rückriem found his chance to make an intervention which would transform the location, and articulate the path as such. He chose a formal location, one which was not illustrative (as was to become dominant in the 1987 campaign). It existed purely from topographical plausibility, which must have been directly conveyed to every passer-by.

Site specificity 1987

In 1977, the concept of the site specificity of sculptures was by no means as current in Europe as it is today. It was coined to describe a restoration of a lost context of a work and its site. If sculptures had traditionally been created for specific situations, their *venue*, the demand for autonomy and the internalisation that had come with modernism had cut short this relationship. Although studio pieces continued to be placed in a landscape, park or urban situation after the end of this unity of presentation, occasionally with great awareness and sensitivity, site specificity meant more than only a spatial and atmospheric correspondence of a work

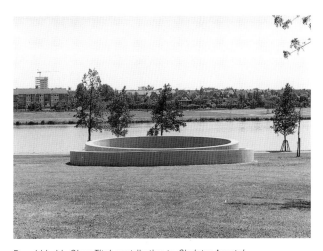

Donald Judd: *Ohne Titel*, contribution to *Skulptur Ausstellung in Münster 1977*, location: southwest lawn of Aasee below Mühlenhof, two nested rings, concrete, outer ring 0.9x0.6 m, diameter 15 m; inner ring rising frame 0.9 to 2.1 m, thickness 0.6 m, diameter 13.5 m, permanent installation, acquired by city of Münster

Ulrich Rückriem: *Dolomit zugeschnitten*, contribution to *Skulptur Ausstellung in Münster 1977*, location: north side of Petri-Kirche, nine-part sculpture, Anröchte dolomite, 3.3x7.2x1.2 m, temporary installation from January 5, 1981, permanent installation since 1986, permanent loan from the artist

and its final location; it implied that they are in some sense *inseparable.*

Richard Serra's *Splash Pieces* are without doubt among the earliest and most radical testimonies to the genre. The distinction which Robert Smithson drew between *sites* and *non-sites* as a working concept from 1968 on is of the same kind, and Land Art in general appears to have been a paradoxical transitory stage for the ideas that were subsequently used to redefine urban art. Most conspicuous in this context are Christo's early works, with which, at the beginning of the 1960s, he may well have been the pioneer of this working approach alltogether. Pop Art came to give art back its narrative dimension, and Claes Oldenburg played it out to the full in outdoor situations, staging anecdotal connections between his sculptures and their sites. In Friedrich Meschede's view, the paramount pioneer of this mental attitude was the architect and sculptor, Tony Smith, who, between 1961 and 1969 prepared the change of paradigm – having exercized his influence on artists of the later generation, including the Minimalists, from 1950 on as a teacher at the Cooper Union, the Pratt Institute and Bennington and Hunter Colleges.

An early testimony for the new thinking in the critical literature is discerned by Claudia Büttner in Irving Sandler's catalog contribution for the New York exhibition, *Sculpture in Environment* (1967). Sandler already made the point that artists may not only place studio pieces in outdoor locations, but work with specific places in mind from the beginning. This option was evidently given half the twenty-four artists who took part in the show. Ten years on, the catalog of the *Skulptur Projekte* reveals a phrasing of Klaus Bußmann's that develops this idea and distinguishes between artists "who trust the autonomy of sculpture (i.e., to put it pragmatically, whose works can be moved from one location to another) and those who make the topographical, urban or social reference an integrated constituent of the work."

That the new idea caught on and was adapted to the German scene was partly due to the close contact existing between the curators of the *Skulptur Projekte* and American proponents of Minimal Art, who were familiar with the new developments, on the other hand it was Ulrich Rückriem who reflected the interdependence of location and sculpture from the beginning of the 1970's. But it was not until the early 1980s that art criticism in the German-speaking countries took to wider discussion of the relationship of outdoor sculptures to their sites. The decisive stimulus came from an essay which Jean-Christophe Ammann published in one of the first volumes of the art journal, *Parkett*, in 1984. He discussed the term of *drop sculpture* which had been coined in criticism of the urban arbitrariness of many outdoor works. Ammann made new demands of art in public spaces. His points of reference included the approach of Siah Armajani and like-minded spirits.

Site specificity was to become a central issue for the second exhibition campaign in Münster, coupled with Kasper König's verbal offensive, "From the Park to the Parking Lot", his honed version of Wim Beerens' palace revolution at Sonsbeek. Once Rudi Fuchs had set himself a limit of some few outdoor sculptures at *documenta 7* in 1982, it was up to *documenta 8* and the *Skulptur-Projekte*, both in 1987, to respond to the new challenge. In Kassel, Manfred Schneckenburger seized the opportunity of his second curatorship to complete the *documenta* event by extending the sculptural contribution not only to the Karlsaue park and in front of the Fridericianum, but also into the townscape. The response in Münster in 1987 was a fundamentally altered concept. Numerous artists were invited to the

town well in advance, to find sites where they could imagine placing an outdoor work. Thus the search for a site, once the final stage in the realization of such pieces, now stood at the very beginning of the production process.

The task confronting the artists now was to engage with the town intensely, in spatial, historical and personal terms; to study painstakingly the urban circumstances into which they were about to intervene. But the situation also gave them the opportunity to let spectacular or unexpected sites become their inspiring venues. What visitors to the completed exhibition encountered as a sum of outcomes, the frequently cogent symbiosis of places and works, had already passed through its most interesting stage – with the city's examination for its usability in the artists' eyes. Some of the artists looked for the kind of spaces to which they were already accustomed to responding; others found locations that presented new challenges; and others again felt the appeal of places that met them, as it were, half-way.

There was the inner courtyard, for example, which Siah Armajani discovered a stone's throw from the Museum and the Domplatz. Until then, it had not figured among the places people knew about in the center of town. It is an inner courtyard populated by exotic trees and geologically significant stones from all over the world; but it is not open to view from the adjoining public steps, thus forming an oasis as accessible as it is empty in the middle of the city, skirted by university buildings and lying above an atom-bomb-shelter where a researcher into ant life kept his laboratory, in the optimum research conditions offered by this vibration and shockproof environment. On this site, Armajani found an ideal location for a research garden, and, in the collection of exotic trees and much-traveled stones, a metaphor for his own inter-cultural identity.

Siah Armajani: *Study Garden*, contribution to *Skulptur Projekte in Münster 1987*, location: garden of Geologisches Museum, Pferdegasse 3, two-part seating group with two corner benches, two benches, four stools, and table, wood, steel, 1.0x5.8x7.8 m and 1.8x1.3x1.3 m, permanent installation, acquired by Westfälisches Landesmuseum

It was an example of how the process of locating a site was able to become integral to an outdoor work. At the other end of the spectrum, Peter Fischli and David Weiss demonstrated a sceptical stance. In the environments of the railway station, they installed a model of an archetypal 1950s building, which they had made for another occasion. Their running theme, the non-specificity of modern locations, was set against the context of the other, happily localized projects, and from their sober detachment, they defined the basic artistic attitude of the 1987 campaign candidly as "contextual kitsch". The contributions to the *Skulptur Projekte in Münster 1987* fell along a line between these extremes – narrative and seri-

Peter Fischli/David Weiss: *Haus*, 1987, contribution to *Skulptur Projekte in Münster 1987*, location: Von-Steuben-Straße, wood, plexiglas, painted, 3.5x5.7x4.1 m, scale 1:5

ous reflections on sites and playful and transient ones were present in equal measure through the greater part of the range. Those familiar with the city were treated to an unintended element of comic irony, however, when Scott Burton entrusted to the video camera his appealing credo, *The site has to be respected* – before the ingratiating, incongruously stylised façade of a department store.

In the end, it was not Burton who used this site, but Katharina Fritsch. Here she installed her highly associative *Gelbe Madonna* (Yellow Madonna). Perhaps the most mischievous work in the 1987 campaign, the *Gelbe Madonna* derived its essential effect from a tension in which skepticism toward the kitsch of context became mixed in a disorientating fashion with

real reverence for the particular arena. In the siting of a popular religious, narrative figure, the Lourdes Madonna, in an inappropriate location, Fritsch interlocked artistic and cultural reassessment, the erecting of a religious instrument of pathos in a consumer zone confronting two competing notions invested in and informing modern life. Thus it was no surprise that the blatant contrast moved the public to correspondingly contradictory reactions, among which were that the figure was repeatedly damaged, but then again hailed with flowers, it remaining unclear whether either response had been to the Madonna as found, or the artist's strategy.

The confrontation of religion and commerce was also a response to art's situation in its latter-day competition with the cultural narrative of consumerism. In modern times, the city is an exhibition space whether it displays art or not; it is a presentation space for the merchandise professionally stage-directed as exhibits in shop windows and display cases, where it offers a tangible foundation of sense to the effort sacrificed in the name of the daily routine. The omnipresence of goods at the eye-level of visitors to the city center shouts down any other offerings to the eye, be they of a historical architectural background or a work of art.

In this competition between art and the consumer culture, it must be said that to bring into play the Madonna of Lourdes with her general reputation for particularly unstinting charity had its own, ample irony. The figure, which appeared to constitute a mental refuge, was cooled in its strident monochrome finish, and presented with almost denunciatory acerbity as a mental and spiritual *ready-made*. The magnification of a usually figurine-sized devotional statue to full life-size invited an interpretation as a parody of the process in which models are

"inflated" for realisation in open spaces. At the same time, the figure's effect was one of a statement on the statistical predominance of conventional sculptures in such spaces.

There will have been the beholders who assumed that erecting the Madonna betokened a post-modern return to decorative and narrative sculpture, a kind of religious version of Charles Moore's *Piazza d'Italia*; but the reference to locality by contrast, the denial effected by the use of monochrome and the self-irony in the artistic sphere pointed interpretations anywhere but naivety. Thus the *Gelbe Madonna* united what some passers-by would have found a touching narrative impulse with divergent options of interpretation, and drew its phenomenal conspicuousness not just from the glaring

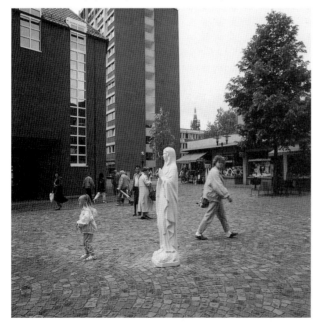

Katharina Fritsch: *Gelbe Madonna*, contribution to *Skulptur Projekte in Münster 1987*, location: Salzstraße, Duroplast, replaced with cast stone after two damagings, 1.7 x 0.4 x 0.34 m, temporary installation during the exhibition (repeatedly vandalized and stolen)

monochrome, but above all, from the contrast in which the work stood to the shopping promenade.

My reference to this contrast should not be taken as a hackneyed criticism of our civilisation, however, for the European city center has always possessed two wholly different centers of energy: the Church, in the shade of which the dead were buried for a long time, creating a zone of double links with the beyond; and the market places. Apart from its role as a meeting place, its significance for jurisdiction and the execution of penal sentences, and as the venue for festivals and showmen, these squares obtained their overriding importance precisely in the commercial practice that gave them their name. So, if one criticizes town centers as zones of consumerism, it is to look at them not so much in a modern, but in a traditional function; albeit that this function has acquired a significance far beyond the one it had in former times, both for the shape of the city and the way of life of its users. In contrast to current critical theories of civilisation, which espy a threat to urbanity in the trimming of city centers into consumer zones, Wolfgang Ullrich sees in the intensive exploitation of costly inner-city plots a concurrent guarantee for a vital compounding of the city structure – much as enforced in times past by, say, the confinement of the city wall. It is precisely the amorphous city centers in formerly Communist regions that supply him with supporting evidence for his argument that the pressure of market economics on public space is indeed culturally productive.

This notwithstanding, proximity to the consumer zone will continue to have a disconcerting effect on art in an urban context. Benjamin Buchloh criticised another contribution to the 1987 project, Thomas Schütte's *Kirschensäule*

(cherry column), in this light for its postmodern amenability. Buchloh saw in it, as he did in Scott Burton's seat pieces, one of the "favorite would-be solutions" of postmodernism, namely the strategy of a "populist iconography: simulacra of nature and seeming utilitarianism; attempts to prescribe sedatives to the observers to pre-empt their outrage at their alienation. [...] The wrong kind of adaptation as a tribute to desublimation serves only to affirm desublimation completely." In fact, it was a characteristic feature of the campaign of 1987 that figurative, narrative and decorative works and the provision of fanciful services were presented in the public sphere in an unselfconscious way that would have been utterly inconceivable just ten years before and would not, in fact, have been in keeping with the aesthetics of a Richard Serra as critically favoured by Buchloh. Along with Katharina Fritsch and Thomas Schütte, Stephan Balkenhol, Fischli/Weiss, Ludger Gerdes, Keith Haring, Thomas Huber, Jeff Koons, Ange Leccia, Matt Mullican, Nam June Paik and Rémy Zaugg were among those who gave the show a narrative bias, while Scott Burton, Dennis Adams, Siah Armajani, Richard Artschwager, Jenny Holzer or Franz West obliged the visitor with usable, but in that quality no less ambivalent sculptures.

Buchloh's criticism was not the only adversity encountered by the *Kirschensäule*; having been purchased, it had to pass through a phase that presented a considerable threat to its presence on its chosen site. The land on which it stood was completely redesigned. During the exhibition, it had been a parking lot where the different colours of car paintwork set up a rapport with the gleaming red surface of the cherries; but then the land was barred to cars, so that it has seemed ever since as if it had been designated a protective zone laid out especially for the sculpture. Far from serving it, however, this

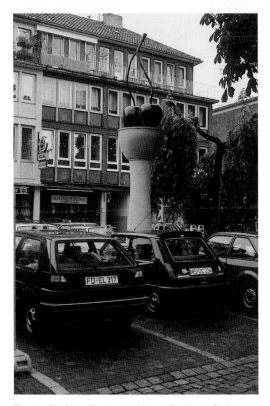

Thomas Schütte: *Kirschensäule*, contribution to *Skulptur Projekte in Münster 1987*, location: Harsewinkelplatz, sandstone, aluminium, painted, height 6 m, permanent installation, acquired by city of Münster

imposes its own esthetics upon the work. In his detailed critic of this redesigning of an urban patch reprinted in this catalog, Friedrich Meschede has discerned an attempt to transform a once intensively used and rather, unattractive site into a cleaned-up show-piece of a zone – at the expense of the sculpture. Meschede sees an affirmation of the high quality of Schütte's sculpture in its having survived the beautification of its environment unscathed – because it took up an ambivalent position in relation to its surroundings at the outset. Even so, its fate is also proof that to place art in any city-center zone where redesignation as a cosy corner for

urban street furniture is a possibility, is to be a glutton for punishment.

Memoria

One way to evade the problems, tensions and imponderabilities of the inner-city shopping zone, of course, was for the participants to locate their sites on the urban periphery from the start, like Ludger Gerdes with his captivating *Schiff für Münster* (Ship for Münster), or on status terrain such as the park behind the Baroque Schloß, where Luciano Fabro found an ideal sounding-space for his bewitching *Demetra*. Other artists who skirted the dilemma from the beginning were those who looked to the city's history and were thus able to escape the inner city with its charge of economic energy, if not in spatial terms, then at least on the time axis. Thus Lothar Baumgarten, by an intervention which was as simple as it was effective, succeeded in calling back to life the Anabaptists for whom Münster's history is famous for, and to set something counter to clerical commemorative practice.

The Anabaptists' revolt against the Catholic Prince-Bishop was a quirky chapter even in the context of the Reformation, and meanwhile, thanks to the tribute paid to it by Greil Marcus, famous theorist of Pop, has come to enjoy international subculture renown. The measures taken by the Catholic Church to torment the captive leaders once the rebellion had been quashed included putting them on show in cages; and when they were executed, their bodies were put in the same cages and in them hoisted up the tower of Lambertikirche, both to deny the rebels a burial and to hold before the eyes of the living the deterrent example of the punishment incurred. As exemplary as one may find the reconstruction of Münster's inner city after Second World War, it remains vexing to the present day that the Catholic Church should have found it necessary to reconstruct the destroyed Anabaptists' cages as well, and to suspend them in their original place. How great must have been the satisfaction, four centuries after the victory, to be able still to humiliate the former foes!

With his project, *Drei Irrlichter* (Three Will-o'-the-Wisps) Baumgarten took issue with this triumphalistic form of commemorative practice, and highlighted it with means both simple and disconcerting. In each of the cages, he installed a light-bulb which would light up at night and, given a breeze, would sway gently, lending the Anabaptists a curious presence in the life of the town. If, during daylight hours, they were as dead as they had once been when pulled up the outside of the church steeple, the

Lothar Baumgarten: *Drei Irrlichter*, contribution to *Skulptur Projekte in Münster 1987*, location: tower of Lamberti-Kirche, Lamberti-Kirchplatz, three incandescent lamps in the Anabaptist cages, permanent installation, acquired by Westfälisches Landesmuseum

night seemed to grant them the lamp of life again. Of all the projects ever realised in Münster, none surely achieved so magical an effect with such limited means as this electric charging of history that animated the city as a narrative space without recourse to a single picture. It appears as one of the belated echoes of the original strife, one might suppose, that it was Münster's merchant class, from whose ranks the resistance against the Bishop had once risen, that collected the means for the purchase of this piece and thus for its remaining on this site.

The same good fortune did not befall another project that related to historical events, albeit more recent ones. Sol LeWitt had erected two corresponding structures in front and behind the Baroque Schloß which once housed the Prince-Bishop and now the University. In front lay a black ashlar, more than head-high, blocking the view of the entrance to the Schloß; behind, at the end of the Botanical Gardens, stood a white pyramid. The iconography of death and survival that was realized with such purely formal means, was featured at first, also in the catalog, under the title *White Pyramid/Black Form* but not long afterwards was given an unexpectedly explicit addition: as *Dedicated to the Missing Jews*, the Black Form was intended now to be understood as a memorial. What was remarkable about this reference was that it was not just to the murder, but also to the *absence* of the Jews; not only the millions who had died in the concentration camps, but their unborn children and grandchildren who could have been the teachers or fellows of all those studying dental medicine or philosophy, law or art history at the University of Münster today. The plan to purchase Sol LeWitt's work for permanent exhibition on the same site was checked, however, by resistance on the part of the University.

The rules of play in the Münster campaigns are that all sculptures are erected, in the first instance, for the duration of the exhibition and the contracts with the site owners, in this case the University, formulated accordingly. The organisers pledge to remove the sculptures at the end of the exhibition where no purchase has been made, or where permanent exhibition is excluded by a veto from the owner of the site of the work. This is precisely what happened when the issue was whether to purchase LeWitt's piece. Although this matter united three of the political parties represented on the city council, the Christian Democrats, Social Democrats and Liberal Democrats, in an agenda item coalition unique for the city, the University turned down a permanent siting of the *Black Form* on its premises. The director of the Botanical Gardens likewise vetoed the permanent placing of the *White Pyramid*, on the grounds that it stood on a meadow of ecological significance – which was dug over as soon as the work was removed, and transformed into a rockery.

Dislocated Sculptures

Following this rejection, Sol LeWitt's sculpture was bought by the City of Hamburg as part of its Art in Public Spaces program, and installed in different constellation in the location of a former synagogue. Which raises the question as to a work's relation to its site all over again, a question that in 1987 was by no means an isolated one and not limited to the Münster event. At almost the same time, a debate on the relation of outdoor sculpture to its sites was taking place and drawing much attention in New York. There, Richard Serra was to be compelled to remove his *Tilted Arc* from Federal Plaza, where he had been commissioned to place it. In this humiliating and scandalous debate, Serra's leading argument was

that removing a site specific sculpture from its context was tantamount to destroying it altogether.

In Münster, Serra's contribution that same year had been a sculpture that united poetry and precision. It related to a Baroque town palace built by the architect of the Schloß, Johann Conrad Schlaun. For his *Trunk, J. Conrad Schlaun Recomposed*, Serra had done a survey of the original eighteenth-century Erbdrostenhof, and derived from its elegant curvature the dimensions for a steel sculpture which was as sparse as it was impressive. It was sited in front of the building. It had been plain from the beginning that the work could not stay there indefinitely, and so its sale to the Swiss town of St. Gallen was organised in good time. In terms of site specificity, the move was as contradictory as another decision that Serra had made that year regarding an exhibition in Berlin entitled *Der unverbrauchte Blick* (The unjaded View). Technical reasons meant that the sculpture, *Berlin Curve's*, of two half-shells of steel, each some thirteen meters long by four high, could not be erected on the intended site, the inner courtyard of the Gropiusbau. So, for the duration of the exhibition, it was put up in changed constellation *in front* of the building. As much as one would have wished for Serra's sake that he might emerge from the dispute over the *Tilted Arc* as the winner, his handling of the site-work relationship question in Berlin and Münster could only vex. People were too aware of Serra's towering artistic status and the conflict still brewing in New York to want to make a public issue of this inconsistency, but it still amounted to the first credibility crisis for the approach of site specificity that Serra had been so instrumental and radical in inspiring some twenty years before.

In the light of these conflicts and contradictions, Schütte's *Kirschensäule* represents the borderline case at the other extreme – the loss of context. The work may have stood its

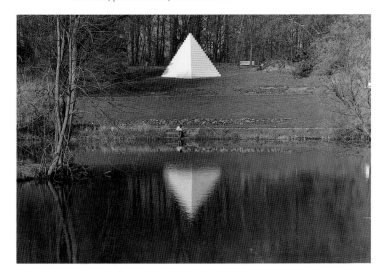

Sol LeWitt: *White Pyramid*, contribution to *Skulptur Projekte in Münster 1987*, location: botanical garden, cellular concrete, painted white, 5.1x5.1x5.1 m

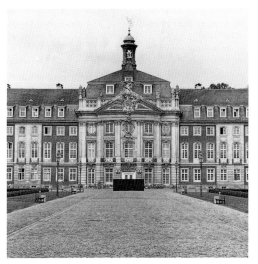

Sol LeWitt: *Black Form – Dedicated to the Missing Jews*, contribution to *Skulptur Projekte in Münster 1987*, location: in front of Schloß, cellular concrete, painted black, 1.75x5.2x1.75 m

ground, but the ground for which it was designed had been utterly transformed in its appearance. The questions with which architect Hans Hollein provoked Serra at a panel debate in Stuttgart in 1988, where Richard Sennett and Eduardo Chillida also took part, targeted a similar issue. Hollein, his own experiences of rejection as an architect very much in mind, asked Serra whether site specific sculpture permitted any change to the surrounding architecture, either by demolition or in the shape of building an extra storey, or even in no more than renewing the flooring. This inversion of the perspective intimated just some of the impasses and quandaries a consistently pursued site specific approach must lead to, if it was no longer to be interpreted as a sympathetic response to the given topographical circumstances, but as making a dominant feature for a site. The fundamental question arising is whether a work designed to relate to a specific place visibly betrays its displacement or misplacement, if, for whatever reason, it has had to be erected somewhere other than the intended site. If such were the case, it would be an interesting blind test in art criticism and we might have to reckon with results as startling as in anonymous wine-tasting experiments. If one concurs with Meschede's assessment that Schütte's pillar works even in its drastically altered situation precisely because its handling of relation to site is inherently ambivalent; if, furthermore, it is accepted that Serra's sculptures can be impressive even in "the wrong" sites – then, the power of a site specific work would still be derived from a considerable degree of autonomy, no matter how residual; that would allow a work to assert itself even in unforeseen situations. At any rate, it would be a foolhardy enterprise to want to forge a postmodern dogma out of modern sculpture's achievement of site specificity.

Richard Serra: *Trunk, J. Conrad Schlaun Recomposed*, contribution to *Skulptur Projekte in Münster 1987*, location: cour d'honneur of Erbdrostenhof, Salzstraße, two-part sculpture, Corten steel. 5.9x4.25x2 m

Muted Euphoria

Dogma or not, the prospect of being able to afford the work of art new social and urban anchorage lent the campaign of 1987 a tremendous impetus. In 1977, the contributions of a Beuys, Judd or Rückriem had set up a relation to place in a more formal sense. In 1987, the narrative variant made its first appearance, and it did so in force. In the works on the *memoria* theme, in which Lothar Baumgarten was joined by Dennis Adams, Daniel Buren, Ian Hamilton Finlay, Rodney Graham and François Morellet, and – with a piece quite out of the ordinary – by Rebecca Horn, as well as in other works, outdoor sculpture in its storytelling capacity, so long held in contempt, appeared to have come to repossess its title.

The charm of the campaign would seem to have been owed chiefly to the collision of the artists with a provincial town with which they were unfamiliar: to the fact that the encounter should have sparked off so intensive an exchange on the local topography and that the topography, should have turned out to be so

inspiring. From the point of view of curators Bußmann and König in this coupling process, observers would have found the role of "oral history" an unexpected indication that the city as a narrative space was still alive and well. Whatever, the present *Skulptur Projekte* have benefited much from the way the curators relate to the city's past and present. What one might take the liberty of adapting as the procedural maxim of the exhibition, *invite globally, act locally*, has only been able to work convincingly thanks to their identifying, with all skepticism, with the venue of Münster. This venue, like Kassel, incidentally, furthermore has a condition to offer which is likely to have been a factor in the success of the exhibitions mounted in both towns: it is the high profile of the events. This would be lost in large cities. Looking at the history of exhibitions in Kassel and Münster, two laws to the advantage of a provincial venue might be inferred: first, the urban background for art events of ambition and scale has to be small; second, a spatially confined venue raises the perceivability of intervention in it.

The idyll which Fischli/Weiss put down with some forbearance as contextual kitsch, the artists as a whole had prepared by a remarkable willingness to suspend the privileges of autonomy and leave the Bermuda Triangle of studio, gallery and collection for an arena of interaction with authorities, churchgoers, business folk, bus passengers, students, visitors of parks and cemeteries, cyclists, casual strollers, philistines, the art industry tribe and night owls. If impressions left by advance preparations for the 1997 campaign are not misleading, then that readiness has receded somewhat in the interim, and the affinity to the gravitational center of the museum has grown again as compared to that of the wider public arena.

One might therefore be excused for wondering whether the *dream of the public domain* is not

to be put down to a characteristic of art in the 1980s. Did the willingness of the participants then, to operate in the public sphere like artists under commission, betray a longing to be able to walk out of the golden cage of autonomy? Were the artists (and the curators) glad to have escaped the persistent taboos of modernism and its long periods of ascetic censorship? Had the innovation of Pop Art, the original spark at the origins of postmodernism, only now arrived in the public sphere? Or was it more appropriate to see the trend as a new-range marketing strategy in a traditionally highly paid, but formally antiquated sector of the art market – that is, narrative relation to place as a new merchandise esthetics in art and its public orientation and interaction, indeed PR only in its narrowed, most promotional sense?

There is no doubt that the boom of the 1980s brought a sense of euphoria to the way art was perceived, both by the contemplators and the makers. But it would be glib to see this as the sole factor in the artists' willingness to enter into public projects and to entertain the purposive siting and deployment of their work within society. Certainly it is a mark of art in urban spaces that it is to be found *on the market place* in all senses of the term, both the town's and its own. Possibly this, too, is the source for the distrust which motivated Buchloh when he unhesitatingly put the *Kirschensäule* into the general context of capitalist smokescreen. What is certain is that the presumed share of the private economy in such interventions shore up some of the reservations passers-by and users and inhabitants of the immediate surroundings tend to have toward the artist's subjectivity, even where the outdoor works, as in Münster, are in the main set up only temporarily and the artists receive only a modest design fee, with no purchase following.

On the other hand, in considering whether the

Skulptur Projekte have achieved their local cultural-political aim of bringing about a more sensitive handling of the urban sphere and the art in it, one may be persuaded to skepticism – of opponents of the exhibition wresting "reality" onto their side between sculpture project campaigns by ameliorating town-center squares with park furniture, for example, so canceling out any potential these sites might have had for orchestration by the project; or outdoor initiatives with popular artists are nurtured to make it quite plain where sanctioned taste lies. Many of these permanent interventions in the urban landscape, including second-rate sculptural fountains (one such having only recently been installed at the railway station, so visitors are alienated early on), have been planned in circumvention of the responsible arts policy committees by being declared as objets d'art; or architects provide stylish leisure zones, and artist associations artistic knick-knacks of calculated parochial standard, to the annoyance not only of visitors to the *Skulptur Projekte*; while on local art-in-architecture panels, the curators often have to admit defeat and must temper their euphoria at this city's having become a venue for international contemporary art not for one, but two occasions to date, with the denial experienced in some lasting ricochets. The purchases that have resulted out of the campaigns, three in 1977, some twenty in 1987, can only provide qualified comfort in this dilemma, for the advantages of the city for exhibitions of outdoor sculpture are a disadvantage when it comes to permanent siting. At any rate, the curators have set themselves the aim of not overloading the town with purchased works, with the consequence that many a parochial solution finds a permanent site whereas most of the art of international esteem leaves the stage on the close of the respective campaign. Another palpable dampener on the campaign of

1987 was that a project of Hans Haacke's which was to be realised on city corporation busses, could not take place. Instead of advertising blurb, the outside flanks of the busses were to have pointed to the equipping of South Africa's Apartheid Police, as then still was, with Unimogs, supplied, like the busses that bore the message, by Mercedes-Benz. But, as a decree allows commercial advertising on busses, but explicitly forbids the expression of political opinions – a ruling which is itself nothing if not a political decision – the project could be documented only in the museum and in the catalog. That the permissible scope for political statements in art interventions is smaller than that conceded to advertising was an unwelcome conclusion to have to draw out of this confrontation. Haacke's ironic reference to place, focusing even more than Michael Asher's on vehicles and set to strike a link between the mutually very distant markets of an industrial concern, came to grief on an unexpected boundary to the artistic freedom of expression. The primacy of consumerism is evidently more assertive on advertising surfaces than on its trading platforms.

Unexpectedly, however, it also became evident that the urban sphere is a functioning narrative space still, only the tales are not articulated now in stone and marble but on posters and advertising lines. As such these had already begun to contest the space that the façades gave architectural sculpture back in the nineteenth century. The city continued to assert its property as a narrative space even after the internalisation of the media and the end of narrative architecture. Poster pillars and hoardings exploit public space as a multiplier of contact, a venue which draws beholders constantly; and as soon as they came onto the scene, public transport vehicles were put to the service of poster-style advertising. The only mass medium

unable to take the common path into its target public's homes and obliged to meet it literally *en route*, the billboard is modernism's contribution to the city as a narrative domain.

On its ubiquitous advertising surfaces today, the urban space is illustrated with the serial strips in praise of the lust for consumption – though not as stories specific to the particular towns where they are displayed, but the standardized trading signs of blanket campaigns. Their shrill beckoning and exaggerations turn the public domain into a realm of importunate urging and communications of vested interest amongst which the passer-by sees himself reduced to his role as a consumer, with little at hand to be able to parry the finesses of the barrage of quick-change icons. The pioneers of the *décollage* who, like Raymond Hains, began making their poster tear-off pieces in the 1950s, are likely even then to have perceived this media upstart and profiteer of modernization as an unwelcome competitor as was made clear in 1987 to Haacke's detriment.

Prospect 1997

If one surveys the projects that have been proposed for the third show and dares venture an assessment of the campaign – two months before the opening – then several striking differences from the predecessors can already be made out. In 1987, relation to the site was the main feature; there were very few works in the form of "artist services". Only Scott Burton's park benches were outright instances of the trend, with, perhaps, the strange seats of Franz West or Siah Armajani's Research Garden as closer relatives. In contrast, Jenny Holzer's inscribed stone benches and the bus stop Dennis Adams supplied with his pictures mixed the invitation to use their services so markedly with historical and literary associations that they became a medium rather of irritation.

In the current campaign, a complete reversal of these proportions is to be seen: whilst some outstanding works represent a narrative and poetic connection with the locality, they are comparatively few in number, whilst works offering a service are numerous. Per Kirkeby's proposal for the 1997 show was to make a brick sculpture, for the first time not only as imitated architecture but as the real, usable thing – in the shape of a cycle shelter for an inner-city parking-lot. The City Planning Office turned the project down, but Kirkeby's second project is also geared to usable architecture and is planned as an enclosed bus-shelter and an acoustic and optical screen between the grounds of a school and a busy road. Tadashi Kawamata is to have a ferry built by the patients of a dutch withdrawal clinic to carry visitors to contributions on the Aasee – and into the Aasee, Jorge Pardo will construct a jetty ending in a roofed belvedere. Kurt Ryslavy will be exhibiting works by his colleague-in-arms, Georg Herold, as *Verkaufswerk Nr. 17* (Sale Work No. 17) on a transport truck; Bert Theis is building a communication platform and Heimo Zobernig is designing hoardings to advertise the *Skulptur. Projekte in Münster 1997* at access roads. Dan Graham is planning a *Fun House für Münster;* Tobias Rehberger will be running a bar, and had intended to provide a hire-car for exhibition visitors as well. Berthold Hörbelt's and Wolfgang Winter's mineral-water-bottle-crate pavilions will be used as exhibition information centers. Another pavilion had been planned by Claes Oldenburg and Coosje van Bruggen, in the shape of a piece of cheese spiked upon salt sticks. Maurizio Cattelan's plan was to have wine bubbling from two municipal fountains, while Fabrice Hybert was contemplating complete ornamental city trees with useful fruit-trees.

Just as these works appear to fit the category

of the catchword *art as a service*, coined as the title to an exhibition of the Schürmann Collection in Munich in 1995, so many others tap subjects exploited by contextual art. 1987 was too early for that genre to play a part in the campaign then, apart from contributions by artists since acknowledged as classic representatives, like Michael Asher, Hans Haacke or Rémy Zaugg. If it is accurate to suppose that the zenith of site specificity has already passed, and that it is about to degenerate into a new academicism, then one might be led to conclude from the number of art-as-services on offer that the 1997 exhibition were pooling a counter-current in its very latest state. Is it a new trend – *the* new trend?

The foundations for such a straightforward diagnosis are none too sound, and not only because the overlaps with typical contextual art themes would undermine it. Many of the contributions are ambiguous, oscillating between service provision, art contexts and irony. The narrative and poetic tendency continues to be excellently represented this time around, as in the contributions of Janet Cardiff, Maurizio Cattelan, Ilya Kabakov, Marjetica Potrč and Allen Ruppersberg, and there are the instances of services which should not be taken too much at their word; these tendencies have been joined in 1997 by many works which relate to the nature of the exhibition campaign.

Such campaigns have long become part of the stock-in-trade of the art industry, and it was inevitable that artists, especially those who have passed through the school of contextualism, should respond to the tendency of such events to develop laws and unwritten byelaws unto themselves. For this reflective response, the fairground offers a handy metaphor. Of course this is no account of the works in their subtlety, but the use of a Ferris wheel by Gabriel Orozco, of a children's roundabout by Hans Haacke and a puppet theatre by Rirkrit Tiravanija, or the static merry-go-round of Kim Adams, provoke associations which crystallize in the unexpected, pithy metaphor of the fair for the esthetic exceptionality of such exhibition campaigns. Elements of the amusement park, too, flow into the unconcerned "festivalizing" of the city. A most striking example, had it been realised, would have been the tunnel crossing which Jeffrey Wisniewski planned for Aasee; so are the exotic miniature islands by Andrea Zittel and the *Grotto of the Sleeping Bear* by Mark Dion.

This said, the funfair, the amusement park and the festival are only some of the things that come to mind in contemplating many of the *Skulptur. Projekte in Münster 1997*. It is a charged spectrum between clown comedy and *son et lumière* that numerous proposals and contributions for the Skulptur Projekte 1997 open the imagination to, in a diversity and perfection that amazes. There is the lantern that talks to passers-by (Tony Oursler); there are sculptures that fly through the air (Ayşe Erkmen); an underground railway ventilation shaft giving forth the typical noise of subway traffic (Martin Kippenberger); a plot of land that to all appearances wanders over the real estate market (Maria Eichhorn); a walking-stick that squirts water (Roman Signer); a hedge clipped into animal shapes, enclosing the perfect imitation of an allotment (Fischli/Weiss); a telescope in which runs a videotape of the ostensible view before one (Janet Cardiff); a body in the lake (Maurizio Cattelan), over which there is a second full moon (Isa Genzken); blinking signal lights as an emblem of cultural sway for the artists and curators involved in the project (Fabrice Hybert); a caravan camp in which nobody lives (Atelier van Lieshout); a *Drive-in Crash Test* on top of a multi-storey car-park (Olaf Metzel); a fictitious bar with a real counter

(Tobias Rehberger); a false Voltaire in the genuine museum (Allen Ruppersberg); the mantle of a cycle tyre, painstakingly laid over a streetlamp (Andreas Slominski) and cycles which travel backwards (Elin Wikström/Anna Brag); a project which was not realized scheduled a tree to revolve once a day on its own axis (Charles Ray) – is the city now just a space for the narration of jokes?

In such works an attitude of irony can be discerned toward the campaign for which they are recommended. Further questions would establish whether perhaps such campaigns have bred their own art. Is the archaic circus-like animism which drives two full moons, the water-gushing walking-sticks, rotating trees and streetlamps which speak to passers-by, an urban charade whose aim is now to festivalize art, too? Is there any more to these pointed works than their indisputably professional show effects? The late nineteenth century, we know now, was full of regret about the esthetics it had generated – exhibition art. Should the late twentieth century regret its campaigning art?

This would not appear to be the case in Münster. Following *Platzsuche*, the search for location, of 1977 and the convincing 1987 campaign, with its location narrative, another contemporary theme will be clarified and become tangible, namely, the *End of Urban Euphoria*. The hopes for which modern art was continually shooed into the city, there to ameliorate or at least paper over the many crises and chasms of mass conurbation have, after the high flights of site specificity, turned into scepticism. This scepticism will not be cynically played down in Münster in order to preserve an important market, it is intelligently instrumentalized and its ambiguity unfolded. The intellectual enjoyment of the campaign, perhaps, lies in this. On the other hand, there is a feeling of despondence that perhaps the well-meaning urbanism of the

podium discussions and development plans might emerge as intellectual (post-)modern kitsch. Thus an element of perplexity appears to underlie these "very earnest jests".

The departure from urban euphoria for the benefit of a meeting of art and urban space, as trenchant as it is non-committal, is not the campaign's only theme, for modern art, to claim any standing, must, above all, speak about its own situation. This is reflected, beyond the element of manifest enjoyment, even in the most light-hearted works in the campaign. Irony grants art not only dispensation from the stringent demands of urbanism, but also from the grandiose overestimation by which the twentieth century has both blessed and burdened it. It is a kind of "irony of release" which affords relief, not only in this campaign, from the exhausting demands the artists have set themselves, and which society has thrust on them. It is an irony of release which is perhaps no mean final chord to accompany the imminent *fin de siècle*.

Can the exhibition thus be regarded as being representative in a contemporary sense? After the boom of the eighties, the different aspects of irony of release are, indeed, enjoying a boom of their own – but this does not make them contemporary. Just as the service-provision theme in art spans generations, not remaining limited to a few newcomers, so there are other examples which show that the irony of release is older than the euphoria of marketing and publicizing seen in the eighties, to which it appears to correspond. Roman Signer, for example, with his water-gushing cane and mobile city fountain in its transport van which are amongst the most vivid in the campaign, has been working since the early seventies on his themes. Which is not to say that they have always enjoyed high currency. It would be more accurate, then, to say that the 1997 campaign

sets another emphasis, without claiming that this heralds any second postmodern era.

From the beginning, Ellsworth Kelly was part of the plans for the 1997 show; this choice of an artist who stands for autonomous sculpture was also integral to particular emphasis. Even though, for lack of finance, his contribution could not be realized, it implies a classical alternative to site specificity; to which the erection of new sculptures by Frank Stella in Jena has lent unexpected new prominence, accompanied by speculation on the return of autonomous sculpture. Carl Andre, Georg Baselitz, Alighiero e Boetti, Richard Deacon, Jeff Koons, Sol LeWitt, Bruce Nauman, Nam June Paik, Lawrence Weiner and Rachel Whiteread are taking part in the 1997 campaign and offer instances of a concept of sculpture balanced more toward the direction of autonomy. Perhaps the most striking example of this is that Franz West, who in 1987, contributed his utilizable seats, this time expressly suggested an autonomous sculpture.

Every accentuation can also be a distortion, admittedly; less in the sense of the exhibition than of this anticipatory summary. The essential aspects of many of the works subsumed beneath the specific categories lie in other spheres, be it the complex urban economy of Maria Eichhorn, the meta-story of Allen Ruppersberg, Hans Haacke's abjuring of the monument or Mark Dion's Sleeping Bear. Of course, much is more earnestly intended than it appears in this summary. Art has many levels of use, and only the exhibition itself can make the entire stage visible.

Notes

This essay is indebted to numerous stimulating and illuminating conversations I have enjoyed over the years with artists and collaborators on the *Skulptur Projekte*, with Klaus Bußmann and Kasper König, Florian Matzner and Friedrich Meschede, and the former Director of the Westfälische Kunstverein, Herbert Molderings.

Wolfgang Ullrich in Munich is due my thanks for important suggestions and information, and not least for his critical review of the manuscript.

If my contribution should show its subject to be an instructive one, then that is due essentially to the conversations with my friend, Jan Pieper, in Aachen, which have been a constant source of inspiration during the last 25 years.

The bibliographical details list only the authors to whose work this essay substantially refers. Suggestions for further reading are given in the titles by Büttner, Grasskamp and Plagemann listed below.

Theodor W. Adorno: Ästhetische Theorie, Frankfurt/1970; English edition: Theodor W. und G. Adorno: Aesthetic Theory, London 1984

Jean-Christophe Ammann: Plädoyer für eine neue Kunst im öffentlichen Raum, in: Parkett, 2, 1984, pp. 6–35

Hannah Arendt: The Human Condition, 1958

Benjamin Buchloh: Vandalismus von oben. Richard Serras »Tilted Arc« in New York, in: Unerwünschte Monumente. Moderne Kunst im Stadtraum, ed. Walter Grasskamp, 2nd edition, Munich 1992, pp. 103–119

Klaus Bußmann: Vorwort zum Katalog Skulptur Ausstellung in Münster 1977, Westfälisches Landesmuseum für Kunst und Kulturgeschichte, Münster 1977, p. 7.

Claudia Büttner: Art Goes Public. Von der Ausstellung im Freien zum Projekt im nicht-institutionellen Raum, Diss., Berlin 1996; Munich 1997

Das Ende der Avantgarde. Kunst als Dienstleistung, Sammlung Schürmann, Kunsthalle der Hypo Kulturstiftung, Munich 1995

Festivalisierung der Stadtpolitik. Stadtentwicklung durch große Projekte, ed. Hartmut Häussermann/Walter Siebel, in: Leviathan Sonderheft, Nr. 12, Opladen 1993

Walter Grasskamp (Ed.): Unerwünschte Monumente. Moderne Kunst im Stadtraum, 2nd edition, Munich 1992

Maurice Halbwachs: Das kollektive Gedächtnis, Stuttgart 1967

Hans Hollein: Fragen und Statements in *Skulptur und öffentlicher Raum. Podiumsgespräch vom 12. Mai 1988*, in: La Piazza. Kunst und öffentlicher Raum, ed. Gisela Febel/Gerhard Schröder, Stuttgart 1992, pp. 110–125

Victor Hugo: Notre-Dame de Paris. 1482, Paris 1831

Kunst im öffentlichen Raum. Anstöße der 80er Jahre, ed. Volker Plagemann, Köln 1989

Friedrich Meschede: Tony Smith – Präsenz der Form, in: Tony Smith, Westfälisches Landesmuseum für Kunst und Kulturgeschichte, Münster 1988, pp. 16–34

Friedrich Meschede: Thomas Schütte oder die Macht der Kirschen, in: Plat*zierte* Kunst, Jena 1996, pp. 100–102, extracts are reprintes in the present catalogue (see Schütte).

Antonio Negri: Die Wiederaneignung des öffentlichen Raums. Metropolenstreik und gesellschaftliche Emanzipation, in: Die Beute, 12, 1996, pp. 80–90

Projektgemeinschaft Stadtentwicklungsplan Öffentlicher
Raum, Entwurf zum Stadtentwicklungsplan Öffentlicher
Raum, Berlin 1995
Skulptur Ausstellung in Münster 1977, Westfälisches Land-
esmuseum für Kunst und Kulturgeschichte, Münster 1977
Skulptur Projekte in Münster 1987, Westfälisches Landes-
museum für Kunst und Kulturgeschichte, Münster; Köln
1987
Sonsbeek buiten de perken, 2 vol., Sonsbeek 1971
Wolfgang Ullrich: Die Eroberung des Außenraums durch
den Innenraum. Ein Manko moderner Platzgestaltung, in:
neue bildende kunst, 2, 1997, pp. 34–39
Wolfgang Ullrich: Marktwirtschaft und öffentlicher Raum,
Vortragskonzept Akademie der Bildenden Künste, München
1997
Martin Warnke: Kunst unter Verweigerungspflicht, in: Kunst
im öffentlichen Raum. Anstöße der 80er Jahre, ed. Volker
Plagemann, Köln 1989, pp. 223–226

1926	Raymond Hains
1927	Paul Armand Gette
1928	Sol LeWitt
1929/1942	Claes Oldenburg/
	Coosje van Bruggen
1931	herman de vries
1932	Nam June Paik
1933	Ilya Kabakov
1934	Jeff Geys
1935	Carl Andre
1936	Hans Haacke
1937	Reiner Ruthenbeck
1938	Georg Baselitz
1938	Daniel Buren
1938	Per Kirkeby
1938	Ulrich Rückriem
1938	Roman Signer
1940	Alighiero Boetti
1942	Dan Graham
1942	Lawrence Weiner
1943	Michael Asher
1944	Rebecca Horn
1944	Allen Ruppersberg
1947	Franz West
1948	Isa Genzken
1949	Ayşe Erkmen
1949	Richard Deacon
1950	Svetlana Kopystiansky
1950	Reinhard Mucha
1951	Kim Adams
1952/1946	Peter Fischli/David Weiss
1952	Olaf Metzel
1952	Bert Theis
1953	Tadashi Kawamata
1953	Martin Kippenberger
1953	Marjetica Potrč

1953	Charles Ray
1954	Huang Yong Ping
1954	Thomas Schütte
1955	Jeff Koons
1956	Hermann Pitz
1957	Janet Cardiff
1957	Tony Oursler
1957	Karin Sander
1958	Heimo Zobernig
1959	Andreas Slominski
1960	Maurizio Cattelan
1960	Stephen Craig
1960	Stan Douglas
1960	Marie-Ange Guilleminot
1960/1958	Wolfgang Winter/
	Berthold Hörbelt
1961	Mark Dion
1961	Bethan Huws
1961	Fabrice Hybert
1961	Kurt Ryslavy
1961	Rirkrit Tiravanija
1962	Maria Eichhorn
1962	Gabriel Orozco
1962	Jorge Pardo
1962	Diana Thater
1963	Eulàlia Valldosera
1963	Rachel Whiteread
1964	Jeffrey Wisniewski
1965	Christine Borland
1965	Elin Wikström/
	Anna Brag
1965	Yutaka Sone
1965	Andrea Zittel
1966	Douglas Gordon
1966	Tobias Rehberger
founded 1995	Atelier van Lieshout

Sculpture. Projects in Münster 1997

1	Landesmuseum	Domplatz 1
1	Janet Cardiff	Landesmuseum and central Münster
1	Maurizio Cattelan	Landesmuseum and no. 41
1	Stan Douglas	Not realized, Landesmuseum
1	Ayşe Erkmen	Roof of Landesmuseum and air over central Münster
1	Rebecca Horn	Landesmuseum and no. 15
1	Fabrice Hybert	Landesmuseum, artists and staff of exhibition
1	Oldenburg/Van Bruggen	Not realized, Landesmuseum
1	Hermann Pitz	Landesmuseum
1	Allen Ruppersberg	Landesmuseum and 11 different places in central Münster
1	Thomas Schütte	Landesmuseum
1	Yutaka Sone	Landesmuseum and no. 9 and various locations in Münster
1	Rachel Whiteread	Landesmuseum
1	Jeffrey Wisniewski	Not realized, Landesmuseum
1	Heimo Zobernig	Landesmuseum and 6 intersections of main access streets
2	Kim Adams	Former gasoline station, Aegidiistraße 45, corner of Mühlenstraße
3	Stephen Craig	Lawn on Promenade at Aegiditor
4	Andrea Zittel	Kanonengraben
5	Wikström/Brag	Promenade between Aegidiistraße and Kanonengraben
6	Karin Sander	Von-Kluck-Straße 34/36
7	Huang Yong Ping	Traffic island at Marienplatz, south of St. Ludgeri-Kirche
8	Paul-Armand Gette	Southeast of the pond at Engelenschanze and no. 17, 28
9	Yutaka Sone	In the pedestrian underpass in front of the Hauptbahnhof and no. 1
10	Winter/Hörbelt	Hauptbahnhof, Berliner Platz, and no. 31, 40, 56
11	Olaf Metzel	Bremer Platz car-park, level 4
12	Jeff Koons	Promenade south of Salzstraße
13	Hans Haacke	Promenade south of war memorial at Mauritztor
14	Atelier van Lieshout	Promenade south of Hörsterstraße
15	Rebecca Horn	Zwinger on the Promenade and no. 1
16	Dan Graham	Promenade west of Neubrückentor, across from playground and no. 27
17	Paul-Armand Gette	Island on the Promenade, west of Kanalstraße and no. 8, 28
18	Franz West	North Promenade, east of Kreuztor
19	Maria Eichhorn	Tibusstraße, corner of Breul
20	Diana Thater	Buddenturm, Münzstraße
21	Raymond Hains	Along Münzstraße in the Buddenturm area
22	Martin Kippenberger	Kreuzschanze, opposite portrait bust of Annette von Droste-Hülshoff
23	Mark Dion	Kreuzschanze
24	Marjetica Potrč	Air-raid bunker on Lazarettstraße
25	herman de vries	Lawn between north garden of Schloß and Einsteinstraße
26	Georg Herold	North part of the Schloßgarten
27	Dan Graham	South part of the Schloßgarten and no. 16
28	Paul-Armand Gette	South part of the Schloßgarten and no. 8, 17
29	Bert Theis	Schloßgarten
30	Nam June Paik	Square in front of the Schloß
31	Winter/Hörbelt	In front of the north gate house of the Schloß and no. 10, 40, 56
32	Ulrich Rückriem	Both sides of main approach to Schloß from Hindenburgplatz, Promenade
33	Richard Deacon	Hindenburgplatz, between the entrance of the pedestrian underpass
34	Douglas Gordon	Pedestrian underpass, Hindenburgplatz
35	Tobias Rehberger	Lecture hall building and terrace on Hindenburgplatz, corner of Bäckergasse
36	Per Kirkeby	In front of the Freiherr-vom-Stein-Gymnasium on the Hindenburgplatz
37	Sol LeWitt	Lawn south of southern gate house near the Schloß
38	Roman Signer	Pond behind the Westfälische Schule für Musik, Himmelreichallee and 12 changing positions in central Münster
39	Rirkrit Tiravanija	Grounds of the former Zoo behind the Westfälische Schule für Musik
40	Winter/Hörbelt	Northwest bank of Aasee and no. 10, 31, 56
41	Maurizio Cattelan	Aasee below Goldene Brücke, Adenauerallee and no. 1
42	Isa Genzken	Northern lawn of Aasee, south of Annette-Allee
43	Jorge Pardo	West bank of Aasee, south of Annette-Allee
44	Ilya Kabakov	Northern lawn of Aasee, east of Kardinal-von-Galen-Ring
45	Tadashi Kawamata	Aasee
46	Bethan Huws	Wooded area Kiesekampbusch, southwest of the Aasee
47	Andreas Slominski	Adenauerallee
48	Fischli/Weiss	Private garden on city moat, north of Westerholtsche Wiese
49	Alighiero Boetti	East bank of River Aa on Auferweg between Stadtgraben and Bispinghof
50	Tony Oursler	Bispinghof, in front of south stairs to Auferweg
51	Christine Borland	Jesuitengang north of Petri-Kirche
52	Thomas Hirschhorn	Next to bottle banks on Katthagen, corner of Rosenstraße
53	Marie-Ange Guilleminot	Interior courtyard of Stadttheater, Neubrückenstraße
54	Eulàlia Valldosera	Karstadt Sport Pavilion and fire wall opposite, Alter Steinweg
55	Georg Baselitz	Cour d'honneur of Erbdrostenhof, Salzstraße
56	Winter/Hörbelt	Salzstraße in front of Karstadt
57	Daniel Buren	Prinzipalmarkt
58	Lawrence Weiner	Domplatz, Michaelisplatz
59	Kurt Ryslavy	Parking place on south Domplatz in front of Landesmuseum
60	Maria Nordman	Wienburg-Park
61	Richard Serra	Avenue of Haus Rüschhaus in district Nienberge
*	Michael Asher	14 changing parking positions in Münster
*	Jef Geys	7 changing positions in front of churches in Münster
*	Svetlana Kopystiansky	Central Münster
*	Reinhard Mucha	8 school classes from Münster
*	Charles Ray	Cinemas in Münster
*	Reiner Ruthenbeck	Promenadenring
*	Carl Andre	No location
*	Gabriel Orozco	Not realized

2	Kim Adams
–	Carl Andre
*	Michael Asher
55	Georg Baselitz
49	Alighiero Boetti
51	Christine Borland
57	Daniel Buren
1*	Janet Cardiff
41, 1	Maurizio Cattelan
3	Stephen Craig
33	Richard Deacon
23	Mark Dion
1	Stan Douglas
19	Maria Eichhorn
1	Ayşe Erkmen
48	Peter Fischli/David Weiss
42	Isa Genzken
8, 17, 28	Paul-Armand Gette
1	Jef Geys
34	Douglas Gordon
16, 27	Dan Graham
53	Marie-Ange Guilleminot
13	Hans Haacke
21	Raymond Hains
26	Georg Herold
52	Thomas Hirschhorn
1, 15	Rebecca Horn
7	Huang Yong Ping
46	Bethan Huws
1	Fabrice Hybert
44	Ilya Kabakov
45	Tadashi Kawamata
22	Martin Kippenberger
36	Per Kirkeby
12	Jeff Koons
*	Svetlana Kopystiansky
14	Atelier van Lieshout
11	Olaf Metzel
*	Reinhard Mucha
60	Maria Nordman
1	Claes Oldenburg/ Coosje van Bruggen
–	Gabriel Orozco
50	Tony Oursler
30	Nam June Paik
43	Jorge Pardo
1	Hermann Pitz
24	Marjetica Potrč
*	Charles Ray
35	Tobias Rehberger
32	Ulrich Rückriem
1*	Allen Ruppersberg
*	Rainer Ruthenbeck
59	Kurt Ryslavy
6	Karin Sander
1	Thomas Schütte
61	Richard Serra
38	Roman Signer
47	Andreas Slominski
1, 9, *	Yutaka Sone
20	Diana Thater
29	Bert Theis
39	Rirkrit Tiravanija
54	Eulàlia Valldosera
25	herman de vries
58	Lawrence Weiner
18	Franz West
1	Rachel Whiteread
5	Elin Wikström/Anna Brag
10i, 31i, 40i, 56i	Wolfgang Winter/ Berthold Hörbelt
1	Jeffrey Wisniewski
4	Andrea Zittel
1, *	Heimo Zobernig

Orléans-

Orléans-Ring

Einsteinst

Wi

◄ 61

25

Rishon-Le-Zion-Ring

R. Koch

Kardinal-von-Galen-Ring

Sentruper Str.

Mühlen-hof

Naturkunde-museum

Allwetter-zoo

45

Aasee

Kiesekamp-busch

Mecklenbecker

46

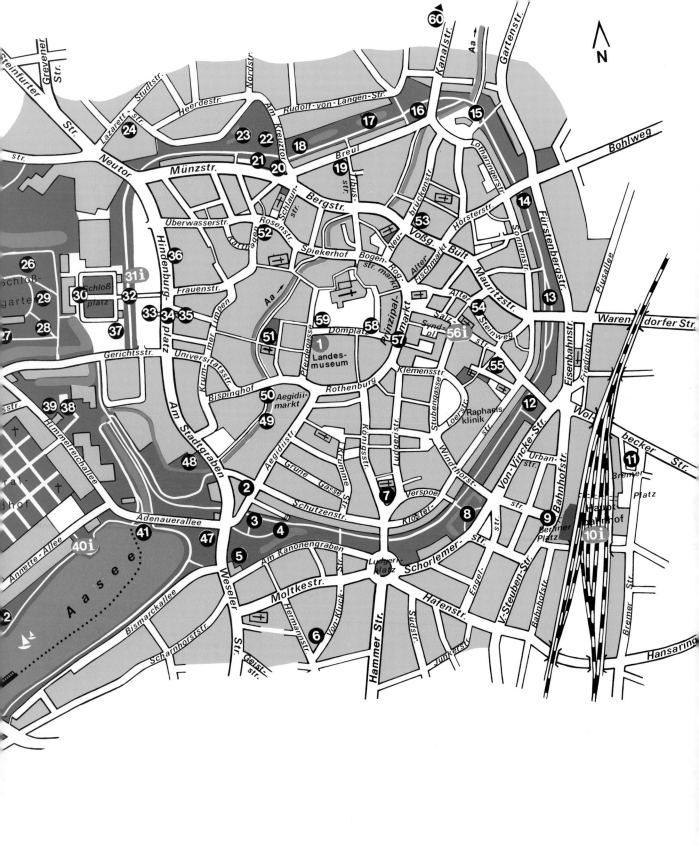

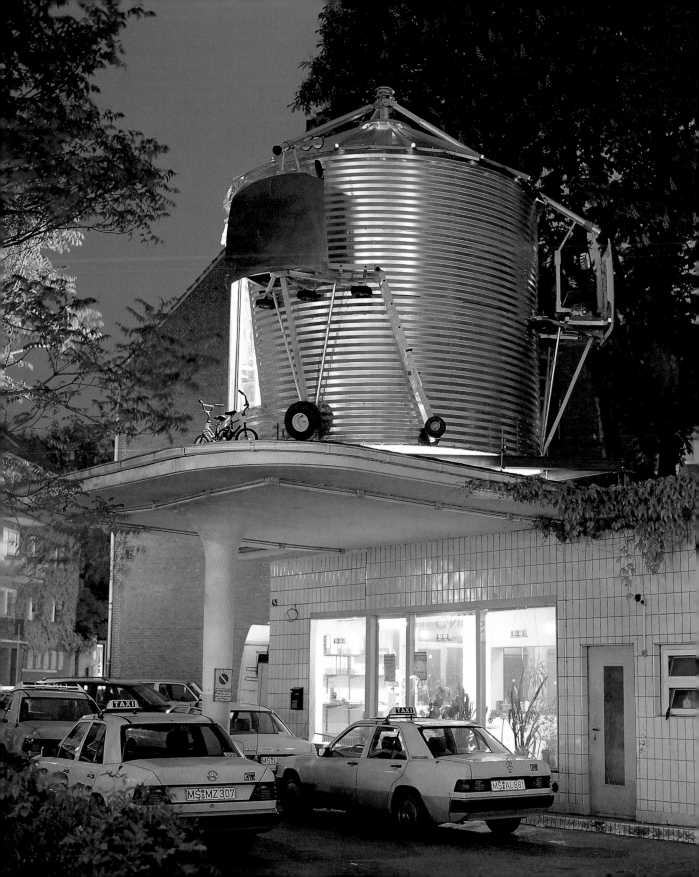

KIM ADAMS

Auto Office Haus
Multi-part installation (steel bin height 5.47 m,
diameter 6.71 m, car hoods and trunks,
aluminium, tires, cart wheels, lawnmowers,
plastic, fluorescent lighting, tractor seats)
Former gasoline station, Aegidiistraße 45,
corner of Mühlenstraße

Nancy Campbell
Kim Adams – *Auto Office Haus*

Born 1951 in Edmonton, Alberta,
lives in Toronto

For information about the artist and additional bibliography see:
Kim Adams, Musée d'art contemporain, Montreal 1996;
Kim Adams, Centraal Museum, Utrecht 1995.

Auto Office Haus sits perched on top of an old
reconfigured gasoline station turned taxi dis-
patch. It is a temporary yet suitable site: nice
view, easy access to the city, reasonable rent,
perfect for the duration of *Skulptur. Projekte in
Münster 1997*. The perch will suffice, that is
until the artist disassembles and moves it, by
necessity, to another place. *Auto Office Haus* is
part home, part office: a complete domestic
and work center constructed out of a pre-fabri-
cated, customized six meters tall grain storage
bin, a configuration of the same bins one sees
dotted throughout the North American agricul-
tural landscape. From the peak of the bin pro-
trude octopus-like arms affixed with car seats
for the occupants to exit in order to get some
air, work outside, or simply have a cigarette.
The out-of-doors is, after all, a necessity of life.
The armature references a merry-go-round or
carnival ride, establishing a surreal yet highly
efficient site for respite. *Auto Office Haus* is
essentially an example of "squatter architec-
ture", which uses the site of the gasoline sta-
tion in Münster as a convenient podium. It is a
contradictory site, being an "elevated squat",

but the artist wasn't doing an eye-level search
for a site. Perhaps it is because Canadians tend
to look up when looking for space, as the vista
across is at times too vast.
Auto Office Haus follows the continuum of
many architectural/sculptural works by Adams
produced since the early 1980s. His examina-
tion of architecture and the conditions and
restrictions inherent in everyday life form the

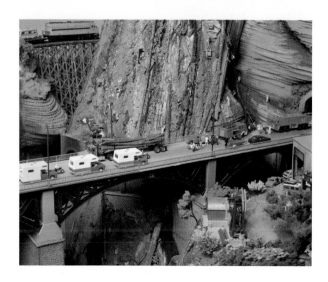

Kim Adams: *Earth wagons,* Detail, 1989–1991 (above), and *He/He*, 1990, tricycles, collection of Christiane Chassay, Montreal (below)

basis of his critique. His works typically employ containers, be they grain bins, garden sheds, sleeper cars, automobiles, or septic tanks. These objects can be found or easily purchased in any large hardware store. Within each structure lies an investigation into the needs and requirements of the individual or society that is seen to occupy the unit. *Chameleon Unit*, 1988, for example, consists of a number of rebuilt semi-trailer sleeping units ingeniously reassembled for communal rest. *Earth Wagons*, 1989–1991, are comprehensive, intricate HO scale models (train set model-size) placed *en scène* in trailers which mimic situations that are prophetic: "leisure as industry", "threats to nature" and "vehicular locomotion" all brought together under the guise of carnivalesque pleasure. Most of Adams' works are fitted with wheels, although this does not always imply mobility. *He/He*, 1993, a reconfigured tricycle, is one piece that can only advance by going backwards, articulating the push and pull so prevalent in Adams' critique. *Auto Office Haus* is also fitted with wheels at the base of the swinging seats, again implying an ability to move around the structure. Kim Adams makes sculpture that moves us, both figuratively and literally. Not only does the work imply mobility, but the artist transports the viewer to the remote places and spaces of the imagination. In short, such prototypes are seen as models for better or alternative living: often fanciful but always with an edge of scathing commentary.

When situating the work of this Canadian artist in an international context, it is helpful to recall two disparate things: the Canadian Pacific Railway and the mobile home. The railway, which is referred to as the national dream, was built by Scottish capitalists, American engineers and Canadian and Chinese labor. Unquestionably, since Donald Smith hammered home the last spike on November 7, 1885 (marking the laying of over 2,000 km of track) the railway has

that 6% of Americans live in mobile homes. It is projected that by the year 2000, 9% of Americans will live this way. Perhaps it is natural for people to desire a more nomadic existence. *Auto Office Haus* can be seen as yet another solution to the restrictions and limitations of our supermodern society. One can work and live in one space. One can move to different locales to demand or according to one's desire. One can traverse the restriction of a defined or prescribed space and place. The *Auto Office Haus* is a space of non-place, creating neither singular identity nor relations, but rather solitude, and similitude.

What reigns in the world of Kim Adams is actuality, the urgency of the present moment in terms of time, site, and participation. The *Auto Office Haus*, unlike many millennial works, does not look toward forging a sense of community,

Kim Adams: View of planned installation, 1996, sketch, felt pen, 38x56.5 cm (above)

View of gasoline station, photo ca. 1955

shaped Canada's identity and destiny. The need for communication and mobility propelled the grand railway project, despite the enormous spaces and sparse population of western Canada. The mobile home, on the other hand, is a pleasure vehicle which, like the railway, is intended to move the occupant from one condition to another, but this locomotion is the result of desire not necessity. It is in the combination of two such ideologies that we can come close to realizing the intention of Kim Adams in the fabrication of the *Auto Office Haus*.

The notions of need, desire, and mobility (both actual and imagined) are not new to architecture. The history of the twentieth century has been riddled with efforts by visionary architects, city planners and artists to create a utopian city or dwelling place. The team which engineered and constructed the CP Railway surely had such an ambition, as do the designers of mobile homes today. This desire and need is reflected in an article in *Forbes* magazine, November 7, 1994, where it was reported

rootedness, and belonging. It is an example of how we can model a life looking outward, a life transient and temporal. In the work of Kim Adams we can contrast "the realities of transit [...] with those of residence or dwelling; the interchange (where nobody crosses anyone else's path) with crossroads (where people meet); the passenger [...] with the traveler [...]; the housing estate ('a group of new dwellings'), where people do not live together and which is never situated in the center of anything [...], with the monument where people share and commemorate [...]".[1] It is a nether world, but one which just might work.

1 Marc Augé: From Places to Non-Places, in: Non-Places: Introduction to an Anthropology of Supermodernity, London and New York 1995, pp. 107–108.

Photograph of Canadian fields for light box of installation,
photo: Paul Litherland (opposite)

Kim Adams: *Auto Office Haus*, views of installation (above)

CARL ANDRE

Born 1935 in Quincy, Massachusetts, lives in New York

Carl Andre: Notes on my recent public sculptural activities

My only public sculpture commission has been *stone field sculpture*, completed in 1977 in Hartford, Connecticut. I have received no other opportunities to create permanent public sculptures. My activities in this direction have increased markedly in recent years by way of private interventions.

One of my greatest pleasures is walking, although I have never been able to follow the example of Richard Long who has raised walking to a high form of art. When in Manhattan, my days are filled with walking. I especially enjoy walking beside New York Harbor in Battery Park at the south tip of Manhattan and around Washington Square Park in Greenwich Village.

It is during these walks that I am able to carry out my private sculptural interventions in public space. A typical item of trash (beer or soda cans and bottles; cigarette packs and candy wrappers; food trays and containers; etc.) commands a level space of about 900 cm² or 30 cm x 30 cm. Removing the item of trash and placing it in an appropriate receptacle creates a newly liberated public space with a volume of

For information about the artist and additional bibliography see: Carl Andre. Sculptor 1996, Krefelder Kunstmuseen/ Kunstmuseum Wolfsburg, Cologne 1996; Carl Andre: Extraneous Roots, Frankfurt/M. 1991.

at least 27,000 cm³ or 30 cm x 30 cm x 30 cm. I invite the people of Münster to join me in this new adventure in public sculpture.

Carl Andre: *Steel Line for Professor Landois*, contribution to *Skulptur Ausstellung in Münster 1977*, location: hill at southwest end of Aasee, ground sculpture with 97 individual plates, steel, 0.005x48.5x0.5 m (opposite), and *Gras und Stahl, 4. Juni '87*, contribution to *Skulptur Projekte in Münster 1987*, location: Busso-Peus-Straße/Gievenbecker Weg, ground sculpture with 207 individual plates, steel, 0.005x1.0x1.0 m each (below)

MICHAEL ASHER

Installation Münster (Caravan)
Installation with caravan
14 different parking positions in Münster,
weekly change of location

Born 1943 in Los Angeles, California,
lives there

For information about the artist and additional bibliography
see: Witte de With Cahier #3, Witte de With Center for Contem-
porary Art Rotterdam, Düsseldorf 1995; Michael Asher, Musée
national d'art moderne, Centre Georges Pompidou, Paris 1991;
Michael Asher Writings 1973–1983 on Works 1969–1979,
Museum of Contemporary Art, Los Angeles,
ed. Benjamin Buchloh, Nova Scotia 1983.

Michael Asher: *Installation Münster,* trailer in changing
locations, parking position 4th week, Alter Steinweg,
across from the former Kiffe pavilion, comparison of
locations from 1997 (above), 1977 (below left), and 1987
(below right)

Michael Asher: Installation Münster, 1977

This has to do with the placement of a caravan in and around the city of Münster for the duration of this exhibition which is 19 weeks. The caravan (- approx. 4 m long) is being relocated every Monday in the proximity of buildings and parks, using 19 various locations in all. The information regarding place and time of the caravan can be picked up at the front desk in the museums lobby.

Statement

I intend to first use locations in the area of the museum slowly branching out to suburban areas and planted settings (parks) with the last few weeks comprising again of settings in town. The settings fulfill the structure of the installation. They consist of supposed places where a caravan can stand (be positioned) – without appearing to be in storage or to be functional.

What interests me in the work is the aspect of mobility for a specific unit. The form (caravan) needs the ground to be positioned but not necessarily anchored. Its setting can change throughout the exhibition but its physical make up remains the same. In this sense it remains a packaged form and does not necessarily have to change physically while being transported to each location. The transit from one position to the other is also part of the installation.

(Text for the catalog *Skulptur Ausstellung in Münster 1977*)

Michael Asher: For Skulptur, 1987

I would like to go over the locations in Münster so as to make sure we have all clearances and the trailer can be located in its exact position. I would like the option of renting one of the old style trailers, if the new ones are not appropriate for this work. This means both types of trailers must be rentable for this project.

Please use the description of the work from the 1977 trailer work. Each week put the new location of the trailer and a description of the work on a padded sheet of paper so the viewer can take a description and location and drive out to the trailer.

(Correspondence to the organizers of the exhibition, 17.3.1987, published in the catalog *Skulptur Projekte in Münster 1987*)

Michael Asher, 1997

My proposal for *Skulptur. Projekte in Münster 1997* involves the reconstruction of the same project realized for this exhibition in 1977 and 1987. The most recent installation will make use of the same temporal structure as well as the original model of caravan, parking positions and procedure used to inform the public of the caravan's location. It will differ owing to the present exhibition's duration of only 14 weeks rather than the 19 weeks in 1977 and the 17 weeks in 1987. Also, alteration of the landscape in the past 20 years has made access impossible to positions during week numbers 3 and 14. During these two weeks, the caravan will be in storage. Also, as in 1977 and 1987, the weekly repositioning of the caravan and the photographic documentation of this will be handled by members of the museum staff.

1977
Michael Asher: *Installation Münster,* location: 19 different sites in and around Münster

1987
Michael Asher: *Installation Münster (Caravan),* location: 17 different sites in and around Münster (sites of 2nd, 3rd, 6th and 16th week have not been photographed)

1997
Michael Asher: *Installation Münster (Caravan),* location: 14 different sites in and around Münster

1977

Parking position, 1st week (July 4–11): Siegelkammer and Pferdegasse

1987

Parking position, 1st week (June 8–15): Siegelkammer and Pferdegasse

1997

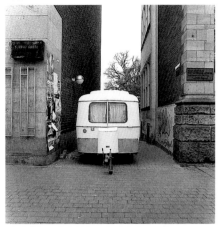

Parking position, 1st week (June 23–30): Siegelkammer and Pferdegasse

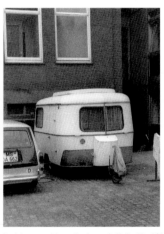

Parking position, 2nd week (July 11–18): Parking space behind building of Regierungspräsident, Geisbergweg 1–3

Parking position, 2nd week (June 15–22): Parking space behind building of Regierungspräsident, Geisbergweg 1–3

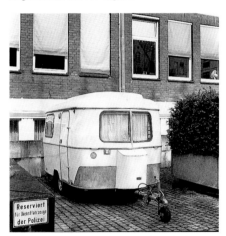

Parking position, 2nd week (June 30 – July 7): Parking space behind building of Regierungspräsident, Geisbergweg 1–3

Parking position, 3rd week (July 18–25): Alter Steinweg, parking space in front of brick wall with sign "Stricker"

Parking position, 3rd week (June 22–29): Alter Steinweg, parking space in front of brick wall with sign "Stricker"

Parking position, 3rd week (July 7–14): Company parking space behind Alter Steinweg 22–24 (installation no longer possible)

1977

1987

1997

Parking position, 4th week (July 25–August 1):
Alter Steinweg, across from Kiffe pavilion, parking
meter no. 274 or 275

Parking position, 4th week (June 29–July 6):
Alter Steinweg, across from Kiffe pavilion, parking
meter no. 2200

Parking position, 4th week (July 14–21):
Alter Steinweg, across from Kiffe pavilion, parking
meter no. 2560

Parking position, 5th week (August 1–8):
Am Hörster Friedhof/Piusallee

Parking position, 5th week (July 6–13):
Am Hörster Friedhof/Piusallee

Parking position, 5th week (July 21–28):
Am Hörster Friedhof/Piusallee

Parking position, 6th week (August 8–15):
An der Kleimann-Brücke 17

Parking position, 6th week (July 13–20):
An der Kleimann-Brücke 17

Parking position, 6th week (July 28–August 4):
An der Kleimann-Brücke 50

1977 1987 1997

 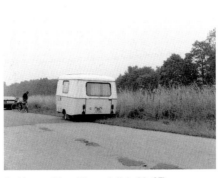

Parking position, 7th week (August 15–22): Dortmund-Ems canal, Rügenufer, ca. 300 m north of Königsberger Straße

Parking position, 7th week (July 20–27): Dortmund-Ems canal, Rügenufer, ca. 220 m north of Königsberger Straße

Parking position, 7th week (August 4–11): Dortmund-Ems-Kanal, Rügenufer, ca. 300 m north of Königsberger Straße

Parking position, 8th week (August 22–29): Königsberger Straße 133–135

Parking position, 8th week (July 27 – August 3): Königsberger Straße 133–135

Parking position, 8th week (August 11–18): Königsberger Straße 133–135

Parking position, 9th week (August 29 – September 5): Near Bröderichweg 36, end of cul-de-sac of Sparkassenschule

Parking position, 9th week (August 3–10): Near Bröderichweg 36/Prothmannstraße 16

Parking position, 9th week (August 18–25): End of Prothmannstraße

1977 1987 1997

Parking position, 10th week (September 5–12):
End of cul-de-sac Idenbrockweg in Kinderhaus

Parking position, 10th week (August 10–17):
End of cul-de-sac Idenbrockweg in Kinderhaus

Parking position, 10th week (August 25 – September 1): Paula-Wilken-Stiege 3+5

Parking position, 11th week (September 12–19):
Coerde-market

Parking position, 11th week (August 17–24):
Coerde-market

Parking position, 11th week (September 1–8):
Coerde-market

Parking position, 12th week (September 19–26):
Church square in Nienberge, in front of grocery store

Parking position, 12th week (August 24–31):
Church square in Nienberge, in front of bakery

Parking position, 12th week (September 8–15):
Church square in Nienberge, in front of No. 6

1977 1987 1997

Parking position, 13th week (September 26 – October 3): Corner of Möllmannsweg/Hollandtstraße

Parking position, 13th week (August 31 – September 7): Corner of Möllmannsweg/Hollandtstraße

Parking position, 13th week (September 15–22): Corner of Möllmannsweg/Hollandtstraße

Parking position, 14th week (October 3–10): Kappenberger Damm/Düesbergweg

Parking position, 14th week (September 7–14): Kappenberger Damm/Düesbergweg

Parking position, 14th week (September 22–29): Kappenberger Damm/Düesbergweg (no parking space any longer)

Parking position, 15th week (October 10–17): Woods at Jesuiterbrook, near Hünenburg

Parking position, 15th week (September 14–21): Woods at Jesuiterbrook, near Hünenberg

Parking position, 15th week: Woods at Jesuiterbrook, near Hünenberg (not used due to shortened duration of exhibition)

1977 1987 1997

Parking position, 16th week (October 17–24): Gerichtsstraße/west side of Hindenburgplatz

Parking position, 16th week (September 21–28): Gerichtsstraße/west side of Hindenburgplatz

Parking position, 16th week: Gerichtsstraße/west side of Hindenburgplatz (not used due to shortened duration of exhibition)

Parking position, 17th week (October 24–31): Parking space in front of Hauptbahnhof, parking meter no. 351

Parking position, 17th week (September 28–October 5): Parking space in front of Hauptbahnhof, parking meter no. 1328

Parking position, 17th week: Parking space in front of Hauptbahnhof, parking meter no. 1328 (not used due to shortened duration of exhibition)

Parking position, 18th week (October 31 – November 7): Sonnenstraße, near Ritterstraße

Parking position, 18th week: Sonnenstraße, near Ritterstraße (not used due to shortened duration of exhibition)

Parking position, 18th week: Sonnenstraße, near Ritterstraße (not used due to shortened duration of exhibition)

Parking position, 19th week (November 7–14): In front of Germanistisches Institut, parking space under trees

Parking position, 19th week: In front of Germanistisches Institut, parking space under trees (not used due to shortened duration of exhibition)

Parking position, 19th week: In front of Germanistisches Institut, parking space under trees (not used due to shortened duration of exhibition)

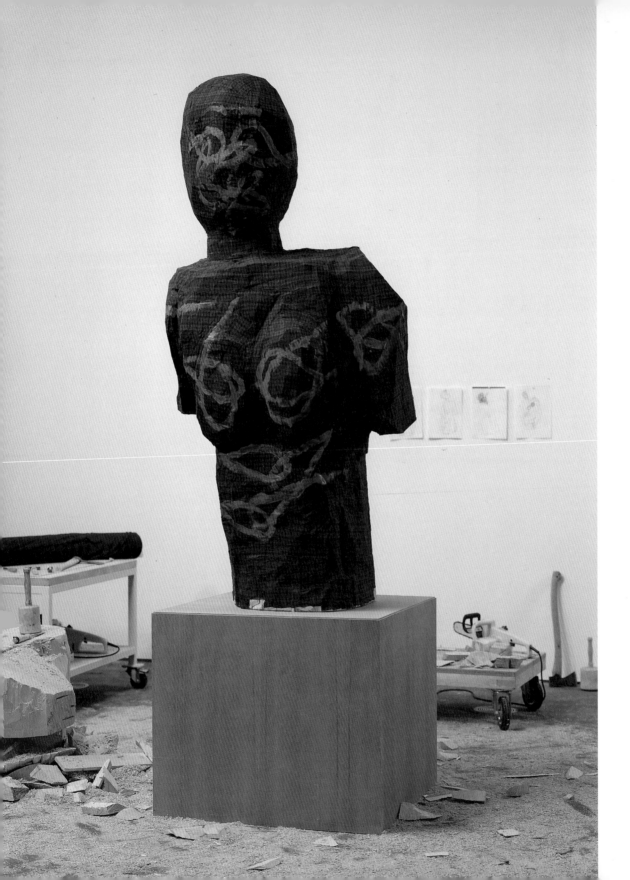

GEORG BASELITZ

Ding mit Asien, 1995
(Thing with Asia)
Sculpture (wood, fabric, oil paint 2 x 1 x 0.7 m)
Cour d'honneur of Erbdrostenhof, Salzstraße

Georg Baselitz: Angels and Dwarves – German Tribal Art

In the search for parents I am somewhat at a loss. I can't make sense of the familiar tradition. The comparison between an angel and a garden dwarf occurred to me, the dwarf as a sculpture with a peaked cap and a friendly face and the angel sculpture as a woman with wings. I don't care if angels are actually male, for me they are female.

History goes forward, but also backward, or it doesn't go anywhere at all. I think I'll make something from a memory. I can also call it utopian; I just make it into the blue when I make sculptures. I move, maybe I only turn. An arrow flies away, but it also flies back. It doesn't fly like this: →, but like this: ↔. A memory doesn't begin, either yesterday or further back. A sculpture doesn't begin, it is not an article for a program.

What immediately strikes me is that the dwarf is ugly-beautiful, while the angel is beautiful-beautiful. It's always that way. The ugliest angel is still beautiful, and the most beautiful garden dwarf is still ugly. If I assume that both angel and dwarf are supposed to be beautiful or were meant to be beautiful by the sculptor, I have to ask why the dwarf is still ugly. One reason: the

Born 1938 in Deutschbaselitz, Saxony, lives in Derneburg and Imperia, Italy

For information about the artist and additional bibliography see: Georg Baselitz, Nationalgalerie, Staatliche Museen zu Berlin - Preußischer Kulturbesitz, Berlin, Ostfildern 1996; Baselitz. Werke 1981-1993, Saarland Museum Saarbrücken, Stuttgart 1994; Georg Baselitz. Druckgrafik 1965-1992, Institut für Auslandsbeziehungen, Stuttgart 1994.

angel represents heaven, the place where God or the gods live. It is the messenger, an ambassador of good tidings, seductively beautiful. Another reason: always, for millennia, painters and sculptors have worked on this idealization, the image of this winged woman. There are wonderful angels in the history of art, not only Christian ones, but older ones too, on vases, in

mosaics, as sculpture, up to modern-day film. And another reason: angels are mostly girls or women. But what is really important is that so many artists in all ages in the Mediterranean world have worked on the angel. It is part of the fundus. An incredible number of angels have been and still are being made since art left its reserved table and went among the people, and that is a point of contact with the garden dwarf, except that the dwarf has no privileges, no place in art history. He comes from the earth, the woods, the mountains, the caves, the sea. He has no contact upwards. He belongs to the world, especially in the Christian sense. He is pagan, represents the underworld, and was sacrificed for the church. The ideology that the society has, i.e. the Christian one, is also its culture; it paints the pictures and makes the sculptures. When this way of living together asserted itself, the old images and sculptures disappeared; but we know that they existed because we can find them in the earth. If we dig north of the Alps, we don't find women with wings, but we do find something like dwarves. Where the Christians come from, on the other hand, many angels have been found, from a time before the Christians – pictures of people situated above the world somewhere. That pictorial idea has prevailed to this day, even with us. The other has disappeared.

We know of exactly the same phenomenon from photographs of Africa, where entire cartloads of sculptures were proclaimed idols and burned. Nevertheless, the angels have stubbornly failed to catch on in Africa.

Dwarves still appear in Romanesque sculpture, where they still have a good form, and still a little in the Gothic, but there they tend rather to be monsters, chimeras, lecherous satyrs, or vulgar, unspiritual types.

The thread broke north of the Alps: the pagan images finally disappeared, and even the representatives of the underworld received wings, though of course they were mostly men with wings. And so we arrive at the peaked-capped garden dwarf. One would think he would have to be an object of folk art, but he isn't. Folk art is only the simpler, more primitive form of art-art, i.e. traditional Christian art. Carnival masks are a small exception: they are fascinatingly beautiful and pagan.

So I don't need angels, and when I look for parents, then not for angels. The dwarves make sense – not as stupid as they look, as a calculated mistake, but still an idea.

From: Georg Baselitz: Frau Paganismus, Anthony d'Offay Gallery, London 1994, pp. 11–13, 35–37.

Erbdrostenhof, vestibule looking south, photo ca. 1900

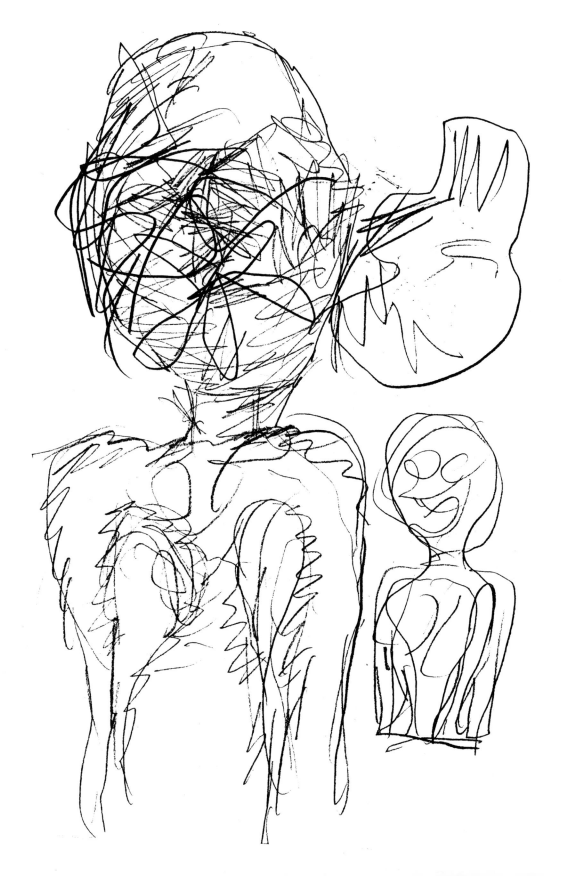

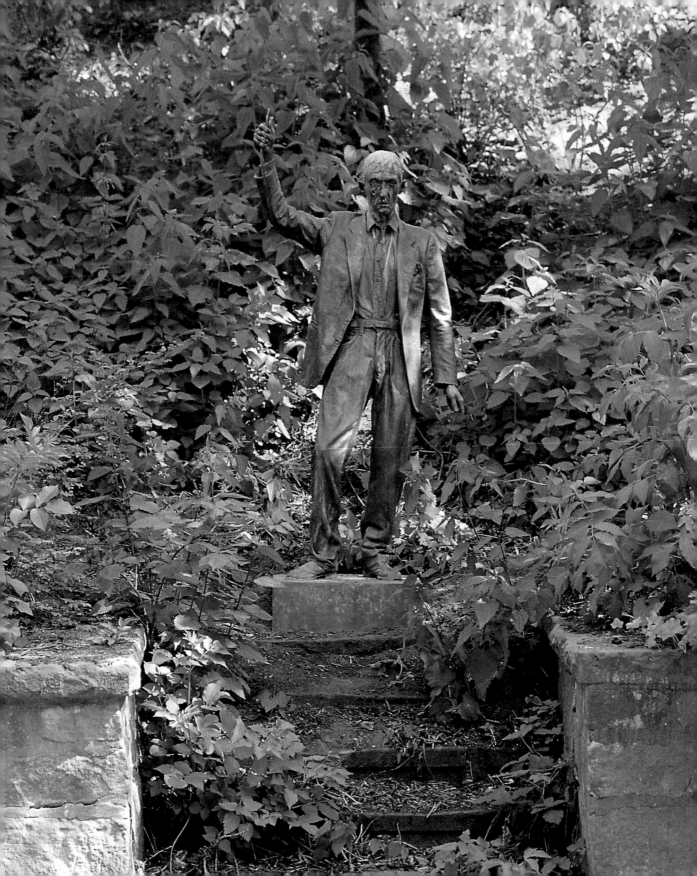

ALIGHIERO BOETTI

Autoritratto (Self-Portrait), 1993
Sculpture (bronce, hydraulic and electric
device, height 1.7 m, collection Caterina
Boetti, Rom)
East bank of River Aa on Aauferweg between
Stadtgraben and Bispinghof

The reproduction of the figure of the artist in
bronze is created in such a way that the head,
heated by means of electrical resistors, gives
off a cloud of steam when a stream of water
falls on it. The work, which Boetti had already
conceived toward the end of the 1960s as a not
unironic reference to the passion of creative
thought, was shown in 1993 in Arnhem at the
exhibition *Sonsbeek '93*. This cast is the fourth
of seven planned by the artist.

From: Alighiero e Boetti, Museum moderner Kunst
Stiftung Ludwig, Wien 1997

Born 1940 in Turin, died 1994 in Rome

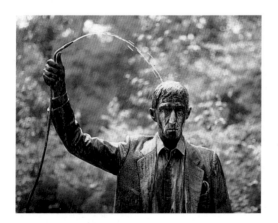

For information about the artist and additional bibliography
see: Alighiero e Boetti. Retrospective, Musée d'Art Moderne,
Villeneuve-d'Asq 1997; Alighiero e Boetti, Museum Moderner
Kunst Stiftung Ludwig, 20er Haus, Vienna 1997; Alighiero e
Boetti: Synchronizität als ein Prinzip akausaler Zusammen-
hänge, Bonner Kunstverein, Bonn 1992.

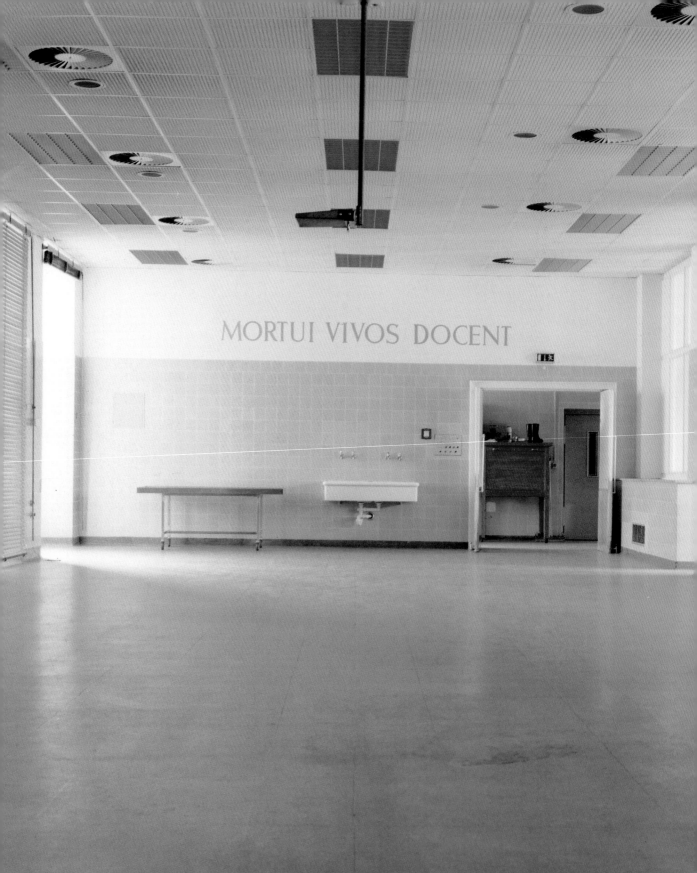

CHRISTINE BORLAND

"Die Toten lehren die Lebenden – The Dead Teach the Living"
Installation
Jesuitengang north of Petri-Kirche

Born 1965 in Darvel, Ayrshire,
lives in Glasgow

For information about the artist and additional bibliography see: nach weimar, ed. Rolf Bothe, Kunstsammlungen zu Weimar, Ostfildern 1996; Christine Borland. Sawn off, Stockholm 1995; Christine Borland. From life, Tramway, Glasgow 1994

Looking for a starting point on familiar territory led to the Anatomical Institute in the faculty of medicine at the Westfälische Wilhelms-Universität. Fortuitous timing facilitated a meeting with someone who was very friendly and a little bored during the summer semester, resulting in a tour of the anatomy department.

The enigmatic inscription, "Mortui Vivos Docent", on one wall of the sun-drenched, blue-tiled dissection theater became an important umbrella title for all that was to follow. The department's anatomical collection, in common with many others I have visited, is an eclectic mixture of specimens, some historical, mixed with contemporary teaching material. It was explained that many gaps existed in the cataloguing of the historical collection because the medical faculties were badly damaged during the Second World War.

Immediately, a display case – almost filled with diverse representations of the head – was of particular interest to me. A shrunken head, the dried head of a Pygmy; death masks from peo-

Dissection theater, anatomical institute, Westfälische Wilhelms-Universität, Münster

ple of different ethnic groups; plaster cast busts taken from rather poor artistic renditions of heads with no obvious anatomical or anthropological interest; a plaster bust of a Synanthropus Pekinensis; and two cracked, long dried-out, clay heads, with what appeared to be stereotypical Aryan features – clearly there was an emphasis on anthropology, but no archival information existed to enable anything more

than speculation as to the exact origin or chronology of the exhibits.

To diversify briefly and account for my interest in the above: in previous projects, I have used the skull and face as the natural focus from which to explore the loss of identity and respect which can befall the "subjects" of medical and anatomical research. This began with the chance knowledge that bones from an unspecified "Asian" source could be bought, easily and legally. After purchasing a skeleton, and with the help of forensic scientists, osteologists, and medical artists, I followed the police procedures to produce a missing persons portrait, which is a portrait made when unidentified human remains have been found in suspicious circumstances and cannot be traced. The results of this project, *From Life*, were an exhibition which documented the process (including the final statistics relating to the skeleton:

The medical faculty of the Westfälische Wilhelms-Universität, Münster, in 1928 (above)
Specimen from the anatomical collection of the anatomical institute, Münster (from left to right): "Synanthorpus Pekinensis", "Dajak, Dayak, Dyak", "Characteristics of the Nordic Race", "Characteristics of the Nordic Race"

Following pages: "Origin unknown, possibly Hottentots from Southwestafrica", "Origin unknown", "Microcephale Schröder, D353.1"
"Synanthropus Pekinensis", film stills from the laser documentation (page 77)

"female; Asian; age 25; height, 5 ft., 2 in.; at least one advanced pregnancy"); the production of a bronze portrait bust; and an enduring interest in this subject matter and its associates techniques.

By embarking on academic, historical research into the medical faculty of the university in Münster, (facilitated largely by the *Skulptur. Projekte in Münster 1997* team), I hoped I could at least define a context for the heads in the anatomical collection. It quickly became clear that, from the early twenties and through the war years, the faculty retained its position as one of the most important in Germany by ensuring that the majority of the professors were members of the NSPAD. The Hygiene Institute in particular became increasingly concerned with the study of Rassenhygiene and eugenics, in accordance with the developing National Socialist doctrine.

Gradually, several professors, who were associated with the medical faculty from the twenties to the fifties, emerged as key figures under the auspices of my original title, "Die Toten lehren die Lebenden – The Dead Teach the Living". These particular characters traversed the complexities and dichotomies of power relations inherent within medical research at that time. Unlike their "study material", whose identity is lost, the contributions of these professors, whether resulting in fame or infamy, are at least recorded. In brief, they include:

Professor Karl Wilhelm Jötten, Director of the Hygiene Institute for over thirty years, until his retirement in 1955. He received numerous honors, including the Bundesverdienstkreuz and a street near the medical faculty in Münster named after him.

Johann Kremer, who studied at the Anatomical Institute from 1929 and was appointed a professorship in 1939. He was a camp physician at Auschwitz, where he obtained the "material" for his anatomical preparations and during which time he kept a detailed diary, now published. After the war he was condemned to death in Krakow and pardoned after ten years because of his age. Four years before he died in 1965 he was stripped of his professorship.

Professor Eugen Kurz, who was Director of the Anatomical Institute during the twenties and thirties; he specialized in the "anatomy of the yellow races", and in anthropology in general. I speculate that some of the heads in the collection date from this period. Kurz was very active in the NSDAP, and was involved in denouncing several of his colleagues for a mixture of religious and political reasons. Three of these included:

 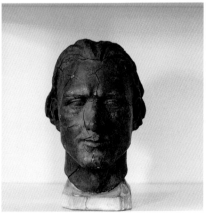 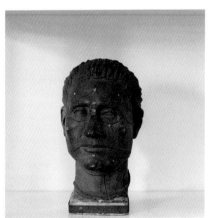

Professor Hermann Freund, Director of the Pharmacological Institute from 1925; he was dismissed in 1935 and died in KZ Mauthausen.

Professor Walter Groß, head of Pathology, who committed suicide in 1933, after accusations surrounding both personal and political motives.

Professor Paul Krause, Director of the University Clinic, who passively resisted the enforcement of the Nazi ideology and was forced from his position by student boycotts. He shot himself in 1934.

Professor Otmar Freiherr von Verschuer, who was appointed Professor of Human Genetics in 1951, had the final association with the university. He gained his position despite this statement from the head of the commission overseeing the reconstruction of the Kaiser Wilhelm Institute for Anthropology in Berlin, where Verschuer had worked:

"Verschuer should be considered, not a collaborator, but one of the most dangerous Nazi activists of the Third Reich. An objective judgment of the investigative committee must recognize this, and thereby take actions to guarantee that this man does not come into contact with German youth as a university teacher, or with the broader population as a scientist in the fields of genetics and anthropology."

A part of my project will include the above research material in an expanded version. Reproductions of the study specimens from the anatomy collection will be publicly sited where they have some relationship to the history of anatomical study in Münster. The method of their reproduction has been as "hands-off" and devoid of artistic interpretation as possible, produced almost completely by computer-generated techniques gaining a little distance from the overtly immotive originals in the anatomy collection, thereby inviting curiosity and interaction. The specimens remain unnamed and unidentified, but at least they have at last been found, contextualized, and remembered.

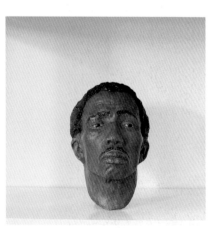 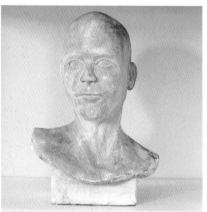

Literature

Ally/Chroust/Pross: Cleansing the Fatherland, Baltimore and London 1994

Auschwitz in den Augen der SS. Höß, Broad, Kremer, with a preface by Jerzy Rawicz, 2nd edition, Katowice 1981

Cathrine Clay/Michael Leapman: Master Race: The Lebensborn Experiment in Nazi Germany, London 1995

Jared Diamond, The Rise and Fall of the Third Chimpanzee, London 1991

Benno Müller-Hill: Murderous Science. Elimination by Scientific Selection of Jews, Gypsies and Others. Germany 1933–1945, Oxford 1988

Daniel J. Kevles: In the Name of Eugenics, Boston 1985

Marek Kohn: The Race Gallery, The Return of a Racial Science, London 1995

Hermann Langbein: "... wir haben es getan", Wien 1964

Robert J. Lifton: The Nazi Doctors, Medical Killing and the Psychology of Genocide, New York 1986

Münster, Spuren aus der Zeit des Faschismus, Zum 50. Jahrestag der nationalsozialistischen Machtergreifung, ed. Hans Günter Thien/Hanns Wienhold/Sabine Preuß, Münster 1983

Mythos Münster. Schwarze Löcher, weiße Flecken, ed. Ulrich Bardelmeier/Andreas Schulte Henning, Münster 1993

Miklos Nyiszli: Im Jenseits der Menschlichkeit. Ein Gerichtsmediziner in Auschwitz, Berlin 1992

Robert Proctor, Racial Hygiene: Medicine under the Nazis, Cambridge, Mass. 1988

"Wer seine Geschichte nicht kennt...". Nationalsozialismus und Münster, ed. Iris Horstmann/Ulrike Junker/Katrin Klusmann/Bernd Ostendorf, Münster 1993

Karl Wilhelm Wutzer: Bericht über den Zustand der anatomischen Anstalt zu Münster im Jahr 1830, Münster 1830

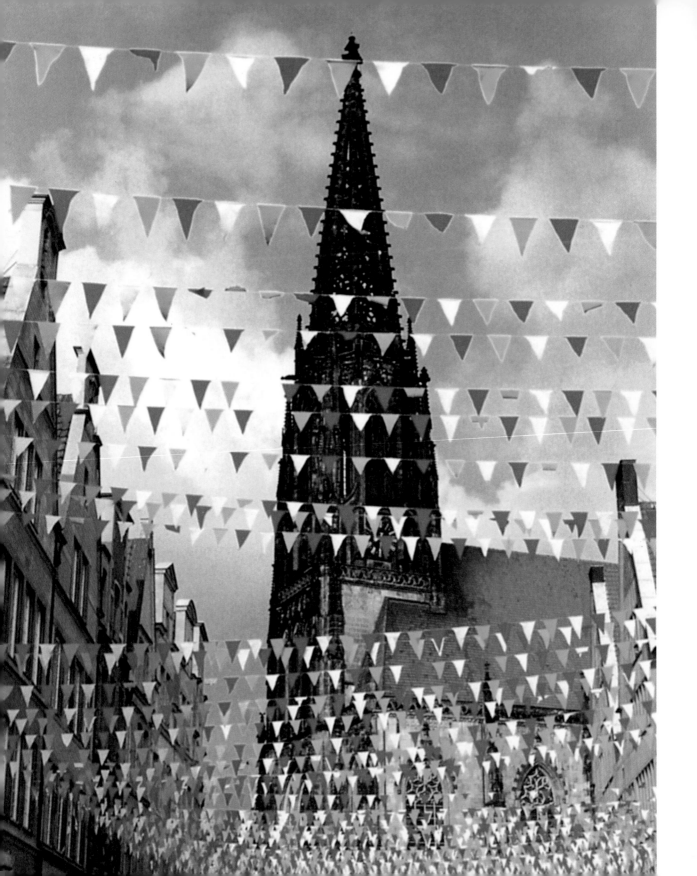

DANIEL BUREN

Travail in situ, Münster 1997
Prinzipalmarkt

Born 1938 in Boulogne-Billancourt,
lives in Paris

For information about the artist and additional bibliography see:
Daniel Buren. Erscheinen. Scheinen. Verschwinden, Kunst-
sammlung Nordrhein-Westfalen, Düsseldorf 1996; Daniel
Buren. Achtung! Texte 1967–1991, ed. Gerti Fietzek / Gudrun
Inboden, Dresden /Basel 1995.

Like a Palimpsest or The Metamorphosis of an Image

Site Specific

Although the term has become hackneyed and meaningless through use and abuse, site specific work has always been essential to my approach.

To believe that site specific work is indistinguishable from so-called "installations", which are at best a form of window dressing, or, again, to believe that it covers only works done on-site for a particular event, is to reduce its scope drastically.

Today there are numerous artists who "install" their works on-site: it's the fashionable thing to do.

However, as I see it, there are few artists who make site specific works in the broader sense in which I understand the term – whether or not they use it themselves is neither here nor there. To clarify my point, although as far as I know he has never used the term site specific for his own work, I would say that, to give an example (but there aren't many more!), Michael Asher is one of the small number of these artists who not only bases the main part of his work on an analysis of the general constraints of a site, and then formulates a response to this (a response which of course does not iron out either the questions or the contradictions arising from this place), but, what's more, accepts all the consequences implied by such an attitude.

To mention only one, I would indicate the difficulty (impossibility?) that the market has in adapting to this type of approach – a phenomenon sufficiently rare in these latitudes to warrant a mention.

Carneval decoration at the Prinzipalmarkt in Münster, postcard from the 1970s

Memory

As for the work I am doing for *Skulptur. Projekte in Münster 1997*, this time my study of the site began not with the physical place itself but with the interpretation of it given in the photograph chosen by the organizers as the poster for the event, which I saw by chance when I was in Münster working on something else!

I asked around and found out not only where this photograph was taken from and by whom, but also when exactly the town of Münster takes on the festive appearance described in the photo. It was taken during the last carnival and the colors used for the flames are those of the town of Münster.

At the same time I remembered that in 1982, during *documenta 7* in Kassel, I used the whole of the garden facing the Fridericianum to plant about sixty masts along all the pathways through this area, hanging from them, above the pathways, multicolored flames. This work on color was accompanied by recorded music (classical music from different centuries and music written specially for the occasion) interspersed with the names of the colors read out in over fifteen different European languages. This was put out from morning to evening throughout the duration of the exhibition by speakers placed around the esplanade.

When all this clicked, when my memory of this past work came together with the photographic image announcing *Skulptur. Projekte in Münster 1997*, I decided to reprise this same kind of work in a different way, taking my inspiration both from what I had done fifteen years before and from the poster I had seen.

Having obtained the agreement of the town council to let me reuse exactly the same positions as those used in general, I decided to change only the design of the flames and to use only one single color for the ensemble, red. A technical detail: the total length of the bunting was over three kilometers.

Daniel Buren: *Wimpel-Text-Musik*, contribution to *documenta 7*, Kassel, 1982, location: Friedrichsplatz, Kassel, ca. 65 wooden poles, ropes, ca. 5,000 plastic pennants, music system (above)

Opposite side: Daniel Buren: *IV Tore*, contribution to *Skulptur Projekte in Münster 1987*, locations: Domgasse (above left, permanent installation), Geisbergweg (above right), Spiegelturm (below right), aluminum, painted, 4.41x4.41x1.05 m

METAMORPHOSIS

This site specific work therefore consists in creating a real space, a horizontal, colorful demarcation of the space at hand, based on

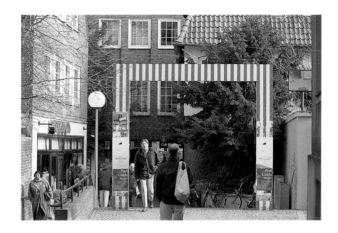

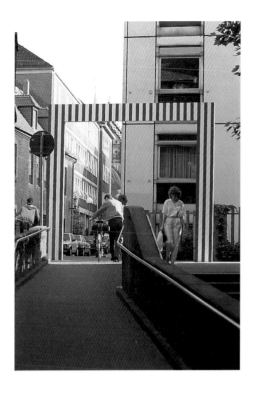

what the photographic document already showed and changing only the design and the colors.

The piece thus constituted is therefore the result both of a reactivated older piece and of a two-dimensional image which is here metamorphosed into three.

The photo-souvenir makes it possible to recreate, give or take a few details, the object that made its existence possible.

Thus, not only is a part of the history of the town reconstituted, but the place reappears in a different light because of this transformation carried out in the particular context of this event.

If, in relation to the memory of the inhabitants of Münster, the piece can be fixed and established using exactly the same hooks as those used periodically for other occasions, it does not correspond to either the dates, the design or the colors whose memory they embody.

Something different has surreptitiously taken form which at first blurs and then replaces the usual image which fades out of the memory.

Superimposed on the earlier image, which is now manifest only between the lines, the new writing takes the place of the old and the place thus renewed becomes like a palimpsest.

New York, April 9, 1997 Daniel Buren

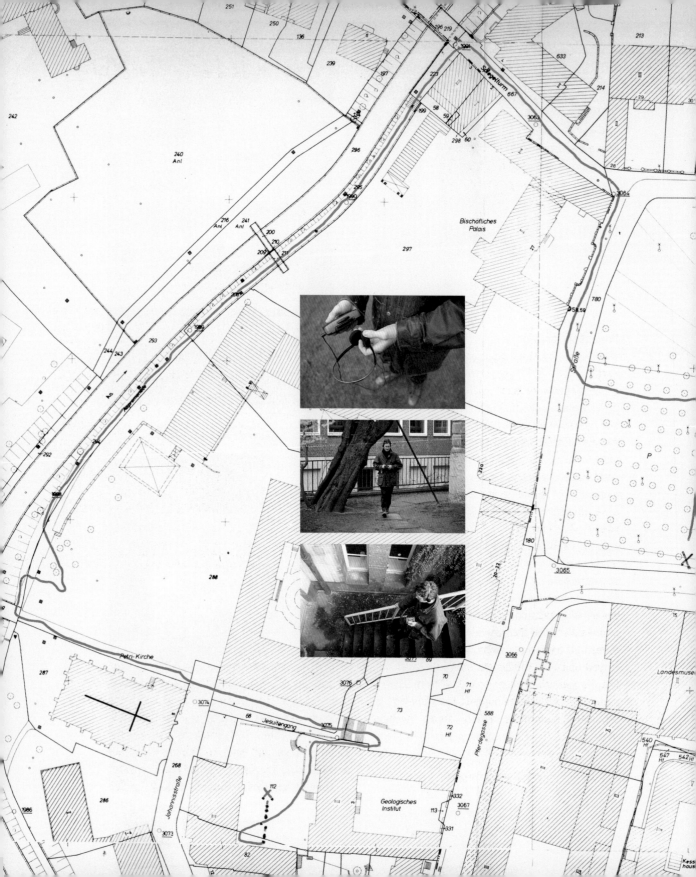

JANET CARDIFF

Walk Münster
Two-part work
Audio tour in downtown Münster and installation in old section of Westfälisches Landesmuseum, 2nd floor, windows overlooking Domplatz

Born 1957 in Brussels, Ontario,
lives in Lethbridge, Alberta

Janet Cardiff:
Project Description

Part 1

I will produce an audio walking tour that will guide participants through the area of streets and parks near the Westfälisches Landesmuseum. The format will echo that of a museum didactic tour, where a person carries a walkman and listens to a voice. On the tape they will hear a mixture of "natural" site specific noises as well as a complex web of "fabricated" sounds and voices. One could relate this work to a movie soundtrack or a radio play that uses an actual physical environment to complement the audio soundtrack.

This piece will be recorded with binaural audio, which is a technique using miniature microphones placed in the ears of a person, or sometimes in the head of a dummy. The result, when played back on a headset, is an incredibly lifelike 3D reproduction of sound. With this technique it is possible to suggest the presence of physical phenomena which aren't actually there.

For information about the artist and additional bibliography see: Now Here Louisiana, Museum Louisiana, Humlebæk 1996; The Dark Pool, Janet Cardiff/George Bures Miller, Walter Philipps Gallery, Banff 1995.

Janet Cardiff: Route of audio tour *Walk Münster* in downtown Münster

The participant carrying the walkman will be instructed by a voice on the tape to follow a specific route. This voice is recorded with the microphones close to the body while walking in the actual site. This method causes the recorded body and voice to feel as if they are almost inside the listener's body, and creates an intimate connection. Subconsciously partici-

Janet Cardiff: Telescope for Westfälisches Landesmuseum, atelier photo (above) and view through the telescope (below)

pants begin to breath and walk in sync with the virtual body on the tape, blurring the distinction between self and other.

I am interested in how audio affects our perception of the physical world. We understand three-dimensional space by using our vision but also by the character of the sounds we hear. If these sounds are manipulated and changed then our perception of reality can be drastically affected. If you are physically walking through an urban space you can suddenly be transported, through binaural sound, to the feeling of walking in a forest.

In this type of work synchronistic events play with the listener's understanding of reality. There is a sense of wonder and shock when events and scenes described on the audio tape coincidentally happen in the physical world. On the other hand when something you hear is not there the viewer is given a sense of displacement, as though they have been transported into someone else's dream.

The narrative that unfolds as you walk through the physical environment will focus on the interrelation of personal experience, history, memory and popular media. In one aspect of the story you will get a strong sense that some crime has been or will be committed and that the two characters on the tape, as well as you, the listener, are inextricably involved. Because audio can simulate any environment I also want to imply a sense of traversing the barriers of time between the past, present and future.

The walkmans will be issued from a stand at the entrance to the museum. There will be two versions, one in German and one in English. There will also be a video element (see Part 2) relating to the story of the piece.

Part 2

The video element will be located in the interior of Westfälisches Landesmuseum, 1st floor in front of the windows. It will take the form of a telescopic device that is pointed out the window and down at the market area in front of the museum. When viewers look into the eyepiece they will see a narrative scene (shot on video

from the exact same viewpoint and using the same focal length as the telescope) that appears to be happening live below them. This scene (approximately one minute long) will connect to the story in the walking tour.

To extend the illusion of surveillance even further the telescope will be mounted on a rotating axis controlled by a motor. When the figure in the market square (on the video) walks to the right the telescope will follow her or him. This will be governed by an electronic control track on the video which signals to the motor when and how to move.

The telescope will be fabricated out of metal, finished with a tin surface. I would like to give it the appearance of being an old object, circa 1940s or 50s. The eyepiece is intended to be a lens that focuses on a high fidelity colour viewfinder from an 8 mm video camera. This will be connected to a laser disc player by a cable. A rewind and repeat circuit will be attached to the playback unit.

Janet Cardiff: *Walk Münster*, video stills

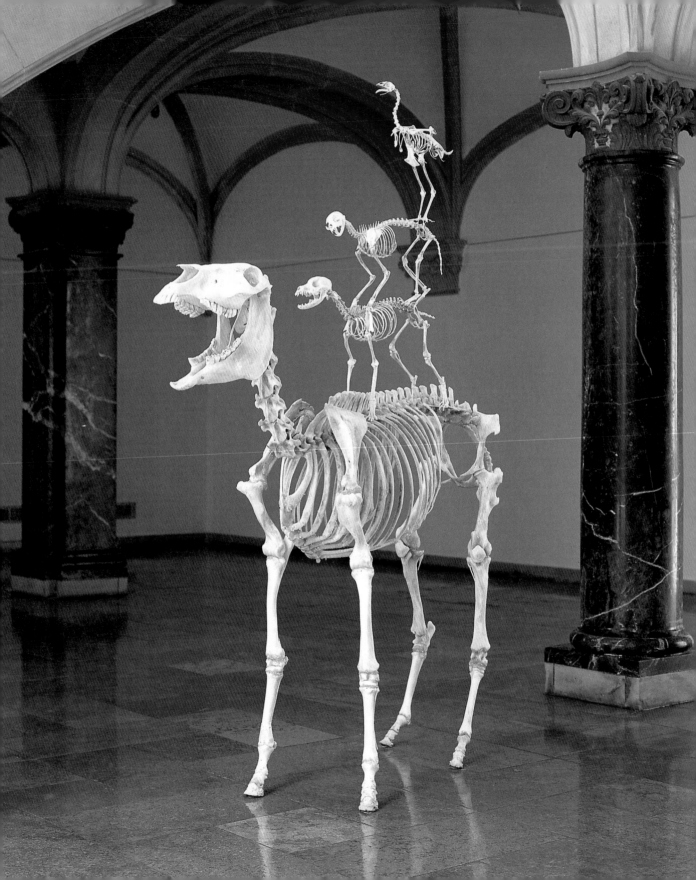

MAURIZIO CATTELAN

Out of the Blue
Installation
Aasee, below Goldene Brücke, Adenauerallee
and Landesmuseum

"Love Saves Live" (Die Bremer Stadt-
musikanten/The Bremen Town Musicians I),
1995
"Love Doesn't Last Forever" (Bremer Stadt-
musikanten II)
Two sculptures
Old section of Westfälisches Landesmuseum

Simplicius Simplicissimus, Impossibile
21 stories by Francesco Bonami after an idea
of the artist, illustrated by Edda Köchl

Born 1960 in Padua, lives in Milan

For information about the artist and additional bibliography
see: Traffic, C.A.P.C. Musée d'Art Contemporain, Bordeaux
1996; Nachtschattengewächse, Museum Fridericianum, Kassel
1993; Aperto '93, Venice Biennale, Venice 1993.

Maurizio Cattelan: "Love Doesn't Last Forever"
(Bremer Stadtmusikanten II), animal skeletons

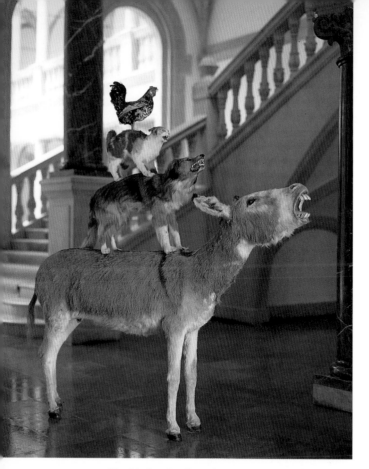

Maurizio Cattelan: "Love Saves Life" (Die Bremer Stadtmusikanten I), 1995, taxidermal specimens, Leggeri Collection

Simplicius Simplicissimus, Impossibile

The Concept

Through a series of conversations and descriptions we rewrite about 20 of the projects that were not realized in Münster in the exhibitions of 1977, 1987 and 1997.

The idea is to go back to the memories of those who have been involved in those projects but also listening to those who listen to the projects.

The idea concerns the transformation of different ideas once they have been re-elaborated by the fantasy of other people. In an age of images we focus on the functions of listening.

The Realization

Once all the different stories have been collected we will rewrite the documentation again creating another version, yet transformed from the original one, according to the impressions that those stories have been able to stimulate.

As a book of tales the final version of the narrative should be illustrated with drawings based on the final version of the story. The drawing should be realized by a regular illustrator of children books or school books.

We believe that we should avoid to involve the artists in the project as witnesses of their own ideas.

It's more interesting to record the distorted memories of other, sometimes quite distant, witnesses.

Destination

The final texts should be included in the official catalog of *Skulptur. Projekte in Münster 1997*.

Out of the Blue

For *Skulptur. Projekte in Münster 1997*, I thought about the Aasee as the location for a work that can only be seen when one uses one of the rowboats that can be found on the bank of the lake. I would like to realize a human-like figure, made out of rubber, dressed in a suit (jacket and trousers), with the feet in a block of cement (the famous "cement shoes") – done in the best gangster tradition.

The body – or, better said – the "corpse", will be sunk in a shallow part of the lake, so that it will still be visible from the surface. The figure should react in the water as would a human body; that means that it should be elastic enough to move, and to give to the Pythagorean pressure; the arms should therefore drift upwards.

The attraction of this work derives less from *Film Noir*, as from a certain peculiar charm: that of bell towers, small villages, and monsters occupying a lake, all of which for various reasons, have become the stuff of which legends are made.

Francesco Bonami:
Simplicius Simplicissimus, Impossibile

Twenty-one stories after an idea by Maurizio Cattelan,
illustrated by Edda Köchl

(All resemblances with any persons living or dead or actual events are purely acccidental.)

The Carrot and the Sacristan

Early one morning the old sacristan began his daily routine of cleaning the Cathedral. While he was sweeping absent-mindedly under the pews, he heard, faraway behind the main altar, a feeble yet shrill voice repeat: "Radical ... radical." It sounded like the voice of a parrot. The old man rested his broom against the wall and toddled curiously towards the big cross hanging above the altar. In the darkness of the transept, seated upon a old chair, was Joseph Beuys – but the sacristan was so busy looking for the parrot that he didn't even notice the odd fellow. He looked high above the huge pillars, but there was no bird up there.

"Radical," the voice mumbled again, this time just under the cross. Using the tremulous light of a large candle, the sacristan approached the place from where the sound seemed to be coming, and there he found a small carrot lying on a shelf. "Radical," the carrot said once more.

"Do you get the meaning of that carrot?" Beuys asked the man from this chair. The poor sacristan looked at him with the same curiosity with which he looked at the carrot, and for a moment he forgot about the talking root vegetable and concentrated his attention on the weird clothes that the man in front of him was wearing. But Beuys continued to

question the sacristan: "You must know, of course, that the Anabaptists were shooting their cannons from the top of the Überwasserkirche over this cathedral? Well, I placed an antenna on top of the church, and from up there I am transmitting inside that carrot-receiver. Are you getting my point?"

The sacristan scratched his head and peeked at the tuned-in carrot, but mostly he kept his attention focused on Beuys's vest. He asked: "Did you just get back from fishing?"

This question caught Beuys off guard; he had never thought that his clothing would be connected with such a useless activity as fishing. He was surprised and awestruck. The amazing simplicity of the sacristan's thinking was disconcerting, perhaps even more radical than the carrot. At that moment, the carrot became mute, but then after crackling with static for a moment it began to transmit a conversation between two taxi radios.

This excruciating interference had for Beuys a deep symbolic meaning: just as the sacristan was interfering with the meaning of his vest, the carrot was affected by a very similar phenomenon. Beuys understood that his whole project was in crisis and, with a gesture of chivalry, he removed his hat to thank the sacristan for his enlightening comment.

When the old man saw Beuys's strange head with all those hairs stuck to his skull, he believed the poor man to be brain damaged, and silently, slightly sadly, he returned to his job of sweeping.

Back home, the sacristan told his wife about the odd encounter. She listened patiently as she cooked the sweet cabbage that had been picked after the first winter frost. Meanwhile, at his own home, Beuys called his family to gather around him, and informed them of his new projects.

Hasty Investment

Sitting at a table in an old pub, the young electrician Lambert was eavesdropping on a conversation between two English-speaking people seated at the next table. One of them was tall and skinny, with ears sticking out prominently from the sides of his thin face. The other was a stranger, whom the electrician had never seen in town before; his name, he would discover later, was Flavin – Dan Flavin – and he was an American. The two were talking about a project with neon lights to be installed in the underground corridors of the town. The stranger, whose idea it must have been, was discussing the number of neon tubes he needed to realize the project: more than a thousand.

When the electrician heard this figure he became very interested; he had just opened his own shop, and this could be his chance to break through. He was very thankful to his parents who had forced him to learn English in school even while he had wanted to go with the much easier French; if not for their strict discipline he would never have been able to focus on this interesting conversation. But then, disappointingly, rather than get more specific about the matter, the two fellows simply gulped the last drops of their beer and left.

Heading back home, Lambert had a fantastic idea: the next morning he would cruise the entire region

in his new van, buying every available neon tube from all the wholesale stores of Westphalia. "I will have the monopoly on neon!" he thought. "I will establish the prices and my profit will be amazing!" he dreamed. "The guy will have to come to me! And … he will have to pay!" The electrician jumped up and down, then went to bed.

Early next morning, as fog still covered the fields beside the road, Lambert was already in his van and ready for the hunting excursion. By evening his shop was filled with neon tubes, but he continued to collect so many that he had to stack them all over his parents' small townhouse, where he still lived.

A few days went by, and Lambert was getting anxious. None of his friends had heard about the underground corridor project. One day he decided to go to the city hall to get more information, but even there, none of the employees knew anything about the strange proposal. Many more days passed, and the electrician began spending sleepless nights, looking at all the neon tubes sticking out from under his bed. He went to the underground corridor every day, just to be sure that nothing was happening without him knowing about it. But nothing was happening: life underground was normal, people going down and in, people going up and out.

His parents became concerned about his strange behaviour, but they thought it was some kind of spring love affair. After a month Lambert lost all hope, and his thoughts became desperate. It was during the peak of his despair that one day, wandering around town at lunch time, he saw the tall and lanky man from the pub walking through the town in the shelter of the buildings, smoking a cigarette as though nothing was going on. Lambert lost his mind. He crossed the street without looking – at the risk of being shish-kebabed by an angry bike rider – and jumped on the poor guy, pushing him against the window of a pastry shop.

The tall man looked at Lambert quite thoughtfully. Lambert was shouting obsessively to the smoking pedestrian, questioning him about the neon and the underground corridor, and threatening to haul him in front of an execution squad if he did not give him a decent explanation for the unacceptable delay.

For a moment the victim couldn't understand the point of the assailant's demands, and was – to say the least – worried. But he soon realized the matter of the virulent monologue and, as calmly as you should be when you have to control a mental case, he explained that his friend Flavin's idea was cancelled for reasons that would have been tedious to explain under the circumstances. Hearing that, the electrician jumped back like he had been punched in the face. He swayed, and then disappeared. The tall guy lit another cigarette.

We know that late at night some friends found the electrician in an old hayloft in the middle of the countryside. They brought him home – he still was in a state of confusion – where his parents consoled him lovingly.

Today, Lambert's electric shop is one of the most successful of Münster. The electrician has taken some time to learn English better so that he can talk fluently with the many tourists arriving from all over Europe to visit the town. There is a rumour that even though Lambert has studied the foreign language assiduously since the first grade, he has never really mastered it completely. Apparently, when he was eavesdropping on the conversation at the pub, he confused the number of watts with the number of neon tubes. In fact, if Flavin's project had ever been approved, it would have been realized with no more than a hundred lights.

Depressed Volleyball

Nobody would have dreamt that the University volleyball team would make it to the finals of the championships. The euphoria soon chilled when the Münster team discovered that each of the finalists had to host one of the final matches on their own court. Thanks to the artist Bruce Nauman, their court had just been transformed into a square which looked like an upside-down pyramid with a kind of depression in the center.

The Dean of the University met with the team coach and with the regional authorities of the sports department; nobody could solve the problem. Giving up the match was suicidal, yet the town had no alternative court capable of accommodating all the people who would want to attend the match. Frantically, all the rules where double-checked, and with great surprise somebody discovered that while the sizes of the court are very strict, nothing is said about the fact that a court has to be absolutely flat. They called some more meetings and it was soon confirmed that the university court met all the specifications for the match.

The other team ranted and raved about the officials' decision, but nothing was changed, and the match was scheduled to proceed. The Münster team went through an exhausting training period to adapt its play to the newly depressed circumstances, and by the end all the players were ready to face the odd challenge. Meanwhile, Nauman was asked to design some kind of scaffolding around the court for the public, and thus he was finally able to build his dreamt-of *Truncated Pyramid Room* around the depressed square.

Everyone was happy. On the day of the match, the seats were packed. The Münster team put all of their taller players down in the center of the court,

while the other team sunk on their own side. It was a lopsided match, and the Münster team won with a shameful score. Riots erupted in the seats among the supporters of the two teams, and some people fell (Nauman had in fact forgotten to install fences or banisters around the benches), but nobody was seriously injured.

Since then, the Münster court has become a mythical place, and winning there is held to be worth more than any national championship title.

A Kilometer of Rope

They were three: Francesco Clemente with his collarless shirt and prematurely receding hairline (being still so young), and another two who were teenagers dressed as altar boys. Each of them was carrying a roll of thick rope under his arm. Actually, it was only one rope rolled in such a way that it could be carried at the same time by three persons. They rented a bike with three seats and, with the

out from the tower and throwing down the rope. Later they saw them running out of the church to reach the rope on the ground, and pulling it, while running, into the field. As the rope was stretching out like a new horizon in the sky, the three figures receded further and further into the landscape until the rope was completely tense and the bells began to ring.

rope rolled over the handlebars, they rode beyond the city walls and into the countryside to seek the church that would suit their purpose.

After half an hour of riding they spotted what they needed: a small church with a very, very tall bell tower, a bell tower which was quite awkward compared to the size of the rest of the building. They knocked on the door and an old priest opened it. Clemente showed him a drawing of his idea. They didn't understand each other at first, but then the priest rolled up the drawing and made it clear that if they wanted to use his bell tower they would have to give the drawing to him as a present.

Clemente agreed, and he and his two altar boys slipped into the church and ran up to the bell tower. People from far away saw the three figures popping

The people who were watching the three young fellows pulling on the rope believed that they were playing with a huge kite that had been lost among the clouds. Meanwhile, the women came out from the farm houses around the church. The priest standing in the churchyard tried to reassure all those people who, on hearing the bells, imagined that there was some kind of an emergency and ran to help their beloved parish.

Many years later, somebody told me that the Clemente drawing was sold at an auction in Bavaria for a lot of money. In the same year, the roof of the small country church was completely renovated.

No Room for Hypos

When the bus arrived at the stop, Mr. Haacke wasn't surprised to see that it was painted like a tank, and he paid no attention to the advertisements printed on its sides; the camouflage colors, in fact, gave him a feeling of security, and brought back a rush of old memories. He boarded the bus mindlessly, showed his pass to the driver, and took his seat. The fact that the driver was wearing a helmet covered with leaves did not scandalize him – he merely thought that the department of transportation had promoted a new uniform, more hygienic and safer in the event of a crash. The trip was longer than usual, but even this fact didn't bother him. One thing caught his attention: the pedestrians along the road were all black. He had not realized that immigration had reached such an outrageous level. Still, he didn't let the thought get under his skin, as he would soon be home where a good dinner surely awaited him.

All of a sudden he felt somehow uncomfortable, and turning around he realized that he was the only white person on the bus. He began to become quite nervous, and though he tried to distract himself by looking out the window at the scenery, he was, this time, not simply surprised by his discovery – he was terrified. The bus was not running through its usual neighbourhood, the one with nice parks and modern buildings; it was crossing a shanty town. He decided to get up, but he saw the menacing gazes of the other passengers and he decided that maybe it would be wiser to stay seated.

Mr. Haacke was sweating; he thought he must been dreaming. He pinched his cheek: he was perfectly awake. The bus stopped for a police blockade, the doors opened and two black policemen got on the bus. They determinedly pushed Mr. Haacke out of the vehicle, and hauled him to the police van. From the back window of the van, Mr. Haacke just barely managed to glimpse the other passengers on the bus cheering with joy.

The Oval Forest and the Trapped Neighborhood

When the trees of the public garden were planted they formed a perfect oval. Much effort had been required to create this special shape, but Katharina Fritsch was finally able to realize her childhood dream. The entire neighbourhood came out to celebrate the oval forest, and their prodigal daughter organized a picnic, with tonnes of food, atop a huge red and white checked tablecloth. In the center of this tablecloth was a big round of cheese with a small black rat made of sugar standing in the middle. People danced and sang around the trees, and the children played endless games of "Ring-a-ring-a-roses", until finally the sun went down and everybody went back home.

A few months went by and the trees slowly started to get sick, the children became teenagers, and the public garden was left empty and eventually abandoned. The oval forest was pitch dark at night, attracting all kinds of people and fishy trades. One day the neighbourhood council decided that the trees had to be cut down, and so they were. Only the round stumps were left, and on Sundays people would use them as seats to watch impromptu soccer matches. Yet, the area was otherwise completely run down and at night it was very dangerous to walk there.

The community complained insistently until the city imposed a kind of curfew and built a huge chainlink fence around the park, one which was higher than the nearby buildings. Those who had been used to sunbathing on their terraces had to stop, as they were developing a grid pattern on their skin from the sun passing through the links of the fence.

One day a man saw the young woman who had dreamt up the oval park on the inside of the huge cage, weeping upon a log. Nobody could ever figure out how she got inside the park or how she eventually got back out, as the cage had been built with no entrances or exits.

The Intelligent Present

At the television station the phones were ringing off the hook. The spot by Jenny Holzer, broadcast on prime time, had caused an unparalleled uproar. Every five minutes one of the most popular family shows in Germany was interrupted by the following message on the screen: "The future is stupid."

To make amends, on the next day the directors of the offending television station broadcast a new message, also at five-minute intervals: "The future is stupid, therefore Channel X has decided to devote itself to your present."

The calls of protest doubled. A survey later revealed that it wasn't the content of the spots that had disturbed the television public, but rather the obtrusiveness of the interruption.

The Pierced Lake

Donald Judd, a handsome gentleman with a white beard, marked a perfect circle ten meters in diameter upon the frozen surface of the lake. The workers then began to cut through the thick ice with their electric saws. When the operation was complete, the huge wheel of ice fell down into the lake's slimy depths. Water rushing to fill the hole immediately froze as it met the air, creating a perfect cylinder. The fish swimming in this water were trapped inside the cylinder's frozen walls, so that from the outside you could see all their tiny fish heads sticking out, resembling a low relief decoration.

The hole became popular right away. Kids skated around it and some of them jumped inside, using the bottom as a small hockey field. In the summer a concrete ring took the place of the iced wall, forming a kind of circular waterfall. The place turned out to be one of the main tourist attractions in the

region, until one night a small boat with two young lovers fell inside; the unfortunate couple had to be fished back to surface as a bunch of cracked bones. The hole was sealed, and the concrete ring was sub- merged in the water. Those who sail on top of it today can see only a heap of empty cans carried into it by the currents.

A Matter of Millimeters

Nobody really knew the purpose of the ninety-nine stainless steel pieces that Walter De Maria wanted to stick into the ground in front of the university building of the Schloß. There was a rumour that the first three segments required more than a year to be placed in the correct position, and eventually they were removed because of some imprecision caused by the incapacity of those in charge of realizing the project. Yet the first two pieces were installed with no problem, and the distance between the two was measured with very sophisticated instruments. Then the third stainless steel segment had to be installed, and it was discovered that the measuring instruments were calibrated with obsolete criteria, according to De Maria.

Other instruments were shipped in from the United States, but for some odd trade regulation they were stopped at Customs, and apparently they are still there. Contact was made with a specialized factory in Siberia, but when the instruments arrived they were inscribed in Cyrillic, and were totally incom- prehensible. Meanwhile, the artist started to get nervous, and in a moment of delusion he kicked one of the two pieces already installed, moving it and irremediably affecting the distance. The same evening, his swollen foot resting in a bucket of ice, Walter De Maria decided that for a matter of milli- meters it was not worth crippling himself, and the following day he left for the United States.

The Overpass of Discord

It was owing to a chain of misunderstandings that one morning two squads of workers arrived at the site, scheduled to build the overpass designed as the *Pedestrian Bridge* by Siah Armajani.

On one side of the road stood a squad of Greek workers, and on the other side stood a squad of Turkish workers. Cars roaring by were making communication between the two groups even more

complicated. Somebody suggested that one of the two squads should go back home, but the workers' reactions were less than encouraging. Somebody else came up with the idea of splitting the groups in two and sending home half of each, which would create a mixed squad – but again the reactions were sad and disappointed, though not violent. Eventually, the decision was made to split the project in two; the two halves were to be built by each of the squads independently.

The workers started just before noon, and in less than half an hour they all stopped for a lunch break. When they started up again the two groups engaged in a fierce competition to build, and in a blink of an eye the overpass was ready. The only problem was that the two halves did not meet. The Turkish section was lower than the Greek section, but because the Turks had been faster, their part was lower but also longer.

Negotiations were begun on how to fix the problem, but because it was almost the end of the day everybody left, and at that point the overpass was left as it was.

That same night, some witless man travelling by foot decided to inaugurate the new overpass so as to avoid being run over by cars, which at night rushed along faster than during the day. Unfortunately, the poor fellow entered the Turkish branch and when he arrived at the end of it he fell into a void, down onto the motorway, where a truck rushing madly squashed him into the tarmac.

Of course, everybody believed that the man had been run over by the truck while crossing the street, and so did the truck driver (who was immediately arrested). The next day, the two squads still couldn't arrive at a decent agreement, and so the overpass was disassembled to avoid any possible riots between the neighbourhoods of the two communities.

The Preacher on the Roof

When the cloud of smoke completely blotted out the moon, the whole town stampeded toward the Überwasserkirche.

But when the people arrived at the church they were faced by an unpredictable vision: the church was not burning! Well, at least not all of it was on fire. Only a section of the roof was ablaze, forming the shape of a huge, crooked cross. Lothar Baumgarten stood screaming on top of the roof. He was railing against priests and against insurance companies, the deadly brokers of our society.

Somewhat disconcerted by this, the crowd began to root for the improvising preacher, applauding his curses against the insurance companies and booing his insults against the harmless priests. Meanwhile, the fire was extinguished, but the red-hot roof tiles glowed spookily. Baumgarten was sweating – some said that he experienced no pain as he lifted the scolding tiles and threw them down to the ground, where they crumbled like delicious cookies.

In the total chaos some hoodlums were attempting to reach the possessed man roosting on top of the roof. Down in the square throngs of people were demanding that the town authorities catch the man responsible for such a disaster, and jail him in a cage hanging from the bell tower of the St. Lambert church. Other people asked for the heads of some men named König, Bußmann, and Beuys – the latter had already been pointed out to the police for having attempted a feast in the middle of the town, provoking the teenagers to practice polygamy and the excesses of the Anabaptists' age. We know for sure that all of a sudden a shower broke from the sky, extinguishing even the last few glowing embers of the roof.

The deranged arsonist was able to escape the enraged mob, and today we believe he is living in Brazil – or someplace nearby – rolling tobacco leaves for highly esteemed cigars.

The Upside-Down Artist

A group of relatives of a deceased soldier who had fought in the Franco-Prussian war gathered around the ditch that had been prepared for the upside-down copy of the Ehrenmal monument. When Raimund Kummer arrived to check if his project was proceeding, he had not been expecting to find such a crowd, but he was very proud of himself for having stirred up such interest in his work.

Nobody talked to him, however, and while he was checking the depth of the ditch the people pressed closer and closer to him. Sensing that some kind of unfriendly moment was approaching, he tried to make his way through the crowd, which by this point was jostling him about. He found it impossible to free himself and they eventually succeeded in pushing him into the hole. A steel grate was ready and in few moments it was cemented in place, covering the opening of the ditch.

Kummer screamed away at the top of his lungs but his voice was drowned out by the patriotic songs being sung by the victim's relatives.

The Twins of the Vitrine

In front of the Museum vitrine, an identical replica of the vitrine had been built, but nobody was paying attention to it or questioning the reasons for that effort. One day, two spinsters arrived to visit the Museum. They were identical twins. Before buying their tickets and entering the Museum, the two women looked at the vitrine containing the announcements of the exhibitions in order to be informed about what their visit would entail.

The twins were standing in between the two vitrines, one looking at the original and the other one looking at the copy. Some passing students were struck by the amazing symmetry of the situation. Within a few minutes, many others were mesmerized by the unbelievable sight. Someone cracked up laughing, somebody else started taking pictures, and another ran home to get the camcorder.

All of a sudden the two ladies realized that they were at the center – or better, that they were the center – of a show. In the beginning they were slightly embarrassed, but soon they began to enjoy the attention they were earning for creating such an unprecedented coincidence. They were asked variously to climb on top of the vitrines, or to hold identical objects, such as two bananas, so as to create a really funny and endless game of mirrors.

In such amusement nobody noticed the small man with glasses who was watching the event from a distance. His name was Reinhard Mucha, and it was he who had had the brilliant idea of the two identical vitrines. But when he saw that his effort had become merely some kind of entertainment, he turned red and furious. He stepped like a beast into the crowd, with unexpected violence. He started kicking left and right, grabbing and smashing every camera or camcorder he could reach. Screaming like Christ in the temple, he swore every type of threat and curse against those who, according to him, were profaning the meaning of his masterpiece.

Somehow he managed to free himself from the grip of a man holding him back, and he punched one of the twins in the eye. The other sister, attempting to save her unfortunate beloved, ended up receiving the same service. When the crowd saw the two poor woman each sporting a black left eye, they couldn't help but burst into laughter.

It was at that point that Mucha totally lost his mind. He grabbed a mallet from nearby workers' trolley and threw himself against the vitrine. The crowd, which up to that moment was still hovering about, vanished instantly. The deranged creator was furiously pounding the stones, and not even the Museum Director who'd rushed from the building could stop him from his destructive action.

It was only by chance that the handle of the mallet broke, its head falling onto the little man's skull and stunning him. When the police arrived they simply had to pick up the limp Mucha and carry him to the neighborhood precinct. Meanwhile, after some medical attention, the twins left on the first train for their village, and they have since cancelled their monthly visits to the Münster Museum.

The Black Hole and the Indian Prince

The German police arrested the Indian Prince Kapoor at Frankfurt airport and immediately drove him back to Münster. Allegedly the charges were "punitive damages" and "lethal subversion of public grounds". It was a cinch for the proprietor of the country restaurant to identify the defendant as the client who had lunched with a beautiful woman in his restaurant the week before. What happened was immediately clear.

Kapoor, whom we soon discovered was not a prince at all, had created a deep, round chasm in the city's promenade, and filled it up with dark blue pigment, so dark as to look black. The same night, a man walking his dog heard some moaning coming from one of the ramps of the promenade. Thinking that somebody was in trouble, he moved towards the direction of the voice, but because it was pitch dark he couldn't see a thing. The man became scared and called his dog back, but the animal – after a piercing yelp – disappeared as though gulped by the earth.

The poor man was terrified and ran to the police station, where the agents thought he was drunk and insisted on driving him home. At home he told the story to his wife, and because she knew that he had never drunk a drop of alcohol in his life, she drove him back to the police station. Finally, they decided to take some action, and the detectives started searching the promenade with powerful lights.

When they arrived at the spot indicated by the man, the policemen noticed that just a few meters ahead the grass disappeared and they could only see a black circle. Nobody wanted to get closer; they called for some extra help. Only at dawn did the police begin moving cautiously closer to the chasm. At first they could see nothing inside, but eventually one of their big torches lit up the head of a girl, then the hair of a boy, and finally the poor dog, all curled up in terror. The fallen creatures were rescued quickly, and it soon became clear that the two lovers had sustained no particular damage. The dog, wagging its tail, jumped all over his owner, turning his beautiful, expensive camel coat blue. The Indian was fined severely and escorted to the airport, where, by mistake, they boarded him on a flight to New Delhi: the fact was, he had always lived in London.

The Criminal Beaver

Floods are rare in Münster; actually, to tell the truth there had never been a flood until a few years ago, when the small channel that crosses the town overflowed, drowning the city in more than a meter of water. That same day, the entire sky turned black because of clouds of birds fleeing a huge fire that blazed in the Rieselfelder. Nobody really knows the true author of these disasters, but it is rumoured that the person responsible for both messes was Joseph Beuys.

The Rieselfelder is a nature reserve with beautiful birds and springs of pure water. Beuys used to go there often for walks and picnics with his wife and children. Apparently, one day he had the idea to build a dam in the bed of a creek with his son.

Beuys was a perfectionist, with a kind of maniacal attraction to grandiosity, and by the end of the long summer day he and his son had put together a serious work of hydraulic engineering. The two managed to create a decent size lake up the river, but in their obsessive structural hobbying it appears that the Beuys family overlooked a campfire they had used to roast some wild hares for their lunch.

To cut a long story short, the entire forest caught on fire. Beuys, realizing only too late what they had done, decided regretfully to open the dam in the attempt to put out the blaze. The amount of water that rushed down surprised nobody more than Beuys's wife, who was until then the most sceptical observer of her husband's whims.

The same evening, back home in Krefeld, sitting next to each other on the couch, the Beuys family listened in silence to the late news on the TV, and in each of their hearts a feeling of relief came when they learned that their excursion had not resulted in any innocent casualties.

The Sacred Swimming Pool

The poor fellow couldn't even pull on his underwear before the Father-Guard slapped him across the face. The girl, completely naked, was trying to cover herself up with one of the towels supplied by the seminary swimming pool which had just reopened to a mixed public.

The story is that the young seminarist in charge of the towels, including the one that now was helping the girl to protect her body from the inquisitive and cursing eyes of the priest, had not been able to resist the provocative gaze of the girl and, considering that business was at that moment rather slow, had followed her into the women's locker room. There the two indulged in an embrace which was, considering the circumstances, quite particular. If it hadn't been for the diligence of the old Father-Guard, suspicious and malicious, the young people could have quietly continued their reciprocal operation to its finish.

The incident created a scandal and the swimming pool was closed for few days. But eventually the devotion and the commitment of Tobias Rehberger, who had conceived and promoted the opening of the religious pool to a wider public, was forgiven by the diocesan head and the pool was reopened again.

However, surveillance was increased and some stricter hygienic precautions were endorsed. The most effective and lucrative of them was the use of

a special chemical that would became red once in contact with the urine of the swimmers. Every day many incontinent bathers were fined or suspended. Even Rehberger, who was an excellent diver, left a red trail behind that embarrassed him among his many admirers for the rest of the summer.

The Mental Tree

For many years the big cedar planted by Charles Ray kept turning and growing slowly, following the course of the days and of seasons. By law, any mechanical or electrical device that was open to the public was required to undergo an annual inspection, and this was also true for the large engine that the artist had installed under the tree so that it could turn. At the end of every June, the old mechanical engineer Hamann arrived to perform his meticulous inspection, up until the day he retired. That day, he consigned his job to the young technician Sebastian. Hamann explained all the details of the operation to his young heir, then left for his summer holidays with his wife.

The following year, Sebastian began his second inspection. He checked the state of the roots to be sure that none of the wires were tangled up in them. Then, with a tiny screwdriver, he adjusted some of the little screws. God only knows what caused it, but all of a sudden the tree started to turn faster and faster. Sebastian, down below the tree, did not know who he could call to help him. He tried to readjust all the screws, but the more he touched them the faster the tree went.

Meanwhile, above ground, someone had already called the environment department, the fire department, the police, and a local gardener from the town administration for help. The tree was whirling like crazy and apparently nothing could stop it. They thought about cutting the electricity to the engine, but this was not possible as the same cable was shared by a nearby hospital. The area was closed to the public and nobody was allowed to approach the tree.

A special squad of experts was expected shortly from Bonn. The Green Party called an emergency meeting of the City Council, and the Minister for the Environment was forced to step down. By the time the special squad arrived, the speed of the cedar was estimated at around 150 kilometers per hour. The demolition experts had no idea how they could begin to solve the problem of the moving tree.

Sebastian, still hiding underground inside the control room, took a deep breath and stuck his screwdriver inside the fuse panel. It was like the end of the world: sparks flew and were immediately followed by a noise that nobody had ever heard before. The ground stopped while the cedar kept turning in on itself like a huge drill bit, then its trunk cracked and the tree was quite eradicated from the soil. For a second, all the people gathered around remained still and mute, and then a thunderous applause broke out to mark the end of the catastrophe.

Sebastian waited until night to go back home in secret. The government of Westphalia approved a law that forbade applying any kind of engines to living vegetables or animals.

The End of Eternity

From the pulpit in the Cathedral the pastor begun his Sunday sermon:

"My dear friends! Today is a day of great joy. As you can see, with the lovely help of our beloved Ayşe Erkmen, we have just installed an eternal clock in the back of this church, a symbol of our holy church mission and of God's grace. Whenever we look at it we will be unable to feel the flow of the time, and thus we will always have in mind the endless love of Christ, our Lord."

At that very moment, a truck driver who was passing by the Domplatz was distracted by the odd time that was marked by the hands on the large new clock at the back of the church. He lost control of his vehicle and crashed into the wall of the Cathedral, ripping through the stone inside the nave, right in the middle of a group of the faithful, exactly under the pastor's nose, who all stared at the big truck, astonished.

Nobody was hurt, but as a result the main entrance was restored to the original façade of the Cathedral. Endless and useless were the complaints of the parking attendant, who was forced to move from an area which for years had been an amazing source of income.

The "Row In"

Jeffrey Wisniewski's idea was to install a "Drive In" on the city's lake – well, considering that the clients would have to get to it by boat, it would be better to call it a "Row In". But what Wisniewski had in mind was not such an obsolete thing as a screen floating upon the water, but rather a multi-screened space where different movies could be presented at the same time.

The idea soon became a project on paper and was subsequently realized. Two long tunnels crossed each other, floating upon the lake. In the middle of each tunnel a movie screen was installed, thus creating four floating theaters. It was an instant success – week after week all the tickets sold out. But one evening, during the last screening of the day, a motorboat, driven by some drunk, flew into one of the tunnels at full speed, miraculously avoiding all the other boats but crashing through the screen and into a Schwarzenegger film playing in the opposite theater. The viewers barely realized that it was not just another rather spectacular special effect, yet they remained impressed.

In any case, the two tunnels damaged by the sudden piercing began to sink, but besides the loss of

money on the tickets nobody suffered any serious losses. Actually, it was quite romantic to watch the crowd, on the shore, watching the end of *Apocalypse Now*, which was projected heroically by a surviving projector, stuck on top of a tunnel wreck, onto one of the white screens still floating upon the water, while a speaker, dragged away by the current, was disappearing into the dark with Reds' soundtrack.

The Wheel of Misfortune

You could see an endless queue of people at the entrance to the new amusement park, just in front of the Schloß, where once stood only a desolate parking lot. The number of people who arrived on the opening day was unusual, but the bizarre attraction awaiting that huge crowd was also unusual. Gabriel Orozco, a Mexican, famous in his own country for some whimsical *extravanganze*, had planned a huge Ferris wheel which, instead of going around up in the sky for half of its diameter, was rotating down inside the earth. The whole province of Westphalia had been subjected to a promotional campaign about this wheel, and a lot of people were fooled by the colored flyers. Many planned the trip to Münster months in advance, draining their bank accounts for some weekends.

The day was gorgeous, and when the gates opened the only trouble was in organizing the throngs at the box office and the crowd boarding the strange plexiglas capsules hanging from the wheel. Once inside the capsule, the doors were locked for safety reasons; outside, nobody could hear a peep. So from the ground the wonder or the fear of those swinging people could be measured only be the mute dimension of their open mouth, smaller or larger according to their level of panic or despair. On the way up the faces looked ecstatic, but as the wheel sunk into the abyss, the riders' eyes appeared

simply horrified. Safe in his mobile office, Orozco concerned himself not with any ecstasy or despair, but only with his calculator, which minute by minute tallied up increasing numbers of tickets sold. His time passed as quickly as that of his customers. Nobody realized that the evening was approaching and that the sky was now jammed with dark and menacing clouds. From out of nowhere a terrible storm descended. When the greedy organizer decided to stop the wheel, a bolt of lightning struck the control room and shut the Ferris wheel down. The big circle stopped in mid-air and in mid-earth. By the distorted faces of those hanging high above you could easily read their mood, but it was impossible to figure out the feelings of those deep down in the ground.

The rain became harder and harder and the help came late. The hole started to fill up with water and some people predicted the worst. If those swinging in the sky risked dying of boredom, the prospect for the others was more drastic – it was possible that they might drown.

The water was rising and the electric lights showed clearly that some of the capsules would soon be submerged. Orozco, pale and soaking wet, was starring at the rising tide, distressed, while in his head he was contemplating the sudden drought befalling his income.

Then, like a miracle, the sky cleared and the storm stopped. Some strong steel cables were attached to fire trucks and the wheel was slowly pulled around. One by one the passengers were brought to sea level. Disaster was avoided, and when the last water-filled capsule emerged from the ground safe and sound, with two red-coated teenagers floating like goldfish, nobody could stop the crowd from laughing.

The Kibbutz of
the Unicorn

The citizens of Münster never liked those strangers who tried to buy property inside the city. Those who tried were discouraged by a nasty bureaucratic maze. But Madame Eichhorn was not easily discouraged; actually, she was so stubborn that even the toughest notable of the town was forced to give up.

So one beautiful March day, Madame Eichhorn signed the contract that made her the owner of a plot of land just outside the promenade along the right bank of the lake. Nobody was able to find out what she wanted to do with that land, and after a while everybody in this traditional and solid town forgot about the thorn in their side. But when two huge trucks unloaded hundreds of olive trees, people's concerns and worries were stirred up once more. Many people gathered around the property as a tall, light blue fence was constructed around it, and as, at its entrance, a menacing sign was posted showing the face of a ferocious dog, suggesting the stong possibility of danger for whoever dreamed of crossing the threshold.

For any Münster citizen the idea of being banned as a stranger from even a square inch of their town's land was a sorrow that could hardly be explained to a foreigner.

But enough was enough, and when another couple of trucks arrived to unload tons of dirt, the city's authorities were called. An emergency meeting of the city council was called, but a series of ancient polemics prevented them from making a decision. The same night two buses crossed the town, and in the new moon darkness the people could make out some bearded and bespectacled silhouettes inside before the gate of the fenced compound closed shut.

For forty days nobody could see or understand anything, but one morning, just before the sun came up, the first few bikers going to work witnessed a breathtaking vision. The blue fence was gone and in its place now appeared a Kibbutz upon small flowered hills, where from dawn to dusk hundreds of settlers of any age and sex were working eagerly. Nobody could find any laws in the city's zoning plans that forbid the creation of a Kibbutz on private property. Eventually the people got used to the new landscape, where for some strange meteorological reason the sun shone all year round. The name of the owner was soon forgotten and those who vaguely remember it referred to that little mountain as "The Kibbutz of the Unicorn".

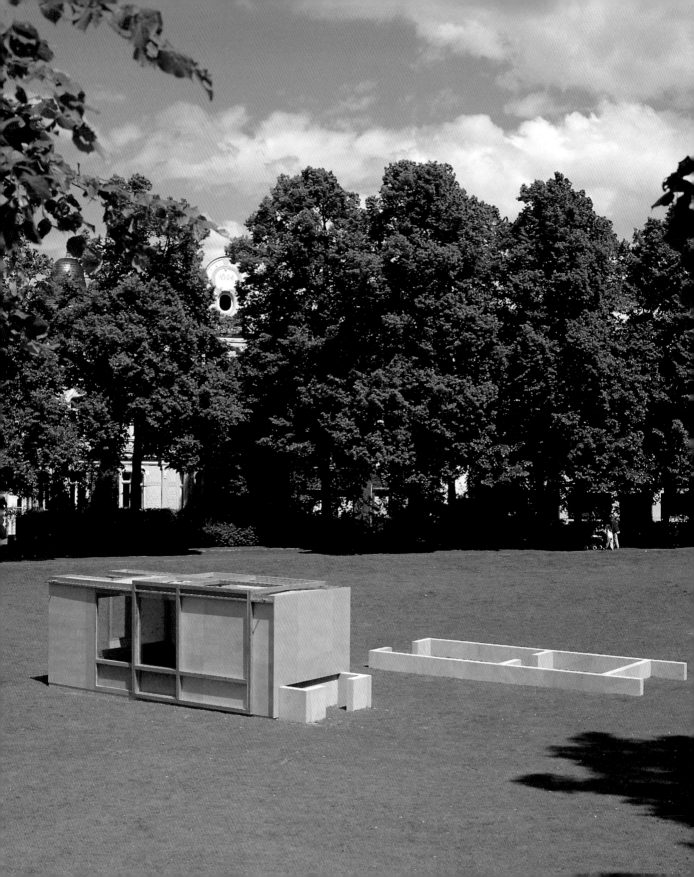

STEPHEN CRAIG

Grundriß Pavillon
Two-part, sculptural architecture (stone,
wood, glass, 0.5x7.5x3.3m and 3x7.5x3.3m
Lawn on Promenade at Aegidiitor

Born 1960 in Larne, Northern Ireland,
lives in Hamburg

Stephen Craig: Contribution to
Skulptur. Projekte in Münster 1997,
August 1996

My work for Münster is a project which involves
the building of a pavilion for an open space (an
inclining grass verge) in an area lying towards
the center of the city. The work comprises
three units which combine to form a whole. A
sculptural architecture. The idea was to create
a work which has a universal character while
maintaining a very site-specific nature for it.
I derived my concept for the work from the idea
of the historical development of a city: in terms
of the architecture, but also in terms of the city
planning as a whole, with all its sociopolitical
cultural components, and its fundamental basis
in ideas of public and private space.
The city of Münster has a very long and varied
history, which contains its fair share of rise and
fall, culminating in the near total destruction
during the Second World War and subsequent
reconstruction.
For me a way of filtering the flow of historical
events was to try to make plastic a frozen seg-
ment of time. The form therefore became a
"still frame" of the reenactment of an archeo-
logical dig.

For information about the artist and additional bibliography see:
Irish Museum of Modern Art. Glendimplex Award, Irish Museum
of Modern Art, Dublin 1997; K3. Exhibition by scholarship
recipients, Kampnagelfabrik, Hamburg 1994; Initiale '92. Junge
europäische Kunst '92, Kloster Haydau, Morschen 1992.

The work will involve the building of two low-lying stone structures, one a little higher than the other (50 cm and 80 cm from the ground). Both in the form of a ground-plan for a house (that is, to the scale of a private dwelling).

Over one of the stone structures, taking its form from the ground-plan, arises a pavilion, constructed in wood and glass. This ground form then becomes enclosed by the pavilion. It is, however, not possible to enter. The ground-plan is in a sense "exhibited" in the showcase of the pavilion. The other ground-plan form, which lies at a little distance and slightly diagonal to the first, remains uncovered, open to visitors walking through, unprotected, and is perhaps a little less noticeable, but assumes an equal presence when considered in relation to the other structure nearby. This relationship is further enhanced at night when the pavilion lights up the underlying

form brightly and throws a gentler light on the form lying further off.

Perhaps the question then arises, consciously or unconsciously: is it an archeological dig, or a representation of one? Are the forms in the process of being laid bare and preserved? Are they ruins at all? Or perhaps the foundation for a new building? Is the pavilion a sort of showcase, a protecting shell, or is it a new structure which has grown up around the old form?

For me the interesting and important things are the questions which the installation may – I hope – throw up, and, perhaps less definitely, the possibility of a certain answer.

The site for the installation is important, in part because of its location in the city. Opening on one side to the park area and green belt "Promenade" and on the other to a busy main street with a chaotic mixture of architecture, private

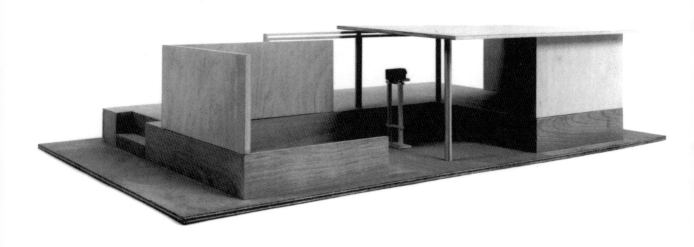

and public space. The form of the site is important because, with its grass verges on three sides, all quite steeply inclined, it resembles a Greek theater and allows the ground-plan forms and also even the roof and so the complete form of the pavilion to be seen from above – to be looked down into. On the fourth side, which opens onto the main road, the pavilion can be seen from ground level and experienced in the same way that one experiences the other architecture along the street.

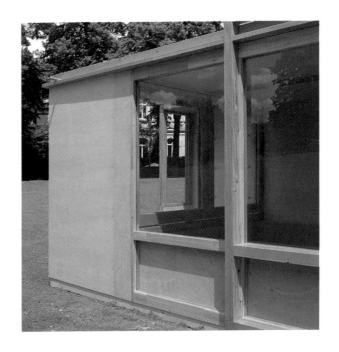

Stephen Craig: Model for *Treppenstraßenpavillon*, contribution to *documenta X*, Kassel, 1997, wood, 0.6x2.5x1.5 m (opposite page)

Stephen Craig: *Grundriß* Pavillon (Ground plan of pavilion), views

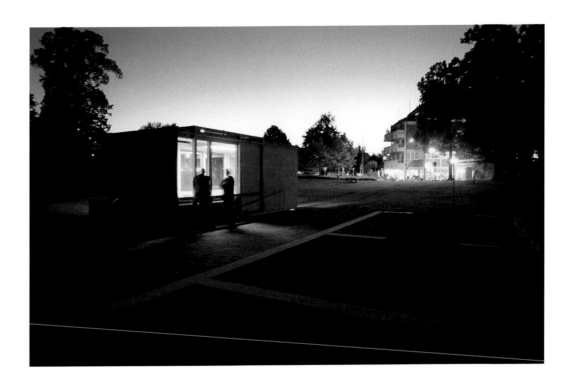

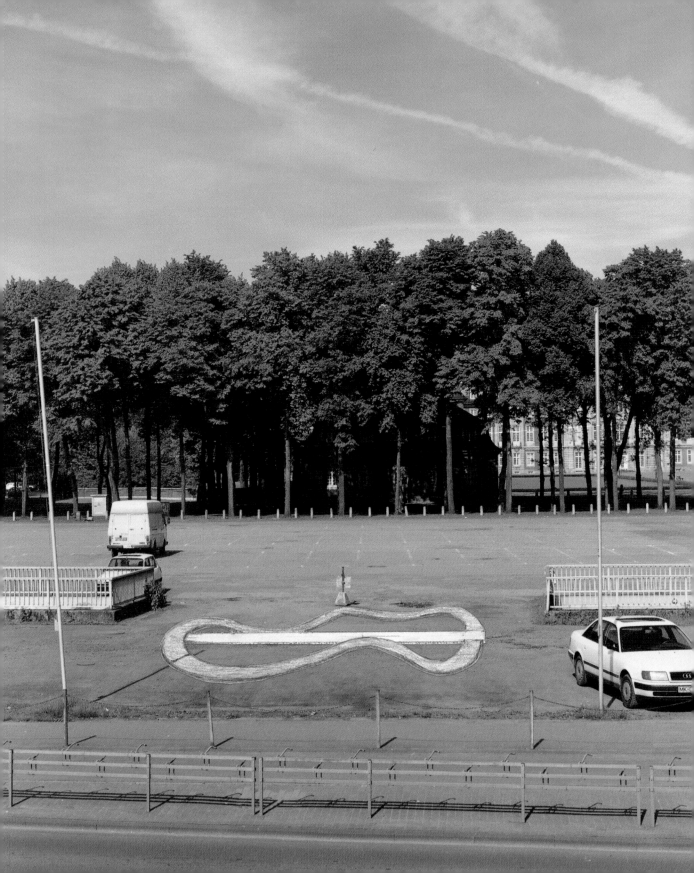

RICHARD DEACON

After Poussin
Sculpture (steel, asphalt,
ca. 1.45x9.3x3.15m)
Hindenburgplatz, between the entrances of
the pedestrian underpass

Born 1949 in Bangor, Wales, lives in London

For information about the artist and additional bibliography
see: Richard Deacon, ed. Jon Thompson, Per Luigi Tazzi, Peter
Schjeldahl, Phaidon, London 1995; Richard Deacon. Skulpturen
1987-93, Kunstverein Hannover, Hannover 1993.

Richard Deacon: Project for Münster

The site is a large open area used mostly as a
car park and occasionally for fairs or other tem-
porary activities. It is not a park. Historically
the site functioned as a drill and parade
ground, that is, had some formal use. Just out-
side the inner ring road this is clearly an urban
area yet is one that is not defined by surround-
ing buildings. The ground surface is of packed
gravel or hard core, a surface which is not
pavement or roadway yet also not grass or
earth. The proposed sculpture is positioned on
the site close to the ring road, between that
road and the two entrances/exits to/from the
pedestrian passage leading under the busy
street. This passage, hardly used, gives access
from the parking area to the historic center. I
was interested in the site because of its open-
ness, the clarity of its urban location, but at the
same time in its rather fuzzy definition. It
doesn't really seem to be owned, which is an
important aspect of any public place, but at the
same time it is a bit scruffy, public in a rather
accidental or useful kind of way.
The sculpture is a self-contained structure hav-
ing two principal elements. One is an enclosed
and continuous serpentine form composed of

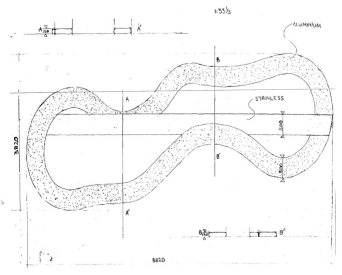

curved tubular sections. This snaking loop is traversed at ground level by a rigid horizontal beam of octagonal section. The serpentine form encloses and terminates this horizontal beam.

In Poussin's painting, *Landscape with a Man Killed by a Snake*, the body lies in the bottom left of the painting, the offending snake wrapped around it. The sight of this body provokes a disturbance which ripples through the rest of the painting. The cause of this disturbance becomes unclear and fades away into the landscape. If we focus on the bottom left we see an inert body lying on the river bank, left arm and left leg trailing in the water, right leg outstretched, the writhing body of the snake draping the corpse. However this is not a pythonesque embrace, the snake's coils do not surround the body, rather it is a loop of muscular rope strewn across and around it. The pair themselves, the undulating serpent and the stiff corpse, echo the landscape and suggest that even the certainty of death – which had seemed the painting's solid foundation – can be seen as a figure/ground problem. After all, if the pair is like the landscape, where is the man and where is death?

Laocoon

Nicolas Poussin: *Paysage avec un homme juyant un serpent. Cadmus ou le paysage au serpent*, ca. 1648, oil on canvas, 119x198.5 cm, National Gallery, London

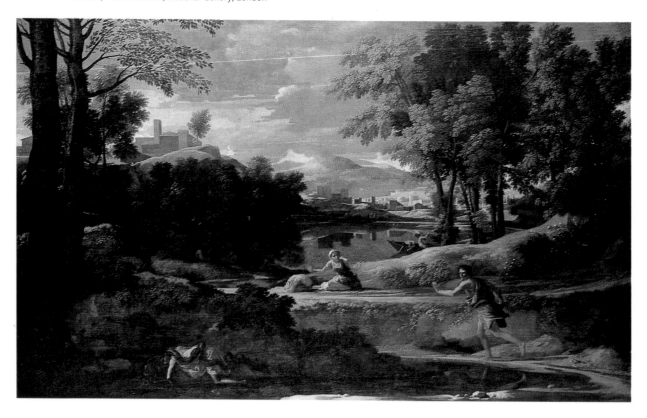

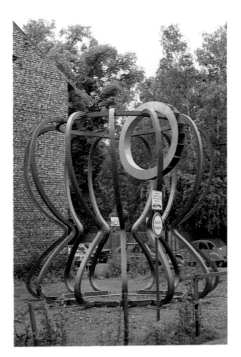

Richard Deacon: Contribution to *Skulptur Projekte in Münster 1987*, *Like a Snail (A),* location: Tibusstraße/Breul, hard fiber, wood, galvanized steel, 5.6 x 6.8 x 5.2 m (above left), and *Like a Snail (B),* location: Tibusstraße/An der Apostelkirche, wood, galvanized steel, 4.65 x 5.26 x 4.5 m (above right), photos 1987

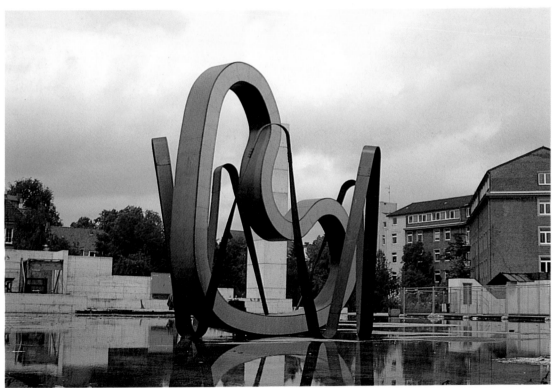

MARK DION

Grotto of the Sleeping Bear (Münster)
Installation (taxidermal specimen, diverse objects)
North area of park at Kreuzschanze

Born 1961 in New Bedford, Massachusetts, lives in New York

Mark Dion: Some Notes Toward *Grotto of the Sleeping Bear*

Few wild animals have endured in the realm of popular imagination as tenaciously as the bear. The bear's scarcity and physical remoteness have only fueled our fascination. Despite the fact that bears have retreated from the everyday lives of most of the inhabitants of their former range, they have far from disappeared. They maintain a strong presence in popular culture, literature, symbolism and folklore. For thousands of years, bears have awed, amused, horrified, delighted and inspired us. Indeed the cave bear-skull shrines of the Neanderthals are "...our earliest evidence anywhere on earth of the veneration of a divine being" (Joseph Campbell). To this day, bears are a primary characteristic in numerous religions and superstitions.

While bears of flesh and blood may never again play a role in the lives of an increasingly urban population, their image is kept alive through an unstoppable parade of surrogates. In a world populated by Stiff teddy bears, Winnie-the-Pooh, Paddington, Yogi Bear, and countless others, few escape childhood without some attachment to the genus *Ursus*. Bears sell us

For information about the artist and additional bibliography see: Natural Fictions and Other Fictions. An Exhibition by Mark Dion, Ikon Gallery Birmingham, Birmingham 1997; The End of the Game, De Vleeshal, Middelburg 1995; Kontext Kunst, ed. Peter Weibel, Neue Galerie am Landesmuseum Joanneum, Graz, steirischer herbst '93, Cologne 1994; Die Kunst-Kammer, K-raum Daxer, Munich 1993.

everything from gummy treats to toothpaste, and are constructed to represent anything from an environmentally propitious governmental agency, to a sign of domestic security.

While the dominant image of the bear for the latter half of our century has been one of benign cuddly cuteness, not long ago the animal's symbolism revolved around an entirely

different set of concepts. The bear remains an icon for secluded wilderness, however the very notion of wilderness has undergone a staggering transformation. The migration of the bear's anthropomorphic persona from ferocious to friendly precisely echoes the shift in the status of nature from something awesome that we need to be protected from to something fragile which we need to protect.

Regardless of how diminished and frail our picture of nature has become, floods, droughts, earthquakes, and climatic changes continually remind us of the power and complexity of the environment and our inability to control or predict it. Similarly, "...the bear still represents something primally threatening: violence, or at least the possibility of violence."[1] Be warned, in the era of ecology, environmentalism, and biodiversity, even Winnie-the-Pooh still bares claws.

The following list is a brief enumeration of some ways of thinking about brown bears, both visually and in written form. Please consider these accounts an incomplete collection of footnotes for *The Grotto of the Sleeping Bear*.

Brown bear, taxidermal specimen, Westfälisches Museum für Naturkunde Münster

BROWN BEAR (*Ursus arctos*)

life span = 20 years (average)
diet = omnivorous
length = 7–10 ft. (tail to nose)
height = 3–5 ft. (paw base to shoulder)
tail size = 4–4.8 inches
mature weight = 725 oz (average, male)
weight at birth = 16 oz
breeding period = May to June
gestation period = 180–210 days
world population = 206,500 (estimate)
note: the brown bear was formerly one of the most widespread of mammals, occurring in a wide range of habitats from deserts, tundra and coastal areas to temperate and tropical forests.
"And behold another beast, a second, like to a bear, and it raised up itself on one side, and it had three ribs in the mouth of it between the teeth of it: and they said this unto it, Arise, devour much flesh." Old Testament, Dan. 7.5
"In stock market parlance, a bear is a speculator who sells a stock that he does not own in the belief that before he must deliver the stock to its purchaser its price will have dropped so that he may make a profit on the transaction." Charles Funk: A Hog On Ice, 1948
"Bears have been shot in recent conflicts and according to a Yugoslavian biologist, at least six brown bears are known to have been killed by mines during the recent Croatia-Serbia war. Bears (and other animals) in former Yugoslavian

zoos have also died of starvation." Gary Brown:
The Great Bear Almanac, 1993
"A furious and hungry bear, which has had no
food for eight days, will attack a wild bull and
eat him alive on the spot; and if he is unable to
complete the task, a wolf will be in readiness to
help him!" 19th century German Playbill

Brown bear extinction in Europe
Holland – 1690s
Austria – 1788
French Alps – 1937
Switzerland – early 20th century

European medieval Christians believed that all
bears were born as amorphous lumps of white
flesh. These shapeless masses were only
slightly larger than a mouse and possessed nei-
ther hair nor eyes. The mother bears would lick
these lumps, eventually sculpting them into the
bear cub form. This process was considered
analogous to the transformation of the heathen
soul through the acceptance of Christ.
The French phrase *ours mal leché* (a badly
licked bear) is still used to refer to an ill-
behaved child.[2]
"We anthropomorphise many animals, but
none as often as bears, and maybe for a good
reason – there are considerable anatomical
and behavioral similarities. To begin with,
bears and humans share mammalian traits, but
also we judge bears by our own senses, abil-
ities, and behavior. For instance, bears stand
bipedal and even occasionally walk in this
manner; sit on their tails, lean back against
objects to rest, and may even fold a leg across
their other leg; appear human when skinned;
scratch their backs against stationary objects;
snore; eat the same foods as humans; enjoy
sweets; eat with paws (hands); use paws and
claws with dexterity; leave human-like foot-
prints; produce similar feces; nurse and disci-
pline their young, even spank; display moods

*For centuries the bear has been the very icon of wilder-
ness*, Geographic illustration, 1873 (above),
American circus advertisement (below)

and obvious affection during courtship (petting); and are inquisitive, curious, and inflexible." Gary Brown: The Great Bear Almanac, 1993

"The Yavapai of Arizona said, 'Bears are like people except they can't make fire'." David Rockwell: Giving Voice to Bear, 1991

"A bear is much subject to blindness of the eyes, and for that cause they desire the hives of bees, not only for the honey, but by the stinging of the bees, their eyes are cured." Edward Topsell: The History of Four-Footed Beasts, 1607

"One evening when James Clubb was presenting his brown bears on Chipperfield's Circus, the generator failed and the lights went out, leaving the ring in pitch darkness. One of the bears immediately rushed to James and hugged him. To begin with, he thought he was being attacked but then he noticed the bear was shaking with fright and he realized she had run to her trainer for reassurance." David Jamieson and Sandy Davidson: The Colorful World of the Circus, 1980

"Bears are tidy housekeepers. There was a narrow entryway, then a hollowed-out room with a platform constructed of pine-tree boughs laid down together. The huge log spanning the ceiling was a structural beam, big enough to support a cathedral. Though the ground was frozen, the den was warm inside, sheltered from wind coming off the drifting snow. On the floor where the bear had laid during the cold months, the ground was packed down flat and beside the sleeping platform was a single pinecone, as if that had been the bear's only toy." Gretel Ehrlich: Neighborhood Bears, 1996

Playful bears in the Münster zoo, photo 1997 (opposite)

Mark Dion: *Polar Bears and Toucans (from Amazonas to Svalbard)*, 1991, mixed media (left), *Polar Bears and Toucans (with two sound recordings)*, 1989, mixed media (above right), *Ursus Maritinus*, detail, 1995, mixed media (below right)

THE CLASSIFICATION OF THE BROWN BEAR

KINGDOM: *ANIMALIA*
PHYLUM: *CHORDATA*
CLASS: *MAMMALIA*
ORDER: *CARNIVORA*
SUBORDER: *FISSIPEDIA*
SUPERFAMILY: *ARCTOIDAE*
FAMILY: *URSIDAE*
SUBFAMILY: *URSINAE*
GENERA: *URSUS*
SPECIES: *URSUS ARCTOS*

"No one ever saw the old bear, but in the muddy springs about the base of the cliffs you saw his incredible tracks. Seeing them made the most hard-bitten cowboys aware of bear. Wherever they rode they saw the mountain, and when they saw the mountain they thought of bear. Conversation ran to beef, bails, and bear."
Aldo Leopold: A Sand County Almanac, 1949

1 Mark of the Bear, ed. Peter Schullery, San Francisco 1996.
2 Facts on File: Encyclopedia of World Mythology and Legend, New York 1988. Additional references found in: Gary Brown: *The Great Bear Almanac*, New York 1993.

Martin van Valkenborch: *The Penitent Maria Magdalena*, 16th century, oil on wood, 15.2x23.2 cm, loan from Westfälischer Kunstverein, Westfälisches Landesmuseum Münster, and views of installation (opposite)

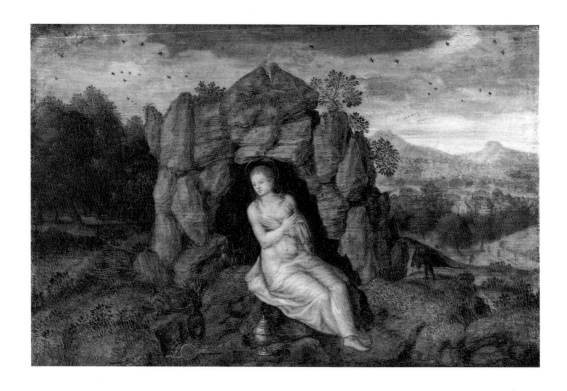

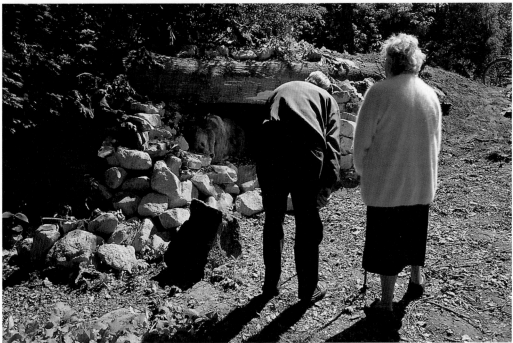

Mark Dion: *Grotto of the Sleeping Bear (Münster)*,
Ansichten

STAN DOUGLAS

Ohne Titel
Daylight projection, photomontage
Stadthaus 1, Syndikatplatz
Not realized

Presentation of the not realized project in the
old section of Westfälisches Landesmuseum

Born 1960 in Vancouver, lives there

Stan Douglas: *Project for the RIAGG Zwolle*

In spite of any claims that they can describe
universal conditions of the human subject, psy-
choanalytical concepts and techniques are
necessarily historical and culturally specific.
The success of Behaviourism in mid-century
Europe likely had more to do with the grim
prospect of postwar reconstruction than many
of its adherents would like to admit, just as
Freud may not have catalogued the basic narra-
tives of human socialization, although he cer-
tainly did create an extremely detailed portrait
of his clientele, the Viennese bourgeoisie of the
late nineteenth century. Holland has a peculiar
psychoanalytic tradition which, based upon the
fragmentation of its society, was not preoccu-
pied with basic structures, but instead with the
complex and contingent relationship between a
citizen and their societal Pillar. A social portrait
as detailed as Freud's was in fact developed by
the Dutch therapist Querido in the early post-
war period when he proposed a method of
social psychology directly drawn from the
example of Dutch society. His key work, *Intro-
duction to Integral Medicine*, made the reason-
able but, until then, unfortunately rare proposi-
tion that it may not only be a patient's interior

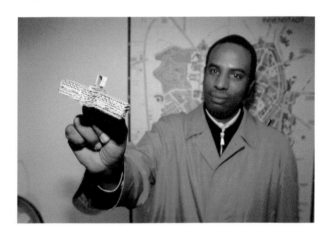

For information about the artist and additional bibliography
see: Stan Douglas. Der Sandmann, 1996. Nu-tka, 1996,
Krefelder Kunstmuseen, Köln 1996; Stan Douglas, Musée
national d'art moderne, Galeries Contemporaines, Centre
Georges Pompidou, Paris 1994; Stan Douglas. Monodramas
and Loops, UBC Fine Arts Gallery, Vancouver 1992.

experiences, but also their exterior relation-
ships, that are the cause of crisis - and that the
"equilibrium" which he regarded as the goal of
therapy could only be achieved in consideration
of these two domains.
The argument of *Integral Medicine* evolved out
of a series of interviews with psychiatric

patients in the months following their release from hospital. The first cases examine how respondents were recovering from more or less somatic illnesses, but the studies that conclude the book narrate recoveries which had been inhibited by extrinsic factors: economic problems as well as conflicts within familial, religious and social relations. Elaborating on Querido's conception, one could suggest that psychotherapy is an attempt to discern that liminal space, or border, which demarcates inside and outside – self and other – and how this border may be shared by both parties. Likewise, this project for the RIAGG Zwolle takes as axiomatic the proposition that a city, much like a human subject, might be best understood from its periphery. Once the manner in which a city or person distinguishes itself from its surroundings is discovered, in that zone where it is no longer self-identical, one can begin to understand how the community or individual tacitly conceives of itself. The project will both represent and have intrinsic to its structure these dynamics of identity and difference, of individual and community. The RIAGG (Regional Institute for Community Mental Health Care) is situated on the banks of the Zwarte Water – a river that, a few hundred meters east, flows around what remains of Zwolle's seventeenth century city walls and in the opposite direction is traversed by a highway that connects the Netherlands from north to south. The Center is literally at the city's margin – just as its crucial function is the negotiation of another liminal space: the permeable membrane that is an individual's coincidence with their community.

A pair of 4.2 meters wide and 5.6 meters tall projection screens will be mounted on top of the RIAGG's elevator shaft, integrated with the existing architecture, and positioned back to back: with one screen facing the highway, and the other inflected toward Zwolle's market square. From dusk until down, pedestrians in

the city Center will be presented with images of people engaged in conversation in peculiar locations at Zwolle's expanding periphery, while motorists on the highway will see conversants in the old town's narrow intersections and cul de sacs. All of the conversations will be dramatic condensations of a selection of the 1,630 interviews conducted in preparation for *Integral Medicine*, however, absenting the interviewer. These discursive fragments – questioning, affirming, explaining, listening, etc. – will be performed in a studio by a company of actors, shot individually in medium and close shots, then composited into their settings, at Zwolle's Center or margin, and mastered on video disc.

The montage on both screens will be generated in real time by computer-controlled disc players programmed in accordance with the so-called "Kuleshov Effect" – the fact that each time the same set of cinematic materials is recombined in a different order, its affective character changes. Thus, the three hundred or so video segments to be presented on each screen can be combined in such a way that the sequence of montage will only repeat itself after a period of twenty-five hours. And these indeterminate dramas, projected on screens marking a point both inside and outside the city of Zwolle, will be timed so that it would likely take six months before a person travelling on the highway or visiting the city Center at the same time every day saw the same conversation – that continuous process of negotiation which is an individual's relationship to their community.

Stan Douglas: *Projekt für das RIAGG in Zwolle,*
Zwolle, interior view (left) and peripheral view (right),
video stills from the installation, 1997

eichhorn UR-Nr.: /1997

- durchgehend einseitig beschrieben -

Verhandelt

am 1997

vor dem unterzeichnenden Notar

erschienen heute

1. Herr
 geboren am
 wohnhaft/geschäftsansässig

2. Frau Maria Eichhorn
 geboren am
 wohnhaft/geschäftsansässig: Altenbraker Straße 25 A,
 12051 Berlin

Die Erschienenen wiesen sich sämtlich zur Person aus durch Vorlage ihrer
jeweils gültigen, mit Lichtbild versehenen Personaldokumente.

Der Erschienene zu 1. erklärt, daß er nich im eigenen Namen handelt, sondern
für die Stadt Münster aufgrund der Vollmacht bei den Sammelakten des Grund-
buchamtes Münster (385 dé 24 Band zur Ordnungs-Nr.).

Die Erschienenen baten um Beurkundung des nachstehenden

Grundstückskaufvertrages

und erklärten

§ 1

1. Die Stadt Münster veräußert an die Käuferin aus dem im Grundbuch von
 Münster, Blatt 5005, eingetragenen Grundstück, Gemarkung Münster,
 Flur 5 Nr. 537, eine Teilfläche in der Größe von etwa 105 Quadrat-
 meter.

2. Die Teilfläche wird nachfolgend als *Grundstück* bezeichnet. Lage und
 Begrenzung des Grundstückes ergeben sich aus der Darstellung im Lage-
 plan der Stadt Münster vom 02. 05. 1997, der dem Vertrag als Anlage
 beigefügt ist. Das Grundstück ist dort rot dargestellt.

- 2 -

3. Die endgültige Größe des Grundstückes wird durch eine amtliche Fort-
 führungsvermessung ermittelt.

§ 2

1. Der Kaufpreis für das in § 1 genannte Grundstück beträgt unabhängig vom
 Ergebnis der amtlichen Fortführungsvermessung

 DM 126.000,00
 (in Worten: einhundertsechsundzwanzigtausend Deutsche Mark).

2. Ein Teilbetrag des Kaufpreises in Höhe von DM 30.000,00 ist innerhalb von
 vier Wochen nach Abschluß dieses Vertrages fällig und an die Stadtkasse
 Münster auf das Konto 752 bei der Stadtsparkasse Münster zu zahlen.

 Bei Zahlungsverzug werden Zinsen in Höhe von fünf Prozentpunkten über dem
 jeweiligen Diskontsatz der Deutschen Bundesbank erhoben.

3. Der Restkaufpreis in Höhe von DM 96.000,00 ist ab dem Tag der Veräuße-
 rung des in § 1 genannten Grundstückes, gerechnet innerhalb von vier
 Wochen, nur dann fällig und zahlbar, wenn der Stadt Münster nicht am
 heutigen Tage das unwiderrufliche Angebot zum Erwerb des in § 1 genannten
 Grundstückes unterbreitet wird.
 Bei Zahlungsverzug werden Zinsen in Höhe von fünf Prozentpunkten über dem
 jeweiligen Diskontsatz der Deutschen Bundesbank erhoben.

§ 3

1. Die Übereignung des in § 1 genannten Grundstückes erfolgt, soweit in
 diesem Vertrag nichts anderes vereinbart ist, in gegenwärtiger
 Beschaffenheit ohne Gewähr für Größe, Güte und Grenzen. Das Grundstück
 wird übergeben frei von Nutzungsrechten Dritter.

2. Der Erschienene zu 1. erklärt, daß - soweit nachstehend nichts anderes
 vereinbart ist - der Kaufgegenstand übereignet wird, frei von Belastungen
 in Abt. 2 und 3 des Grundbuches, daß Ansprüche Dritter, die aus dem
 Grundbuch nicht ersichtlich sind (z. B. Baulasten), nicht bestehen,
 Miet-, Pacht- oder sonstige Nutzungsverträge an dem Grundstück nicht
 begründet sind und daß Steuern, Erschließungs- und Entwässerungsbeiträge
 sowie sonstige öffentliche Lasten, für die das Grundstück haftet, weder
 fällig, angefordert oder rückständig sind.

3. Als Zeitpunkt der Übernahme und Übergabe des Grundstückes gilt der
 15. 06. 1997.

- 3 -

§ 4

1. Die Käuferin räumt der Stadt Münster ein unbedingtes, frei von allen er-
 denklichen Ansprüchen, auch soweit sie urheberrechtlich geschützt sein
 könnten, Wiederkaufsrecht an dem in § 1 bezeichneten Grundstück ein. Im
 Falle der Ausübung des Wiederkaufsrechtes hat die Käuferin das Grundstück
 frei von Rechten Dritter sowie frei von baulichen Anlagen im Sinne von
 § 2 Bauordnung in Nordrhein-Westfalen an die Stadt Münster aufzulassen.
 Im Falle der Ausübung des Wiederkaufsrechtes zahlt die Stadt Münster
 keinen Kaufpreis bzw. Entschädigung für das in § 1 bezeichnete
 Grundstück.

 Zur Sicherung des Anspruches auf Rückübertragung des Grundstückes an die
 Stadt Münster bei Ausübung des Wiederkaufsrechtes wird eine entsprechende
 Auflassungsvormerkung zugunsten der Stadt Münster in das Grundbuch einge-
 tragen.

 Der von der Käuferin gezahlte Kaufpreis in Höhe von DM 30.000,00 wird
 seitens der Stadt Münster dem "Verein zur Erhaltung preiswerten Wohn-
 raumes e. V.", ansässig in Breul 32, 48143 Münster, zur Durchführung von
 Sanierungsmaßnahmen an den Häusern Breul 32 und Tibusstraße 30 A C, zur
 Verfügung gestellt. Der Verein kann bei Nachweis entsprechender Maßnahmen
 die DM 30.000,00 bei der Stadt Münster auch teilweise abrufen. Die Stadt
 Münster wird die Verwendung der DM 30.000,00 zu gegebener Zeit
 nachweisen.

 Die Käuferin kann nach dem 28. 09. 1997 von der Stadt Münster verlangen,
 daß die Stadt Münster ihr Wiederkaufsrecht ausübt. Die Käuferin ist inso-
 weit frei in der Wahl des Zeitpunktes, wann sie die Ausübung des Wieder-
 kaufsrechtes von der Stadt Münster verlangt.

§ 5

1. Die Vermietung und Verpachtung des Grundstückes oder von Teilen des
 Grundstückes und die Errichtung von baulichen Anlagen im Sinne von
 § 2 Bauordnung Nordrhein-Westfalen auf dem Grundstück sowie unterhalb der
 Erdoberfläche und das Einbringen oder Abstellen - auch nur vorüber-
 gehend - von Sachen oder sonstigen Gegenständen, die unter die Legal-
 definition des § 2 Bauordnung Nordrhein-Westfalen zu subsumieren sind
 und/oder gegebenenfalls ihren Zweck in sich selbst darstellen (Kunst-
 werke) bedürfen mit allen Einzelheiten der vorherigen schriftlichen Zu-
 stimmung der Stadt Münster.

 Diese Einschränkung soll nicht das Eigentumsrecht der Erwerberin
 begrenzen, sondern legt lediglich eine Koordinationspflicht der Parteien
 im Hinblick auf die Nutzung des Grundstückes fest.

- 4 -

§ 6

Alle Kosten, Gebühren, die Grunderwerbssteuer sowie die
Vermessungskosten, die sich aus dem Abschluß und der Durchführung dieses
Vertrages unter Abgabe des unwiderruflichen Angebotes auf Erwerb des in
§ 1 genannten Grundstückes an die Stadt Münster sowie dessen Annahme
ergeben, trägt die Käuferin. Dies gilt auch für den Fall des
Wiederkaufes. Die Kosten für die Vermessung und Ver-
markung, (die Kosten für die Absteckung (gegebenenfalls auch für die Ab-
steckung des Schnurgerüstes), für das Aufzeigen eventuell vorhandener
Grenzen sowie die Kosten für die Übernahme der Vermessungsergebnisse zum
Kataster.

Der erforderliche Auftrag wird im notwendigen Umfang von der Stadt
Münster erteilt.

§ 7

1. Die Käuferin bevollmächtigt hiermit den Erschienenen zu 1. und den
 Städtischen Oberverwaltungsrat Dieter Buth, jeden für sich unter Befreiung
 von der Beschränkung des § 181 BGB in seinem Namen, alle Erklärungen
 abzugeben und entgegenzunehmen, die zur Anerkennung der alten und neuen
 Grenzen, zur Stellung der Anträge auf Teilung und Vereinigung von
 Flurstücken und zur grundbuchlichen Durchführung dieses Vertrages,
 insbesondere auch für die Auflassung erforderlich oder dienlich sind.

2. Die Bevollmächtigten sind berechtigt, Löschungs- und Eintragungsanträge
 zu stellen, sie können Anträge ändern oder zurücknehmen, auch wenn sie von
 den Parteien selbst gestellt sind.

§ 8

Der Erschienene bat um eine Ausfertigung, die Käuferin bat um eine Aus-
fertigung und drei beglaubigte Ablichtungen dieses Vertrages.

Der der Niederschrift beigefügte Lageplan wurde den Erschienenen zur
Durchsicht vorgelegt und von ihnen genehmigt.

Vorstehende Niederschrift wurde den Erschienen von dem Notar vorgelesen,
von ihnen genehmigt und wiefolgt eigenhändig unterschrieben.

MARIA EICHHORN

Erwerb des Grundstücks Ecke
Tibusstraße/Breul, Gemarkung Münster,
Flur 5 (1997)
(Acquisition of a Plot)
Tibusstraße, corner of Breul
Landesmuseum, Domplatz (10)
Land-register/Amtsgericht, Gerichtsstr. 2 - 6

Born 1962 in Bamberg, lives in Berlin

For information about the artist and additional bibliography see:
Arbeit/Freizeit: Maria Eichhorn, Generali Foundation Wien,
Vienna 1997; Abbildungen, Interviews, Texte, Maria Eichhorn
1989-1996, Kunstraum München e. V., Munich 1996;
Kopfbahnhof/Terminal. Maria Eichhorn, Douglas Gordon,
Lawrence Weiner, Förderkreis der Leipziger Galerie für zeit-
genössische Kunst, Leipzig 1995.

What is the origin of a city? – From initial settlement on, cities develop and change through acquisition and occupation of land, through conquest, subjugation, exercise of power, trade, war, peace, destruction, reconstruction, and city planning. Settlement and residence are connected with possession and property, and therefore with the accumulation of possessions and property.[1] Property requires protection. Fortifications, watchtowers, and moats signal and emphasize the readiness for defense. Cities were conquered, razed, fortified, defended, opened up. Cities arose through trade and served as markets. Since the High Middle Ages, the "city" has been associated with the idea of the university.

A city is first of all "city", and then a particular city, for example Münster. The founding of Münster goes back to Charlemagne's conquest and conversion of the Saxons. Around 793, Liudger was sent as missionary to the West Saxons and the Frisians. The geographical and economic advantages of the site (the River Aa and the intersection of two important trade routes) determined his choice of location. The plan of the monastic settlement formed the nucleus around which the city developed. The settlement grew from the market of the trades- men. Münster was the seat of a bishop as well as a center of trade. It attained municipal status around 1170 and was a member of the Hanseatic League from the thirteenth to the seventeenth century. The years 1534-35 saw Anabaptist rule and 1648 the Peace of West- phalia; Münster was the capital and residential city of the prince-bishop until 1803 and capital

of the province of Westphalia from 1816 on. Up to 63% of the city was destroyed in the Second World War; 1975 saw the incorporation of nine outlying municipalities.

Land-register and cadaster – The cadaster was established for purposes of property taxation, the land-register for the safeguarding of real property and property transfer.[2] (In: Max Geisberg: Bau- und Kunstdenkmäler Westfalens, Stadt Münster, vols. I–VI, Münster 1932–1941, each illustration and description of a building is accompanied, under the heading "historical information", by the names and occupations of its successive owners and residents according to historical street cadasters.) The cadaster is the public register maintained by the land-registry office, which represents and describes the real property of a region. It contains information (name, date of birth, occupation, address) on the owners of property and buildings and those with the legal right of construction and use. On the basis of surveys, it indicates the division of the land into parcels and provides individual specifications (location, size, use). The results of a survey are entered in a cartographic apparatus that is maintained in the form of skeleton maps or area maps. The cadastral maps constitute the representational part of the real estate cadaster. In the maps, parcels and buildings as well as other important objects are represented to scale. A parcel is a section of the surface of the earth, enclosed by a boundary line fixed in the real estate cadaster and designated by a number. In the real estate cadaster the parcel is treated as an individual object.

The land-register (property, easements, change of owner, servitudes, mortgages) records the material rights on real property as well as changes in its status. It serves as proof of possession and of other rights on pieces of property. The register is continually updated and

1 Regarding the distinction between possession and property: Proudhon, for example, gives an unequivocal answer to the question, "what is property": "Property is theft." Property is the comprehensive, exclusive sovereignty of a person or number of persons over a thing. The owner of a thing can, insofar as it does not conflict with the law or the rights of a third party, dispose of the thing at will and exclude others from influence over it. The basic constitutional law of Germany subjects property to a so-called social obligation and allows expropriation under special circumstances. The right of possession, on the other hand, means the rights to that which suffices for work and consumption. Income from credit transactions, houses, land, capital, inheritance, and the like are to be distinguished from the "possession as usufruct" of the means of production. Possession is tied to use by the individual. Like Proudhon, Gustav Landauer also distinguishes between possession and property; Landauer, however, does not reject possession, but rather the lack thereof. His demand for equality of property proceeds on the assumption that all cultures from time immemorial have been founded on possession and that the real problem is not ownership, whether common or private, but rather dispossession: "In the future I see private ownership, cooperative ownership, communal ownership in their finest flower – possession not merely of the things of immediate use or the simplest tools, but that which is so superstitiously feared by many, possession of all kinds of means of production, of houses, and of land." (Landauer: Aufruf zum Sozialismus, reprint of 4th edition 1923, Philadelphia 1978, p. 136). He rejects only "laborless income", i.e. that property that makes possible the private appropriation of surplus value.
2 Generally speaking, the legal foundations of the cadaster and land-register systems can be divided into two main classes: those influenced directly or indirectly by Roman law (e.g. via French legislation during Napoleonic rule), and those influenced by Anglo-Saxon law (e.g. colonization or via common development with Anglo-Saxon countries). The German Civil Code has been in effect since January 1, 1900. In the establishment of a uniform private law, the concern was to carry out social reforms and/or adapt the existing law to changing social relationships. The model was France with its *Code civil*. The individual German territories such as Prussia, Bavaria, Saxony, Württemberg, and Baden had been independent states since the Peace of Westphalia (1648), claiming for themselves the right of legislation and jurisdiction. The cadaster that exists today in the Federal Republic of Germany arose out of the different cadastral surveys of the former kingdoms and duchies at the beginning of the 19th century.
3 Cf. David Ricardo: On the Principles of Political Economy and Taxation (1817); Fernand Braudel: The History of Civilization; Friedrich Engels: The Origins of the Family, Private Property and the State; excerpted in: Gilles Deleuze/ Felix Guattari: Tausend Plateaus, Berlin 1992, pp. 588–655.
4 Cf. Hannah Arendt: Vita activa, Munich 1996, pp. 75–76: "It seems to lie in the essence of the relations prevailing between private and public realms that the decay of the public in its final stages is accompanied by a radical threat to the private. Insofar as these things have been dealt with at all in the modern era, discussion has continually focused

can be referred to at the land-registry office. The basic unit of the land-register is the plot. A plot can consist of a number of parcels, but a parcel cannot consist of plots. Parcels not subject to record are resident-owned watercourses, waterways, and ditches. In its designation, description, and delimitation of plots, the land register is based on the information in the real estate cadaster. Both instruments together constitute complete documentation.

Each piece of land is surveyed, registered, and owned. The property value map indicates the value of a plot. Unlike air and water, land can be acquired and compared. Comparison always presupposes ownership. In contrast to other commodities, land as a definable whole cannot be reproduced.[3]

To whom does the city belong? – Private property is for the most part enclosed and delimited by gates, fences, or walls; it is not freely accessible. Public property is the property of the city or province. Public facilities, the media, squares, streets, and paths all constitute so-called public space. Is public space available to all? The image of the city as the mirror of practices in defense of the norm – who or what is the norm, and who defends the norm? Examples: Do-not-walk-on-the-grass signs on public lawns, parks and squares opened and closed according to bureaucratic schedules, benches replaced by individual seats, the spigots of public fountains turned off, public toilets closed. Prohibitions and signs impose certain rules of behavior. No parking without resident permit. Buildings are not renovated in an effort to hasten and legitimate their demolition.[4]

Münster: The Hotel Lindenhof (Kastellstraße 1) was to be torn down and a large international chain hotel erected on the plot. Opposition on the part of residents prevented the demolition; now the former Hotel Lindenhof is occupied by immigrants from CIS countries. Parts of the building stand empty and neglected.

In 1989, students occupied emergency housing on Steinfurter Straße which, despite the general housing shortage, was scheduled to be cleared. The occupants placed their own apartments at the disposal of foreign students and demanded that the city confiscate empty apartments and repair or renovate houses that were unrentable or threatened with demolition.

Imagine: Sinti and Roma living on Schloßplatz. The entrance area in front of the Regierungspräsidium is frequented by skaters, who are not tolerated; they are identified by the police and excluded by means of fines.

Students wanted to roll the *Giant Pool Balls* by Claes Oldenburg into the lake. The lawn on the Aasee was "their" lawn.

The houses Breul 31–38 and Tibusstraße 30a–c were scheduled for demolition; the area was to be redeveloped with expensive condominiums (1989). The tenant association founded the *Verein zum Erhalt preiswerten Wohnraums e.V.* (Association for the Preservation of Affordable Housing) and went public with posters, flyers, petitions, press conferences, and street festivals. Radio, television, and the press fanned the flames of widespread public interest. Today, the Verein is the tenant and administrator of the building.

Berlin: caravan locations in the inner city are cleared by the police (e.g. the Engelbecken caravan on Waldemarstraße in Berlin-Kreuzberg in 1993). Currently there are twelve caravan sites in Berlin, of which two on the periphery of the city are officially approved. According to a decision of the Senate from July 1996, the ten inner-city caravan sites in the area around the Wall are to be cleared until the end of 1997.

New York: Property tax in poor districts can amount to half the rent income. Often it is cheaper to let the buildings revert to the city than to pay the property tax. Owners let the buildings decay until they have to be torn down

for fear of collapse. (In the late 1970s and early 80s, 65% of the houses in Harlem, a large part of the buildings on the Lower East Side, and numerous buildings in Brooklyn and the Bronx were burned down to collect insurance money, given up by the owners, or confiscated by the city to cover back taxes.) The city leases the ruined plots to residents and transforms them into Community Gardens, among other reasons to preserve or increase their value. The users do not own the plots. If the city wants to sell the plots, the lease is not renewed and the gardens are cleared.

How public is public space? – The city is the owner of land and real estate. The boundaries between private property and state or city property are fluid. Private enterprises receive state subsidies. The private economy participates in state projects and plays a role in city planning. The owner determines what happens on and with the plot.

What other owner than the University of Münster would accept the sculpture *Black Form – Dedicated to the Missing Jews* (1987) by Sol LeWitt (two parts, a black stone block on the central axis of the Baroque Schloß and a white pyramid at the end of the axis in the Schloßgarten, destroyed after the exhibition at the request of the university) on university property?[5]

Can the ground on which a sculpture stands be separated from the sculpture? How mobile or immobile is a sculpture? The more immobile, the more lasting, the more valuable? To what degree does art and the presentation of art influence urban development? What activities or works address the theme of ownership and property? Examples: Alan Sonfist, *The Time Landscape* (1969), New York; George Maciunas, *Koop-System in SoHo* (1965), New York, *Prefabricated Building System* (1965), New York; Diana Balmori/Margaret Morton, *Transi-*

on the question of private property; and this is no coincidence, for even in ancient political thought, the word 'prvate' loses its privative character and is no longer necessarily opposed to the public when it appears in connection with property, as in private property. Clearly, property possesses certain qualities which, though of a private nature, are nonetheless highly essential to the political."

5 Editor's note: The statement is formulated as a paradox: if the owner of the land on which the sculpture stands is the university, no other owner can accept the sculpture on university property.

6 Cf. Theodor W. Adorno: Minima Moralia, London, 1984, p. 39: "'It is even part of my good fortune not to be a house-owner', Nietzsche already wrote in *The Gay Science*. Today we should have to add: it is part of morality not to be at home in one's home. This gives some indication of the difficult relationship in which the individual now stands to his property, as long as he still possesses anything at all. The trick is to keep in view, and to express, the fact that private property no longer belongs to one, in the sense that consumer goods have become potentially so abundant that no individual has the right to cling to the principle of their limitation; but that one must nevertheless have possessions, if one is not to sink into that dependence and need which serves the blind perpetuation of property relations."

7 In the foreword the author writes: "Real estate prices in the more attractive city centers are oriented increasingly not to the local market, but to regional, national, and international standards. In the future, prices could reach a level to which, besides the traditional property owners such as city, state, and church, only especially well-financed, trans-regional investors could aspire. The latter, however, contribute relatively little to the specific quality of a city center; rather, they render it interchangeable with any other city and thus do more to hurt it than the automobile or telecommunication. Over the course of millennia the impetus for development in European cities has always been above all the involvement of the citizens. Spatially speaking, exorbitant real estate prices could push this involvement further and further back into only a few remaining niches of the inner cities. For this reason, it is of the highest political priority to recognize and bridle this trend."

tory Gardens, Uprooted Lives (1993), Yale University Press; Gordon Matta-Clark, Reality Properties: Fake Estates (1973), Queens and Staten Island; Michael Asher, Property Line (1973), Los Angeles; Simon Rodia, Watts Towers (Nuestro Pueblo = Our Town), Los Angeles (1921–1954); Verein zum Erhalt preiswerten Wohnraums e.V., Münster (since 1989).

How private is private property? – Privacy is only made possible and protected through ownership and/or tenancy. Money.[6] Up to a certain point: under certain circumstances, even owners and tenants are threatened with expropriation, removal, clearing.

Examples: In 1987 in San Francisco, Donald MacDonald set up two City Sleepers (minimal shelters for the homeless) in a parking lot rented by him. The owner of the lot (California Department of Transportation) initiated a legal process against him. MacDonald was forced to move the City Sleepers onto private property. In 1988 in Atlanta, Madhouser – a group of young architects – built accommodations for the homeless in module construction and placed the huts on public and private property.

In Lipstick Traces, Greil Marcus describes how the Anabaptists, under the leadership of the baker Jan Matthys, took over Münster in 1534 and established a theocracy: "All property was expropriated and money abolished. They saw to it that the doors of all houses stood open day and night. All books other than the Bible were burned on a huge pyre. 'The poorest among us,' stated a Münster broadsheet aimed at converting the surrounding countryside, 'who were despised as beggars now go around clothed as elegantly as the highest and most aristocratic people.' All things 'were to be common property,' Jan van Leyden later said. There was to be 'no private property, and no one was to do any work, but simply trust God.' Without exception, the new decrees were enforced with threats

of execution." (Greil Marcus: Lipstick Traces, Hamburg 1992, p. 96)

Property and ownership can be transferred, sold, inherited, forfeited, stolen. Owners can be dispossessed by the state. Example: "Insofar as the houses were in the possession of Jews, i.e. now in the possession of the State, the costs are to be covered from the estates of the Jews." (Minutes of a confidential conference on November 20, 1941, in: Geschichte original – am Beispiel der Stadt Münster, No. 5, Münster 1988). "The Aryanization of Jewish possessions/property. Almost without exception, shops, businesses, and real estate were sold far below the actual commercial value. In these cases it is therefore justified to speak of a state-supported and sanctioned 'plundering'" (in: Münster – Streifzüge, ed. Ulrich Bardelmeier/Andreas Schulte Hemming, Münster 1995, 75).

The city of Münster – The master plan "Rahmenplan Münster-Altstadt – Altstadt und Bahnhofsviertel" (1995), commissioned by the city of Münster from the Office of City Planning and Urban Research, gives an overview of urban development in Münster.[7] It publishes the planned usage of squares, open areas, and interspaces, of "waste areas" and "building gaps", and integrates zoning plans. By means of a catalog of deficiencies, potentials, and solutions,[8] districts including the cathedral area, the Marktring, the north edge of the city, the Hauptbahnhof and university districts, Hindenburgplatz, the Überwasser and Kuh districts, the Martini district, the Promenadenring, and the Aa loop are analyzed, with possible or planned changes being indicated.

Every open space, every fallow piece of land in the city is integrated into the zoning plan. Usage is defined and planned from the beginning to forestall the acquisition and occupation of places for purposes other than those produc-

ing economic surplus value (e.g. for mobile dwellings and lifestyles).

Public spaces are those spaces whose use is not (pre-)determined and fixed, not those that are designated "public".

The following statement holds true for almost all of the proposals in the master plan: "What is needed is more the involvement of private investors than that of the city. In many places, we can even count on income from the sale of municipal plots. There would then be an urgent need for an active clearing station for property questions, including the active mobilization of municipal plots." Private investors change the city. The old city of Münster is, according to the writers of the plan, not a "crisis region". Rather, the urban planning measures to be undertaken are "everyday tasks": "Questions of property, for example, are hardly ever so complicated that they can only be solved through transferral or expropriation."

("Expropriation" = the withdrawal or limitation of property rights by state power according to Art. 14 of Basic Constitutional Law for the common weal and only by law or according to laws regulating the type and amount of compensation.)

The development of the inner city in recent decades has led to the disappearance of affordable housing and/or to the driving up of rents through repair and renovation. People who can't afford expensive housing have been gradually pushed out of the inner city area. Satellite suburbs like Berg-Fidel, Kinderhaus/Brüningheide, and Coerde have arisen. Citizen initiatives demand that the city provide and maintain affordable housing in the central district. If necessary, the city must make use of its right of eminent domain in order to gain possession of affordable housing threatened by demolition.

The case of Breul/Tibusstraße is exemplary in this respect, and also with regard to the entanglement of municipal politics and private enterprise. At the end of the 1980s, the owners (at that time the city and private investors) strove to exploit the advantageous central location of the property under exclusively economic considerations (i.e. demolition and lucrative redevelopment). The Verein zur Erhaltung preiswerten Wohnraums e.V., formed out of protests against eviction, has in the meantime become the tenant and administrator of the property; the sole owner is the city. The residents developed a model proposal for the modernization of the building and in a comprehensive working paper (December 1996) formulated their social, ecological, and architectural goals.

The proposal *Entwurf zur Lokalen Agenda 21* (commission of the Rio Conference 1992), developed by the project group Zukunftsfähiges Münster, contains 15 theses. Thesis 7 reads: "Münster puts a stop to land consumption. Within the next ten years, the city of Münster along with its surrounding municipalities will end additional consumption of land for purposes of residential development. The alternative: reuse of existing building areas." Thesis 12: "For an ecologically, socially, and developmentally sound communal place of work and business. Even in Münster there is a growing number of welfare recipients, homeless, and

8 Examples of deficiencies: In the cathedral area, lack of design at the south edge of the square; hard-to-find, bicycle-filled passages between the university buildings; awkward, indeterminate tree locations. In the Marktring/Bahnhof district: desolate areas; pollution from motorized traffic; ruptures between City/Altstadt and City/Bahnhofsviertel. On the Aa loop: incongruously located buildings at the edges (large-scale structures in the west, gas station with annexes in the east) as well as at the city pool in the middle. Überwasser and Kuh districts: few, but awkward building gaps; optical breaks in the southern Jüdefelder Straße; shortage of parking for residents.

unemployed. The integration of these segments of the population into the labor market must be more forcefully addressed in future projects."

Land usage in the city, a total area of 30,245 hectares, is classified as follows: built and open areas 5101 hectares, commercial 137 hectares, recreational 559 hectares, traffic 2,248 hectares, agricultural 16,304 hectares, forestry 4,590 hectares, water 766 hectares, and "other" 540 hectares.

The civil engineering office of the city of Münster offers "creek sponsorships". The city of Münster supports the nature conservation society with the purchase or rental of land to establish water biotopes and frog ponds. In the area of water maintenance, the Münster civil engineering office supports ground unsealing and cooperates with the owners of plots to realize projects for improving the water quality of the Aa. Waterways of the first order are the property of the province insofar as they are not federal waterways. Waterways of the second order are all other waterways. In Münster, the Ems and the Dortmund-Ems canal are waterways of the first order.

Acquisition of land – The work consists in acquiring a piece of land. It comprises all the transactions and procedures involved in the purchase/sale of a plot, including research of open areas for sale, viewing, choice, title transfer, change of owner, entry in land-register, and use.

Which plot? – The plot is to be an undeveloped open space in central Münster. Particular specifications such as position, location, size, price, and owner will become clear in the course of the acquisition: Which plots (open areas, building sites) are offered for sale? Size? Address/location? For what price? By whom? Reason for sale?

Location/position – The choice of location is determined by the availability of open plots and the deliberate search for plots. The plot is acquired as a plot.

Change of owner/property – Contract of sale. Title transfer. Who was the owner, who is the new owner? How is the change recorded? Notarial certification of the legal agreement. Entry of legal change in the land-register.

Real value/symbolic value – The real value of the work is constituted by the transactions and procedures involved in the acquisition and use of the plot. The real value increases or decreases with the size, location, and use of the plot. The symbolic value of the sculpture increases with the reduction of the real value. The greater the real value, the less the symbolic value.

BIBLIOGRAPHY
Hannah Arendt: Vita activa oder Vom tätigen Leben, 8th edition, Munich 1996
Klaus Bußmann: Architektur der Neuzeit, in: Geschichte der Stadt Münster, vol. 3, ed. Franz-Josef Jakobi, Münster 1993
Rolf Cantzen: Weniger Staat – Mehr Gesellschaft, Grafenau 1995
Mike Davis: City of Quartz. Ausgrabungen der Zukunft in Los Angeles und neuere Aufsätze, Berlin/Göttingen 1994
Gilles Deleuze/Felix Guattari: Tausend Plateaus, Berlin 1992
Max Geisberg: Bau- und Kunstdenkmäler Westfalens, Stadt Münster, vols. I–VI, Münster 1932–1941
Grundbuch- und Katastersysteme in der Bundesrepublik Deutschland – Entwicklung und aktueller Stand (Schriftenreihe DVW), Stuttgart 1993
Grundstücksrecht (Beck Texte im dtv), Munich 1996
Jürgen Habermas: Strukturwandel der Öffentlichkeit, 5th edition, Frankfurt/M. 1996
Geschichte original – am Beispiel der Stadt Münster, No. 5 and No. 18, Stadtarchiv und Stadtmuseum Münster, Münster 1988 and 1992
Gerhard Köhler: Deutsches Privatrecht der Gegenwart, Munich 1991
Gustav Landauer: Aufruf zum Sozialismus, reprint of 4th edition 1923, Philadelphia 1978
Greil Marcus: Lipstick Traces, Hamburg 1992
Münster – Streifzüge, ed. Ulrich Bardelmeier/Andreas Schulte Hemming, Münster 1995
Rainer Nitsche: Häuserkämpfe 1872/1920/1945/1982, Berlin 1981

Rahmenplan Münster-Altstadt, Büro für Stadtplanung und
Stadtforschung, Münster 1995
Thesen "Zukunftsfähiges Münster", Beirat für Kommunale
Entwicklungszusammenarbeit der Stadt Münster, Münster
1995
Wem gehört die Stadt, ed. Elisabeth Blum, Basel 1996

TELEPHONE CONVERSATIONS
City of Münster, Land Office, Herr Althues: "Building gaps
are being closed, open areas remain open; I refer you to the
building plan. What do you intend to do with the plot?"
Property manager Herr Heidmann: "Price per square meter
for undeveloped open spaces in the city center is between
500 and 1000 DM; plots are hardly available on the open
market, they're sold under the table."
City of Münster, Civil Engineering Office, Herr Wermers:
"Why are you interested in creek sponsorships when you
don't live in Münster?"
Verein zur Erhaltung preiswerten Wohnraums e.V., Erich
Varnhagen: "I'll send you a chronology of events."
Irmtraud Grünsteidel, author: "That's the whole problem.
The people are not the owners of the Community Gardens
and don't have any rights. They themselves can't buy plots
that cost $6000."

FILE
(Contents of folder with project proposal)
a Project proposal
b Illustrations
c Information on "creek sponsorship", sample of sponsor-
ship contract
d Extract from real estate cadaster, section
110220–112489 from October 22, 1996, Surveyor's Office,
Berlin-Neukölln
e Field map and extract of surveying law
f Minutes of a confidential conference on November 20,
1941, in: Geschichte original – am Beispiel der Stadt
Münster, No. 5, Stadtarchiv and Stadtmuseum Münster,
Münster 1988
g Rahmenplan Münster-Altstadt, ed. Büro für Stadtplanung
und Stadtforschung, Münster 1995
h Documents/materials (working papers, correspondence,
minutes, etc.) relating to the complex Breul/
Tibusstraße from the Verein zur Erhaltung preiswerten
Wohnraums e.V.

Former Hotel Lindenhof, Kastellstraße 1

Façade ruin on Julius-Voos-Gasse

Façade ruin in interior courtyard of Stadt-
theater, Neubrückenstraße 63

Garden/gap between buildings at Domplatz 25

Ballspielfläche für Jedermann (Ball Field for Everyone) on the grounds of the
Alter Zoo between Himmelreichallee and Hüfferstraße

Tents on the sports field

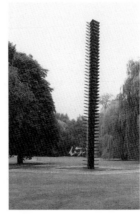

Sculptures on public and private property (Domgasse: Daniel Buren, *Tor,* 1987; Harsewinkelplatz: Thomas Schütte, *Kirschensäule,* 1987; Himmelreichallee 40: Otto Heinz Mack, *Wasserplastik,* 1977; Henry Moore, *Dreiteilige Skulptur (Wirbel),* 1968/69)

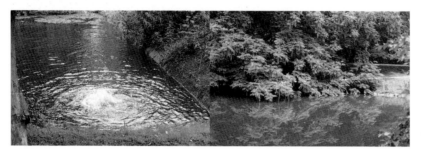

Improvement of water quality/standing water, Schloßgraben/Kastellgraben

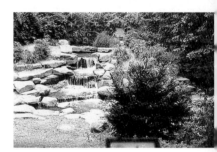

Artificial waterfall, Promenade/Kreuztor

Oxygenation for improvement of water quality, Schloßgraben

Gap between buildings on Von-Steuben-Straße/Hafenstraße

Skater in front of Regierungspräsidium, cathedral square

Overnight accommodation on large
benches, Promenade/Wallgraben

Single seats, Aegidii-Kirchplatz

Public fountain, Promenade/Kanonengraben

Closed public toilets, parking lot between
cathedral square and Hindenburgplatz

Military security zone, German-Netherlandish Corps, Hindenburgplatz 73

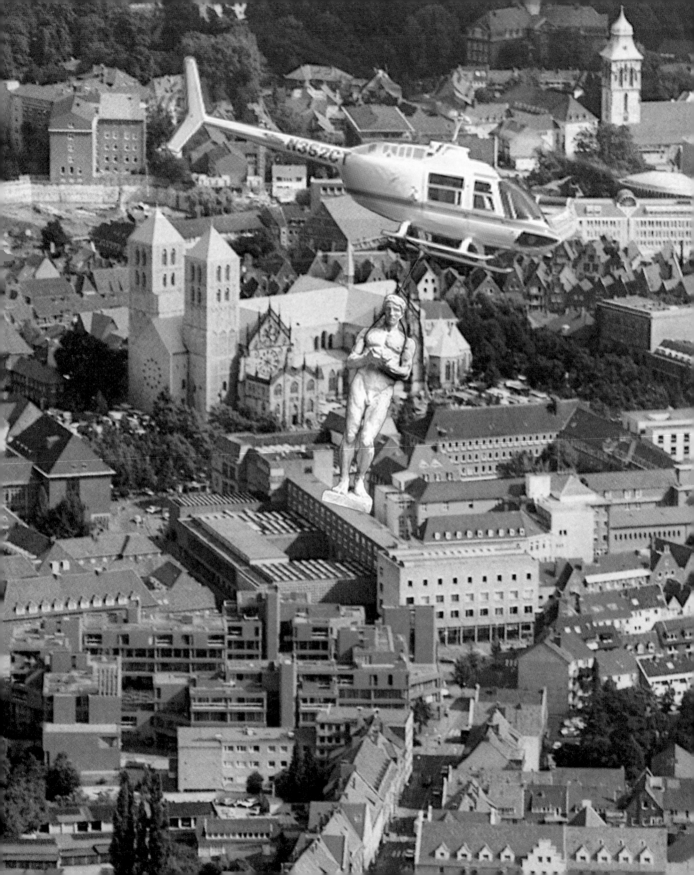

AYŞE ERKMEN

1. The Clock
Installation, two brass beams, painted black
West façade of St. Paulus Cathedral
Not realized; rejected by the Cathedral
Chapter in June 1996

2. The Covers
Installation, two red plastic caps
West façade of St. Paulus Cathedral
Not realized; rejected by the Cathedral
Chapter in December 1996

Born 1949 in Istanbul, lives there

3. The Lights
Installation, 18 street lamps
Cathedral square before the west façade of
St. Paulus Cathedral
Not realized; rejected by the Cathedral
Chapter in December 1996

4. Sculptures on the Air
Regularly repeated action, helicopter, various
sculptures of the 15th and 17th centuries
from the collection of Westfälisches Landes-
museum
Air over central Münster and roof of old sec-
tion of Westfälisches Landesmuseum

Ayşe Erkmen: View of action *Sculptures on the Air*, com-
puter simulation

For information about the artist and additional bibliography
see: Zuspiel. Ayşe Erkmen, Andreas Slominski, Portikus,
Frankfurt/M. 1996; Ayşe Erkmen. Der Weg, ifa-Galerie Bonn,
Bonn 1994; Ayşe Erkmen. Das Haus, Deutscher Akademischer
Austauschdienst, Berlin 1993.

Ayşe Erkmen: Four Projects

The City

Münster for me is a city in two layers. The first layer is today. It is practical, easy, very colorful, fashionable. It moves, it buys, it sells. I bought a long and narrow Westphalian table on my first visit. And sunglasses on my second visit, on an extremely dark and rainy day. You must walk: the city is a huge pedestrian zone, a shopping mall. It is crowded; you learn to disregard the bicycles instead of being careful. It is young. Then you look up, and immediately! it is old. The color changes from multi to mono. The movement stops. The bisection of the layers can be seen as clearly as a straight line. It is as simple as one on top of the other, one layer being as different as can be from the other. You are puzzled. It is not easy...

First Project: The Clock

In the city center but seemingly quiet, is Domplatz. The west wing of the Dome. Previously the entrance, it has twelve large windows forming a circle and four smaller ones in the middle, which together make up a rose window, or a rose ornament as we call it here. This wall no longer has any opening to act as an entrance, nor an exit. A dumb wall which can see but cannot speak. There is no receiving from here, nor any giving. Only the light which comes in through these windows tells what time it is to those inside. This huge, clean-cut wall is not complete. It needs to function. The twelve round window holes are perfectly situated to form the outer circle of a clock, left as though incomplete, as though the drawing/construction of the wall had been stopped midway. It needed two hands, an hour and a minute hand. I proposed to place an hour and a minute hand, each connected through the middle, and installed on the wall in the middle of four smaller round windows, which are also in the

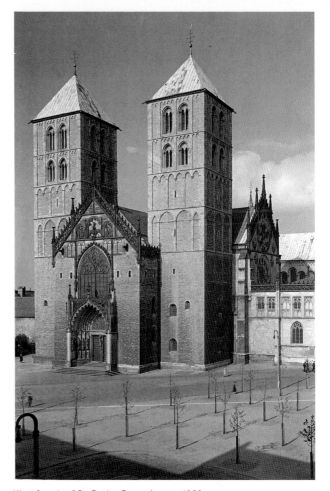

West façade of St. Paulus-Dom, view ca. 1939

middle of the twelve windows. I want these hands to be of equal length, an abstract cross, an Orthodox/Byzantine cross (*crux quadrata*). This will make the reading of time more difficult, less spontaneous. Although the clock will work properly and show the right time, in order to know what time it is one will have to think of one's position within the day. All visitors would have to consult their individual timetable in order to find out. And as this sculpture/clock

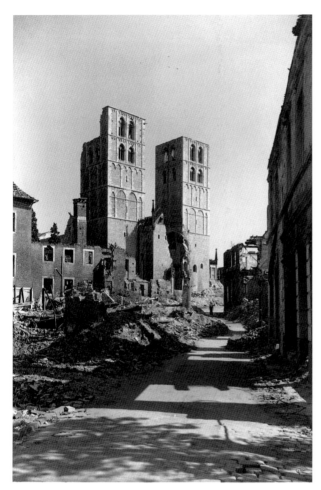

West façade of St. Paulus-Dom, view ca. 1945 (above) and 1995 (below)

of that day and therefore on the part of the day in which one finds oneself. This way, the wall of the west wing of the Dome might now be said to have two essential things at once, a cross and a clock. The wall may now have something to say and to give, something to say about itself and what lies behind it, and about the outside, the day. It will have light and darkness, night and day – every second from morning to evening will be known. The wall will be looked upon, will be needed, necessary. It will have a sign...

Second Project: The Covers

Again, this project makes use of the rose window on the west wing of the Dom, with its twelve large and four small windows all placed exactly in the middle of the façade, which let the light inside. I propose to cover one of each of the smaller and bigger windows with a lid. A

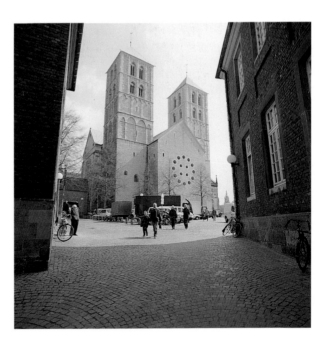

will change constantly, it will give a different perspective according to the position from which is viewed or a different viewpoint according to the perspective. Here time will change the perspective as well as the positioning of the person looking: even when one is not moving, one will be moving. As the windows let daylight or darkness into the church they will also tell the time to the outside, but only with the help of individual thinking, reflecting on the events

Ayşe Erkmen: *The Clock*, 1st project, west façade of St. Paulus-Dom with clock hands, frontal view, 1996, computer simulation (opposite above); *The Covers*, 2nd project, west façade with caps over round windows, 1996, computer simulation (opposite below); *The Lights*, 3rd project, west Domplatz with street lamps, 1996, computer simulation (above)

lid which can be taken off and replaced again as necessary. It should be of light plastic, colored red. The two lids will change places at certain times. There will be a schedule of movements, a timetable. The changeover will coincide with an important event or an anniversary or anything similar. The positioning of both lids will be changed in a clockwise fashion. So at a certain time, when the lids are moved to celebrate or to commemorate an event, as the larger lid moves one step further clockwise, the smaller will also move one step further. As there are twelve large and four small windows, the outer circle will need twelve events to celebrate in order to complete the circle, while the windows in the center will make three complete

turns during the same period. They will function like the hour and minute hands of a clock; they will show the passing of time in a special way, like a calendar. They will prevent light from falling into the cathedral at two points: there will be two dark points inside and two red points outside which will not stay permanently in one place, but will move as time passes and on particular occasions. They will be there to make people remember…

Third Project: The Lights
The location is the area between the façade of the west wing of the Dom and the historic walkway. This is the previous entrance to the Dom, before the new wall was built. Now that there is

no longer any functional entrance, the area is used as a parking lot on market days, twice a week. This whole area is packed with cars and vans. And there are street lamps in this area, all identical, very simple ones. They are "the street lamps", they have the essential form of a lamp ending in a round bulb. These lamps are scattered all around Domplatz. I thought I should make a gathering of them in front of the wall of the west wing, the former entrance. They would keep the vehicles from blocking the entrance and would stand there in three rows starting from the wall to the walkway. The lamps would be turned on when the other street lights in Münster are on and would be turned off when the others are off. The round bulbs of these street lamps would be lighted when it is dark, just at the time when the roundels of the rose window can no longer bring light to the inside. There will always be light there...

Various stone statues of the 15th and 16th centuries from storage in the Westfälisches Landesmuseum Münster, used for the action *Sculptures on the Air* (below); scenes from Federico Fellini's *La Dolce Vita*, 1959, four film stills (opposite)

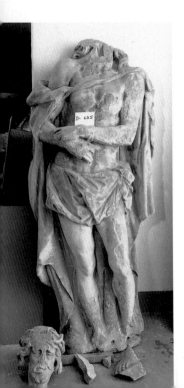

Fourth Project: Sculptures on the Air

This work is about transfer, exhibiting and being on the air. One sculpture will be taken out of storage, tied to a helicopter with a cable or a rope so that the sculpture will be hanging from it, as seen in the illustration. Then the helicopter bearing the sculpture, after making a few round tours over the city, will place the sculpture on the roof of the museum. The sculpture will stand there overlooking Domplatz, until the next sculpture arrives to take its place. This event will be repeated at certain intervals (every two days, every three days, twice a week…) depending on the budget. The next time, the helicopter will bring another sculpture from the same museum store, the same way. After placing the new sculpture on the roof it will take away the one placed there previously and return it to storage, again making a few tours over the city as before. This way there will always be one sculpture on the roof/on the air, to be replaced when the next one arrives.

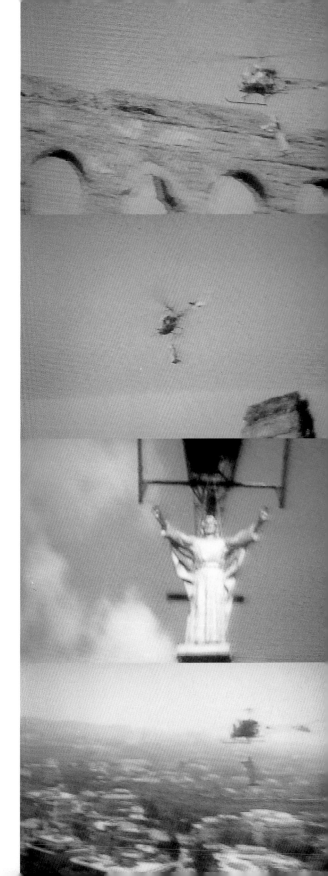

PETER FISCHLI/DAVID WEISS

Garten
Garden complex
Private garden on city moat between
Westerholtscher Wiese and Lipper-Mauer
on the River Aa

Born 1953 and 1946 in Zürich, live there

Patrick Frey
It Grows: Notes on the *Garten* by Peter Fischli
and David Weiss

"I think it is just as important to live with flowers as it is to eat cabbage and turnips, though we have to eat cabbage and turnips; but when we do, there should be flowers around, at least in memory."[1]
My earliest memories of gardens include not only very specific, clearly illuminated fragments of imagery – pole beans with the pastel of the sweet pea winding up through their rich green, beds of lettuce surrounded by sunflowers, red

For information about the artists and additional bibliography see: Peter Fischli/David Weiss, ed. Bice Curiger/Patrick Frey/Boris Groys, XLVI Biennale di Venezia, Venice 1995; Peter Fischli/David Weiss: Raum unter der Treppe, Museum für Moderne Kunst, Frankfurt/M., Ostfildern 1995; Peter Fischli/David Weiss, Musée national d'art moderne, Centre Georges Pompidou, Paris 1992.

slugs sitting on the giant leaves of a ripe rhubarb plant – but also the mixture of scents and tastes associated with different times of day, intensified by a backdrop of sound, that "green rustling" punctuated by the rhythm of light, melodious tones that evokes the vegetative, brooding quiet of the garden.

There is the morning scent of young, freshly-pulled carrots with clods of earth still sticking to them, the perfume of lavender with the bright buzzing of countless bees, mixed with the aroma of sun-warmed strawberries; in the afternoon the nervous humming of flies and the soft scraping of small lizards hurrying away, with the fragrance of ripe wall peaches next to the peonies; or the sparrows twittering, the chirping of the crickets, and the faraway sound of a dog barking after sunset, when the honeysuckle begins to exude its scent and the sweet, intoxicating fragrance mixes with the voluptuous sourness of a stalk of rhubarb. Then there is tactile nostalgia: when I remember the gooseberries that grew between the raspberries and the potatoes, the first thing that comes to mind is the furry sensation on the tongue that has to be overcome before the skin bursts and surrenders the pulp. And in addition to all that, the recurring scent of freshly mown grass and beneath it the underlying smell of the different soils, the odors of rot, decay, and mold as well as the highly complex, organic stench of the compost heap, which for me will forever be associated with the smell of coffee grounds and rotting orange peel.

Garden memories of this kind are almost always nostalgic, marked perhaps by a vague sense of homesickness. They are memories of the intoxicating, sensual immersion in a world protected on every side, where the useful never seems ugly because it is necessarily, and seemingly effortlessly, connected with the beautiful, indeed to some extent cannot even be distinguished from it. It is not like a "sculpture garden", for example, where usefulness is less obvious than in a bed full of lettuce, and where beauty less effortlessly permeates (and transcends) the material than in the slow reddening of a tomato. This remembered immersion in a world which, unlike the paradisiacal jungle, is still ordered by both utilitarian and aesthetic considerations – a world which can nevertheless surround and enclose like a rain forest or a paradise – is always marked by a deep-seated sense of longing, perhaps because it is the memory of a kind of time travel. Amidst the pervasive rhythm of the vegetation, a rhythm that seeps into you in a slow intoxication, you abandon your own temporal framework and give yourself over to a paradoxical security marked by the feeling that time is standing still – paradoxical, because this longed-for, sensual experience arises in the face of the purest transience, the most intimate contact with growth, blossoming, and decay.

The farm garden to which the ecological or "natural" garden alludes denies neither its agricultural nor its Romantic roots. For this reason, in its seclusion – both temporal and spatial – it can create a "Romantic" situation similar to so-called wild nature, a situation "which, without being threatening or wild, must radiate quiet and solitude so that the soul is not distracted and can surrender itself undisturbed to the gentleness of deep feeling", as the Marquis de Girardin, the builder of the park at Ermenonville where the solitary hut of Jean-Jacques Rousseau stood, described it in 1777.[2]

It was above all the farmers' wives who cared for the traditional farm gardens. These mixed-crop gardens reflected in miniature an agrarian economy that was already radically changing:

"Grüner Zoo", garden planted ca. 1900, view of pruned hedge and view of garden during flooding of river Aa, photos from family album of owner, photos ca. 1920

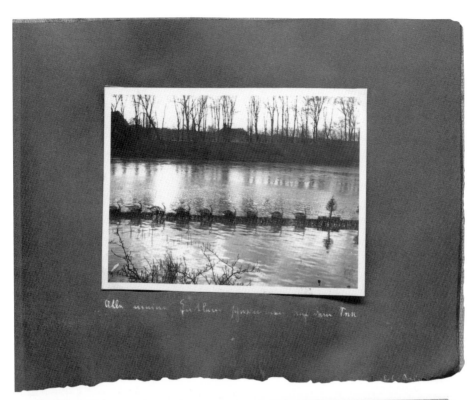

Alle meine Entlein schwimmen auf dem Inn

Besuch bei Vater Schwan.

while they provided vegetables and fruit for the families living on the farm, their usefulness was no longer essential to its survival. They were functional idylls, the product of feminine industry on the margins of an agricultural world which already at the end of the eighteenth century was caught up in the early phases of industrialization and the growth of technology.

Already the bourgeois flower gardens of the prerevolutionary period – small fragrant scenes of "quiet beauty and modest grace" where "persons of a gentle and mild character were most in the habit of conversing" – had been refuges of feminine consciousness.[3] In fact it seems as if the industrious cultivation of such showpieces (among which the small ecological garden plots of the present day number as well) symbolized the uselessness of traditional female time, a corrective counterpart, as it were, to the "productive timetable" of the industrially active man. Conversely, one could surmise that for this reason women had more frequent, or, at least historically speaking, earlier experiences with what might be called vegetative real time.

The visualization of and reflection on real time results from a concern for the world of the usual and for the objects of everyday life. In the work of Fischli and Weiss, this concern has always been driven by more than just disinterested pleasure; indeed, at times it has attained the intensity of participatory observation.

Already the videos for the Venice Biennale were intended, among other things, to transform the conventional perception of a work of art into a situation where the viewer can observe how the temporal structure of everyday life articulates itself in a variety of diverse processes, from a sunrise in snow-covered mountains to a bicycle race in a noisy hall.

This participatory observation of real time sequences – undertaken not from an ethnographic, but from an aesthetic point of view –

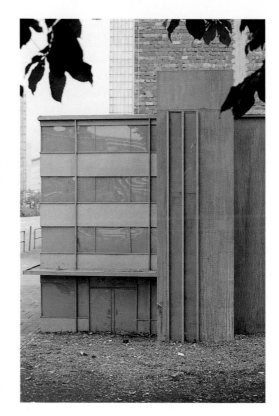

Peter Fischli/David Weiss: *Haus*, 1987, contribution to *Skulptur Projekte in Münster 1987*, location: Von-Steuben-Straße, wood, plexiglas, painted, 3.5x5.7x4.1 m, scale 1:5

resembles a specific form of waiting. It is a waiting to see what will happen, without being able to change it; but in fact it is often a waiting where, in terms of the observation of events, "nothing", or "almost nothing", happens. Or to put it in contemporary terms, the Biennale videos, like other works by Fischli and Weiss, celebrate a certain paradoxical, primeval sensation in which the motto of an experience-oriented society – "experience your life" – undergoes a radical loss of dynamism and excitement and, through its inability to endow actual everyday waiting with the character of an experience, acquires an undertone as deeply ironic as it is existential.

Thinking of the Lipper-Mauer, the wall angling inward that bounds and encloses Fischli and Weiss's G*arten* on two sides and conceals it from view, I remember the "wall" Fischli mentioned – an image Paul Virilio used to conceive of real time, in a certain analogy to the idea of a wall of sound – and I remember Fischli saying that there is no better place to converse about real time than in a garden.

In his text on the "gesture of planting", in which he reminds us that "planting is the root of possession and of war", Vilém Flusser associates planting with waiting: "As the ancients knew, but we have forgotten, the gesture of planting is the overture to the gesture of waiting. After covering the seed with earth, one sits down and waits. The Latin word *colere*, from which *cultura* is derived, means not only 'to harvest', but also 'to cultivate', that is to wait attentively, to expect solicitously, and *agricultura* is not only planting and harvesting, but above all jealously and covetously guarding."[4]

The covetous guarding of the idyllic plot is not what stands in the foreground here. The fictive "tiller and beneficiary of the idyll", as Fischli and Weiss characterize the "imaginary owner" of their garden in their project description, is less controlling than the imaginary residents of Fischli and Weiss's earlier interiors, the garages and storage closets inhabited by polyurethane foam objects. The gardener is one who lets growth take its course in attentive expectation, an observer participating in real-time processes that come to completion very slowly and whose results provide nourishment in a number of ways.

The *Garten* by Fischli and Weiss is, of course, neither an art-garden nor some sort of garden art. There is no aesthetic of decay, no ruin-mannerisms, no play with any kind of natural ready-mades. And neither the objects and equipment lying around as in a normal kitchen garden, nor the "objects" that are raised over the course of the year – flowers or potatoes, for example – are more than what they are: on the one hand, tools, and on the other, "things" that delight either the eye or the stomach and that in the natural "course of things", in the harvest, disappear again.

Even if this garden is the creation of two artists, nothing here is "handcrafted" in the sense of artistic authorship, not even if Fischli and Weiss could do the gardening themselves, as they wanted to, but which of course for reasons of real time (!) was impossible. For, according to Fischli, one can hardly speak of "homemade lettuce", or even "homemade honey". It is pre-

Views of gardens

cisely the complete absence of artistic gesture that allows the fictional element – an inspirative deception concealed in the autonomous self-creation of the vegetation – to so unmistakably emerge.

In Jean-Jacques Rousseau's novel *La Nouvelle Héloïse*, M. de Wolmar says that the Chinese garden is "created with such artfulness that no art appears in it at all".[5] The imperceptible design of Chinese landscape architecture had a special name, "Sharawadagi", a term already used by English garden architects at the end of the seventeenth century. Above all in its meaning of "irregular grace", it designated those

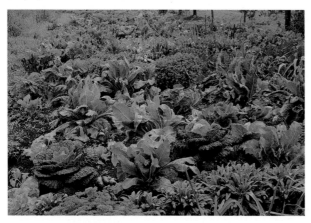

View of garden

compositions "in which no order is visible", as William Temple put it in 1685, conceiving "order", of course, as a category of art.[6]

The order that characterizes the *Garten* by Fischli and Weiss differs little from that of a traditional farm garden. Two large beds with mixed plantings of indigenous vegetables, fruits, flowers, and berries conceal the intimate nucleus where, next to the glass-roofed hotbeds and trays with their seedlings, there stands a small shed with tools and a place to sit; along the

wall are the pole beans, and toward the corner, the compost heap. Only in the tapering, right-hand section of the terrain are planted two larger fields of corn and potatoes, a slight departure from the traditional farm garden. The artists' plan calls for a garden that would feed a family of at least twelve. Ordering concepts such as crop rotation and crop mixing or "good" and "bad neighbors" in the juxtaposition of flowers and vegetables play an important role; also important is the treatment of the gardener's Good and Evil, i.e. the more or less ecological approach to parasites, wire-worms, slugs, various caterpillars, the ichneumon fly, the hover-fly, and above all the plague of rabbits so prevalent in that region, against which nets, screens, and other protective devices must be installed. Precisely because Fischli and Weiss adopt neither a "Romantic" nor a "Chinese" manner and thus do not attempt to imitate the irregularity and disorder of "wild nature", but rather, through an overt emphasis on utility, strive for a prosaic equilibrium between beauty and yield, there arises – not least of all through the fictional presence of the "imaginary owner" – an evocation of the prototypical and yet fictive that characterizes many important works by the two artists. In the *Garten*, the artistic is, as it were, concealed in perfect mimicry beneath the husks of the organic and vegetal. The art grows of its own accord, in the proliferation of real life.

In a compilation by missionaries from the year 1782, the Chinaman Lieoutcheou is quoted as saying that "the art of designing gardens consists in combining points of view, variety, and solitude in such a way that the eye has the illusion of simplicity and rusticity, the ear perceives silence or that which breaks through it, and all the senses experience joy and peace [...]".[7] Fischli and Weiss have said: "What we are seeking are the metalevels produced through the garden in and of itself. What pro-

duces the metalevels is dispensable, decays, is forgotten." For this reason, when viewers who are not especially informed about art and the work of Fischli and Weiss look at this work of art, they will presumably see, hear, and smell nothing but a garden. When more artistically informed viewers, on the other hand, pass by the Romantic animal figures and proceed over the small wooden bridge into the *Garten*, they may at first perceive no garden at all, but only an exhibition piece, an installation, or something else of an artistic nature. As the artists conceive of it, such viewers should then be conducted along a path leading to a place where even they now "only" see a garden, a place where their consciousness finally arrives down there by the lettuce, a place where perhaps that other, "fuller" world will first become visible, "the one with the transparent horizons, surrounding a garden in whose axis stands the tree of life".[8]

1 Gerhard Meier: Das dunkle Fest des Lebens. Amrainer Gespräche, Cologne / Basel 1995.
2 Alain Corbin: Pesthauch und Blütenduft. Eine Geschichte des Geruchs, Berlin 1984.
3 Ibid.
4 Vilém Flusser: Gesten. Versuch einer Phänomenologie, Düsseldorf / Bensheim 1991.
5 Quoted in Jurgis Baltrusaitis: Imaginäre Realitäten, Cologne 1984.
6 Quoted in Baltrusaitis.
7 Quoted in Baltrusaitis.
8 Quoted in Flusser.

Peter Fischli / David Weiss: *Garten*, temporary garden complex

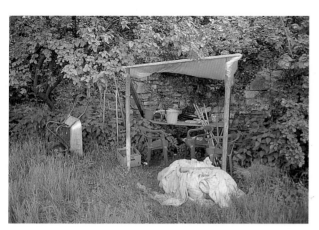

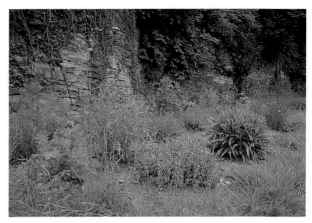

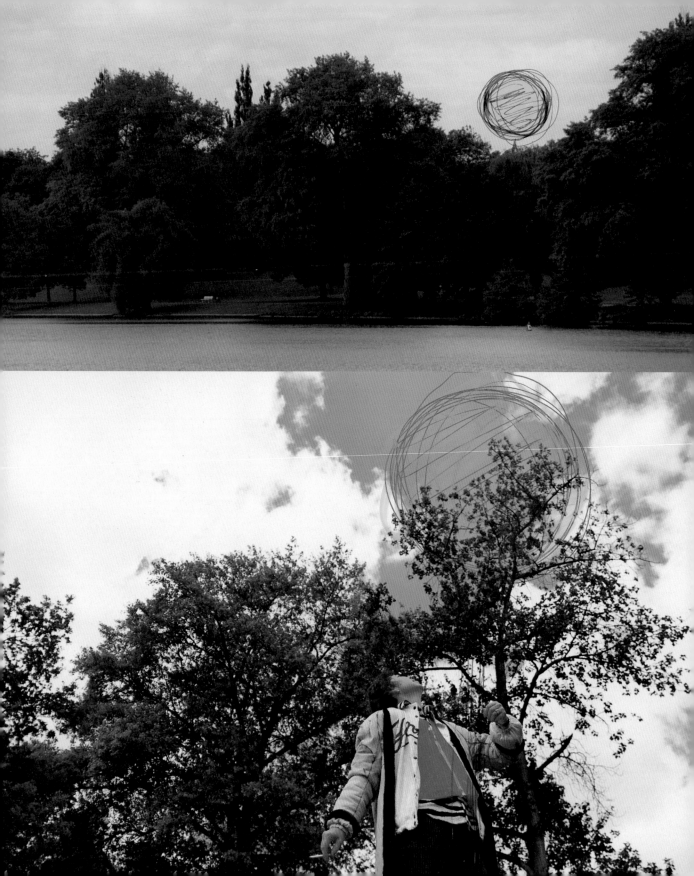

ISA GENZKEN

Vollmond
(Full Moon)
Sculpture (glass diameter 2.5m, metal
length 14m)
Northwest lawn of the Aasee, below
Annette-Allee

ABC, 1987

Concrete is forced nature. If I go into a museum
and enter a room full of bad paintings, and if I
then suddenly discover a painting in front of
which I stay for a while, then I forget the others.
Public sculpture today takes place in the area of
contention existing between newly-built housing
and a traditional monument. I find the use of
rough materials in the construction of new buil-
dings interesting, because the rational thoughts
of the engineer have more to do with truth than
does the routine covering of façades with
pseudo-precious materials.

Vollmond, 1997

My sculpture *Vollmond* consists of a frosted
glass sphere 2.5 m in diameter, illuminated
equally by day and night, supported by a 20 m
high pole of refined steel. The sculpture is cal-
culated for visibility at great distance. At the
same time, it is related to a location in which
there is no other artificial illumination at night,
and thus functions as a great street lamp for
the vicinity.
On the beautiful Aasee, about ten minutes away
from the center of town, the *Vollmond* can be
seen towering up among the treetops. The *Voll-
mond*, realized artificially as a sculpture, here
appears as a mediator to the natural moon

Born 1948 in Bad Oldesloe, lives in Berlin

For information about the artist and additional bibliography
see: Isa Genzken. MetLife, ed. Sabine Breitwieser, EA Generali
Foundation, Vienna 1996; Isa Genzken. Jeder braucht
mindestens ein Fenster, ed. The Renaissance Society at the
University of Chicago, Cologne 1992; Isa Genzken, Rheinisches
Landesmuseum, Bonn/Munich 1988.

between earth and the sun. And once a month
we have the pleasure of seeing two full moons
at the same time.
By way of comparison: in my work *ABC*, created
for *Skulptur Projekte in Münster 1987*, I picto-
rially integrated the changing appearance of
the sky by means of two free-standing frames
of refined steel mounted on concrete pillars.

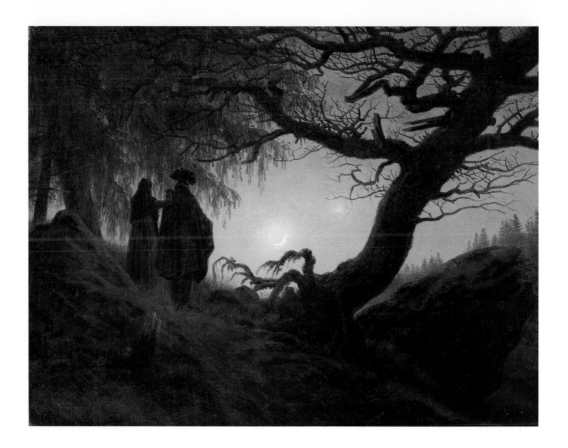

Caspar David Friedrich: *Mann und Frau den Mond betrach-
tend*, ca. 1824, oil on canvas, 34x44 cm, Nationalgalerie,
Berlin

As long as man has existed, he has been fasci-
nated by the moon. The moon is the origin of
many myths, the occasion of a variety of sto-
ries, and the catalyst for strange events. From
childhood on it is the planet of our longing. Man
has always liked to gaze at the heavens. The
dream of exploring faraway stars and planets is
an ancient one and continues even today.
Already in the Romantic period, the moon was
a favorite subject in German literature. It
reflected the condition of the soul. An early
example is the famous song *Abendlied* by Mat-
thias Claudius (1779), a song every German

knows: "Der Mond ist aufgegangen..." But the
moon has also been blamed for a lot of things
that are not so certain. It is said, for example,
that a full moon makes us all a little crazier than
usual. At the very least there is a widespread
belief that the moon possesses special psychic
powers against which we are defenseless.
In this connection I find it interesting to
observe the usage of the words connected with
the moon in the English language. Here two lin-
guistic roots are at work: the Latin *luna* in luna-
tic, loony bin, or more recently Looney Tunes
(the cartoons), and of course the Anglo-Saxon

moon, which corresponds to the German *Mond*. In English, *moon* also means backside, and *to moon* at somebody is to show him your naked bottom or to "make an ass of him". A *mooner* is an alcoholic or a slightly crazed person. *Moonshine* is illegal liquor, especially homemade whiskey, but it is also a word for nonsense or foolish talk; *moony* means drunk. One sees here that in contrast to the English *moon*, the word *Mond* in German awakens more of a romantic impression.

Isa Genzken

Isa Genzken: *ABC*, concrete, refined steel, 14.85x11.2x0.4 m, at the university library, temporary installation until 1988

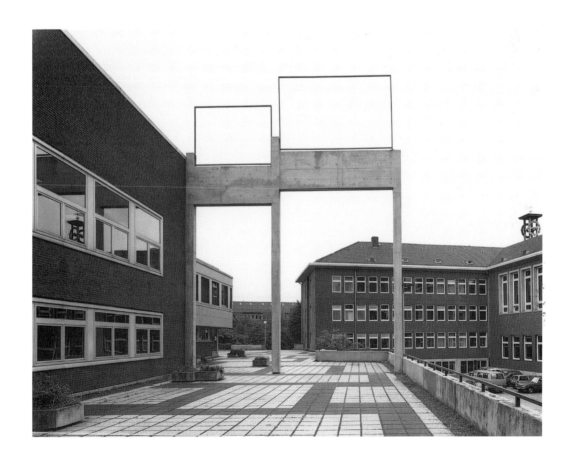

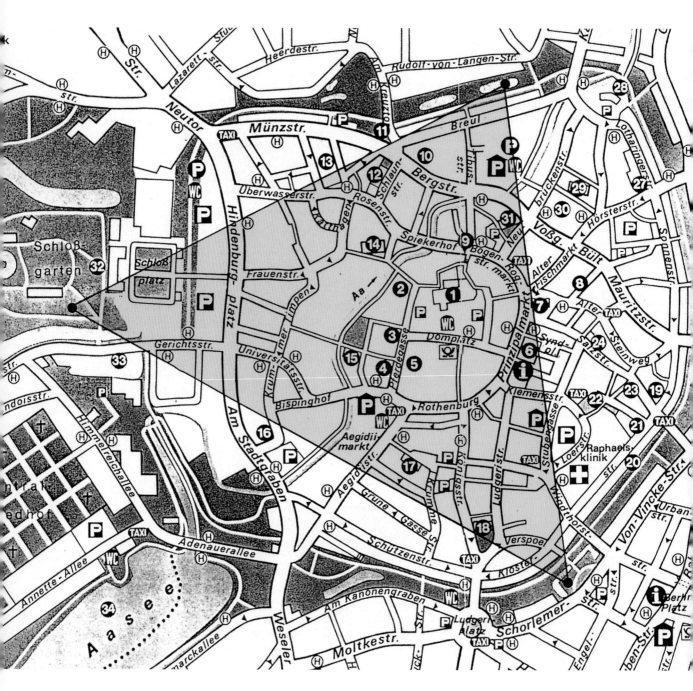

Paul-Armand Gette: *Virtuelle Skulptur oder das Zeichen der Aphrodite*, work shown on map of downtown Münster

PAUL-ARMAND GETTE

Virtuelle Skulptur oder das Zeichen der Aphrodite
(Virtual sculpture or The Sign of Aphrodite)
Three-part work
South Schloßgarten
Southeast of pond at Engelenschanze
Island of pond on Promenade, west of Kanalstraße

Born 1927 in Lyon, lives in Paris

For information about the artist and additional bibliography see: Le Mineral dans l'œuvre de Paul-Armand Gette ou de la transparence à la métaphore, Musée d'Art et d'Histoire, Belfort 1996; Nymphe. Nymbæa et voisinages, Magasin Grenoble, Grenoble 1989; Textes très peu choisis, Adac, Dijon 1988.

Paul Armand Gette: On Virtuality in Sculpture

To choose three points in the environments of Münster, three points that would connect with each other to form a triangle, is most certainly not a chance action. The center of the city used to be the abbey; now it is the cathedral that is located in the interior of my triangle. Is it the Bermuda triangle, where all the missing ships go, or the triangle of the goddess the *Mons Veneris*, the sex of Aphrodite? So many questions to answer.

I have always loved the little signs in gardens dedicated to that most charming of sciences, the one that busies itself with flowers, with the counting of stamens, with the observation of the pistils and ovaries of plants, and which is carried out with the greatest attentiveness but with much tenderness as well – the science which charmed Carl von Linné, Jean-Jacques Rousseau, Johann Wolfgang Goethe, Wilhelm von Humboldt, and me, if I may presume to add myself to this select list. Ah! Flora, delightful goddess, you have devoted lovers.

Unfortunately, my purpose here is not to sing praises but rather to describe my project (artistic nature, if possible) and in particular with respect to sculpture – I who am not a sculptor!

Dear reader, you can imagine my dilemma. I feel rather more inclined to take a walk (right, Lucius Burckhardt?) from Vesuvius to the Furka Pass, from Iceland to Brazil, or wherever you want, just call me and I'll come, I can always set up some little signs.

I will install my first point at the edge of the botanical garden, a *Mons Pubis* of signs, a homage to nomenclature, to botany, and to that most enchanting goddess of love. The signs say

Cypripedium calceolus L.; it is the lovely orchid, lady's-slipper, where we will now pause for a moment. I can already hear Punch saying that no one understands what I do, but art doesn't need to be understood, it is enough just to look at it.

Cypripedium calceolus L.

Blätt. breit-elliptisch, stgumfassend; Infl. m. 1–2 großen Bltn.; Schuh (=Lippe) 3–4 cm groß; äußere Perigonblätt., schokoladenbraun, etwas gedreht; ausdauernde Pflanzen; V–VII. Schattige Wälder (bis 1600 m); kalkliebend; *v* bis *z* Alp.; Voralp. Hegau-Alb-FrSchweiz, *z* N-Württ. u. nördl. bis Hildesheim, Th; sonst *s,* NW-Grenze: SO-Be/Eifel/Bonn/Osnabrück/Uelzen/Rügen; auch Da, *f* Ho, Sa.

Aus: Schmeil/Fitschen; *Flora von Deutschland und angrenzender Länder*, Heidelberg/Wiesbaden 1993

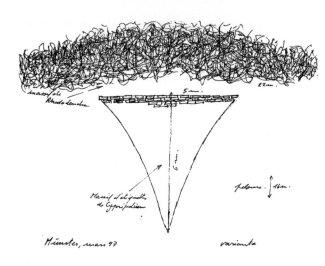

Paul-Armand Gette: *Variante de forme pour le pubis d'étiquettes*, 1997, sketch

With the goddess's slippers we have arrived at fetishism, though personally I prefer small panties, but I haven't found a flower that has that form. I should have suggested making a flowerbed in order to flatter the gaze of the passerby, but the little signs have the advantage of being less fragile and still attractive. I have often covered the pubic bone of my models with gravel, shells, algae, and rose petals, but here in Münster I offer to the goddess an ornament of names, a gift that I hope will please her.

The second point of my triangle is a small island in the north part of the city. I have never seen such a beautiful island. A bamboo group lends it an air of exoticism and reminds me of my stay in Berlin in 1980 (*Exoticism as Banality*). There are only two trees there, which constitute the entire flora. It is a botanical garden in miniature, a tiny forest, a paradise on earth; an island from an open map that still remains to be discovered. Later, as I viewed the cathedral and admired the calendar of the astronomical clock, I saw that the medallion and text for the month of May (the month of my birth) could be exactly applied to my small island: *Ros et frons nemorum Maio sunt formes amoris.*

Of course I could have stopped there; my project could have succeeded that way too. Visitors would have seen two extensions of the botanical garden, not very orthodox, to be sure, but art is so close to science that I can probably permit myself a few defects. And besides, the straight line would have been the shortest, if not necessarily the most agreeable way from one point to another, satisfying the demands of geometry. On one side of my line would have been botany, and on the other, I don't know what, maybe the astronomical clock or the Landesmuseum, for those who prefer art to the passage of time.

After a number of walks (4.5 km each!) through the city, I discovered the third point of my proposal and therewith the third point of my triangle. And so I will write the sacred sign of Aphrodite within the greenbelt; a circle with a triangle

and water in the golden interior, for lovers of symbolism. *Voilà*, a proposal for the city that could be preserved, a sculpture that would disturb very little, indeed in a certain sense would be virtual – believe me, that is the future, take my word for it! I will adorn my last point with an Om., which the visitor can view in two ways, for it is reflected in the water. I took this Om. to the mountaintops in order to demonstrate the origin of the landscape, to the edge of the sea to point to its disappearance, and into the Wilhelmshöhe park in Kassel in 1985 in order to present it to the visitors. I have also placed it, following Courbet, on the pubic bone of my chosen models, as the place of the origin of the world.

Paul-Armand Gette
Paris, March 1997

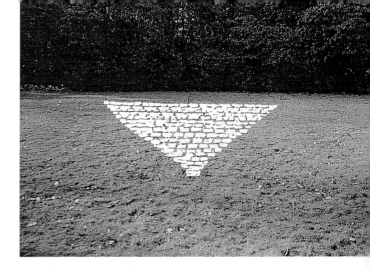

Paul-Armand Gette: *Virtuelle Skulptur oder das Zeichen der Aphrodite*, views of the three locations: south palace garden, 600 white plastic labels with the lettering *Cypripedium calceolus* L.; island of pond on Promenade, west of Kanalstraße, 3 white plastic labels with the lettering Crataegus sp., *Alnus glutinosa (L.) Gaertner, Phyllostachis bambusoides Sieb & Zuc.*, labels 7x11x0.1 cm each; pond at Engelenschanze, white plastic sign with the lettering *Om.*, 32x45x0.5 cm, photomontages

JEF GEYS

Born in Leopoldsburg, lives in Balen, Vorst, and Reckheim, Belgium

Geloof niet wat U ziet
(Don't believe what you see)
Seven different locations: in front of the churches St. Paulus cathedral, St. Lamberti-Kirche, Apostelkirche, Liebfrauen Überwasserkirche, Petri-Kirche, St. Aegidii-Kirche, St. Ludgeri-Kirche

A hoisting device will lift up persons on certain days during a certain time in different places in the city.

INFORMATION
Hour, date and place can be asked for at the information desk of the Westfälische Landesmuseum für Kunst und Kulturgeschichte

Jef Geys: Apocalypse

Behold, *He is coming with the clouds*, and every eye will see Him, *even those who pierced Him*; and *all the tribes of the earth will mourn over Him*. As always, he comes by train at 8:30 and after a cup of coffee in the station restaurant, he goes directly to his mother. I was in the Spirit on the Lord's day, and I heard behind me a loud voice like the sound of a trumpet, saying, "Write in a book what you see, and send it to the seven churches: to Ephesus and to Smyrna and to Pergamum and to Thyatira and to Sardis and to Philadelphia and to Laodicea." And I turned to see the voice that was speaking with me. And having turned I saw seven golden lampstands; and in the middle of the lampstands *one like a son of man*, clothed in a robe reaching to the feet, and *girded across His breast with a golden girdle*. In Maasmechelen the tribes tried to survive in the framed lettering of the pub names and as the signs of shoe stores. On the other side stands Jan, who tells a story about his finds in Bosch's hay wagon, about the twelve constellations and the enveloping. He has become even fatter, and his glasses of copper wire leave green marks on his face. And when I saw Him, I fell at His feet as a dead man. Well, I'm not quite dead, but very frightened. Write therefore the things which you have seen, and the things which are, *and the things which shall take place after these things*. As for the mystery of the seven stars which you saw in My right hand, and the seven golden lampstands: the seven stars are the angels of the seven churches, and the seven lampstands are the seven churches. I stood on the street in Beringen and acted as if I saw what was happening on the processional car; my eyes were bad and I wore no glasses! I never found out what happened on this car. I advise you to buy from Me gold refined by fire, that you may become rich, and white garments, that you may clothe yourself, and that the shame of your nakedness may not be revealed; and eye salve to anoint your eyes, that you may see. The salve that my mother stroked onto my knee was green and smelled like cheap soap.

After these things I looked, and behold, a door standing open in heaven, and the first voice which I had heard, like the sound of a trumpet speaking with me, said, "Come up here, and I will show you *what must take place after these things*." My brother lay next to me in the iron bed. With my face to the wall I poked at the loose pieces of plaster. Behind the wallpaper with the great red flowers, behind plaster, boards, plaster again, and wallpaper again slept my father and my mother. And behold, a throne was standing in heaven, *and One sitting on the throne*. Next to the bicycle stood a tin can with a couple of keys, next to that a tube of glue, two small levers for removing the covering from the wheel, round pieces of rubber for plugging the holes, a piece of old emery paper and a shiny piece of metal with holes. And I saw in the right hand of Him who sat on the throne *a book written inside and on the back*, sealed up with seven seals. And I saw a strong angel proclaiming with a loud voice, "Who is worthy to open the book and to break its seals?" The big black book with all the debtors in it, which was looked into hopefully during the war, was all that they had kept from their shop days. And I saw in the middle of the throne and of the four living creatures, and in the middle of the elders a Lamb standing, as if slain, having seven horns and *seven eyes*, which are the seven Spirits of God, *sent out into all the earth.* The day the troops invaded Normandy was also José's wedding day. The goat my father grazed on a different spot every day was slaughtered, and the celebration lasted until the late afternoon. And I looked, and I heard the voice of many angels around the throne and the living creatures and the leders; and the number of them was *myriads of myriads, and thousands of thousands*, saying with a loud voice, "Worthy is the Lamb that was slain to receive power and riches and wisdom and might and honor and glory and blessing." As far as I could see, the heather was in bloom. At the water tower a couple of pines stood out green against the white storm clouds, that frayed out over Leopoldsburg in the powerful gusts of wind. And I saw when the Lamb broke one of the seven seals, and I heard one of the four living creatures saying as with a voice of thunder, "Come". Louizette's old grammophone was a provocation for the soldiers marching by in long columns. And I looked, and behold, a black horse; and he who sat on it had a pair of scales in his hand. On the cabinet shelf the cast iron pounds and kilos looked paltry next to the shining copper hundred-gram weights. And when He broke the fifth seal, I saw underneath the altar the souls of those who had been slain because of the word of God and because of the testimony which they had maintained. When I looked out the window in the evenings, I saw the raked paths of the cemetery with the traces of the last visitors. And I looked when He broke the sixth seal, and there was a great earthquake. As I sat in the covered ditch that served as a sentry post, just before the first bombs fell, a man leaped in cursing. After this I saw four angels standing at the *four corners of the earth*, holding back *the four winds of the earth*, so that no wind should blow on the earth or on the sea or on any tree. And I saw another angel ascending from the rising of the sun, having the seal of the living God. The pears under the tree were full of wasps. I took a blade of grass and poked carefully at the hindmost one of the greedy creatures. After these things I looked, and behold, a great multitude, which no one could count, from every nation and all tribes and peoples and tongues. What used to be a bicycle racing track is now only a steep sand hill. In front of the chapel stood a lot of murmuring women and children. The prayer, or whatever it was, made a desperate but certainly also an aimless impression. And I saw the seven angels who stand before God; and seven trumpets were given to them.

The drummers kicked each other's heels, and the drum major was drunk. There was no question of harmony. It was above all a pitiful sight, sometimes quite funny, but mostly pitiful. And I saw a star from heaven which had fallen to the earth. The shell was empty and still somewhat warm. The airplane was long gone, its enemy's bullets after it. Thus I saw in the vision the horses and those who sat on them: the riders had breastplates the color of fire and of hyacinth and of brimstone; and the heads of the horses are like the heads of lions; and out of their mouths proceed fire and smoke and brimstone. The gray-green jackets stood slightly open, so that one could see the shining breastplates glinting in the sun. And I saw another strong angel coming down out of heaven, clothed with a cloud; and the rainbow was upon his head. My friend was a year older than I. His sister had red curls. Their mother worked in the barracks and their father was dead. And the angel whom I saw standing on the sea and on the land *lifted up his right hand to heaven, and swore by Him who lives forever and ever, who created heaven and the things in it, and the earth and the things in it, and the sea and the things in it*: "There shall be delay no longer." After the streetcar line came a bus entrepreneur who, after he had brought the workers to the mine and taken a brisk dip in the canal, sat down again behind the wheel and made sure that the early commute from Heppen to Oostham was taken care of. And after the three and a half days *the breath of life* from God *came into them, and they stood on their feet*; and great fear fell upon those who were beholding them. My brother-in-law's suede shoes were a size too big for me. The problem was solved by padding the toes. And I saw *a beast coming up out of the sea.* Come, chicken, come! And I saw another beast. Behind the meadow lay a great oak forest. After the film I withdrew and with the rope that my father used to tie up the sheep I swung from one branch to the other. And I looked, and behold, the Lamb was standing on Mount Zion, and with Him the 144,000. The school excursion was an event that consisted of eating egg sandwiches as fast as possible and then, half-sick, looking out through dirty windows. And I saw another angel flying in midheaven. Formations of B 29s drew white stripes across the sky. The hunters fell back and bit at the tails of the enormous swarm of flashing cigars. *And I looked*, and behold, a white cloud, and *sitting on the cloud was one like a son of man*, having a golden crown on His head, and a sharp sickle in His hand. The first and the last carried sticks to which were tied white cloths. Nothing was left of that proud horde with flashing eyes and shining weapons. And I saw another sign in heaven, great and marvelous, seven angels who had seven plagues, which are the last, because in them the wrath of God is finished. And I saw, as it were, a sea of glass mixed with fire, and those who had come off victorious from the beast and from his image and from the number of his name, standing on the sea of glass. Between the bakery and the seating area was a double door. The glass in the upper part was opaque. The small sandblasted figures seemed to be of sugar, and here and there the light of the oven refracted in the polished edges. After these things I looked, and the temple of the tabernacle of testimony in heaven was opened. Little figures of painted wood were screwed onto the organ. The books of sheet music were folded in zig-zag in the boxes. A short drum roll sounded whenever the dance began. And I saw coming out of the mouth of the dragon and out of the mouth of the beast and out of the mouth of the false prophet, three unclean spirits like frogs. The bubbles in the water announced the wide mouth of the carp. Startled gold carp swam slowly around the edge of the pond. And one of the seven angels who had the seven bowls

came and spoke with me, saying, "Come here, I shall show you the judgment of the great harlot *who sits on many waters.*" Up on the cement roof lay the cashier's daughter. Her blue wool bathing suit was almost dry. Here and there damp spots could still be seen. The wet spots next to her indicated that she had company. And I saw a woman sitting on a scarlet beast, full of blasphemous names, having seven heads and ten horns. On the hooks hung the grey cups from which the hotel guests drank their coffee or tea in the mornings. And when I saw her, I wondered greatly. A runner was painted on the steps with oil color. Here and there the imitation marble of the banister was worn away. Before the stairs lay a threadbare coconut mat. "The beast that you saw was and is not, and is about to come up out of the abyss and to go to destruction." The merry-go-round had to be pushed. Around it was a ditch formed by the feet of those pushing. To swing up on iron bars was the height of agility. And he said to me, "The waters which you saw where the harlot sits, are peoples and multitudes and nations and tongues." Around the blonde girl's neck hung a pig's tooth. Her uncle had brought it back from his travels as a missionary. There were spaces between her teeth. "And the woman whom you saw is the great city, which reigns over the kings of the earth." The restaurant where my sister and I go to eat is called "L'Huile Impériale". After these things I saw another angel coming down from heaven. What I think of those beets will probably remain a secret forever. And I saw heaven opened; and behold, a white horse, and He who sat upon it is called Faithful and True; *and in righteousness He judges and wages war.* Paul ate sugar cubes from my father's hand. At that time I learned that whenever I wanted to give the horses something sweet, I must hold out my open hand. And I saw an angel standing in the sun. It was much too far away for me to be sure. And I saw the beast and the kings of the earth and their armies, assembled to make war against Him who sat upon the horse, and against His army. The sisters' school was the setting for a colorful society of foreign troops; Germans, Moroccans, Tunisians, Belgians, Finns, Belarussians, and northern Frenchmen. And I saw an angel coming down from heaven, having the key of the abyss and a great chain in his hand. The deeper the ditch, the more life could remain hidden under a green surface. And I saw thrones, and they sat upon them, and judgment was given to them. The trim of their bathrobes was rubbed through on their backs from long wearing. And I saw a great white throne and Him who sat upon it. Later I saw that everything hanging in the apple tree was part of a great spider web that began on the roof gutters. And I saw the dead, the great and the small, standing before the throne. The old man entered the crosswalk carefully. He could no longer distinguish between red and green, but still dared to undertake his very last act of resistance. And I saw *a new heaven and a new earth*; the first heaven and the first earth have vanished, and there was no sea anymore.

And I saw *the holy city*, new *Jerusalem*, coming down out of heaven from God, *made ready as a bride adorned for her husband.* In the glass case lay the shaving brush next to the toy cars. Faded blue cards were supposed to show the prices, but had become illegible to every buyer through long exposure to the sun. And I saw no temple in it, for the Lord God, the Almighty, and the Lamb, are its temple. At the entrance stood two soldiers of marble. My eyes were about at the level of their teeth. And behold, I am coming quickly. I was probably standing in front of "Information". And I, John, am the one who heard and saw these things. And when I heard and saw, I fell down to worship at the feet of the angel who showed me these things. From letting myself be dragged behind a freight car,

He-erdestr.

Kleimann- Am Kreuztor

Rudolf-von-Langen-Str.

Co- platz Zeppelin-str.

Straf- vollzug anstal

He- str. 37

str. 38

Kreuz- Schanze 55

Neubrücken- promenade

Neu- br. tor

Was- ser-ringer-str.

Sch. Lotha-

Garten

Aa- kamp.

Münz- str. Finanz- amt

Promenade Breul

Buddenturm

Tibus- Pl. 29 Tibus- str. 18

An der Sch.

Martini

Stittsherren- Hörster- tor

Hörste- platz Staa archiv

Fürstenberg-str.

Dr. Hindenburgplatz Am Stadtgraben

Jüdefel- der str. Kuh- str.

Überwasser- str.

Hollen- becker- str. Budden- str.

Schlaun- str.

Berg-Straße

Apostel- kirchhöfe Voß- G. str.

Theat.

Hörsterstr.

Stein- G. Ritterstr.

Kordua- nenstr.

Sonnen- str.

Hörster- tor

Wes-

Gymn. Sch.

Rosen- platz

Katthagen der

Rosen-str.

Spiekerhof

Budden- turm

Magda- lenens-tr.

Humborg- weg- str.

Weges- ende

Bogen- gen-str.

Neu Rog.

Fischer- markt

Stadt- Bücherei

Petri- kirche

Albersloh- sche Gasse

Roland- G. Gymn.

Weveling- hofergasse

Zoll

Frauen- str. Bäcker- gasse

Timpen

Überwasser- kirchpl.

Horste- berg

Dom- bel gasse

Dom- mkt.

Syndi- katg.

Stubatg.

Asche Brüning- str.

Mauritz- str.

Mau- ritz- tor

Wilmer- gasse Universitäts- str.

Univ.

Bischöfl. Generalvikariat

Siegel- kammer Univ.

Dom

Micha- elis- Domplatz platz

Syndi- katg. markt Ratht.

Alt. Steinweg

Loer- gasse Ringolds- gasse

Mus.

Univ. Krummer Georgs- kom platz

Jesuiten- gang Univ. Peters- gasse

Landes- mus.

Geisberg- weg

Reg.

Klemensstr.

Servatii- kirchplatz

Loerstr.

Univ.

Bisping- hof Johannisstr.

Aegidii- markt

Rothenburg

str.

Stuben- gasse

Aa

Aegidiikirch- platz

Lütke Gasse Ger.

Hötte- weg

Windthorst- Mus.

Synag.

Raphaels- klinik

Servat platz

Mühlen- str.

Aegidii-str. Grüne- Gasse Str.

Breite G.

Krumme Str.

Marieven- winkel- G.

Harse- winkel- G.

Urban- str.

Jungfer- str. Willem. Gymn.

Marien- platz

Beelert- stiege

Verspo

Von-Vincke-Str.

Wall- tor

Haindor- Stiege

Schützen- str.

Kloster- Promenade

Engelen- schanze

Achtermann- str.

Berliner Platz

Mensa Kloster- Kl. str.

Moltkestr.

Kanonengraben

Wehr- str.

Ludgeri- platz

Schorlemer- str.

Her- warth- str.

Engel- str.

Bahn-

Gymn.

Stadt-

Hafe

the skin of my knee was full of tiny stones. I testify to everyone who hears the words of the prophecy of this book: if anyone adds to them, God shall add to him the plagues which are written in this book. 290. Shooting stars 291. In memory of the future – Lophem 292. Fries Rekem – Reckheim 294. Preliminary design for a program 295. Air Alexander 296. What shall we eat today? Design "Le Chanel" 297. 3 x K. I. B. Special edition Alexander Polder 298. See fast – Act fast – Prontophot 299. Opening and Closing of the Office – Brussels – Rennes – Reckheim 300. Real – Wiener Sezession 301. Walter, Joris & Leo 302. There's Hans again! 303. V. Z. W. – K. I. B. 304. Artificial intelligence 305. What shall we eat today? Witte de With 1994 306. Das Standard Museum in progress 307. Songs with Bert. CD 1995 308. Do it – Home version 309. A. Serpentine gallery Take me I'm yours B. 310. Frac Reims Champagne proposal 311. Frac Reims – La reine Margot. Video 312. Liége – Loco – Citato 313. Spaced out – Munich 314. Dedoublements '96 – Rennes 315. Marie-Ange on Building 316. Café Reckheim – also in Brussels 317. Implicit network E. B. P. 318. Tortoza & Hans 319. Münster '97 Don't believe what you see.

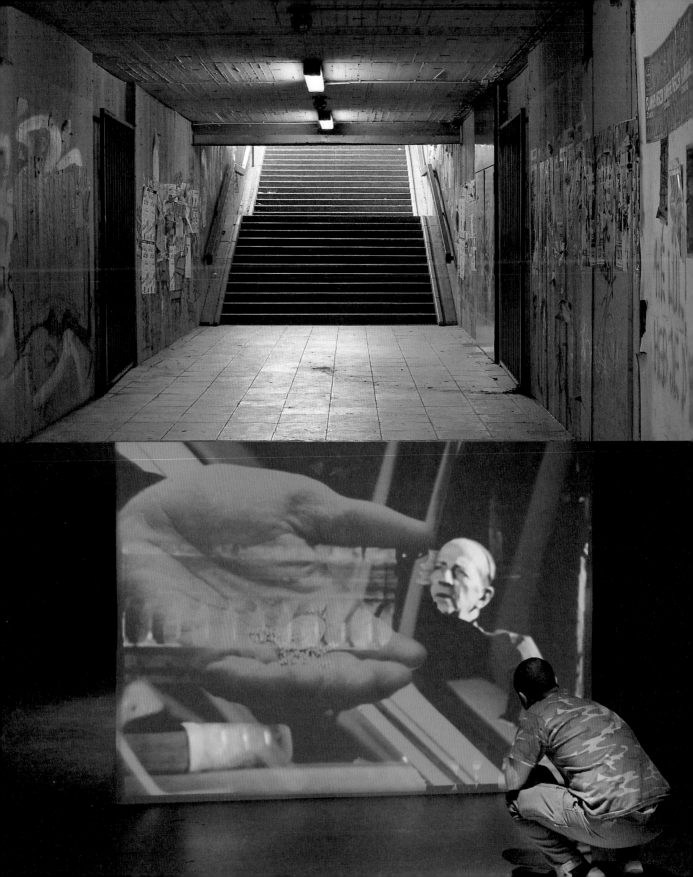

DOUGLAS GORDON

Between Darkness & Light
(after William Blake)
Video installation
Pedestrian underpass, Hindenburgplatz

Born 1966 in Glasgow, lives in Glasgow,
Hannover, and Berlin

The work itself is called *Between Darkness & Light (after William Blake)*, and I think that the Fußgängertunnel is an ideal place for this piece.

Having spent some time in and around the underpass, I began to focuss less on the architecture of the space, per se, and more on the function of "passing through" from one place to another; in a concrete sense, and also on a metaphorical level.

The underpass is neither above the city, nor beneath; it exists as a conduit between one state, and another. This can be read as a kind of "purgatory", especially in a city like Münster, considering the history.

So, taking purgatory as a starting point, I thought that it might be interesting to initiate a dialogue, in abstract, between two representations of opposing philosophical positions. I want to show two films in the underpass; screened simultaneously, on the same surface, and visible from both sides.

The films are *The Exorcist* by William Friedkin (1973), and *The Song of Bernadette*, by Henry King (1943).

For information about the artist and additional bibliography see:
Close your eyes and open your mouth, Museum für Gegenwartskunst, Zurich 1996; *Entre acte # 3*, Stedelijk Van Abbemuseum, Eindhoven 1995; *24 Hour Psycho*, Tramway, Glasgow 1993.

The films will run continuously, until the sequences of image & sound begin to repeat themselves; a duration of circa 2 hours.

Douglas Gordon, 12. April 1997

Oscar van den Boogard talks with Douglas Gordon
Amsterdam, January 16, 1997

A couple of months ago at the Tate Gallery, I saw a video installation by the 30-year-old artist Douglas Gordon, entitled *The Confessions of a Justified Sinner*. For this work, Gordon used scenes from the 1930s film version of *Dr. Jekyll and Mr. Hyde*, based on the novel by Robert Louis Stevenson. Frederick March played the doctor who wants to save the human soul from its evil, bestial impulses. His scientific experimentation, however, unfortunately has the opposite effect, with irrevocable, fatal consequences. Gordon used three clips from the film in which the saintly Jekyll changes into the diabolical Hyde. Enlarged and projected in slow motion on two screens – one positive, the other negative – the film clips show the struggle between good and evil. The films are spliced into a loop, so that good and evil appear in continuous succession. Another work in the Tate Gallery is called *A Divided Self*. On two television monitors, two arms are shown simultaneously – one hairy, the other clean-shaven – wrestling together on a bed sheet. They are the artist's own arms, and the reference is all too clear to the struggle between good and evil.

In the meantime, Douglas Gordon has joined me here at the table. Although he had a late night last night, his gaze is clear. His T-shirt says "teenage fanclub", the name of a band from Glasgow. The last time he stayed with me in Brussels, his head was still shaved. Now his hair has grown out again, a favor to his mother. He holds a pair of horns in his hands and plays with them ceaselessly. On his left arm are the words TRUST ME. Forewarned is forearmed. Everything in Douglas Gordon's world is true and untrue at the same time, positive and negative, image and mirror image.

Douglas Gordon: I come from a conservative Scottish family, Protestant Calvinist. My mother converted to the Jehovah's Witnesses. I was raised with a very strong, almost corporeal belief in the devil. My mother told a lot of stories about him. It was like the devil was everywhere. I learned that you had to protect yourself mentally, physically, and spiritually against the devil. If you didn't, he would push his way in. I was forced to think about concepts like fate, trust, and guilt. Recently someone asked me if I believe in God. For me that is a problematic question, for I could never say no. It would be very disappointing if the devil existed but God didn't. I was raised to believe that it is your own responsibility to be good. You have to decide for yourself. God and the devil are always playing their game on the backs of human beings.

Oscar van den Boogard: When people talk about the devil, I think of Heavy Metal music, hot dog stands and farmer boys, mopeds with waving foxtails.

I think it is hard to find the devil in the city. It's a complex idea for which you need real space and time. Maybe a rural setting is just the thing. There are people who can do it in the city too. In New York, the Voodoo cult is supposedly very widespread. But of course everyone has to be stoned first. Actually, I don't really know whether I believe in an entity or whether the devil and God exist, but I think it's an interesting idea, an idea almost like a work of art. One could use the idea of the devil to think about certain things.

To what extent are you like Mr. Hyde?

Maybe I do bad things, normally not so much physically, that would be too obvious. I know that some people think I am really offensive, and they are probably people quite close to me... I can't tell you what the worst thing I have ever done is; what's bad ... is to break trust with someone. That's the worst thing you can do if you do it intentionally...

Stills from *The Exorcist* by William Friedkin, 1973, and
The Song of Bernadette by Henry King, 1943

I have to trust someone: tomorrow I'm sup-
posed to have my left shoulder blade tattooed
for Reflection at Hanky Panky in Amsterdam –
the word GUILTY in mirror image.

Listen, Oscar, when they do your tattoo, you
have to think about the worst thing you've ever
done. It's like a catharsis. But don't worry, it'll
be a great work. We've been talking about it for
more than a year now. I think you want it. It fits
you. I like the idea that when you don't do any-
thing wrong during the day, and then look in the
mirror before going to bed, you see your guilty
alter ego. That can be satisfying, right? But it's
just as nice when you know you have done
something wrong and can recognize your
reflection in the mirror. A tattoo like that has
something Lacanian about it. To look in the mir-
ror for the first time, see your own reflection,
and that reflection shows your guilt ... I wish I
were getting the tattoo myself.

No, Douglas, this tattoo is a work of art. That's
what we agreed on. I wear the tattoo, and you
make a photo edition of it. And as far as Lacan
is concerned, once I put my cat in front of the
mirror, but nothing happened. Well, actually, a
couple days later he ran away and never came
back.

If you had put him a room full of mirrors, he
probably would have noticed. He would have
gone completely crazy. Do you know the work
of Lucas Samaras, the artist who builds entire
rooms of mirrors? It was the first work of art I
can remember. I saw it when I was still a teen-
ager. You could go into it and see yourself in
endless mirror reflections. It made a great
impression on me. Later in New York I saw a
box with knives, needles, and talismans. Appar-
ently it was also by Samaras. They told me he
was the most sinful person they had ever met.

Then is Douglas Gordon a Dr. Jekyll who wants
to save the soul of the evil, bestial writer?

A lost cause with you. No, I view myself differ-
ently – you know the stories from the Middle
Ages about people who came to the village and
sold drugs, some substance or other, as the
elixir of life. There are people for whom art is
something like that. I believe in a new kind of
medievalism. It's an obsession for me. A little
shamanistic – but I would never claim to be a
shaman.

But the quacks weren't respectable. Weren't
they swindlers, charlatans?

I don't view them so negatively. They were an
essential part of the community. Unlike them, I

don't claim to possess an elixir of life. Still, maybe there are things there one can use. It probably has something to do with my background. I didn't grow up in a house full of artworks. I come from a household with functional objects like a kettle or a toaster. We owned no antiques. I never thought about the value or status of an object as object. At home we talked about television or the movies. For me, art is something that makes conversation possible. I don't want people to visit my exhibition and be so shocked that they turn off. I want them to be intrigued by the ambiguity of my work and then begin to think or talk about it in the pub with other people. That is actually the only thing I'm concerned about. My work is only a trigger for conversation. It can also be a conversation in your head. That's why I also like pictures by Barnett Newman or Bruce Nauman, or a Fellini film. I like to read Beckett and Joyce, but what I like even more is to talk about them. I think they wrote so that people would discuss them. They provide the scent of an idea. One can catch wind of it and keep thinking about it. I hope that my work will start people thinking. It makes my life interesting, and hopefully other people's too. The tattoo will make you more aware. Every time you turn around in front of the mirror and read the word GUILTY, you'll think about it.

Do you think that good will triumph over evil in the end?

No, I don't think so, but of course good still exists.

But then is development anything but the constant alternation of good and evil?

Yes, maybe that's what development means. Rocking back and forth between this and that. Then you finally get old and die.

In heaven or in hell?

I grew up in a community where people believed that one day Armageddon would come, that all the bad people would be killed and all the good would live forever. As a child in bed, I used to imagine living forever. The idea tyrannized me, for it means that there is no challenge any more. It became difficult to me to reconcile the idea of eternal life with the idea of salvation. It made me crazy. Other people saw something good in it. It was like the Greek myths we read in school about people who were condemned to live forever like a vampire – though I think a vampire's life must be pretty exciting, the worst thing is that he can never die. Sucking blood is nice, but living forever is bad!

Is there salvation in your work?

No, I hope not. I have never looked for salvation.

The title of your work on Dr. Jekyll and Mr. Hyde is a play on The Private Memoirs and Confessions of a Justified Sinner *by the Scottish writer James Hogg. A book from 1824!*

That is a fantastic story. Unbelievable! It's about a young Scottish man who encounters the devil. The devil challenges him to kill his brother. Finally the young man goes crazy, and you don't know whether the devil exists in his imagination or in reality. Shortly before he kills himself, he writes his memoirs. His manuscript is buried with him somewhere far outside the village. A publisher who hears of the story exhumes the body and steals the manuscript. Everyone is guilty, everyone does something wrong! In the autumn I'm going to write a scenario about it in Berlin. I want to move the action from the 19th century into the American Midwest of the 21st century.

Films are an inexhaustible source of inspiration for you. In every conversation you refer to

them, you use them in your installations, you cut them up, change their context. Your key work is 24 Hour Psycho, *where you reduce the speed of the Hitchcock film to two frames a second.*

There I was concerned above all with the role of memory. While the viewer remembers the original film, he is drawn into the past, but on the other hand also into the future, for he becomes aware that the story, which he already knows, never appears fast enough. In between, there exists a slowly changing present, which dissolves into itself but stands outside of time. My project based on *The Searchers* (1956) by John Ford is even more radical. The original film lasts 113 minutes and takes place over a period of five years. I want to extend the presentation of the film over the real time span of the action. The image will change only every 15 minutes, so that on a single day of exhibition day only about a single second of the film is shown. Here of course the need for memory is extreme.

Another work about memory is The List of Names.

In 1990 I was invited to participate in the exhibition project *Self Conscious State* in Glasgow. I had lived in London a few years and had just returned to my home town. I thought about how I could condense everything that Glasgow means to me into one work. Then I turned the idea around: I could also begin with something small and make something endless out of it. That's how the first *List of Names* was created.

I began with my uncle's name, and after that I wrote down the names of other people I know. It became an obsession. Within a day, I had a thousand names. It was a strange stream of consciousness. I ended up with 1440 for the exhibition. Strange, only now does it strike me, it really was purely a formal concept, but I must be a religious fanatic: in the Book of Revelation it says that 144,000 elect will go to heaven. I

had already collected a hundredth part of this number.

(Douglas, I think you're taking the place of God! May I express my hearty thanks that my name, too, was included in the list of names in the Van Abbe Museum?)

When I meet people, I don't immediately write their name down. I wait until the next exhibition where I want to show the names. In Eindhoven, there are 2756 names on the list. My concern is that everything be strictly formal. In straight columns, almost like on a war memorial. In the interest of honesty, it should only represent what I can remember. I don't known when I'm going to make a list like that again. Hopefully no time soon. It is quite tedious and obsessive. In Glasgow it was a disaster: I had forgotten a couple of my best friends. They were puzzled and annoyed.

In the Bloom Gallery in Amsterdam you'll be showing a self-portrait, Self-Portrait (Kissing with Scopolamine). *It's a negative slide of you kissing yourself in a mirror with closed eyes. Your lips are covered with a truth serum.*

It seemed an exciting thing to me to sum up all these ideas about reflection and mirroring in a single work. Then it would be almost impossible to still find a logic in the picture. The viewer sees a negative of the truth, and a negative of the self, and a negative of the reflection of the self ... I love that kind of endlessness. It's the same mirror space we spoke of earlier. It's an endless image, an endless game.

I thought you didn't believe in immortality.

I know, it's a contradiction. But I stand outside my work, outside of everything. I provide the board, the pieces, and the dice, but you are the ones who have to play.

And why the preoccupation with the truth?

I think that in the end, everyone wants the truth. Everyone needs it. Food, for example, is a basic human need. I don't want to wax political about the food scandals in Great Britain. But

you do have to be able to trust what you eat and drink. It could be poison. You always have to be concerned with the truth, your whole life long. You even have to be able to trust the idea of death.

In the Tate Gallery I saw a photo of you wearing a blond wig. It was also the press photo that went around the world when you won the Turner Prize.

That photo was taken by chance. I hadn't thought much about it. A lot of people thought I wanted to disguise myself as Kurt Cobain, others thought of Marilyn Monroe or Andy Warhol. For me, it was more Myra Hindly, the child murderer from Yorkshire. I could make a work out of that entitled *Self-portrait as Kurt Cobain, as Andy Warhol, as Marilyn Monroe, as Myra Hindly.* Maybe that's how I'd most like to see myself.

On the evening of the opening of Douglas Gordon's exhibition, the power goes out in the whole district of Jordaan. In the Bloom Gallery, people stand around in the dark and talk. Douglas's installations are silent and dead. I find the artist in a pub around the corner. I kneel in front of him and pull up my T-shirt. By the light of a candle, Douglas looks at the tattoo. He grimaces devilishly. He is pleased with it, very pleased. The lights can go on now.

Douglas Gordon: *Between Darkness & Light (after William Blake),* views of installation

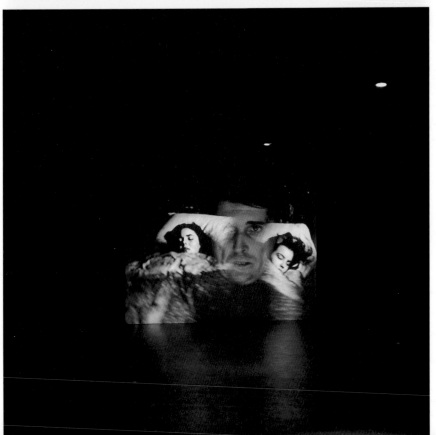

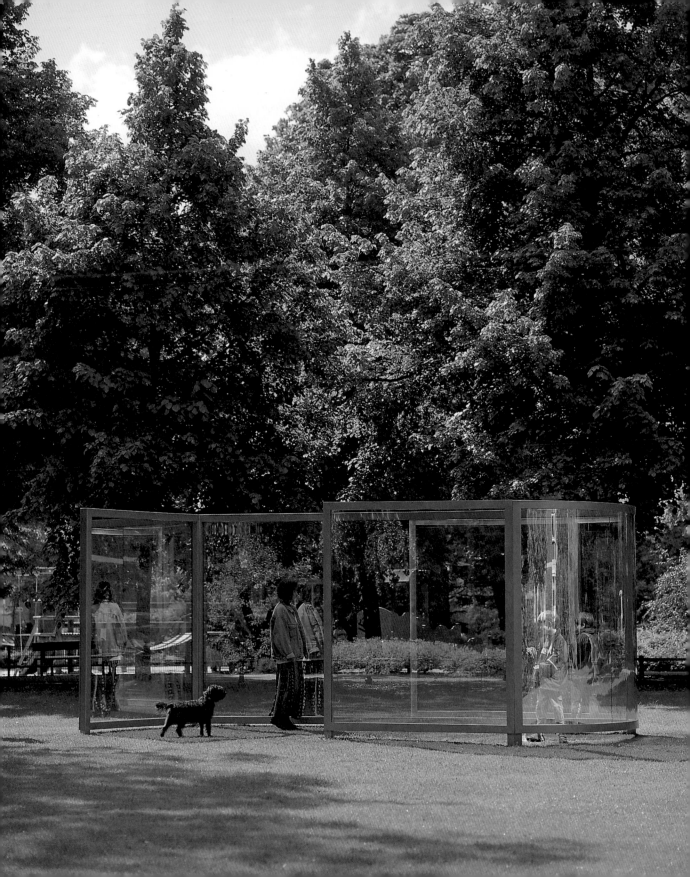

DAN GRAHAM

Fun House für Münster
Pavilion (two-way mirror glass, steel construction, 2.3x5x2m)
Promenade area west of Neubrückentor,
across from playground

Born 1942 in Urbana, Illinois,
lives in New York

Dan Graham: *Fun House für Münster*

The 1987 *Oktogon für Münster* and the 1997 *Fun House für Münster* are both amusement park-like follies – *Oktogon* is a hybrid of neoclassical "rustic hut" and "lust" pavilion. It creates a kaleidoscopic prism effect from the inside. *Fun-House* alludes to baroque painting and church ceilings as well as the amusement park "fun-house" mirror in its anamorphic effects.

Both pavilions utilize two-way mirror glass. Both sides of each pavilion are simultaneously reflective and transparent. The properties of this material exposed to changing overhead sunlight cause one side to be either more reflective or transparent at any given moment. Spectators inside or outside see superimposed views of their bodies and gazes as well as surrounding landscape.

Both pavilions are "photo-opportunities" for parents and children and places to rest in a picnic site park setting.

Both works are sited in relation to the larger park and urban plan. The *Oktogon* relates to now destroyed earlier octagonal pavilions placed in the *Allees* radiating from a large palace. The *Fun House* relates to a nearby play-

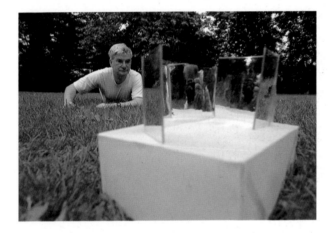

For information about the artist and additional bibliography see: Dan Graham, Models to Projects 1978–1995, Marian Goodman Gallery, New York 1996; Rainer Metzger, Kunst in der Postmoderne – Dan Graham, Kunstwissenschaftliche Bibliothek, vol. 1, Cologne 1996; Two-way Mirror Pavilions/Zweiwegespiegel-Pavillons 1989–96, Städtische Galerie Nordhorn, ed. Martin Köttering/Roland Nachtigäller, Nordhorn 1996; Dan Graham, Ausgewählte Schriften, ed. Ulrich Wilmes, Cologne 1994.

ground; its curved surface relates to the circular Roman plan of the city. The use of two-way mirror glass relates to the recent urban office, government and bank buildings which utilize the same material. The *Fun House* is a thin parallelogram with three straight, two-way mirror

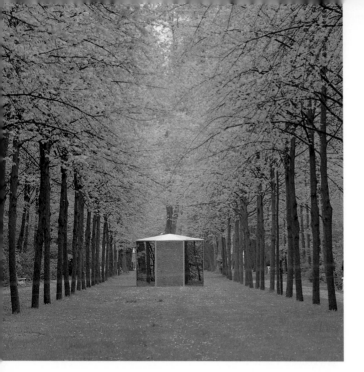

Dan Graham: *Oktogon für Münster*, contribution to *Skulptur Projekte in Münster 1987*, permanent installation in June 1997, location: south palace garden, two-way mirror glass, metal, wood, height 2.40 m, diameter 3.65 m, photo 1987

of the spectator on the curved surface distends and topologically alters as the spectator changes their position.

In addition to the allusion to bank façades the form and its optics allude to the spectator's experience of encountering his or her body and gaze in the passageways of a shopping mall, where one's gaze is often simultaneously superimposed onto other people looking at the commodity within the showcase window. Here the "cinematic", urban, psychological effects are superimposed onto an Arcadia parkscape.

Oktogon für Münster, 1987, built for the exhibition *Skulptur Projekte in Münster 1987*, consists of eight two-way-mirror side panels topped by a wooden roof sloping at an angle of about 15 degrees. One of the panels is a sliding door which allows spectators to enter the interior. A wooden pole in the center of the interior space connects roof to floor. The work was sited in the middle of a tree-lined *Allee* in the park surrounding an eighteenth-century palace of the ruling Prince. With the exception of this *Allee*, the original baroque design for this park had been converted to a picturesque English garden, which was later subdivided into a university botanical garden and public park in a nineteenth-century style. When the park was still classical, various octagonal pavilions surrounded the palace at regular intervals. At present only one, now a music kiosk, has survived. My *Oktogon für Münster* faced the rear of the palace towards the left, equivalent to the position relative to the palace at the rear on the right side at the music pavilion.

While the pavilion's octagonal form, its siting in the *Allee* and the use of mirrored surfaces related it to the classical baroque period, the use of wood, the "primitive" wood pole and the compact scale alternatively related the pavilion to the simple "rustic hut" associated with Romantics, the antiurban ideology of the post-Enlightenment garden. The music pavilion,

sides, an opening on one side and a fourth side which is a concave two-way mirror on the interior and a convex mirror on the outside, creating anamorphic distortions. The regular geometry of the non-curved sides re-reflects the anamorphosis of the fourth side, so all sides have anamorphic qualities. There is a contrast between the effect of the curved and the flat surfaces. The curved side relates to the curvature of the spectators' bodies and their visual fields and also to the surrounding skyline. Unlike the spectator's relative fixation of gaze and the Renaissance perspective two-dimensionality of the flat mirror surface, the anamorphic image

which is open on five of its sides, is something like a gazebo. My pavilion has a similar relation to a nineteenth-century gazebo, but contradicts this traditional form. Instead of the sides of my *Octagon* being open so that those inside might have the prospect of the natural setting and be better seen by those outside the pavilion, the use of the two-way mirror turns both inside and outside views into self-reflections.

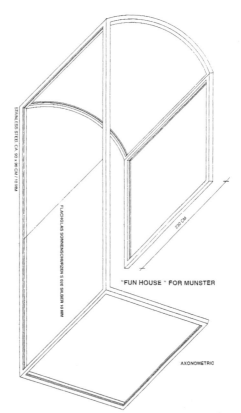

Dan Graham: Axonometric projection of *Fun House für Münster*, 1996, construction drawing, 21.6x28 cm (above), and view of installation

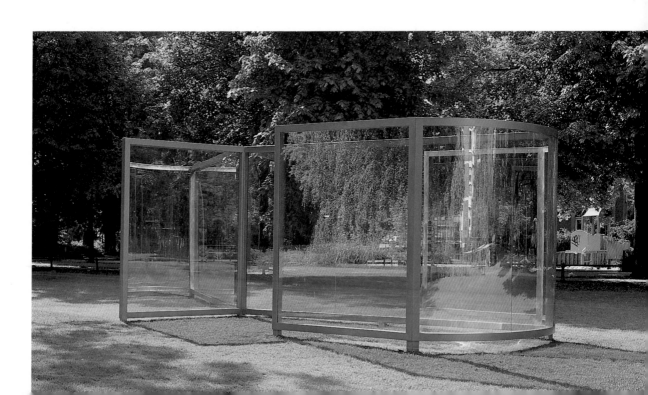

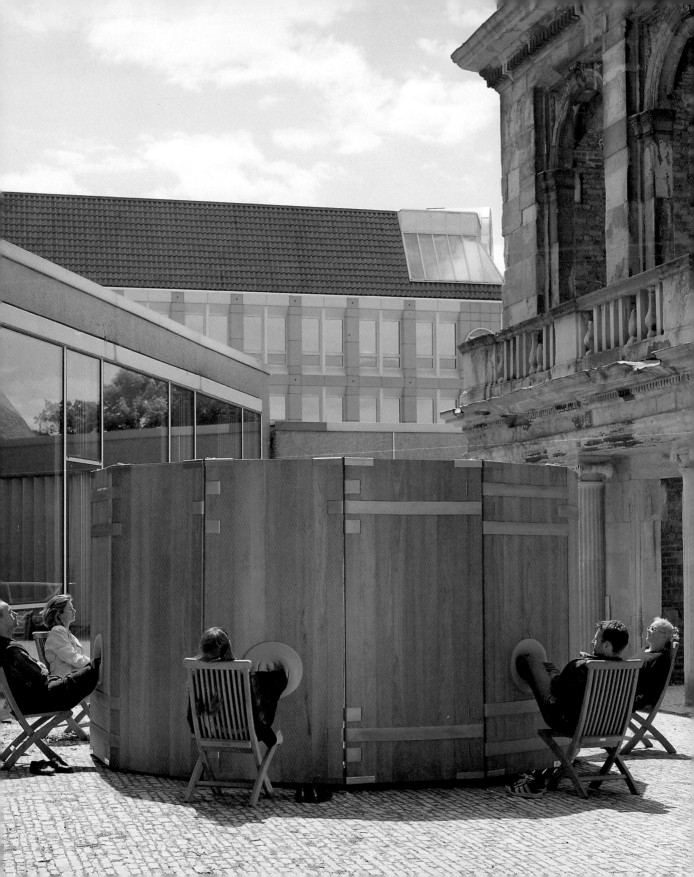

MARIE-ANGE GUILLEMINOT

Le Paravent
Installation (stainless steel, teak, fabrics,
3.7x2.1m)
Interior courtyard of Stadttheater,
Neubrückenstraße

Born 1960 in Saint-Germain-en-Laye,
lives in Paris

Ariella Azoulay: Marie-Ange Guilleminot –
A Lexicon

Ecology

This term offers a temporary summary of all the
others. The word "ecology" was coined in
1866, and its primary literal meaning is the
logic (logos) of the home (oikos). It deals with
the study of humans (and other living beings) in
relation to their surroundings. Because of an
erroneous understanding of the term and/or
the political movements named after it, it has
become customary to identify ecology with the
conservation of Nature. There is absolutely no
link between Marie-Ange Guilleminot and the
conservation of Nature, yet all the same her
project is very much an ecological project,
since it investigates the individual's private
space, economy, dimensions and needs. The
research tools are quite limited, amounting to a
number of objects of indefinable form: nylon
stockings filled with grit and talc (*my dolls*),
nylon hose knotted in various ways (*back-
pack*), a rolled-up piece of cloth tied in a ribbon
(*life-hat*), and 100 grams of plaster and vaseline
(*bellybuttons*). Anyone is invited to provide
these objects with a singular form by virtue of
the use made of them. This is not only an inves-

For information about the artist and additional bibliography
see: De-Genderism, Setagaya Art Museum, Tokyo 1997; Migra-
teurs, ARC, Musée d'Art Moderne de la Ville de Paris, Paris
1996; Marie-Ange Guilleminot, Israel Museum, Jerusalem 1995;
Marie-Ange Guilleminot, Galerie Chantal Crousel, Paris 1995.

tigation of existing manners of life, but one sug-
gesting practical new manners as well. First of
all, a "concern for the self", i.e. the develop-
ment of an ethical/esthetic attitude towards
the self based on an economical system of bal-
ances: fewer objects, less unnecessary move-
ment, less paraphernalia, less consumption,
less waste. The construction of the self is per-

formed by means of a limited and precise number of objects that can serve several functions with only minimum changes to their form. These objects may also be made compatible with several different life situations, and again, with only minor adjustments.

Back-Pack

It begins with a pair of nylon stockings worth ten dollars. It's best to buy those of the non-transparent variety. The color doesn't matter. First-timers should also purchase a video with instructions how to prepare the stockings for at least twelve additional uses. At this stage, the video is available only at supermarkets in France. Within a short time it will be a world-wide hit, available even in the Tokyo suburbs. The stockings do not have to be unrolled in public. One can begin directly with the intermediate stage, using them as a back-pack. The straps of the back-pack can be stretched elegantly, turning it into a brassière. If it begins to rain, the back-pack easily becomes a protective hat. If you are invited on short notice to a celebration requiring a gift, you may give it as a present. The initial distribution of the back-pack will take place in the economic sphere. After buying your first video along with the stockings, you are invited to pass on to the next sphere – that of piety. You can make your next back-pack on your own, with no regard to manufacturers' rights. All on condition that you change your attitude towards the environment, and learn to endow one object with at least eight needs and operations and ten different uses.

Bellybutton

The police can identify you by means of a fingerprint; the Ministry of the Interior, by means of a snapshot. Technology is currently set to replace these identification processes with the structure of the pupil of the eye. Here we are dealing with another means of identification: the abilty to create out of the hollow (the negative) in the center of a person's stomach, a (positive) image which has never been seen by its owner. But casting the image is also an opportunity for hands that provide treatment to meet a body eager for treatment. Contact requiring no excuse; treatment, but of no disease. Marie-Ange Guilleminot has cast the belly-buttons of 75 different people: "For me, even though I made them, their point of view is from inside. There are people who have very deep bellybuttons, and the material receiving the impression of that depth has hardened and turned into the shape of a knife or syringe."

Feelings

A familiarity with the term life-hat is necessary before one reads this entry. *Contained Feelings* is a video exhibited in a public space. However, as mentioned in the entry for the term "Hands", Marie-Ange Guilleminot cannot be said to be exhibiting anything, because the space in which the video is being shown is not a public space. How can this be possible? How can Marie-Ange Guilleminot exhibit a work of video art in a football stadium, yet the exhibit remain not public? The video screen is covered by a black life-hat. In order to see it, you must insert your head inside the life-hat, sweat inside the cloth channel connecting your interiority with the images of Marie-Ange Guilleminot flashing on the screen. If you remove your head from the life-hat, you will find yourself in the public space of the museum and the video will disappear. It will reappear only when you re-assume your one-on-one position, the position of the individual in the confessor's box, of the pre-confession or post-confession. When you are once again inside the black, woollen tube, you find yourself opposite a formless face which only you, with the mirror-image that you provide, can endow with form, and fix permanently as a portrait of

suffering, pleasure, pain or excitement: "This video is something completely personal. I am searching for a form of anonymity in order to say something. I am exposing myself as well as looking for a way to defend myself."

Foot

If you happen to pass near the screen, all you need do is sit down on the chairs behind the screen and stick your legs inside (through the life-hat waiting there for that purpose) till they disappear from your view. Reflexologists and various experts specializing in the treatment of your feet are waiting behind the screen. "There are reflex areas in the foot. These areas are like an aircraft's instrument panel, they provide testimony in regard to what's happening inside your body. One can act on the body by acting on the foot. What interests me about the screen is the ability to touch someone in a way that's never been tried. Someone strolls through the garden and encounters an object, which at a certain moment receives a function. Whoever sits there won't have any eye-contact with what is going on inside. There will be no operating instructions. When we touch someone, we generally see what we're touching. It is quite rare for us to have contact with someone we don't know and can't see."

Guilleminot, Marie-Ange

French artist. To date, she has cast the belly-buttons of 75 people, using small quantities of plaster of Paris, distributed ten odd life-hats to various people, performed dozens of demonstrations of formless objects crying out to be handled by people, in order to ascertain the exact use to which might they might be put, and participated in several museum exhibitions in France, Japan and Israel. The sentences appearing between quotation marks in this lexicon are hers.

Hands

Through two holes drilled in the wall, Marie-Ange Guilleminot stuck out her hands in such a way that the rest of her body remained hidden behind the wall. It may be said that she exhibited her hands, but use of the verb "to exhibit" is misleading. The act of exhibiting is generally associated with a public space such as a museum. Marie-Ange Guilleminot did indeed place her hands on display – and anyone who wanted to could see them – but she prepared a private space for this purpose. Private doesn't mean intimate, it only means each individual in his or her separate state and free from being observed. In principle anyone can take part, but each in turn. One after another, various individuals who waited outside entered the cell. Inside the cell they encountered a pair of (delightful) hands. The hands were there, appealing directly to whoever came inside. They seemingly designated each entrant, saying "You!" to them. And "you" responded. The Catholic church appeals to each individual separately in much the same way, but it guarantees salvation. Here there is no mention of salvation or of the release of the spirit from the body; at most it is an airing of the spirit by the body.

Identity card

Like a deck of cards, twelve wooden boards lie on top of each other in a pile ready for delivery. From Paris (France) to Tokyo (Japan) and now to Münster (Germany). This isn't the last stop, by any means. The twelve boards are interconnected in such a way that they can fold in upon each other like a fan and be concealed, each in the appearance of another. There are two kinds. The smooth ones, devoid of any identifying marks, and those in which a hole has been punched. When the pack is opened they appear to be with, without, with, without, and so forth. Those without a hole will remain impermeable. Those with a hole will function like a "screen of

occurrence"; however, this won't be broadcast from one side of the screen to the other, but will take place at the exact meeting point between the feet coming from one side and the hands coming from the other side, in the meeting between limbs whose identity is bounded and restricted to their identity as such. The identity of these limbs is granted no supplement from the data carried on the ID cards of their owners, from medical files, from their actions in kindergarten or in school.

These are "liberated limbs" free of their bodies and able to meet. Where does the meeting take place? In the area defined by the boards, which delimit a closed internal space. From above, the shape of this space is reminiscent of a panopticon (quod vide, below). The panoptic structure, in keeping with its name, expresses a pretension to a penetrating view capable of identifying what it sees, an omnipresent, omniprescient and omnipotent view which places the inhabitants of the panopticon in the position of subject (usually one in need of repair). Marie-Ange Guilleminot's screen, conversely, turns the panoptic point – the center of the screen – into a blind spot, into an obstructed field of vision. Whoever is situated at this point sees nothing except that which approaches very close by and asks to be touched. The truncation of the panoptic point of view also has a bearing on those in the hold of its truncated view. Whereas those subject to a panopticon's gaze usually learn to internalize the externally supervisory panoptic eye, to accept their identity as binding, and become normalized in order to avoid friction between themselves and the

Marie-Ange Guilleminot: *Geste*, 1994, New Central Bus Station, Tel Aviv

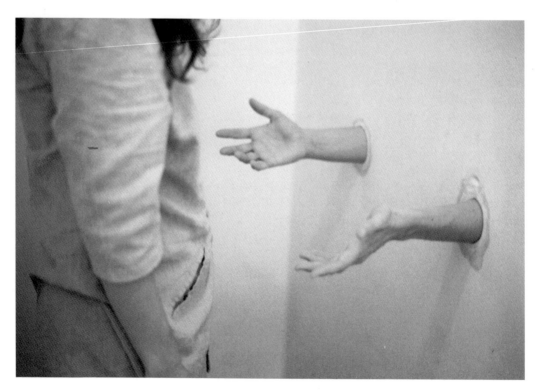

supervisory position, here, in the "voided panopticon" built by Marie-Ange Guilleminot and in the absence of an external panoptic eye, no position as subject awaits the inhabitants. They are not asked to demonstrate or express their identity. Feet dangled inside will not be interrogated about where they come from, where they intend to go, what has caused this hardening of the sole, or why the dead skin hasn't been removed from the heel three times a week. None of those sitting behind the screen has the knowledge, authority or ability to deduce from the foot to the entire leg and from the leg to the body and personality, or to draw any conclusions or interpretations from it.

Labyrinth

This lexicon is going to reveal a secret to you. In the heart of the screen, right in the center on the floor, there is a drawing of a maze. The lexicon is telling you this because you won't be able to see it from your position. Only whoever is situated behind the screen and awaiting the soles of your feet can see it. It's a small maze, and whoever is sitting behind the screen and looking at it from above can easily find the way without navigating the pathways. Actually, every maze has a secret, a key which is usually kept by somebody on the outside, not those who tread the pathway. The lexicon is revealing this secret to you not in order to provide you with the solution but just to inform you of the secret's existence and take this opportunity to say something about the structure of secrets and their relation to Marie-Ange Guilleminot's screen. The secret of mazes is usually the secret of the planner, the one in the know, the one with the bird's-eye view. It is theirs because they are situated outside the visual field under discussion, and therefore they can observe it better than those situated inside it. Their secret – despite being the key to achieving the goal – is not always, and not necessar-

ily, worth more than the secrets which may be in the hands of whoever stumbles along the maze's pathways and points out the meanings and directions along the way. Their secret, the secret of the maze or the secret of the solution, resembles a sealed package that can be – if so desired – delivered to others without anything happening to it or to its contents in the process. The wandering of the secret from ear to ear leaves it unchanged. The secret is grasped as the thing itself and precedes the exchange relations of which it is the object, remaining separate from them. Marie-Ange Guilleminot's screen seems to be a space delimiting six positions of privacy, of confession. However, these are not linguistic spaces, resonant spaces, spaces of subjectivity. These are spaces in which the secret appears as a structure of intimate exchange rather than the movement of a sealed unit. Whoever is sitting behind the screen, in the heart of the maze, knows no more than you about the moment in which a foot will meet a hand in the center of the museum courtyard or at the heart of an exhibition. They know nothing about the intimacy that will be created there between limb and limb, about the closeness, the touch, because they too have never before been stripped of their bodies, their authority, and their overriding, examinatorial view. From either side of the hole extend limbs devoid of body, position and subjectivity. Among them no purpose is discovered, no purpose for which they are intended. There is an initial groping, an experience made possible only if the owners of foot and hand renounce the position of an overriding view, a view that functions as a point of subjectivity by means of which it recognizes the other and receives the same recognition in return. A renunciation of the omnipotent view, that which establishes the other and establishes itself as subject. Only a foot and a hand, neither outside nor inside.

Life-Hat

The life-hat is Marie-Ange Guilleminot's proposed solution for the need of a friend (Hans-Ulrich Obrist, himself a curator), who used to bang his head against a wall wherever he went. Marie-Ange Guilleminot sewed him a hat to protect him from recalcitrant walls. The hat developed a life of its own (for which reason it has been called a life-hat). It is made of a roll of elastic cloth. Rolled up in the form of a hat, it resembles the Orthodox Jew's Streimel more than anything else. Stretched out, it may serve as a sweater, also as a dress; stretched to the limit, it functions as a sleeping bag. To date, at least fourteen different uses have been found for this very simple form. From time to time, Marie-Ange Guilleminot demonstrates some of the uses, but they constitute only a small part of the repertoire. The others are defined, formulated, effected and accumulated by the various users. A mother recently reported having used a life-hat after giving birth. Even the newborn babe has defined a new use for it: chewing the upper fold of the hat when teething.

Panopticon

The architectural scheme of the mobile screen designed by Marie-Ange Guilleminot is reminiscent of the panopticon designed by Jeremy Bentham at the end of the eighteenth century. It is an architectural similarity riddled with differences, which will become clear upon reading both entries in the lexicon (Panopticon & Screen). These differences stem from the management of the space and the uses made of it, and they illustrate to what extent the physical organization of space is only one – sometimes marginal – dimension of the organization of the social relations within its framework. In *Discipline and Punish* Foucault analysed the architectural figure of the panopticon and depicted it as paradigmatic of disciplinary society, and of the forms it has introduced for managing space and the population of individuals within it. The panopticon is a structure of light and transparency suitable for various purposes: prison, school, factory etc. An external ring of illuminated cells envelops the watchtower overlooking the entire space. The view from the tower can focus on any of the cellular units lying in the monitored space. On the other hand, the view from inside each cell is strictly circumscribed. For someone imprisoned inside them, there is no looking right or left, only straight ahead, where one will always see the watchtower. One will never be able to know whether the tower is inhabited, because it is always illuminated, it is the source of light. For someone inside one of the cells, power is there even in its absence. One will always feel watched by it, one cannot be rid of the presence of power. One's view, which looks out at the place of power and recognizes it all the time, is a part of what makes power what it is.

Plasticine

"I am doing the same thing all the time, and it is the form that changes in relation to what it is being used for, the user or the context. It is my impression that between the dolls, the backpack, the hat, and even the bellybuttons (when I do them the plaster of Paris is still soft), there is a sequence of things that penetrate life more and more. It began with forms such as the dolls, which at first had no function other than being offered to be touched, like a crying out to be touched. With each touch the doll loses its form and assumes new forms. The back-pack is a continuation of the dolls, although it is filled with a keyholder, diary, or anything else that creates the intimate interior of anyone. What I realize in the material is plastiline. It begins as one form, and each time there is something that develops and the new thing replaces the former."

Screen

The mobile screen is made of twelve partitions. When set up in the museum garden or in any other exhibition context, it assumes a closed form. At its center, removed from the screen-users' visual field, are the possessors of knowledge and authority, reflexologists who have the ability to decipher the code engraved upon the user's feet and to release desirable energies inside his or her body. But the spatial organization of the screen transforms them also into screen-users by deconstructing their knowledge position (see also the entry on labyrinth). The user, who lacks professional knowledge, serves as the object for the treatment and gaze of the expert sitting opposite. In another moment the expert will coax from bodily indications the meanings, by which he will know what

treatment to use. (And if the user of the screen is sensitive to tickling, some discomfort may be caused.)

In contrast to the view of those in the panopticon, here the user may look right and left, but can't look straight ahead. The view straight ahead is blocked, i.e. there is no-one there to affirm the user's identity, and consequently there is no need to fabricate an identity for oneself. The user's body is divided into two: one part is outside the screen, while the other – the part ending in feet – is inside. Neither the user nor the user inside the screen – who ostensibly has a panoptic viewpoint – can see him- or herself as a whole, as a unity, as an entity, as an identity. The spatialization of the body resulting from the particular use of the screen-panopticon and its management of the

Marie-Ange Guilleminot: Demonstration of *Chapeau-Vie* on March 8, 1995 in the Maremont Gallery of Pre-Columbian Art, Israel Museum, Jerusalem

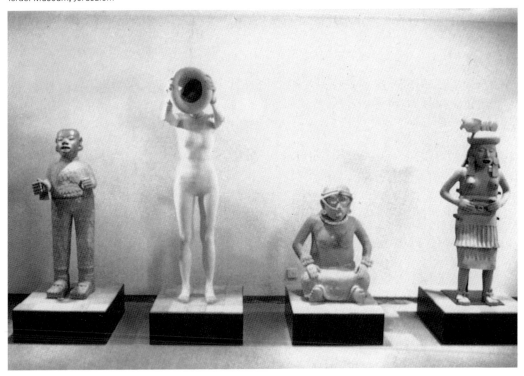

point of view do not enable the establishment of the disciplinary fantasy of the individual possessing inner truth. The reflexologist has only a partial view of you the user – if there is any point to saying "of you" anymore – and has no way of extrapolating from the indications on your foot to the secrets of your soul. At least not in such a way as to demand you to subordinate every movement and gesture to one determinate identity. You may address yourself to contact without making it dependent on having a view of the one making contact, and without making contact dependent upon speech.

Just one more thing in regard to the difference between the mobile screen and the panopticon. You can come and go without rendering any account to those sitting in the watchtower or in the bunker in which the feet are supervised. You can also come back whenever you want. There is no process that you have to conclude in order to pass on to another stage. Here you are invited to a different cycle of time, an eternal repetition, everything returning again and again.

Viewer

There is no such thing. Marie-Ange Guilleminot isn't exhibiting anything. You can go home and return your art lovers' club membership card. There is no display space, no show, the tellers' booths have been shut. If you want to stay anyway, you've got to take off your shoes, put on stockings, put on a hat. There is no place for you here if you've come to watch others. There is no longer a place only for the purpose of viewing.

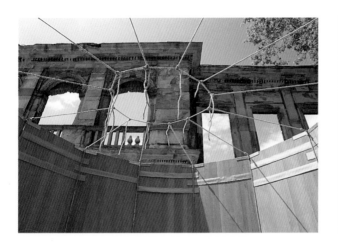

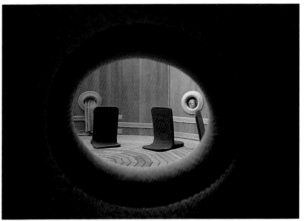

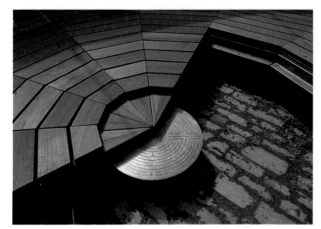

Marie-Ange Guilleminot: *Le Paravent*, views of installation

HANS HAACKE

Standort Merry-go round
Installation
Park area on Promenade south of *Ehrenmal am Mauritztor* (war memorial at Mauritztor)

Born 1936 in Cologne, lives in New York

For information about the artist and additional bibliography see: Pierre Bourdieu / Hans Haacke: Freier Austausch. Für die Unabhängigkeit der Phantasie und des Denkens, Frankfurt 1995; Hans Haacke. Obra Social, Fundació Antoni Tàpies, Barcelona 1995; Hans Haacke. Bodenlos, ed. Klaus Bußmann / Florian Matzner, Ostfildern 1993.

Hans Haacke: Standort Merry-go round
(Location Merry-go round), 1997

In 1909, the *Ehrenmal am Mauritztor* was inaugurated on the Münster promenade with a nationalist celebration. The sculptor Bernhard Frydag from Münster chiseled into his monument the following dedication: "1864 1870–71 1866 IN MEMORY OF WARS AND VICTORIES; AND THE RE-ESTABLISHMENT OF THE REICH."

The dates refer to three wars Bismarck waged against neighbors of Prussia. In German history books they are known as the German-Danish War which led to the annexation of Schleswig-Holstein by Prussia and (for two years) by Austria; the German War between Prussia and Austria, and the German-French war. In Versailles, in 1871, the Prussian King Wilhelm I was proclaimed emperor of the newly established Reich. Since 1815, Münster has been part of

the Prussian province Westphalia. In Münster the *Ehrenmal am Mauritztor* is popularly called "Mäsentempel" (monument of asses).

During *Skulptur. Projekte in Münster 1997*, a cylindrical shack is to be erected next to the *Ehrenmal* from rough planks, matching the monument in diameter and height (six to seven meters). Razor-wire on the top prevents the wall from being scaled. A children's carousel with lights and music turns around and around directly behind the planks.

Only at those places where the planks do not fit together snugly is it possible to have a glimpse of the carousel.

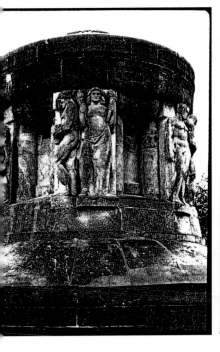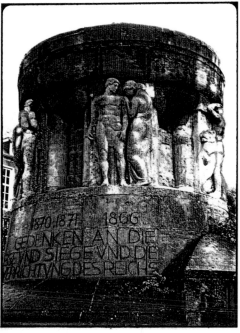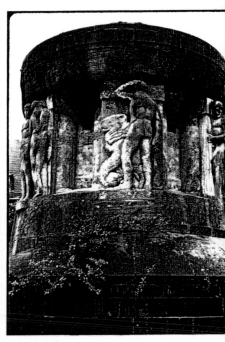

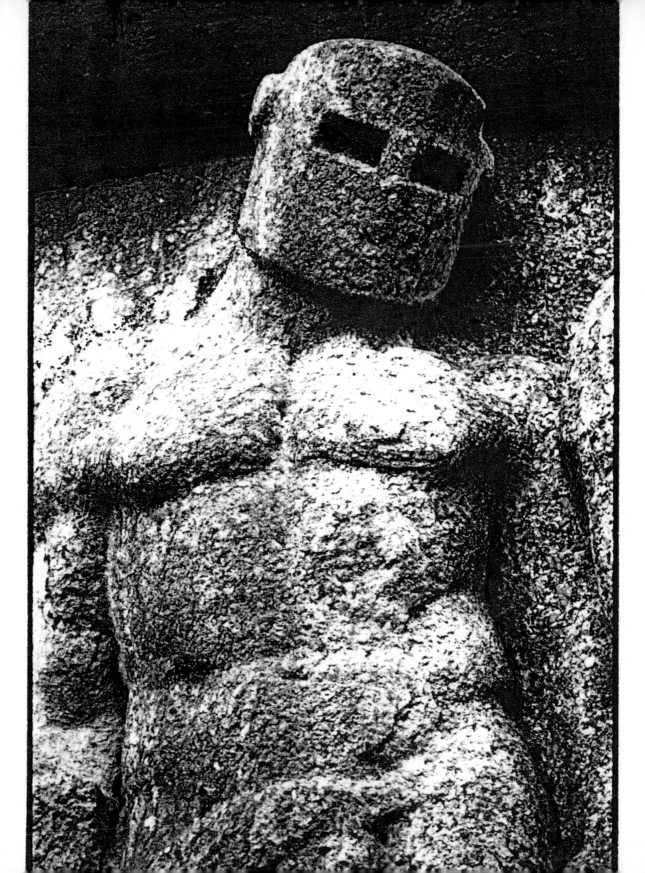

RAYMOND HAINS

Untitled
Two-part installation
Four billboards (french billboards of the
Dauphin company, each 3x4m)
Along Münzstraße in the Buddenturm area
Exhibition collage
Old section of Westfälisches Landesmuseum

Born 1926 in Saint-Brieuc,
lives in Paris and Nizza

Raymond Hains, May 1996–April 1997,
recorded by Robert Fleck

For information about the artist and additional bibliography
see: Raymond Hains. Akzente. 1949-95, Museum moderner
Kunst Stiftung Ludwig, Vienna 1995; Raymond Hains. Gast auf
der Durchreise, Cologne 1995.

"I like the way this exhibition was put together. Both of the times I went to Münster to make preparations everything was very relaxed, in comparison to other large international exhibitions. Not stressful, and I find that – important. In general I feel very comfortable in Germany, though I'm ashamed to say I still can't speak the language.

Since I celebrated my 70th birthday last fall, I am basically disqualified from participation in the Olympiad – and Venice, Kassel, and Münster do have something of the Olympics about them. At my age, one should sit down and consolidate the things one has begun. I, especially, have the impression that there are many things I have only begun to suggest in my artistic life. Today, even the Nouveau Réalisme should be reworked in detail. This event too was misunderstood and in part completely misinterpreted. What it signifies for me is a turning point in the conception of art. Nowadays art is in a confused and disoriented state. What should be done is to work through a very few things in order to establish clarity. So I should actually return to my home in Nizza and work on the many things I have left undone now at least from two years ago. But the exhibition in Münster is, as I said, very agreeable, and I am very pleased to have been invited.

What really interested me in Münster were the Anabaptists. The work by Lothar Baumgarten on the church, left over from the *Skulptur Projekte in Münster 1987*, is fantastic. It really couldn't be done any better. I photographed the cages; at that moment the light was also quite

good. Maybe we can show these photos. In the Fondation Cartier in Paris, where I exhibited in 1994, there happened to be a monumental birdcage by Jean-Pierre Raynaud. The parrots were in the cage, and the exhibition visitors approached the cage like a picture, disturbing the birds all day long. With the Anabaptist cages, the whole thing was horribly reversed: the people were in the cage and the birds were outside attacking the corpses. One of my favorite torn-down posters bears the title *Colette Allendy's Parrot* (1958), because the almost monochrome blue area, a homage to Yves Klein, is damaged and torn in a form resembling a parrot. Colette Allendy was an important gallery owner in postwar Montparnasse. In 1948, she hung my first solo exhibition of abstract photographs, while on the ground floor of the gallery were abstract textiles by Hans Arp, Sophie Taeuber-Arp, Sonja Delaunay, and others. In 1957, Jacques Villeglé and I hung the first exhibition of torn-down posters in this gallery. Shortly before, our friend Yves Klein had shown his first blue monochrome at Colette Allendy. For my 70th birthday the Fondation Cartier gave me a color copy of that torn poster, and it looks deceptively genuine. Thanks to color copy technology, in the future I can exhibit many works that were lost.

For Münster I am interested in continuing my exhibition of 1995 in the Portikus in Frankfurt. The poster and invitation for the Portikus reproduced a calligram by Guillaume Apollinaire that refers to the antique Maison Carrée in Nîmes. I had used the latter – together with the construction site for the Museum Carré d'Art by Norman Foster – for my solo exhibition in the Centre Pompidou in 1990. To exhibit in Frankfurt meant looking for traces of Goethe. I often proceed from the place and the names associated with it; I am interested in the subterranean relationships that exist between things and places, for example through plays on words. That may often appear demented, but actually it is reality that is demented. Goethe's trip to Italy exercised a formative influence on him. Apollinaire was the one who brought me to Italy. In April 1960 we, the later founding members of Nouveau Réalisme, exhibited in Milan for the first time, and in fact at the Galleria Apollinaire. That was my first trip abroad, and I ended up staying in Italy for years. In Münster I would like to continue the Apollinaire story from the Portikus. And then there is the Peace of Westphalia, in which French became the language of diplomacy, and so on.

In Münster I collected a lot of good photographic material. Münster has numerous variants of what I call *sculptures de trottoir* (sidewalk sculptures), anonymous sculptures that originate on streets and sidewalks before and after the end of construction activities in the form of random, unintended piles of building materials. They are found in various public spaces as well as in the construction area of the old section of the Westfälisches Landesmuseum. Exhibiting them in the form of large-scale photos measuring 3 x 4 m in locations subject to heavy traffic would be a nice point of departure. The museum posters we removed from a construction wall of the Landesmuseum are also very nice. You can mount them on canvas and hang them in the museum. I should keep working on that a while longer. There is always so little time for exhibitions like this. I also think that some things should be improvised. It's always too fussy when you try to predetermine everything from the beginning."

Raymond Hains: Billboards, details

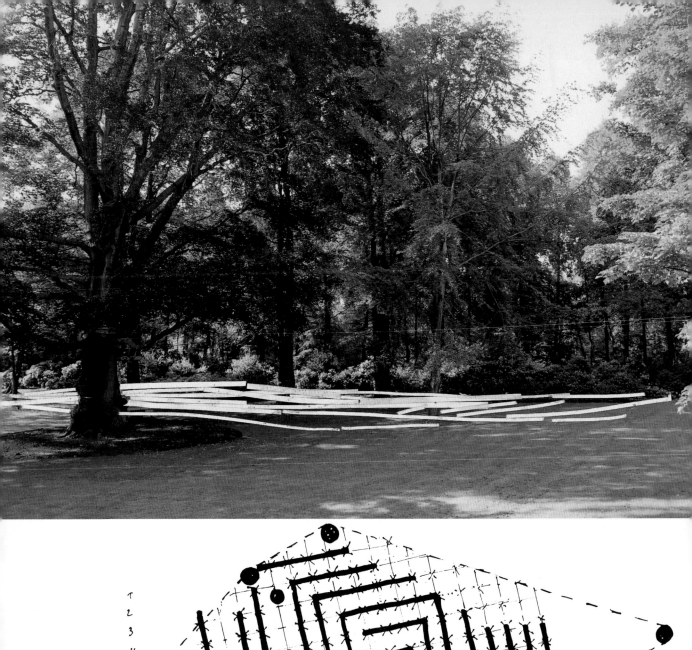

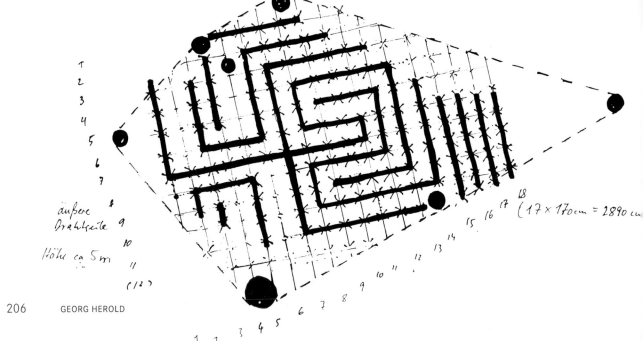

äußere
Drahtseile

Höhe ca 5m

GEORG HEROLD

GEORG HEROLD

bent poetry
w. up!
Installation (ca. 250 roof batten, steel cable)
North part of the Schloßgarten

Born 1947 in Jena, lives in Cologne

For information about the artist and additional bibliography see: XTOONE. Georg Herold, Kunstmuseum Wolfsburg, Wolfsburg 1995; Georg Herold. Gekrümmte Poesie/Shifted Verses, Stedelijk Museum of Modern Art, Amsterdam 1993; Georg Herold, Westfälischer Kunstverein, Münster 1986.

Georg Herold: "And squarely, firmly,
the boy shattered the mirror with an ax."
(Federico García Lorca)

In Münster, the wheel has been newly invented. Like a Mandelbrot set, the sculptures flow out into every corner of the city – one sees more bicycles than people. Architecture has a new competitor: the bicycle as road surface. Everyday, the same – and everyday, formed anew. Here, the human marks her territory with the bicycle.
Münster is a city of fractals, with a cityscape that once was – only not as it is. Houses, that once were, only not exactly as they are; trees that once existed – as well as new ones that still produce the same play: parks and countryside. And with an ambience that, in the search for the most beautiful environment, is constantly in motion and yet always produces the same patterns – which branch out into further complexities while simultaneously remaining even more static. The beauty has a particular order and the order has a particular beauty. So far, in order. Equally, the transformation has a particular beauty. Traffic, business, and communication structures must be rebuilt according to new ecological principles. The cityscape is stamped with orderly reglimentation and construction sites, so that the network of arranged order is refined with soon-to-be-replaced replacements.
Ten years ago, I found it appropriate to use the waste architecture in Münster as impetus for the work, *Lehrbuch der Architektur* (Textbook of Architecture). The need to change the configuration of everything, to cultivate the wild growth of waste disposal, elevated the trash

can to sculpture. Today the landscape has clearly changed. A search for beauty in waste disposal equipment shows a tendency towards the invisible. This development in the visual cityscape offers itself for the continuation of peripheral contemplation: what actually, should the culture *of* a city be? The widespread notion that culture is to be found *in* a city means, specifically, the placing of culture; it means, to create a cultural offering: a display of culture. Does that describe the existence of culture, detached from life, detached from environment? Culture, a well-assorted grab bag, suitable for children's parties?[1] That art distribution as well as theory take this route means that they become an inspection agency of a special type. Then it is logical to call ideas such as drop sculpture, belatedly discovered disgraces. As long as culture is broken down into available single parts that partly supplement, but are not called upon to form a cultural coherence, this idea of culture characterizes exactly the predominant culture.

The Labyrinth of Poetry produces spaces that are not accessible but can be experienced. The moment vanishes. A wooden, hovering labyrinth can generate a sensory experience of a condition that one *can* experience, but is not compelled to experience. Wandering through a labyrinth produces the experience that one is moving through a vast space. In the Labyrinth of Poetry, one leaves a preexistent space and creates one of one's own.

1 The term "Kulturbeutel" is not particularly translatable in this case. In English, it becomes "toiletries bag", which certainly destroys the original play on words. A "grab bag" is a bag containing small articles which are to be drawn (as at a party or a fair) without being seen. In the U.S., the term "grab bag" is commonly used in popular art criticism when referring to an assortment of apparently non-related objects.

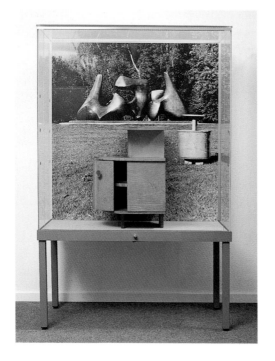

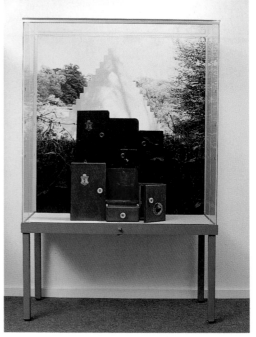

Georg Herold: *bent poetry, w. up!*, details of installation

Georg Herold: *Wir richten uns ein I und II*, contribution to
Skulptur Projekte in Münster 1987, location: Westfälisches
Landesmuseum, display cases with small furniture items
and photo, collection of Westfälisches Landesmuseum,
photo 1997

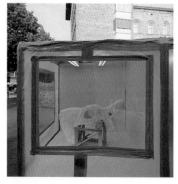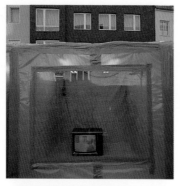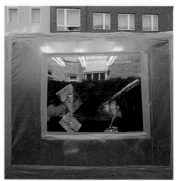
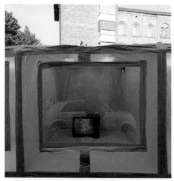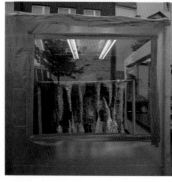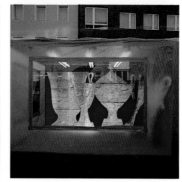
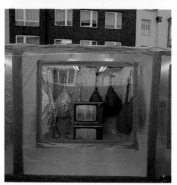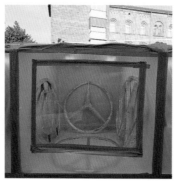

THOMAS HIRSCHHORN

Prekäre Konstruktion
(Precarious Construction)
Installation (wood, plastic, plexiglas, neon
tubes, cardboard, ca. 2.5x8x5m)
Next to bottle banks on Katthagen, corner of
Rosenstraße

Born 1957 in Bern, lives in Paris

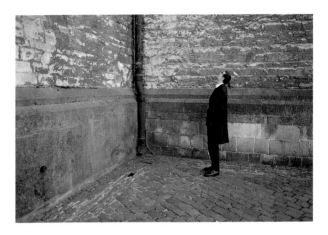

For information about the artist and additional bibliography
see: Katalog. Thomas Hirschhorn, Kunstmuseum Luzern,
Lucerne 1996; Im Rahmen der Ausstellung. Thomas Hirsch-
horn, Galerie Susanna Kulli, St. Gallen 1996; vor ort 1996.
Georg Winter. Thomas Hirschhorn, Stadt Langenhagen,
Hannover 1996.

In Münster I am making a sculpture sorting sta-
tion. It is a freestanding, precarious construc-
tion of roof battens, plastic, wood, plexiglas,
neon tubes, and cardboard. The neon lighting is
important, because I want the interior of the
station to be visible day and night, seven days a
week. The lighting is also important because it
gives the space an autonomy, makes it an alien
body, a space without time, a space free of
hierarchy. Of course the electricity for the light-
ing has to come from somewhere. But I like the
fact that this also demonstrates a connection,
a dependency, a belonging: even this room
must be supplied with energy, must be sup-
ported.

The viewer cannot enter the room, but is able
to look in from all sides. The space is subdi-
vided into ten different parts, into stalls, as it
were, draped with differently colored, printed
or unprinted linen sheets. The size of the stalls
is determined by need. In them are exhibited
the sculptures or videos that I will make espe-
cially for this purpose.

First of all, the sculptures and things to be
shown. They are relatively large, handcrafted
trademarks made of cardboard: the Mercedes
logo, the VW logo, then the peace sign and the
Chanel logo. All of them are flat forms covered

in silver paper, the kind of things seen in televi-
sion reports of demonstrations. This group of
sculptures, for example, is placed in a stall
draped with a red sheet. I should add that the
stall doesn't reach to the ground, but only to
about table height, like a display window.

Sculptures similar to the trademarks are the aluminum cups. Trophy forms are again cut out of cardboard, so as to resemble the kind seen at soccer games or other sporting events where the fans wave handcrafted oversize trophies – World Cup, Cup of Champions, European Cup, Cupwinners' Cup, Intercontinental Cup – in order to spur their team on. These sculptures are exhibited in a stair-step form in a special stall, as in any clubhouse. There is also an Otto Freundlich video: I plan to go to Pontoise, a suburb of Paris, and film the two bronze sculptures by Otto Freundlich – whom I adore – in the garden of the local museum there, in order to show them in Münster. Of course in Münster there is also a wonderful sculpture by Otto Freundlich, but it is exhibited in a terrible location, which means that his work still isn't given the distinction it deserves, namely the very highest! Even the Nazis paid tribute to the explosive plasticity of his sculptures by using a picture of one of his sculptures, *Der neue Mensch,* for the title page of the catalog *Entartete Kunst.* My video is a homage.

In another sculpture, likewise a homage, I will reconstruct a work by the artist Rudolf Haizmann which is no longer in existance. A small illustration of this sculpture is shown in the catalog *Entartete Kunst* of 1937 in Munich. In the catalog, the 1928 work is called *Fabelwesen* (Mythical Creature). We know only that it was made of marble, of unknown dimensions, and acquired by the Museum für Kunst und Gewerbe in Hamburg. Presumably it was destroyed. The artist was born in Villingen in 1895 and died in 1963 in Niebüll. For Münster I will create a cardboard and wood reconstruction of the photographed sculpture, which I have known for a long time. In so doing I want to recall it, reexamine it, imitate it, just as when an important scene is replayed again and again in slow motion, in order to comprehend it better.

A Marlboro video will also be shown as an unending video especially for the sculpture sorting station. In it, someone tries to erect a monument out of empty cigarette boxes; it collapses again and again.

There will also be a stall with tears, silver paper tears, which I first made in Berlin in the Künstlerhaus Bethanien and called them *Robert Walser Tränen.* These tears are of varying sizes, and are made from coloured silver paper or covered with spray paint. There are red tears, blue tears. Two videos of a woman making a slight up and down movement with her head will also be shown in the stall. In one she is associated with red, in the other with blue tears hanging on the wall behind her.

Another stall shows stalagmites and stalactites of silver paper, hanging in front of a theme panel with the subject of "spoons for collectors". The stalagmites and stalactites are proof of the reversal of the prevailing fascination with the dominant discourse, since that which comes from below becomes greater and greater, while that which comes from above grows smaller. Hence also the "spoons for collectors" theme: here I want to take seriously the unbiased, inner illumination of these spoons, but also their limitation. No place for kitsch, no space for cynicism, no air for *2ème Dégré.*

In another stall, art postcards and posters of sculpture are shown, which are given volume by being pasted onto wood. They are a personal sculpture collection. It is not my collection, but I am attached to them inasmuch as they apprehend the sculpture not as volume, not as the mastering of space, but as a picture, i.e. something two-dimensional.

All of my sculptures for Münster proceed from the two-dimensional. It is the rejection of context, background, origin, circumstances. My works in public space are never about context. Nor am I trying to provoke some reaction or

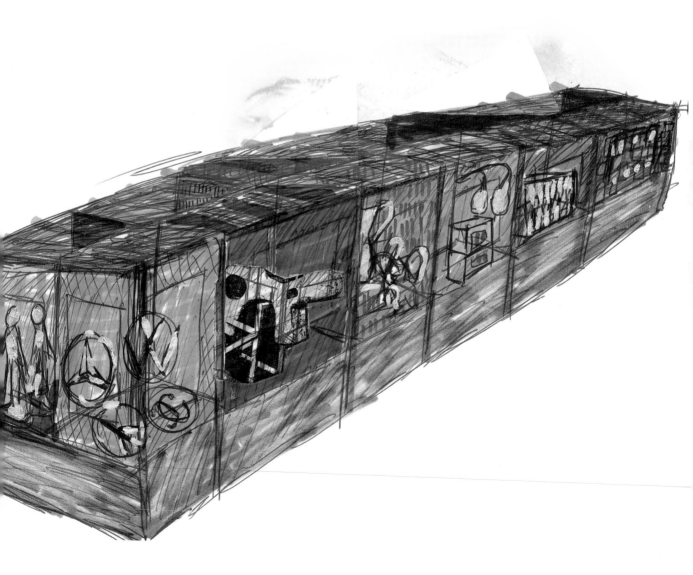

Thomas Hirschhorn: Study for *Prekäre Konstruktion*, sketch, watercolor, 21x29.7 cm

Thomas Hirschhorn: Artist's Scarves, 1996, Limerick, Ireland

Thomas Hirschhorn: *M²–Social*, 1996, Metz

other. For me, questions of context and, more recently, of decontextualization are only the stuff of conversation, a distraction from work. In fact, this empty conversation is eminently suited to avoiding discussion of questions of commitment or the strengths and weaknesses of the work. Works in public space, however, have a great deal to do with weakness, I mean the admission of weakness, of plastic weakness. For me that is commitment, not being shrewd, smart, clever. I don't want to have ideas for public space, I want to show my work, anywhere, with no distinction between important and unimportant places, just as I don't want to distinguish between important and unimportant people. It is also the resistance to the virtual: being up is being up, being down is being down. More is more, less is less. An unemployed banker is as unemployed as an unemployed taxi driver. The motor of my creation is not esthetic questions or art questions. Rather, it is the human condition and questions of life that give me the energy to work. I want to work from necessity.

Back to the stalls: in a double stall there will be a Robert Walser Prize and an Emmanuel Bove Prize. For both writers I will make trophies in different sizes, statuettes like those awarded to the prizewinners at the Oscars or the Goldener Löwe. For Münster, of course, this is just an excuse to make a sculpture for my beloved writers, a mobile monument, so to speak. The sizelessness of these sculptures is important, for they can be larger or smaller; an essential part of them is reducibility, enlargeability, multiplicity. Another stall shows an architectural model of wood, cardboard, and styrofoam and a gallery model in which eight of my works are exhibited. It is not an exhibition proposal. It is a real exhibition, since the works are real. It is not the works that are reduced, but the space, so much so that now the works appear gigantic, because the viewer optically enlarges them.

The name sculpture sorting station is derived from the location of my work. It is a provisional location, since the construction will be dismantled after the exhibition. But it is a location that is unequivocal – unequivocal because I am invited to Münster, a city I don't know and whose history and inhabitants I know nothing about. But I come with the desire to make sculptures and show them to the residents and visitors of this city. And so I don't want to make reference to anything that has to do with the city; that would be pretentious. For that reason I need a location where, on the one hand, my work can be viewed day and night, seven days a week, and which on the other could just as well be in another city, another country. So I selected a location that is a non-place, i.e. a place where people can or must go for reasons that have nothing to do with the geography or history of the place. One such place is the paper and glass recycling depot, those lines of containers where people go to bring their garbage, not for art. There are other such places – automatic bank machines, telephone booths, cigarette and condom machines. I chose the garbage collection site because materials with which I work are brought to it: cardboard, old magazines, plastic, aluminum. I work with these materials because they are economical. Economical is not cheap; economical is political. I work with these materials because everyone knows and uses them. These materials are disposable. They exist, though not for the purpose of making art. Economy interests me. Economy has nothing to do with rich or poor; economy needs connections, it connects. Economy is boundless, economy is active, offensive. Ecology, on the other hand, bores me, and this nombrilistic, dull, passive ecological thinking has long been a source of irritation for me. These garbage collection depots are an expression of it. Here nothing is constructed, no projects are devised; rather, good conscience is

collected and conformity verified. The human energy needed to distinguish between brown and green glass is energy drained, energy burned, which is then unavailable to perceive real differences, make life decisions, adopt positions. Someone who cleans, collects, and carries yogurt cups to the recycling center has no energy left to fight injustice, racism, and burgeoning fascism. But that's what I want to do. I want to make my art political.

Thomas Hirschhorn: *Prekäre Konstruktion*, view of installation

Lola II (Ten years after)

1997

REBECCA HORN

Das gegenläufige Konzert
(The Contrary Concert)
Installation
Zwinger, on the Promenade

Lola II (Ten Years After)
Installation
2nd floor, old section of Westfälisches
Landesmuseum

Born 1944 in Michelstadt, lives in Berlin,
New York, and Paris

Edith Decker, Rebecca Horn: The Zwinger –
On the History of a Building

Built between 1528 and 1536 on the site of the
old northeast tower, the Zwinger was erected
as part of the city fortifications. With a diame-
ter of 24.3 m and an original height of almost
15 m it is comparable to the great fortified tow-
ers of Goslar. Old illustrations show it with a
conical roof and embrasures. In the early sev-
enteenth century, the transformation of the
tower into a prison was considered, but the
idea was at first dismissed. Instead, the
Zwinger housed first one, then two horse-
driven mills; in addition, it was used for powder
storage. Not until 1732 was the former defense
tower turned into a prison.

The new plans for the building were drawn up
by Johann Conrad Schlaun, who integrated the
Zwinger, now a prison, into a larger complex
with a two-winged penitentiary. The three sto-
reys of the building were provided with six cells
each: those in the cellar were without light, the
ground floor cells each had a small window to
the circular yard, while the cells in the upper
storey not only had windows, but could even be
heated. Toward the end of the nineteenth cen-
tury, the prison was closed.

For information about the artist and additional bibliography
see: Rebecca Horn. Installation, Objekte, Kestner-Gesellschaft,
Hannover 1997; Rebecca Horn, Nationalgalerie, Staatliche
Museen zu Berlin – Preußischer Kulturbesitz, Berlin 1994;
Rebecca Horn, Fundació Espai Pobleno, Barcelona 1992.

In 1911 the city acquired the Zwinger, now a
monument under historic preservation. Follow-
ing a few structural changes, it was used for
emergency housing after World War I; among
others, a painter was quartered there. In 1938,
the Zwinger was handed over to the Hitler
Youth in a ceremonial act and newly outfitted

with "squad and troop rooms". In the last years of the war, the Gestapo took over the building. Polish and Russian prisoners of war were executed in the narrow yard; the usual technique was to hang four people at once. Toward the end of the war, bombs destroyed the roof and the interior courtyard, and from this point on, the Zwinger lost any practical function.

The city walled up and barricaded the doors and windows from the outside, thus refusing all entrance and enforcing the distance to the horrors of former years. Though locked from the outside, in the interior the tower lay open through a gaping wound and was exposed to all the elements. Timidly, new organic life began to develop in the Zwinger. Trees extended up toward the heavens from the walls and empty windows, ferns and moss grew on the stairs and passages. A wild paradise garden covered over the once bare masonry.

Rebecca Horn: *Das gegenläufige Konzert*, 1987, photograph of Zwinger with installation elements drawn in, 39.5x40 cm

Rebecca Horn: Das gegenläufige Konzert.
Description of installation
Odenwald, April 20, 1987

Through the cellar door you enter the dark, damp vault of the interior. Small flickering oil lamps light the round passage up to the outer courtyard. From far away and from every direction you hear a soft knocking. A large opening in the masonry leads back into the light, into an untouched garden, a miniature wilderness. You follow the cleared path and ascend a stair, holding onto elderberry bushes.

On the upper platform, still in the open air, the knocking sounds grow louder in an alternating rhythm. Within the niche of the first cell, a feather wing opens slowly and without any mechanical sound, spreading until the first feather touches the last. For a few seconds the wheel turns in a circle, then suddenly, disturbed in its balance, collapses quietly and

jerkily. Small steel hammers affixed to the walls and ceilings of the cells and passageways invent their own, shared, ever-changing rhythm – knocking signals from another world. From the second cell in the upper storey (where the interior wall was ripped out by a bomb), you can see, as if from the platform of a loggia, down into the round interior courtyard.

High in the trees, which grow skyward at right angles from the walls, hangs a great glass funnel, its bowl filled with water. Every twenty seconds a drop falls 12 m into a round basin. The circular ripples smooth into a black mirror until the next drop sets the beat to the contrary concert. A pair of snakes, earthbound, observe and monitor the comings and goings over the course of the months.

Rebecca Horn: *Das gegenläufige Konzert*, contribution to *Skulptur Projekte in Münster 1987*, location: Zwinger on the Promenade, installation

Zwinger on the Promenade after restoration, photo 1997

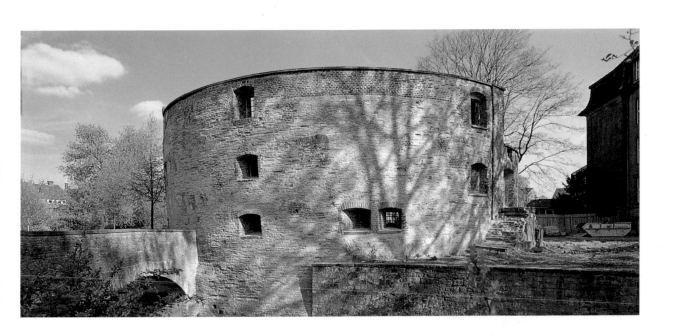

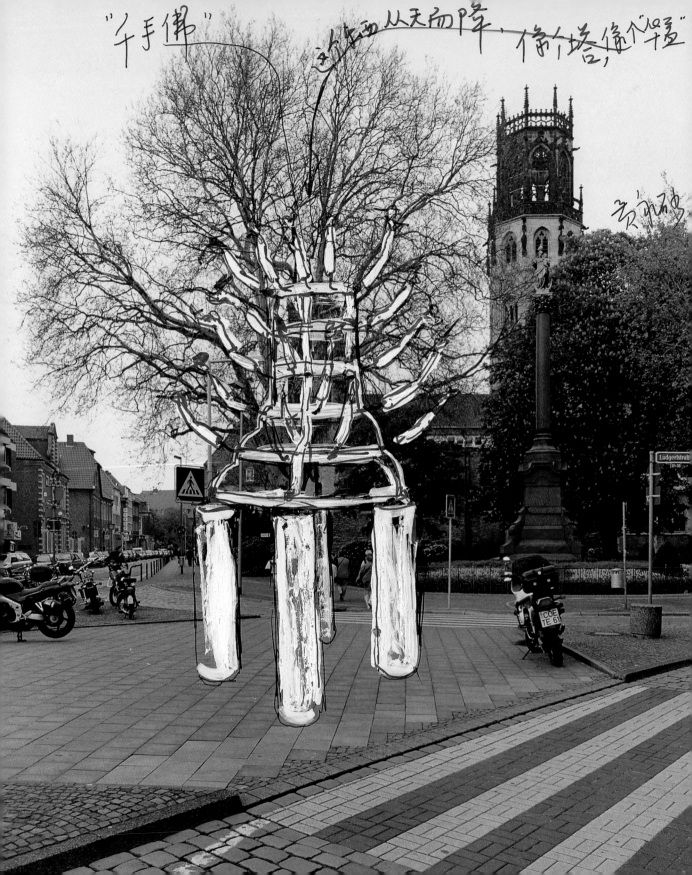

"千手佛"

这车子从天而降，像个塔，像个架子"

贾有福书

HUANG YONG PING

100 Arme der Guan-yin
(100 Arms of Guan-yin)
Sculpture
Traffic island at Marienplatz, south of
St. Ludgeri-Kirche, Königsstraße

Born 1954 in Xiamen, China, lives in Paris

Huang Yong Ping: Thousand Armed Buddha

On the empty square between the street and
the main portal of the church of St. Ludgeri in
Münster an oversize bottle rack will be set up,
with a height of 6 m and a ground diameter of
3.19 m. Stuck onto the bottle rack (égouttoir)
are 1000 industrially manufactured mannequin
arms with 1000 different objects in their hands.
I call it the Thousand Armed Buddha.

The idea came to me while I was viewing the
Jesus sculpture in the church of St. Ludgeri.
The two arms of this sculpture were destroyed
in World War II. The statue has remained in this
condition to the present; instead of replacing
the two arms, an inscription has been
mounted: "I have no hands but yours". It is
entirely as if this Western, armless Jesus had
inspired me to erect an Eastern, thousand-
armed Buddha.

The idea is based on the congruence of form
between things that are different, but which
also resemble one another:
1. the millipede – animal kingdom
2. the Thousand-armed Bodhisattva Guan-yin
 – Buddhism
3. the bottle rack (égouttoir) – Marcel Du-
 champ

For information about the artist and additional bibliography
see: Péril de mouton, Fondation Cartier pour l'art contempo-
rain, Paris 1997; Inclusion-Exclusion, Steirischer Herbst '96,
Reininghaus, Graz 1996; Manifesta 1, Natural History Museum
Rotterdam, Rotterdam 1996; Pharmacie, Galerie Froment &
Putman, Paris 1995.

All these things have many members proceed-
ing from a single center:

an insect with a thousand feet
a man with a thousand arms
an object with a thousand supports

The "bottle rack" is not only a support for the
thousand arms, it also serves as an art histori-
cal reference. Duchamp's ready-made *Bottle*

Rack also alludes to sexuality in the projecting supports and the open bottle mouths. From this familiar form in Western art "grow" the thousand arms of the Eastern Guan-yin.

Here the arms symbolize action and praxis, and not merely concept and theory. The "Thousand Arms" symbolize inexhaustible transformation and unfettered vigor.

In the objects held by the thousand arms, the cult utensils of the Thousand-Armed Guany-in

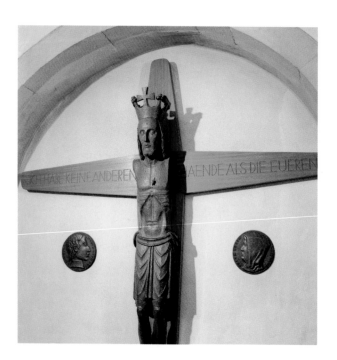

(instruments with definite religious significance such as bells, Vajra scepter, bow, arrow, sword, wheel, seal, etc.) are exchanged for everyday objects familiar to the public.

My project is concerned with change and transformation of form and meaning. Here East and West, art and religion mix with one another.

Heinrich Bäumer: Kruzifix, 1929, St. Ludgeri-Kirche. The arms were destroyed at a bomb attack in the Second World War (left)
Huang Yong Ping: Study for *100 Arme der Guan-yin*, plastic copies of the thousand armed Buddha (dynasty of the 500 Arhats) and of the *Flaschentrockner* (1914) by Marcel Duchamp, put one on top of the other (above and opposite left)
Huang Yong Ping: *100 Arme der Guan-yin*, model, clay, iron stand,, 130 x 83 x 83 cm (right)

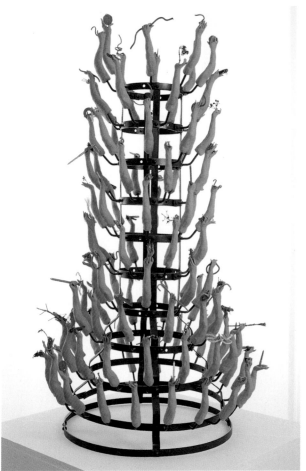

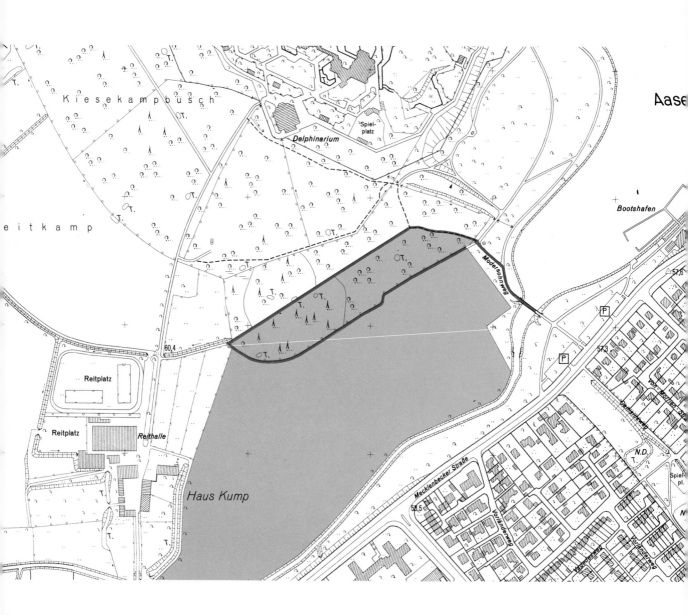

Bethan Huws: Area and Walk, March 19, 1997

BETHAN HUWS

The Quest for the Self
Tour
Wooded area Kiesekampbusch, southwest of
the Aasee

Born 1961 in Bangor, Wales,
lives in Malakoff, Paris

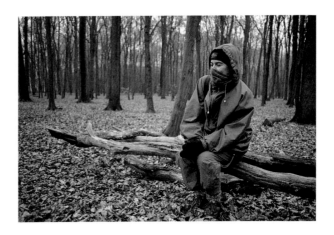

For information about the artist and additional bibliography,
see: Insomnie, Domaine de Kerguehennec, Centre d'art,
Locmine 1995; Uscita di Sicurezza, Castel San Pietro, San
Pietro 1995; Bethan Huws. A concert for the sea, Northumbria,
Museum Haus Esters, Krefeld 1993; Maria Eichhorn. Marcus
Geiger. Bethan Huws. Hartmut Skerbisch, ed. EA-Generali
Foundation, Wiener Sezession, Vienna 1992; Bethan Huws.
Works 1987–1991, Kunsthalle Bern/Institute of Contemporary
Arts, London 1991.

Bethan Huws: Area and Walk, March 19, 1997

Bethan Huws: Proposal

(THE SITE IS AT THE BEGINNING OF LAKE Aa.)
ON THE BRIDGE A MAP INDICATING:

> AN AREA.
> AN AREA WITHIN.
> A ROUTE.

SEPARATE TO THIS A WRITING.
PRIMARILY CONCERNED
WITH DEFINING TERMS WITHIN
THIS PLACE:

> NATURE.
> CULTURE.
> HISTORY.

PLACE AS SOURCE.

TO MAKE A WRITTEN PIECE ABOUT A GIVEN SITE AND
SITUATION THAT WAS FOUND AT THE BEGINNING OF
LAKE Aa.
AT ITS END THERE IS THE CITY OF MÜNSTER.

AT THIS PLACE THERE IS, A RIVER, A FIELD,
A FARM, AND A FOREST.

AN OUTLINE.

FIRST PART.

AND SUDDENLY.
TO ARRIVE
to have moved somewhere without realizing it
IN A DIFFERENT PLACE.
to begin with a perception, a recognition of a different
place
compared with Münster
nature
TO BE OUTSIDE.
compared with Münster

IT IS QUIET.
compared with Münster
IT IS OPEN.
source of which is the field
IT IS WILD.
source of which is meteorological, moving the grass
to be free.human nature
to be fluent. to be able to communicate and express our-
selves
THERE IS A NATURAL STILLNESS.
cause is geographical.realised in the line of the trees
IT IS BEAUTIFUL.
realized in the spectacle
what other things do people find beautiful
why, for what reason

SECOND PART.

WE ARE REMINDED OF A NEGATIVE EVENT IN OUR
HISTORY.
BY A REAL THING NOT BY WORDS. IN ITS PRESENT
STATE.
the source of which is the perception or recognition
of a bomb crater
WHAT WE DISCOVER IS THAT TIME IS REAL.
THAT WE CAN KNOW THE YEARS.
realized in the covering of the crater
IT IS STILL.
compared with our knowledge of the explosion
THERE IS A REALISATION THAT THE PAST,
IS PAST.
that a thing is done at the moment its realization arrives
THERE IS PEACE.

Bethan Huws: *The Quest for the Self*, views of woods

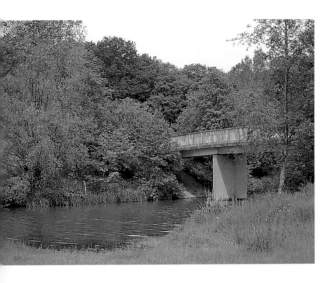

FABRICE HYBERT

1. Fruit-tree
Not realized

2. Flashing Light for Cultural People
Around 100 flashing lights
Artists and staff of *Skulptur. Projekte in Münster 1997*

3. City Zoo (My Zoo)
Not realized (partially realized as sculpture consisting of various animal elements in plasticine in old section of Westfälisches Landesmuseum)

4. Biennale-Beitrag
(Biennale Contribution)
Film about *Skulptur. Projekte in Münster 1997*

Fabrice Hybert: Projects for Münster

The first project was determined in 1989 when I made some photographs of fruit-trees and exhibited real trees under the title *The Insurer*. One question was very strong in my mind: "Why are there no fruit-trees in the city, only decorative trees?"
We could think about pollution; but during the last century there was not so much pollution, and now the geneticists have made stronger fruit-trees.
We could think also about the market for fruit, but now groceries can sell fruits out of season and seasonal fruits aren't so important a part of a year.

Born 1961 in Luçon, lives in Paris

For information about the artist and additional bibliography see: Berechenbarkeit der Welt, Bonner Kunstverein, Bonn 1996; Plus lourd à l'intérieur. Fabrice Hybert, Musée d'Art Moderne, Saint-Étienne 1995; Fabrice Hybert. Le Creux de l'Enfer, Centre d'Art Contemporaine, Chiers 1992.

The most important advantage of fruit-trees in a city is to provide the possibility of eating for people of no fixed address. I'm sure that the budget in a city for looking after fruit-trees (not so different to that for looking after decorative trees) would balance with a part of the budget for those of no fixed address.

a board.

←--- Tree

We can create a structure to support this plan (a foundation, an association…)

The second project is the *Flashing Light for Cultural People*. A red light with a green cover in three possibilities: ring, armband and an actual flashing light.

The flashing light is for *information,* not to express urgency. At this moment I have an exhibition, *i TESTOO*, Station Ü 841 (Galerie Arndt & Partner, Berlin) where I am showing the prototypes and where, for the duration of the exhibition, visitors can write down their views on the criteria for the selection of the people who can wear the flashing light.

This is a real indication for "culture" and it could be worn by all cultural agents (for music, the theater, exhibitions, etc). All guides could be indicated by an armband, for example.

The third project is, like the others, designed to show in a different light, from its origins, a behavior or a structure that is generally accepted. When I was in Münster, the Zoo appeared to me like a huge "information center" about animals with a lot of images and information.

But what do we desire of each animal for ourselves? I have always imagined which animal I could be.

I wanted to make an encyclopedia of all the animals of the *CITY ZOO* or all the animals of *MY ZOO* (the oldest zoo would be a good place for this).

For the city zoo, I could find for all the animals the part or aspect of them we would like to have, or the reason we would like to actually become one. A book can be given away or sold cheaply at the entrance to the zoo in Münster (and in other cities perhaps). This book can show all our desires for animals. "The human desire to become animal" of Gilles Deleuze is one of the powerful ideas I encountered when I was 16. A lot of cartoons, movies and pop stars show this desire.

After this we can imagine a "human" put together with all the animal parts, to scale.

For *MY ZOO*, I can do a cheap book with all the animals I wanted to be and build the zoo of my animals… There are fewer animals than in the city zoo! But the different animals would make a very strange zoo.

I have already made my self-portrait in sponge in the water, with air bubbles!

(Each person can have a zoo-portrait.)

4th Project (editor's text)

Fabrice Hybert represents France at this year's *Biennale d'Arte* in Venice. In the context of his Biennale contribution for the French Pavilion, Fabrice Hybert and his film crew will come to Münster on June 20–21 to make a film on and in Münster which, depending on the subject, will be one to several hours long. This contribution will be prepared in Venice and shown there during the entire Biennale on one of 15 monitors.

In addition, the "Münster Contribution" is tentatively scheduled for broadcast on international television (the broadcaster was not yet certain when this catalog went to press). Hybert could also conceive of a second team, commissioned by the artistic directors in Münster, producing a contribution which would then be "spliced" or mixed with his film and shown in Venice.

Fabrice Hybert: *Fruit-tree*, sketch, paper, felt pen, 5x10 cm (opposite), *Prototyp Nr. 33 "Le Sang de ..."*, 1996, view of installation (below) and detail (right)

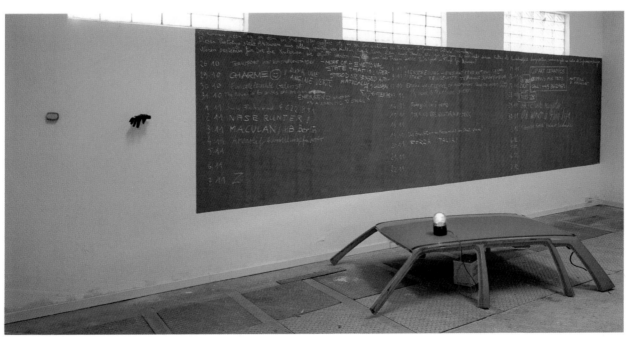

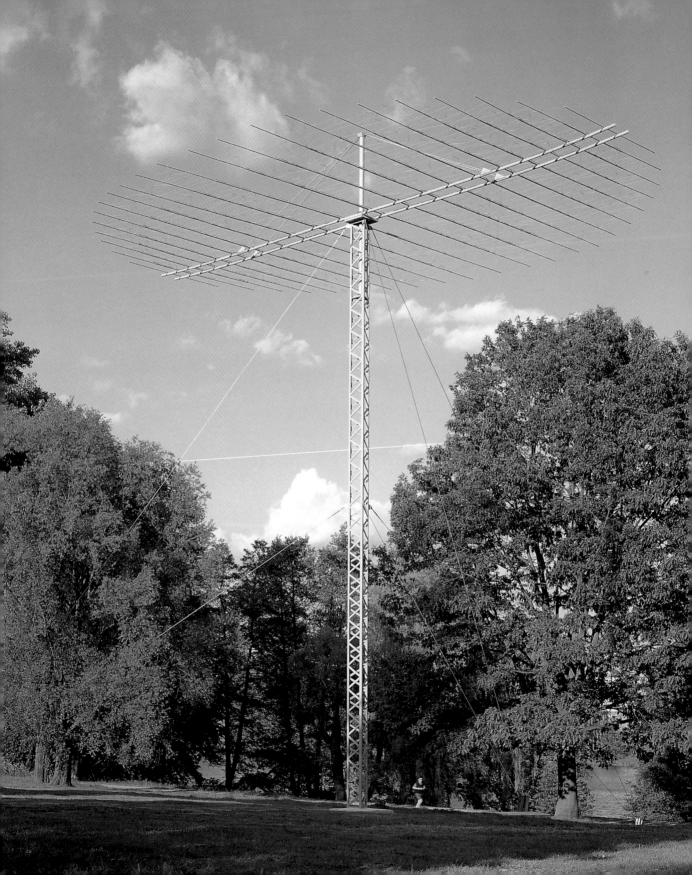

ILYA KABAKOV

"Blickst Du hinauf und liest die Worte ...",
"Looking Up. Reading the Words..."
Installation (steel, height 15 m, inscribed area
14.45 x 11.3 m
North lawn of the Aasee, east of Kardinal-von-
Galen-Ring
Permanent exhibition beginning May 1997

Born 1933 in Dnjepropetrovsk, Ukraine,
lives in New York

Ilya Kabakov: "Looking Up, Reading the
Words..."

1. In an open place, not far from a river where
the slightly hilly shore is covered with grass in
the summer and where there are not too many
people around, a metal construction is erected
which is similar in appearance to a radio an-
tenna that gives and receives signals. When the
viewer approaches closer to it and looks at it
from bottom to top, he notices with surprise
how barely visible letters that combine into
words are arranged between the "feelers" of
the antennae. If you muster your attention, you
can read an entire text:
"My Dear One! When you are lying in the grass,
with your head thrown back, there is no one
around you, and only the sound of the wind can
be heard and you look up into the open sky –
there, up above, is the blue sky and the clouds
floating by – perhaps this is the very best thing
that you have ever done or seen in your life."
The entire "salt" of the installation is achieved by
the thickness of the lines which form the letters
and the entire written text. The thickness of
these lines (the wire is 3 mm in diameter) is such
that against the background of the sky at a dis-
tance of 13 m from the ground they create the

For information about the artist and additional bibliography see:
Ilya Kabakov. Der Lesesaal, Bilder, Leporellos, Zeichnungen,
Deichtorhallen Hamburg, Hamburg 1996; Ilya Kabakov. Sur le
toît, installation, Palais de Beaux-Arts Brussels, Brussels 1996;
Ilya Kabakov: Installations 1983–95, Forum du centre national
d'art et de culture, Centre Georges Pompidou, Paris 1995; Ilya
Kabakov: Ein Meer von Stimmen, Museum für Gegenwartskunst
Basel, Basel 1995.

effect of a unique twinkling: "I see – I don't see"
(a similar effect emerges when looking at a
spider's web stretched across branches in the
forest). That is, given a certain effort of vision,
we can read the written text, but without this
effort, it could seem that it doesn't exist at all.
The text seems to appear before our eyes and
then dissolve against the background of the sky.

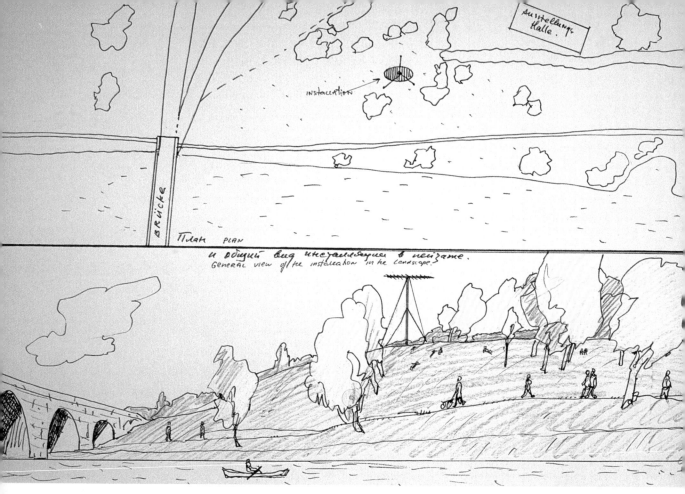

Ilya Kabakov: *"Blickst Du hinauf und liest die Worte ..."*,
"Looking up. Reading the words ...", overall views of
installation, 1996, 1st and 2nd pages of sketchbook,
sketches, chalk, watercolor, and ink, 27.3x41 cm (above)
and 41x27.3 cm (opposite)

But it is precisely this twinkling as we try to make out the text that coincides with the ambiguity of the meaning of this text, which can also be perceived as a vision, a mirage arising before us.

Always, whenever we look up at the sky, we involuntarily have a presentiment, unconsciously we anticipate some sort of "communication" from there, it seems that "something" will be addressed directly to me, that a personal contact might be established specifically with me.

But this is precisely what seems to be happening to my unbelieving eyes. In some strange way, an enormous screen of an antenna has received this "information" and is passing it on to me, for me, as I stand below, having raised my head up. But, I would like to repeat once again, this effect of the strangeness and unexpectedness of the address emerges only when one's consciousness and eyes are not entirely certain that they have actually discerned something at a great height against the background of the sky and white clouds.

2. The reason why the idea for such an installation was selected for this place rests in the general topography of this part of Münster and more precisely, the proximity – along the same shoreline – to the beautiful sculpture of Donald Judd. In all of its construction, this work is turned upward, to the sky, and when standing next to it, one's glance involuntarily rises upward; a connection between the earth and sky occurs in this place thanks to the work of a great artist. Having been impressed by this work, I would like to repeat the same theme, since the shoreline surrounding the landscape and the very aura of the place for a great distance remains one and the same.

3. There is one more, you could say game element to the proposed installation. The radio antenna is sort of a synonym, a symbol of our technical civilization, of its interminable "progress". This is a means for conveying "information" to the entire earth and in turn receiving it from everywhere, information the volume of which increases with each year, and which, as everyone knows, increases the sum of all human potential. The proposed installation, its entire "pathos", consists precisely in disconnecting ourselves from the wind of civilization, remaining alone with ourselves and with nature, hearing the sound of a different wind.

And the fact that this symbol of communication – an antenna – strays from its usual function, that it ceases to be an instrument for that communication, and on the contrary, becomes only a prop, a frame for simple human words—in this the antenna can also be read as a unique symbol, in part a protest although it is uttered in this ironic, playful form.

A Brief Technical Description
The installation comprises a steel construction consisting of a mast and 22 metal "antennae" attached to its top, between which thin (3 mm) metal letters are welded.
1. The mast (13 m in height) is three-sided, the width of each side is 45 cm. It is secured below on a cement block (20 cm above the ground).
2. On the very top of the mast, two aluminum pipes 4 cm in diameter are secured. The length of each is 14.45 m. They serve as the support for the pipes of antennae lying perpendicular on them. These aluminum pipes lie parallel, the

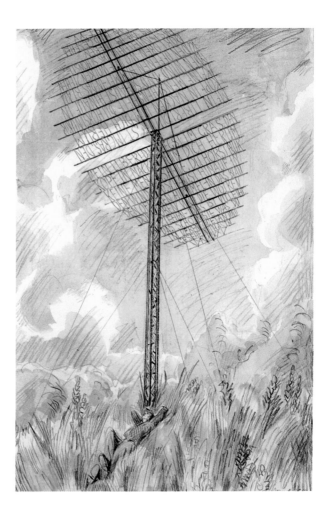

distance between them is 45 cm. They are tightly fastened to the top area of the mast to prevent them from turning.

3. Twenty-two antennae of various lengths are attached to these pipe-supports. They are sectional (see sketch) and in the middle section they are inserted (screwed) into each other. At the ends they are ordinary rods 2 cm thick. The distance between them is greater toward the center of the construction, and smaller toward the edges (see sketch).

4. Letters are secured between the pipes of the antennae. They are made of metal wires 3 mm in diameter, and are attached to the antennae either by welding or with screws. Since the wind might cause the antennae to sway, the method by which the letters are fixed to them must be carefully thought through, as a separate task.

5. The anchoring of the mast and the antennae. The mast is secured by six bracing wires which run to the cement column, and are anchored into the earth at a distance of 10 m from the mast. Three extension wires (8 mm in thickness) run from the top of the mast, three run from the first center. So that the support to which the antennae are attached does not bend, they are secured to it with two similar extension wires in addition. For this a vertical beam (2 m in height) is attached to the top of the mast, and two extension wires run from it and are secured to the supports of the antennae so that they are prevented from bending and remain constantly in a horizontal state.

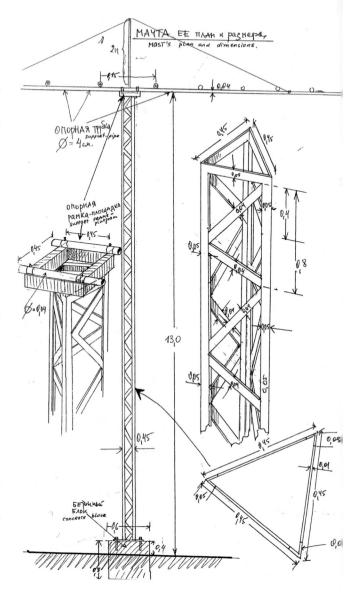

Ilya Kabakov: *"Blickst Du hinauf und liest die Worte ..."*, *"Looking up. Reading the words ..."*, plan and dimensions of pole, 1996, 6th page of sketchbook, construction drawing, ink, 27.3 x 41 cm (above) and views of installation (opposite)

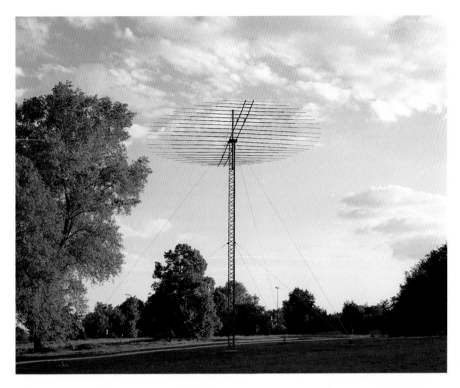

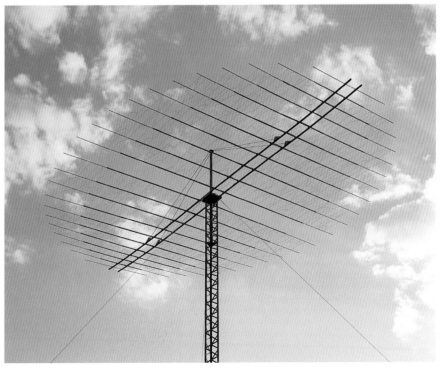

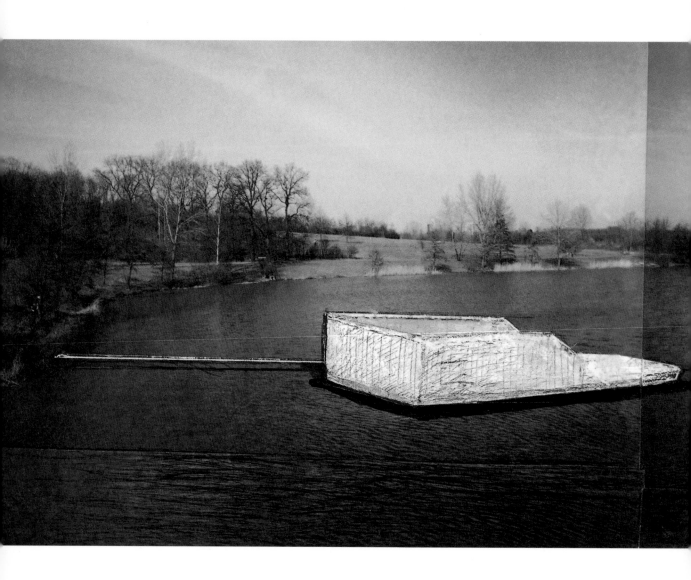

TADASHI KAWAMATA

Boat Traveling
Commissioned by the *Brijder Foundation*,
Alkmaar, advised by the *Office for the
Realization of Commissions in the Visual Arts*,
a department of the *Mondriaan Foundation*,
Amsterdam
Aasee

Tadashi Kawamata: *Boat Traveling*, photomontage
(completed after publication of catalog)

Born 1953 in Hokkaido, Japan, lives in Tokyo

For information about the artist and additional bibliography
see: Tadashi Kawamata. Work in Progress in: Zug, Kunsthaus
Zug, Zug 1996; Tadashi Kawamata, Museu d'Art Contemporani,
Mirades (sobre el Museum), Barcelona 1996; Tadashi Kawa-
mata, Kunsthalle Recklinghausen, Recklinghausen 1995;
Kawamata. Projects. Maquettes, Koolama Gallery, Osaka 1992.

Ronald van Tienhoven: Working Progress

One of the projects now in progress under the
auspices of the Mondriaan Foundation's Office
for the Realization of Commissions in the Visual
Arts and presented in Münster in a modified
form, is *Working Progress* by the Japanese art-
ist Tadashi Kawamata. The project was com-
missioned by the Brijder Clinic for the treat-
ment of addiction. The foundation's new clinic
is located on the edge of the city of Alkmaar.
With the help of patients and staff, Kawamata
plans to establish a new link between the clinic
and the city centre. Small pavilions, wooden
walkways and a footbridge running along and
across a waterway in the vicinity of the clinic
lead to a landing stage where passengers can
board a boat, built by patients of the clinic, to
Alkmaar and other destinations. Obviously, the
trip is not only physical but symbolic too. At the
same time, the project, which was partially
realized in 1996 and 1997 and for which other
elements are planned over the next few years,
establishes new contacts between the clinic
and the residents of Alkmaar. Perhaps it can
help to reduce patients' isolation and stigmati-
zation and create greater openness in what is a
dramatic social problem. To a large extent

Kawamata's plan is based on the active partici-
pation of patients, attendants, directors and
the local authority. The Alkmaar Municipal Cor-
poration is keenly interested in the project and
has decided to play a supporting role in its real-
ization.
Tadashi Kawamata's proposal is one of a series
which he has realized over the past ten years. It
is one of his most probing projects, owing to
the five-year span during which it will take

shape, but also because of its scale and social consequences. Seen in this light, Kawamata's project might be termed radical, albeit a radicality in which the artist does not remain aloof but demonstrates his desire for active participation. It is evident that Kawamata's sensitive and intelligent formulation of the project is conducive to an affective continuum which can be understood, experienced and enacted at all levels. As such, Kawamata's project is the quintessence of the ideal but scarcely attainable marriage of conceptual keenness and artistic generosity.

For Münster, Kawamata has modified the walkways and footbridges, which wend their way through one-and-a-half kilometres of polderland to Alkmaar, transforming them into a walkway running parallel to the Aasee, a platform and a floating walkway leading to the Brijder boat. Patients and staff of the Brijder Clinic worked in situ on this contribution to the Münster Sculpture Projects. The boat they built in Alkmaar has been transported to Münster. Interested visitors who take a trip by boat along the banks of the Aasee will get a good idea of the intentions and conditions of the Alkmaar situation.

This is an edited version of Ronald van Tienhoven's "In defence of chain smoking", in: PBK 91-95 Five years of commissioning art, Amsterdam 1996, pp. 34-42, 38.

Jan van Adrichem: Notes on projects of the Office for the Realization of Commissions in the Visual Arts, a department of the Mondriaan Foundation

Stan Douglas's and Tadashi Kawamata's projects are presented by the Mondriaan Foundation's Office for the Realization of Commissions in the Visual Arts at the invitation of the *Skulptur. Projekte in Münster 1997*. The two projects were developed for an institute for mental care in Zwolle and an addiction treatment center in Alkmaar respectively.[1] Although they have been modified for their temporary presentation in Münster, a venue in which their function and appearance differ strongly from the places for which the two works were originally conceived, they clearly reflect what Douglas and Kawamata had in mind for the specific locations and circumstances in the Dutch cities of Zwolle and Alkmaar. Both the *Project for the RIAGG Zwolle* (Douglas) and *Working Progress* (Kawamata) are to be implemented as part of a Dutch scheme for incorporating art in new buildings housing public health institutions. The said scheme enables directors of institutions, advised by the Office for the Realization of Commissions in the Visual Arts, to act as exemplary patrons of the arts. Although the therapeutic environment of Douglas's and Kawamata's projects may convey the impression that the Office collaborates exclusively with medical institutions, this is not the case. The chief reason for referring to these projects here is that they are indicative of the quality aimed at by the Office.

The Office works on a national level. In offering advice and financial aid, it endeavours to stimulate potential commissions for exemplary public art projects and to bring Office expertise to bear on their execution. Although the Office has been involved to an increasing extent in the public health sector in recent years, its horizons are wider: it encourages and supervises projects for local and national government, statutory organizations, enterprises and foundations.

Tadashi Kawamata: *Boat Traveling*, construction drawings, 29.7x42 cm each

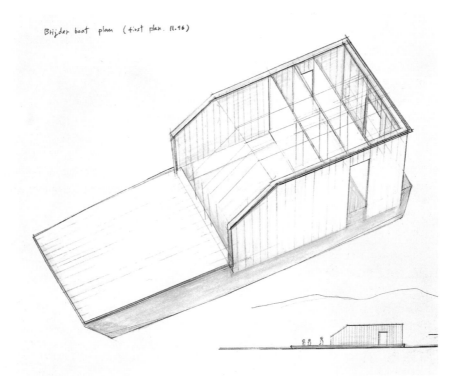

Brijder boot plan (first plan. 11.96)

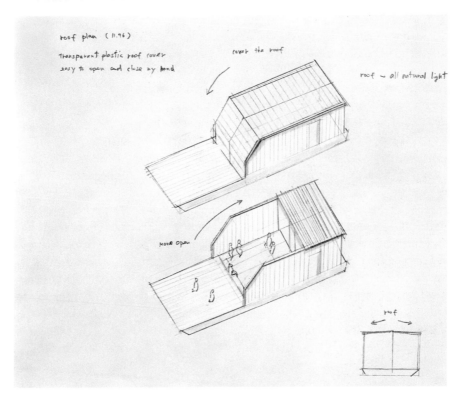

roof plan (11.96)
Transparent plastic roof cover
easy to open and close by hand

cover the roof

roof ~ all natural light

move open

roof

The locations in which projects are realized, and the nature of such projects, display a greater diversity than is suggested by the two projects presented in Münster, regardless of the considerable difference between the two. Both clearly express the growing social awareness which has come to affect artists more and more in recent years and is consequently a more prominent aspect of the Office's art projects. As a result, the projects are assuming an increasingly complex nature. An unexpected combination of site-specificity, emphasis on formal aspects and a patently obvious sociocultural aspect is to be seen in Ulrich Rückriem's sculpture on the Amsterdamse Veld near Klazienaveen. The Office was involved in the realization of this work, whose shape – a rough-hewn block – as well as the nature and weight of the stone acquire unexpected but generally valid relevance as a monument to the cessation of peat-cutting in this area of the province of Drenthe in 1992. The work is a compact, appropriate metaphor for the harsh reality of life in the peat moors.

By contrast, Thomas Schütte's group of bronzes for Utrecht's Griftpark qualifies as a public-spirited urban monument. Schütte's three dramatically deformed and oversized figures symbolize the completion of a highly ambiguous urban recreation area: a new park on a heavily polluted but locally stabilized site, the result of years of campaigning by residents to get the authorities to solve this local environmental problem.

Other projects address the connection between a surprising, original idea for a specific location and the incorporation of that idea as a work of art in the functional treatment of a landscape area. John Körmeling has made works of this kind which are inextricably linked with their surroundings. This *Circuit II*, realized in collaboration with the Office, was designed in 1995 for a residential centre for the disabled

Tadashi Kawamata: *Boat Traveling,* construction work, Münster, June 1997

in the coastal resort of Zandvoort. It takes the form of a route through the dunes for walkers and wheelchair-users. Close by is the Zandvoort car-racing track, but Körmeling's frank reference to it, an allusion which certainly means no disrespect to the disabled, results in an alternative circuit for people who, paradoxically, are virtually immobile.

Even more immaterial is *Angels*, Moniek Toebosch's contribution to the ABRI (Shelter) project of the Professor Van der Leeuw Foundation. Toebosch responded to the assignment – to design modern places of introspection and contemplation as an alternative to those of religious life – by proposing the car as an appropriate place for the late twentieth-century European to indulge in self-communion. At the beginning of the water-bordered route along the dyke from Enkhuizen to Lelystad, drivers are asked to tune in to a particular FM station. The celestial sounds of angels' voices issuing from the radio aurally transform the landscape into a Dutch Arcadia. This semi-permanent example demonstrates that the Office not only promotes permanent projects but also those with an event-like character, such as the two

most recent *Sonsbeek* exhibitions in Arnhem (1986 and 1993).

Office-aided exemplary projects are subject to concordance between the Office and the commissioning instance as to the formulation of the commission, the choice of artists and the available budget. The important criteria for the Office's involvement are the exemplary effects that a commission can generate. The issue is whether a commission is "challenging", and if so, to which artist. Approximately half of the potential commissions discussed by the Office every year are assessed positively. The Office then submits these projects to an advisory committee which examines the Office's proposals in the light of their effectivity in a commission situation. Roughly 10% of its proposals are rejected. In 1995 the Office processed a total of 80 projects which had been passed by the committee. Forty-eight of them were new projects and initiated that same year; 23 were regular projects and 25 were related to the Public Health scheme.

The objective of realizing exemplary projects in the changeable field of art today means that the Office should not adopt overly rigid views. In order to maintain flexibility and react to new developments, the Office's small nucleus of permanent staff recruits temporary internal advisors with whom they develop proposals for projects, and advise on them. Owing to its often lengthy involvement and funding of projects and the provision of expertise, the Office assumes a responsibility towards the particular commission, the art and the artist, and by that token frequently adopts a "parental" attitude to projects. As "foster parent" and "project developer", the Office has pioneered innovation in Dutch commission policy since it was set up in September 1982.

Just as the choice of specific artists for certain commissions is not confined to the Netherlands, the nature of discussions in which the Office adopts a particular stance is not strictly national in its orientation either. Notably the previous presentation of the *Skulptur. Projekte in Münster 1997* drew new attention to social aspects of sculpture in public spaces. The Office regularly collaborates with artists who emphasize that aspect in their work, bringing it to the attention of those prepared to grant commissions for works orientated towards the social role and delimitation of art, and to its integration in a variety of unexpected aspects of daily life. In the current debate on the innovative functions of sculpture in public spaces, the Office thus boldly opts for adventure and the unexpected.

1 The Mondriaan Foundation is a Dutch cultural fund which supports and stimulates special activities related to the visual arts, design and museums. The foundation was established in 1994, since when the Office for the Realization of Commissions in the Visual Arts has been an integral department.

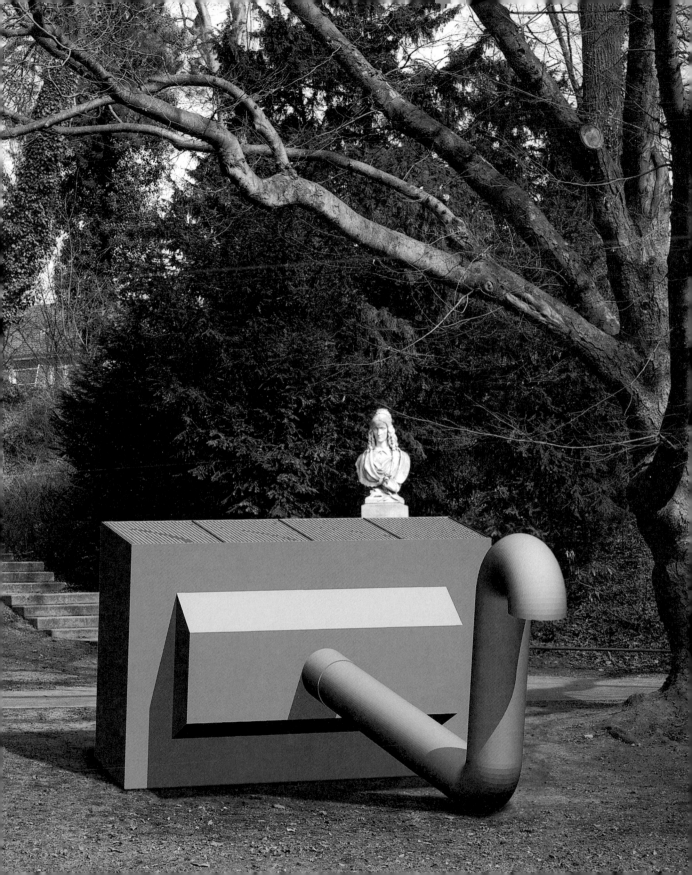

MARTIN KIPPENBERGER

Metro-Net. Subway Around the World
Installation (ventilating shaft made of sheet
steel, 1.2x4x0.5m, intake pipe, length 5.09m)
Kreuzschanze, opposite portrait bust of
Annette von Droste-Hülshoff

Born 1953 in Dortmund, died 1997 in Vienna

Veit Loers: Martin Kippenberger, *Metro-Net
Münster*

There before me yawns the hall,
Gray its gate, long and low
And within resounds the fall
Of strange footsteps, heavy and slow.
<div align="right">Annette von Droste-Hülshoff</div>

Beneath the deep, severe eyes of Droste-
Hülshoff – or rather of her stone bust at the
Kreuzschanze in Münster – Martin Kippenber-
ger has placed a subway ventilation shaft, an
abstract sculpture supplied with fans and sub-
way background noise, a sculpture with as
much formal severity and depth of content as
the gaze of the Westphalian poet. A homage to
Droste on her 200th birthday? At any rate, a bit
of labeling fraud: Münster has too many bicy-
clists to need a subway, and the ventilation
shaft is too high for bums to sleep on it in the
winter. The ventilation shaft is first of all a con-
voluted structure with strange associations,
part of the Kippenberger network *Metro-Net.
Subway Around the World*, which in the sum-
mer of 1997 will stabilize in four places around
the world: at the Kreuzschanze in Münster, at
documenta X in the Fulda-Aue in Kassel, and in

For information about the artist and additional bibliography
see: Martin Kippenberger. Der Eiermann und seine Ausleger,
Städtisches Museum Abteiberg Mönchengladbach,
Mönchengladbach/Cologne 1997; Martin Kippenberger,
Hirschhorn Museum and Sculpture Garden, Washington 1995;
Martin Kippenberger. The Happy End of Franz Kafka's America,
Museum Boymans-van Beuningen, Rotterdam 1994; Martin
Kippenberger, Ten years after, ed. Angelika Muthesius, Cologne
1991.

two previous locations, the Subway Station
Lord Jim on the Cycladic island of Syros and the
subway exit of the Underground Station Daw-
son City West. Thanks to satellite transmission
and digital communication, we are drawing ever
closer to one another on a global scale, not

only through the logos of the multinational corporations, but also artistically: instead of monuments to Hitler after the *Endsieg* or Lenin after the proletarian world revolution, monuments by Calder, Moore, Serra, or Dubuffet are networking countries like the United States, Japan, France, and Germany into an Eldorado of modern art. The idea of global artistic production has been employed repeatedly since the Hellenistic period – and probably much earlier as well – to distinguish the cultured and civilized from the barbarian. One recognizes one's own image in the trademark, whether under SPQR or SPAR.

When it comes to subways, all travelers have their own anecdotes. My first experience was the Metro in Paris. The smell of ozone had something cosmopolitan, almost erotic about it, and the fragments of billboards whooshing by – Du, Du Bon, Dubonnet, conceived for passengers in transit – were far more than just advertisements for pastis. And then there were the curving, labyrinthine access corridors, sometimes with street musicians, the automatic doors for incoming trains, the entrances with the characteristic Art Nouveau "M" by Hector Guimard. In New York, it can happen that a train suddenly mutates from local to express service and thunders past the station where you wanted to get out. In London you dare not be color blind if you hope to find the right line; Berlin has its picturesque stations, the Noli Me Tangere of the S-Bahn, and the earlier fear of unwittingly ending up in East Berlin; Moscow is a Stalinist paradise of underground escalators and station palaces. Munich is perfect, but with a payment system comprehensible only to high IQs and bad news for ticketless passengers, while in Cologne the subway is nothing but an underground streetcar system.

Here Martin Kippenberger takes it a step further: he builds entrances and ventilation shafts, all that is visible of the subway above ground,

Martin Kippenberger: *Metro-Net. Subway Around the World: Entrance to the Subway Station Lord Jim*, 1993, location: Kthma Canné on the Cycladic island of Syros, Greece (above), *Metro-Net. Subway Around the World: Exit of the Underground Station Dawson City West*, 1995, location: Dawson City, Canada (opposite above), *Metro-Net. Subway Around the World: Transportabler U-Bahn Eingang documenta X*, 1996, computer drawing (opposite below)

parts that become autonomous and constitute Kippenberger's extensive complex *Unsinnige Bauvorhaben* (Nonsensical Building Plans).

It should not be forgotten that in 1989 he arranged a remarkable exhibition in Vienna in an unfinished subway station on Maria-Hilf-straße.

In the end, what remains of the whole idea are two disparate parts: the communicative network of fraternity, which sometimes functions better below ground in the kingdom of the sewer rats than above, and the idea of Hades, the entrance to the underworld, which the Greeks thought to have found in especially bizarre and desolate regions of the Old World.

In Münster, Martin Kippenberger lets his ventilators whirr in an idyllic little corner; he shows a piece of Minimal Art with intake pipe as in the

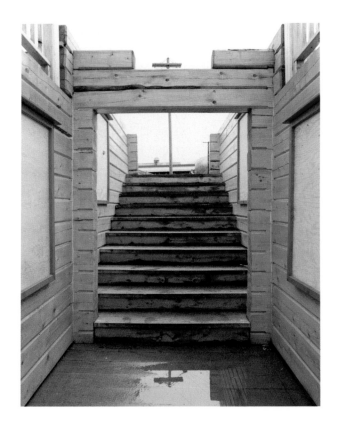

days of the best German "Kunst am Bau" of the 1960s, and maintains control over the underground – the former walls, moats, and fortifications. Together with Annette von Droste-Hülshoff, he sets a *memento mori* for all that remained incomprehensible to us in the striving for culture and a better future, *pars pro toto,* the working of mysterious powers. A construction drawing for the fans resembles a mixture of modern universal mechanics and a Dada machine: the conjuring of a functional universe reinterpreted by an individual mythology, but with special attention paid to the generator that supplies power for the virtual trains thundering by.

Seeing the sculptural arrangement of the *Spiegeleikarussel* (Fried Egg Carousel) in the Westfälisches Landesmuseum, with its two rotating airplane seats and umbrellas as in *Der arme Poet* (The Poor Poet, 1839, painting by Carl Spitzweg), and connecting it with the egg cabinet of Droste-Hülshoff, testimony to the collecting activities of a contemplative poet, one can hardly doubt that Martin Kippenberger is concerned with a cosmos of a special kind – *Die Verbreitung der Mittelmäßigkeit* (The Dissemination of Mediocrity), as one picture is titled, on an egg-shaped globe. A survey plan prepared by Kippenberger shows his subway stations distributed over just such an egg-globe. One harbors secret hopes that this global vision will somehow manage to keep from wobbling.

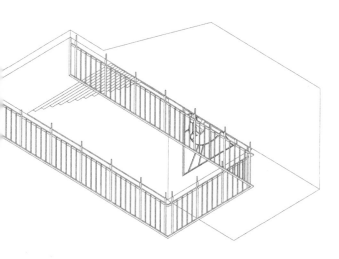

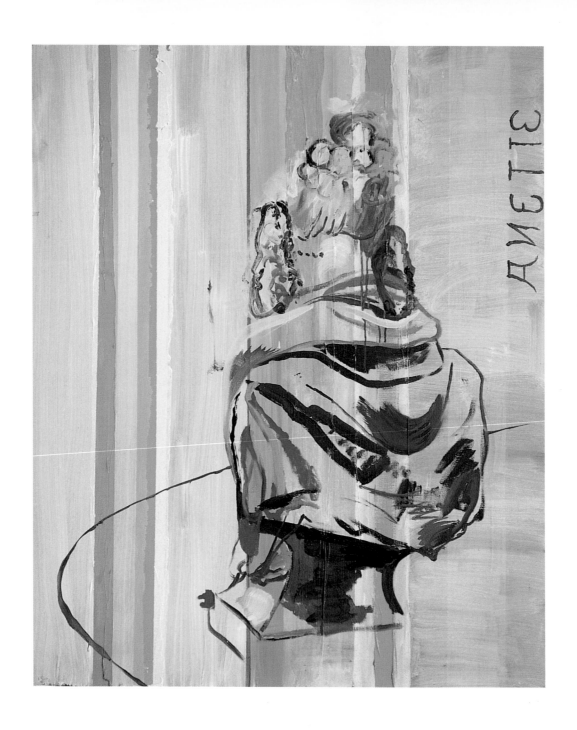

Martin Kippenberger: *Ohne Titel*, 1996, oil on canvas,
1.20x1 m

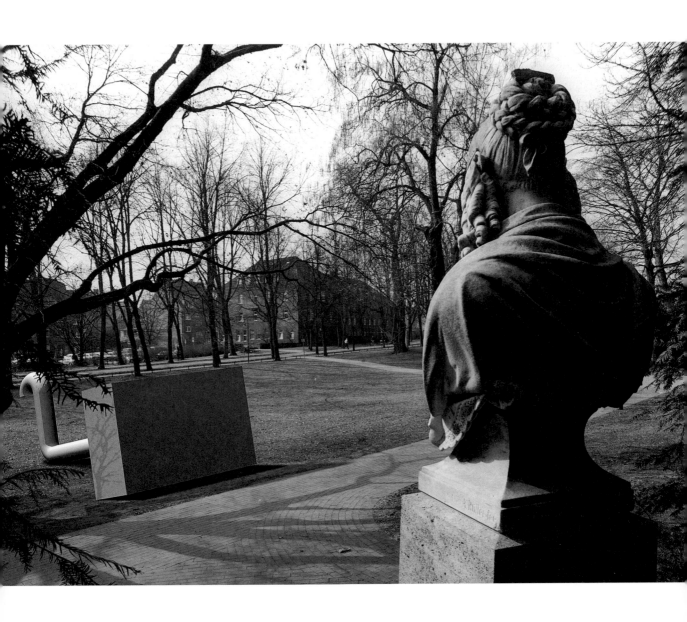

Martin Kippenberger: *Metro-Net. Subway Around the World,*
computer simulation, 1996

PER KIRKEBY

Kleine Markthalle für Fahrräder
(Small Covered Market for Bicycles)
Square in front of Apostelkirche on
Neubrückenstraße
Not realized, rejected by Münster urban
planning office in November 1996

Bushaltestelle
(Bus Stop)
In front of Freiherr-vom-Stein-Gymnasium on
Hindenburgplatz

Born 1938 in Copenhagen,
lives there and in Frankfurt

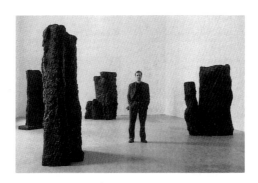

Per Kirkeby: *Kleine Markthalle für Fahrräder,*
October 1996

A large city square with parked bicycles is as
unattractive as a parking lot full of cars. And a
large ensemble of bicycle shelters looks even
worse, like a dreary suburban train station.
But the bicycle is the future of the city. So the
problem has to be solved, one way or the other.
A "covered market" for bicycles – simple,
streamlined, urbanistic. One sees the logical
conclusion, instead of these "undecided"
sheds. Of course it must remain transparent.

For information about the artist and additional bibliography
see: Per Kirkeby, Arken 1996; Lars Morell / Jens Lindhe:
Per Kirkeby. Bygningskunst, Copenhagen 1996; Per Kirkeby.
Nabeelden, Openluchtmuseum voor Beeldhouwkunst Middel-
heim, Antwerpen 1995; Per Kirkeby, Kunstausstellung der
Ruhrfestspiele Recklinghausen, Kunsthalle Recklinghausen,
Recklinghausen 1994.

Philipp Mouser: Koolhaas' Urban Sculpture.
Small-Scale Architecture in Groningen

With the 1990 open-air festival "A Star is Born",
the Groningen urban planning authority ini-
tiated its second major campaign to revamp the
Netherlandish city. International figures from
the architectural scene – Rem Koolhaas,
Manuel de Solà-Morales, Fumihiko Maki, and
William Alsop – designed small-scale buildings.
While the three foreigners erected idiosyncratic

stage structures in cooperation with artists, the
Dutchman Koolhaas ironized a public toilet
facility: the small structure, its plan reminiscent
of the Far Eastern yin-yang symbol, is sur-
rounded by photographs of dancing people. The
steel ceiling panel hovers like a suspended roof
over a structure measuring barely 4 x 4 m. Here
a simple accoutrement of the city is stylized

into urban sculpture. The other designs, however, are geared entirely to the festival, which lasts until September 29. The Japanese Maki placed his stage as a swimming island in the Diepenring surrounding the old city, while the Spaniard de Solà-Morales cantilevered a platform 50 m² in size out over the bank. The Englishman Alsop realized the most eccentric contribution with his brightly-colored, open-air stage. These drolleries carry Groningen a step further on its way to becoming a city of architectural collage. The Groningen museum, opened in 1995, boasts individual building parts designed by different star architects.

From: Neue Zürcher Zeitung, No. 224, Thursday, September 26, 1996, p. 45.

Per Kirkeby: The moral: if architecture now wants something colorful and "artistic", then we must save architecture – simple, utilitarian/ functional = moral!

Per Kirkeby: *Backstein*-Skulptur, contribution to *Skulptur Projekte in Münster 1987*, location: north side of Hindenburgplatz, brick, 0.5x4.03x4.03 m and 4.92x2.06x2.06 m, photo 1997 (below)
Per Kirkeby: plan and elevation of the *Kleine Markthalle für Fahrräder*, 1996, construction drawings, pencil, 21x29.7 cm each (opposite)

Per Kirkeby: "Textbook" for construction of *Bushaltestelle*, four drawings, pencil, 21x29.7 cm each (pp. 256 – 259)

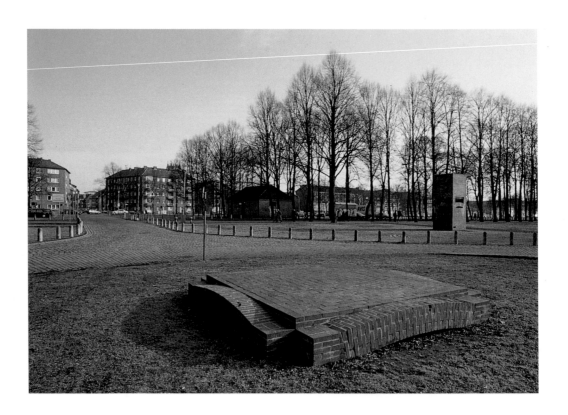

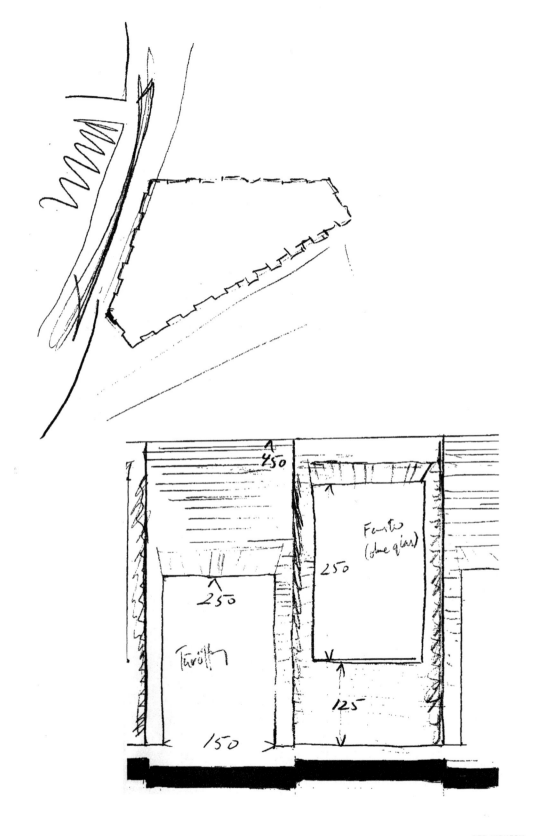

Mauer —
kein Haus
aber doch ein Zweck

— Ornament

Halbdach —
kein Haus
doch Zweck —
hur Zweck

Mane Halbdach

zugeschoben

aber bleibt unabhängige Elemente

= Zweck + Zweck = Bushaltestelle

bleibt offen
noch kein Haus
noch kein Skulptur

4

Haus

Skulptur

Zusammenschmelzen

a) Teilweise = Haus

b) Total = Skulptur

dazwischen ~~●~~ steht Bushaltestelle

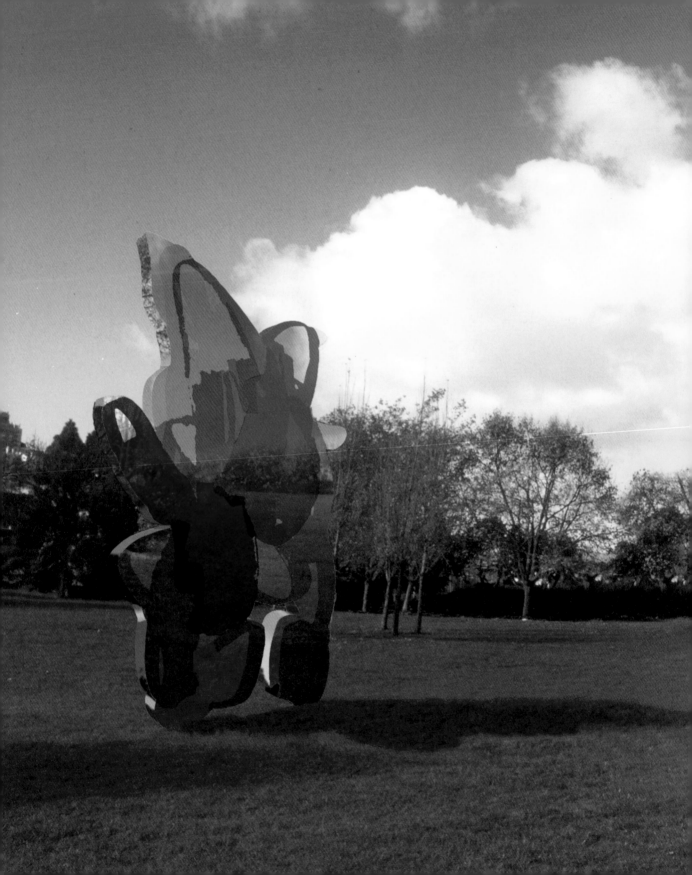

JEFF KOONS

Coloring Book
Sculpture (chrome steel, 5.64x3.34x0.23m)
Promenade south of Salzstraße

Jeff Koons: *Skulptur. Projekte in Münster 1997* – Statement

Being invited to participate in *Skulptur. Projekte in Münster 1997* is very meaningful to me. Münster has been and continues to be an opportunity for artists to be able to reveal the possibilities of what public sculpture can be and what types of interaction can occur with the public. The international art world which is drawn to Münster to view first-hand the projects achieved is one of the most adventurous audiences in the art world, and the German people have always been one of the most supportive art audiences.

My participation in the *Skulptur Projekte in Münster 1987* had a profound impact on my artwork for two reasons; it was the first opportunity I ever had to create an outdoor public sculpture, and due to technical problems which occurred in the creation of my work, I was liberated to develop my dialog with the readymade in a more open and generous manner.

For the *Skulptur Projekte in Münster 1987*, I displayed a work entitled *Kiepenkerl*. This work is a recasting of a bronze sculpture which is located in the town center of Münster. The original bronze Kiepenkerl has always been a very

Born 1955 in York, Pennsylvania, lives in New York

For information about the artist and additional bibliography see: Thomas Zaunschirm: Kunst als Sündenfall. Die Tabuverletzungen des Jeff Koons, Freiburg 1996; Jeff Koons, San Francisco Museum of Modern Art, San Francisco 1993; The Jeff Koons Handbook, London 1992; Jeff Koons, ed. Angelika Muthesius, Köln 1992.

meaningful and identity-based sculpture to the people of Münster, symbolizing self-sufficiency, abundance and a moral relationship with the world. The Kiepenkerl is an image of a man coming to market with a Kiepe on his back. It's filled with eggs, potatoes, a hare, pigeons, and other symbols of self-sufficiency and abun-

dance. My idea, on finding the Kiepenkerl in the town center outside a restaurant carrying its name, was to contemporize the public's symbol of self-sufficiency and economic security – to recreate an icon that could once again meet the needs of the public. I chose to recreate the Kiepenkerl in highly-polished stainless steel, the luxurious material of the proletariat, in order to transform it into a contemporary symbol for a society which itself has transformed from agrarian to economic.

The *Kiepenkerl*, like all of my previous work, was based upon the readymade. If I recast an object, it would be an exact copy of the original object in a different material, while maintaining all the integrity of the original – its perfections and its imperfections. However, during the process of casting the *Kiepenkerl* in stainless steel, I encountered great technical difficulties which included distortions from the original model. I had to decide whether to withdraw from participating in Münster, because of the lack of time to recast the sculpture, or to make radical plastic surgery on the *Kiepenkerl*. I decided to do radical plastic surgery, and working with unsurpassed technical steel workers, we put this Humpty Dumpty back together again. This liberating experience offered me as an artist the opportunity to go on and create my own objects in such bodies of work as *Banality*, where I did not work with direct readymade objects but created objects with a sense of readymade inherent in them.

Having the opportunity to return to Münster a decade later, I hope to push myself to my creative limits in exploring the possibilities of public sculpture by creating a work which invites all viewers to find fulfillment from their interaction with the work.

My new work, *Coloring Book*, is a fabricated stainless steel sculpture which has been polished to a mirror finish and coated with transparent colors. The sculpture is derived from my spontaneous reaction to a coloring book image. I wanted to create a work that would involve my most sincere and uninhibited gesture, and hopefully a work which would function as an archetype of our personal involvement and understanding of art.

The Kiepenkerl as motif for morale-raising poster by Böckeler, 1944, offset, published by District Propaganda Office of North Westphalia (above)

Jeff Koons: *Der Kiepenkerl in Edelstahl*, contribution to *Skulptur Projekte in Münster 1987*, location: Spiekerhof / Bergstraße, stainless steel replica of bronze sculpture (opposite)

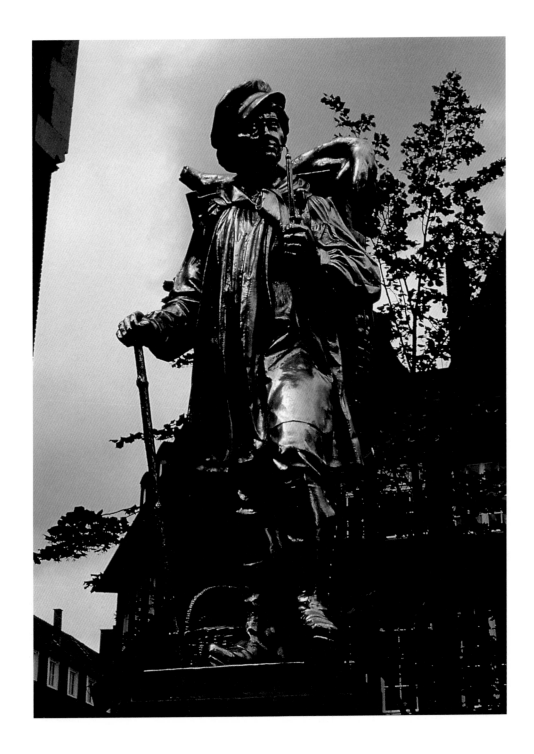

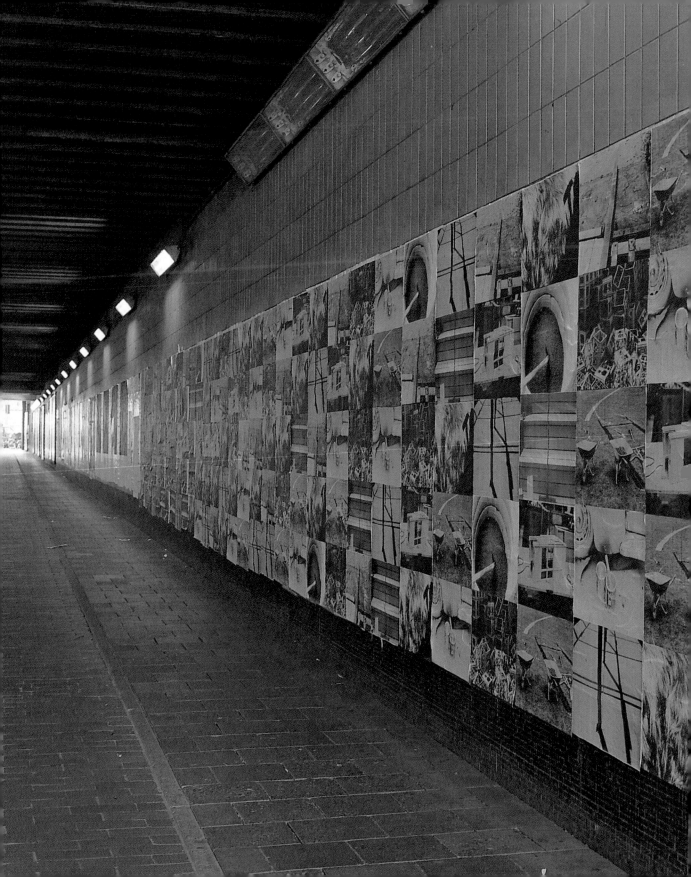

SVETLANA KOPYSTIANSKY

Born in Voronezh, Russia, lives in Berlin and
New York

For information about the artist and additional bibliography see:
Svetlana Kopystiansky. Shadows Gravitation, Art Institute of
Chicago, Chicago 1996; Svetlana Kopystiansky. The Library,
Kunsthalle Düsseldorf, Düsseldorf 1994; Igor & Svetlana
Kopystiansky, daad Galerie, Berlin 1991; Svetlana Kopystiansky,
Dany Keller Galerie, Munich 1989.

Onthology or Things that Might Have Been
The theme of the work is the change and
development that occurs in the process of
creating works of art
Installation
Bill boards in Münster

Skulptur [lat.], → Bildhauerkunst.

Bildhauerkunst, Bildnerei, Skulptur, Plastik, die Kunst, die aus
festen Stoffen (Stein, Holz, Metall, Ton, Gips, Knochen, Elfenbein
u. a.) körperhafte Gebilde schafft. Sie können allseitig durchgebil-
det (rund-plastisch) sein und so mit der Selbständigkeit eines
Gegenstandes im Raume erscheinen; sie können sich aber auch,
dem → Bilde vergleichbar, einer Fläche als Erscheinungsebene für
die Gestalten bedienen (→ Relief). Der Übergangsformen sind
viele. Die Weise des Bildens hängt von dem Stoff ab. Ton wird
geknetet (modelliert), Holz gehauen oder geschnitzt. Stein
gehauen, Metall geschlagen oder gegossen. Schon die Verschie-
denheit des Stoffs und die Bearbeitungsweise schafft sehr abwei-
chende gestalterische Möglichkeiten und Wirkungen. Holz erreicht
niemals die Festigkeit des Steins, dieser niemals die Weichheit des
Tons. Zuerst hat sich der Mensch der leicht zu bearbeitenden
Stoffe, wie Knochen und Ton, bedient. Viele der alten Mythen von
der Erschaffung des Menschen schildern den Schöpfergott als Ton-
bildner. Den Stein mag der Mensch zunächst unbearbeitet aufge-
stellt haben (→ Bild). Aber schon im 3. Jahrtausend v. Chr. besaß er
die Werkzeuge, ihn auch zu bearbeiten. Es gehört zum Staunens-
würdigsten der Menschheitsgeschichte, wie rasch der Mensch in
Mesopotamien und in *Ägypten* dazu kam, selbst den härtesten
Gesteinen wie Granit und Diorit, an die sich trotz der modernen
techn. Erleichterungen heute nur sehr wenige Bildhauer wagen,
Gestalt abzugewinnen. Wegen der Mühseligkeit und der körperli-
chen Anstrengungen seiner Arbeit war der Bildhauer bei den alten
Völkern der unangesehenste unter den Künstlern, obgleich er die
gestalterische Entwicklung lange maßgeblicher bestimmte als der
Maler. Die entscheidende Tat war die Erfindung der *Statue*, die
wohl auf das 3. Jahrtausend zurückgeht. Die ältere, aber auch spä-

ter noch vorkommende standflächenlose Figur hat keinen
bestimmten Ort; man kann sie grundsätzlich überall hinbringen,
legen, anlehnen, stellen, wie es sich gibt. Plastische → Idole haben
sich denn auch so gut in den Häusern wie in Gräbern oder wo der
Zufall sie sonst hinstreute gefunden. Die Figur, die eine Stand-
fläche hat, ob sie nun sitzt oder steht, verlangt grundsätzlich die
Aufgerichtet und den bestimmten Ort. Die Zahl der Plätze, die
für sie in Frage kommen, ist beschränkt; es gibt für sie sinnvolle
und sinnwidrige Orte. Soviel wir zu erkennen oder zu erschließen
vermögen, vollzog sich die Entwicklung der Figur zur Statue im
Zusammenhang mit der Architektur. Es waren dies wohl zunächst
nur der Tempel, der königl. Palast und das monumental ausgestal-
tete Grab. Da nun die vollkörperl. Figur eine eigene Standfläche
hat, drängt sie dahin, von den Bindungen frei zu werden, die ihr
die Architektur auferlegt. Das Körpervolumen der Figur nimmt zu.
Je mehr Volumen eine Figur hat, um so entschiedener schafft sie
sich durch ihre Körperlichkeit selber Raum. Sie will *Freifigur* wer-
den, die nun ihrerseits den Raum, in dem sie erscheint, bestimmt.
In Mesopotamien, selbst in Ägypten ist es zu dieser Freifigürlich-
keit nur in eingeschränktem Maße gekommen. Sie ist die Leistung
der *Griechen*, die in jahrhundertelangem Bemühen und schritt-
weise die Figur von den Gesetzen der Architektur lösten. Sie war
an eine geistige und an eine handwerkliche Tatsache gebunden.
Die geistige war, daß die griech. Plastik sich vornehmlich an der
menschl. Gestalt entwickelte, der Grieche den Menschen aber in
seiner Freiheit zu begreifen lernte. Die handwerkliche lag in der
Arbeitsweise begründet. Im Gegensatz zu dem spätantiken,
vollends zu dem modernen Bildhauer, ging der frühe und klassi-
sche griechische nie von einem Teil aus, sondern bearbeitete den
Block gleichzeitig von allen vier Seiten. Er trug ringsherum eine
dünne Schicht nach der anderen ab. In den vielen Formzuständen,

die der Block durchmachte, erschien er daher jeweils als ein Ganzes und kam als solches zu wachsender Bestimmtheit.

Der große Brockhaus, sechzehnte, völlig neubearbeitete Auflage in zwölf Bänden, zweiter Band, F. A. Brockhaus Wiesbaden 1953

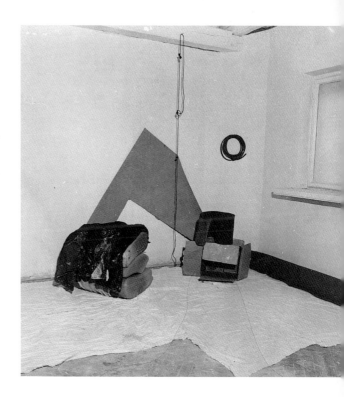

Sculpture, Art of

Sculpture is not a fixed term that applies to a permanently circumscribed category of objects or set of activities. It is, rather, the name of an art that grows and changes and is continually extending the range of its activities and evolving new kinds of objects. The scope of the term is much wider in the second half of the 20th century than it was only two or three decades ago, and in the present fluid state of the visual arts nobody can predict what its future extensions are likely to be. Certain features, which in previous centuries were considered essential to the art of sculpture, are not present in a great deal of modern sculpture and can no longer form part of its definition. One of the most important of these is representation. Before the 20th century, sculpture was considered a representational art; but its scope has now been extended to include nonrepresentational forms. It has long been accepted that the forms of such functional three-dimensional objects as furniture, pots, and buildings may be expressive and beautiful without being in any way representational; but it is only in the 20th century that nonfunctional, nonrepresentational, three-dimensional works of art have been produced.

Again, before the 20th century, sculpture was considered primarily an art of solid form, or mass. It is true that the negative elements of sculpture – the voids and hollows within and between its solid forms – have always been to some extent an integral part of its design, but their role has been a secondary one. In a great deal of modern sculpture, however, the focus of attention has shifted, and the spatial aspects have become dominant. Spatial sculpture is now a generally accepted branch of the art of sculpture.

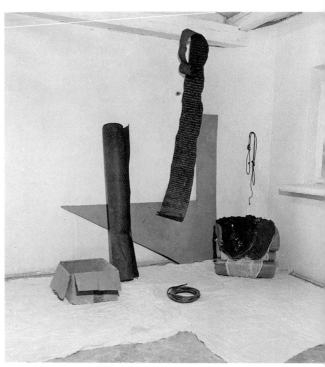

It was also taken for granted in the sculpture of the past that its components were of a constant shape and size and did not move. With the recent development of kinetic sculpture, however, neither the immobility nor immutability of its form can any longer be considered essential to the art of sculpture.

Finally, 20th-century sculpture is not confined to the two traditional forming processes of carving and modelling or to such traditional natural materials as stone, metal, wood, ivory, bone, and clay. Because present-day sculptors use any materials and methods of manufacture that will serve their purposes, the art of sculpture can no longer be identified with any special materials or techniques.

Through all of these changes there is probably only one thing that has remained constant in the art of sculpture, and it is this that emerges as the central and abiding concern of sculptors: The art of sculpture is the branch of the visual arts that is especially concerned with the creation of expressive form in three dimensions.

Sculpture may be either in the round or in relief. A sculpture in the round is a separate, detached object in its own right, leading the same kind of independent existence in space as a human body or a chair. A relief does not have this kind of

independence. It projects from and is attached to or is an integral part of something else that serves either as a background against which it is set or a matrix from which it emerges.

The actual three-dimensionality of sculpture in the round limits its scope in certain respects in comparison with the scope of painting. Sculpture cannot conjure up the illusion of space by purely optical means or invests its forms with atmosphere and light as painting can. It does have a kind of reality, however, a vivid physical presence that is denied to the pictorial arts. The forms of sculpture are tangible as well as visible, and they can appeal strongly and directly to both tactual and visual sensibilities. Blind people, even those who are congenitally blind, can produce and appreciate certain kinds of sculpture. It has, in fact, been argued by the 20th-century art critic Sir Herbert Read that sculpture should be regarded as primarily an art of touch and that the roots of sculptural sensibility can be traced to the pleasure one experiences in fondling things.

All three-dimensional forms are perceived as having an expressive character as well as purely geometric properties. They strike the observer as delicate, aggressive, flowing, taut, relaxed, dynamic, soft, and so on. By exploiting the expressive qualities of form, a sculptor is able to create images in which subject matter and expressiveness of form are mutually reinforcing. Such images go beyond the mere presentation of fact and communicate a wide range of subtle and powerful feelings.

The aesthetic raw material of sculpture is, so to speak, the whole realm of expressive three-dimensional form. It may draw upon what already exists in the endless variety of natural and man-made form, or it may be an art of pure invention. It has been used to express a vast range of human emotions and feelings from the most tender and delicate to the most violent and ecstatic.

All human beings, intimately involved from birth with the world of three-dimensional form, learn something of its structural and expressive properties and develop emotional responses to them. This combination of understanding and sensitive response, which constitutes what is often called a sense of form, can be cultivated and refined. It is to this sense of form that the art of sculpture primarily appeals.

The New Encyclopaedia Britannica in 30 Volumes, Volume 16, 15th Edition

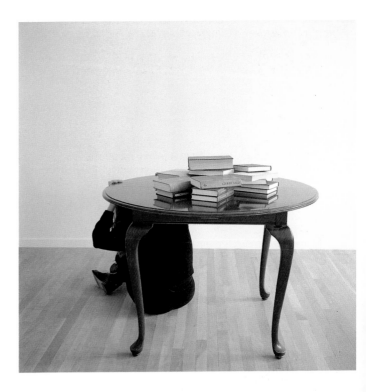

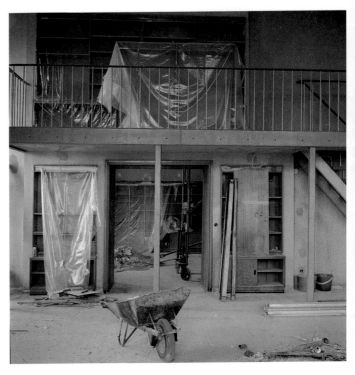

Svetlana Kopystiansky: *Changes of the Form of Emptiness*, installation 1979, (opposite, above and below); each object of this installation was considered as a sculptur surrounded by emptiness. Objects were moved and the shape of emptiness changed.
Svetlana Kopystiansky: *Performance*, one hour performance, 1990 (above), and *The Library*, Humboldt Universität Berlin, 1993 (below); the process of renovation and changes of space become a subject of the work. It was documented by the artist taking photos every day over a period of one week.

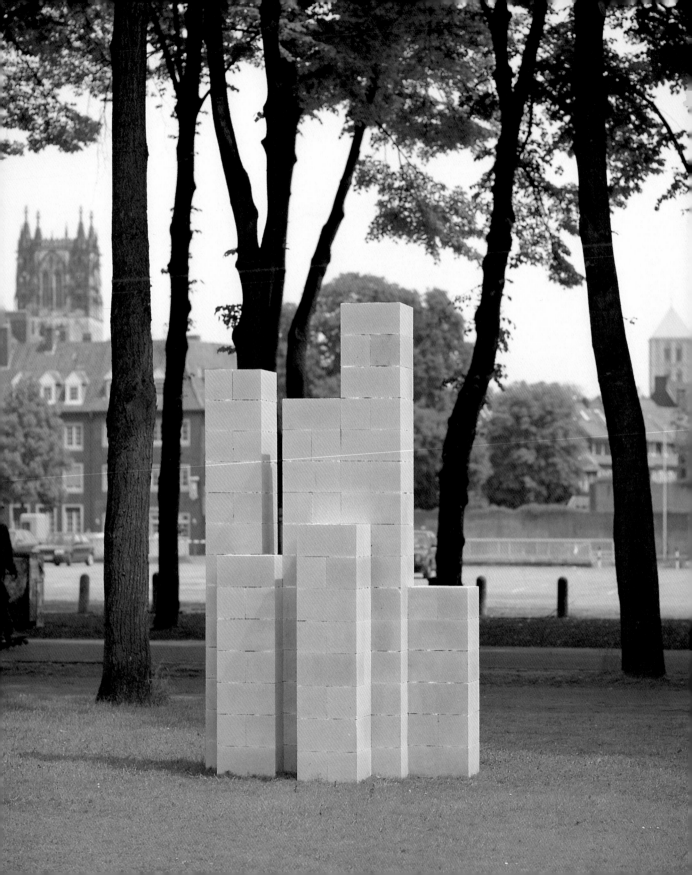

SOL LEWITT

Concrete Blocks/Six Vertical Rows
Sculpture (chalky sandstone, 3x2x1.2m)
Lawn south of southern gate house near the
Schloß

Here is a proposal for Münster. It is made of
concrete blocks 20x20x40 cm (standard mea-
sure) consisting of six piles (120, 300, 160,
240, 140, 260 cm). They must be cemented
together and it must be level, not painted.

Born 1928 in Hartford, Connecticut,
lives in Chester, Connecticut

Sol LeWitt: *White Pyramid,* location: botanical garden,
cellular concrete, painted white, 5.1 x 5.1 x 5.1 m (below
left) and *Black Form – Dedicated to the Missing Jews,*
location: in front of palace, cellular concrete, painted
black, 1.75 x 5.2 x 1.75 m (below right), contributions to
Skulptur Projekte in Münster 1987

For information about the artist and additional bibliography
see: Sol LeWitt. Critical Texts, ed. Adachiara Zevi, Rome
1995; Sol LeWitt. Structures 1963-93, The Museum of Mod-
ern Art, Oxford 1993; Sol LeWitt, Wall Drawings 1984-1992,
Kunsthalle Bern, Bern 1992.

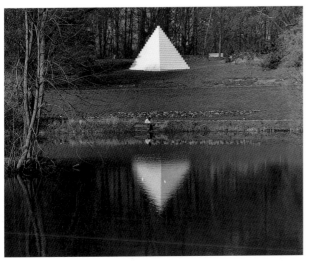

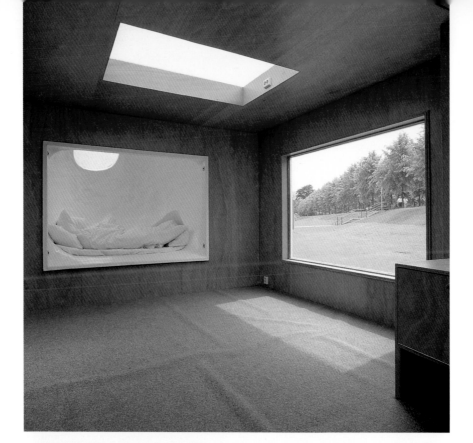

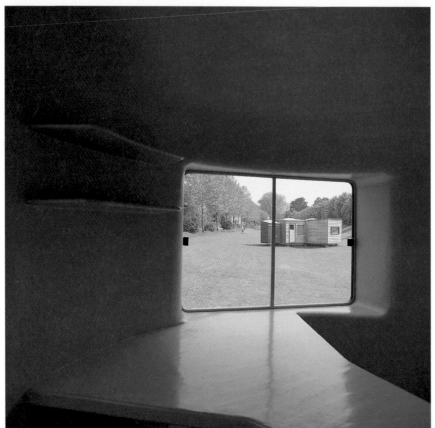

ATELIER VAN LIESHOUT

Hausfreund II
(House Friend)
Four-part installation consisting of:
Mobile Home for Kröller Müller, 1995
Collection of Kröller-Müller Museum, Otterlo
Modular House Mobile, 1995–96
Collection of the artist
CAST Mobiel, 1996
Cast collection, Tilburg
Autocrat
Depression in terrain of Promenadenring, near
Hörsterstraße across from the Staatsarchiv

Atelier van Lieshout: *Mobile Home for Kröller-Müller*, and
CAST Mobiel on the Promenade

Founded 1995 in Rotterdam

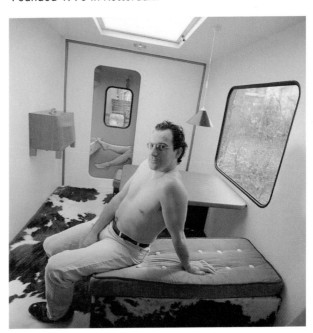

Camiel van Winkel: Joep van Lieshout –
Not Depressed

It would seem that Joep van Lieshout has been
able to work through his last identity crisis of
over twelve years ago. The question of whether
the things he produces are art doesn't interest
him (any more): "The main thing is, I can make
what I want." Making ends meet doesn't seem
to be a problem either: in order to handle the
volume of commissions, he founded the Atelier
van Lieshout with a number of colleagues: it is
a business where all the objects are still mod-
elled and executed individually by hand. Within
a few years, production has expanded from
individual pieces of furniture to integrated inter-
ior designs. The ambiguous identity of the

For additional bibliography see: Atelier van Lieshout: "Hausfreund",
Kölnischer Kunstverein / Museum Boymans-van Beuningen, Ost-
fildern 1997; Bars. Atelier van Lieshout, Kunstverein Reckling-
hausen, Recklinghausen 1996; Raw Material, Kröller-Müller
Museum, Otterlo 1995; Dutch Design Café, Museum of Modern
Art, New York 1995; Album, Museum Boymans-van Beuningen,
Rotterdam 1995.

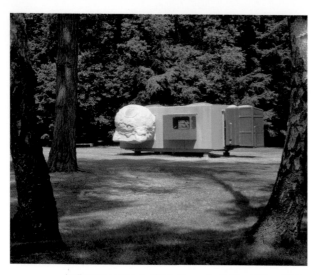
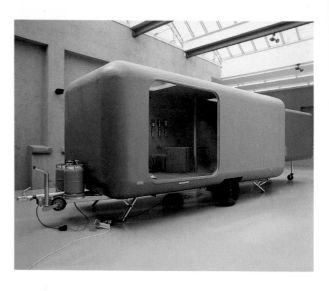

Atelier van Lieshout: *Mobile Home for Kröller-Müller,* 1995, collection of Kröller-Müller Museum, Otterlo (left) and *La Bais-o-Drôme,* collection of FRAC Rhône-Alpes, Lyon (right)

present work is certainly not due to any existential indecision on the part of its creators. Rather, it is a programmed, intentional ambiguity, a strange play within a particular field of application. Take for example the *Sensory Deprivation Helmets* and the *Sensory Deprivation Chambers,* to mention two clearly recognizable variations of this strangeness. Here, quiet and comfort are suddenly no longer suitable for humans. The close-fitting helmets and booths with their biomorphic exterior ensure complete isolation and separation from the outside world. Those who expose themselves to these objects are, so to speak, "thrown back on themselves", and they soon feel the limitations: the capsules even inhibit the air supply.

Since 1989, when Joep van Lieshout first began working with a universally applicable object coating consisting of a combination of glass fiber and polyester, he has used it to create an extensive corpus of monochrome tables, chairs, cabinets, desks, sinks, bathtubs, toilet bowls, urinals, kitchen units and home bars –

all the way to complete bathroom and kitchen installations. With the *Prefabricated Sanitary Units for Application in Mobile Homes* (1992) he expanded his field of activity to include the world of campers and mobile homes. For himself, he transformed an old truck into a luxurious camping vehicle decorated with furs on the interior and drove it across North America. The impression of luxury and Epicureanism increased still more in the telescoped, veneered *Bais-o-Drôme* of 1995, with all kinds of built-in equipment for music, relaxation, and beverages. The architectural assemblage on wheels finally reached a rather grotesque high point in the *Mobile Home for Kröller-Müller,* also of 1995, in which various *Slave Units* could be combined at will with the *Master Unit.* At first glance, the philosophy of this flexible-decadent lifestyle seems oriented to the modular hedonism described by Rem Koolhaas in his book *Delirious New York*: the cinematic, episodic existence of the big-city cosmopolite, whose rhythm of life is defined by a succession of

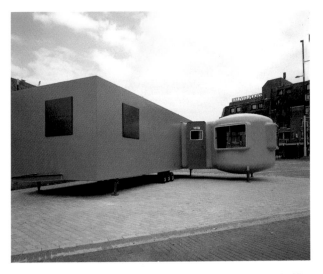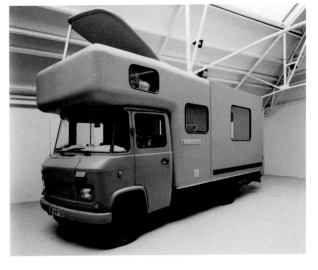

Atelier van Lieshout: *CAST Mobiel,* 1996, collection CAST, Tilburg (left) and *Modular House Mobile*, 1995/1996, collection of the artist (right)

attachments to various distribution centers of bodily stimuli: eating oysters without taking off your boxing gloves. The architecture Koolhaas associates with this phenomenon is an over-programmed setting with different modules for each individual body function.

The limited applicability of this interpretation to Joep van Lieshout, however, is apparent from his last work, Survival Unit *Autocrat.* This fully equipped mobile home was developed to accommodate an isolated, spartan life: its in-habitant must be able to survive with a mini-mum of comfort on what nature alone provides. The unit has facilities for catching rainwater, slaughtering animals, drying, salting, and pre-serving meat, heating with wood, etc. Rather than hedonism, it is the frontier spirit of the fur trapper in his log cabin that rules here – the will to survive as a solitary individual, without the advantages (or even the availability) of super-markets, cable television, or pizza delivery.

Such romantic isolationism seems a typical male fantasy – in the same way, incidentally, as

the hedonistic body attachments; in both cases, the female element is present "only" as an invisible energy source, as a drive keeping the male motor running. But the two worlds are also completely mutually exclusive: self-disci-pline is either a necessity or a sport, and mas-culinity either a matter of conditioning or an image – or at least so it seems. But is all this a fact, or merely an ideological persuasion? It is striking how seldom the art world asks whether what Joep van Lieshout makes is art or not. I admit it is a somewhat superfluous question, a non-question even, but that still doesn't explain anything. Perhaps the reason the question is so little asked is that the art world itself is marked by the same double standard: on the one hand, sensual pleasure and graphic enrichment, and on the other isolation and mental concentra-tion. The experience of sensual beauty almost always takes place in the monastic austerity of some white cube or another. Joep van Lieshout is tolerated and his art welcomed, not only because his colors are considered so exciting

and his interior designs so realistic, but above all because he presents a dialectical solution to this dichotomy. His solution consists, one could say, in parables on the relationship between master and slave. They are cheerful parables, almost homey, do-it-yourself parables, that allude to the connection of the individual with the circumstances of his life. They show how every attempt at isolation congeals into paradoxes. Just as the master is dependent on the slave and the slave on the master, so the master of the house is dependent on his home furnishings as well. The instrumentality of modern comfort is reversible; our relationship to the bathtub is reversible, we ourselves are reversible. (In the fetishistic world of architecture, where behavior tends to be either emphatically progressive or emphatically conservative, and always at just the wrong moment, van Lieshout's isolation paradox has the effect of a strong antidepressant.)

Very well. Although the artist does not exclude the possibility of selling his business one fine day and retreating into the sticks with his *Survival Unit*, I can hardly believe that the Atelier van Lieshout could continue to produce without van Lieshout himself. In the final analysis, his work is much more personal than it appears at first glance. Despite the flexibility that renders it generally accessible, the specific reversal of the positions of *Master* and *Slave* is a personal repertoire. No one besides Joep van Lieshout himself could have recognized the futuristic, sensual potential of the camper-aesthetic – originally the aesthetic of the *petit bourgeois* – and granted it autonomy as a universal, organic mode of construction that is everywhere more than welcome.

Atelier van Lieshout: *Autocrat,* 1997, exterior and interior view (below); *Mobile Home for Kröller-Müller*, construction drawing, 1996 (opposite)

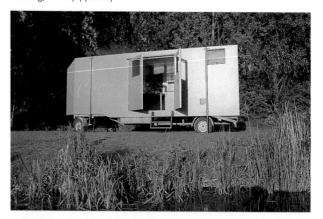

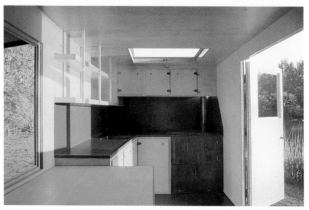

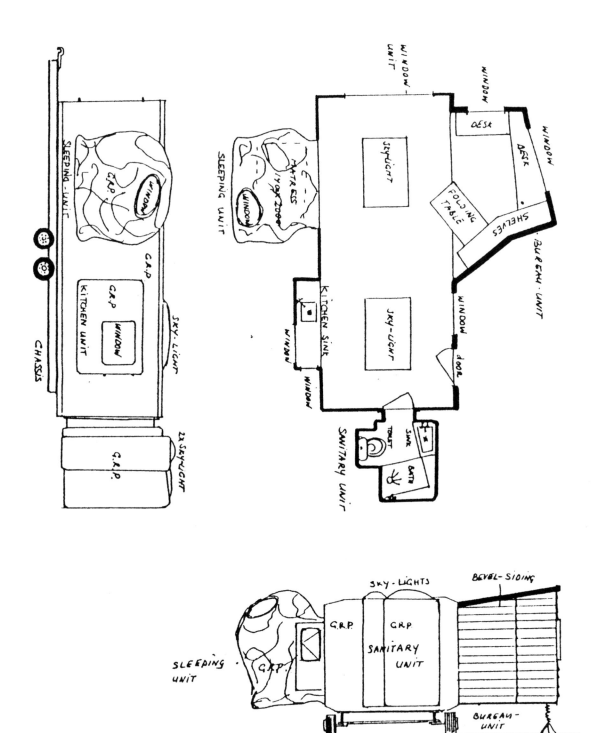

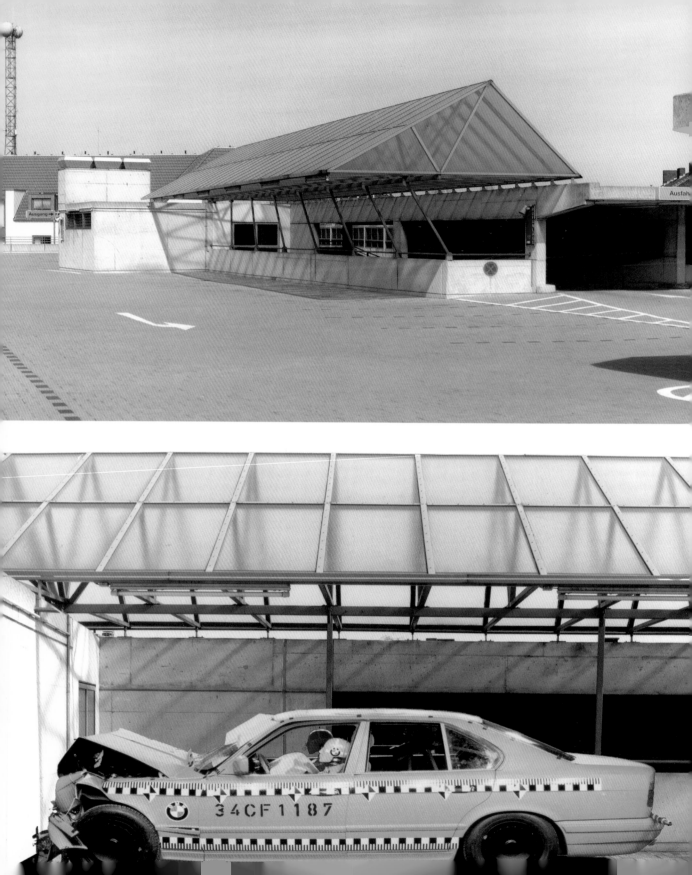

OLAF METZEL

Parkhaus Bremer Platz, Ebene 4
(Bremer Platz Car-park, Level 4)
Installation

Ludgeristraße (gegenüber von McDonalds')
(Ludgeristraße [across from McDonald's])
Installation
Not realized

Born 1952 in Berlin, lives in Munich

Olaf Metzel: Free Guts

In 1982, a lot of gas stations were closed or abandoned due to rising gasoline prices, which in turn were due to the oil crisis. Here one always remembers the automobile-free Sunday. Nowadays, when freeways are barricaded, it's because of miners.

Back then I had an offer to exhibit at Kunstraum München, and it seemed logical to turn a gas station into a sculpture. The search for an appropriate object took somewhat longer. In the process, I learned a lot about mineral oil companies, about landlords and tenants, and also about the role of municipal authorities. The *Tankstelle Landsberger Straße 193 (B2)* proved suitable, and we talked about a drive-in exhibition. In its three rooms I concentrated on sale, repair, and car washing. As usual with exhibition preparations, time was short, and I had to work nights as well. This was very interesting, for as it turned out, in those days the arterial street Landsberger Straße, i.e. the Bundesstraße 2 (a federal highway), was also frequented by streetwalkers. So there were conversations about the work, and an audience already before the opening. As with later projects, reactions were varied. I still remember

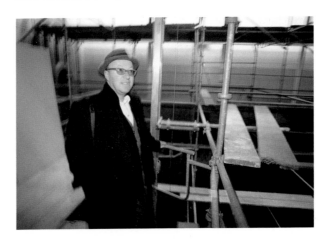

For information about the artist and additional bibliography see: Olaf Metzel. Freizeitpark, Städtische Galerie im Lenbachhaus, Munich 1996; Olaf Metzel. Zeichnungen und Modelle zu Projekten im Außenraum, daad Galerie, Berlin 1995; Olaf Metzel, Hamburger Kunsthalle, Hamburg 1992; Olaf Metzel. Zeichnungen 1985–1990, Kunstraum München/Westfälisches Landesmuseum für Kunst und Kunstgeschichte Münster, Munich 1990.

the way a Munich newspaper formulated it: "…erected a sculpture at a gas station". Today the site is occupied by government-subsidized housing.

An example of the use of familiar street objects was the work *13. 4. 1981* (April 13, 1981) created for *Skulpturenboulevard* in Berlin in

1987. It consisted of an ensemble of police barricades wedged together as well as a shopping cart, with a total height of 12 m. In order to emphasize the limited period of installation, the sculpture was weighted only with cement blocks. Its location was the street intersection at the corner of Joachimstaler Platz and Kurfürstendamm.

On a Sunday evening in April, 1981, 200 shop windows on Kurfürstendamm were shattered in a spontaneous demonstration. The violence was in reaction to a hoax launched by the media shortly before the elections.

The press with its headlines is part and parcel of the *Skulpturenboulevard*. And when those headlines refer to the place where sculptures are to be set up, it seems logical to make the headline-making and obviously recurring event the subject of the sculpture and the date its title. The (predictably) vehement reaction of the press was part of the spectacle, since the work was about manipulation by the media. In the *Tagesspiegel*, for example, art critic Heinz Ohff wrote that the work was a garbage heap and that therefore the culture pages were not obligated to cover it. Ephraim Kishon published an announcement stating that he was a trained metal sculptor and therefore qualified to recognize scrap when he saw it, namely the project I realized on Kurfürstendamm. Applause for his opinion was certain; I think he then went on to hawk his newly published book.

In spite of this, the sculpture was also received positively by the population. It became the cen-

Olaf Metzel: Model for *Ludgeristraße (gegenüber von McDonald's)*, 1997, scale 1:20, brass, steel, sheet metal, 66x35x33 cm (below); *Meistdeutigkeit*, 1996, location: Bonn, Parlamentsplatz (opposite left); *13.4.1981*, 1987, location: Kurfürstendamm, Berlin, installation (opposite right)

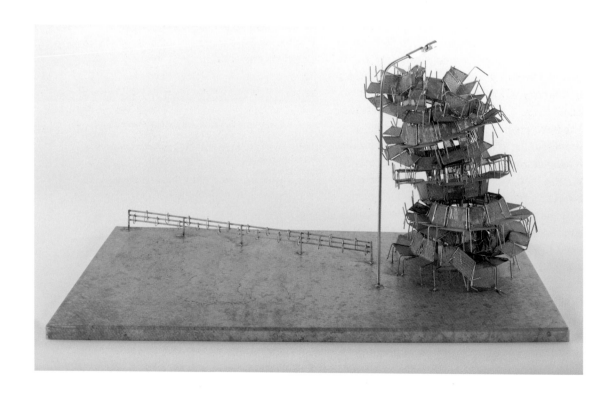

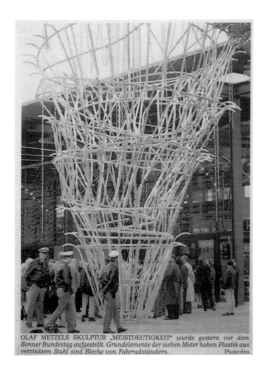

OLAF METZELS SKULPTUR „MEISTDEUTIGKEIT" *wurde gestern vor dem Bonner Bundestag aufgestellt. Grundelemente der sieben Meter hohen Plastik aus verzinktem Stahl sind Bleche von Fahrradständern.* Photo: dpa

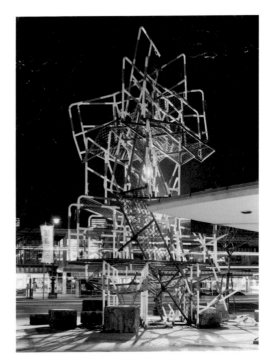

tral meeting place for demonstrations, it rained flyers during the census boycott, at the Tour de France it served as a tribune, and the police themselves thought about the barricades in a different way. The conclusion was unambiguous: away with it. In a TV broadcast with Thomas Gottschalk, the then Mayor Diepgen promised to have the garbage heap cleared away if he was reelected. In 1988, the sculpture was dismantled.

Since then, reconstruction has increasingly become a topic of discussion. Maybe not in East Berlin, since – as architectural critic Wolfgang Kil remarked before the advisory committee on art – it is, after all, West-art, and in general he knew the Vietnam war only from television.

Another element of urban furniture that cannot be imagined away are bicycle racks. They exist in every variation. In front of public buildings they are ubiquitous.

In a place approached on foot or in a service vehicle, a bicycle rack is superfluous. This describes the idea for a sculpture set up in 1996 in front of the Deutscher Bundestag in Bonn. It takes over the function of the parliamentary delegates as representatives of the people and visualizes it with an everyday object: a bicycle rack on the square.

Normally, bike racks are set up in a straight line. Here, they assume the form of an upside down piece of a cone, with individual segments joined into a circle and inverted. Chains, wound around the steel pipes at irregular intervals, underline the transience of the arrangement.

Freed from its usual function, the bicycle rack gives rise to new and unusual meanings and ways of seeing; the title is *Meistdeutigkeit* (multivocality; after Elias Canetti).

In the pedestrian zone *Ludgeristraße (gegenüber von McDonald's)* in Münster, a bicycle rack is already present, as well as several litter bins,

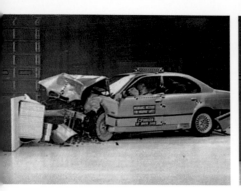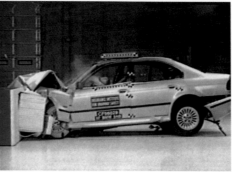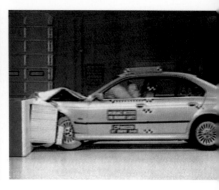

dispensing machines, and the usual street lamps. The latter are to be supplemented by an additional one – but this time with a whipping post. What is lacking, however, are the places to sit that are found elsewhere in the pedestrian zone. Steel seating units are available in pink, blue, violet, orange, white, and green; in each case, twelve seats form a ring. These round seating groups are to be stacked in and against each other in varying color sequences up to a height of ca. 6 m.

Erst rechts, dann links, dann immer gerade aus (First right, then left, then straight ahead), a 50-meter-long double row of freeway crash barriers mounted over each other and along eight concrete pillars at eye level and bathed in yellow light – part of the Freizeitpark 1996 in the Kunstbau of the Lenbachhaus in Munich. The Belgian freeway, lighted by night, was to be the greatest Land Art project – viewed from outer space. "Fahrn, fahrn, fahrn auf der Autobahn" (Kraftwerk) or "Things act, people happen" (Bruno Lader); in any case without boredom no aggression. Sooner or later comes the crash – fascinating, both on account of the high speed and because expensive material is destroyed. Roads and traffic are a place for unloading aggressions.

In the *Parkhaus Bremer Platz, Ebene 4* is the top parking deck, covered only on the entry and exit ramps. You can reach it by car for a charge of DM 1 (not including the charge for parking) or by stairs or elevator. A sign says that the car-park is suggested by the automobile club. The turns can be taken well. The circling up and down movements give a subdued impression of the spatiality. The self dynamic of these turns can be seen very well in the car chases of the movie *Blues Brothers*. There it was emphasized by the spiral architecture of the Marina Towers in Chicago and the popular

Olaf Metzel: *Tankstelle Landsbergerstr. 193 (B 2)*, 1982, location: Landsbergerstraße, Munich, installation (below); *Erst rechts, dann links, dann immer geradeaus*, 1996, Lenbachhaus, Munich (opposite below)

orgies of destruction. This acoustic installation is based on a crash test. In it, a vehicle is pulled against the wall by a steel rope. The noises during the test, from ignition to crash, are to be broadcast in Dolby-Surround-System triggered by sensors. The location for the proposed project is the covered parking space next to the exit ramp and stairwell. The loudspeakers are arranged under the roof, over a distance of 20 m. The parking places in this area should remain empty. The sounds from the real crash will be mixed in the studio, and recorded onto CD. Illustrated here is a computer animation simulating a crash test in this location.

Every city has its pedestrian zones; they define the image of the downtown area. Hence the many parking garages for parking as well; how long these spaces will remain public, who they belong to, when they will be privatized, i.e. roofed over, heated, and guarded, or when they will mutate into giant shopping centers, is a question of time. The furnishing process continues. Innumerable catalogs display the options available in "attractively designed and sturdy", i.e. indestructible, secondary architecture. And of course there are helpful customer service representatives as well. The service industry is everywhere. Public employees' jobs are made easier and we are familiarized with the concept of design. The only thing different from designer furniture is the price – these are cheaper. Münster, too, has its pedestrian zones and parking lots. That's why I proposed two projects: *Ludgeristraße (gegenüber von McDonald's)* and *Parkhaus Bremer Platz, Ebene 4.*

REINHARD MUCHA

(1997) Nach vorne
([1997] Forward)
Eight school classes from Münster

Born 1950 in Düsseldorf, lives there

Reinhard Mucha, April 1997

As my contribution to the exhibition *Skulptur. Projekte in Münster, June 22–September 28, 1997*, I would like to present my work up to this point to eight classes from different schools in Münster, personally and in their classrooms. The title of this project is: *(1997) Nach vorne*. It would be good if not only upper-level schools could be found for the project, but also elementary schools, vocational schools, etc. In the exhibition catalog, each individual class will be shown in a group photo in front of their school, staged as much as possible by the students themselves.

For information about the artist and additional bibliography see: Reinhard Mucha. Mutterseelenallein, Museum für Moderne Kunst, Frankfurt/M. 1992; Reinhard Mucha. Gladbeck, Musée national d'art moderne, Centre Georges Pompidou, Paris 1986; Reinhard Mucha. Das Figur-Grund Problem in der Architektur des Barock (für dich allein bleibt nur das Grab), Württembergischer Kunstverein, Stuttgart 1985.

From left to right: Intermediate grade of the Adolph-Kolping-Schule, 12th grade of Ratsgymnasium, 12th of Marienschule, 12th grade of Hittorf-Gymnasium, 9th grade of Realschule des Kreuzviertels, 7th grade of Geistschule, two 7th grades of Uppenbergschule, 2nd grade of Hermann-Grundschule

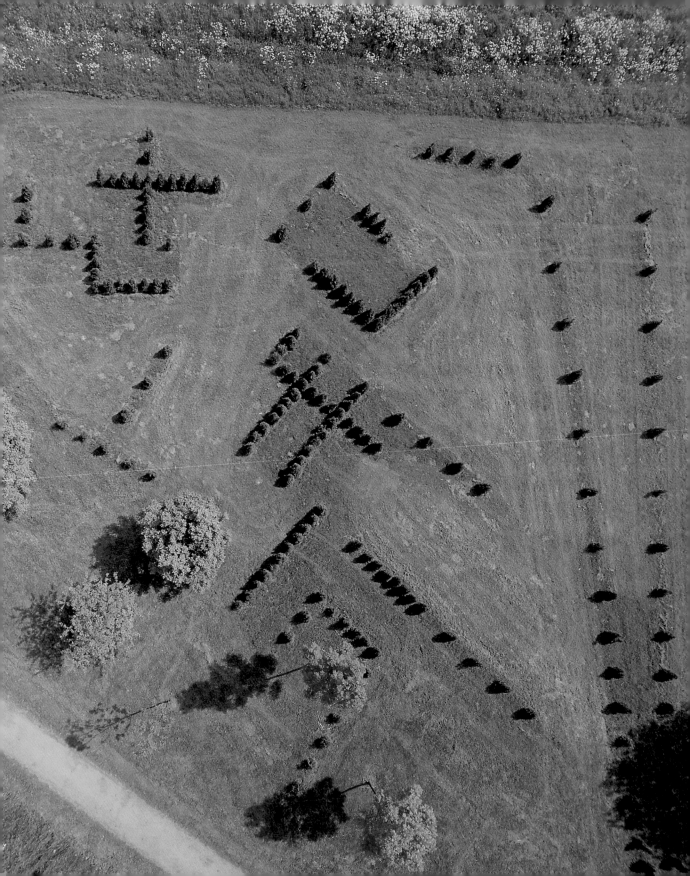

MARIA NORDMAN

De Civitate, 1991
Sculpture (Ginkgo biloba, Metasequoia glypto-
stroboides, Thuja occidentalis, water, air, light
from sun, moon, stars, grasses, flowers)
Wienburg-Park

Born 1943 in Görlitz, lives in Santa Monica,
California, and in the cities, where she works

Erich Franz: Maria Nordman, *De Civitate,*
Münster 1991

Maria Nordman's works are impossible to sur-
vey from a distance or take in at a single
glance. Ever since her first sculptures of fire
(*Garden of Smokeless Fire,* 1967) and smoke
(*City of the Clouds,* 1967), the "body" of her
sculptures has at the same time been the
"space" of the viewer. Her work is public in its
substance; it is a space with people in the city.
Inside and outside, work and viewer, sculpture
and space, art and reality are not disconnected
in her sculptures, drawings, structures, and
space projects; rather, they permeate one
another, cooperate with and influence each
other, become elements of one another. The
sculpture *De Civitate* is saturated, as it were,
with its surroundings – with the park and fields
opening up on all sides, with the space of the
viewers' movement and their penetrating,
changing gazes, with the light of the sun and
the moon, with the air and the rain, with the
ground that nourishes the plants, and with the
plants' activities and reactions to light, climate,
and the seasons.
The arrangement of trees on a lawn in three
sections running parallel to a path is a commu-

For information about the artist and additional bibliography see:
Maria Nordman. De Sculptura/De Civitate, Museum Folkwang,
Essen, Ostfildern 1997; Maria Nordman. De Theatro. Staats-
galerie Stuttgart, Ostfildern 1996; Maria Nordman. Markt
Stommeln, Stadt Pulheim, Cologne 1996; Maria Nordman.
De Musica.New Conjunct City Proposals, Münster/Lucerne/
New York/Hamburg 1993.

nicative, inclusive, and open sculpture, yet it is
still a *sculpture:* a visually perceptible body in
space, surrounded on all sides by open areas,
defined and constructed internally according to
a formal geometry, and made of a lasting mate-
rial – trees with a long life. But not only is this
sculpture surrounded by space, it is filled with
it; space and sculpture are in fact indistinguish-

able. The life principle of the plant, the *osmosis* through the cell walls, constitutes the design principle of this sculpture as well: its form can only be perceived and experienced as an *interchange* between interior and exterior, to the point of negating the distinction. The life of plants and the light of the sun stand in a reciprocal relationship to each other, and through the open, gradually expanding geometry of the visible forms, this absorption and transformation is turned into a visual, sculptural experience. Its fixed form brings the changes in the plant and the changes in the light into contact with another kind of change: the processuality of human sense experience (sight, but also exploratory movement and touch, with the images and memories associated with them). The crucial element is the openness of these geometric arrangements, which in different ways also incorporate "exterior" space.

The sculpture is likewise filled with *time*: in its fixed form it does not stand outside of time, but rather incorporates it as process and change.

The alternation of day and night, winter and summer, takes place *within* the sculpture; the movement of growth and the development of life belongs to it. There is also tranquillity and perpetuity – not as timeless rigidity, but as gradations of slowness: the evergreen of the Thuja tree, the seasonally changing "needles" of the metasequoia, and the ancient *Ginkgo biloba*, a primitive, fan-leaved tree that has remained unchanged for 270 million years and that has reached ages of up to 1000 years in China. In the sculptural "material" of the trees, the experience of permanence – over the course of days, seasons, years, millennia, millions of years – is here freed from petrification: permanence as change, changing permanence.

Very slowly, without contrasting hardness, the geometry comes to life in a free, open process of growth, a geometry that the eye first apprehends as design; then vision itself comes to life, unifying design and growth, sculpture and nature, the space of seeing and the space of movement. For the most part the Thuja trees

are planted so thickly that they form walls, chambers and spaces that one can enter, boundaries and openings for the human body, here above all for children. The other two sections (with trees that renew their foliage yearly) lie parallel to the straight course of the path (here, too, there is interpenetration of boundary and opening); these sections are surrounded by avenue-like double rows of deciduous trees in a U-form, oriented in opposite directions. Both the gaze and the sunlight penetrate the rows in rhythmic sequence. The avenues leading away from the path focus the direction of both sight and shadow; in the midday sun, the shadows form a single line running exactly north-south along the course of the avenues. One U-form thus turns toward the midday sun, the other toward midnight. The visual scale expands in stages – from the surveyable and *see*-able, to the unity of the three sections that can no longer be apprehended in a single glance, to the space "above" (in the direction of the branches) and "below" (the roots), to the space

of the sun, the source of the light that moves through the rotation of the earth, and lastly – in a final outward expansion – the night-time space of the stars.

In this carefully ordered place of visual experience, there are two processes that gradually but inevitably encounter and affect one another: the living, unfixed motion of the world and of nature, and the living, unfixed motion of human visual perception. For a moment they meet at the juncture of artistically designed, geometric forms, only to pull away from each other once more to reach beyond this fixity. In the process, the boundaries of the work itself are annulled. When we see the sculpture, its modest yet emphatic transparency leads beyond it to that which surrounds and – in the interchange of interior and exterior – fills it. The boundaries we customarily use to define both

Maria Nordman: *Untitled* (opposite), *[/] Ground Owl/ Ground Squirrel Park*, 1978, Bakersfield, California, 1978, planting plan, drawings on tracing paper

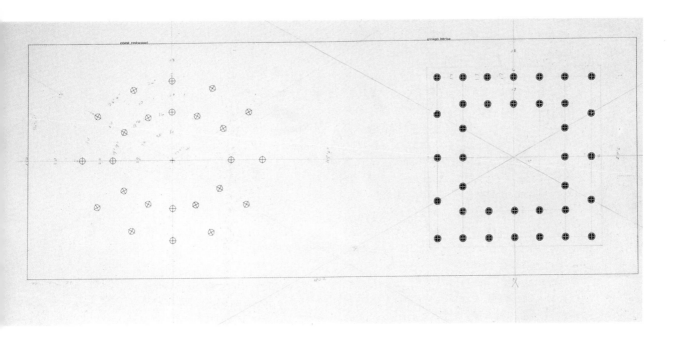

Maria Nordman: *De Civitate*, 1st draft, 1991

nature and art disappear; our traditional mode of thinking in boundaries – with the corresponding distinction between "interior" and "exterior" in traditional sculpture – becomes an osmotic, permeating, opening apprehension: nature as movement, art as a membrane for contacts, light as a transitory process, and time and space as an earthly, sensual experience and at the same time a sublime perpetuity and vastness, transcending our senses.

Maria Nordman's early tree-sculptures from 1977–78 on were already marked by this interactive relation between art and the surrounding space (which is also "interior" space) and between art and viewer. These works explored the transparency of inside and outside through the osmotic separation and connection of two equivalent yet different parts. The plan for *Coulter Pine/California Fan Palm Park* of 1977–78 calls for two quadratic spaces sur-

rounded by pines and palms with a boundary/juncture common to both areas. The plan[1] emphasizes the permeable nature of these "boundaries": "The right of passage/from every direction/through the walls of trees//On public land/surrounded by parklands or streets/a levelled ground/covered with grass/light and sound//specifications/– contains no objects to the edge of the grass/– between the trees is a distance of 20'/– grass continues to 20' outside the perimeter of trees/– selective watering for a similar growth rate of trees." The plan is inscribed "Public Square"; the decisive plastic element of this tree-sculpture is its "open walls" – open for light, sound, air, animals, and people.

Since 1969, Maria Nordman has been realizing sculptures in *public* space: not only does she exhibit objects, she opens the body of these sculptures to the encounter with the chance passer-by. At first they were rented spaces outside the official context of art (museum or gallery), spaces with *transparent walls*, for example the early *Workroom*[2] with two-way mirror glass: from the outside, passers-by see the image of their own exterior space; from the interior, within the boundary of the space, they watch the "film" of the happenings outside. Shortly thereafter the artist began creating "boundaries" that were even more permeable, for example through a precise demarcation in lighting that served to create *two* spaces within a single darkened, and once again rented, space (*4th and Howard*, San Francisco 1973; repeated in Varese, Collection of Panza di Biumo). In this darkness, all that is visible is a "boundary" of light.

Maria Nordman's tree-"sculptures" belong in the same category as these variously defined interrelationships of transparent and traversable areas, bodies, and spaces. The plan for a park *Linden Tree and Nordman Pine Park* shows a more marked contrast between two quadratic tree-"bodies": an *open* square of

lawn, irregularly "filled" with individual linden trees, and a quadratic "clearing" *enclosed* by a thickly growing row of pines, accessible through four "entrances" (1982).[3] In 1978 she executed *Ground Owl/Ground Squirrel Park* in Bakersfield, across from California State College.[4] The oval ring of an unpaved footpath about six meters wide is encompassed by a double row of sequoia trees. The inner area of the oval remains as uncultivated and available to the local flora and fauna as the surrounding area.[5] A second, quadratic footpath of packed local soil, surrounded by Ginkgo trees, itself surrounds a cultivated lawn extending on the outside to an area of 30x30 m. Here it is not only art and nature that are interrelated in a differentiated way, but also the gradations of "cultivated" and "uncultivated" nature – gradations which in turn connect up with the further gradation of nature formed by art. Here, everything – every level of the formed as well as the unformed – is contained in everything: the boundaries of "art" have been dissolved.

1 Maria Nordman: De Sculptura. Works in the City, Munich 1986, p. 88, figs. 42, 43.
2 Maria Nordman: De Musica. New Conjunct City Proposals, Münster/Lucerne/New York/Hamburg 1993, p. 32.
3 Maria Nordman: De Sculptura, p. 88, figs. 47a, 47b.
4 Ibid., p. 85.
5 Characteristic of Maria Nordman's work is the difference between this sculptural and real *permeability* and the *sanctuarium* created 18 years later in Münster by herman de vries, a work which is comparable to Nordman's in its openness to the chance arrival of flora and fauna and even in the oval form of its "boundary".

Maria Norman: *De Civitate*, 1991, aerial view of the sculpture, 1997

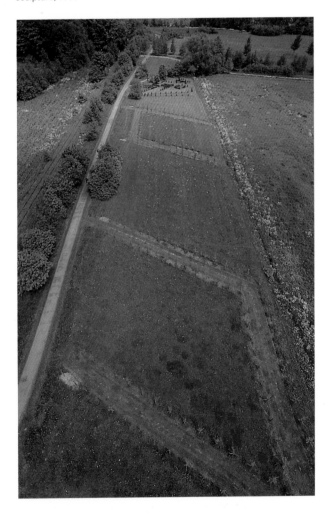

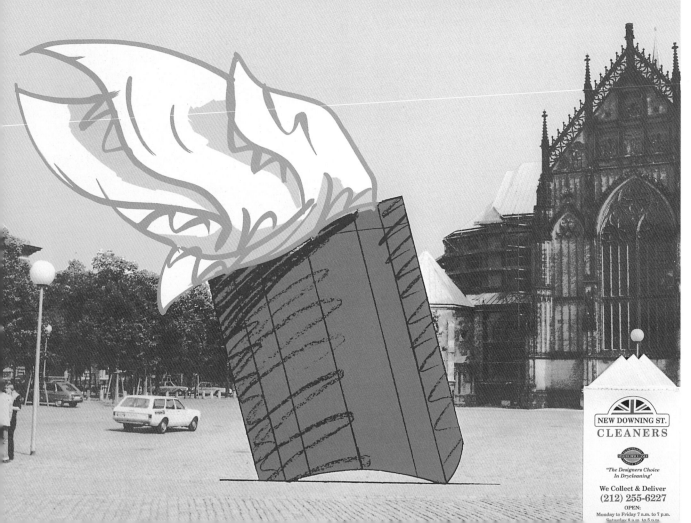

NEW DOWNING ST.

CLEANERS

*"The Designers Choice
In Drycleaning"*

We Collect & Deliver
(212) 255-6227

OPEN:
Monday to Friday 7 a.m. to 7 p.m.
Saturday 8 a.m. to 5 p.m.

CLAES OLDENBURG/COOSJE VAN BRUGGEN

The Architect's Handkerchief
Sculpture
South Domplatz
Not realized, presentation of the project in the
old section of Westfälisches Landesmuseum

Born 1929 in Stockholm and 1942 in Groningen,
live in New York

Claes Oldenburg/Coosje van Bruggen:
The Architect's Handkerchief

The handkerchief in the breast pocket has gone
out of style, at least in the western world, but at
one time it was the *sine qua non* of the perfect
gentleman's dress. It survives as a symbol in
the card slipped into the pocket of a suit when
it is returned from our local cleaners, on Down-
ing Street, which exploits the coincidence of its
address with that of the Prime Minister of the
United Kingdom.
Peter Blake wrote of Ludwig Mies van der Rohe:
"He is, indeed, something of a dandy in a sub-
dued way: there is generally a very soft, very
expensive handkerchief trailing out of his
breast pocket, and he obviously likes fine qual-
ity in all his personal belongings."[1]
In fact photos of Mies always show a breast
handkerchief always in a different arrangement,
suggesting that it is not just an ornament. Per-
haps he has just had to mop his brow or maybe
he wishes to signal his playfulness. We take it
as a sign of the architect's state of mind, his
invention. We liken it to the contrast Mies
achieves when he places a figurative sculpture
in the geometrical environment of the Barce-
lona pavilion. We did something similar in plac-

For information about the artists and additional bibliography
see: An Anthology, Guggenheim Museum, Washington/Bonn/
London 1995–96; Claes Oldenburg/Coosje van Bruggen:
Large-Scale Projects, New York 1994; Claes Oldenburg, Tel Aviv
Museum of Art, Tel Aviv 1994; Claes Oldenburg: Large-Scale
Projects. 1977–1980, New York 1980.

ing the *Monument to the Last Horse* for a sea-
son in front of the Seagram building in New
York, before it reached its permanent location
at the Chinati Foundation in Marfa, Texas. This
sculpture sets out to isolate the handkerchief in
its pocket, like a torch, the token of the
bearer's inspiration. We represent it from two
viewpoints: the one facing out – the public side;
and the one facing the person (the heart) – the

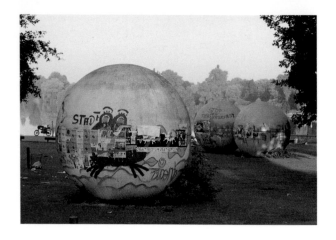

private, backstage view. Folded pocket hand-kerchiefs are made to look best from one side; the other side merely gathers the remainder of the fabric.

To give the subject more independence as a sculpture it is tilted leftward, as no breast pocket would be, and the handkerchief emerges opposite to its proper direction.

In order to explore the lost knack of folding the handkerchief according to convention, Coosje went to the conservative haberdashery Brooks Bros. for lessons from a veteran salesman, though in the end, she devised the solution by lifting the square from the center. This is what Mies must have done in the photo chosen from the variations we had seen, given the softness and casualness of his handkerchief.

Despite its derivation from the example of Mies, the *Architect's Handkerchief* is intended to refer to any combination of rigidity and soft-ness, structure and freedom. It has no particu-lar site though a setting with an architectural character would be best. Like the *Pool Balls* it could be anywhere around town. One could begin by trying one or two of the locations given the loose *Pool Balls* in 1977.

1 Peter Blake: The Master Builders, New York 1970.

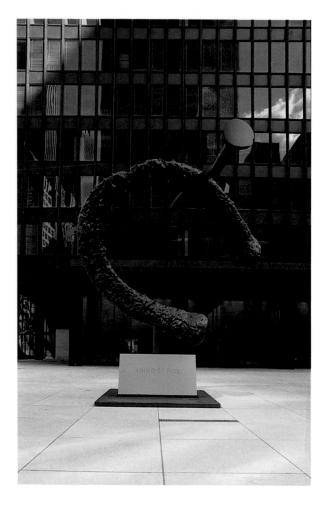

Claes Oldenburg: *Project for Münster II,* location: Aasee terraces, *Giant Pool Balls* (concrete, diameter 3.5 m each), contribution to *Skulptur Ausstellung in Münster 1977,* photo 1997 (above)
Claes Oldenburg/Coosje van Bruggen: *Monument to the Last Horse,* 1991, aluminum and polyurethane foam, pain-ted with polyurethane enamel, 6 x 5.18 x 3.76 m, collection of Chinati Foundation, Marfa, Texas (below)

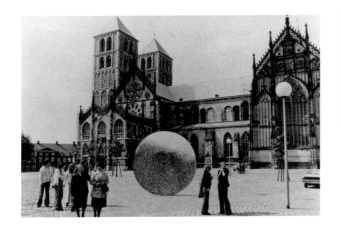

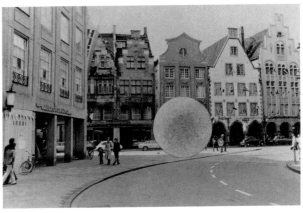

Claes Oldenburg: *Project for Münster I,* not realized, photo-
montages (above) and *Project for Münster II,* location:
Aasee terraces, *Giant Pool Balls* (concrete, diameter
3.50 m each), photo 1977, contribution to *Skulptur Aus-
stellung in Münster 1977,* (below)

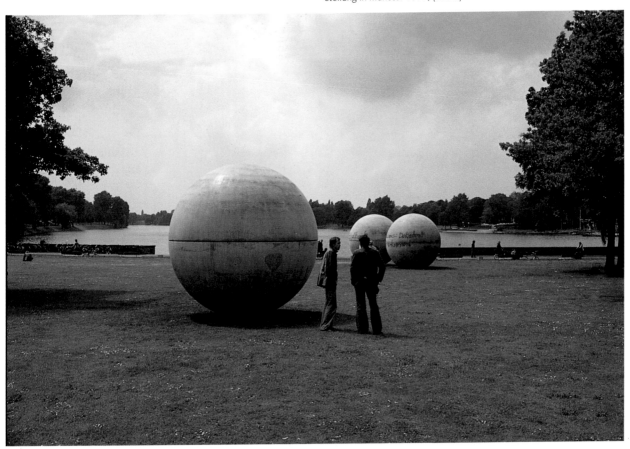

To Gabriel Orozco
c/o Marian Goodman
To Kasper König
Fax 001 / 212 / 9950711
and 001 / 212 / 581 51 87
FAX 0251 5907167

Münster, 15th February 1997
New York, 18th February 1997

Skulptur Projekte in Münster 22. Juni – 28. September 1997

Dear Gabriel,
Dear Kasper,
Dear Florian,

As promised we are sending you a brief report on the status of your proposal. A ferris wheel not
Thank you for your report. It is perfect. I don't know what to say. The ferris wheel idea (half and half)
smaller than 12 meters diameter to be put half underground with an underground entrance and
(day and night) (light and dark) (under and over) (life and death) (earth and sky) (horizon) (resurrec-
emergency exit will cost us 150,000 DM. On top of this we have to guarantee the owner of the ferris
tion) (movement) (circle) seems to be banal enough to be explained. It is not important. It is very
wheel 200,000 DM for a period of three months in order to make sure that he does not lose any
important. It is again nothing really. Rotating in the middle of the horizon. The people out looking at
money, as he could not participate in other fun-fairs for this period. If we guarantee him 2,000
the people in crossing the earth going downstairs. The people in (using the ferris wheel) looking at
customers a day for three months this money will come back to us. I have spoken to Mr. Scheneen
the sky, the line of the ground, and the darkness of twelve meters underground. The moment of who will
sponsor your project to the extent of 80,000 DM if he decides to partly garantee the *contact (eye con-*
tact) between the people standing outside at ground level and the deposit of 200,000 DM. He believes
that it's going to be difficult for him. Maybe you and Marian *people going up and down. Up and down. Up*
and down. And the view of a landscape that goes up Goodman will have an idea how to obtain this guar-
antee. We believe we know exactly which ferris *and disappears when you go down. The axis of rotation at*
ground level. The circle cut in half. In and wheel will be available and who our business partner is going to
be by the end of February. The *out the landscape. In and out the view. Coming and going. Close your*
eyes, open your eyes, the advertisement has been placed in their magazine, the basic okay for the site
has been given by the *landscape is always different. That infra space in which everything is transformed.*
The line of the city departments and the state technical service for overseeing ferris wheels is informed
and sees *horizon under our feet.*
no problems.
Please send us as promised a basic outline of your piece – so far all communication was verbal. We
Dear Kasper, I think of you and Florian and your team in Münster trying to realize this big project
guarantee you 30,000 DM towards the realization of your project (plus fee, hotel and travel costs).
and that's enough pleasure for me. The wheel of the will in you amazes me. Thanks again. I don't
So we are still missing 30,000 DM towards the realization and 200,000 DM as a guarantee deposit.
know why I think we are going to do this, when it is so big, so expensive, and impossible, and deep
underground.

Best from all us

Hasta la Vista!
Gabriel Orozco

Kasper König

Florian Matzner

GABRIEL OROZCO

Ferris wheel, half sunk in the ground
Hindenburgplatz
Not realized

Born 1962 in Veracruz, lives in Mexico City
and New York

For information about the artist and additional bibliography
see: Gabriel Orozco, Museum für Gegenwartskunst, Zürich
1996; Gabriel Orozco. Projekt Gelbe Schwalbe, daad Galerie,
Berlin 1995; Gabriel Orozco, Kanaal Art Foundation, Kortrijk
1993.

TONY OURSLER

Streetlight
Installation (streetlight, light- and
sound-installation)
Bispinghof, in front of south stairs to
Aauferweg

Born 1957 in New York, lives there

For information about the artist and additional bibliography
see: Tony Oursler. Dummies, Clouds, Organs, Flowers, Water-
colours, Videotapes, Portikus Frankfurt/M. 1995; Tony Oursler,
Salzburger Kunstverein, Salzburg 1994; Tony Oursler. White
Trash and Phobic, Centre d'Art Contemporaine, Geneva 1993.

Tony Oursler: STREETLIGHT

IT MAY AFFECT THE WORKINGS OF YOUR MIND, CAREFUL, QUITE, SHADOWS.
MORE DARK! MORE DARK! MORE DARK!
IT HAPPENS WHEN YOU ARE NOT THINKING ABOUT IT.
ON, OFF, ON, OFF, ON, OFF, ON, OFF, ON, OFF, ON, OFF, ON, OFF, ON, OFF, ON, OFF.
THESE ARE FANTASIES WHICH BECOME A REALITY.
IT WILL ESCALATE, IT WILL BLOW UP ... INTO LIGHT
YOUR VIEWERS, YOUR VIEWERS, YOUR VIEWERS MAY WANT TO KNOW
A SUDDEN DRASTIC CHANGE, IN PERSONALITY
WHAT HAPPENED?
VISIBLY ALTERED STATES OF AWARENESS
A REALITY, WITHIN A REALITY, WITHIN A REALITY, WITHIN A REALITY ...
IMPAIRED REASONING OR DECISION MAKING
INVISIBLE! INVISIBLE! INVISIBLE! INVISIBLE! INVISIBLE!
VIOLENT OUTBURSTS
OUTRAGEOUS OUTRAGEOUS OUTRAGEOUS OUTRAGEOUS
PRONOUNCEMENTS.
SUDDEN CHANGES IN HABITS
HA AH AH HHHHHAAAAAEEEEEAAAA HHHHHHHAAAAA HA HA
ON, OFF, ON, OFF, ON, OFF, ON, OFF, ON, OFF, ON, OFF, ON, OFF, ON, OFF, ON, OFF.
BELIEFS WHICH CANNOT BE EXPLAINED COHERENTLY
IT HAS BEEN ENGINEERED OR INDUCED ...
AWARENESSAWARENESSAWARENESSAWARENESSAWARENESSAWARENESS
SCHEME, HATCH, FABRICATE, ACCIDENTAL
A SUDDEN DRASTIC CHANGE, IN DESIRE
BRIGHTER! BRIGHTER! BRIGHTER! BRIGHTER! BRIGHTER! 100 PERCENT!
DON'T BE A DUMMY DIM WIT IDIOT BURN OUT HA HA AAAAHHHH HAA
LIGHT, SHADOW LIGHT, SHADOW LIGHT, SHADOW LIGHT, SHADOW
AWE STRUCK ...
RECOGNIZE THE STRENGTH THE WEAKNESS
CAN YOU FEEL THE HEAT
CAN YOU FEEL THE POWER
ON, OFF, ON, OFF, ON, OFF, ON, OFF, ON, OFF, ON, OFF, ON, OFF, ON, OFF, ON, OFF.
SPACE, TIME, ENERGY, SPACE, TIME, ENERGY, SPACE, TIME, ENERGY
RAYS ARE STRIKING YOU, PENETRATING YOU
RADIATION
A SUDDEN DRASTIC CHANGE, IN ...
TAKE ONE'S RIGHTFUL SOURCE OF ILLUMINATION
ACCOMMODATE YOUR CHANGING BODY
WHAT EVER HAPPENS NOW IS BEAUTIFUL
LOOK AROUND YOU
EVERYTHING IS ALIVE IN THE LIGHT
LOOK INTO THE LIGHT
FOCUS ON THE LIGHT

303

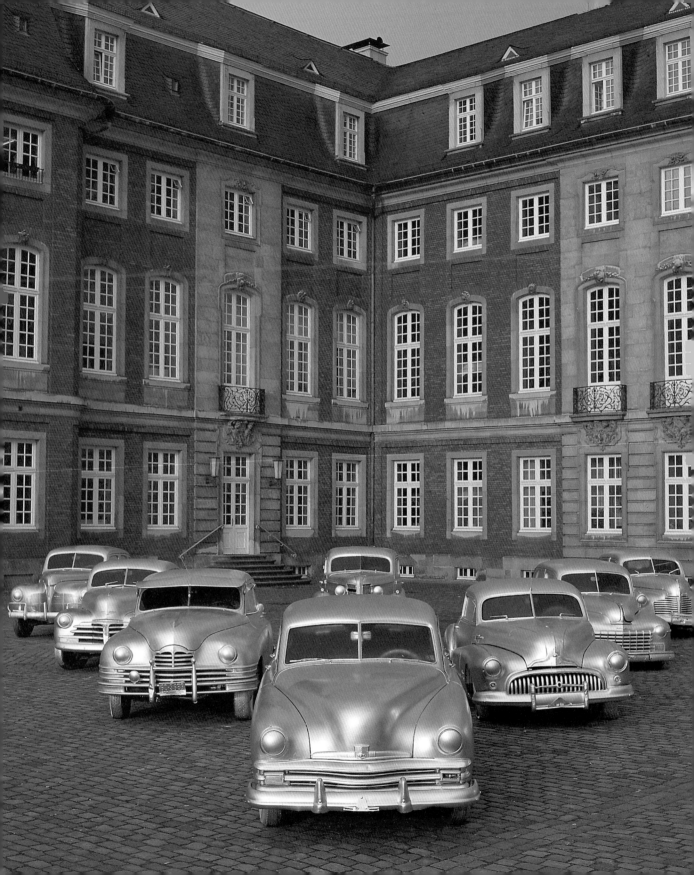

NAM JUNE PAIK

32 cars for the 20th century: play Mozart's Requiem quietly
Installation (32 cars, music equipment)
Square in front of the Schloß

Born 1932 in Seoul, lives in New York

Nam June Paik:
The collective title of the 32 cars is: *play Mozart's Requiem. Mozart's Requiem must be played from Sundown to 11.30 pm until people complain about it.*

Characteristics of the 20th century are
1. Organized violence
2. Media
3. Car-cult
One common denominator which goes through all 3 factors is consumerism (violence is the No. 1 item for the consumers).
Titles – Matzner, choose:
1. 32 Cars for 20 Megatods
2. Requiem 20/32
3. 20/32 Requiem
4. Adieu Marlene 20/32
5. 20/32 Herz
6. 20/32 Mega Herz
7. 20/32
8. 20 ± Mega Tods
9. 20 Megatod Century + 32
$$\sqrt{PAIK}$$
10. 20 Megadeath Century ± 32
<div align="center">PAIK</div>

11. 32 Cars for 20 Megadeath Century
12. 20/32 Adieu

For information about the artist and additional bibliography see: The Electronic Superhighway. Nam June Paik in the Nineties, Indianapolis Museum of Art, Indianapolis 1995; Nam June Paik. Baroque Laser, ed. Florian Matzner, Ostfildern 1995.

13. 20 Megadeath Century + 32
14. Megatod Jrhdt + 32
15. For 20 Megatod Jrhdt
16. 20 Megadeath Century(adieu / 32
17. 20/32 Megadeath Century
18. 32 cars for the 20th century: play Mozart's Requiem quietly

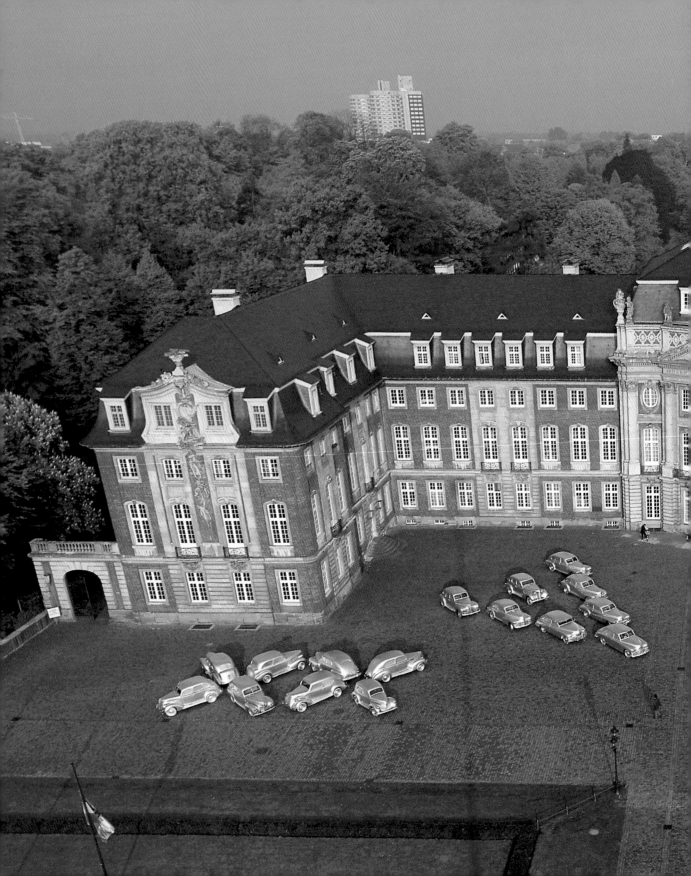

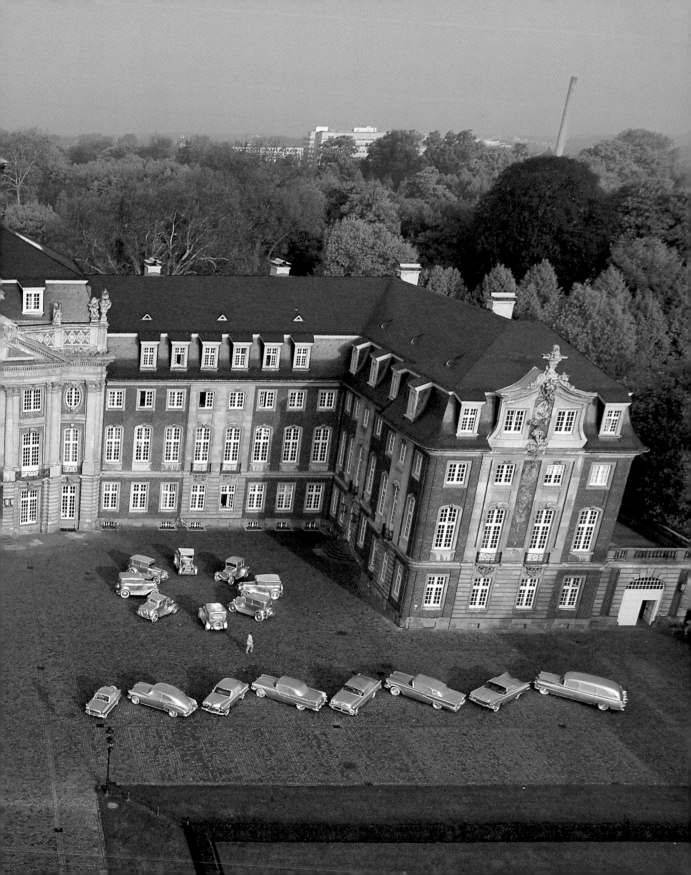

Ulrike Groos/Florian Matzner: a P.S. to N.J.P.

Paik in Münster, three times now: in 1987 with the whimsical-contemplative *TV-Buddha für Enten* on the Aa river, in 1994 with the installation *Mongolian Tent* in the atrium of the Westfälisches Landesmuseum – a reference to Paik's own biography and a homage to his great artist friend Joseph Beuys – and in 1995 with the technically elaborate yet meditative laser video installation in the Baroque Loreto chapel of the Dyckburg outside Münster. During the legendary opening performance of the latter – repeated over a dozen times to accommodate the unending masses of spectators – Paik "touched" the laser beam with his eyes and was almost blind for a number of days. When we visited the doctor the next day here in Münster, Paik told him: "I am the dumbest man in the world, or at least in Germany, and that's pretty dumb!"

And now, in the summer of 1997, the Baroque Schloß erected by Johann Conrad Schlaun in Münster becomes a theater stage for Paik: the splendid display of the architecture of absolutism becomes the setting for an updated version of Mozart's Requiem.

Thirty-two American automobiles symbolize the revolutionary history of technology in the twentieth century. The oldest is a 1924 Willy, the newest a 1959 Buick – cars from four decades, mobile signs of the American Dream in form, dimension, and horsepower. These old-timers, however, cannot be driven: the cars are "eviscerated" of their engines and technology and (car freaks will be horrified) are all painted metallic silver. The real car has become a model, an illustration of a car.

Only the windshield reveals a view of the interior, where relics of the television age are piled up into classically composed "still lifes".

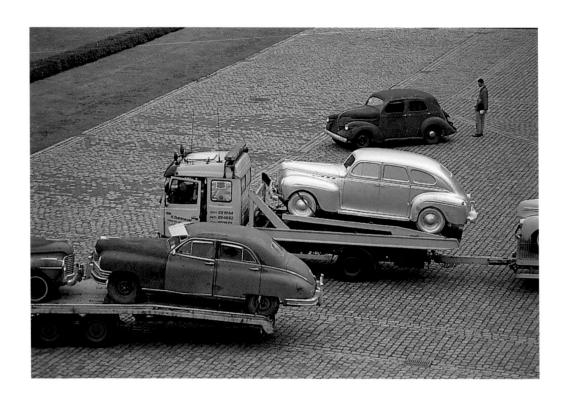

Paik, but with a new twist: no video, laser, neon, computer, or high tech – only a CD-player playing Mozart's *Requiem*. The mobile cars have become petrified into sculptures, arranged in four decades according to the primary geometrical forms of the circle, triangle, square, and line. If it is true that the automobile and television are the inventions of our century with the greatest significance for science and society, and at the same time the most important symbols of Western consumerism – as Paik puts it, "Parking is the most serious problem confronting twentieth-century man" – then with his work in Münster the artist is driving industrial society to "megadeath". Like the automobile from the 1920s to the 1950s, television functioned as a prominent symbol of mobility and world-wide communication up to the late 1980s. At the end of the millennium, however, the electronic superhighway – Internet, e-mail, and the like – has assumed a leading economic role in industrialized nations. As Paik suggested already in 1974 in a study for the Rockefeller Foundation, this shift signifies the transition of human society from the exchange of hardware (cars, TVs, washing machines) to the exchange of software – the world-wide purchase and sale of information, data, and knowledge.

A fundamental shift from one form of society to another occurred in Europe already two centuries ago. As the last Baroque structure to be built – the French Revolution had already taken place in Paris when it was completed in 1784 – the Schloß in Münster marks the transition from the courtly society of absolutism to a bourgeois, democratic age. Paik's cars, "petrified" into gigantic sculptures, represent the transition from the industrial to the information society: "play Mozart's *Requiem*. Mozart's *Requiem* must be played from sundown to 11:30 p.m. until people complain about it."

Nam June Paik: *TV-Buddha für Enten*, contribution to *Skulptur Projekte in Münster 1987*, location: Philosophenweg on the Aa river (above) and *Baroque Laser*, 1995, location: Dyckburg chapel near Münster, laser video/music installation, performance at opening (below)
Nam June Paik: *32 cars for the 20th century: play Mozart's Requiem quietly* (opposite and next two pages)

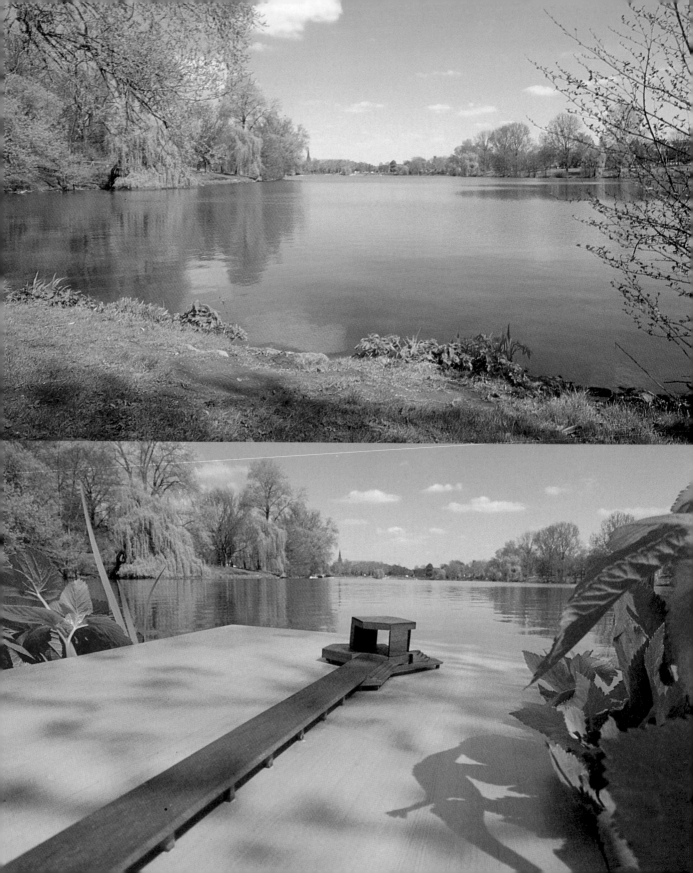

JORGE PARDO

Pier
Installation (California redwood)
West bank of Aasee, south of Annette-Allee

Born 1963 in Havana, lives in Los Angeles

Jorge Pardo's proposal calls for the construction of a pier, about 40 m long, on the Aasee. Supported by about 50 pairs of pillars of California redwood, the pier leads to an open hexagonal pavilion and a likewise hexagonal viewing platform with steps to the lake. It makes possible a view across the lake to the nearby city.

For information about the artist and additional bibliography see: Jorge Pardo, Museum of Contemporary Art, Los Angeles 1996; nach weimar, Kunstsammlungen zu Weimar, Ostfildern 1996; Das Ende der Avantgarde. Kunst als Dienstleistung, Sammlung Schürmann, Kunsthalle der Hypo-Kulturstiftung, Munich 1995.

Jorge Pardo: Model of pier at scale of 1:5, 1996, wood, 39.7x78.5x6.2 cm, and construction drawing of pier, 1996, pencil, ink (p. 314); construction work (p. 315)

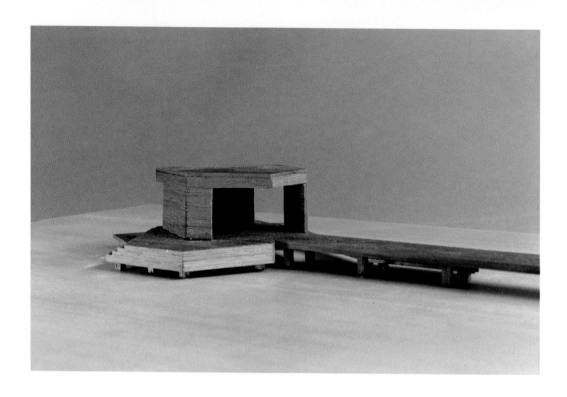

HERMANN PITZ

Innen, Außen
(Interior, Exterior)
Two-part installation
Old section of Westfälisches Landesmuseum,
west façade, second storey and correspond-
ing interior space

Hermann Pitz: 1977–1987–1997

1977

I was an art student in (West) Berlin and went
to Münster for the opening of the *Skulptur
Ausstellung in Münster 1977* on July 3, 1977. It
was my first (and only) hitchhiking trip, taken
together with my fellow student Wolf Pause. Of
course we stopped to have a look in Kassel, but
it wasn't until Münster that we really began to
be amazed. In retrospect, this amazement had
two causes. In the historical part of the exhibi-
tion, *The Development of Abstract Sculpture in
the 20th Century*, we discovered Lucio Fon-
tana's *Concetti spaziali del ciclo delle nature*
and much more. Equally important, however,
was the *Project Area*, with works in public
spaces at various points in the park landscape
of the Aasee. Here, above all, were also shown
a number of works that were either unfinished
or not entirely "successful" in the sense of
autonomous sculpture, works by Bruce Nauman
(problems with approval? too expensive?),
Joseph Beuys (technical problems, the material
didn't cool off in time), and Michael Asher
(ephemeral placement, the aspect of mobility
within the city). The fact that these three works
still evinced a great sensual and spatial pres-

Born 1956 in Oldenburg, lives in Düsseldorf

For information about the artist and additional bibliography
see: Hermann Pitz. Orte, Ereignisse/Lieux, Événements,
Württembergischer Kunstverein/Palais des Beaux-Arts de
Bruxelles, Brussels 1995; Hermann Pitz – Libros y Obras/
Bücher und Werke, IVAM Centre del Carme, Valencia 1994;
Hermann Pitz – Livres et Œuvres/Books and Works, Musée
Départemental d'Art Contemporain de Rochechouart,
Rochechouart 1995; Panorama Hermann Pitz MCMXCI, Witte
de With Center for Contemporary Art, Rotterdam 1991.

ence as well as high communicative value is what produced my amazement, and I think that these were among the most lasting impressions for the development of my own art.

1987

In the years that followed, I made a number of attempts to apprehend space, sometimes in the narrowest sense as three-dimensional space *per se*, sometimes as urban space or the social territory of a space – the site as a place of meeting – and this often in cooperation with others. The works that originated in this way – not infrequently in the ephemeral state learned in 1977 – had already led to a sense of unease in dealing with art in public space, when Mr Bußmann and Mr König invited me to take part in the exhibition *Skulptur Projekte in Münster 1987*. The uneasiness was due less to the superfluity that generally characterizes art in social processes than to the ostensive rejection of that art, up to and including vandalism. There was no legal foundation and no justification for works of art laying claim to public space. In retrospect, A. R. Penck's design for Münster gave this lack of demand its most

Hermann Pitz: *Uhr im Treppenhaus*, contribution to *Skulptur Projekte in Münster 1987*, location: Landesstraßenbauamt, Hörsterplatz, parabolic mirror, diameter 1.6 m, depth 0.23 m

pointed expression: "January 1, 1987. A Small Sculpture (of my own) for the desk of the mayor of Münster in Westfalen (DM 15,000.00)" (catalog, *Skulptur Projekte in Münster 1987*, Münster 1987, p. 216). Here the representative of the city is directly obligated (in both a legal and a monetary sense). My strategy was more evasive: in order to transport the actual object of my artistic exploration, namely the effect of optics and dioptrics on our ability to perceive, I combined the aesthetic object with the function of a *Uhr im Treppenhaus* (Clock in Stairwell). So the work was always able to counter rejection with its functionality.

1997

Today the concept of "public space" is in need of redefinition. In the last ten years, an additional public site has come to the fore that is not bound to a specific geographical location: the virtual (communication) space of TV, Internet, and e-mail. Today it seems more difficult to put together an exhibition of contemporary art under the heading "Public Space" than it was ten years ago. Back then, public space was the catchword for the interrogation of the role of art in society and of the nature of the (design) task assigned to the artist by the public. Today, it is arguably no longer even possible to pose the question to the artist in that way: conventions have changed, and the electronic media generate so many commissions for entertainment that public demand can be taken for granted. Of course, art sculpture must now also compete with the entertainment industry to a much greater degree.

My concern in *Skulptur. Projekte in Münster 1997* is to devote a pictorial contribution to precisely this competition. Admittedly, I myself don't own a computer or use a portable telephone; in other words, I must describe or consider the new electronic space using conventional means.

Already in 1986, Wolfgang Siano pointed to the extraordinary increase in the significance of a concept like compatibility: "Today, every individual becomes a self-administered collective that must join together into greater production units. To modify one of Heartfield's magazine titles, the call could be formulated in this way: To each his own personal computer" (R. Kummer, H. Pitz, F. Rahmann: Büro Berlin – Ein Produktionsbegiff, Berlin 1986, p. 137). Since then I have gotten to know people who are familiar with these virtual levels of public space, and I watch them with skeptical curiosity. In my opinion, the connecting element between real spatial structures (my interest) and the virtual telegenic space (of the screen user) is light. In the screen, light is not experienced as a source; the screen itself is illuminated from the inside, and illusions of side light, for example, are simulated through light-dark contrasts on the surface of the screen. This procedure can also be used in real space – e.g. in the (dark) space of the theater stage – but the actual advantage of real space remains that it can reveal to the viewer where the light is coming from. The light source (window or lamp) will thus play a leading role in my contribution. But unlike the reception of the theater or the screen, here the viewer does not remain seated in one place, but chooses the point of view for himself.

1. Exterior

A window in the second storey of the old section of the Westfälisches Landesmuseum, preferably near the extension building, is covered (behind the natural stone cross) with the same black mica schist (Maggia granite) found behind the Albers relief on the extension building (above the current main entrance).

Maggia: River in the Swiss canton of Tessin; "The Valle di Maggia (German 'Mainthal'), is 22 km long and ca. 1 km wide at its base. Opening to the south, with 1,800 to 2,500 m high chains

of gneiss and *mica schist*, it evinces both an Alpine and an Italian character [...] *Mica schist*: an extremely slaty rock consisting of a mixture of mica (partly light muscovite, partly dark magnesia mica, partly a combination of both) and quartz in widely varying proportions; the extremes in this series of varying compositions are a slate consisting almost entirely of mica and a micaceous quartzite slate. The mica forms isolated flakes and sheets or continuous membranes; the quartz, in lens-shaped grains and thin layers, usually emerges only on the cross fault; occasionally it forms larger knots or bulges. The non-flaky, low-quartz mica schists possess the most perfect and thinnest cleavage. *Mica*: a mineral group whose individual members possess characteristics including an extraordinarily perfect cleavage along planar surfaces; [...] sheets and flakes of these minerals are widespread as essential components of many old stones, e.g. *granite*, gneiss, *mica schist*, but also younger igneous rock, basalt [...] Mica, occurring in *transparent* layers often many square feet in size, is used for *window panes* in Peru and Siberia [...]. In more recent times, mica windows have also come into use in Europe, particularly in machine shops (especially in England) and on warships, since they do not shatter as easily as glass. *Slate*: a type of rock that can be split into thin, even layers, owing primarily to the parallel layering of leaf- or lamella-shaped mineral particles (especially of a micaceous nature). It occurs in different forms including *mica schist*, quartz slate, schist, marl slate, calc-schist, hornblende schist, etc." (Brockhaus Universallexikon, Leipzig 1980; author's emphasis)

2. Interior

– The inside wall on the second storey, behind which the window in question is located, is articulated with the window that is no longer in use on the exterior. It leans against the wall in a frame construction in which the sandstone cross from the exterior is replaced by a wooden construction.

Hermann Pitz: Study for light sources, 1995 (below), and *Innen, Außen,* sketch of the construction, May 10, 1997, ink on paper, 40 x 29.6 cm (right side)

– Holux-UNIVERSAL/ELEKTRONIKA repro camera on a 6 m long optical bench. The working photo shows the equipment as I received it from Bavaria and set it up with the employees of the art transport firm Knab. I will temporarily store the machine here in Düsseldorf and alter it where necessary. In particular, I want to remove some of the mechanical parts in order to give the apparatus a more suggestive form as a whole; I also want to investigate the physical presence of the machine with reference to the window. What has already become clear at this point is the use of light. The room as a whole is dark, without overhead light. All visual experiences will be effected through additional light sources, which will thus constitute a part of the work.

Düsseldorf, January 1997

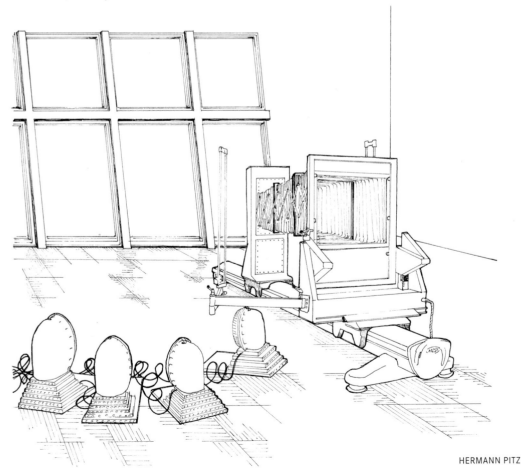

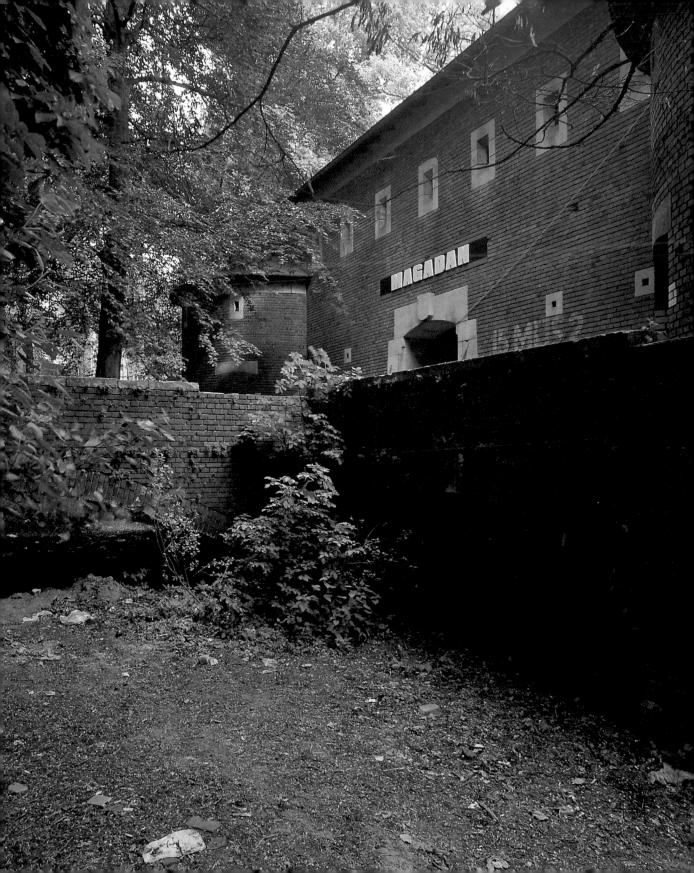

MARJETICA POTRČ

Vilnius
Installation
Not realized

Magadan
Installation
Grounds of air-raid bunker on Lazarettstraße

Born 1953 in Ljubljana, lives there

For information about the artist and additional bibliography
see: The Collection of the P.A.R.A.S.I.T.E. Museum, Museum
Bochum, Bochum 1996; Universalis, São Paolo Biennial, São
Paolo 1996; Four Sculptors from Slovenia, The Contemporary
Art Center of Vilnius, Vilnius 1996; Urbanaria, Soros Center for
Contemporary Arts, Ljubljana 1995.

Vilnius

I propose to empty a house in the center of Münster and name it *Vilnius*. The ground floor windows are to be walled up. Some rooms are to be walled up as well. Visitors will be able to stroll through the empty house. On the walled-up doors and walls they will see frescoes depicting scenes from Vilnius, while through the windows they will have a view of Münster.
In front of the house called *Vilnius* the core unit will be built. This is a small brick building equipped with electricity, running water and a toilet. The core unit is small and ugly. It is the counterpoise to the fictional world of *Vilnius*.

Magadan

A walk through an imaginary city *Magadan*, named after a far eastern Russian port, begins when one enters a huge building on the NW side of the Promenade. The building looks like a castle from the outside but is in fact a bunker. It was built in 1941 to fool the eyes of pilots. Even today, it is hidden away well. It is still overlooked, now by the city's citizens.
For the project *Magadan* the castle is opened up to people so it can be walked through. The stroller walks down the corridor of the bunker and exits into an empty water channel. This is a wild green area where three small houses stand with doors opened. When you enter a house you actually exit into the green area: there is no house at the back. From there, a pathway leads you to a parking lot where the walk ends.
I think it is good for Münster to have someplace which is all that Münster is not, to have something unexpectedly deserted, shabby, wild,

uncontrollable and disorderly, something of no use to the city. I think cities need empty buildings (places of rest) like a man needs a place to sleep. Besides, urban voids are good for daydreaming.

Marjetica Potrč: THESES IN FAVOR OF A VACANT HOUSE

BEAUTY
Moscow
I love to return to unpredictable cities. Thus I never tire of Moscow, which must be the most uncontrollable and unfathomable of European cities. It is a far cry from comfortable or harmonious; its fascinating, preposterous medley of architectural styles is like a labyrinth in which it is hard to find one's way. What if I get lost – I don't even understand the language – what if I get mugged? Anything can happen to me there. This unintelligible, precarious character of the city is what quickens my pulse. Although dysfunctional, to my eyes Moscow is beautiful.

Beauty and utility
Formerly, beauty had other connotations. In his book *Michelangelo and the Language of Art*, David Summers writes how during the Italian Renaissance the concept of beauty was identified with usefulness or function. He quotes Castiglione: "Columns and architraves support high loggias and palaces, but they are no less pleasing to the eye than useful to the structures…" Behind the notion that beauty is never found separated from suitability or function lies the idea that nature does nothing in vain; everything in nature follows the principle of order. Thus it has been possible, in terms of order, to explain the universe and its processes, architecture and objects, man and his body.
Likewise, the city has always depended on the principle of order. The words "ordinare" and

"ordinatio" were terms for town planning even before the Renaissance. The whole notion of planning perhaps stems from man's desire to identify, differentiate and classify. After all, most of us seem to be constantly working on planning our lives, with varying degrees of success, to understand them better, control them better, and to move more freely inside them. And for all this, the points by which we orient ourselves must be readable.

Building in Pagan, photo 1996

UNREADABILITY
Pagan
Where Moscow is beautiful, dysfunctional, and very hard to read, Pagan is just plain beautiful. One does not read Pagan for the simple reason that there's next to nothing to read there. It is the former capital of former Burma. All that remains of the town is pagodas and temples scattered around the overgrown land. Years ago, farmers lived amid the pagodas, but they have been exiled, so as not to mar the view for the tourists who come seeking the solitude of ruins. Pagan's fate is however better than that

of Tikal in Guatemala: in Pagan, the jungle has not yet become transformed into a park; in Tikal, the temples stand upon park-like lawns. The preservation of abandoned towns seems to have become a world-wide fashion, and the act of preservation can easily get out of hand.

I adore going to see abandoned towns. The less I know about the civilization which built the town – the less I can read there – the more I am impressed by it. Empty towns fill me with exhilaration and a sense of loss at the same time. I go there to gaze at that which is not my time and place, that which is not the time and place of the city in which I live.

USELESSNESS
Vilnius

There are Eastern European cities that give me the same feeling as Pagan. What really sets them apart is the abandoned houses, neglected yards and unkempt lawns. Approximately a fifth of the houses in the center of Vilnius are empty. A local friend told me how he wished that all the run-down houses in town were restored. For a moment I pictured it in my mind: the deserted and shabby Vilnius transformed into an orderly German city full of stores and bars. I realized that if I had to choose, Vilnius would be the more beautiful of the two. Thanks to the vacant houses, which are so numerous they are unavoidable. When strolling about, one is affected by them as one is by the unexpected vistas in an English park: entering a street one suddenly comes face to face with vacant windows staring back. Sometimes the sky can be seen through them, sometimes there is only darkness. It is similar with dreams: some of my friends claim dreams are light, others say that they are dark. Dreams are also not clearly articulated – often one does not even remember what one has dreamed about. Empty houses are just like that – they simply abide there, and no more. In their windows there is nothing, or at least nothing tangible – no piece of furniture or an old lady looking out. A vacant house only shows itself, its own body.

The body affects us differently than thoughts. We all know the power human touch has to confuse thoughts. It is the same with the city. When the body of a city steps to the foreground, the city itself becomes unreadable. And also unusable: as if it were shrouded in fog.

Ljubljana in fog

Some years ago, when visiting a friend on a foggy evening, I wandered into such a thick patch of fog that I did not recognize the house I was going to. For a moment I was overpowered by anxiety; in my mind's eye I can still see the wall I stared at. The house was, naturally, the right one, but I felt as though I had never seen that wall before. The same phenomenon occurs in Venice when parts of the city are submerged. It seems completely unfamiliar, as if seen for the very first time. Or when heavy snowfall covers the city in the winter. Or when it gets so hot in the summer that there's no-one in the

Destroyed, abandoned house in Vilnius, photo 1996

streets. These are all situations that silence clings to. The city becomes useless. But still, even if one cannot find one's way around, the city at least offers its body.

On an ordinary day in an ordinary city the body of the city is hardly noticeable, even the façades. There's the hustle and bustle of people, the stores are open. The blending of people and reality is the simple *raison d'être* of a town. But I believe that there is another reason for the coexistence of man and city, a reason beyond usefulness. Peter Handke once wrote: "We live on illusions. Without illusions we would never do anything." If so, illusions are the precondition of reality. Cities need vacant, unused spaces and haziness, just like people need sleep. Furthermore, one does not need to go to faraway exotic places to gaze at empty towns if one has a similar vacant space conveniently close at hand.

I grew up in Slovenia, where real space was not cultivated. Thus for me space has always been a fiction. Facetiously I might say I should feel at home in foggy places. Likewise, I should feel at home where things do not go like clockwork.

DISORDER

I always become skeptical when I am told of a planned, orderly city. Imagine a city where every single thing functions. How tedious in its predictability. Yet the idea of creating a city *ex nihilo* has so much appeal, the venture is repeatedly undertaken. Cities actually exist which are the product of ideas. They are the realized visions of great architects – first these were rulers, later on urban planners. Nowadays we call them regulators, and they no longer work (or think) on a grand scale – they content themselves with parts, since they cannot have the whole. But what they all have in common is that they strive to control the city, rationalize it and introduce order into it. Such ideas are linear and realizable in geometry.

Recently I was leafing through a book on urban planning, when on one of the last pages – probably dealing with city development – I saw a schematic drawing of Caracas. A mass of criss-crossing lines represented the planned city, and on the periphery there were black blotches. Opposed to the linear geometry, they looked organic. The organic form induced a sense of malaise, as though the blotches were out of control and growing irrepressibly – which of course they are. I know two examples of such a living body of a city: urban voids and unapproved construction, which in Brazil are called the *favelas*.

These, like fully realized urban visions, are imaginary places. But the latter have the advantage over the former of requiring no special effort: they grow of their own accord.

Favela

Last fall I went to Saõ Paulo – it was spring there – and I was unexpectedly enchanted by the city. It is like the future realized, like Babel: it is alright that the languages have gotten all mixed up. All manner of architectural styles coexist perfectly harmoniously, cheek by jowl: on the main street, in the midst of corporate buildings there is even a vacant house. There is also no shortage of *favelas*. Anyone who has ever seen a *favela* from up close knows it is fresh and beautiful. It is an assemblage of impossible and improbable materials, colors and odors. The time needed to get lost in a *favela* is a mere instant. It is an incarnation of confusion, obstruction, and proximity of touch – of both dwellings and their inhabitants. Here the body resides: the body of the house which shelters the body of the inhabitant. These constructions convey a single message, they speak of man. They are dwellings and nothing else.

Urban voids

There is a great deal of disordered space in Ljubljana. The squares are not completely delimited: there are always a few illegally parked cars in some corner, or a cluttered yard, or a house shedding its plaster. I do not find these things ugly, nor do I see them as the city's wounds. The walls of Venice sport the beauty of falling plaster with panache. Interestingly, the disorder in Ljubljana, as in Venice,

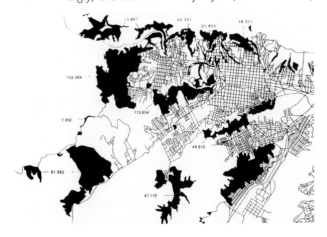

Map of Caracas, 1971, favelas marked as black spots on the periphery of the city

appears to have a will of its own. These gray zones, these dysfunctional city areas persist in the teeth of the dark mutterings of urban regulators. And, of course, in such a gray zone a vacant house is likely to appear. Regulators have a funny name for vacant houses, they call them "urban voids". An urban void is defined as an abandoned space which embodies the promise of a future useful locality. Here is the catch. I believe that if all urban voids were to be transformed into functional sites the city would begin to lose its body. A vacant house has a similar effect on people as a city enveloped in a mist or as do *favelas*: the city cannot be read in full, nor used in full. Which makes it much easier to daydream in.

UNOBSTRUCTED VIEWS
Brasilia

In Brasilia, unobstructedness existed before the city itself did. The terrain on which the capital of Brazil was built is an arid plain, in its flatness reminiscent of the piece of paper on which the city was drawn. Brasilia does not conceal its origin on paper. Everything in the city points to it. In Brazil, a country known for its rainforests, the capital Brasilia stands in a region perennially starved of water. There is no wild nature, no lush tropical foliage growing of its own accord. Messy metropolitan life is minimized as well, and the sky above the city is wide. The urban planners took great care to keep the city unobstructed. The sixteen shanty towns which sprang up simultaneously are separated from the city by a belt several kilometers wide. Is it possible then to regulate *favelas*, this virus in the planned body, this wild nature of the city? But then again: just a few minutes from the presidential palace, squatters have built houses, without bothering with zoning laws.

Iram

Somewhat like Brasilia, the town Iram from the *Arabian Nights* is a product of the imagination. King Shaddad has the many-columned city of Iram built as a terrestrial paradise. Once the construction work is completed, he sets out for it with his entourage. But they never reach the city, they never even see it from afar. "When but one day's journey between Shaddad and Iram remained, Allah sent down on him and on the stubborn unbelievers a mighty rushing sound from the Heavens, which destroyed them all with its vehement clamour, and neither Shaddad nor any of his company set eyes on the city. Moreover, Allah blotted out the road which led to the city." God knew that visions are best when they are not realized: that explains the success of the idea of Heaven.

Realized visions never live up to expectations. The idea is usually more successful than its worldly outcome.

Münster

Not so long ago Münster as a city also had to deal with its own clarity. It was 1941 and Münster had to prepare for the possibility of Allied bombing. The city authorities made plans for bunkers to shelter the inhabitants. They were not some dank vacated cellars, but houses as large as public buildings. Great care went into choosing their exterior image and location – both were intended to fool the eyes of bomber pilots. Two of these bunkers are in the center of the city; one looks like a school building, the other like a castle. A compact building with two turrets, a draw-bridge (made of concrete), a moat (without water) encircling three-quarters of the building – these are all signs by which a castle is recognized, not only from up close but also from a bird's eye view.

It is fascinating how firmly the planners believed in the readability of city form. I can relate to that, since I was raised to believe in form myself – I studied architecture. Nobody would believe in form that way today, however. Nowadays, cities do not share an easily readable image. Meanings change; *this* has already become *that*. The bunker in Münster has taken on a new role: it has become an urban void in the city fabric. When I was looking for a vacant house for my first proposal for *Skulptur. Projekte in Münster 1997*, no one was aware of the quantity of empty space we had right under our noses; not to mention the mass of walls more than a meter thick. We had all overlooked the bunker. As a vacant house it had become a dormant and unnoticed area in the inner city.

On the other hand, the clear visibility of the city was to Münster's detriment. The easy aerial readability of the inner city facilitated the thoroughness of the bombing: by 1945 nothing remained to obstruct the view from one end of the Promenade to the other. This void in the city brought about a new city, which, like the bunker, has been in disguise since its beginning. The façades which at first sight appear old are in fact not; but conceal behind them modern architecture. Münster pretends to be old, but fools only the eyes, not the feeling. It feels like a displaced body, devoid of *genius loci*. There is nothing wrong with that, I for one like it, since it makes me feel at home.

MUTATION OF EMPTINESS

When presenting a city, people usually recite facts: the history, the important buildings. What effect would it have if the strategy were reversed, if cities were spoken about from the perspective of empty space rather than facts? We would say that a medieval town grows from its square, that Haussmann's Paris embodies the array of avenues, and that modernist architecture displays transparency in all the glass façades which enable one literally to see through the building so that the image of the building begins to disintegrate in one's gaze. After the transparent building came the reflecting building, which replaced glass with reflective windows, and the transparency of the body with the reflections of its surroundings. Because of this it resides in the city in a very special way. Contrary to other buildings which strive to be present in space, it pretends not to be there. The reflecting building is practically the first conscious urban void. The current city presents emptiness in a new way, by exposing vacant houses. They are better than reflecting buildings, which only display emptiness. Vacant houses embody emptiness.

There is nothing wrong if something in the city is resting. Vacant houses where nothing ever happens, and vacant cities the world over – there is no rational reason for their continued existence, and yet they are there. I know I find

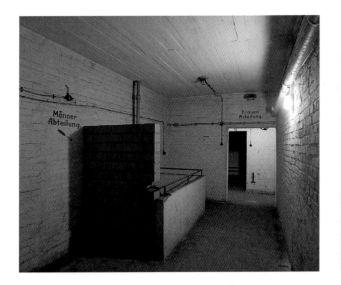
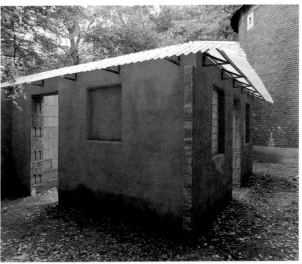
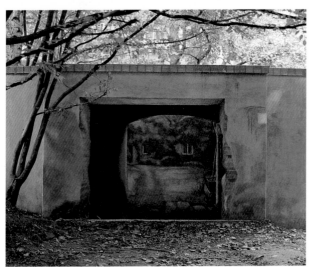
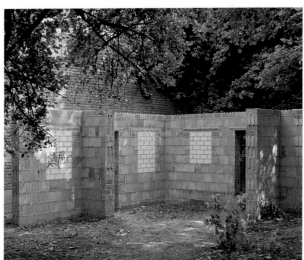

Marjetica Potrč: *Magadan*, views of installation

vacant houses a sight to behold. Sometimes I feel we nurture and protect them as though they were alive. Every living being needs rest and sleep to regenerate. Cities need vacant houses just as we need sleep, this uncontrolled space of our existence. That is why I like looking into empty houses: it is like an insight into my sleep.

Apart from taking on the traits of life by resting, vacant houses also behave like living beings – they grow. They appear unpredictably, organically, like wild growth in the city. The city is nowadays understood differently than in the Renaissance. Then it strove to follow the principle of order, to be understood and read – to be different from the wild nature beyond the city walls. The city of today, or rather, its urban condition, incorporates that wild nature – all the unkempt parks and vacant houses – into itself.

narration, carrying the subject matter of literary, familiar and recognizable knowledge and experience. Potrč is a storyteller who continuously builds stories with architectural material. Potrč's work has the meaning of a classical frieze where the language of sculpture is inseparably incorporated into the language of architecture, and where the ontological connotations of the classical world are displayed as a screen for storytelling. Potrč's walls of *Suburbia* and *Kampala*, among others, are built as fragments of an urban space which behaves like a body: unpredictable, decaying, cancerous, spreading, difficult to cure yet resistant and always alive. The viewer of Potrč's "imaginary city" is always already the *flâneur* throughout the theme park of both the recognizable and unrecognizable, that which is desired in a collective and private memory.

Goran Tomčić:

Architecture is the most immediate, expressive and lasting art ever to record the human condition. Cities are the containers and generators of our history, desire and culture. We have learned to gaze upon the city as artifact through illustrated portfolios, architectural guidebooks and tourist guides that have their own procedures for characterizing place and tradition. We often find city forms to be a theatrical art of scenographic composition, resurrected on an imaginary stage where its vanished architecture and ruins are given new life and arrangement. Marjetica Potrč, an architect and sculptor by vocation, has in the past ten years built an "imaginary city" within the spaces of the gallery and the museum, composed of her double-sided walls, panoramas and copies of real city façades.

The theatrical framework of Potrč's walls is "screen-like": a system built with the method of

Marjetica Potrč: *Suburbia*, contribution to Biennale in São Paulo 1996, installation, building materials, 2.1x18x4 m (opposite above); *Kampala*, contribution to exhibition *Sarajevo 2000*, 1996, Moderna Galerija, Ljubljana, installation, building materials, frescoes by Taylor Spence, 3.4x12x1.1 m (opposite center); and *Theatrum Mundi: Ljubljana, Trieste, Annandale-on-Hudson Territories*, 1996, installation, building materials, 2.2x7x2 m (opposite below)

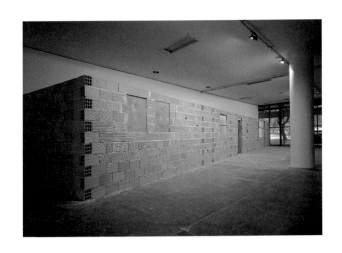

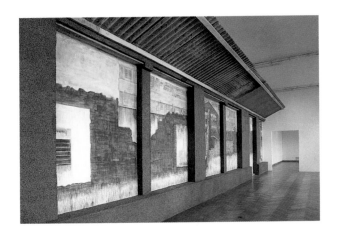

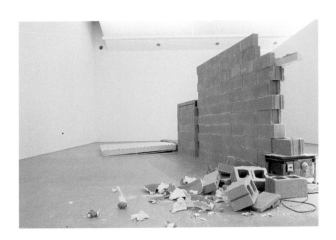

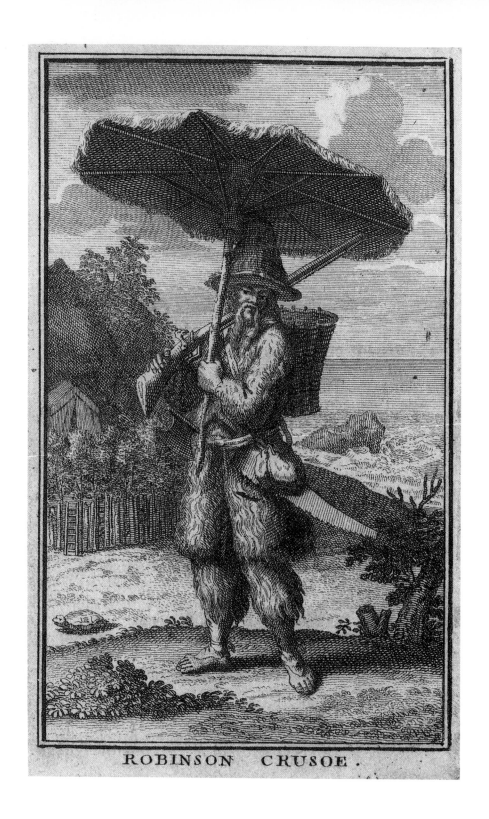

ROBINSON CRUSOE.

1. *Turning Tree*
Not realized

2. *Self Portrait with Handmade Clothes*
Movie, 2 min
Projected daily as a trailer in Münster cinemas

Lisa Phillips: Interview with Charles Ray,
4/10/97

LP: Why did you want to make a film to begin with? What attracted you to film?
CR: A few years ago I was trying to make an abstract sculpture and I kept running into problems. I was about to give up when I saw a photo of Caro's *Early One Morning* up on my bookcase. On this particular day there was a cider bottle turned sideways in front of the photo. Looking at it through the cider jug gave me the idea of building a sculpture in a bottle. Eventually I built my portrait in a bottle and the space became abstract while the sculpture itself turned figurative. My film *Fashions* uses the obsolete and abandoned space of 16mm film in the same way that the *Puzzle Bottle* uses the space from the genre of a ship in a bottle. Both works also use the figure as a structure to build a space that becomes a kind of abstract space. The space or place in the *Puzzle Bottle* exists outside of time while the turning girl with the changing clothes in *Fashions* makes a sculpture that is drawn in time.

Robinson Crusoe, engraving from first French edition of the book of Daniel Defoe 1722

Born 1953 in Chicago, lives in Los Angeles

For information about the artist and additional bibliography see: Distemper. Dissonant themes in the Art of the 1990s, Hirshhorn Museum and Sculpture Garden, Washington D. C. 1996; Charles Ray, Rooseum – Center for Contemporary Art, Malmö 1994; Charles Ray, Newport Harbor Art Museum, Newport Beach 1990.

LP: You made clothes in *Fashions*.
CR: Yeah, but they're not real, they're scotch-taped together. But it gave me the curiosity to start thinking about making real clothes and so after a while I started looking at sewing machines and then started to make my own clothes.
LP: You didn't know anything about sewing before this project?
CR: No.

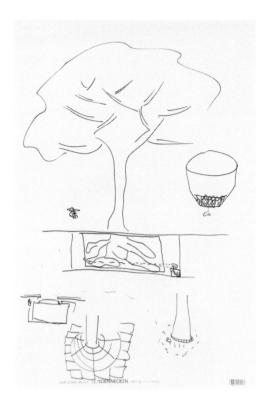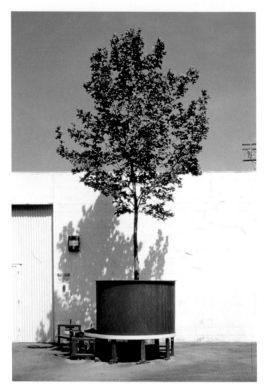

Charles Ray: *Turning Tree*, sketch of proposal for Münster
(left), and *Turning Tree*, 1992, model (right)

LP: Did you learn on your own or did you apprentice with someone?

CR: No, I learned on my own... Did you ever sew a dress?

LP: I used to sew all my clothes in high school.

CR: Do you think you could make a pair of shoes?

LP: I don't think so. I never thought about it.

CR: Have you ever seen a woman shoemaker?

LP: Did you have the vicarious experience of being a seamstress or shoemaker? Or did you always feel like yourself?

CR: I felt like myself.

LP: So why was it so important for you to make everything from scratch?

CR: You put your clothes on everyday and just don't know how they're made. That part is nice – you don't really know until you try to make them. You take them apart and you don't really know, but when you try to make them, you find out. The time and effort to learn to sew, make shoes, grind glasses, make socks and underwear etc. turned my body into an armature to show off my labor in the film. But it flips to the opposite and the clothes become an armature for my portrait. They give me a formal grounding in the film and a reason to be there.

LP: And what will the action be in *Self Portrait with Handmade Clothes*?

CR: I'm not sure because I haven't started film-

ing. Actually, I'm still working on the shoes, but I think it will be very simple and basic. I want to compress a year and a half of labor into ninety seconds.

LP: What relation do the clothes have to you?

CR: They're the kind of clothes I generally wear.

LP: They're the kind of clothes you wear, but you'll only be wearing them for this film portrait?

CR: Yes, just for that. The reason I don't want to wear them everyday is just because … if I wore them they'd get wrecked. Why would I wreck them? It took me all those years to make them. At the same time I don't want them to end up as precious objects in a gallery or something.

LP: But they're special to you.

CR: Yes, and they'll be special in that film. That's the dimension they were made for … why wear them out here? Robinson Crusoe wouldn't wear his grass skirt back in England after he was rescued. I kind of think of the piece as a modern Robinson Crusoe. I'm shipwrecked, abandoned, but self-sufficient in a contemporary media space. That's why the film only plays in a commercial theater, embedded in the pre-feature trailers. It's a celebration of my self-sufficiency, adrift in a contemporary media space which is our public space.

LP: You said you think of film as public sculpture in some way.

CR: Yes, it's very public.

LP: So you see film as sculptural?

CR: I think we're so close to it that we don't know what it is. I just see it as really, really important, you know – just in terms of how you talk to your mom, brother and sister and me about a film all in the same way – "it had no drive or it was boring", you know what I mean? But we talk about art differently, to different people.

LP: You mean because film is a common shared experience or language?

CR: It shows us how to kiss, how to drive a car, how to drink coffee in a coffee house, how to pack your luggage, how to get on an airplane, how to sit on a horse, how to hold yourself. That's what Greek sculpture did. Film is really important, really vibrant but we're too close to it somehow.

Thomas Stothart: *Robinson Crusoe and the Footprint*, engraving of 1790

Tobias Rehberger

Offenes Bad und Mobile Bar
(Open Pool and Mobile Bar)
Two-part work: Open-air swimming pool of
Bischöfliches Generalvikariat on Annette-Allee
and in and around Donald Judd sculpture on
lawn of Aasee
Rejected by Bischöflicher Generalvikar on
September 13, 1996

Mobile Bar mit Parkplatz und Custom-car
(Mobile Bar with Parking Lot and Custom Car)
Three-part work in and around Donald Judd
sculpture on lawn of Aasee and on the streets
of central Münster
Rejected by the Amt für Grünflächen und
Naturschütz (Office of Parks and Nature
Conservation of the City of Münster)

Günter's (wiederbeleuchtet)
(Günter's [relit])
Two-part work (furnishings, artificial lawn,
light)
Lecture hall building and terrace on Hinden-
burgplatz, corner of Bäckergasse

T

Born 1966 in Esslingen, lives in Frankfurt

For information about the artist and additional bibliography
see: nach weimar, Kunstsammlungen zu Weimar, Ostfildern
1996; Tobias Rehberger, Museum Fridericianum Kassel,
Ostfildern 1995; Tobias Rehberger, Kölnischer Kunstverein,
Cologne 1995.

Tobias Rehberger: 1st Project Proposal for
Sculpture Exhibition 1997, June 1996
The project proposal involves a "double inter-
vention", first of all in the two concrete rings by
Donald Judd on the Aasee. Few passers-by
identify the work by Donald Judd in the rear
area of the Aasee as a work of art.
For a period of three months, this blind spot in
the public perception will be partially redefined
as a new place: every evening, from twilight on
into night, a "mobile bar" will be erected here.
The outer ring can serve as a seating area for
visitors, the inner one as a bar for drinks and a
mixing area for the disc jockeys. By day, the
sculpture remains in its original condition; at
night it functions as a bar, but without any
direct intervention in the sculpture. All infra-
structure modifications should be accom-
plished with the least possible means. The
sculpture is to be renovated prior to the exhibi-
tion.

Parallel to this evening activity, a change of function is planned for the episcopal open-air pool only a few steps away, which is normally closed to the public. By day, it is to be opened to the public, and sculptures are to be developed which, reflecting the new conditions of use, are prosthetically joined onto the 1950s architecture. One example would be the installation of a sculpture to be used as a ladies' changing room.

Episcopal baths, so-called "Zölibad" (celibate pool), southwest of Annette-Allee (above)

Donald Judd: *Ohne Titel*, two nested concrete rings, contribution to *Skulptur Ausstellung in Münster 1977*, location: southwest lawn of Aasee, photo 1997 (below)

Tobias Rehberger: Drawings of planned parking-lot installation, 1997, sketch, watercolor, 44x63 cm each (opposite)

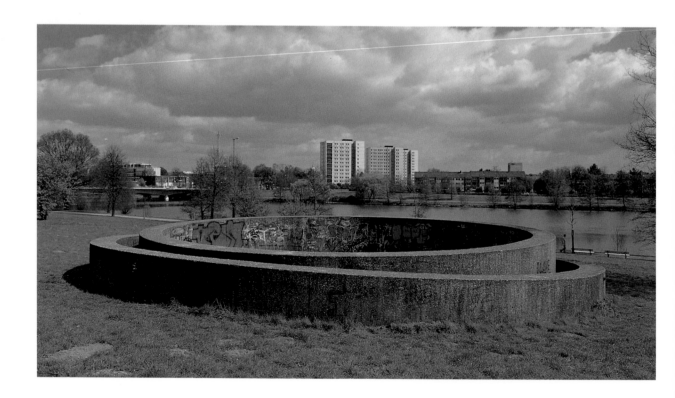

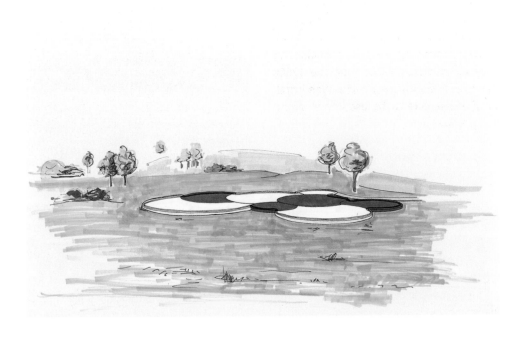

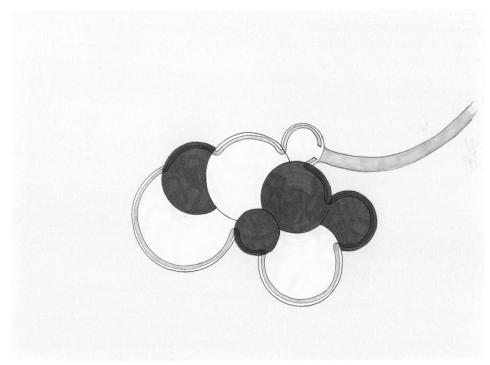

2nd Project Proposal

The second, three-part proposal likewise proceeds from the concept of a "Judd Bar". In addition, a small public parking lot is to be constructed within viewing distance (about 200–300 m away). The parking lot consists of a platform 30 cm high in the form of overlapping rings, some of which are covered with highly phosphorescent paint. By day, the platform (like the Judd sculpture) remains unused. At dusk, the phosphorescent paint begins to glow. As soon as this happens, the parking lot and the bar are opened. The phosphorescent paint glows for differing lengths of time depending on the length and intensity of solar radiation during the day (at full radiation for the entire day, about four to five hours). When the paint stops glowing, bar and parking lot are closed.

In addition, an automobile is to be customized (after the fashion of American custom cars). Each part, however, is to be customized autonomously, so that the automobile itself functions only as an architectural space. Concretely, this means that the left fender, for example, would be designed in a completely different way from the right. With respect to sound and acceleration, the car should be oriented to full performance. As a city car, however, its speed is limited to 65 km/hr. Furthermore, a navigation system should be installed in which all the contributions to the *exhibition Skulptur. Projekte in Münster 1997* are entered. Anyone can rent the car by the hour from the Landesmuseum.

3rd Project Proposal

The third project proposal centers around the university building on Hindenburgplatz at the corner of Bäckergasse.

The building consists of a single storey occupying approximately a third of the total height and an upper part which makes up about two-thirds of the height of the building and is almost entirely glazed. Sufficient quantities and different kinds of white light should be installed in the upper part of the building, in order that the glazed portion lights up the outside; in other words, not only is the building itself illuminated, but the light from the building radiates to the outside. In this way the whole building becomes a giant lamp. This lamp is the sole illumination for a bar installed on the large second-storey terrace of the university building. Formally, the constructions accord with the permanently installed concrete benches and are thus easily used as a bar, storage space and DJ mixing desk in the evening. By day, the parts are dismantled and used as tables for the concrete benches. For definition, the terrace should also be provided with a red rubber floor.

Tobias Rehberger: *Günter's (wiederbeleuchtet)*, 1997, computer simulation (opposite)

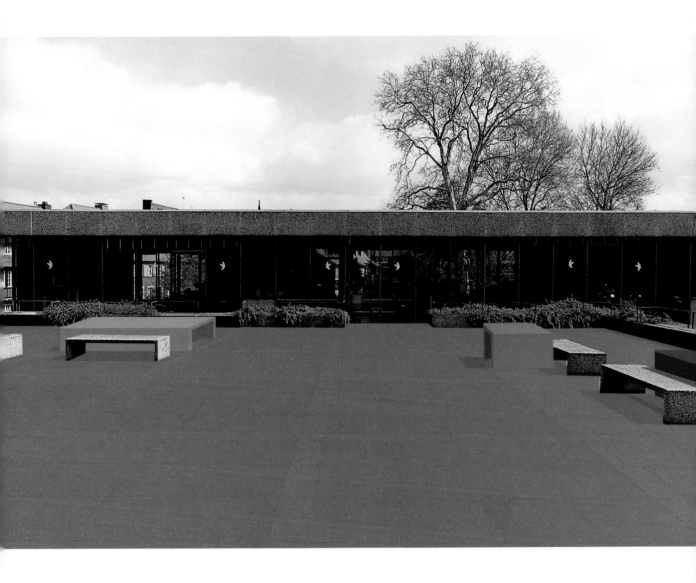

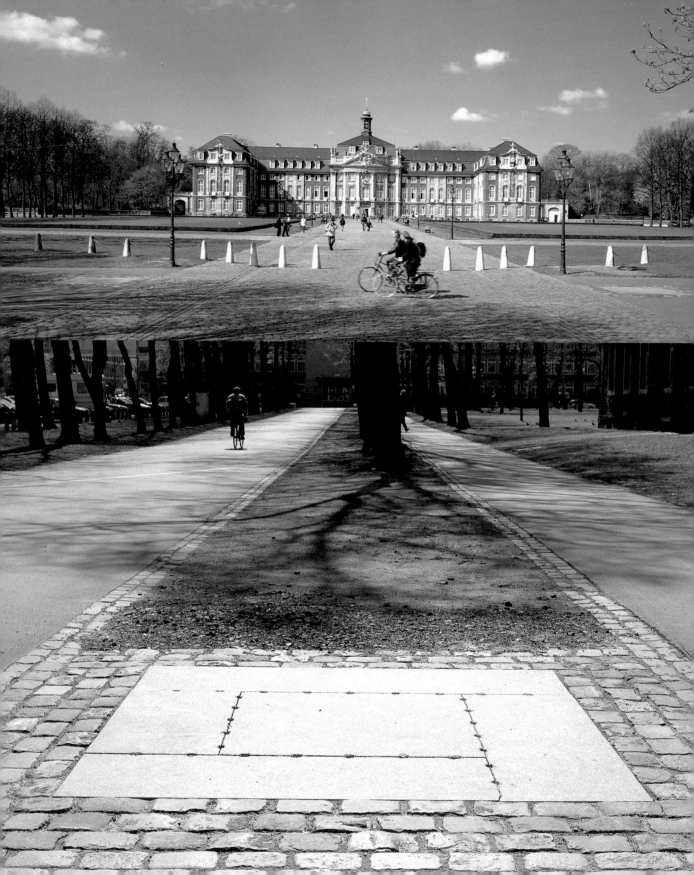

ULRICH RÜCKRIEM

*Bodenrelief, geschnitten, gespalten,*1996
(Ground relief, cut, split, 1996)
Two-part sculpture (Granit Bleudevire,
0.12 x 2 x 2 m)
Both sides of main approach to Schloß from
Hindenburgplatz, promenade area between
footpath and bicycle path

Born 1938 in Düsseldorf, lives in Ireland
and Normandy

Ulrich Rückriem: The Work for Münster, 1997

Two granite slabs are cut to quadratic form;
each is split in the same way into five parts and
reassembled into its original form.
The slabs are embedded into the ground up to
their top edge and arranged in relation to each
other in a particular place.
The place selected in Münster is by the University, in the promenade area between Hindenburgplatz and Schloßplatz.
This objective description would need no further comment from me if this were not Münster
– or rather, not the city itself, but the initiators
of this and previous exhibitions. Over a period
of decades, with admirable tenacity and circumspection, they have successfully opened up
the city again and again to the theme of "Sculpture in Public Space". Each of the artists invited, including me, was given the opportunity
to contribute his or her ideas, and for the most
part mine were able to be realized. In my case,
the freedom given meant that over the course
of 20 years I have been able to realize all my
subjects in this one city in a variety of indoor
and outdoor settings.
Of these sculptures, three have remained in
place, at the Petrikirche, in front of the

For information about the artist and additional bibliography
see: Ulrich Rückriem, Städtische Galerie im Lenbachhaus,
Munich 1995; Ulrich Rückriem. Arbeiten, ed. Heinrich Ehrhardt,
Cologne 1994.

entrance to the Westfälisches Landesmuseum,
and in the museum foyer. They are sculptures
placed on their sites without any change to the
existing situation. The atmosphere of the place
is influenced to a greater or lesser degree by
the sculptures. The two slabs embedded in the
ground in the square before the Schloß are only
visible at the last moment, often only when one
happens to step on them. Their sole orientation
is horizontal.

Today this is my favorite kind of work, because it shows the greatest possible reduction of a sculpture while still being recognizable as such. Here I learned something about the choice of site for a sculpture as well as about the incorporation of the immediate and extended vicinity.

The site chosen for a sculpture has its own pre-existing formal and visual reality and a history closely connected with it, a history that often has many layers. The place can have a number of practical functions. The continuation of these functions in the future and of the visual reality closely connected with them can of course be planned, but often it cannot be predicted. The place is also shaped by the interaction of political and organizational groups, communities of interest and individual persons as well as patrons and sponsors.

I can place a work on a site, emphasize the location, and view the work as something quite independent and autonomous, showing no regard for the factors I have just mentioned. But I can also integrate the work, incorporate the immediate or extended vicinity, i.e. include it in the design. I can give the place new, additional content and even change its practical function.

My own work, however, can also be completely omitted. Here the central focus is on the alteration in the site and its surroundings, and this in cooperation with landscape architects, city planners, and many others.

I have attempted the latter a number of times, yet without success, for it requires ideal pre-

Ulrich Rückriem: Plan für Münster, view of ground relief from above, 1996, construction drawing, 29.7x42 cm

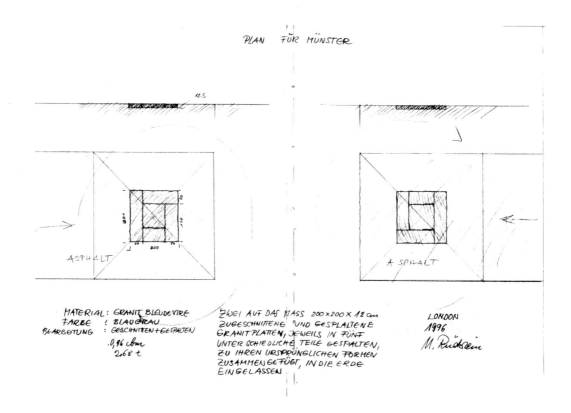

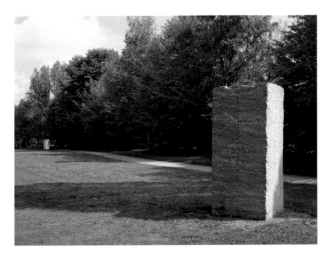

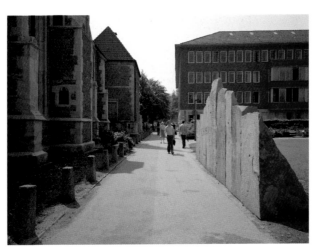

Ulrich Rückriem: *Finnischer Granit gespalten*, contribution to *Skulptur Projekte in Münster 1987*, location: north lawn of Aasee; and *Dolomit zugeschnitten*, contribution to *Skulptur Ausstellung in Münster 1977*, location: north side of Petri-Kirche

conditions and good teamwork, which up to this point I have not found.

For this reason, if I attempt to design more from the setting, I run the risk of treading on the toes of other planners, architects, and landscape designers, or of making foolish compromises.

The care and long-term preservation of the work should not be underestimated; it is an important consideration in planning and production as well as installation. Otherwise, after a number of years I won't dare look at the work again.

Wouldn't art in public space on a temporary basis really be the best solution?!?!

Or is it just the course of time that can't be stopped? Art objects in public space, whether accepted by the public or not, are subject to the same conditions as telephone booths, park benches, or flower beds. They are vulnerable to rapid decay through wind and weather, neglect and vandalism, often even complete destruction.

These difficulties have to some extent caused me to retreat into interior space.

In the last eight years I have built the hall in Clonegal (Ireland) and the halls in Sinsteden (Germany). They are ideal spaces for my installations. But even here there have occurred other, unforeseeable organizational difficulties that I won't mention further here.

In any case, for a short time it was a great feeling of happiness finally to be able to see the works just as I always imagined them, but had never been able to see them.

To return to the work in Münster:

It is no coincidence that I have "sunk" into the earth with the two stone slabs. For one thing, this theme has been missing from my work here in Münster, and for another, almost 70% of my works emphasize the horizontal. In order to design the horizontal immovably in exterior space, I have to embed it in the earth, and that's all.

Clonegal, February 1997

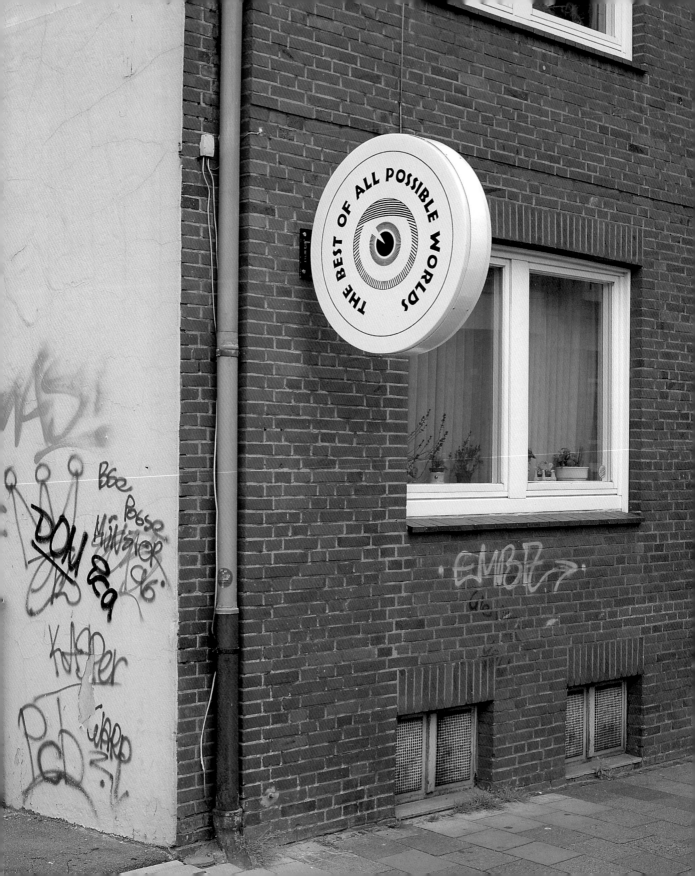

ALLEN RUPPERSBERG

The Best of All Possible Worlds
Two-part work
Old section of Westfälisches Landesmuseum
and eleven different places in central Münster

Born 1944 in Cleveland, Ohio,
lives in New York

For information about the artist and additional bibliography
see: Where is Al? Allen Ruppersberg, Magasin-Centre National
d'Art Contemporain de Grenoble, Grenoble 1996; Allen Rup-
persberg: A Different Kind of Never-Never-Land, ed. Dirk The
Nighthawk van Weelden, De Appel Foundation, Amsterdam
1995; Cocido y Crudo, Centro de Arte Reina Sofía, Madrid
1994.

Allen Ruppersberg: The Best of All Possible Worlds
A re-enactment of Voltaire's *Candide* as a new tour of Münster

All Nature is but Art, unknown to thee;
All Chance, Direction, which thou canst not see;
All Discord, Harmony, not understood;
All partial Evil, universal Good;
And, spite of Pride, in erring Reason's spite, One truth is clear,
"Whatever is, is right."
(Alexander Pope: *Essay on Man,* 1733)

This proposal is both a specific response to an eighteenth-century literary event which began in
Westphalia, and a general appreciation of the historical and visual pleasure of Münster itself.

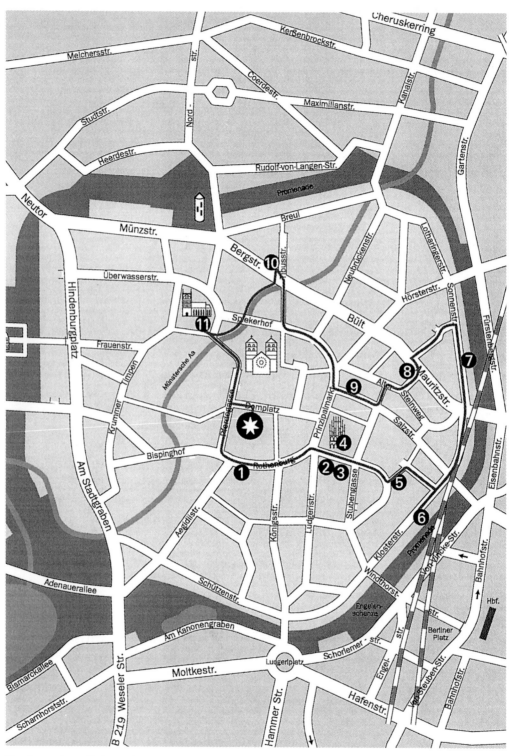

Allen Ruppersberg: *Die beste aller möglichen Welten*, tour with 11 stops beginning from old section of Westfälisches Landesmuseum

"There lived in Westphalia…" So begins *Candide* Voltaire's "philosophical tale" of 1759, a satire of the notion that this is the best of all possible worlds or that "all that is, is well" – an idea even more ludicrous today than in Voltaire's era. So begins my project for *Sculpture '97*.

The viewer, and how he becomes involved in the work

There are four basic elements which form the structure of this work. The first is an installation in the old section of Westfälisches Landesmuseum, which has just been reopened. Our hero, the viewer, enters the restored nineteenth-century Neo-Renaissance building (1879–1908) and, after being introduced to the exhibition, begins his tour of the commodious spaces filled with contemporary artworks. At one point the viewer enters into a room containing what appears to be some sort of theatrical set made to resemble a combination of a backstage dressing room and the interior of a travel office. There are many strange props and a sign above a desk which reads, "The Best of All Possible Worlds".

Prominently seated at the desk is a man dressed in an eighteenth-century costume who introduces himself as Candide from Westphalia. This actor introduces the viewer to the second element of the work, a new walking tour of Münster. The tour takes a circular route around the inner ring of the old city and has eleven different stops. The last stop brings the viewer back to the museum.
Our hero listens intently as Candide explains the nature of the tour. "The stories of Münster," he begins, "though normally concealed from the casual view, can reveal the particular mix of historical reality and dream that characterizes this city. These stories have been collected and organized to form the basis of this tour. Through interviews with people who have lived in Münster for long periods of time, a list has been developed of sites that are a particular focus for personal experiences, places where something of importance or significance has happened. Thus the selection of locations for the tour derives from the memories of the citizens themselves and becomes a way to look past the stone façades and take individual experience into account. The tour becomes a search for first-person memories in a city that was virtually destroyed by World War II. What are the consoling memories with which people live? How many memories are rooted in historical event? The tour spirals out of the public space of the museum to the private space of personal memory."
Candide is now up from his desk directing the viewer's attention to some of the brochures lying around the office. He tells our hero how the "plot" of the tour is circular and how he, the viewer, can become the "author" of it. He explains the relationship of things seen and things invisible, and about the overcoming of the second by the first – about the world that was and the world that is and the tension between the two.

The viewer's attention is beginning to drift, and Candide takes him by the arm. He quotes from his old companion Cacambo, from the period of their adventures together in the Americas.
"When you don't get what you expect on one side, you find it on the other. Fresh insights and fresh adventures are always welcome."
Our hero is intrigued and asks Candide how long the new tour will take. Candide replies that this is, of course up to each participant, but in general about thirty minutes. He mentions that his own original journey took much longer and included travels around the globe. But that was in the eighteenth

century; now he just works in this travel office part-time. And he assures the viewer that, although the new tour through the streets of Münster is not equal in length to his own, it will none the less be just as rewarding and metaphysically challenging.

After this preliminary chat, Candide shows the viewer the guide book. The guide book is the third element of the work and will function both as a standard guide for the tour, with maps, photos, and descriptions, and as a parallel guide to the world of Voltaire's *Candide*. Our hero is immediately impressed with its quality. It is a handsomely printed and designed affair with a general introduction to the city that includes notes on all the historical monuments, lavishly illustrated by color photographs. Advertising pages are kept to a minimum.

The viewer sees that each stop on the tour is clearly marked on large readable maps, and that the name of each of the people who has contributed memories is given, next to the location with which they are connected. There is also ample documentary evidence provided for each stop, consisting of old family or historical photos and descriptions of the events by the participants. Additional quotations from city historians add color and depth to the story of each location.

The viewer comments to Candide that the names of the contributors set out next to their locations become like characters in a novel or play. Candide agrees and points out that the number of stops on the tour corresponds to the number of characters in his own story, and that in his mind he has attached one of their names to each location. "It is almost as if each location is a chapter and the guide book becomes in the end, the novel," he says.

"What location is Cunegonde?" asks the viewer, displaying a little knowledge of Candide's story.

"I think you will have to discover the parallels yourself," replies Candide. "The stories chosen for the tour are placed in the unifying structure of a narrative, but the collection of seemingly random events they represent bring me to my dear Pangloss's ideas of cause and effect. Pangloss always tried to determine the present situation, then he would argue that everything in the past had led up to it. Does this not sound similar to the tour of the past and the present on which you are about to embark?"

Candide continues, "I have returned to Westphalia knowing it is not the best of all possible worlds but you, my friend, are just about to begin your journey. In this collection of stories for the tour I see similarities with the episodic construction that makes up my story, but that is just the beginning of the symmetry between my journey and the tour that I perceive. There is also a geographical shape to this tour, a 'plot' to it, that will frequently recall my story to you as you walk around Münster. I also went between the old world and the new world, you know, just as you are about to do."

"Does the success of the tour ultimately depend on the representative quality of the stories within the locations?" asks the viewer.

"Yes and no," replies Candide. "Sequence is at the core of a spiral, and, as you encounter one circle or ring after another in the succession of the locations, I believe you will learn many things, just as I did many years ago: the more bizarre the tale, the more absurd or comic the encounter, the more such things are touched with meaning and, of course, the better the tour. But even in the customs of Westphalia visible on this tour, you will find universal truths."

Now our hero is really excited and can't wait to begin. "I am ready to start," he tells Candide, "but I have one more question. Even though I have my guide book with its excellent maps, how can

I be sure I have found the exact location, since it may or may not look as it used to?"

"There is one thing I have not yet told you," answers Candide. "Do you see that sign above your head? This is the fourth element of the work. Eleven new plastic franchise signs, designed and produced in Münster and made to look as if they were from a new contemporary chain store, are placed, one each, at every location on the tour. All read 'The Best of All Possible Worlds', and all are identical."

The viewer steps back and examines the sign, which is about the size of a tyre on a small car or a Heineken beer sign on the side of a building. It is round, of course, and looks like a target, but has a drawing of an eye in the center. Around the perimeter, following the curve of the target are the words, "The Best of All Possible Worlds". Candide explains to the viewer that when he sees this same sign at each location he will know that he has found the exact spot.

"I might have found the right spot," the viewer says, "but I don't understand the signs. If they all say this is 'The Best of All Possible Worlds', how can they all be right and how do they connect with people's memories anyway?"

"I see that you have already begun your tour!" exclaims Candide excitedly. "Entrances and exits can both be alike, don't you think? You have entered the stories and you haven't even

An actor dressed as Candide receives visitors in the old section of Westfälisches Landesmuseum and sends them on the tour of Münster

left the museum yet! The great world of paradox is outside waiting for you."

"Your voyage begins voluntarily, unlike mine which started when I was literally kicked out of my Westphalian paradise," continues Candide. "I am a piece of historical fiction much like the signs on the tour which mark spots of non-existent places. Where now the plastic sign stands was for a moment something of importance and significance for someone. What if you find on your tour one of these best of all worlds signs on top of a McDonald's sign? What will you think?"

The possibilities of paradox, reversals, and parallels excite Candide, and he rapidly continues. "The sign states that you are now at the best of all possible worlds, an ideal place to be, and we know that at one time, in someone's life, it was the best of all possible worlds. But the sign is also a part of the actual world, in fact right on top of McDonald's. Most people couldn't tell one from the other. But if the site is a memory of a vanished ideal, then it means that the best of all possible worlds is the actual world and that the sign exists to tell you so, even when right on top of McDonald's.

Emil Stratmann: *Steinhoffs Zuckerhut – Erbaut 1751*, ca. 1960, oil on canvas, 31.5x39 cm, private collection. Among the artists who used this house as a motif, even into the 1960s, was Emil Stratmann. With his town views and landscapes he made a name for himself in Münster and the surrounding region. The story is told that he used this picture to pay his bill at the tavern "Steinhoffs Pümpken" on Mauritzstraße, where it hung for many years.

Friedrich Peschlack: View of Mauritzstraße 1, ca. 1930, sketch, red chalk, 55x42 cm, collection of Johann-Conrad-Schlaun-Gymnasium. – Before its destruction, the small half-timber house at Mauritzstraße 1 with its unusual ground plan, crooked walls, and flower-decorated windows was one of the most popular motifs for artists and photographers in Münster. The house was not destroyed during the air-raids in Münster, but was torn down piece by piece after the war by people looking for firewood and other usable materials. In the 1930s, Peschlack often came here to draw with his art teacher and fellow students from the former Oberrealschule on Sonnenstraße (now the Schlaun-Gymnasium). Herr Peschlack's stories and those of the former owners of the house occasioned Ruppersberg to make this location one of the stops on his "Tour durch Münster" (Tour of Münster, location no. 8).

The memories will disappear but the sign will remain — old memories, new signs. Simple, don't you think?" asks Candide.

"I don't know," replies the viewer. "It says 'The Best of All Possible Worlds,' but in a way it represents the worst of everything. The loss of the individual in the plastic world of non-existent places, the best pitted against the worst, etc. If all these places which have been singled out to be the best of all possible worlds don't any longer exist, where is the best of all possible worlds?"

Now Candide shows himself a literary critic. "The major structural technique for the evocation of the absurd is the juxtaposition of the ideal and the real," he says. The viewer looks puzzled as Candide continues. "My dear Pangloss was always talking about the Great Chain of Being, how causality explains all things. For instance, the nose was made in order to wear spectacles. But as I have said before, that was in the eighteenth century, and now it seems to me that this 'great chain of events' is no more than a franchise sign. All the same signs all around the world. I certainly never saw this in my original travels. And, I must say now that there is nothing less metaphysical than McDonalds. That's why I am content now to stay here in Münster and tend my own garden even if I do have to work part-time in this travel office. Talk about symmetry, I should have stayed in El Dorado!"

The viewer is exhausted but now wants to experience these ideas for himself. He accepts the offer of going on the new tour of Münster, receives his guide book and a complimentary copy of Voltaire's masterwork and begins his journey.

<div style="text-align:center">

What he sees and how it came to be
To be continued

</div>

Allen Ruppersberg 1996

REINER RUTHENBECK

Begegnung Schwarz/Weiss
(Encounter Black/White)
Action (two horses, two riders, moving in
opposite direction around Promenadenring)
Promenadenring

Born 1937 in Velbert, lives in Ratingen

Reiner Ruthenbeck: Concept for *Begegnung
Schwarz/Weiss* for *Skulptur. Projekte in
Münster 1997*

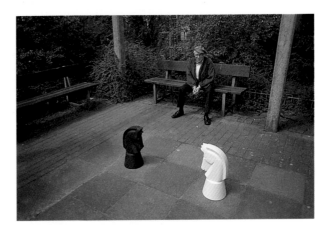

For information about the artist and additional bibliography
see: Reiner Ruthenbeck, IVAM Centre Julio González, Valencia
1995; Reiner Ruthenbeck, Goethe Institut, London 1994; Reiner
Ruthenbeck, Staatliche Kunsthalle Baden-Baden, Baden-Baden
1993; Reiner Ruthenbeck. Arbeiten 1965–1983, Kunstverein
Braunschweig, Braunschweig 1983.

This "kinetic sculpture" belongs to a series of
works with the basic theme of POLARITY, sub-
theme ENCOUNTER. Polarity with local color. A
black horse and a white horse with riders in
standard riding outfit are to circle the Prome-
nade in Münster in opposite directions, thereby
encountering each other twice on each circuit
in varying locations.
Planned time: about three hours every day (?)
Needed: two docile horses of about the same
size
The black horse should be as black as possible,
the white one as white as possible. The riders
should be fairly inconspicuous and not too dif-
ferent from each other (i.e. not fat/thin, old/
young, etc.)

Other projects on the theme of POLARITY/ ENCOUNTER
In the action installation *Blau/Rot* at *Hamburg
Projekt '89*, every day for several hours two
trucks with loading areas illuminated in blue
and red drove around the Binnenalster in oppo-
site directions.

At the installation *Red Lift – Blue Lift* at *docu-
menta IX*, two elevators operating next to each
other in the Fridericianum encountered each
other at irregular intervals in the course of
being used.
Another theme I often use, CROSSING OVER,
likewise represents a kind of encounter, espe-
cially when the two elements - sticks, bands,
ribbons, etc. - are of opposite colors. At the

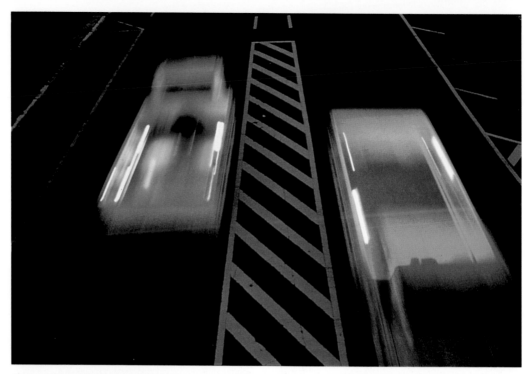

Reiner Ruthenbeck: *Blau/Rot – LKW-Begegnung*, contribution to exhibition *Hamburg Projekt '89*, 1989, two trucks circling the Binnenalster in opposite directions (above); *Red Lift – Blue Lift*, contribution to exhibition *documenta IX*, 1992, two elevators (below); and *Lodenfahne*, contribution to *Skulptur Projekte in Münster 1987*, location: atrium of old section of Westfälisches Landesmuseum (opposite)

point of crossing over, there is a brief spatial encounter, an overlapping and apparent union.

"[…] A primary theme of my work is polarity, duality, and/or its neutralization in the work of art. I try to attain a kind of suspended balance in my art and thus in the consciousness of the viewer […]" (1986)

"Polarity is the foundation of manifest creation. Without polarity there would be only the absolute, which cannot be realized and of course cannot be represented (by whom indeed?) But what interests me is less polarity than unity as its actual basis. […] I want to show polarity and unity at the same time. […] The unity consists in standing before the work and recognizing the whole as art. Otherwise there would be, for example, only a blue and a red ribbon. The moment of unity lies in perceiving this form as a self-contained work of art […]" (1989)

"[…] I try to attain as high a level of abstraction as possible, and I began working in art above all with polarities […] because for me this is the highest form of abstraction. Every step beyond this leads out of what can be represented. Without polarity, there would be only pure, unmanifest being. As an artist one can perhaps convey this sense by bringing the polarity into balance in such a way that a feeling of unity arises, of wholeness, of quiet and balance in consciousness […]." (1993)

Bernhard Holeczek: Polarities

The determining factor in the work of Ruthenbeck are opposites, their tension and resolution. One could even speak of an overarching principle of dualism which provides a *tertium comparationis* even in the most diverse works. Here the contrast in material acquires early and decisive significance, and formal correspondences necessarily follow. Without much searching, a good dozen pairs of concepts quickly add up, which we encounter in all of Ruthenbeck's objects, one way or another, in more or less pronounced form: soft/hard, light/dark (also in the color contrast white/black), warm/cold, light/heavy, transparent/opaque, male/female (also, as for warm/cold, in the opposition of the colors red/blue), open/closed, round/angular, amorphous/shaped, relaxed/tense (limp/taut), unstable/stable. The list of opposites could be continued indefinitely, for example for the (few) kinetic objects with stillness/movement or action/reaction. Opposites are not confronted with each other arbitrarily, but rather are brought into relation with each other, with the goal of finding a formal solution to their apparent irreconcilability.

From: Reiner Ruthenbeck: Institut für moderne Kunst, Nuremberg 1986

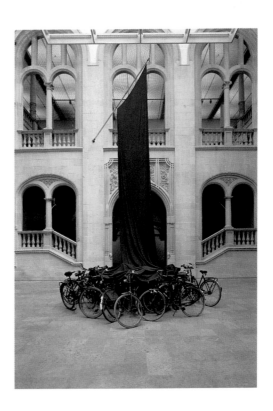

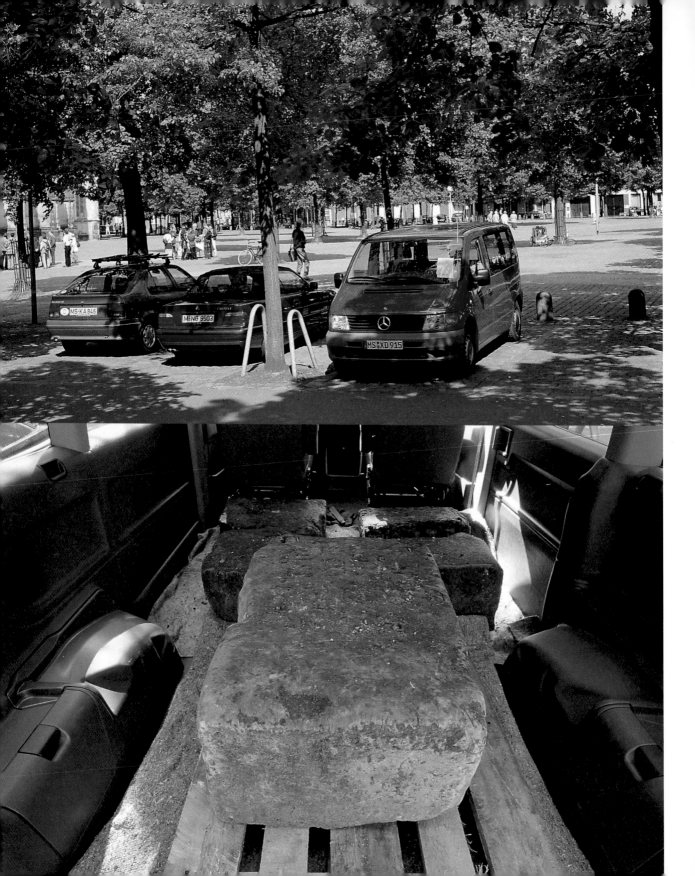

KURT RYSLAVY

Verkaufswerk Nr. 17
Installation (Mercedes Vito 110 D, stone
sculptures by Georg Herold)
Parking space on south Domplatz in front of
Westfälisches Landesmuseum

Born 1961 in Judendorf/Graz, lives in Brussels

Kurt Ryslavy: *Verkaufswerk Nr. 17,* 1995/96
(Work for sale No. 17)

External form:
MERCEDES VITO 110 D (transport vehicle –
type "small delivery van", load capacity ca.
1,000 kg); windows on all sides.
Installation site: Parking space in front of the
Westfälisches Landesmuseum für Kunst und
Kulturgeschichte, in the "front row" so that visi-
tors approaching the museum must pass by it.
The interior/loading area of the vehicle (with
wood paneling) contains two to three SCULP-
TURES by Georg Herold. The sculptures,
arranged on small palettes, are the marlstone
blocks from the symposium *Alleen de verander-
ing houdt stand* (Meerssen, Netherlands, 1987),
illustrated in the Herold catalogue raisonné. In
the illustrations from the catalogue raisonné,
these marlstone sculptures are shown in a
freshly worked condition; their present state, as
intended for the Verkaufswerk, is weathered
and moss-covered (the individual works are
identified by Herold).
Behind the windshield (next to the parking
authorization) is placed a CERTIFICATE with all
the technical data, provenance, etc. of the *Ver-
kaufswerk Nr.17* by Kurt Ryslavy. The vehicle is

For information about the artist and additional bibliography
see: Degustation, Kunst+Projekte Sindelfingen e. V., Stadt-
museum Sindelfingen, Sindelfingen 1996; Het volk ten voeten
uit. Naturalisme in België en Europa. 1875-1915, KMSKA/ICC
Koninklijk Museum voor schone Kunsten, Antwerpen 1996;
Akustikbezogene Rauminstallation. (Es spricht Gerhard Polt),
Wiener Secession, Hauptraum, Vienna 1993; Kunst Austria
Libera. Hedendaagse Kunst uit Oostenrijk, Ghent 1992.

officially registered (license plate, registration
papers) and ready to drive.
Verkaufswerke by Ryslavy (since 1992) are a
three-dimensional, processual continuation of
his so-called projection area pictures. They
consist of two parts: the artwork of an expen-
sive colleague and a receptacle/case specially
fitted for it (plus all the written and photo-

graphic documents accompanying the sale). The receptacle is suitable for TRANSPORTING the artwork in question. *Verkaufswerke* can always also be separated (receptacle and contents) and separately presented when the sale intended in the work has been realized – whether it be the "art work of the expensive colleague" or the *Verkaufswerk* by Ryslavy himself (the vacancy in the "emptied" *Verkaufswerk* evokes the memory/mental image of the missing "art work of the expensive colleague").

For the duration of the exhibition, the installation of *Verkaufswerk Nr. 17* in the parking space in front of the Westfälisches Landesmuseum corresponds to the presentation of a series of other (smaller) *Verkaufswerke* in the museum itself. (In order to demonstrate the mobile character and interactive potential of *Verkaufswerk* Nr. 17, one could consider periodically bringing the delivery van along on guided tours of the exhibition *Skulptur. Projekte in Münster 1997* – like a dog on a leash – and afterwards parking it again in the same location.)

"Better Living"? A Fax-Dialog between Kurt Ryslavy and Vitus H. Weh

Vienna, March 10, 1997, 10:24 am. Dear Mr. Ryslavy,

I see two alternatives for the text. Since your work in the wine business/wine tasting and the project *Verkaufswerk Nr. 17* for Münster have much to do with communication (indeed probably center around it), a dialog text, i.e. an interview, would be quite appropriate. In that case I would send you questions by fax in the next few days, which you would then answer as soon as possible, also by fax. The questions and answers would be provisional and could be revised by both of us right up to the final stages.

The other alternative would be to write a "compact" text on the significance of context in contemporary art, using your work as the central example. For this, however, I would also need a statement from you (on the subject of sale/presentation as "context").

Which variation is more to your liking?

Brussels, March 10, 1997, 4:00 p.m. Dear Mr. Weh,

I think that interviews are a good form of communication for occasions when the interviewer approaches the interviewee – and not, as in our case, the other way around. In the former situation, the interviewer already brings with him particular contexts and concerns within which he wants to present the interviewee (e.g. an interview in a news magazine or the like). In the present case, however, I approached you to ask for a text that would so to speak make a statement about the connection of my work to the (or a) current discourse on art. The "dialog", as it were, should rather take place between my work and your knowledge of this contemporary discourse.

For that reason I am in favor of the second alternative you suggested in your fax today.

I have to say beforehand that due to an inescapable lack of time (bread-winning) I have only a very eclectic knowledge of contemporary art discourse; but I think that my *Verkaufswerke Nr. ...* go beyond the (still current?) issue of "contextualism".

The *Verkaufswerke Nr. ...* revolve around the ambivalence between the classical notion of sculpture and an immaterial, objectless conception of art. These works resulted from a relatively pragmatic analysis of dialogic concerns in my painting and writing.

On the other hand, my pictures *Factures décoratives* and *Les monochromes avec ses arrière-plan économique* have the qualities of critical thinking about art as well as those of a purely

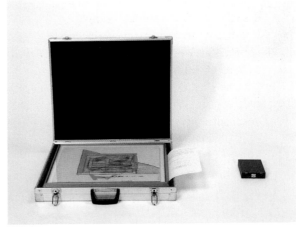

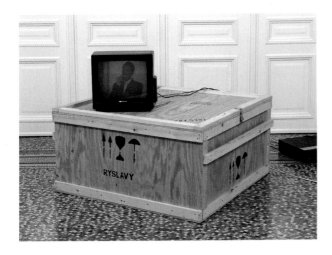

Kurt Ryslavy: *Verkaufswerk Nr. 10*, 1994, installation, pres-
entation case, imitation velvet, ca. 8x37x31 cm, contains a
work by Franz West, 1979–80; *Verkaufswerk Nr. 13*, 1994,
installation, presentation case, imitation velvet, ca.
7x36x28 cm, contains two works by Franz West, 1980–81;
Verkaufswerk Nr. 3, 1993, installation, presentation case,
imitation velvet, ca. 7x51x42 cm, contains a work by Martin
Kippenberger, 1987 (above left); *Verkaufswerk Nr. 1*, 1993,
installation, metal-braced instrument case, foam-padded,
ca. 10x57x70 cm, contains a work by Dieter Roth, 1982;
Verkaufswerk Nr. 9, 1994, installation, jewelry case, imita-
tion velvet, ca. 3.5x15x13 cm, contains a work by Dieter
Roth, 1982 (above right); and *Verkaufswerk Nr. 5*,
1992–1997, installation, overseas transport box, laminated
wood, foam, wood, video system, ca. 0.9x1x1 m, contained
a work by Franz West, 1983–84 (center)

painterly nature. My nightmare as an artist has
always been to be pigeonholed within a current
"ism"; at the same time, I have had the harsh
experience of the relative unsaleability of my
works, owing to their not belonging to an "ism"
and/or the lack of a pronounced external dif-
ference between the one or the other group of
works. A logical consequence thus appears to
be the artistic travesty as a materially indepen-
dent entrepreneur. The *presentation* of art con-
tinues to be associated with the bourgeois

notion of the sublime in which everything mon-
etary is taboo.

My explicit concern with these issues has,
understandably, often led to misinterpretation.

Vienna, March 10, 1997, 5:10 p.m.
I've already begun work: it will most certainly
not be a matter of pigeonholing you in an "ism"
(if that's what you're worried about) - quite
apart from the fact that the context discourse
continues to be relevant and in recent times

has oscillated between art-immanence and the socioanalysis of other social fields.

But apart from the momentary state of the discussion: a text on your work will by no means be able to evade the issue of "context" and the "givens" of art. For decades now the question of what actually belongs to the work of art has occupied art historians as well, though their concessions to a more complex mode of perception appear downright absurd in the light of artistic production. Parasitic, dadaesque, and analytical strategies are constantly intermixing. Couldn't one say that your work has, so to speak, "contaminated" areas such as picture *title, opening, display*, or *sale* through estheticization?

Brussels, March 10, 1997, 8:30 p.m.
I am in agreement with the idea of the "contamination" of the areas you mentioned as a point of departure.

Probably a fundamental characteristic of my work, which should therefore be included among the issues addressed in the text, is its continual ambiguity. On one occasion, for example, an exhibition curator who was very open-minded and well grounded in art theory actually betrayed shock (and initially wanted to cancel the planned solo exhibition) when, in addition to the invitation aimed at the art public, I independently sent out an invitation aimed at the commercial public – *even though* all this was described in detail in the exhibition proposal approved by the curators. Sometimes this ambiguity (not only of form, but also of content) can have a very surprising effect. What always plays a role as well is the "expansion of the definition of art by including the option of banal, superficial, and one-dimensional reception", for example when I had Gerhard Polt deliver the opening speech for my installation in the main room of the Vienna Secession four years ago.

Vienna, March 10, 1997, 11:00 p.m.
Regarding your insistence on ambiguity: the epicurean pose, your role as a knowledgeable cigar smoker and wine taster, the (padded) packaging of the art of others, etc. are indeed very ambivalent. They are so ambivalent that one could well criticize them; indeed one would probably have to. My question is, does your ambiguity go that far?

In other words, could you even swallow a text on your pages of the catalog that asks whether the reveling in estheticisms or the estheticization of physical pleasure, i.e. the "in-corporation of oneself", isn't actually the very paradigm of our capitalistic logic? – etc.

Brussels, March 11, 1997, 7:18 a.m.
The "epicurean pose" would be better referred to as "the quotation of an epicurean pose" – especially with regard to the padded packaging of the art of others (perhaps less with respect to cigar smoking).

The ambiguity in my work is simply present; what it is I am insisting on I don't want to nail down at this point. I thought that an anecdote might amuse you...

Reveling in estheticism, or the estheticization of physical pleasure, is indeed the paradigm of our capitalistic logic, as you say. But here my question is: do you know of any artist who doesn't estheticize (including adepts of Karl Rosenkranz)?

On the other hand, I simply can't afford to revel in aestheticisms (and I doubt whether I would want to even if I could). My euphoria has to do rather with formal pragmatics.

The text on my pages of the catalog should above all serve the purposes of mediation. In that sense I can "swallow" anything in it with no problem. Of course if it said only that I revel in estheticisms as a paradigm of our capitalistic logic, I wouldn't think that was sufficient. But I can't imagine you would want to write that way. [...]

Brussels, March 13, 1997, 12:45 a.m.
Many thanks for your fax today and for the draft of the text "Better Living".

As I understand it, this text takes the "packaging aspect" as a point of departure and then describes further manifestations of my work one after another in an amusing way, directly and without distance.

For the moment I am at a loss, and I doubt whether the narrative and anecdotal can serve to mediate my work or whether the exhibition catalog is the proper place for a text with those qualities.

In any case, an analysis of the formal necessity of the facts described in the text eludes me, as does at least an indication of where the interactive power of this art could possibly lie, apart from the "attractive appearance" and various social skirmishes.

Tomorrow I'll think about it some more, and in the meantime I appreciate your understanding.

Vienna, March 13, 1997, 8:25 a.m.
I am not surprised that you are astonished by my text proposal, since I had in fact first talked about other approaches. But I still consider the text a viable option for *mediating* your work (which, by the way, it does do from an appropriate *distance*). I experimented with other textual possibilities, for example embedding it in the theoretical discussion surrounding context-art, etc. But as you yourself guessed in one of your letters, this discourse has passed its zenith, and to try to link your work to it would, I think, tend to convey the impression of a late arrival.

Rather, what distinguishes your work is a playful, sometimes even dadaistic character resulting from the exaggeration of the banal (e.g. your expensive cases for "worthless" beer coasters and the like). I think this is where one should focus the attention of the interested reader.

This, however, is not possible through an "analysis of the formal necessity" as you describe it. I fear that such a text would make your whole project seem incredibly didactic and trite and would *convey* nothing of this sparkle and ambivalence.

Vienna, March 13, 1997, 9:30 a.m.
Regarding your reference to Susan Hapgood's text *Doppelhelix Kunst und Geld* (in Museum in Progress, August 1996): how would it be to use a quotation from that article as a motto preceding "Better Living"? It would provide a nice balance: "At the end of the twentieth century, few taboos remain in art. Money, however, continues to be a subject not considered appropriate for polite conversation about art. The equation 'good art = high monetary value' is not expressed in so many words, but is nevertheless all the more present."

With best regards, Vitus H. Weh

KARIN SANDER

Schwerpunkt der Stadt Münster 1997
(Center of Gravity of the City of Münster 1997)
Von-Kluck-Straße 34/36

Gauß-Krüger coordinates:
Easting: 3405456.8 m Northing: 5758707.1 m
Geographical coordinates:
Latitude: 51° 57' 20.24" N
Longitude: 7° 37' 28.35" E

Born 1957 in Bensberg,
lives in Stuttgart

"The center of gravity is that point of a body in which its entire weight can be thought of as concentrated. If a body is supported in its center of gravity, it cannot fall. If a body is the same in all its parts, the center of gravity coincides with the center of the body." (Brockhaus)

If one were to project the perimeter of Münster to scale on a steel plate of uniform thickness – for example, at a scale of 1:5,000 – and then cut by machine along this perimeter, the cut urban area (12.14 m²) would achieve balance when supported at the center of gravity.

For information about the artist and additional bibliography see: Karin Sander, Kunstmuseum, Kunstverein St. Gallen, Ostfildern 1996; Karin Sander. Projects 46, The Museum of Modern Art, New York 1994; Karin Sander. Rubens-Förderpreis, Städtische Galerie, Siegen, Ostfildern 1994; Karin Sander, Städtische Galerie Nordhorn, Ostfildern 1993.

Karin Sander

In the Middle Ages, the center of Münster was the cathedral square, the Prinzipalmarkt, and the Rathaus. This area represented both the geographical and the political-social center of the city. With increasing growth of the urban area, however, the periphery of the city moved ever further and more irregularly away from the original center. Because of this shift, the historical town center and the geographical center of the city of Münster are now no longer identical. This project conceives of the total urban area of Münster as a body "the same in all its parts", in which the physical center of gravity and the geographical center coincide. Using a method of calculation which was developed especially for this purpose and which surpasses previous methods in accuracy, the exact center of the present city was established with reference to the current administrative boundaries and with the help of official coordinates (patent applica-

tion no. DE 19716 93 60,8). In the following, the method of calculation will be described and illustrated in more detail.

The current center of gravity/geographical center is located in the garden between Von-Kluck-Straße 34 and 36 on the boundary between a private lot and the grounds of a Catholic girls' school far outside the historic town center. Its location is defined with reference to global coordinates and marked by a circular area 130 cm in diameter, a size which corresponds to the margin of error for the calculation of the center of gravity.

The place, thus recovered from anonymity, receives a new identity and becomes a point from which historical change and social restructuring can be projected and perceived; the perception of it as center of gravity and geographical center leads to a spatial conception of the city as sculpture.

Like other city sights, the newly defined place will be illustrated on a picture postcard available at kiosks or the museum.

Map of center of Münster, with red dot marking center of gravity on Von-Kluck-Straße 34/36, scale of 1:20,000

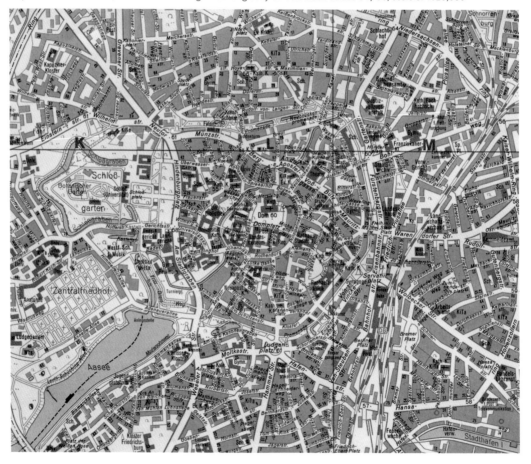

Hubert Hagedorn:
Determination of Center of Gravity of Münster

For the exhibition *Skulptur. Projekte in Münster 1997*, Karin Sander intended to calculate the center of gravity of Münster, to mark it locally and define it within a system of global coordinates.

With the methods of calculation known up to this point, the center of gravity could be determined with an accuracy of only ca. ± 300 m. Thus Karin Sander's idea provided an opportunity to rethink calculation methods for determining the center of gravity with a view to a considerable increase in accuracy. As a result, two entirely different methods of calculation were developed especially for *Skulptur. Projekte in Münster 1997* by Dr.-Ing. Dieter Grünebaum, physicist, and by Olaf Lenzmann, electrical engineering student, and Prof. Dr. Ing. Lothar Lenzmann, land surveyor. Based on a ± 10 m margin of error for points on the perimeter of Münster, Grünebaum's method now allowed the center of gravity to be calcu-

lated with an accuracy of ± 15 m, while Lenzmann's method even permitted an accuracy of ± 0.7 m.

The basis for the calculation of the center of gravity were the Gauß-Krüger (GK) coordinates of all 2,808 inflections on the perimeter of Münster, as determined by the Surveying and Cadaster Office of the city of Münster through digitalization of the German Standard Map at a scale of 1:5,000. Since 1923, the datum plane in Germany has been von Bessel's 1841 rotation ellipsoid, flattened at the poles. It results from the rotation of the meridian ellipse on its small axis, with the small semiaxis (distance between center and pole) measuring 6,356,079 m and the large semiaxis (distance between center and equator) measuring 6,377,397 m in length. Subdividing the surface beginning with the prime meridian of Greenwich (seat of the London observatory) and proceeding eastward in meridian sections of 3° latitude each, each meridian section constitutes a coordinate system in itself. The limited east-west extension enables each section to be illustrated in the

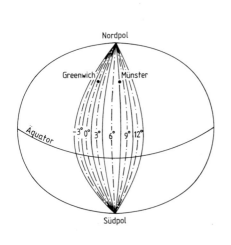

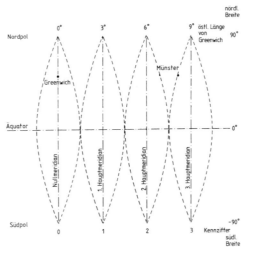

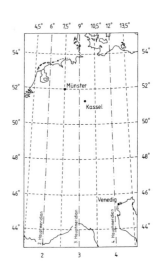

cartographic plane with little distortion of angles, with distortion increasing toward the edge of the section.

In this congruent GK representation, the two-dimensional depiction is similar to the ellipsoid prototype in the smallest parts or in the differential. The easting GK coordinate value in each case is determined with reference to the main meridian, i.e. each meridian divisible by 3, while the northing value is determined with reference to the equator. In order to obtain positive easting values for all points of a meridian section, the easting value of the main meridian itself is always fixed at 500,000 m. In addition, the corresponding reference number of the meridian section is prefixed to the easting value.

Since the area of the city of Münster extends over two meridian sections, the GK coordinates of all the inflections lying in the second section were converted by computer into the system of the third section. After the coordinates were established within a uniform system, the GK coordinates of the center of gravity could be calculated using the methods newly developed by Grünebaum and Lenzmann.

According to the more accurate method of Lenzmann, the center of gravity of Münster corresponds to the following coordinate pair in the GK coordinate system:
EASTING: 3,405,456.8 m,
NORTHING: 5,758,707.1 m

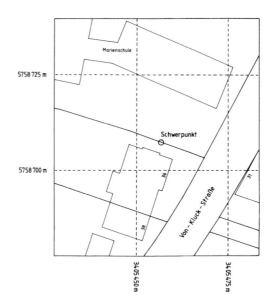

The center of gravity thus lies 94,543.2 m west of the third main meridian (9° meridian) and 5,758,707.1 m north of the equator.

The GK coordinates can be converted into the following ellipsoid geographical coordinates:

LATITUDE (φ): 51° 57' 20.24"
LONGITUDE (λ): 7° 37' 28.36" E

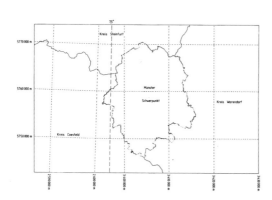

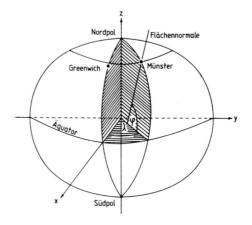

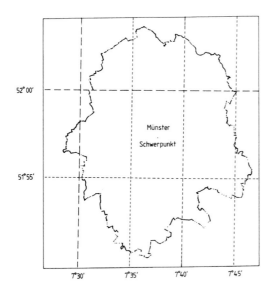

The geographical latitude here corresponds to the angle measured in the meridian plane between the ellipsoid equatorial plane (x,y plane) and the surface normal (vertical direction) in the center of gravity of Münster, while the geographical longitude corresponds to the angle measured in the equatorial plane between the prime meridian plane (x-axis) and the meridian plane of the center of gravity. In this system "φ" is positive to the north and negative to the south, while "λ" is positive to the east. The ellipsoid meridian plane is formed by the surface normal and the z-axis.

The position of the center of gravity on the actual site was established by means of the GK coordinates with the help of local surveying points in the vicinity whose GK coordinates are recorded at the Surveying and Cadaster Office.

3071 3401526.7 5747000.0 | 2454 3405705.7 5747533.0 | 2308 3408738.5 5749995.2 | 2135 3409884.1 5752183.3 | 1947 3412022.9 5752942.4 | 1756 3415712.2 5754828.8 | 796 3414131.2 5757460.1 | 566 3413397.9 5762173.3 | 39 3412282.7 5767137.5 | 303 3407406.0 5766950
3069 3401562.2 5746951.9 | 2456 3405715.3 5747529.7 | 2307 3408745.9 5749994.3 | 2136 3409874.6 5752189.7 | 1946 3412024.0 5752940.0 | 1757 3415714.3 5754832.6 | 797 3414101.9 5757459.2 | 567 3413400.2 5762186.7 | 38 3412290.7 5767168.1 | 304 3407416.4 576948
3068 3401602.3 5747000.5 | 2455 3405719.2 5747531.9 | 2306 3408769.4 5749990.6 | 2137 3409861.7 5752200.5 | 1945 3412033.1 5752919.5 | 1758 3415700.0 5754847.9 | 818 3414066.1 5757455.8 | 568 3413398.3 5762197.3 | 37 3412301.5 5767194.1 | 305 3407420.0 576944
3030 3401653.9 5747053.8 | 2453 3405723.8 5747534.3 | 2305 3408787.6 5749967.7 | 2138 3409855.3 5752213.7 | 1953 3412034.4 5752916.5 | 1759 3415682.2 5754854.1 | 819 3414035.3 5757451.0 | 570 3413390.1 5762210.4 | 36 3412306.3 5767216.5 | 306 3407440.7 576942
3022 3401694.1 5747096.7 | 2450 3405727.3 5747534.5 | 2304 3408811.6 5749967.1 | 2139 3409852.3 5752233.7 | 1961 3412057.9 5752893.0 | 1760 3415710.5 5754905.9 | 817 3414038.8 5757523.1 | 571 3413401.9 5762324.4 | 34 3412243.5 5767246.8 | 307 3407440.0 576939
3021 3401703.7 5747143.4 | 2449 3405911.7 5747634.8 | 2303 3408830.6 5749976.3 | 2140 3409853.9 5752277.4 | 1962 3412057.9 5752823.9 | 1761 3415708.1 5754905.5 | 768 3414025.2 5757524.7 | 569 3413428.2 5762311.0 | 31 3412243.5 5767297.8 | 309 3407445.3 576937
3025 3401727.1 5747143.4 | 2448 3406006.3 5747729.1 | 2302 3408840.6 5749976.3 | 2141 3409867.8 5752356.3 | 1963 3412070.1 5752852.9 | 1762 3415710.7 5754910.9 | 778 3414014.4 5757558.4 | 560 3413430.0 5762315.1 | 30 3412135.9 5767326.1 | 310 3407440.6 576936
3029 3401735.0 5747172.0 | 2445 3406246.7 5747811.6 | 2301 3408849.5 5749975.5 | 2142 3409891.9 5752729.9 | 1959 3412101.8 5752820.0 | 1763 3415719.3 5754919.0 | 777 3414010.5 5757579.7 | 561 3413454.8 5762369.1 | 31 3412155.1 5767327.2 | 311 3407436.1 576933
3028 3401742.4 5747213.6 | 2446 3406349.5 5747864.7 | 2299 3408901.7 5749986.0 | 2124 3409891.9 5752729.9 | 1958 3412106.1 5752820.0 | 1764 3415740.1 5754932.5 | 780 3413992.2 5757589.5 | 559 3413471.8 5762401.6 | 32 3412179.9 5767359.1 | 312 3407433.0 576931
3026 3401745.9 5747227.2 | 2443 3406385.7 5747880.1 | 2298 3408907.4 5749986.0 | 2123 3409883.2 5752736.9 | 1956 3412152.0 5752799.0 | 1767 3415751.6 5754973.1 | 782 3413893.8 5757620.8 | 557 3413482.8 5762422.6 | 33 3412099.0 5767359.1 | 313 3407427.6 576930
3024 3401752.0 5747240.5 | 2442 3406393.0 5747911.1 | 2294 3408954.6 5749991.5 | 2120 3409842.1 5752734.3 | 1954 3412157.0 5752796.7 | 1769 3415723.0 5754999.8 | 784 3413842.1 5757646.6 | 554 3413512.1 5762481.9 | 45 3412072.3 5767345.8 | 314 3407419.4 576937
3023 3401778.8 5747294.9 | 2440 3406410.3 5748000.0 | 2293 3408967.0 5749990.0 | 2122 3409783.9 5752716.6 | 1957 3412157.0 5752796.7 | 1770 3415715.7 5755005.0 | 787 3413834.3 5757675.1 | 553 3413547.7 5762553.9 | 46 3412005.0 5767333.1 | 315 3407414.4 576930
3014 3401787.0 5747310.3 | 2439 3406412.3 5748028.1 | 2292 3409093.4 5749990.6 | 2115 3409804.4 5752714.3 | 1967 3412496.2 5752629.6 | 1749 3415714.4 5755014.1 | 785 3413828.5 5757706.6 | 552 3413547.3 5762773.3 | 47 3411978.0 5767298.1 | 316 3407408.0 576930
2985 3401813.3 5747344.5 | 2410 3406416.4 5748089.3 | 2317 3408976.5 5749994.4 | 2106 3409766.9 5752894.4 | 1966 3412706.1 5752526.9 | 1735 3415692.3 5755027.3 | 770 3413819.0 5757755.4 | 551 3413570.1 5762834.5 | 48 3411959.1 5767298.2 | 317 3407399.7 576929
2972 3401817.1 5747339.9 | 2409 3406416.4 5748231.7 | 2316 3408993.2 5750000.6 | 2105 3409735.3 5752859.9 | 1964 3412940.4 5752413.3 | 1736 3415701.4 5755024.9 | 772 3413795.0 5757854.2 | 548 3413759.1 5762983.6 | 58 3411801.7 5767418.4 | 322 3407394.0 576930
2971 3401839.2 5747327.6 | 2378 3406652.2 5748189.9 | 2287 3409370.5 5749912.0 | 2108 3409711.5 5752859.9 | 1915 3412941.6 5552127.1 | 1737 3415704.3 5755146.2 | 774 3413796.7 5757868.1 | 547 3413770.9 5763000.3 | 57 3411755.0 5767419.0 | 323 3407389.3 576931
2973 3401853.9 5747304.7 | 2377 3406665.1 5748212.2 | 2286 3409521.3 5749912.0 | 2107 3409700.5 5752789.6 | 1914 3412941.6 5752427.1 | 1739 3415715.5 5755233.2 | 761 3413899.5 5758073.3 | 528 3413820.5 5763064.9 | 56 3411739.8 5767511.4 | 324 3407351.7 576931
2982 3401860.6 5747249.6 | 2406 3406495.1 5748210.0 | 2285 3409718.6 5750024.0 | 2103 3409795.6 5752865.6 | 1917 3412942.2 5752433.6 | 1740 3415712.3 5755237.0 | 724 3413842.6 5758187.3 | 527 3413805.1 5763070.7 | 55 3411719.6 5767519.8 | 325 3407357.4 576930
2984 3401868.3 5747249.6 | 2405 3406495.1 5748215.0 | 2291 3409179.2 5750057.4 | 2114 3409711.5 5752844.4 | 1919 3412944.9 5752442.4 | 1741 3415638.8 5755014.4 | 776 3413844.4 5757950.0 | 523 3413827.2 5763073.0 | 50 3411719.6 5767518.5 | 326 3407374.9 576930
2983 3401873.3 5747211.2 | 2291 3409111.5 5750038.2 | 2290 3409093.3 5749999.8 | 2117 3409700.1 5752833.6 | 1921 3412949.0 5752405.0 | 1743 3415612.8 5755378.1 | 759 3413891.1 5758046.1 | 524 3413844.3 5763158.0 | 66 3411678.6 5767504.7 | 327 3407315.3 576930
2981 3401893.5 5747174.5 | 2405 3406546.5 5748208.4 | 2288 3409358.0 5749912.0 | 2116 3409711.5 5752804.3 | 1920 3412950.8 5752438.8 | 1745 3415606.3 5755387.6 | 760 3413895.5 5757804.4 | 515 3414032.2 5763354.1 | 67 3411625.7 5767413.3 | 334 3407296.9 576930
2980 3401917.2 5747174.5 | 2291 3409179.2 5750057.4 | 2289 3409357.1 5749910.4 | 2111 3409784.0 5752785.3 | 1918 3412957.2 5752553.0 | 1744 3415610.8 5755384.2 | 772 3413803.3 5757802.2 | 516 3414019.1 5763362.5 | 62 3411607.0 5767391.5 | 336 3407292.1 576930
2979 3401930.3 5747154.7 | 2403 3406564.2 5748208.0 | 2283 3411027.4 5749509.1 | 2110 3409745.3 5752765.3 | 1910 3413151.6 5755443.4 | 763 3413914.4 5758142.8 | 514 3414043.5 5763361.9 | 63 3411589.1 5767374.5 | 335 3407291.1 576930
2978 3401938.8 5747138.7 | 2406 3406609.9 5748169.3 | 2284 3410000.0 5749556.6 | 2103 3409795.6 5752865.6 | 1907 3413150.7 5553091.4 | 754 3413944.5 5758317.9 | 517 3414050.2 5763407.1 | 65 3411439.0 5763362.5 | 331 3407286.8 576930
2977 3401962.2 5747052.1 | 2401 3406672.2 5748183.9 | 2282 3410080.3 5749509.1 | 2098 3409847.5 5752895.5 | 1904 3413828.6 5752434.2 | 758 3413977.3 5758147.3 | 520 3413820.5 5763456.7 | 71 3411523.7 5767358.8 | 339 3407154.2 576930
2976 3401966.1 5747045.5 | 2278 3410237.7 5749374.1 | 2095 3409888.3 5752995.4 | 1903 3413943.9 5752573.5 | 731 3413877.3 5758417.1 | 523 3413849.3 5763356.1 | 72 3411505.1 5767365.5 | 340 3407148.1 576930
2974 3401980.3 5747017.7 | 2386 3406642.2 5748183.9 | 2277 3410050.1 5749296.0 | 2094 3409913.3 5752915.5 | 1899 3414075.0 5752275.8 | 730 3413845.9 5758516.1 | 513 3413611.6 5763348.7 | 85 3411175.6 5767480.0 | 341 3406846.9 576930
3067 3402000.7 5746958.0 | 2379 3406642.2 5748183.9 | 2273 3410821.7 5749503.9 | 2091 3409889.3 5752928.7 | 1898 3414117.1 5752265.6 | 744 3414012.9 5758544.1 | 510 3413588.0 5763555.1 | 87 3411175.6 5767500.7 | 342 3406835.9 576930
3066 3402007.7 5746958.0 | 2375 3406662.2 5748187.9 | 2272 3410835.0 5749494.3 | 2089 3409963.2 5752931.5 | 1894 3414122.3 5752260.0 | 742 3414046.6 5758623.2 | 529 3413588.0 5763557.1 | 84 3411165.6 5763837.0 | 343 3406835.9 576930
3065 3402010.4 5746920.6 | 2374 3406674.4 5748244.4 | 2271 3410840.6 5749500.3 | 2090 3410010.9 5752945.7 | 1897 3414307.2 5752248.6 | 741 3414043.5 5763583.1 | 537 3413510.6 5763817.1 | 71 3411523.7 5767358.8 | 350 3406746.5 576930
3060 3402072.9 5746885.5 | 2382 3406900.0 5748426.3 | 2269 3410840.6 5749500.3 | 2088 3410100.9 5752945.7 | 1890 3414310.6 5757173.0 | 739 3414006.5 5758814.1 | 536 3413610.2 5763823.1 | 86 3411210.4 5767459.1 | 351 3406595.1 576930
3061 3402110.7 5746800.0 | 2387 3406899.7 5748407.5 | 2268 3411007.1 5749700.3 | 2086 3411091.3 5749487.8 | 1887 3414586.6 5752262.5 | 712 3413436.0 5755667.0 | 543 3413393.6 5763855.2 | 81 3411358.1 5767500.7 | 355 3406570.9 576930
3062 3402166.0 5746800.0 | 2366 3406907.9 5748592.5 | 1995 3411227.7 5749860.7 | 2082 3410116.3 5752290.1 | 1891 3414678.5 5757230.0 | 716 3413412.9 5755715.5 | 541 3413411.1 5763824.7 | 80 3411117.2 5763574.9 | 356 3406223.3 576935
3063 3402245.2 5746828.6 | 2385 3406898.7 5748592.1 | 1996 3411222.2 5749860.7 | 2074 3410182.4 5753036.1 | 1892 3414741.6 5752380.0 | 717 3413799.1 5755715.6 | 533 3413404.4 5763819.9 | 93 3411212.7 5767547.6 | 357 3406220.3 576935
3064 3402270.3 5746806.7 | 2365 3406910.0 5748663.1 | 1997 3411215.3 5749902.7 | 2073 3410241.6 5753051.5 | 1893 3414721.1 5752380.0 | 713 3413381.1 5755704.9 | 178 3413249.7 5764093.1 | 454 3410979.8 5767549.9 | 366 3406249.5 576368
2936 3402331.1 5746786.1 | 2361 3406864.1 5748714.2 | 2001 3411408.0 5749880.3 | 2076 3410293.9 5753076.6 | 1899 3414075.0 5752275.8 | 715 3413830.5 5755799.0 | 150 3413822.9 5764250.1 | 455 3410939.8 5767558.5 | 364 3406267.7 576688
2937 3402343.1 5746782.8 | 2360 3406864.1 5748714.2 | 2002 3411194.7 5749999.8 | 2075 3410306.1 5753080.6 | 1889 3414111.7 5752275.8 | 714 3413830.0 5755868.7 | 181 3413228.7 5764314.1 | 456 3410891.4 5767533.9 | 357 3406272.0 576692
2938 3402348.8 5746789.7 | 2391 3406883.4 5748289.7 | 1980 3411175.2 5750059.7 | 2067 3410306.1 5753080.6 | 1885 3414300.9 5752262.5 | 724 3413470.0 5755921.7 | 169 3413208.8 5764314.9 | 459 3410778.6 5767622.8 | 359 3406325.7 576685
2939 3402362.7 5746777.4 | 2386 3406893.5 5748343.9 | 1982 3411175.0 5750070.5 | 2066 3410310.4 5753082.0 | 1866 3414860.0 5752084.5 | 724 3413474.7 5755921.7 | 167 3413189.5 5764344.1 | 461 3410694.5 5767614.4 | 360 3406325.7 576685
2941 3402375.3 5746773.1 | 2374 3406893.5 5748343.9 | 1981 3411144.2 5750151.6 | 2071 3410306.1 5753080.6 | 1752 3415261.8 5756233.7 | 720 3413427.9 5755927.7 | 172 3413101.6 5764451.4 | 462 3410658.2 5767591.0 | 367 3406337.7 576685
2942 3402378.3 5746772.2 | 2384 3406889.7 5748430.9 | 1984 3411007.1 5750266.7 | 2083 3410296.6 5753079.7 | 1871 3414796.5 5755311.5 | 725 3413393.3 5755929.7 | 173 3413101.6 5764451.4 | 463 3410632.3 5767581.9 | 368 3406337.7 576690
2946 3402382.2 5746772.2 | 2386 3406893.5 5748343.9 | 1983 3411084.1 5750393.5 | 2084 3410351.5 5753097.5 | 1870 3414840.6 5755146.6 | 729 3413399.3 5755927.7 | 176 3413064.6 5764500.6 | 464 3410573.1 5767495.0 | 380 3406207.1 576693
2948 3402395.1 5746768.5 | 2383 3406900.3 5748426.3 | 1987 3411051.9 5750479.3 | 2074 3410351.5 5753097.5 | 1871 3414712.5 5755482.7 | 727 3413339.3 5765910.0 | 181 3413068.1 5764508.0 | 467 3410458.5 5767435.9 | 390 3406407.1 576690
2950 3402403.7 5746764.4 | 2382 3406900.1 5748479.8 | 1990 3411042.1 5750459.2 | 2047 3410380.4 5753107.0 | 1863 3414607.6 5755627.9 | 670 3414148.4 5756615.2 | 163 3413159.7 5764838.8 | 491 3410916.5 5767386.3 | 370 3406550.1 576687
2947 3402409.6 5746761.9 | 2398 3406336.3 5748979.6 | 1993 3411227.7 5749860.7 | 2050 3410351.5 5753097.5 | 1869 3414586.6 5755320.0 | 673 3414148.4 5756615.2 | 144 3413302.4 5764934.2 | 485 3410950.6 5767698.9 | 371 3406805.9 576689
2945 3402463.9 5746741.3 | 2397 3406206.7 5748485.6 | 1986 3411042.1 5750460.1 | 2069 3410405.8 5753133.0 | 1854 3415000.3 5755748.0 | 674 3414712.5 5755495.6 | 143 3413398.4 5764934.2 | 480 3410836.0 5767728.7 | 372 3406882.9 576689
2944 3402527.5 5746703.9 | 2336 3406206.5 5749048.1 | 1991 3411031.8 5750486.9 | 2067 3410306.1 5753080.6 | 1851 3414707.7 5753755.3 | 670 3414148.4 5756615.2 | 143 3413398.4 5764934.2 | 482 3410935.8 5767678.0 | 374 3406880.9 576689
2943 3402552.7 5746637.1 | 2359 3406231.6 5749068.1 | 1985 3411041.4 5750461.2 | 2041 3410638.3 5753291.0 | 1847 3415007.1 5753999.9 | 705 3414707.2 5756693.8 | 142 3413398.4 5764934.2 | 483 3410948.7 5767719.7 | 373 3406909.0 576689
2927 3402622.3 5746627.1 | 2358 3406525.5 5749303.1 | 1989 3411040.5 5750572.0 | 2065 3410435.2 5753145.6 | 1840 3415133.0 5754148.9 | 703 3414707.2 5756693.8 | 140 3413398.4 5764934.2 | 477 3410916.5 5767867.6 | 451 3405705.2 576896
2926 3402653.2 5746636.4 | 2337 3406400.9 5749496.0 | 1992 3410118.2 5753092.8 | 2062 3410466.5 5753154.0 | 1844 3414712.3 5753495.6 | 706 3414625.3 5755741.0 | 149 3413415.5 5764934.8 | 474 3410949.5 5767867.6 | 450 3405704.4 576900
2925 3402541.1 5746539.9 | 2334 3407022.5 5750000.0 | 1994 3410121.3 5748714.2 | 2063 3410510.8 5753174.0 | 1813 3415136.3 5754048.7 | 627 3414629.3 5755741.0 | 152 3413163.6 5766014.7 | 473 3411028.7 5767743.6 | 449 3405704.4 576904
2935 3402556.6 5746539.9 | 2366 3406910.0 5748663.1 | 2013 3410241.6 5753063.7 | 2061 3410524.7 5753171.0 | 1830 3413141.1 5755064.3 | 698 3414652.7 5760299.2 | 126 3413226.1 5766055.1 | 210 3409617.3 5768070.3 | 441 3405702.4 576902
2934 3402561.5 5746501.2 | 2339 3407009.7 5749832.9 | 2016 3410108.2 5749999.9 | 2060 3410533.6 5753180.5 | 1832 3413116.5 5755130.0 | 684 3414662.9 5755770.8 | 127 3413227.0 5766055.1 | 204 3408536.9 5767870.3 | 445 3405740.9 576902
2932 3403011.0 5746705.6 | 2329 3407122.6 5750175.9 | 2022 3410713.3 5753347.4 | 2058 3410561.7 5753196.8 | 1835 3415187.0 5753759.0 | 681 3414767.2 5755940.7 | 128 3413113.4 5766074.4 | 205 3409519.5 5768206.3 | 459 3405748.9 576891
2922 3403010.6 5746707.0 | 2324 3407252.4 5750121.7 | 2018 3410715.3 5749999.9 | 2057 3410570.6 5753223.4 | 1838 3415165.6 5754224.4 | 636 3414646.6 5755940.7 | 123 3413112.2 5766060.1 | 431 3405459.9 576929 | 453 3405760.7 576896
2924 3403101.6 5746709.0 | 2325 3407311.8 5750052.0 | 2019 3410108.2 5749999.9 | 2054 3410589.3 5753236.6 | 1837 3415159.4 5754228.3 | 637 3414776.0 5756041.3 | 121 3413044.5 5766038.1 | 432 3405532.9 576929 | 452 3405760.7 576895
2929 3402999.8 5746786.3 | 2323 3407187.6 5750052.0 | 2020 3410919.3 5749999.8 | 2052 3410589.3 5753236.6 | 1836 3413149.6 5754159.2 | 646 3414676.1 5755810.4 | 249 3407636.8 5769557.6 | 437 3405452.4 576926 | 448 3405800.9 576895
2931 3402999.8 5746786.3 | 2398 3406336.3 5748979.6 | 2021 3410919.3 5749999.8 | 2053 3410395.3 5753262.4 | 1833 3414441.7 5755748.2 | 616 3415029.0 5760135.6 | 245 3407381.0 5769553.7 | 436 3405445.1 576926 | 444 3405803.0 576895
2928 3403186.8 5746851.1 | 2397 3406267.1 5749048.1 | 2018 3410853.8 5752833.0 | 2047 3410611.2 5753269.4 | 1834 3415000.0 5755748.0 | 617 3415024.0 5760090.5 | 248 3407304.0 5769483.6 | 434 3405368.1 576926 | 446 3405844.0 576895
2899 3403197.3 5746856.3 | 2359 3406231.6 5749068.1 | 2074 3410351.5 5753097.5 | 2041 3410638.3 5753291.0 | 1809 3414988.2 5755972.3 | 626 3415021.5 5760202.7 | 140 3413394.8 5765761.2 | 445 3405772.6 576963 | 447 3405848.7 576890
2900 3403209.2 5746865.1 | 2340 3406977.6 5749895.3 | 2149 3410094.2 5751192.0 | 2044 3410646.3 5753293.0 | 1840 3415133.0 5754148.9 | 613 3415015.4 5760182.6 | 138 3413907.3 5766934.2 | 453 3405372.3 576962 | 415 3405784.1 576880
2903 3403244.9 5746981.5 | 2342 3406968.2 5749872.9 | 2146 3410209.0 5751075.8 | 2044 3410646.3 5753293.0 | 1810 3414963.9 5755972.3 | 621 3415016.2 5760145.2 | 139 3413398.8 5765950.2 | 248 3407322.5 5769246.1 | 417 3405793.2 576890
2904 3403351.7 5746981.1 | 2334 3407022.5 5750000.0 | 2147 3410224.8 5751091.0 | 2037 3410703.2 5753325.5 | 1806 3414964.7 5755831.0 | 628 3415031.2 5760202.7 | 246 3407365.2 5769037.4 | 416 3405810.0 576935 | 414 3405807.8 576877
2902 3403491.7 5746930.1 | 2331 3407007.5 5750035.3 | 2214 3410004.1 5751075.0 | 2061 3410524.7 5753171.0 | 1793 3415077.0 5755078.0 | 585 3413300.1 5760299.9 | 226 3407424.4 5769037.4 | 401 3405779.6 576937 | 413 3405763.1 576870
2898 3403617.5 5746884.7 | 2351 3406882.3 5749964.3 | 2213 3410070.0 5750981.0 | 2058 3410561.7 5753196.8 | 1808 3414964.7 5555822.2 | 565 3413313.3 5762169.2 | 225 3407424.4 5769076.1 | 404 3405775.2 576935 | 410 3405764.5 576890
2895 3403684.1 5746848.5 | 2350 3406848.8 5749596.8 | 2209 3410525.1 5751000.0 | 2057 3410570.6 5753223.4 | 1812 3414982.9 5759190.6 | 572 3413375.2 5762165.4 | 224 3407434.5 5769637.6 | 413 3405790.4 576935 | 411 3405804.9 576890
2896 3403700.4 5746736.2 | 2347 3406838.8 5749602.0 | 2210 3410532.5 5751000.0 | 2051 3410576.6 5753232.4 | 1861 3414548.0 5753750.9 | 575 3413363.6 5762165.4 | 250 3407632.5 5769198.6 | 410 3405832.4 576890 | 409 3405828.4 576890
2897 3403700.7 5746736.2 | 2353 3406899.6 5749720.4 | 2158 3410570.0 5750918.0 | 2050 3410585.4 5753235.4 | 1857 3414712.5 5753755.3 | 598 3414147.4 5760463.3 | 202 3408535.9 5767870.0 | 411 3405803.0 576890 | 408 3405848.7 576890
2917 3403700.4 5746634.9 | 2358 3406525.5 5749303.1 | 2160 3410444.8 5751081.8 | 2047 3410611.2 5753269.4 | 1854 3414995.8 5753746.0 | 596 3414147.4 5760463.3 | 203 3408536.9 5767870.3 | 397 3405777.6 576690 | 407 3405848.7 576890
2918 3403493.9 5746634.9 | 2349 3406905.1 5749720.4 | 2157 3410387.9 5751100.0 | 2044 3410646.3 5753293.0 | 1857 3414812.2 5755785.9 | 597 3414149.6 5760299.9 | 300 3407313.0 5769517.9 | 372 3406882.9 576689 | 378 3405848.7 576890
2920 3403493.9 5746305.2 | 2338 3406937.8 5749807.6 | 2153 3410336.3 5751160.7 | 2041 3410668.5 5753298.5 | 1847 3415011.1 5755832.1 | 590 3414452.5 5760160.7 | 301 3407372.0 5769495.3 | 420 3405808.2 576890 | 401 3405777.6 576690
2910 3403719.9 5746305.2 | 2343 3406968.2 5749872.9 | 2155 3410444.8 5750870.0 | 2040 3410668.5 5753298.5 | 1859 3414995.0 5753746.0 | 591 3414452.5 5760160.7 | 227 3407480.2 5769529.0 | 396 3406407.1 576690 | 396 3406407.1 576690
2909 3403775.3 5746276.5 | 2340 3406977.6 5749895.3 | 2152 3410295.5 5751190.2 | 2041 3410638.3 5753291.0 | 1858 3414667.9 5769517.9 | 592 3415017.7 5759741.0 | 229 3407636.8 5769552.4 | 295 3407374.1 576692 | 294 3405784.1 576880
2907 3403795.3 5746271.7 | 2301 3407317.8 5750022.9 | 2166 3410044.8 5750920.0 | 2044 3410646.3 5753293.0 | 1796 3415019.2 5760299.9 | 562 3413363.6 5762165.4 | 227 3407480.2 5769529.0 | 292 3407434.5 576692 | 293 3405763.1 576870
2906 3404037.8 5746236.8 | 2342 3406968.2 5749872.9 | 2183 3410033.1 5751741.8 | 2044 3410646.3 5753293.0 | 1787 3415557.1 5754536.6 | 816 3414097.1 5757518.8 | 280 3407426.1 5769248.1 | 291 3405763.1 576870 | 291 3405763.1 576870
2905 3404037.8 5746236.8 | 2340 3406977.6 5749895.3 | 2180 3409919.5 5751798.7 | 2037 3410703.2 5753325.5 | 1791 3415532.7 5754566.2 | 815 3414044.1 5757480.9 | 246 3407365.2 5769037.4 | 282 3407394.0 576688 | 281 3405849.7 576770
2523 3404036.0 5746236.8 | 2229 3408967.3 5750039.4 | 2180 3409919.5 5751798.7 | 2044 3410646.3 5753293.0 | 1943 3411223.8 5752070.6 | 92 3411644.7 5766861.8 | 277 3407413.9 5769559.9 | 272 3405849.7 576770 | 277 3405849.7 576770
2529 3404032.2 5746223.5 | 2225 3408499.7 5750007.8 | 2184 3409982.4 5751741.8 | 2113 3409925.8 5753055.1 | 1947 3412022.9 5752942.4 | 97 3411624.7 5766861.8 | 294 3405784.1 576880 | 301 3407374.1 576692 | 294 3405784.1 576880
2911 3404029.4 5746138.3 | 2310 3408605.5 5749997.9 | 2184 3409982.4 5751741.8 | 2111 3409926.5 5753080.6 | 1777 3415715.2 5754796.6 | 95 3411624.7 5766861.8 | 297 3407373.0 576692 | 283 3405849.7 576770 | 283 3405849.7 576770
2530 3404029.4 5746138.3 | 2312 3408635.5 5749997.9 | 2112 3409888.2 5753056.1 | 1780 3415715.2 5754796.6 | 96 3411625.2 5767906.8 | 445 3405740.9 576902 | 283 3405849.7 576770 | 283 3405849.7 576770

2,808 Inflection numbers, easting and northing values of the ring polygon of the city of Münster

Olaf Lenzmann: Center of Gravity of a Closed Polygon (Münster)

The center of gravity of an area described by a closed polygon has the special physical property that in it the sum of all torsional moments disappears; in addition, it has the statistical property that its coordinates *Xs, Ys* are equal to the average of all coordinates x and y of the domain. Therefore one may correctly conceive of the center of gravity as the center point or simply the center.
In the following, the computation of the center of gravity of a planar, bounded area is derived and its accuracy derived.
Let the polygon which describes the area have no intersections, be oriented in a counter-clockwise direction, and lie in the x,y-plane of three-dimensional space. Let it have N vertices $\vec{P_i}$, and let \vec{P}_{N+1} defined as \vec{P}_1 Thereby

$$\vec{P_i} = \begin{pmatrix} x_i \\ y_i \\ 0 \end{pmatrix}.$$

By definition the x-component of the center of gravity computes as

$$X_s = \frac{1}{F} \iint_B x \, dB = \frac{1}{F} \iint_B x \, |d\vec{F}|.$$

F is the size of the area and B the domain surrounded by the polygon. On the right is an area integral where $d\vec{F}$ is the vectorial element of the area, which is always perpendicular to the area over which the integral is taken. Since the polygon lies in the x,y-plane, dF has only a z-component. Hence follows

$$d\vec{F} = \begin{pmatrix} 0 \\ 0 \\ 1 \end{pmatrix} |d\vec{F}|$$

and

$$x \, |d\vec{F}| = \begin{pmatrix} 0 \\ 0 \\ x \end{pmatrix} \cdot d\vec{F}$$

as well as

$$X_s = \frac{1}{F} \iint_B \begin{pmatrix} 0 \\ 0 \\ x \end{pmatrix} \cdot d\vec{F}.$$

The further computation is successful with the help of Stokes' integral theorem:

$$\iint_B \nabla \times \vec{A} \cdot d\vec{F} = \oint_{\partial B} \vec{A} \cdot d\vec{s}$$

It says that the area integral of the rotation of a vector field \vec{A} over a domain B is equal to the integral of the vector field itself over the boundary ∂B of this domain. Required is a vector field \vec{A} where

$$\nabla \times \vec{A} = \begin{pmatrix} 0 \\ 0 \\ x \end{pmatrix}.$$

This requirement is fulfilled by

$$\vec{A} = \begin{pmatrix} -xy \\ 0 \\ 0 \end{pmatrix}.$$

Now the area integral can be converted into a one-dimensional integral over the boundary, namely the closed polygon. The further computation requires a parametrization of the boundary curve, in order to once again convert the boundary integral into a common integral over a scalar variable. Thus

$$\oint_{\partial B} \vec{A} \cdot \vec{ds} = \int_0^T \vec{A}(\vec{O}(t)) \cdot \dot{\vec{O}}(t) \, dt \, ,$$

where the function $\vec{O}(t)$ for $0 \leq t < T$ runs through the entire curve of the polygon once. $\dot{\vec{O}}(t)$ is the derivative $\vec{O}(t)$ with respect to t. A possible segmental parametrization of the boundary of the polygon that fulfills the above-named requirement with $T = N$ is

$$\vec{O}_i(t) = \vec{P}_i + (t - i)(\vec{P}_{i+1} - \vec{P}_i)$$
$$\dot{\vec{O}}_i(t) = \vec{P}_{i+1} - \vec{P}_i$$

where $i = 1..N$ and $i - 1 \leq t < i$. Since the boundary curve is defined segmentally (the polygon consists of N segments) the integral to be computed must be divided into the same number of sections:

$$X_s = \frac{1}{F} \int_0^T \vec{A}(\vec{O}(t)) \cdot \dot{\vec{O}}(t) \, dt = \frac{1}{F} \sum_{i=1}^N \int_{i-1}^i \vec{A}(\vec{O}_i(t)) \cdot \dot{\vec{O}}_i(t) \, dt$$

Inserting the functions $\vec{A}(\cdot)$ and $\vec{O}(\cdot)$ gives

$$X_s = \frac{1}{F} \sum_{i=1}^N \int_{i-1}^i \vec{A}\left(\vec{P}_i + (t-i)(\vec{P}_{i+1} - \vec{P}_i)\right)\left(\vec{P}_{i+1} - \vec{P}_i\right) \, dt$$

$$= \frac{1}{F} \sum_{i=1}^N \int_{i-1}^i \begin{pmatrix} -(x_i + (t-i)(x_{i+1} - x_i)) \cdot (y_i + (t-i) \cdot (y_{i+1} - y_i)) \\ 0 \\ 0 \end{pmatrix} \cdot \begin{pmatrix} x_{i+1} - x_i \\ y_{i+1} - y_i \\ 0 \end{pmatrix} \, dt$$

$$= \frac{-1}{F} \sum_{i=1}^N \int_{i-1}^i (x_i + (t-i)(x_{i+1} - x_i))(y_i + (t-i)(y_{i+1} - y_i))(x_{i+1} - x_i) \, dt \, .$$

After integration, insertion of boundaries, and summarizing, there results

$$X_s = \frac{-1}{6F} \sum_{i=1}^N (x_{i+1} - x_i)(2x_i y_i + x_{i+1} y_i + x_i y_{i+1} + 2x_{i+1} y_{i+1}) \, .$$

The y-component of the center of gravity is computed analogously

$$Y_s = \frac{1}{6F} \sum_{i=1}^N (y_{i+1} - y_i)(2x_i y_i + x_{i+1} y_i + x_i y_{i+1} + 2x_{i+1} y_{i+1}) \, .$$

The area of the polygon is computed in the customary way

$$F = \frac{1}{2} \sum_{i=1}^N (y_{i+1} - y_i)(x_{i+1} + x_i) \, .$$

Assessment of error

First the partial derivatives of the coordinates of the center of gravity must be determined with reference to the vertices of the polygon. The x-component of the center of gravity is computed by

$$X_s = \frac{-Q_x}{6F} \; ;$$

where

$$Q_x = \sum_{i=1}^{N} (x_{i+1} - x_i)\,(2x_i y_i + x_{i+1} y_i + x_i y_{i+1} + 2x_{i+1} y_{i+1}) \,.$$

Thus

$$\frac{\partial Q_x}{\partial x_i} = x_{i-1}(y_{i-1} - y_i) + 2x_i(y_{i-1} - y_{i+1}) + x_{i+1}(y_i - y_{i+1})$$

$$\frac{\partial Q_x}{\partial y_i} = (x_{i+1} - x_{i-1})\,(x_{i-1} + x_i + x_{i+1})$$

$$\frac{\partial F}{\partial x_i} = \frac{1}{2}(y_{i+1} - y_{i-1})$$

$$\frac{\partial F}{\partial y_i} = \frac{1}{2}(x_{i-1} - x_{i+1}) \,.$$

The computation of the partial derivatives of the coordinates of the center of gravity follows according to the quotient rule with

$$\frac{\partial X_s}{\partial x_i} = -\frac{\frac{\partial Q_x}{\partial x_i} F - \frac{\partial F}{\partial x_i} Q_x}{6F^2}$$

and

$$\frac{\partial X_s}{\partial y_i} = -\frac{\frac{\partial Q_x}{\partial y_i} F - \frac{\partial F}{\partial y_i} Q_x}{6F^2} \,.$$

Finally, the application of Gauß' *Law of Error Propagation* yields

$$\sigma_{X_s}^2 = \sum_{i=1}^{N} \left(\frac{\partial X_s}{\partial x_i}\sigma_{x_i}\right)^2 + \left(\frac{\partial X_s}{\partial y_i}\sigma_{y_i}\right)^2 \,.$$

$\sigma_{Y_s}^2$ is computed analogously with the partial derivatives of the auxiliary quantity Q_y

$$\frac{\partial Q_y}{\partial x_i} = (y_{i+1} - y_{i-1})\,(y_{i-1} + y_i + y_{i+1})$$

$$\frac{\partial Q_y}{\partial y_i} = y_{i-1}(x_{i-1} - x_i) + 2y_i(x_{i-1} - x_{i+1}) + y_{i+1}(x_i - x_{i+1}) \,.$$

The resulting coordinates for the center of gravity of Münster:

x_s - 3,405,456.8 m \pm 0.4 m

y_s - 5,758,707.1 m \pm 0.5 m

Method developed by Dieter Grünebaum for calculating the planar center of gravity of the city of Münster

In the present case the planar center of gravity was determined by means of the torque.
Torque: A lever is balanced when the two torques are in a state of balance. The center of gravity is located at the point where the product of load and leverage is the same on both sides.

Applied to a plane, this means that the center of gravity must be determined within a two-dimensional object.

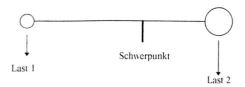

Last 1 Schwerpunkt

 Last 2

For this purpose a rectilinear coordinate system is superimposed on the plane. In a first approximation, we place the origin of the coordinate system at a point that might correspond

to the center of the plane. If we now divide the plane into strips parallel to the y-axis, we can determine the torque for each strip with reference to the coordinate origin. The torque of a strip is then the area of the strip (load) times

the distance to the coordinate origin (leverage). In order to increase the accuracy of measurement, the number of strips is increased with a corresponding reduction of the strip width. (In the present case the section width was 1 m.)

$$D = Ly * dx * x$$

D = torque
dx = strip width
Ly = strip length
x = distance to coordinate origin

If we assume that the coordinate origin is identical with the center of gravity, the sum of all torques in the x-direction is 0, since both positive and negative x-values are present.

A corresponding PC program calculates all the torques for the initial coordinate origin and then by shifting the coordinate origin in the x-direction determines the point at which all torques are compensated.
The same procedure is repeated in the y-direction. The planar center of gravity is then established through this pair of coordinates.

Polygonal center of gravity:
x = 3,405,464 m y = 5,758,717 m

Harald Welzer: The Sanderian Point

Our story begins with Professor Otto Liden-brock, the choleric author of a treatise on transcendental crystallography, flipping through an old book on the evening of March 24, 1863. Among its pages he discovers an even older parchment containing an encoded message, and after lengthy attempts at deciphering it, Lidenbrock and his clumsy nephew Axel determine that it is a Latin text written backwards in Icelandic runes, dispatched into the future as a kind of message in a bottle by a 16th century naturalist named Arne Saknussem. The text contains an astounding message: the reader is apprised of the entrance to the descent into the center of the earth, which Saknussem had found by luck and tested for himself.

Axel, who doesn't really believe the message from the past, tries to convince Lidenbrock of the hopelessness of the whole enterprise: "All scientific theories prove that such an undertaking is impossible." "Is that what all the theories prove?" scoffs Lidenbrock, an eccentric with a bent toward the transcendental. "Ah, those wretched, wretched theories! They will be very troublesome to us, those miserable theories!"

And so Lidenbrock and Axel betake themselves to Iceland, where the entrance is found at the bottom of the crater of an extinct volcano. The journey to the center of the earth begins. Lidenbrock, who views himself as the Columbus of the earth's interior, will open up the undiscovered inner world of our planet to science. But not only does the journey into the interior, recorded by nephew Axel, lead through undiscovered spaces, it suddenly becomes clear that the wanderers are embarking on a journey through time as well. The layers of the earth's crust also represent the history of the earth – the Cambrian, Silurian, Devonian periods – and in the end it is this that is the most fantastic adventure of all, placing the travellers entirely under its spell. There are immense fields full of animal bones, subterranean seas, petrified plants – and it becomes evident that everything is really quite different from what science had prophesied. Jules Verne's *Journey to the Center of the Earth* not only varies the old theme of adventure in the discovery of unknown worlds and the metaphysical idea of finding the center of the world, but the adventure itself becomes the journey to its own origin: the center of the earth is the center of history, the origin of the race of man. Yet ironically, Lidenbrock and Axel finally shoot past this very point at high speed as a volcanic eruption on the other side of the earth's surface sends them back up toward the light.

The search for the center is always the search for the origin, from which all else has developed. Karin Sander plays with this underlying metaphysical idea when she interprets the program of the *Skulptur. Projekte in Münster 1997* in an almost naively literal way, a program that calls for the production of references to the place itself, the exposing of historically grown structures, and the identification of sociologically significant places. Art thus assumes the task of delivering a topography of history; and in addition, the official project description for 1997 names as a central theme the relationship between periphery and center, between "interior and exterior, private and public" – and this, once again, with reference to the "historically grown" structure of the city: "In the center of Münster lies the cathedral square and the Prinzipalmarkt with the cathedral and the bourgeois Rathaus." Karin Sander can indeed provide material for the desired discussion "of the more or less public ruptures in the development of the city center", for in her work, a complicated mathematical calculation identifies a completely insignificant place as the center of a city rich in history, a place which, unlike the market square, cathedral, or city hall, possesses no

historical significance whatsoever. And this is supposed to be the center of Münster?

History, it seems, has either never concerned itself with the geographical center or has shifted it away from the middle in the process of urban growth. Viewed in this light, it is the city's history itself that has annulled the center – and the center now rediscovered is entirely profane. This accords with the fact that the scientific effort involved in discovering the center is disproportionately large. The result is entirely unspectacular, and the accompanying disappointment exposes in a single stroke the degree to which the search for significant places in the city is loaded with historical-metaphysical speculation and the myth of origin – as if the place where history happens could actually be discovered, as if places could tell us where something was or how it came to be. What the Sanderian center shows is that places say nothing: the most that a structural analysis using the means of art can show is the unrelenting constructive activity of every *recherche du temps perdu*. We do not decode meanings, but rather furnish them; the places are as invented as the history that is supposed to have happened there.

The journey to the center of Münster is, like the one to the center of the earth, a sobering adventure, for in the end the result is nothing more than the realization that history has played itself out in a location different than we had imagined. The dislocation of the center is a dislocation of imagination, and at the same time a decentering of those historical images based on the notion of something proceeding from a center and expanding outward in concentric rings. History is not a ring surrounding a center – such is the terse conclusion of the physicists who discovered the center of Münster. It accumulates in banal places, and there is no path leading from the present back to a point of origin.

Sander's cool, calculated marking of a scientifically identified location serves not only to document once more the precision of local allusion that has always characterized her work, but also to demonstrate her own, original ability to transform precision, laconism, and frugality into a peculiarly poetic and yet witty composition, one that shows in a flash that everything could actually be different too. The geographical center, the physicists write, would coincide with the center of gravity if one were to mill a model of Münster out of steel; it would be the point at which the city *qua* sculpture would come to rest in perfect balance. The center of gravity would at the same time be "that point in which the entire area can be thought of as con-

Karin Sander: *Wandstück* (Piece of Wall), Kunstmuseum Bonn 1993, wall paint, sanded (above)
Karin Sander: *Hühnerei, poliert, roh, Größe 0* (Chicken egg, polish, raw, size 0), 1994 (below)

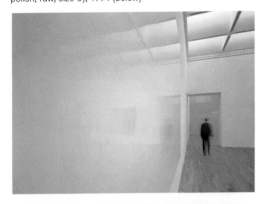

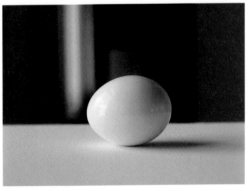

centrated". With this statement, the natural scientists touch on a thoroughly classical sculptural theme – and we see that the concept of the Sanderian point conceals a work that makes Münster itself, with all its towers, buildings, objects, and sculptures, into a single mega-sculpture, and at the same time immediately negates itself through the absolute lack of extension of the identified point.

The Sanderian point is the paradox of an inverse sculpture, and as such is closely related to the artist's other works – for example the polished wall pieces created not through addition, but through rubbing off a layer of paint, or the whitewashed house passages in the Polish city of Lodz, where the transitory element of a changing history is arrested by removing the traces of that history and replacing them with an amnesiac white. The polished chicken egg Sander placed on a pedestal in the exhibition *Leiblicher Logos* (Corporeal Logos), which paradoxically combines the reflection of its surroundings with the transparency of the original object, manifests the play with both the metaphor of origin and the inversion of sculpture. In a peculiarly frugal and precisely calculated fashion, Sander exposes the narrative structure of places and objects, and in this act of poeticization once again demonstrates the power of her art to lay open, the subtlety of its intervention in suddenly revealing a view that was formerly hidden.

Sander's gesture may seem minimalistic; but in contrast to the Minimalist credo that "what you see is what you see", here we suddenly see much more than is visible, as the artist opens up a situation that beforehand had seemed so hermetic. Sander's language is as simple as it is precise, and her works draw their illuminating wit from the apparent ease with which she evokes these flashes of insight – as if, each time, she had found that point at which the familiar is effortlessly turned upside-down.

Karin Sander: *Schwerpunkt der Stadt Münster*, Center of Gravity of the City of Münster 1997, diameter 130 cm, liquid plastic on conrete (below) and view from a height of 35 m

Karin Sander: View from the center of gravity of Münster towards the Dome, the City-Center and the City-perimeter (opposite)

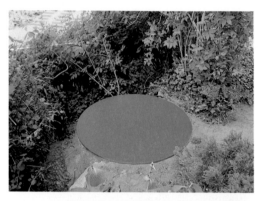

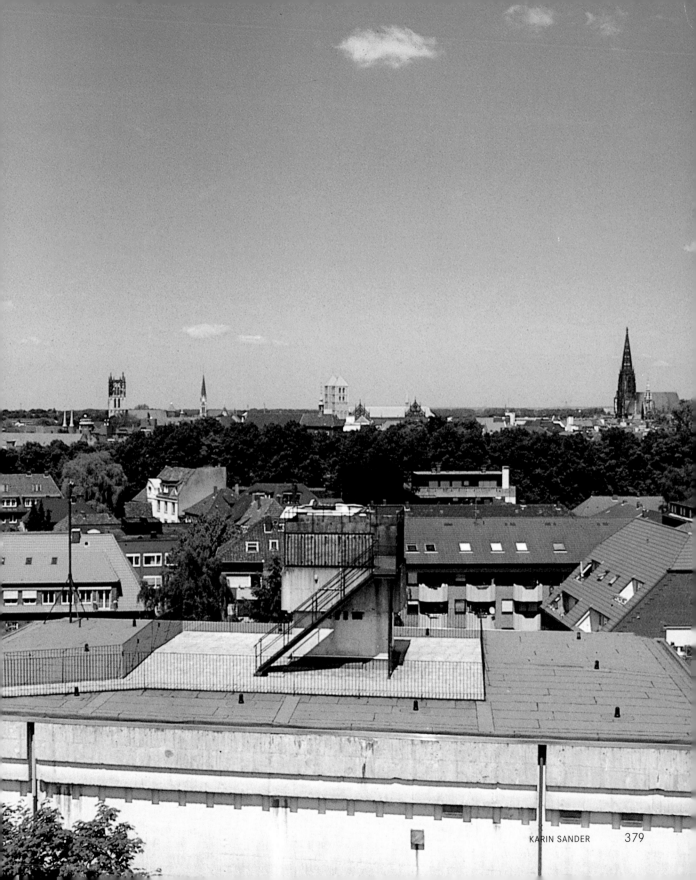

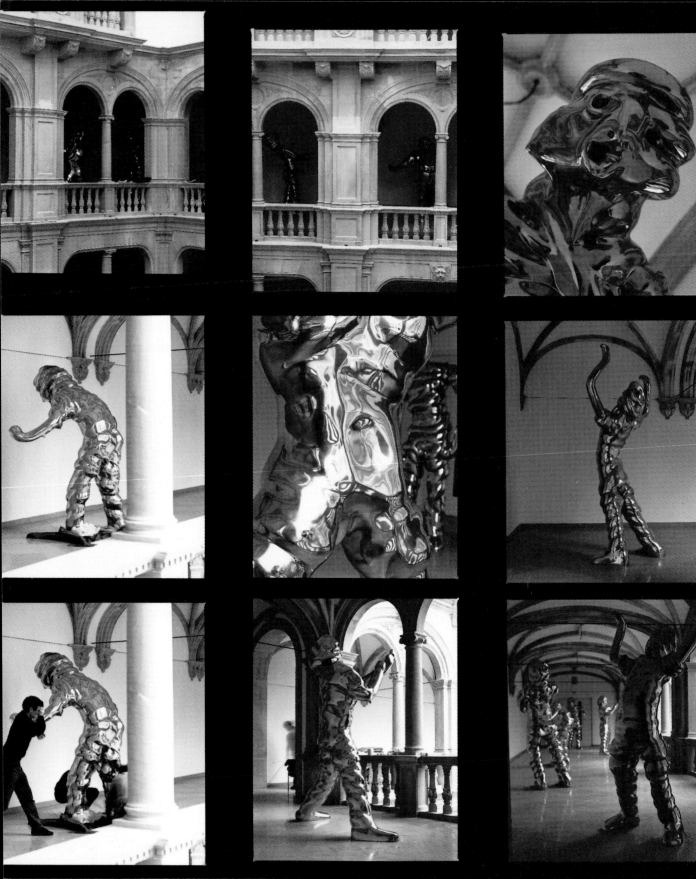

THOMAS SCHÜTTE

Grosse Geister
(Large ghosts)
Four sculptures (cast aluminum, each ca. 2.5m)
Old section of Westfälisches Landesmuseum,
south gallery, 2nd floor

Born 1954 in Oldenburg, lives in Düsseldorf

Friedrich Meschede: Thomas Schütte, or,
The Power of Cherries

The artistic world of Thomas Schütte finds its elemental expression in drawings and water-colors; in the stories and ideas he presents in this medium, Thomas Schütte manifests himself as a narrator. His stories represent moments, moods, humorous scenes, and the weaknesses of his figures, whose characterization develops out of this very vulnerability. The sculptural world of Thomas Schütte is a stage on which a variety of figures and an assortment of objects are dramatized.

This is a fundamental point about Thomas Schütte's work, important because it makes his approach to three-dimensional works more clearly comprehensible. The motifs, converted into a kind of interior decoration, resemble set pieces in their respective ambiences, like props in a production that is only redeemed by the set. In recent years, Thomas Schütte has repeatedly taken advantage of opportunities to realize such scenes, giving them form as buildings in the outdoors. The draftsman and painter Schütte has monumentalized motifs from his image world in order to make them public.

For information about the artist and additional bibliography see: Thomas Schütte, ifa/Museum Fridericianum, Kassel 1997; Thomas Schütte. Kunstpreisträger der Stadt Wolfsburg, Städtische Galerie und Kunstverein Wolfsburg, Wolfsburg 1996; Botho-Graef-Kunstpreis der Stadt Jena '96, Kulturamt der Stadt Jena, Jena 1996; Thomas Schütte. Skizzen und Geschichten 1990–1995, Kunstraum München, Düsseldorf 1995.

[...] The sites Thomas Schütte seeks out for his works have something obvious and unspectacular about them; all the more clearly, then, does the addition of a sculpture transform the expression of the place. Schütte's three-dimensional commentary as reaction to the situation opens up a new level of narrative, as is demonstrated by his *Kirschensäule* (Cherry Column), created for the *Skulptur Projekte in Münster 1987*. When Thomas Schütte first looked at the central square in Münster, he saw that it was defined by the numerous elements that constitute the trappings of cities everywhere. Next to garbage bins and glass recycling containers stood bicycle racks and telephone booths; the parked cars were surrounded by a wall of yellow construction containers. The square looked like a mundane storage place for functional forms. Its center was marked by a large tree, next to which stood a dead cherry tree that was to be felled. In allusion to the latter, Schütte decided to simply "garnish" this arrangement, as he put it, by placing a pair of cherries atop a column there. The *Kirschensäule* became a monument, the traditional conception checkered with monumentalized irony by the heroization of the cherries. This visual commentary also took place against the background of the changing conception of the function of so-called art in public spaces. Ten years after the first sculpture exhibition in Münster in 1977, dominated by the austere designs of an expressive form shaped by Minimalism, Schütte in effect conceded the futility of art in public space inasmuch as it always caters to what the public considers to be art. Three works had remained from 1977 having been acquired by the city of Münster – the *Giant Pool Balls* by Claes Oldenburg, Donald Judd's concrete rings, and a sculpture by Ulrich Rückriem. To these was added the sculpture *Kirschensäule* which had already during the exhibition attained the status of a landmark. Thereafter, the caricature acquired a life of its own, and the changes in the square took their own course. As if taking Thomas Schütte's sculptural allusion seriously – the garnish on the urban "furniture" – the city of Münster began to redesign the square. For a time all the everyday objects disappeared: bicycle racks were removed, parking places leveled, telephone booths dismantled, and more out-of-the-way storage places found for the glass recycling containers. The square was repaved in its entirety, and an area of planting was laid out at the foot of the tree to protect the area around its base. Proposals were put before the artist to let his *Kirschensäule* wander over the square like a chess piece, proposals which Schütte rejected, especially since the *Kirschensäule* had derived its location from the tree that had previously stood there. Today, the border of the planted area runs as an invisible line through the middle of the column base. Traffic was banned from the square, and the former course of the street is now visible only in the color variations in the paving. The gutters for rainwater, in combination with the adjacent pedestrian zone, now give the area the effect of a backyard terrace. In a new and yet constant way, the *Kirschensäule* serves as a commentary on the place; the sculptural garnish has in fact become a monument commemorating feats of urban planning.

Indeed, for a short while, contemporary sculpture was made to serve as a kind of experimental grounding for the development of urban architecture. A shelter was set up on a trial basis around a newly designed bicycle rack with metal parts matched to the red of the cherries. For a short time, the sculpture became a homage to the "corporate identity" of urban space. It is unclear whether it was insight, understanding, or uneasiness that limited the construction of the bicycle shelter to a temporary intermezzo. In any case, the square was not left alone after this tidying up; it was

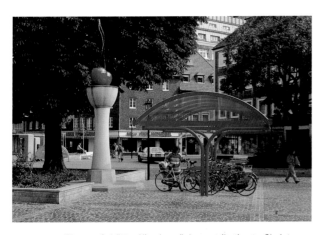

Thomas Schütte: *Kirschensäule*, contribution to *Skulptur Projekte in Münster 1987*, sandstone, aluminum, painted, height 6 m, permanent installation, photo 1997

turned over to the city planning office for further development, with the result that now a fountain sculpture distinguishes the site as well. Now, after the artistic results of two urban sculpture exhibitions have left their mark, such additions to the square no longer make it past the art commission and other municipal advising committees. This use of sculpture, particularly on fountains – as also at the main railway station in Münster – is categorized as "applied art", thus denying it any relevance to the discussion of art in public space.

It remains to be noted that Thomas Schütte's *Kirschensäule* has outlived all attempts to improve on it throughout the various phases of planning. The column of Baumberger sandstone with its pair of cherries on top still dominates the site on which it has had such influence in an ever persuasive way. The expression of absurdity as a metaphor for the possible irreconcilability of modern art and urban space remains manifest.

The dimensions and proportions of the column in relation to the square can never quite be grasped; sometimes it appears as the enlargement of a fictive chess piece, sometimes as a postmodern burlesque of the history of the column. The stylization of the motif, its alienation as a vehicle for the presentation of cherries, calls into question the significance of public forms of representation in general. Only the unequivocal recognizability of the object makes the visual figure universally comprehensible; the pictorial joke provides what is perhaps the only chance to recover the shared, communal element lost to all contemporary sculpture in public space, a loss which accounts for the difficulty in mediating between sculpture and the public. In public urban space, every sculpture is exposed to every gaze, every interpretation, every commentary. Thomas Schütte's artistic strategy in response to this loss of shared identity is to use caricature to present his image-world, thus protecting what is his from the public. Schütte's places have the character of a stage on which stories are played out, stories written by life itself, in which all observers are invited to participate in their own act at a particular time.

Thus Schütte's works for public space, especially the one permanent sculpture in Münster, become didactic plays dealing with our attitude to and understanding of public space. The *Kirschensäule*, in particular, runs the gamut of all the stages of interpretation, depending on how it is read. It is a sculpture, it became a landmark, it shows itself as a monument, though perhaps it is only a sign, it presents itself playfully as a homage to the entire history of monuments, and as an urban set piece is still somehow funny. And only in this way does Thomas Schütte's sculpture survive – despite all attempts to appropriate it – as a work of art.

From: Botho-Graef-Kunstpreis der Stadt Jena '96, Kulturamt der Stadt Jena, Jena 1996

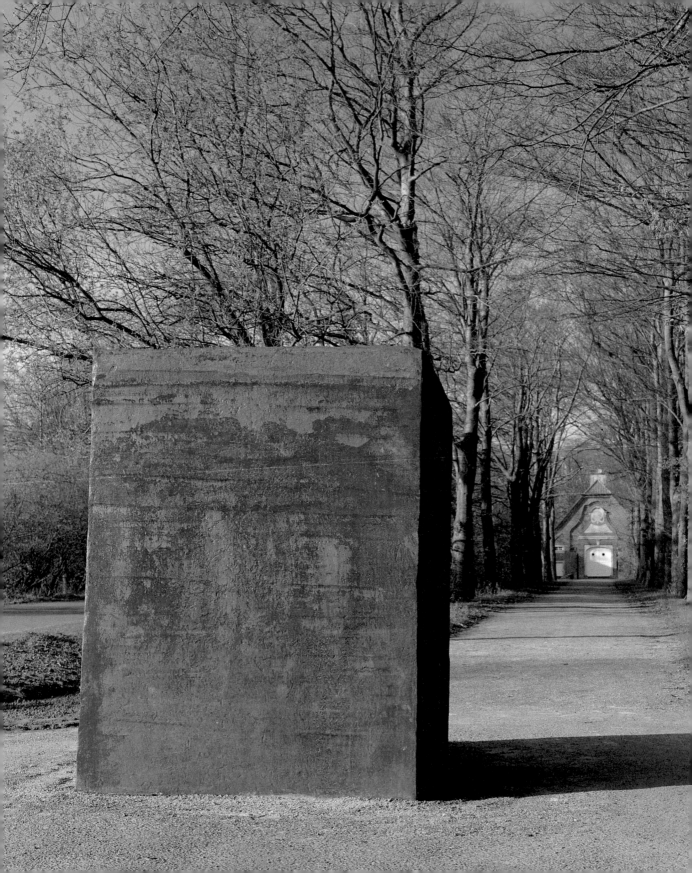

Dialog with Johann Conrad Schlaun, 1996
Sculpture (Corten steel, solid 2 x 1.5 x 1.5 m)
Avenue of Haus Rüschhaus in the district
Nienberge

Born 1939 in San Francisco, lives in New York

For information about the artist and additional bibliography
see: Richard Serra. Running Arcs (For John Cage). Weight and
Measure. Drawings, 3 vol., Düsseldorf 1992; Richard Serra.
Drawings, Zeichnungen 1969-1990, ed. Hans Janssen; Berne
1990; Richard Serra. Schriften, Interviews. 1970-1989, ed.
Harald Szeemann/Clara Weyergraf-Serra/Theres Abbt, Berne
1990; Richard Serra, ed. Ernst-Gerhard Güse, New York 1988.

Ulrike Groos/Florian Matzner: Richard Serra
and Johann Conrad Schlaun

Today, tourists visiting the Haus Rüschhaus out-
side Münster – a jewel of Westphalian Baroque
architecture and one of the most popular
attractions in the region – approaches the com-
plex by a different route than did residents and
visitors in the eighteenth century. Arriving by
car, bus, or on bicycle, modern-day sightseers
go first to the parking lot at the side of the
Rüschhaus and from there pass directly over
the moat into the forecourt of the estate.

But when Baroque architect Johann Conrad
Schlaun, the builder and owner of the
Rüschhaus, visited his country house for a few
days of recreation and rest from his duties as
Generalmajor and Oberbaudirektor in Münster,
he drove his coach up a long representative
avenue, which, flanked by a moat on both sides,
formed the central symmetrical axis of the
entire complex and leads to the main house.
This historical situation is shown in an overall
plan prepared in 1791 of the Rüschhaus with its
surrounding estates. Schlaun even went so far
as to secure the avenue with turnpikes, thus
infringing on the neighboring farmers' right of
way. The latter ended the legal conflict after

their own fashion: under the leadership of the
impoverished Herr von Schenking, they took
the church pew of the "high Herr Schluen" in
the parish church of Nienberge, broke it into
pieces, and threw it before his doorstep.

Turnpikes block the path even to this day, while
street signs and an unofficial garbage dump do
their part to obstruct and turn into a "non-
place" the representative beginning of the

Rüschhaus complex – a beginning from which, as you approach along the avenue, the Baroque estate displays itself like a theater set.

In 1995, Richard Serra was in Münster on the occasion of the 300th birthday of Johann Conrad Schlaun (1695–1773), one of the most important German architects of the Baroque period. During a sightseeing tour of Schlaun's existing buildings, Serra instinctively made the decision for the Haus Rüschhaus. Schlaun had built the Rüschhaus for himself from 1745 to 1748 as a country house in addition to his town house on Hollenbecker Straße in Münster. The Rüschhaus had to meet the demands of both an elegant Maison de Plaisance and a simple farm: it was intended as a place of both courtly, public representation and of private family retreat.

As the overall plan from the late eighteenth century shows, the estate – consisting of the main house with flanking dependencies and Baroque ornamental and kitchen gardens – was organized around a central, symmetrical axis, defined by the long avenue approach whose beginning – the planned site for the sculpture by Serra – offers as it were the "opening scene" for the stage-like arrangement of the entire complex.

The artist describes his project as follows: "This sculpture consists of a block forged of solid, weatherproof steel measuring 200 cm (height) x 150 cm (width) x 150 cm (depth). The sculpture weighs about 40 tons. The front side of the block is tilted forward about seven degrees and sunk into the ground in such a way that the back side is exactly at ground level. In this way it inclines as if toward the main building of the Rüschhaus at the other end of the axial approach. The desired dialog with the building by Johann Conrad Schlaun, however, is effected not only by this 'inclination', but also by the dimensions of the sculpture, which are derived from, and therefore make reference to, the measurements of the building. Each of the

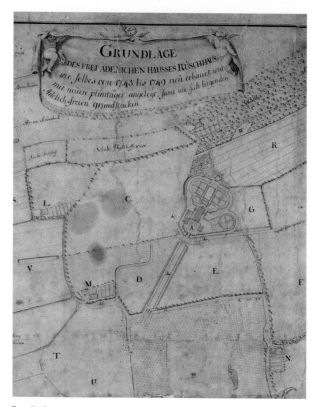

Detail of overall plan of Haus Rüschhaus with its estates, Joseph Schmeddes after Friedrich Mertz, 1791, collection of Westfälisches Landesmuseum

two lower panels of the gate, also located on the central axis of the above-mentioned building, measures 200 cm (height) x 150 cm (width). The sculpture, placed exactly opposite this entrance gate in the axial extension of the approach, thus adopts the harmonious proportions of the latter in a ratio of 3:4. Unlike my previous project in the cour d'honneur of the Erbdrostenhof in Münster, a building by the same architect, this time in order to avoid disturbing the picturesque character of the ensemble I related my work to the architectural details in terms of dimensions, but placed it antipodally a considerable distance away. In this manner the axial inclination of the sculp-

ture connects its compact, rigid, cubic form dialogically with the lighter, more buoyant architecture of Schlaun."

With the reference to the representative city palace of the Erbdrostenhof, Richard Serra alludes to a tradition begun by him in sculpture exhibitions in Münster in 1977, that of using contemporary art to render visible the city's historical, social, urban, and esthetic structures and allowing them to be experienced in a new way. During a long working visit to Münster in the context of preparations for the *Skulptur Projekte in Münster 1987*, Serra had meticulously studied the work of the Westphalian Baroque architect. His sculpture *Trunk, J. Conrad Schlaun Recomposed* in front of the Erbdrostenhof took up the forms of the middle bay of its complex façade in proportion, curvature, and individual dimensions. The result was a brilliant interpretation of the urbanistically ingenious spatial solution of the Erbdrostenhof and its splendid architecture: the curving steel plates complemented each other like parts to a whole, manifesting in symbolically concentrated form the centering of the middle façade bay on the one hand and the symmetrical division into extended wings on the other, reflecting the division between the chambers of the architect and those of his ideal guest, the electoral prince. The slightly inclined steel plates in the central axis of the complex were shaped in such a way that the viewer could experience the architecture and the sculpture inspired by it from a variety of perspectives.

Already in 1977, Richard Serra had shown a provocative work in the project area of the *Skulptur Ausstellung in Münster*. In the large central parking lot at Hindenburgplatz in front of the Baroque palace – the latter likewise designed by Johann Conrad Schlaun - Serra placed a two-part sculpture of steel plates, more than 13 m long. Through its diagonal placement, the sculpture constituted a visual barrier between the Schloß area and the line of the street, while at the same time it self-consciously broke the strict axial symmetry of the Baroque complex. In addition, it produced a space within a space – a clearly defined "private" space within the unbounded space of the "public" realm. Serra "furnished" his work at that time with the following "statement" (as he called it): "There are no established patterns or expectations of audience awareness. The observed fact and experience of the work is not the preconceived idea of its construction."

For the Rüschhaus, as well, Richard Serra employs his conception of the understated, persuasively simple interpretation of pre-existing architectural contexts, yet without artistic intervention in the architecture itself. With his project *Dialog with Johann Conrad Schlaun* at Haus Rüschhaus, Serra himself speaks from a respectful distance of almost 300 m. Nevertheless, the site chosen by Serra is visible already from a distance for visitors arriving from the

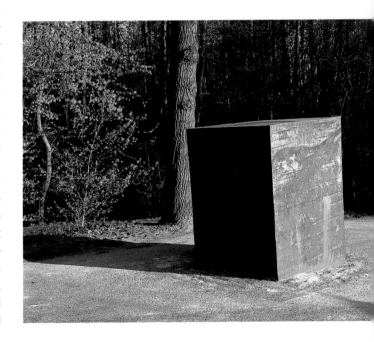

main street. It thus marks the least representative and at the same time the most significant place in the ensemble, a place which heretofore has not been architecturally "occupied". The placement of the great steel block is to be understood as the subsequent completion of the historical complex, yet without changing it esthetically. Its location not only emphasizes the symmetrical Baroque axis but at the same time negates and blocks it: "What interests me is not the form that follows the function, but the attempt to make visible through sculpture the tension between that form and the function of a given architectural context", Richard Serra says. He continues: "What interests me is the opportunity for all of us to become something different from what we are, by constructing spaces that contribute something to the experience of who we are."

main street. It thus marks the least representative and at the same time the most significant place in the ensemble, a place which heretofore has not been architecturally "occupied". The placement of the great steel block is to be understood as the subsequent completion of the historical complex, yet without changing it esthetically. Its location not only emphasizes the symmetrical Baroque axis but at the same time negates and blocks it: "What interests me is not the form that follows the function, but the attempt to make visible through sculpture the tension between that form and the function of a given architectural context", Richard Serra says. He continues: "What interests me is the opportunity for all of us to become something different from what we are, by constructing spaces that contribute something to the experience of who we are."

Richard Serra: *Ohne Titel*, contribution to *Skulptur Ausstellung in Münster 1977*, location: Hindenburgplatz, two-part sculpture, Corten steel, and *Trunk, J. Conrad Schlaun Recomposed*, contribution to *Skulptur Projekte in Münster 1987*, location: cour d'honneur of Erbdrostenhof, Salzstraße, two-part sculpture, Corten steel

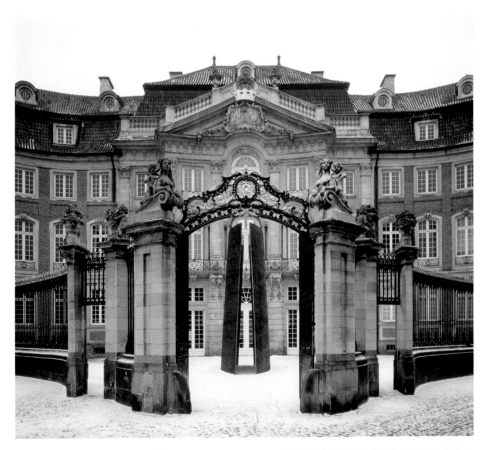

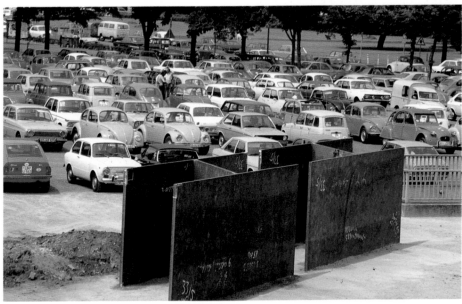

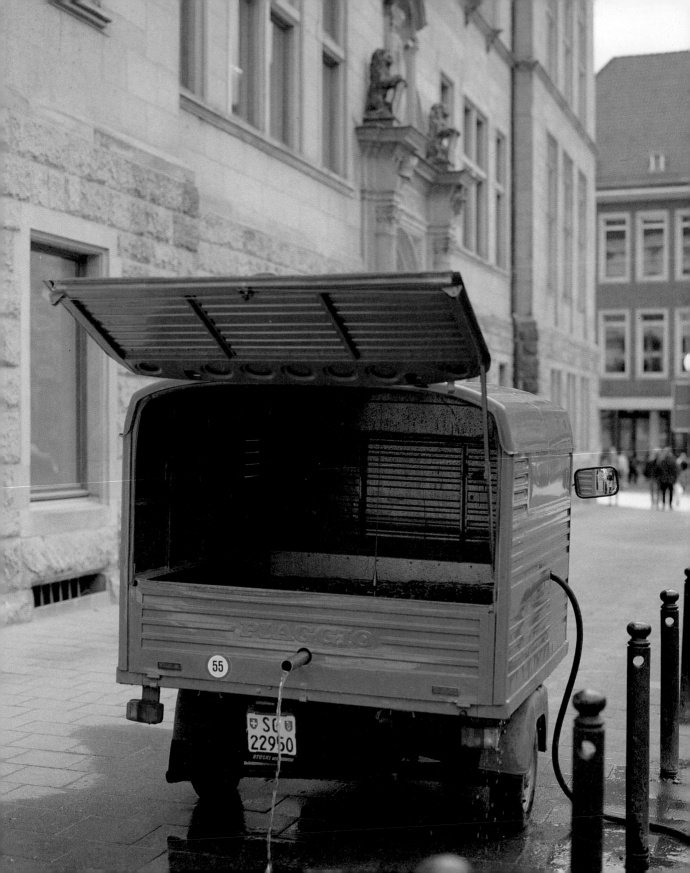

ROMAN SIGNER

Fontana di Piaggio, 1995
Mobile fountain (Piaggio, hose, water)
14 different locations in the city

Spazierstock, 1995/1997
(Walking Stick)
Kinetic water sculpture (aluminium, height
ca. 70 cm)
Pond on the grounds of the former Zoo behind
the Westfälische Schule für Musik, Himmel-
reichallee and 12 changing position in the
center of Münster

Susanne Jacob: Roman Signer – WATER.
Sculpture Between Experiment and Event

"Water is like a thread of vitality accompanying
me through my entire life"(Roman Signer).[1]

Since his public debut with works of art in the
early 1970s, Roman Signer has used a specific
repertoire of materials and objects for his sculp-
tures and events. The diverse sources of inspira-
tion for his ideas include the natural elements of
fire, water, sand, and air, as well as industrially
manufactured materials and objects such as bal-
loons, buckets, barrels, and crates, personal
objects and means of transportation such as
bicycles, kayaks, and Piaggios, but also mascu-
line "toys" like rockets, fuses, dynamite, and
revolvers. These raw materials typically possess
great potential for transformation, combination,
variation, and augmentation. At the same time,
personal memories and preferences also play a
considerable part in Signer's choice of materials,
so that in his work one can speak of a private ico-
nography of substances and processes. The ele-
ment of water, in particular, is closely connected
with Signer's biography and for this reason not
only occurs as a raw material, but can also deter-

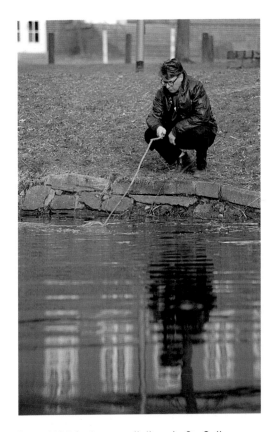

Born 1938 in Appenzell, lives in St. Gallen

For information about the artist and additional bibliography
see: Roman Signer. Works, The Galleries at Moore, Moore
College of Art and Design, ed. Goldie Paley, Moore College
of Art and Design, Philadelphia 1996; vor ort 1995, Kulturamt
der Stadt Langenhagen, Langenhagen 1995; Roman Signer.
Skizzen, Forum Schlossplatz, Aarau 1995.

mine the choice of location for his sculptures. As
the artist himself says, "When I enter a new city,
most often I look for the water".[2] In searching for
a suitable location for his works in Münster, the
artist chose a small pond near the Westfälische
Musikschule for the sculpture *Spazierstock* of
1995/1997, which under the massive pressure of
the water begins to "dance" and "sketch" over
the surface of the pond.

Water Sculptures and Water Games

Along with sand, the natural element of water had already assumed a central function in Signer's early work. Air and fire would feature later. In addition to its biographical connotations, this choice was determined above all by the specific qualities of the element itself: water is an amorphous, mobile, and adaptable material that can also assume various forms of aggregation. Roman Signer's interest in physical processes and plastic sequences of action – and with it the rejection of a finite conception of the work – was already formulated in the installation *Tropfenraum* (Drip Space) of 1974–76, in which drops of water fall at regular intervals from the ceiling of a darkened room into a transparent plexiglas cube. The drop hitting the surface of the water produces a sound and a ring-shaped structure which is projected onto the ceiling through a light source contained in the cube. Notwithstanding its sacral-meditative effect, the *Tropfenraum* already possesses the qualities of an experimental procedure. The installation visualizes an energy cycle that is less a matter of scientific conception than of sensual perception: in the different states of plasticity assumed by the liquid element; in the graphic structure evoked by a physical process (displacement of mass), a structure which, as a light drawing, returns to the original point of departure of the process; and finally in its acoustic and temporal structure, which is expressed in the regular alternation of the sound of the drips and silence.

Transformations

This early work should be viewed in the context of a series of other water-related or water-driven sculptures and (material) arrangements, including the *Spazierstock* of 1995 and the group of works entitled *Fontäne* (Fountain) developed since 1976. To this latter group belongs the event-sculpture *Fontana di Piaggio*,

presented both in 1995 in the series *vor ort* in Langenhagen and in an altered form at *Skulptur. Projekte in Münster 1997*. Signer frequently modifies and augments previously realized sculptures, as the result of conclusions drawn and further inspiration that comes to the artist while works are being executed. This procedure extends through all his groups of works, and shows itself as well in individual event-sculptures which manifest a number of different material and formal states; in the mobile fountain *Fontana di Piaggio*, for example, the element of water appears as droplet, spray, stream, rill, and puddle.

Fontana di Piaggio

Most of Roman Signer's water sculptures are complex systems,[3] appearing not in a single, permanently fixed form, but in a variety of forms and states – as a static or mobile arrangement (state of being), as a physics experiment (process), as a graphic structure, a painterly gesture, a plastic or acoustic signal (aesthetic result) – which, in contrast to traditional artistic procedures, constitute the traces and material deformations of more or less controlled processes. These works, including the *Fontana di Piaggio*, can only be fully experienced at the moment of the event. Only to a very limited extent can photographic or video documentation reproduce the multilayered effect of these real-time processes. In the final analysis, however, it is precisely this incommunicability – and therefore also unmarketability – that constitutes an essential aspect of Signer's complex event-sculptures: there is always something that remains inexplicable, invisible, mysterious. This holds true for the mobile sculpture *Fontana di Piaggio*, the fountain of which is partly visible and partly invisible. Partially concealed within the metal body of a sea-blue automobile, manufactured by the Italian bicycle company Piaggio, is a metal basin

installed by the artist with feed pipe and spray nozzle. While the external form of the Piaggio remains unchanged, its interior life and function are changed from that of a utilitarian vehicle to a non-functional fountain sculpture. The absurd combination of automobile (machine) and water, of industrially manufactured product and natural element, can also be read as a parody of permanent urban fountain monuments and tourist attractions like the Fontana di Trevi in Rome. At the same time, the seemingly anachronistic fountain-vehicle plays on nostalgic values closely connected with the romantic idea of the automobile as the epitome of individual freedom of movement.

Choice of Site, Operation, and the Dimension of Time

In the project *vor ort*, the mobile fountain-vehicle progressed through the city of Langenhagen over a period of six days. Each day the artist chose a different location for his unusual fountain, a location selected not for its touristic attractiveness but rather as an authentic site of banal and incidental rituals; the way home from school, the daily shopping excursion, or the drive to work led past Roman Signer's mobile fountain. At the junctions of car, bicycle, and pedestrian traffic, the *Fontana di Piaggio* joined into the din of everyday noise with hissing and rumbling, sometimes even aggressively drum-

Roman Signer: *Fontana di Piaggio*, 1995, Piaggio (hand truck), hose, water, located during 1st week of exhibition in front of old section of Westfälisches Landesmuseum

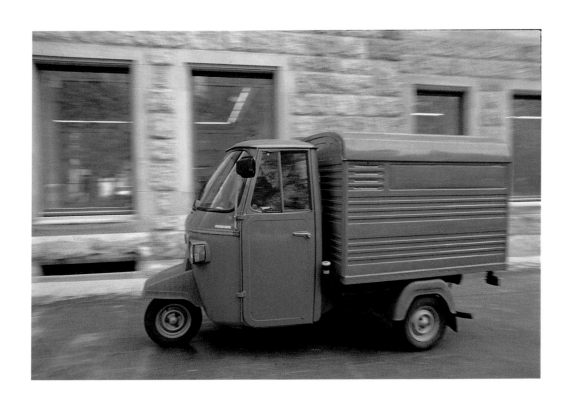

ming sounds. Only in a static condition, hooked up to a public hydrant, did the strange vehicle unfold its aesthetic quality as a spraying, dripping, rumbling event-sculpture. Unlike traditional fountains, Signer's percussive sculpture also possesses the character of an experiment aimed at exploring the physical qualities of water and the variety of its aural and formal possibilities; the differing degrees of pressure and speed regulate not only the amount of water put out, but also the strength and sequence of the acoustic signals. But it is above all the fourth dimension, as moment and duration, as transitory, stationary, and processual time, as rhythm and interval, that is an essential structuring element of the sculpture as a whole. It will be interesting to see how the choice of location and expansion of the temporal parameters planned for Münster will alter the character of the mobile event-sculpture.

1 Roman Signer in a conversation with the author, February 9, 1997.
2 Ibid.
3 In this context the term "system" refers to non-static sculptures involving a conversion or transformation of material, energy, and information.

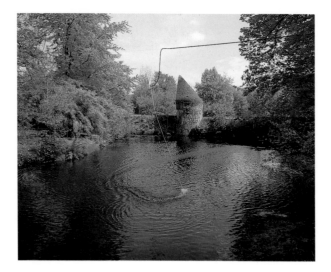

Roman Signer: *Spazierstock*, 1995/1997, aluminum, height ca. 70 cm (below and opposite)

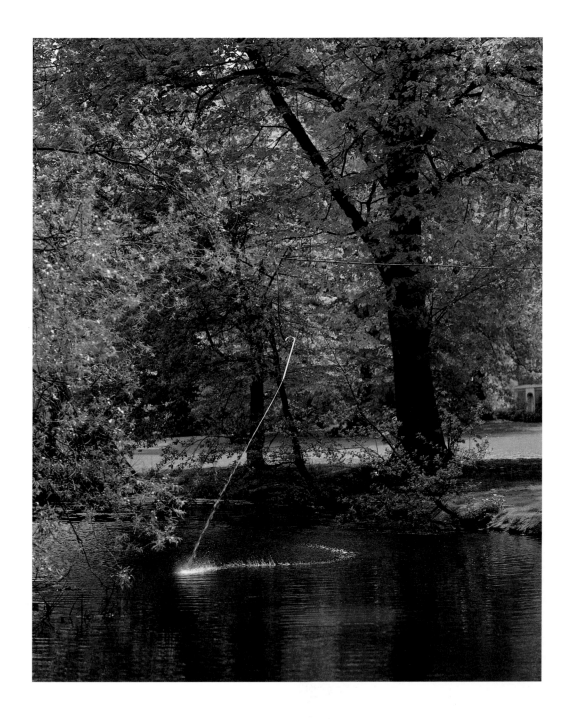

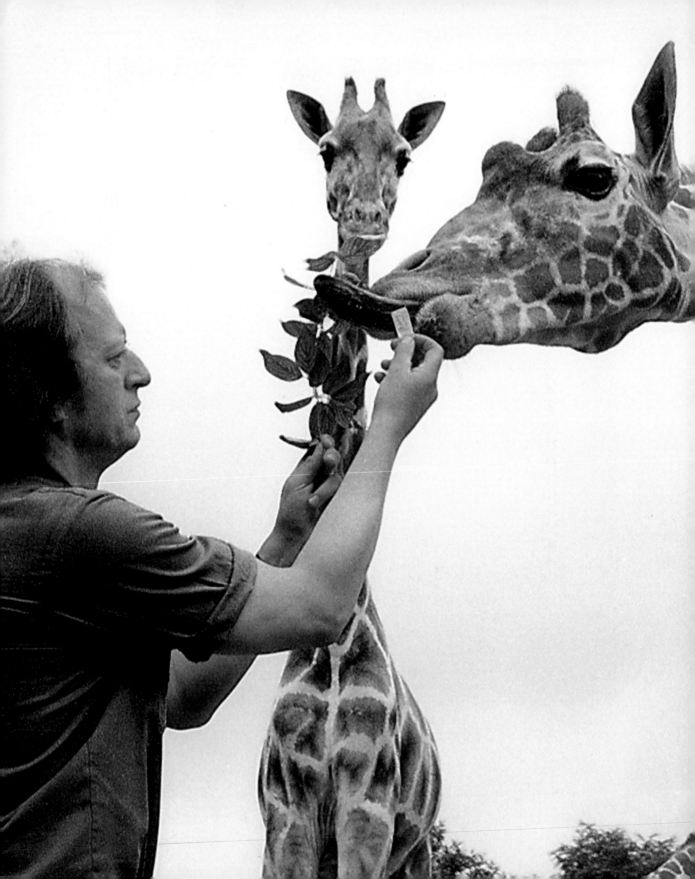

ANDREAS SLOMINSKI

Ausheben der Laterne für das Umlegen des Reifens
(Raising of Street Lamp for Placement of Tire)
Installation
Adenauerallee

Anfeuchten einer Briefmarke
(Moistening of Stamp)
Action on June 27, 1996
Münster Zoo

Born 1959 in Meppen, lives in Hamburg

For information about the artist and additional bibliography see: Ayşe Erkmen. Andreas Slominski. Zuspiel, Portikus, Frankfurt/M. 1996; Andreas Slominski, Museum für Moderne Kunst, Frankfurt/M. 1993; Andreas Slominski: Andreas Slominski. (grün). Die Geige, die Geige, Hamburg 1986.

Anja Tippner: Andreas Slominski. On Context, Function, and Giraffes

I. Context

City and museum are not equivalent exhibition spaces. The institutional structure alone into which a museum places artistic productions seems to guarantee their claim to validity. Previous works by Andreas Slominski, such as the kitchen towels exhibited in the Museum für Moderne Kunst in Frankfurt or the strangely auratic bicycles loaded with plastic bags, demonstrate this by attributing significance to everyday objects in their materiality. Their status as works of art is, though not undisputed, at least safeguarded by the institution of the museum. To this extent they represent an answer, though not the first, to the question not of "when", but rather "where" something is "art".

Things are different when works of art are positioned in urban space. This situation allows substantially more freedom of interpretation than the installation in an official gallery. Here, "art" as a framework of reference is not a given, but rather must be "asserted" in a double sense. But degrees are apparent even in

this fundamental question of institutional frames of reference. Unlike other works created in connection with *Skulptur. Projekte in Münster 1997*, a work like Andreas Slominski's street lamp action from November 1996 was not already safeguarded by the label "exhibition"; the time lapse was simply too great. Thus all the more pronounced is the challenge posed by such a work and the feeling of insecurity it produces. The tire was threaded onto the street lamp, not from above, as would appear "natural", but from below. In order to accomplish this, the lamp had to be lifted out of the ground, the post stuck through the tire, and then buried again. Once the bicycle tire had been placed on the street lamp in a technically difficult and seemingly senseless action, it remained in its location hardly a single week. Subsequently, the tire of the service bicycle of

the Landesmuseum was removed by an unknown perpetrator.

To the eyes of "order-loving"[1] passers-by, it was not evident that this was a work of "art". And how indeed? The resulting object was too inconspicuous, the street intersection on Adenauerallee too much of a non-place in comparison with more prominent urban landmarks, and certainly with the museum. The index is missing. The context is missing, or in other words, the city is not an established picture frame. The same holds true for the moistening of a stamp by Ole, a friendly giraffe at the Münster Zoo. The action itself appears bizarre and pictu-

Andreas Slominski: *Ausheben der Laterne für das Umlegen des Reifens*, action on November 27, 1996, Adenauerallee (below), and street lamp with tire, 1996 (opposite)

resque enough, but its result – the stamped letter – is hardly spectacular. If it were not accompanied by information on the circumstances preceding the stamping, if it were not exhibited, it would vanish into an ocean of mail.

The presentation of the three works in a catalogue alters the interpretative possibilities opened up by the concrete placement of the works in the city and narrows the range of sense perception. For one thing, the index "art" manifests itself in the catalog in a canonized form (exhibition catalog); for another, the arrangement of the works on the pages of a book suggests parallels that cannot be produced (any more) in urban space, simply because of the spatial and temporal distance involved. The long necks of the giraffes seem to correspond to the curved line of the street lamp; the playfulness of both actions, as well as the fact that the overcoming of distance plays a central role in both, appears more clearly as a constant in these snapshots. On the street, however, where the viewer's perception of context as a giver and receiver of meaning is shaped by everyday patterns of life, a substantially different range of interpretative possibilities comes into play.

II. Function

"The functional perspective allows us to view things as events without denying their material reality", writes the semiotician Jan Mukarovsky.[2] Andreas Slominski's works in Münster emphasize the association of object and function in different ways. The objects undergo a strange metamorphosis as their individual qualities are accentuated: the opening of the tire and the projection of the lamppost, the complementarity of stamp glue and the moisture from a giant tongue. What happens when the position of an object is shifted? Or when functions are shifted, as with the giraffe tongue used to moisten a stamp? Such operations are

"practical jokes". Their product is surprise, if not bewilderment. They are "made" and not found – which, according to Freud, is what distinguishes the joke from comedy.[3] One of the jokes of Slominski's works consists in the fact that they seem like *objets trouvés*, but in reality are artefacts.

What it demands from the viewer is a way of perceiving that is at least analogous to that of the artist. The viewer's task consists in recognizing the particular "make" of these "made" works, tracing back in thought, as it were, the shift effected by the artist, and accepting the altered "is"-condition as a new hypothesis. In other words, the viewer must attribute a function to the giraffe tongue and to the tire placed around the street lamp. At the practical level, this function can consist in the moistened stamp being affixed to a letter. Or, at the metaphorical level, it can consist in associating the tire and the street lamp with the rings and sticks of a children's game with its intimation of an opposing, more functional movement – that of throwing the ring over the post. What is important is to play the game, and that, to quote Andreas Slominski, it "remains unpredictable to the end".

1 The connection between institutionalization, signature, and interpretation is addressed indirectly in an article in the Westfälische Nachrichten for December 5, 1996. Under the heading "Short work made of unrecognized art on street lamp", the process is described. What is of interest in this article is above all the remark that the unknown perpetrator "needs fear no prosecution, since the work of art was not labeled." Or did the unknown person appropriate the tire in an intentional effort to negate its character as art?

2 Jan Mukařovsky: Zum Problem der Funktionen in der Architektur (1937), in: idem, Kunst, Poetik, Semiotik (Frankfurt/M. 1989), p. 109.

3 Sigmund Freud, "Der Witz und seine Beziehung zum Unbewußten" (1905), in: idem, Studienausgabe, vol. IV (Frankfurt/M. 1975), p. 169.

YUTAKA SONE

Birthday Party
Performances
Various locations in the city
Video installations
In the pedestrian underpass in front of the
Hauptbahnhof, Berliner Platz, and in old
section of Westfälisches Landesmuseum

Born 1965 in Shizuoka, lives in Tokyo

Yutaka Sone: *Birthday Party*

I try to have my *Birthday Parties* as often and in
as many places as possible.
In Münster, I will celebrate my birthday with my
lover. Just the two of us. Or another party with
children singing for me. Or with my mother,
father and other family members. Big parties
with friends. Celebrations with people involved
in my projects, anybody who happens to be
there and strangers.
All kinds of music with violin, piano and other
instruments. Songs. Flowers and wine. Lights.
Decorations, candles and heartfelt presents (of
course I manage it without them). Various
words spoken in celebration.
I throw my *Birthday Parties* in my room, hotel
rooms, friends' flats, local restaurants, trendy
pubs and many other places. As for a birthday
cake, I ask someone else to buy one for me,
because I wouldn't feel that it was my birthday
if I myself went to buy it.
A birthday tells the history of each our lives,
and it's the first proof that we have had a life in
this world. Every Birthday Party is a chance for
us to remember that all of us live with and
among others. Any cities, any places, are built
on the personal histories of the people living

For information about the artist and additional bibliography
see: Yutaka Sone. Building Romance, ed. Takeharu Ogai, Tokyo
1996; Min Nishihara: A Miracle Rat Race, in: Studio Voice,
April 1995; Nutopi, Rooseum, Center for Contemporary Art,
Malmö 1995.

there. But we scarcely see any personal histo-
ries in public spaces.
Therefore, I record my very own personal his-
tory, my *Birthday Parties*, on video and edit the
tapes. I will make an installation in the museum
and the underground pass of Hauptbahnhof,
which is a most public space with countless
people walking by.

I record smooth and sleek memoirs of visual images; intimate *Birthday Parties* with a tiny cake in a small room, a magnificent one in a grand decorated hall and many, many other *Birthday Parties* with people singing songs celebrating my birth and my blowing out candles on cakes.

"Happy Birthday dear Yutaka, Happy Birthday to you!"

Someday, after a long, long time, so many things in the world will have totally changed and nobody will be able to imagine what it is like today.

Then art might be a birthday cake.

I'm making this work, *Birthday Party*, based on my imagination of the visual images created in such times in the future.

Yutaka Sone: *Birthday Party*, location: pedestrian underpass in front of Hauptbahnhof, Berliner Platz, freehand drawing (below), and video stills (opposite)

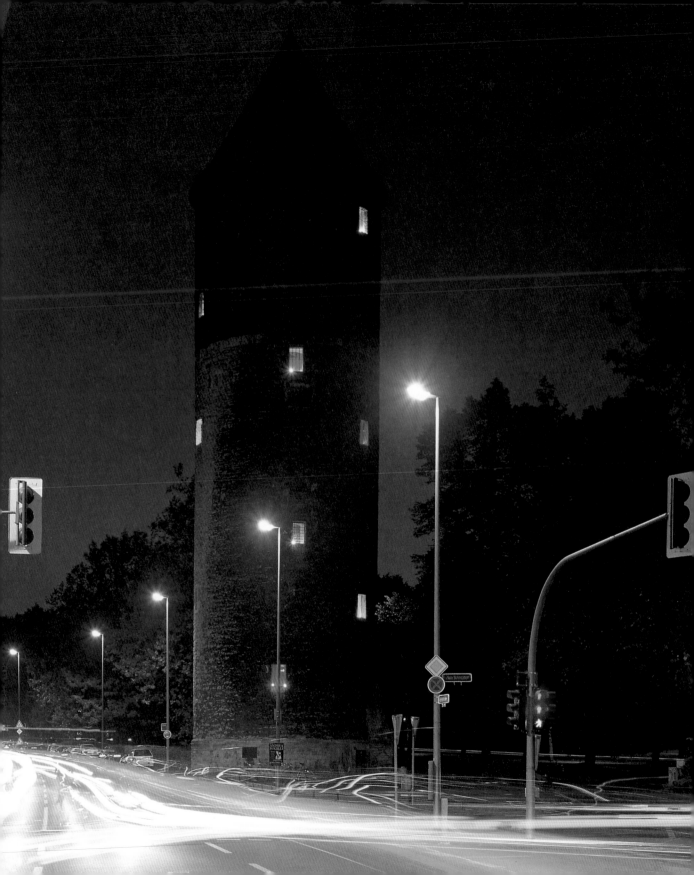

DIANA THATER

Broken Circle
Video installation (six video projectors,
six laserdiscs)
Buddenturm, Münzstraße

Diana Thater: *Broken Circle*

"For the principle task of civilization, its actual
raison d'être, is to defend us against nature."
Sigmund Freud: *The Future of an Illusion*

Broken Circle is a video installation designed
for the Münster Sculpture Project. The piece
will be installed in the Buddenturm, a 12th cen-
tury structure that is the only remaining tower
from the town's medieval fortification walls.
The work, a synchronized six-projector installa-
tion, is approximately 30 minutes long and will
play continuously on four floors of the tower.
The footage for the installation was recorded in
January of 1997 on the Ugland Ranch in Cas-
taic, California. It is made up of six images
which were shot simultaneously with six Sony
BetaSP video cameras. For the shoot, a plat-
form was built in the middle of a long canyon
bounded by mountains on two sides and by a
stream on the other two sides. The cameras
were set on the platform in a circle facing out-
wards, thus recording a 360 degree panorama
of the canyon and all the activity within it.
Once the cameras were set, Polly Ugland, a
professional rider and her assistant, Shawn
Howell, brought a herd of 30 trained horses

Born 1962 in San Francisco,
lives in Los Angeles

For information about the artist and additional bibliography
see: Diana Thater. Electric Mind, Salzburger Kunstverein,
Salzburg 1996; The individual as a species, the object as a
medium. Diana Thater. Selected works 1992–96, Kunsthalle
Basel, Basel 1996; Diana Thater. China, ed. The Renaissance
Society at the University of Chicago / Le Creux d'Enfer Centre
d'Art Contemporain de Thiers, Chicago 1995; Whitney Biennial
Exhibition, The Whitney Museum of American Art,
New York 1995.

and mules into the canyon. They galloped the horses back and forth from one end to the other attempting to split the herd around the camera set-up each time. The shoot lasted for approximately four hours until the horses would no longer perform.

The animals chosen for the shoot are professional performers who work regularly in television and the movies. In addition, two trick horses, Woody and Ajax (who fall and rear on command), were brought in by the wranglers for specific shots. This herd of Hollywood horses was hired to stand in for the herd of wild Westphalian horses that Florian Matzner and Ulrike Groos took me to see at Mervelder Bruch, near the city of Dülmen. It is those **real** Westphalian horses who inspired the piece and who appear in the poster designed to advertise it (titled *The Future Was an Illusion*).

The work was shot and designed in a round format, however in the Buddenturm it will be installed on several floors as a broken circle, making it impossible for the viewer to experience the piece as a complete thing which surrounds her/him once she/he enters the interior. Instead, the viewer must use the narrow wooden staircase at the center of the tower to go from floor to floor, finding on each a part of the story. The work can then be reconstructed by each viewer over time as the circular system by which it is made is revealed when the top of the tower is reached and as the piece plays itself out from beginning to end.

Broken Circle is laid out as follows: The credit sequence plays on the first floor of the installation; on the second floor are long continuous shots of the horses heading toward the camera; on the third floor is an edited sequence that forces the movement around the interior walls of the tower with increasing speed; and on the last floor of the installation is the final shot of the herd disappearing in the distance. In this way the work plays itself out like a movie in the

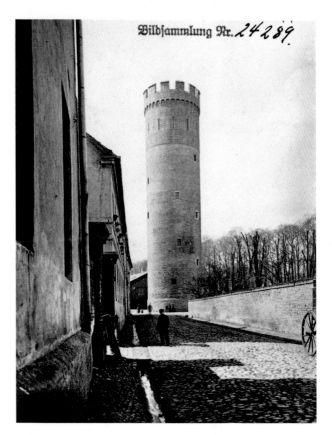

Buddenturm, view from south, photo ca. 1880–1890

tight winding spaces of the tower where visitors must physically walk from the beginning of the story to the end. The images will also alternate from floor to floor between full naturalistic color and the separated component colors of the video spectrum (red, green, blue, cyan, magenta, yellow) in order to move the viewer back and forth between consciousness of what is actual, real and physically present and what is an illusion.

The single shot that makes up this piece can be easily recognized as one taken from a John Ford or Akira Kurosawa film. It is the kind of second unit shot in which horses desperately gallop toward and past a still camera, that is

intercut into a battle scene. The piece is then prompted by this image from a medieval western: the tower and the horse (perhaps Bresson's *Lancelot du Lac*); tight dark claustrophobic space intercut with the image and symbol of wide open spaces (Ford and Kurosawa). Though it looks nothing like Kurosawa or Bresson, *Broken Circle* sets about constructing the same kind of effect present in the chaotic horse and rider sequences of those directors' films. In this installation, what in narrative film is a single insert shot, is given the time and space of a complete and complicated story. Once this single shot is allowed to expand into spatial and temporal depth, it becomes possible to force many different kinds of stories out of the work. Thus, the making of meaning no longer rests fully with the image and the wishes it fulfills for its viewer, but is born out of an actual physical relationship between the projected image and the walls it is projected onto and the viewer who moves in and out of these projections. Here, either the three-dimensional (architecture/video equipment) or the two-dimensional (horses/moving image) may dominate the piece depending on where the viewer is moving (on the stairs between images, or on one of the floors inside an image). And the narrative becomes that of the exchange between two kinds of space: illusory and real (the past and the present; the shoot and the installation); and two kinds of subjects: the viewed and the viewer (real wild horses and trick horses; film crew and viewer), overlaid on top of one another, alternately negating and reinforcing one another.

Diana Thater: *The Future was an Illusion*, serigraphy, 61 x 81.3 cm

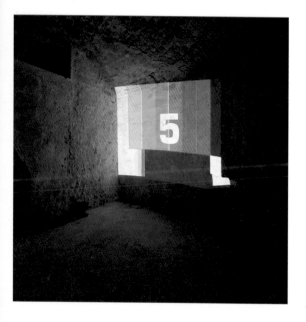

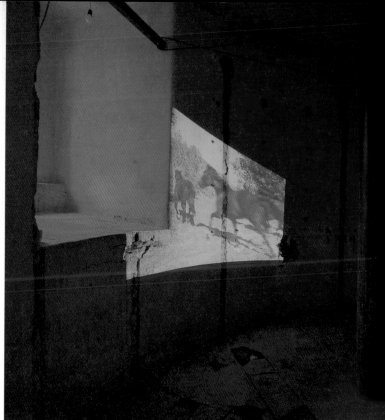

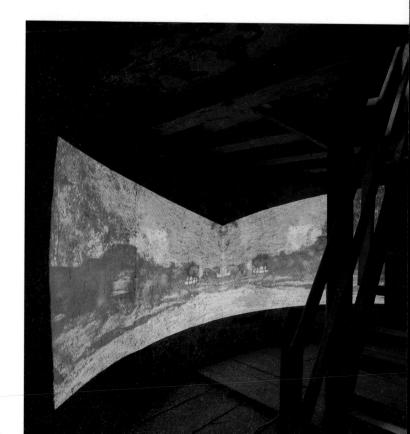

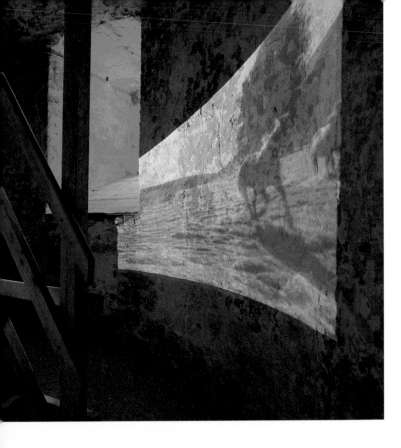

Diana Thater: *Broken Circle*, installation in Buddenturm. The order of the images follows the sequence of the levels in Buddenturm.

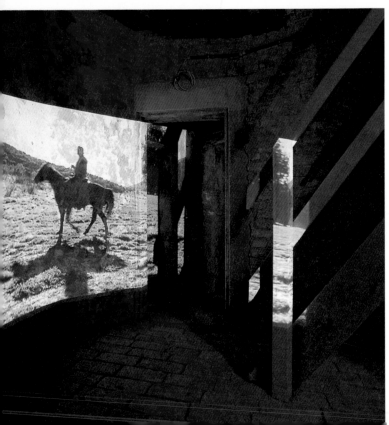

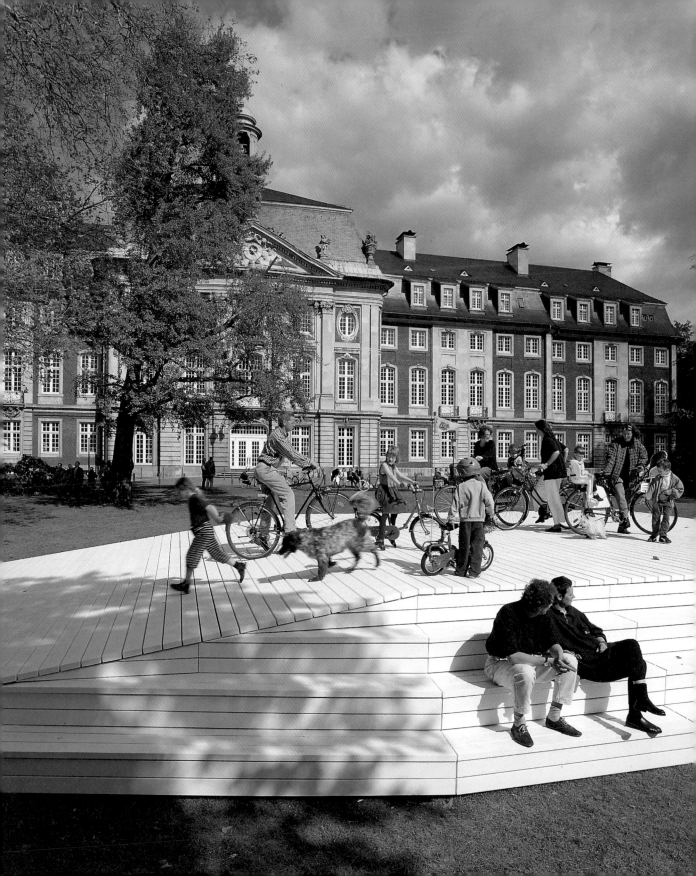

BERT THEIS

Philosophische Plattform
(Philosophical Platform)
Installation (wood, metal, technology)
Lawn between Schloß and Botanical Garden
Old section of Westfälisches Landesmuseum

Born 1952 in Luxemburg,
lives in Luxemburg and Milan

Bert Theis: *Philosophische Plattform*

By day the *Philosophische Plattform* emits muffled rumblings from its interior; at nightfall it discharges a cloud of steam.

Unlike other philosophical creations, this uplifting construction (wood, metal, technology, 23 x 10 x 1.2 m) has both an epistemological function and a concrete practical value for audience and population: it can be walked on, driven on, sat on, slept on, danced on, played on...

The platform is to be constructed in twentieth-century physical reality in the Schloß garden, and in virtual reality at the same location in the eighteenth century, between the *Gefühl des Schönen und Erhabenen* (Feeling of the Beautiful and the Sublime, 1764) and the *Ende aller Dinge* (End of All Things, 1794), after the model of Schlaun's unrealized garden.

For information about the artist and additional bibliography see: Bert Theis, Galerie Heinrich Schmidt, Grenzach-Wyhlen 1996; Bert Theis. Potemkin Lock, ed. Ministry of Culture, Luxembourg 1995; La Biennale di Venezia, Venice 1995.

Conversation between Bert Theis and
Carlo Dolci

Carlo Dolci: How do you justify the title *Philosophische Plattform*?
Bert Theis: Does a title need a justification?

CD: Not necessarily, but it seems to me that an explanation is required in this case.
BT: The title is to the work as the third arm is to the *Pietà Rondanini*.
CD: Could you be more concrete?
BT: The platform is the result of philosophical considerations and a potential point of departure for new philosophical excesses.

Its function is more to pose questions than to answer them – among others, the ontological question of its own essence. The beginning of philosophy is always a question.

CD: Would you agree with Richard Rorty's assertion that philosophy is no longer an argumentative discipline, but rather more closely approaches poetry?

BT: Similar remarks have been made by Wittgenstein or Derrida, but in order to prevent misunderstanding I want to emphasize that I approach the problem from the opposite direction, that of art. A few years ago, when I watched how hundreds of tourists applauded the sunset every evening in Ia on Santorini, I thought involuntarily of the Suprematist question of 1922: "Is it perhaps for aesthetic reasons that the sun sets?"

CD: In order to develop his concept of the "non-representable", Lyotard, following Kant, distinguishes between two kinds of representation or exposition: the "modus logicus" and the "modus aestheticus". He notes that this opens the door to the arts, even if they cannot be put on the same level as philosophical-logical exposition. The platform seems to me to represent an attempt at synthesizing these two "modi".

BT: It is interesting to observe the forms that "exposition" can take on in the age of Karaoke. Last summer, Copenhagen Zoo exhibited two examples of *Homo sapiens*. A Danish couple lived for three weeks in a plexiglass cage with furniture, telephone, fax, and computer. In a communication it was stated that since man is the last ape on earth, it is only natural to exhibit him too.

Another example is the "Papamobile". An ingenious invention: a mobile exhibition space completely immune to the tiresome problem of low numbers of visitors. The "exposition" is no longer bound to a particular location, it can take place anywhere.

Bert Theis: *Potemkin Lock, Fake Pavillon*, detail, contribution to Venice Biennale 1995 (above), and public interventions in *Potemkin Lock* (opposite)

In general, it seems to me that today, "exposition" is no longer so embedded in the problematic of the "site-specific", but rather is defined by a more comprehensive theoretical or ideological context, while the erstwhile specialized discipline of "aesthetics" has ascended to the status of universal philosophy and grapples with the problem of hermeneutics.

CD: An essential element of your work – the sound – is invisible, and therefore difficult to document in a catalog. The rap you exhibited in 1995 in Venice, with the voice of Marcel Duchamp sampled on CD, eluded most of the Biennale visitors predisposed to optical consumption, even many specialists, journalists, and critics.

BT: Perhaps it would be appropriate nowadays to extend Benjamin's idea of the distractedness of the mass of viewers to include the mass of commentators as well.

CD: The soundtrack emitted by your platform in Münster is based on noises from your own body which are computer-processed into a thunderstorm of sound. This produces a technologically mediated body contact with observers and passers-by, who are unable to ward off these

vibrating sounds – you can look away, but you can't "listen away". The words "body" and "technology" make me think of Baudrillard and Virilio, who point to the danger for humanity inherent in the conflict between these two poles. Virilio, for example, says that on the information superhighway, we have attained a speed that can no longer be exceeded.

BT: Wouldn't it be better to qualify such statements and add: "…at the present state of development of the human body and technology" – or to pause for reflection at the Copenhagen Zoo? As the astounded Schwarzenegger is told by his telematic alter ego in the film *Total Recall*, "Watch out, you're not yourself!"

CD: While I would adopt Shusterman's aesthetics of pragmatism as an interpretive key for the Duchamp-Rap, the rumbling noises at Münster make me think instead of Nietzsche's statement about the philosopher who lets all the tones of the world echo within himself in order to develop his concepts from the entirety of that sound.

BT: What both of the sound productions you mentioned have in common is their mode of creation: computers and samplers have opened up more new possibilities than the invention of the organ or the electric guitar. The difference between them is that in the Duchamp-Rap, I proceeded from a poetic, i.e. rhythmic deconstruction of an interview text, while the score for Münster consists of the text of a thinker transformed into sound, and therefore has a chaotic character.

CD: I mentioned Nietzsche, but Heidegger too speaks of the "ear of thought" and of listening as a prerequisite for thinking.

BT: What occurs to me is a saying of Jimi Hendrix; when asked what his favorite activity was, he answered: "Lying on the beach with my eyes closed, listening to my beard grow."

CD: I wouldn't necessarily mention Hendrix in the same breath as Heidegger and Nietzsche, but I think I understand your allusion to the double character of the platform: body sound, so to speak, as the fourth dimension of the three-dimensional sound-body. While the sound-body is continually present, the body sound unfolds in time. This makes it difficult to isolate an ideal point in time for an encounter with the work. You always run the risk of missing something. Especially when you don't have time to be present at the evening steam ejaculation.

BT: Even now, as we sit here talking and sipping espresso, we are missing a lot of more or less interesting things, just as the reader of this conversation misses a lot by reading. Life could be described as a series of missed opportunities. Karl Popper, for example, missed the opportunity to throw the fugue he wrote into the waste basket. Now it is performed for the ostensible edification of professors at the incidental programs of philosophy congresses.

CD: In your works you use sound consistently, but in different ways. In an installation for the Galleria d'Arte Moderna in Bologna, visitors could sit on a platform, covered in plastic wrap, and listen to the audio simulation of a sphere moving through space on headphones while

they themselves were observed by the rest of the audience.

At *Art Frankfurt*, on the other hand, you gave fair visitors the opportunity to climb a four-meter-high tower and there, equipped with binoculars and walkman, watch the business of the fair from a critical distance while listening to the sounds of a Spanish city on the headphones.

Does this calculated use of hearing as a counterpoint to seeing have some connection to your series of advertisements in daily newspapers in different countries, where a small unprinted area was accompanied by the text "Don't participate in the iconographical contamination"?

BT: Iconographical hygiene, a Sisyphian task, a really pointless undertaking! It appears that it is impossible to dam the flood of images or hold back the image producers; market and media are both pushing in the opposite direction. A purifying iconoclasm, as in Münster in 1532, is nowhere in sight.

By the way, it wasn't always easy to publish those ads. In Casablanca, for example, the editor-in-chief of the largest daily newspaper refused publication, stating that he didn't know if his party shared my views on iconographic contamination. That decision could only be made by the party's presiding committee in Rabat. He refused my offer to explain my idea to the party leaders and sent me to an opposition newspaper instead.

CD: When one considers the *Philosophische Plattform* from a formal perspective, one sees that it has something of a stage or an empty pedestal. The *Installazione per una sera* in Bologna seems to me to be a kind of preliminary stage or germ of the installation in Münster. It, too, has the character of an "opera aperta", an open work in Umberto Eco's sense, which is completed or altered through the presence or action of the viewer.

The same, by the way, is also applicable to the *Fake-Pavilion* at the Venice Biennale.

There, the person entering was faced with the question of whether the people sitting in the deck chairs in the rear courtyard were part of the exhibition or not. Many viewers apparently felt themselves so strongly catapulted into a world outside the public exhibition that they covered all the available surfaces with graffiti and commentary, from the deck chairs to the wooden partitions to the wall of the adjacent Belgian Pavilion.

BT: That work also had a political dimension that is little known. The Biennale directors and the city of Venice approved the project, but with the stipulation that we also had to obtain the consent of the owners of the adjacent pavilions, Holland and Belgium. This resulted in an absurd, months-long diplomatic guerrilla war in the Benelux countries, aimed at reducing my pavilion to the size of a doghouse. We never received their consent. Obviously, the exercise of "territorial pissing" is an unavoidable reflex for culture bureaucrats when art is appropriated for purposes of national self-representation.

CD: Your construction was oriented to the proportions of the neighboring pavilions?

BT: I halved Rietveld's square and used it as a module, just as in Münster I proceeded from the central part of the Schloß façade opposite.

CD: The platform in Münster introduces a new element: the chance to experience the work dynamically. The access paths allow the exhibition visitor to ride up and over the platform without stopping.

BT: One definition says that sculpture is whatever is standing in the way in a museum or a city. It seemed to me to be a matter of elementary politeness to spare the inhabitants of Münster, who are passionate bicyclists, an additional obstacle. I could imagine an exhibition that would consist only in removing sculp-

tures and objects from the city and preventing them from being replaced by something else. After all, subtracting is an elementary plastic act in classical sculpture.

As far as forward motion is concerned, the great geometric axes of the baroque Schloß-garten allowed the experience of the landscape and architecture to be accelerated by coach or horseback. I am convinced that Johann Conrad Schlaun, the architect of the Schloß, would have liked my installation.

CD: Is that the justification for the intervention in the model of the garden?
BT: I always wanted to exhibit in another century.

Bert Theis: *Philosophische Plattform*, garden of Schloß in Münster

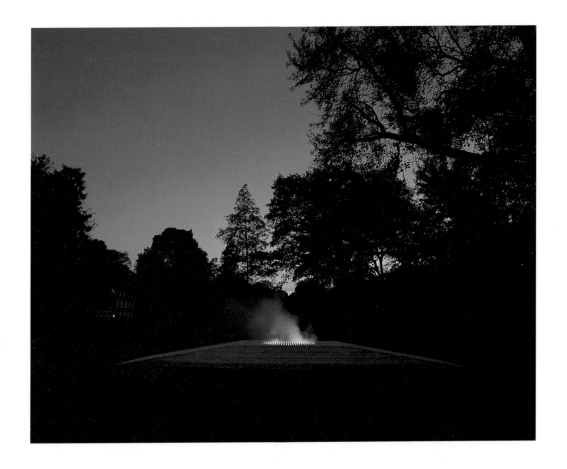

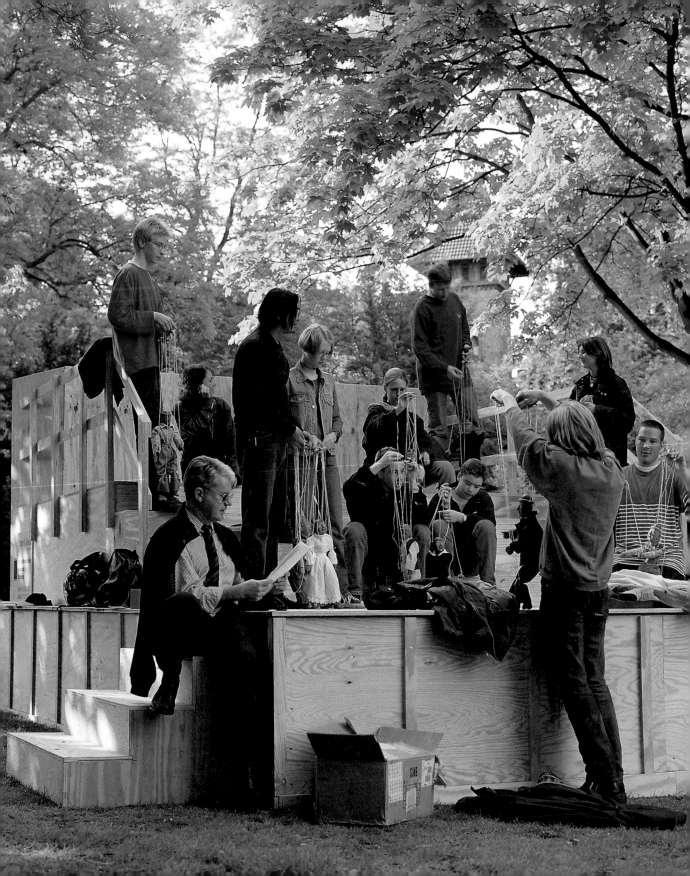

RIRKRIT TIRAVANIJA

Untitled, 1997 (The Zoo Society)
Theater stage with regular performances
(puppets, wood stage, 2.7x6.6x4 m)
Grounds of Alter Zoo behind Westfälische
Schule für Musik, Himmelreichallee

Born 1961 in Buenos Aires,
lives in New York

Rirkrit Tiravanija: To Professor Landois,
October 1996

For information about the artist and additional bibliography see:
Untitled, 1996 (tomorrow is another day), Kölnischer Kunstverein,
Cologne 1996; Untitled, 1996 (one revolution per minute),
Le Consortium, Centre d'art Contemporain, Dijon 1996; Gabriel
Orozco. Rirkrit Tiravanija, The Living Museum, Reykjavik 1996;
Traffic, CAPC Musée d'art Contemporain, Bordeaux 1996;
The Whitney Biennial, Whitney Museum, New York 1995

Dear Professor Landois,
I hope this letter reaches you in good form. I am writing to you concerning my recent visits to your home town of Münster, and subsequently to the grounds of your renowned Zoological Gardens.
To my great disappointment (of which I cannot be certain that you may approve), all I found was some fragments of your former Zoo. The owl house, the eagle cage and your little castle, which is now occupied by an art gallery. The most prominent is a very large modernistic (if one could even call it that!) architectural structure which looms large on/over the former grounds of your old Zoo.

I also had the great pleasure of taking a boat trip on the Aasee (on a boat named after you), to the new grounds of the Zoo. This particular Zoo has the unique feature of being an "all weather" Zoo; I had always thought that zoos always worked under all weather conditions! I had read some place that your collection of animal specimens was overwhelming the old Zoo Garden, and it was best for the "collection" to

be housed in a more suitable location and space. I could agree with that, but my sentiment is that a very lively feature of Münster is now so dislocated from the town itself. Did you know that they had also removed your likeness, the sculpture (which you had made yourself), from the original location in front of your castle, and had it placed at the new Zoo grounds? I suspect they needed the historical context.

Now let us get closer to the point of my visit, thought there is much more to report to you about the going ons in present day Münster. I had been walking around and reading about the town of Münster when I first came across your name and your contribution to Münster cultural life. I was particularly interested when I saw an old photograph of your former Zoo. The photograph (reproduced as source material for an artist project for the Münster sculpture exhibition), was a vertical image which features in the foreground a miniature villagescape. The miniature villagescape just partially recorded (since no other photos have been found from the city archive) what later was explained to me as the Hamster cage/environment. If the information is correct, my understanding is that the miniature was a replica model of the town of Münster of the time. In this scaled down village was the environment in which the Hamsters of the Zoo lived. This was subsequently reinforced with my visit to the Stadtmuseum, where miniature models of the Münster townscape were on display to illustrate the development of the town from its inception through to the war and the post-war reconstruction. Well, that was just the beginning of my inquiries into your life, work and your accomplishments.

At the Staatsarchiv, where I was kindly brought along to research the photograph of the Hamster habitat, I came across abundant materials through which I have now come to focus my relationship to Münster and to you. There were at this archive (I think) pretty much every pos-

sible picture and postcard featuring the animals from the Zoo, the Garden and the Zoo itself. We did find the picture of the Hamster houses, but what intrigued me most were the photographs which documented some bits of the zoo society. These were pictures of men in various theatrical staging, but what was curious was that most of the plays only featured men. Men dressed up and acting roles as men but also men dressed up and acting in women's roles. The pictures presented me with a certain notion and moment of Münster in time. This zoo society theater as I understood it was a part of your interest in the cultural life but also

Soirée of the Zoo Society: *Söffken van Giefenbeck*, 2nd act, artist's atelier Romani, photo 1903 (above) and photo 1985 (opposite, left)
Rirkrit Tiravanija: *Untitled (The Zoo Society)*, 1996, sketch (opposite, right)

acted as a society which could raised and fund your zoological project.

With all of that in mind, I am writing to inform you of my intentions. Which is to tell you of my interest in reviving your zoo society for an event which will take place in your home town of Münster in the summer of 1997.

I would like (with your permission) to construct a theater/café in the vicinity of your former Zoological Garden. In this theater I would like to

stage over a period of three months (or four) the conditions which would revived the spirit of the zoo society. However, I would like (going back to my initial interest in the Hamster habitat in the former Zoo) to stage, instead of plays with live actors, plays with puppets. The plays performed will be combinations of adaptations from stories/music written in the original days of the zoo society, however, I also would like to combine these situations with the contemporary life of presentday Münster. The scenery and sets of the theater will reflect the surroundings of Münster, as did the Hamster habitat of

atmosphere of theater and music seems quite important. It would be important to re-animate both the idea of the Zoo and the zoo society with the participation of the local people who could be interested. To bring back again an aspect of the life which was once vital to the identity and character of Münster.

I hope you would agree to let me pursue such interests and construct the theater with your approval. Therefore I am writing this letter to inform you.

With Best Regards,

Rirkrit Tiravanija

16/12 '96 21:35 SE./EM. NR.1368 S.003

the former Zoo. All of the puppets will be male, as were the actors from the original days, and they will perform both male and female roles.

In order to construct the theater, the troupe of puppet actors, and to perform the plays, I am requesting for possible participation from the local people of Münster. We would be able to create a workshop around the zoo society, to form another society to construct the sets and the puppets and to produce some of the plays in the summer of 1997. I also understood that the musical aspect of the plays were very important, and to be able to recreate the

Untitled, 1997 (The Zoo Society)

A building/pavilion/theater/café/lounge/workshop will be constructed in the area of the former Zoological Garden of Münster which was founded by the renowned Professor Landois.

The structure will house the puppet theater and café (or an area in which the audience can socialize and watch the puppet plays). It would be important to note that the activity is not purely one of an audience watching a staged performance. But rather an atmosphere of socializing while there is a performance happening at the same time. It is also significant that the space is functioning as a place for socializing or rest, even though the plays are not being performed (but there is still a possibility to "see" some aspects of the theater). The structure should be a site for different levels of activities, i.e. a puppet theater, a still life set which the puppets perform in, a pavilion in which to rest and have a drink, a place to meet to have a drink and watch or look at the activity on the stage, a place to meet while the children are entertained, a place to meet drink watch the play listen to music and sing, a place to come and work, a place to work in the café, a place to work on the stage, to perform the play, to play music for the play, to move the set and stages and props for the play, a place to come and work on the next play, to make more puppets for the next play, a place to make the costumes for the puppets to wear in the next play, a place to work on the new sets for the next play, a place to rehearse the next play, a place to clean up after all the others above have done all they can to the place, a sculpture.

The workshop aspect of the project. It is possible that there is continuous activity going on throughout the summer of making new sets and puppets and costumes and prop for the next play to be put on. This activity as a process can be quite transparent, meaning that it should mesh into the other aspects of the idea of the theater (people who come to visit can also see the rehearsals, the constructions of the sets and puppets, etc.). Of course for the group who will work on the theater and puppets and whatnots, this space and the activity is also a part of socialization.

The theater or the idea should be purely amateur. It should be put together with some respect to a structure, however, this is an amateur theater as was the zoo society. It will or could become entertaining through imperfections, through some degree of faults and mistakes. So, we are not looking to put on a seamless, highly produced stage production. It is about being at home, kicking off your shoes and putting on a play. It is (though scripted and with a musical score) improvisational, it is about having a good laugh even though the plays might even be serious. But it is an important aspect that the staging and going ons around the sets are transparent, that the process is also a part of the play.

It would be possible to plan the project in different phases. The initial phase is to find people and persons who will be interested to be involved, this can be also to different levels. They can be involved at the initial stage, which is to begin and build up the actorpuppets (the troupe) and the initial stage sets and props.

At this point I think we should start with working around the existing plays. (We will have to find the scripts and translate them into situations which could be staged and performed by the puppets. I think that most of the plays are musical, or sung.)

Initially I think we could possibly work on at least ten to fifteen puppets, which will form the troupe. They should all be male puppets. Each puppet should have its own identity, they should have their own names and features (i.e. face, hair or no hair, height, weight). It is possible when we initiate the workshop that stu-

dents or persons involved can (in teams or individually) develop the identity of the puppet as they are making them.

[At this point I am not certain which type of puppet will be suitable for the situation, however, I have always imagined them to be on strings and operated from a scaffold structure above the stage.]

Simultaneously as the puppets are being constructed, we can plan out the plays which could be staged for the opening of the *Skulptur. Projekte in Münster 1997*. (I am interested in the play which the Professor himself wrote titled *Die Pfahlbauern oder der Kampf ums Dasein*, as the play for the premier.) As the play is scripted (with music) for the puppets, we can construct the sets and props, which will be necessary for the production of the initial play. (I see the sets for the theater growing with the different productions of the plays, this also depends on how many plays we will plan to produce.)

Once the initial play is in production and performed, we could work on the pre-production for the next play (script, music, costumes, sets). This will continue in the form of a workshop which will also operate in the theater/pavilion, when the plays are not being performed.

Zoo Society: scene from *Jan van Leyden*, photo 1925

We will need to initiate different teams for the theater, they being the puppet handlers (who will make the puppets and costumes and manipulate the puppets in the play), the stagehands (who will be in charge of the production of the sets and props and stage manage the sets and props for the plays), the musical team (which performs the music), the dialog team (which will perform the dialogs of the puppets), the café attendants (who will run the café), the cleaners.

Students and persons interested can involve themselves also through out the whole projects but they can also work on the projects in different phases depending on interest. However, it would be important to have a core team which will run the production from beginning to the end.

But it is important that this is an amateur production and that the plays will be produced according to the input of the community and the people of Münster. As they are to be enjoyed by both the visitors to the theater/café and by the people involved in animating the project. It should be a Zoo.

Rirkrit Tiravanija: *Untitled (The Zoo Society)*, theater
performance by the pupils of the Gymnasium Paulinum,
classes 9–13, directed by Rirkrit Tiravanija and supervised
by Dr. Manfred Derpmann

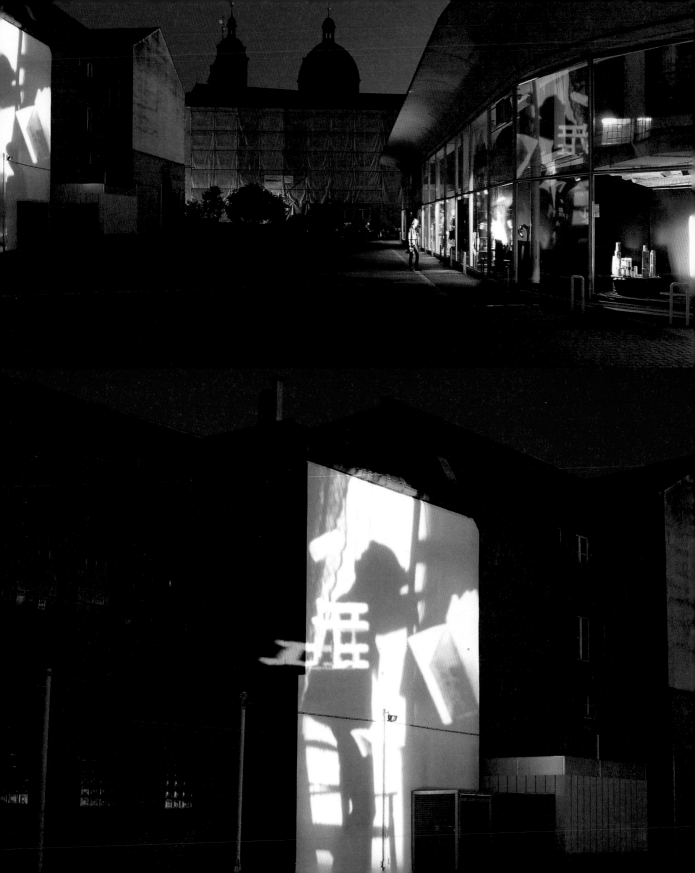

EULÀLIA VALLDOSERA

Twilight Zone/Zona en Penombra
Two-part light projection (four scanner projectors with gobos, two mirrors, turntable, electronics, display window decoration)
South display window of Karstadt sport pavilion, and fire wall opposite, Alter Steinweg

Born 1963 in Vilafranca del Penedés near Barcelona, lives in Barcelona

"Illumination is not obtained by imagining figures of light, it is obtained by bringing consciousness into darkness." C. G. Jung

Introduction

While the street lighting in Münster's town center is not particularly bright, the shop windows provide an extra measure of light which helps you to find your way through the lonely streets, by night. This is a common feature of European cities. Shops and small businesses, with their display windows fronting the street and with a large number of glass panels at pavement level, are stealing a march on the other ways in which the historical signs of identity of different places have been visible. Apart from creating a certain cultural uniformity between cities, they also subtly inspire a feeling of security in local people, and an even greater one in outsiders.

The shop windows which display fashionable items of clothing construct apparent identities based on a notion of being personal and different. A person who approaches a shop window both projects and momentarily exchanges his or her image with that of the dummies, superimposing his or her unique condition onto an image which is, in the end, a standard one.

For information about the artist and additional bibliography see: Aparences d'Eulàlia Valldosera, Sala d'exposicions El Roser, ed. Ajuntament de Lleida, Lleida 1996; Eulàlia Valldosera. Palma 19, Galeria Palma Dotze, Vilafranca del Penedés, Barcelona 1995.

There is an exchange of projections. And if you are unaware of the effects of the mirror, you are inevitably absorbed by the anonymous shadows.

A twilight zone – a semidark place – is that with the ideal quantity of light, that which permits us to perceive reality in all its changing aspects, without illusions or areas of complete darkness. In this way, projections which happen to

come from our own expectant look or from that of the other, will no longer confuse us. In the the twilight zone shadows become transparent and fear vanishes into thin air.

Location

Right in Münster's Old Quarter: this is one of the few places where the city's huge rebuilding operation is visible. Between two streets is a *dead zone* which is currently an open-air car park, flanked by two buildings of contrasting appearance. One is the former Kiffe-Pavilion, now used by the sports department of Karstadt, a department store chain. It is a modern glass-fronted building in the new international post-war style, which looks like a typical early plastic toy version of a multi-storey car park. On the other side, the partition walls of a housing estate can be seen where a factory probably used to stand.

The contrast between the new and the old, with no bridge between them, is highlighted by the twenty meters of paving which separates the two buildings.

Project

The typical elements used in display windows (dummies, false objects made to altered scales, etc.) are strategically repositioned in front of several light projectors. Different mirrors capture the shadows and silhouettes cast in order to project them from certain points in the display window against the immense wall facing the shop. At night, three different images alternate on three sections of the wall, giving a narrative meaning to the whole. The shadows cast from the display windows are occasionally mixed with those of casual spectators who happen to be walking around the shop. In the daytime, only the objects displayed in the window can be seen, blindingly bright.

Eulàlia Valldosera

Eulàlia Valldosera: *Twilight Zone/Zona en Penombra* (opposite)

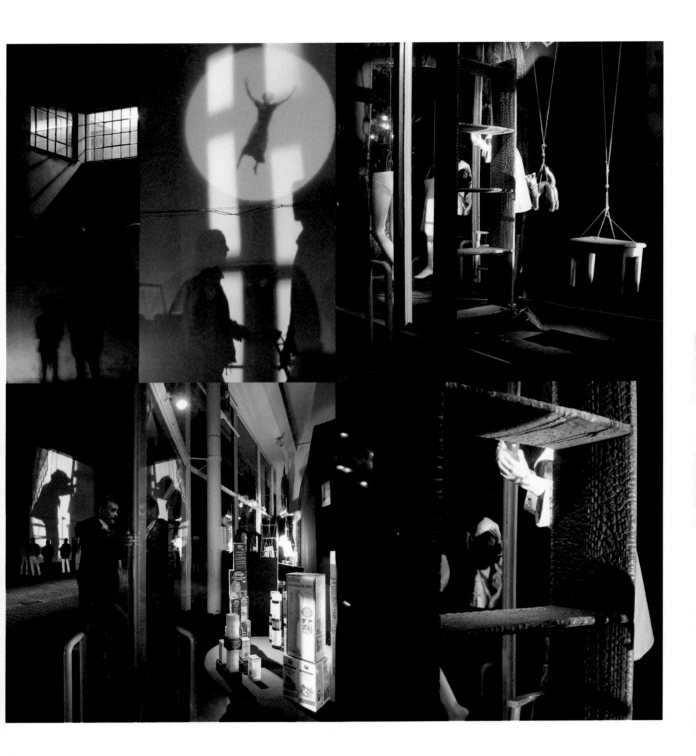

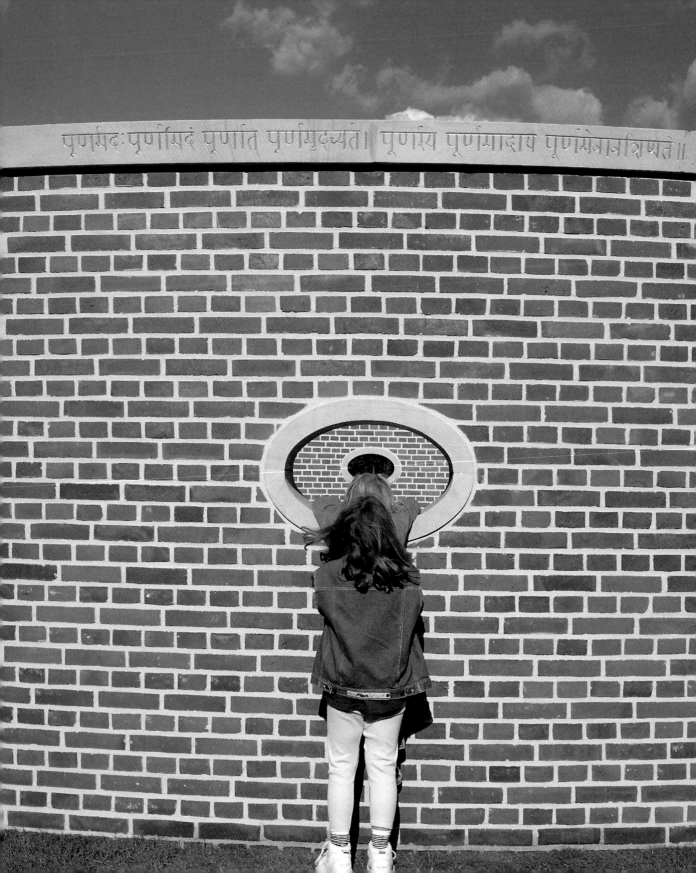

HERMAN DE VRIES

sanctuarium
Sculpture (brickwall, height 3 m, diameter
14 m, thickness 0.4 m sandstone crown,
thickness 0.55 m
Lawn between north garden of Schloß and
Einsteinstraße, near the *Void-Stone* by
George Brecht

"the dignity of the human being is inviolable"
Banner, two trees
Roof of the prison, Gartenstraße
Not realized, rejected by the Münster
prison direction in May 1997

Born 1931 in Alkmaar, Netherlands,
lives in Eschenau, southern Germany

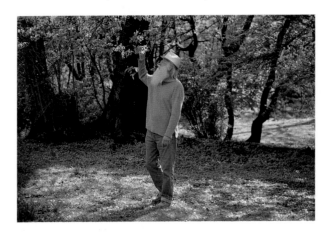

For information about the artist and additional bibliography
see: Aspekte niederländischer Kunst heute, Skulpturmuseum
Glaskasten, Marl 1996; herman de vries: to be. texte –
textarbeiten – textbilder, Ostfildern 1995; herman de vries:
meine poesie ist die welt. aus der heimat von den pflanzen,
Städtische Sammlungen Schweinfurt, Oberhohenried 1993.

a *sanctuarium* is a respected, protected space.
the english word *sanctuary* signifies both shrine
and nature reserve.
sanctuarium comes from the latin *sanctus*:
"sacred, holy, venerable", "inviolable, untouch-
able, exalted"; *sancire*: "to sanctify, to establish
as holy and inviolable, to seal by law"; *sacer*:
"holy", with the english derivations *sacred*:
"holy, cultic", and *sacrament*: "holy rites, relig-
ious mystery, mysterium"; *sancio*: "to sanctify,
i.e. to make inviolable through religious conse-
cration", etc. all of these meanings are more or
less applicable to *sanctuarium*. let us also
recall that churches and temples were pro-
tected spaces where even criminals found
safety from the public when they sought refuge
there.
this new *sanctuarium*, too, is meant to be a
respected and protected space. the protection
is provided by a massive, round wall, inaccess-
ible because it has no gate, 14 m in diameter,
2.65 m high, with an eye in each of the four
directions of the wind, i.e. an opening in the
wall through which the occurrences in the
sanctuarium can be observed. within this
space, nature is free from human intervention;
it is a protected space for free development in
the midst of a cultivated park (suppressed
nature). nothing is sown, nothing planted. the
soil in this space comes from a place where
pioneer plants imbued the bare earth with life;
thus the soil itself is filled with *life*.
now, in spring 1997, the space is empty. a
promising emptiness. what will nature do here?

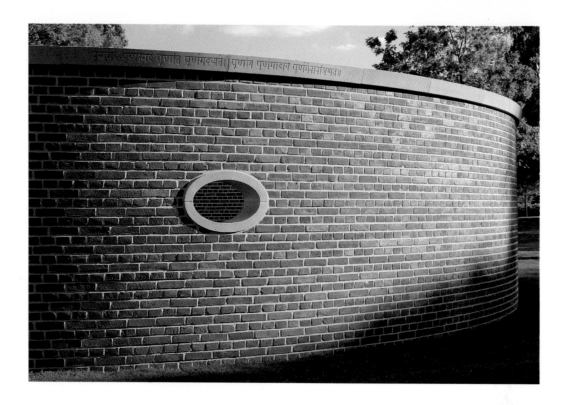

it will do *something*. nature, the primary reality, is a *revelation*. as a manifestation, it tells us everything that is vitally important. the rest – culture – is its accessory. the decision i made here to let nature manifest itself freely and to limit my design only to protection and presentation – demonstrates my attitude toward this revelation.

what am i? – what am i a part of? – what is my life? – to what is my life connected? – these basic questions of philosophy, and their answers, are all embraced in this primary reality that reveals itself to us.

"what is mystical is not how the world is, but that it is", wrote ludwig wittgenstein in the midst of the uncertainty, chaos, and desperation of the front in the first world war; "the unspeakable does exist, it shows itself, it is the

herman de vries: *sanctuarium*, brick wall, height 3 m, diameter 14 m, thickness 0.40 m, sandstone crown, thickness 0.55 m (above and opposite)

mystical." the *sanctuarium* is not about philosophy; it is a place where an occurrence is shown, a place for *looking*.

and so this *sanctuarium* is also a challenge to look and to reflect; it is also an act of resistance against the threat of the one-sided development of our technological-commercial culture. for my part, i also see it as a cultural choice, in the knowledge both of ignorance and of the necessity for insight and healing.

the bare earth of the sanctuarium is grown over only slowly. much too slowly for people who want to see the finished product, the end result right away. there is no end result – a natural succession can develop to the optimum, and in

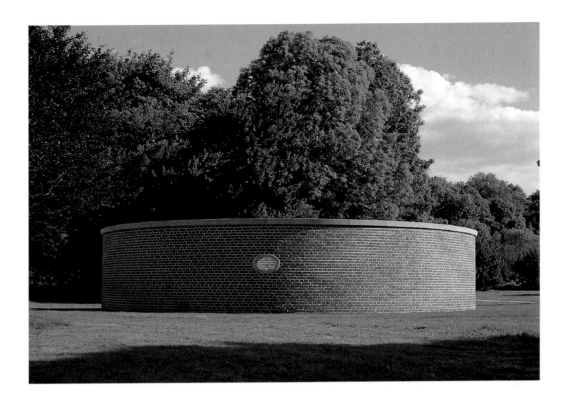

central europe this is mostly a forest milieu. this optimum can extend over centuries and still remain dynamic. nothing is lost.

the art does not consist first and foremost in the design and realization of the wall. that is the frame. the most important thing is what takes place within the wall, the plants that take root there, especially the very first small ones. my poetry is the world.

the sanskrit text inscribed over all the eyes of the *sanctuarium* comes from the Tsá-upanishad and is approximately 2,700 years old. for decades, the upanishads have belonged to the literature from which i have drawn essential inspiration. the quotation expresses most clearly what i want to convey.

from a number of different translations i chose the one by w.b. yeats:

"om. this is perfect. that is perfect. perfect comes from perfect. take perfect from perfect, the remainder is perfect."

in other translations, *perfect* is also rendered: *infinite, full,* and *all.* these translations make sense too. they do not exclude each other. observing the interior of the sanctuary through each of the eyes, one can meditate on another text. outside the sanctuarium, as well, it is applicable to every situation of nature, our primary reality.

– physics and metaphysics are one –

On the second project:

article 1.1 of german constitutional law reads: *"the dignity of the human being is inviolable.* to respect and protect it is the obligation of all state power."

i have noticed that there are many people who don't even know this fundamental statement of our basic rights! dignity sounds almost old-fashioned.

it was in southern india that i perceived dignity most clearly: before us on the street an old farmer, barefoot, clad in loincloth and turban with a short white beard, hoe on his shoulder, conscious of his duty in life, strode toward his small field; just as his father, grandfather, and great-grandfather hundreds of years ago worked the same piece of earth to feed their families. he wasn't in a hurry, he didn't loiter, he walked upright. do we know this demeanor?

dignity for all! for children and the elderly, for students, teachers, employees, employers, for the sick, the dying, for drug addicts, for prisoners, for the victims of crimes, for foreigners and asylum-seekers.

one's own dignity always embraces the dignity of the other as well. fundamental right is also fundamental obligation. to realize dignity in our society is a great collective art.

art lets us experience, perceive. art has to do with processes of becoming aware and with being aware.

herman de vries

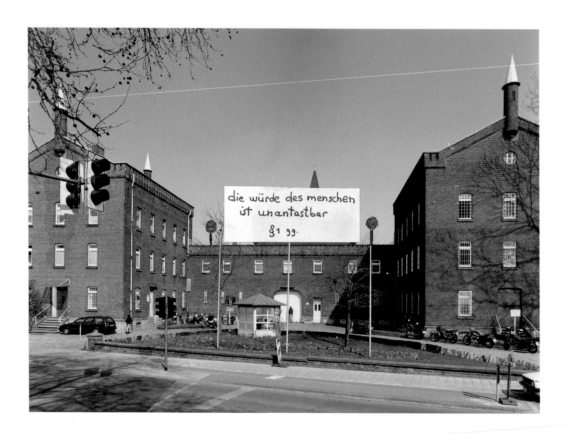

herman de vries: *"die würde des menschen ist unantast-bar"*, view of banner with two laurel trees on roof of penitentiary in Münster, 1996, photograph and sketch, 21x29.7 cm (opposite), and view of *sanctuarium* (below)

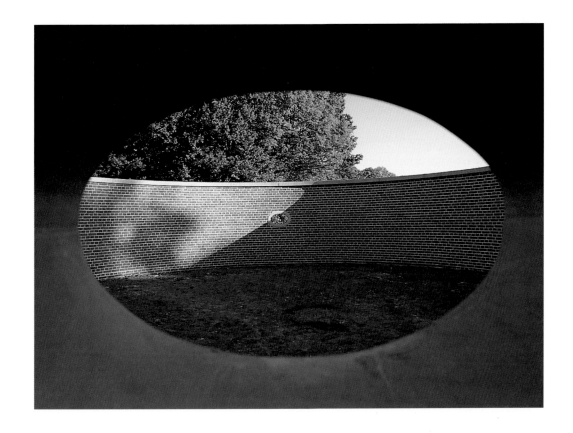

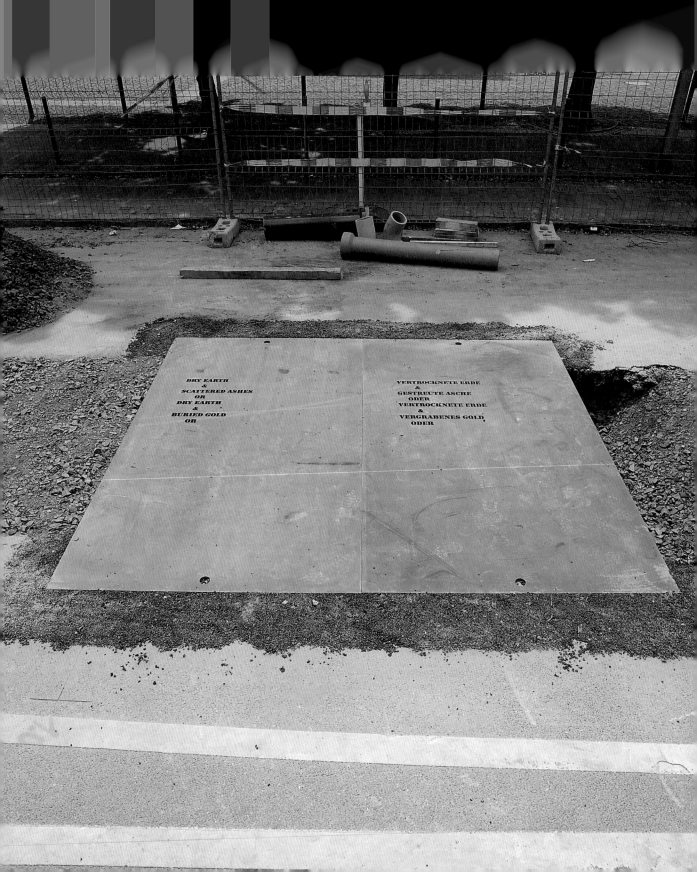

LAWRENCE WEINER

Skulptur Projekt Münster 1997
Four steel plates of the municipal office
for underground works (two with English
and two with German punched writing,
each 0.02 x 2.5 x 1.7 m)
Domplatz, Michaelisplatz

Born 1942 in Bronx, New York,
lives in New York

For information about the artist and additional bibliography
see: Lawrence Weiner. From Point to Point, Kunstverein,
St. Gallen, Ostfildern 1995; Lawrence Weiner. In the Stream,
IVAM Institut Valencia d'Art Modern, Valencia 1995; Dieter
Schwarz: Lawrence Weiner. Books 1968–1989. Catalogue
Raisonné, Le Nouveau Musée Villeurbanne, Köln 1989.

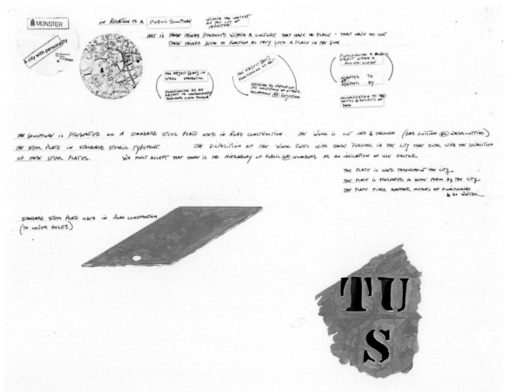

MÜNSTER

SKULPTUR PROJEKTE
1997 (JUNE)

IN RELATION TO A PUBLIC SCULPTURE

ART WITHIN A PUBLIC SITUATION IS
MADE VIABLE
AS THOSE THINGS PRODUCED BY
HUMAN BEINGS
IN A RELATION TO OBJECTS &
PRESENTED WITHIN
THE CONTEXT TO OTHER HUMAN
BEINGS.

THEY HAVE NO
PLACE

THEY HAVE NO
METAPHOR

THEY HAVE NO
USE

THEY SEEM TO FUNCTION AS THEY
ATTEMPT
TO FIND A PLACE IN THE SUN

THE OBJECT [ART]
IS STASIS STANDSTILL

FUNCTIONING AS AN
OBJECT TO CONTEMPLATE
EVEN PONDER

THE OBJECT [ART]
FUNCTIONING AS ART

SEEKING BY VIRTUE
OF INSISTENCE
ACCEPTANCE *OR* REJECTION.

FUNCTIONING AS A

PUBLIC OBJECT WITHIN
A MIS-EN-SCENE

ADAPTED TO
OR
ADAPTED BY
ACCOMMODATION TO THE
NEEDS & DESIRES OF
THE SITUATION

THE SCULPTURE IS PRESENTED UPON
& WITHIN
THE CONTEXT OF THOSE STANDARD
STEEL PLATES
USED WITHIN ROAD CONSTRUCTION
TO COVER HOLES
IN THE STREET.

USE OF STANDARD
STENCIL TYPEFONT
CUT INTO THE STEEL

THE WORK IS PRESENTED
IN ENGLISH &
IN GERMAN

EACH LANGUAGE HAVING
ITS OWN PLATE

AS MANY SETS WITHIN
THE CITY AS IS BOTH
POSSIBLE PRACTICAL

DRY EARTH
&
SCATTERED ASHES
OR
DRY EARTH
&
BURIED GOLD
OR

VERTROCKNETE ERDE
&

GESTREUTE ASCHE
ODER
VERTROCKNETE ERDE
&
VERGRABENES GOLD
ODER

THE DISPOSITION AND PLACEMENT
OF THE WORK
RESTS WITH THOSE PERSONS IN THE
CITY OF
MÜNSTER THAT DEAL WITH THE
DISPOSITION OF
THESE STEEL PLATES.
WE MUST IN THE CONTEXT OF PUBLIC
SCULPTURE
ACCEPT THAT ALL WITHIN THE
SOCIETY CONSTITUTE
A PUBLIC & THEREFORE NO HIERAR-
CHY *OR* NUMBERS
AS AN INDICATION OF USE FACTOR.

THE WORK FUNCTIONS
AS WHAT IT IS.

HAVING MOBILITY AS
A PART OF ITS
INTEGRAL MAKE-UP

& SO WEITER

LAWRENCE WEINER
NEW YORK CITY 1997

Lawrence Weiner: *Skulptur Projekt Münster
1997*, details

VERTROCKNETE ERDE
&
GESTREUTE ASCHE
ODER
VERTROCKNETE ERDE
&
VERGRABENES GOLD
ODER

DRY EARTH
&
SCATTERED ASHES
OR
DRY EARTH
&
BURIED GOLD
OR

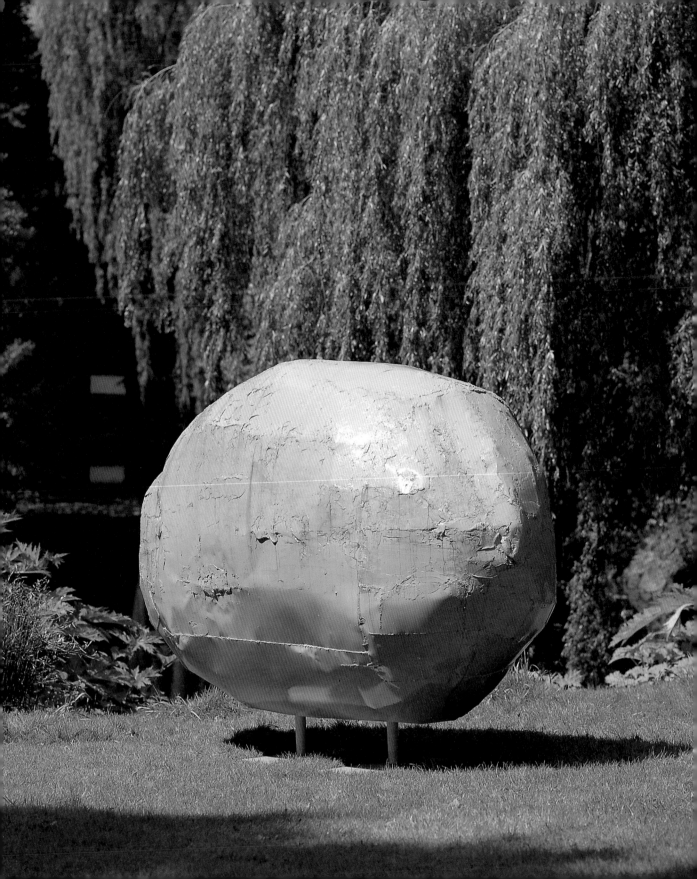

FRANZ WEST

Warum ist etwas und nicht Nichts?
(Why is Something and not Nothing?)
Two sculptures
Autostat, 1991 (sheet steel, painted, 1.6 x 4.6 x 1 m)
Etude de couleur, 1991 (copper pipe, brass,
lead, hose, polyester, 1.56 x 2.12 x 0.85 m and
0.13 x 16 x 1 m)
North Promenade east of Kreuztor

Born 1947 in Vienna,
lives there

For information about the artist and additional bibliography
see: Franz West, Kunsthalle Basel, Basel 1996; Franz West
& Hans Arp, Kunstverein Hamburg, Hamburg 1996; Proforma,
Museum für moderne Kunst Stiftung Ludwig, Vienna 1996.

Franz West: *Warum ist etwas und nicht Nichts?*

For Münster I want to take a sculpture of sheet metal welded onto an iron frame and extend it by about 1.5–2.5 meters. It's already standing in the courtyard of a former abbey that now belongs to the forestry service, whose boss, a senior forest ranger, got all hot under the collar about it - very original - but even I am not all that happy with it, because it's really too short for its title - for the length of its title. This sculpture, or one like it, is going to be set up in Laa, or near Laa, a town about 40 km northwest of Vienna, on a rural lane at a place where you can't see the street or any telegraph poles or electrical pylons or trees. In 1987, at the *Skulptur Projekte in Münster,* my sculpture appealed to the sense of touch - actually the sense of sitting - that is, the mode of reception was a seated persistence on the sculpture. This one is meant to be seen - one finds it in front of oneself and internalizes it, and not oneself in it, which is supposed to mean that one does not externalize oneself into it - it is nonobjective, unusable, unlike the one exhibited at the last *Skulptur Projekte in Münster, eo ipso* (which in English means something like "this very one" or "the same"), which was a sculp-

ture for sitting on but which nevertheless stands in relation to this project, since the earlier title was an answer to the unasked question *Was soll und ist das?* (What is that and what is it supposed to be?), while this sculpture has a question as a title. In 1996 I had a retrospective, and while choosing pieces for exhibition I saw my reliefs and collages from the early 70s, which I had hoped never, ever to see again, since they were really lousy, but that's exactly what I liked about them now - taboos are

always changing, getting new meanings – and fortunately I was able to remember the reason why I went to the academy: I wanted to transform the pink papier-mâché reliefs I had made at that time into sculptures for the outdoors as well, to stand in the open air. But at the academy I was only interested in the series *Paßstücke* (Fitting parts) that I had begun then, which in the galleries, contrary to my intention, were not allowed to be touched or handled. Through seeing what I had repressed once more at this retrospective, I hit upon the title *Warum ist etwas und nicht Nichts?*, which I think is a statement from Parmenides, Heraclitus, or some other pre-Socratic, I can't remember exactly who and I don't feel like spending days searching for the name of the author, since I'm always poking around in any number of my many books, but I read it just recently (this sentence, I mean). Once again:

To go with this lengthy title I'm making a few outdoor sculptures. The first is already standing in the courtyard of a former abbey in the country which is now occupied by the forestry service, and the senior forest ranger got upset about its positioning – original for nowadays – but I'm not happy with the sculpture either: on the one hand because I painted it glossy and on the other because it's too short (ca. 3.5 meters long). I'm going to take this one and extend it in Münster by about 1.5–2.5 meters; that will be simple, since it's made of sheet metal welded over an iron frame. One sculpture from this group will probably be set up in or near Laa, a town about 60 km northwest of Vienna, on a rural lane at a place where no street or telegraph and power lines can be seen, or any trees. I already made outdoor sculptures for the Biennale in Venice, but of course they were cast, and the *Lemurenköpfe* (Lemur Heads) that were shown at the last *documenta* were casts too. The current sculptures, however, are non-objective and are not usable, unlike the

Traum der französischen Bonne: Alles da, nur kein Damenstehpissoir (The Dream of the French Maid: Everything's there, just no ladies' wall urinal), from Sigmund Freud, Interpretation of Dreams (1900), addendum of 1914, from the Hungarian comic paper Fidibusz

one shown at the last sculpture exhibition in Münster, *eo ipso*, which I think means something like "this very one" or "the same", which was a place to sit but which nevertheless stands in relation to the current project, inasmuch as the title back then was an answer to the question *Was soll und ist das?*, while this sculpture has a question for a title.

In 1987 it was the sense of touch or actually of sitting that I appealed to, that is, the mode of

Franz West: *Etude de couleur*

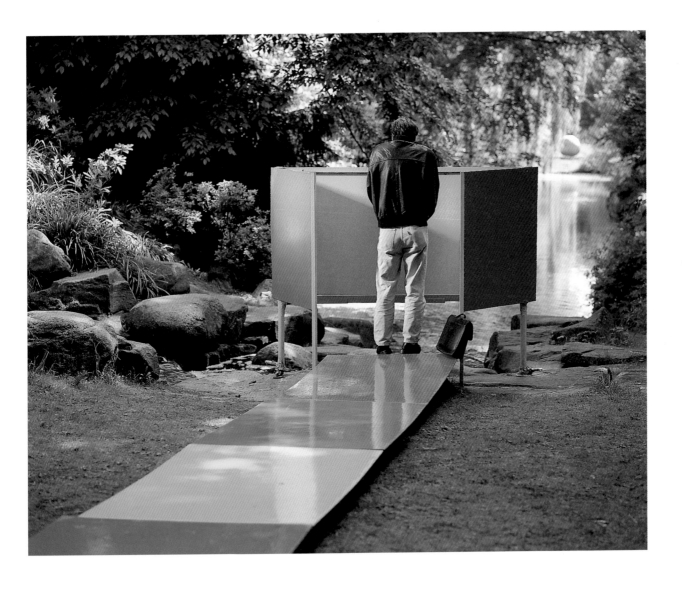

reception was a persisting in the sculpture; now one sees the sculpture, finds oneself in front of it, has to internalize it and not oneself in it. Last year I had a retrospective and while making the selection was forced to look at my reliefs and collages from the early 70s again, which I actually didn't (ever) want to see again, because I thought they were so bad, but I made friends with them again – taboos change – and at the same time was also able to remember why I went to the academy: I wanted to take the (pink) reliefs I had made then and do them again for the outdoors, i.e. of a permanent material and physically free-standing, in other words turn them into sculptures. But at the academy I was only now interested in the series I began at that time, *Paßstücke*, which, however, in the galleries – supposedly for reasons of maintenance, but there might also have been disciplinary considerations behind this argument – were not allowed to be touched, or rather handled. So then the *Paßstück* was split into the chair, the place to sit, and the small-scale sculptures (*Kleinplastiken* [Small sculptures] – which was also the title of an exhibition at that time in Budapest). And so through seeing again at the retrospective what I had repressed, I thought of *Warum ist etwas und nicht Nichts?*, a statement I think from Parmenides or some other pre-Socratic, I can't remember exactly who and I don't want to look for it any more – I just read it recently, but I'm always poking around in a number of books and I don't feel like spending weeks looking for the author. So once again: Through seeing the repressed once more at the retrospective I arrived at the *Warum ist etwas und nicht Nichts?* – I think a statement of Parmenides or some other pre-Socratic, I can't remember exactly who, but I don't want to look for it any more; I just read it recently, since I'm always poking around in a number of my books, and I don't have the slightest desire to spend days searching for the

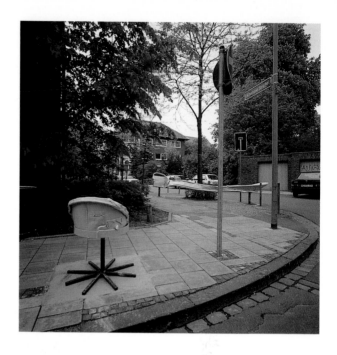

Franz West: *EO IPSO*, contribution to *Skulptur Projekte in Münster 1987*, location: Breite Gasse / Krumme Straße (iron, painted, 1.18x5.46x1.15 m and 83x57x52 cm)

author in order to find his name. At the academy I was only interested in my series *Paß-stücke* that I began at that time, which in the galleries, for disciplinary reasons of maintenance, were not allowed to be touched, or rather handled, for which reason the *Paßstück* branched off into the chair and the *Kleinplastik*. Last year I had a retrospective and while selecting things to show I was appalled to see my reliefs and collages from the early 70s, which I had actually never wanted to see again, since they were so bad, but that was exactly what I liked about them again (taboos change) and fortunately I could remember why I actually went to the academy – because I wanted to

take the pink papier-mâché reliefs I made at that time and do them for the outdoors as well, to stand in the open air, i.e. transform them into sculptures.

In 1987 it was the sense of touch or actually of sitting that was addressed, that is, the reception was a seated persistence in the sculpture; now one sees it, finds it before oneself, internalizes it, and not oneself in it – one doesn't externalize oneself in the sculpture. The current sculptures, however, are non-objective and unusable, not like the one shown at the last *Skulptur Projekte in Münster*, *eo ipso* (which means something like "this very one" or also "the same"), which was and is a place to sit, but still stands in relation to this project because the title at that time was an answer to the unasked question *Was soll und ist das?*, while this time it has a question as the title. A sculpture like it will be set up at or near Laa, a town about 70 km northwest of Vienna, on a rural lane at a place from which no streets or telegraph and power lines are visible, or any trees.

In Münster I want to extend the sculpture by about 1.5–2.5 meters – it is made of sheet metal welded over an iron frame – which is very simple, for it is already standing in the courtyard of a former abbey which now houses the forestry service, whose boss, the senior forest ranger, got upset about it – very original – but I'm not happy either, for it is too short for this long title: *Warum ist etwas und nicht Nichts?*

Appendix

Warum ist etwas und nicht Nichts? is a metal sculpture (sheet steel welded onto a metal chassis and painted pink), an ellipsoid. From the place in which this sculpture should be set up there are visible neither trees, streets, nor telegraph poles, no houses either, only a rolling, cultivated landscape. The ellipsoid is not an autonomous sculpture, but a "monument" in the etymological sense, referring to this place, the body of the title. The ellipsoid is the simplest form that can best lie on the ground. The ground is understood as the unequivocal boundary of the gaze. It is the resting place for the embodiment of the abstract question.

In the summer of last year I accepted an invitation to a metal symposium for outdoor sculpture in Spital on the Pyhrn – contrary to my custom, because for me a sculpture for the outdoors lies outside the natural frame of presentation. As a result of this I became aware of my working process, that I only begin to work when the piece is finished. What results is a body that has to conform itself to aesthetic expectation. I chose the pink color intuitively. I suspect in hindsight that the motive of this intuition was the human body, one's own body, as the next-best color ground. Thus the question (why is there something and not nothing) is in this place inverted into a monument that is doubled through the penetratingness of its title – penetratingness understood as a motif of multiplication – in sculptures that will be seen, among other places, in Münster at a large sculpture exhibition. In other words: the current elaboration will be divided and one part completed and shown in Münster, while the second part for Laa is to be completed here in Vienna. The more precise contours will emerge only with the work. Generally speaking, however, it will be not especially unlike the current one. Of course if this sculpture is not taken for Laa, then it too will come to Münster.

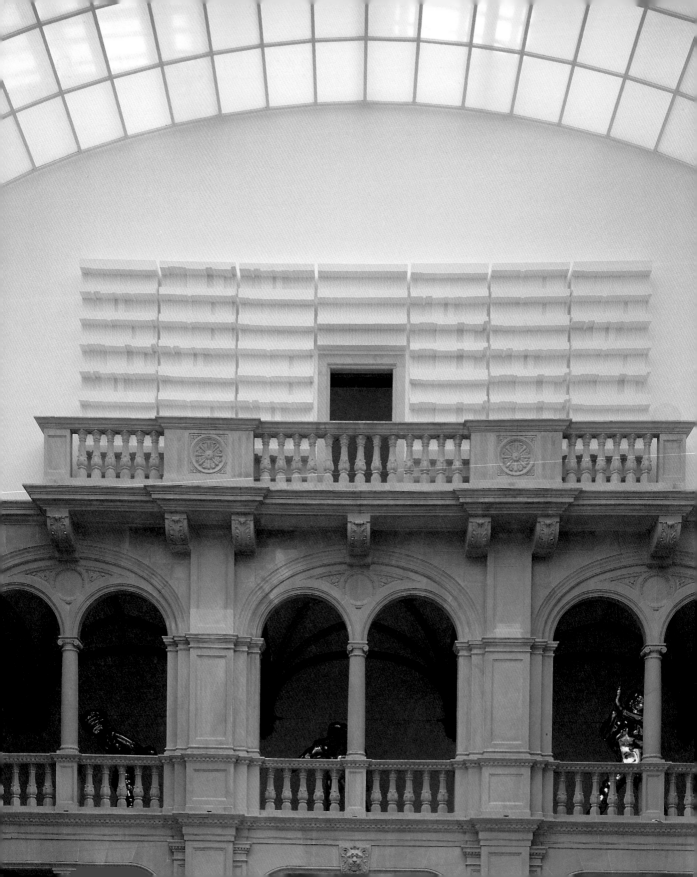

RACHEL WHITEREAD

Untitled (Books)
Installation (steel construction, plaster and
polyurethane foam)
Balcony, second floor of atrium of
Westfälisches Landesmuseum

Born 1963 in London, lives there

Richard Shone: Rachel Whiteread in Münster

For information about the artist and additional bibliography
see: Rachel Whiteread. Prix Eliette von Karajan '96, Salzburg,
Vienna 1996; Rachel Whiteread. Shedding Life, Tate Gallery
Liverpool, London 1996; Rachel Whiteread. House, ed. by
James Lingwood, London 1995; Rachel Whiteread, Kunsthalle
Basel, Basel 1994.

The crucial role of books in Western history, as
disseminators of knowledge and beliefs, has
been memorialized in much late twentieth-cen-
tury art. The magical resonance of books –
keepers of a civilized conscience as much as
agents of a spiritual life – found recognition
since the earliest "libraries" of sacred texts
were gathered and guarded by priests. At the
same time, their power to influence and
enslave has been a constant of history from the
destruction of the Alexandrian Library, the
greatest of the ancient world, to the Nazi book
burnings of our own century. Books should
"affect us like a disaster", wrote Kafka. "A book
must be the axe for the frozen sea inside us."
The transforming, even revolutionary aspect of
books has been less embedded in visual art
than have their creative or regenerative charac-
teristics. In Rachel Whiteread's proposed Holo-
caust Memorial for Vienna, the collective
charge of a library encapsulates both grave
public events and the survival of individual
achievements, her casts from books becoming
the very architecture of history. For her work in
Münster, a wall of similar casts takes to an
extreme the entwined aspects of private and

public, of knowledge as power and knowledge
as freedom. The past as a site for the archeol-
ogy of individual experience is a theme physi-
cally embodied in much of Whiteread's sculp-
ture. Here, it assumes metaphorical layers of
meaning and allusion built upon the common-
place object of a book.

It is surprising how seldom books have been portrayed in art with any degree of prominence. They appear in depictions of saints, in portraits, and as an element of still life, but their presence is secondary; they are there as a prop, an extra, something to underline a mood, on which to lean an elbow, suggest an occupation or profession or to buttress a tabletop of objects. Sometimes their symbolic charge is powerful. In Dutch vanitas still lifes they are the embodiment of learning and a caution against the pride that learning might bring. There, the grave, leather-bound volumes, their well-thumbed state suggestive of their readers' search for eternal meaning, are morally and visually yoked to the presence of a skull as an emblem of transience and mortality. By contrast, in French rococo painting they are something with which to while away the hours under the trees, neat tiny volumes easily held in a lady's hand and perfect for the hiding of a billet-doux. In sculpture their symbolic role is tied to compositional tactics – one of the grandest depictions is the stack of books on which Sir Isaac Newton rests, in Rysbrack's monument in Westminster Abbey; and one of the most intimate, the book case behind the mathematician, Matthew Raper, carved in ivory relief by Le Marchand in 1720. The genre of the scholar or writer surrounded by his books or in a library, stemming from traditional depictions of St. Jerome, became more common in the nineteenth century. In paintings by Degas and Cézanne, writers are portrayed in their studies, against shelf upon shelf of unparticularized books, upright and leaning, domestic backgrounds formed from the tools of their trade.

But as the chief constituent of a work of art, the book is infrequent. An eccentric exception is a painting by Giovanni Maria Crespi of shelves of bound musical treatises in which the architectural beauty of the volumes is as explicit as the scholarly pleasures they invite.

Van Gogh's *Parisian Novels* (1888) is one of the rare still lifes exclusively devoted to books, heaps of them on a table, all at angles, their ochre paper bindings curling like sunflower petals. While in this work no titles are visible, in an earlier painting of three books, Van Gogh has made sure the viewer can read the names of Zola, Richepin and de Goncourt on the spines, thus turning the work into a naturalist manifesto. But more often than not books appear in portraits as symbols of the literary life (as in the paintings by Degas and Cézanne), of the social or intellectual prestige of the sitter or as an adjunct of tranquil absorption (as in works by Matisse and Léger). In more recent decades, books themselves have appeared as part of assemblages and collages denoting intellectual turbulence and historical upheaval. In Britain in

Rachel Whiteread: Model for *Vienna Project*, 1995 (below) and view of installation in Münster (opposite)

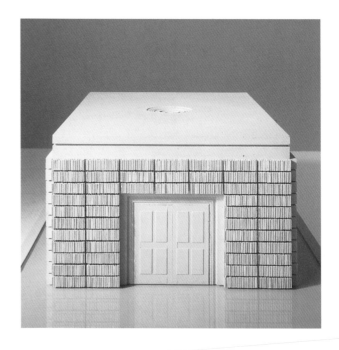

the late 1950s, for example, John Latham incorporated books into reliefs and paintings, often burnt, painted, half-destroyed or resting vulnerably open on their support. He was acutely aware of both their physical solidity and shapeliness as objects and of their agency as insidious carriers of cultural prejudice and sterility. Battered and bruised, they become the shards of outmoded thought. This archeological look suffuses the rows of lead books on library shelves in Anselm Kiefer's sculpture *Zweistromland* (Mesopotamia). These massive volumes contain rich and varied supplies of visual imagery but are almost inaccessible to the viewer, thus acknowledging the impossibility of any single consistent reading of history.

The expressionist tenor of Kiefer's or Latham's work is not to Whiteread's purpose. She is a slower, less extrovert artist, keeping to a human scale and an ordered appearance. The objects she chooses to cast have already had an existence, carry their own scars, a particular wear and tear resulting from ordinary human activities. Books are a relatively recent addition to her repertory of domestic objects and came about through her work two years ago on the proposed (and still unrealized) Holocaust Memorial. There, her basic unit is a concrete cast

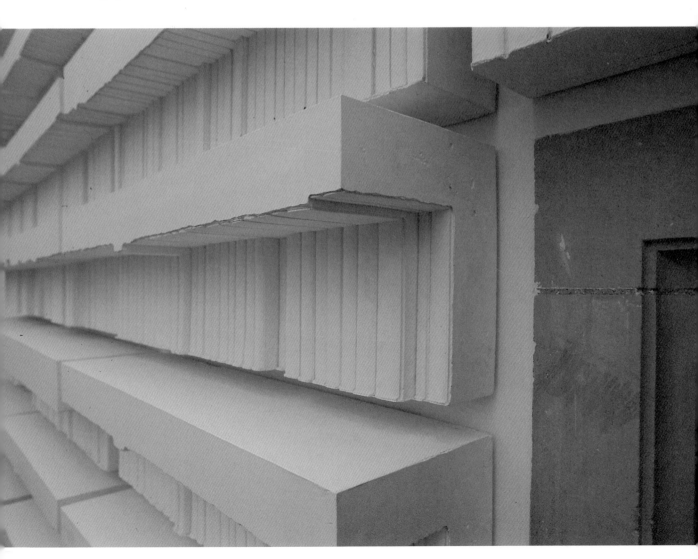

Edgar Degas: Study of bookcases for *Edmond Duranty*, 1879, sketch, charcoal and white chalk, Metropolitan Museum of Art, New York

For Münster, Whiteread has extended the basic outline of the door-bearing wall of the Vienna Memorial to suit the lofty, balconied space within the Museum. Here it is not books themselves that have been cast but the void that exists between a wall or shelf-back and a row of closed books – the often dusty, even secret space, glimpsed only when removing a book. The shelves of white plaster either side and above the central door make a striking contrast with the ceremonial and elaborate air of the room. While the impact of the work can be registered from ground level, it is difficult to see it at close range and then only from either side. In most of her other sculptures, close inspection of the surface is imperative. Here, what little surface detail there is has been subordinated to the architectural concept of the whole. Whiteread's habitual ambiguity is present throughout – inaccessibility in a public space, the "building" of a library without the presence of a single "book", the work's hefty physicality grounded in the casting of thin air, the evocation of a room in so shallow a space. Whiteread's sculptural conceits have an element of wit frequently missed by the solemn viewer. At the same time, the complex gravity of the whole, calling to mind some library of tablets in ancient Egypt or Babylonia – "Dispensary of the Soul" were the words carved over the entrance to the great library of Rameses II – is brought about by relatively simple physical procedures. Much of the emotional charge of *House* (1993) came from a minute attention, at the most practical level, to considerations of material, texture, scale and placing. It is all too easy to dismiss Whiteread's espousal of casting as some kind of facile strategy for producing work. In fact it involves all the crucial elements of traditional sculpture while allowing her to deal with her most intimate concerns as a humane artist in the late twentieth century.

of a shelf of books of the same size but each differing slightly in character; 20 such molds were made and could be used either way up. Multiplied and then stacked, shelf by shelf (eleven units high), they form the exterior of a rectangular library. Sealed double-doors (also cast) are placed at one end. A flat roof with an inverted circular ceiling-rose completes this modest-seeming yet monumental structure.

In her three major commissioned sculptures – *House*, the Holocaust Memorial and *Untitled (Books)* for Münster – Whiteread has brilliantly translated her personal language into the public domain. Since that very early cast of her own ear (1986), through small domestic objects and then through the materialization of a modest room, she has maintained her private voice within the range of increasingly sophisticated concepts. Childhood memories of being in a wardrobe, hiding under a bed or arranging her books remain fundamental to her creative impulses. The bigger themes her works evoke – death, communal events, collective history – are grounded in the memory of personal experience rather than political dogma. No rhetorical embellishment is needed when her work is specifically public. Her materials remain demotic, a half-way house between kindergarten and High Art, often bearing a curious, even sly relation to the objects from which she has cast – the light-greedy, sensuous resin of *Untitled (One Hundred Spaces)* or the friable dental plaster used to cast the moist interior of a hot water bottle in *Torso*. Now, casting from a shelf of books – perhaps the most ubiquitous and, in a sense, most mysterious object she has yet chosen – she erases nearly all information, just as the books themselves are destroyed in the process, leaving only a recollection of their presence. Here is a vanitas without a moral, a memorial without a name. She leaves it to us to clothe our recognition of what she has made. If Whiteread is not alone among artists in dealing with so elusive a content, none has found a solution that embodies such universal content in so unmistakably personal a form.

PROMENADE →

By learning to move in a new direction, we want to create

ELIN WIKSTRÖM/ANNA BRAG

Returnity
Installation (wood, electronic displays,
bicycles)
Promenade, above depression in terrain
between Aegidiistraße and Kanonengraben

Born 1965 in Västeras and 1965 in Karlskrona,
live in Göteburg and Malmö

Maria Lind: Elin Wikström/Anna Brag –
Returnity

The experience of learning to ride a bike is
among the childhood events that people
remember most vividly. The feeling of suddenly
being able to keep your balance and wobble
forward is usually easy to recall. It was as envi-
able and difficult before mastering the skill as it
was easy afterwards. But once you've learned
it, it stays in your bones, and so even if it's
been 50 years since the last time most people
can get on a bike and take a spin.
Elin Wikström's and Anna Brag's cycling club
Returnity at Münster's circular bicycle track on
the Promenade involves eleven seemingly ordi-
nary bicycles. However, these cheap and envir-
onmentally friendly transport vehicles, which
exist the world over, have been rebuilt so that
when you pedal forward you go backwards
instead. Those *Returnity* bikes are lent free of
charge to the public who are also offered spe-
cial training along with special protective gear
suitable for beginners new to the art of riding a
bike backwards.
A round clubhouse beside the bicycle track,
built for the purposes of the project, functions
as a meeting place where you can unwind after

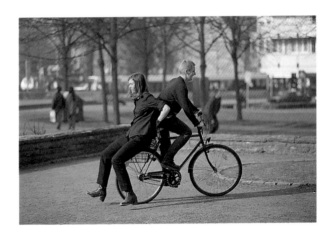

For information about the artists and additional bibliography
see: Anna Brag. Incognito II, ArtSpace, Arlanda Airport, 1997;
Nowhere, Louisiana Museum of Contemporary Art, Louisiana
1996; Elin Wikström. Se hur det käänns!/See how it feels like!,
Rooseum – Center for Contemporary Art, Malmö 1996.

the training session, exchange tips and discuss
the project with the artists who will be present
during the run of the exhibition. One of them
will concentrate throughout on counting what
number of regular cyclists pass by and what
number of *Returnity* cyclists successfully com-
plete laps around Promenade. An electronic
display on the façade on the clubhouse shows

these statistics, as a kind of pulsating energy. The club also organizes lectures and excursions and there is a workshop for the inspection and repair of bicycles.

During the three months of *Returnity*'s duration, the thoughts behind the project will develop through dialog with the participants, who slowly – and laboriously, to be sure – are given the opportunity to acquire a new skill where they are forced to see and experience the world with new eyes and new sensibilities. This simultaneously psychosocial and epistemological experiment is in a sense a micro-utopia, where a cyclical activity which challenges traditional ideas of progress are central. The rebuilt bicycles the result of a skill which has something everyday and unpretentious about it and they are evidence of an improvisatory rather than high-tech refinement. It is a kind of hobby which, framed by the context of the club, gains larger implications than merely being a way for a person to use their spare time; which leaves the privacy of the garage and becomes public.

Returnity-bicycling does involve progress, but it is more about a concrete physical knowledge, and not about the cult of skill which the heritage of the Enlightenment stipulates. It also privileges cyclical rather than linear development. The statistics include the exception as well as the rule – you count things in, rather than counting things out – and together they shape an economy where a residue, the visible leftovers, are included. It is not simply that you see how many actually master the skill of bicycling backwards; you also simultaneously count all the regular cyclists who could be biking in other ways. This is why *Returnity* is a way of making possibilities visible, all those instances where reality really could look different.

Returnity can also be seen as a part of the contemporary tribalism that builds on a skepticism towards the overarching and abstract collective (mass-)opinion and alliance. Places where one is rather a part of a cluster of more or less random groupings – one's work group could be one, housing board another, and one's circle of friends the third. Within these compartments the engagement can be strong but it is important to be able to move between them.

The cycling club is also directly related to Münster, which is a kind of German bicycle capital. Not only is the number of bicycles which the visitor arriving in Münster sees around the rail or bus station striking; the bicycle is also the city's symbol on maps and tourist brochures. There is furthermore a parallel between the site of the project (Promenade, once a moat built as a part of a defense strategy) and the bicycle, which is an important element in the classical pacifist idea about how one can transform the military industry into civil production, how weapons factories can become bicycle factories instead.

An essential element in *Returnity* is neither to mimetically reflect nor represent reality in other ways, but to be in the middle of it, and a part of it. To shape the space, to really be able to test and challenge ingrained ideas, to create the possibility to literally acquire knowledge in other ways than we are used to. The goal is not to establish a permanent club, with all the accompanying paraphernalia, but it is instead determined according to practical factors: Wikström and Brag set up what is required for this activity, and then take it down after use. It is an exercise in practical, hands-on philosophy which afterwards leaves behind concrete memories of a very different sort, first-hand experiences from an unusual kind of bike tour.

PROMENADE →

"By learning to move in a new direction, we want to create
a field of thought and experience in which we can apprehend
reality differently, the relation between the motion of
the body and the motion of the bike, between the bike and
the surroundings, other cyclists, directions et.c. and the
complexity of regarding this through the driving mirror."

E.W. & A.B.

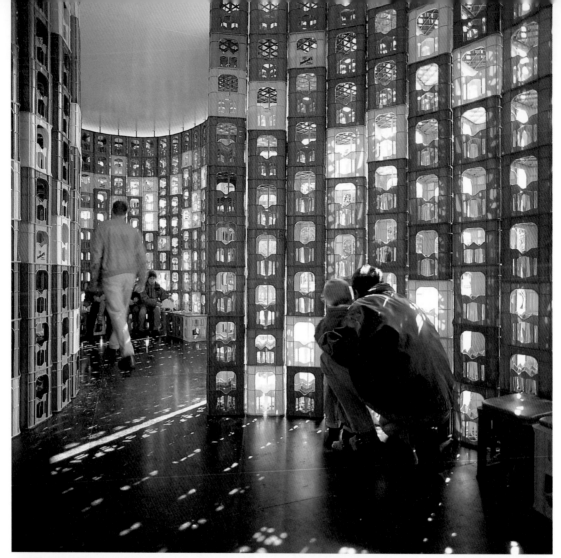

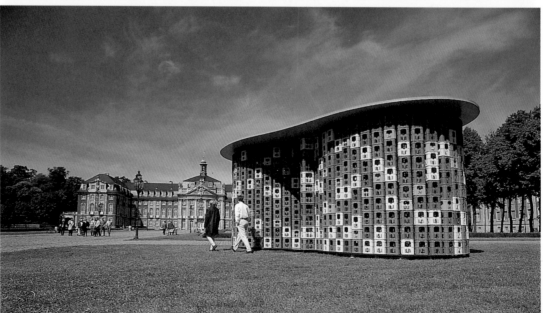

WOLFGANG WINTER/BERTHOLD HÖRBELT

Kastenhäuser
(Crate-houses)
Four temporary structures used as
information stands
Hauptbahnhof, Salzstraße in front of Karstadt,
northwest bank of Aasee, in front of north gate-
house of Schloß (department of musicology)

Born 1960 in Offenbach and 1958 in Coesfeld,
live in Frankfurt/M. and Havixbeck and
Frankfurt/M.

Wolfgang Winter/Berthold Hörbelt:
Kastenhaus xxx.x

Title: Kastenhaus (crate house) is the name we
give to our walk-in sculptures of stacked crates
used for transporting bottles. The number code
in the title designates the number of crates
used and the number of crates per stack.
Material: so-called FTK (Flaschentransport-
kästen = bottle transport crates) from the
bottling company "Deutsche Brunnen AG",
used in Germany as containers for bottles of
mineral water; their special design renders
them stackable and very strong. They are made
of mostly brown, green, or white pigmented
plastic; the pigmentation or coloring is highly
UV-resistant. In 1985, about 150 million crates
circulated in West Germany, some over 15
years old.
Materials are used in the sculptures so as to
aid stability, in addition to floor panels and cov-
erings such as fiberglass laminate over packing
plywood. Particular details (such as special
floor coverings) are determined by the function
of the sculpture. Interior furnishings are deter-
mined according to function and installation
site.

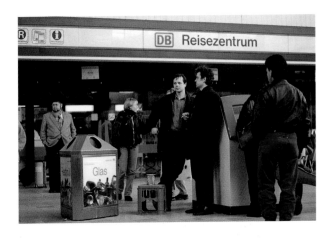

For information about the artists and additional bibliography
see: Dem Herkules zu Füßen, Museum Fridericianum, Kassel
1995; Sammlung C&L, Frankfurt/M. 1995; Galerie Tabea
Langenkamp, Düsseldorf 1994.

Method: vertical bracing of individual elements
(FTK) with ceiling and base plate (sandwich
construction).
Form/size: without geometric aids, the stacked
crates are joined together on a flat surface
(walling). The minimum entrance width and
ceiling height reflect the guidelines for govern-
ment-subsidized housing in Germany, ensuring
for example wheelchair accessibility. These

minimum dimensions may be exceeded. Further dimensions and proportions are determined according to the particular installation site. In terms of design, the functional interior space takes precedence, and its construction method determines the form of the outer shell.

Content/Intent: Walk-in sculpture for the outdoors with a concrete function (as a place of retreat, an information and reading center, walk-through construction fence...).

The Conception

In 1995, a few beverage crates standing around in our studio led us to make inquiries at the bottling plant Kaiser Friedrich Quelle in Offenbach as to whether it would be possible to borrow 500 empty crates for a sculpture from the "Deutscher Brunnen AG". Since crates in everyday circulation can be rented for a fee of 3 DM apiece, it was agreed that we would handle the affair as an ordinary rental. Following use, the crates would be returned to their original function and our outlay (the deposit fee) would be returned to us. (It is unclear whether this would also be possible after a period of, say, 20 years.)

Since on a windless day it is possible to carry a stack of up to eight crates at a time, within a day the crates were on location.

At first we were going to combine the crates with *Hoewi 301* (a material we developed with viscous qualities) and use them as a kind of "skeleton" for a giant hollow sculpture. When the surface was covered with our material, the resulting body would appear solid. But then we noticed the wasted space within the structure – a problem with many hollow sculptures – and

Wolfgang Winter/Berthold Hörbelt: Ground plan of *Kastenhaus 424.8* (below left), and works with *Hoewi 301*, an animal-glue based material with thermoplastic properties (below right), atelier photo, Frankfurt 1996, view of *Kastenhaus,* Salzstraße (opposite)

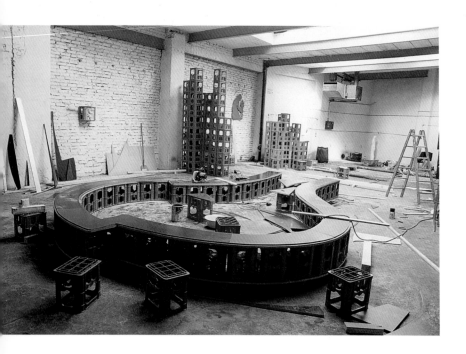

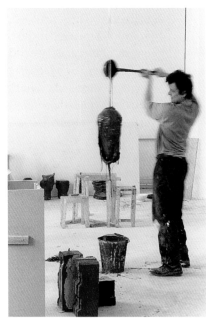

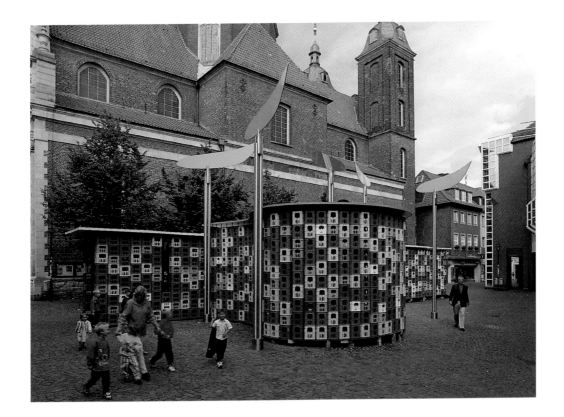

removed a few stacks of crates to make an entrance. The resulting space could now be entered comfortably, and found temporary use as an office and sleeping space. Finally, we ended up removing the skin of *Hoewi 301* from the framework of beverage crates; now one could sit within the interior space and perceive the exterior through the openings.

(The term "hollow sculpture" is used here to designate a work of art which encompasses an empty space and thus produces a defined space within an undefined one. Hybrid forms, for example perforated walls, suggest the existence of interior space – the vessel, the vase...)

Our 500 crates were activated once more in the development of a garden house as a retreat for the residents of a rehabilitation center for the severely and multiply handicapped (the Schwarzach Project). We began by shifting the walls into a rectangular structure 8 m long, 5 m wide, and ca. 3 m high (we later referred to this process as "walling"), equipped with an opening for the entrance and an improvised roof. By chance, on this day the sun happened to be shining into the studio. The walls of the almost flesh-colored crates grew slightly transparent in the sunlight, awakening the reminiscence of holding a flashlight under one's hand in the dark and observing the transparent, reddish shimmering of the flesh.

The rectangular buildings became round ones, as we found this form more sculptural and more intimate for the intended purpose.

A new changing cubicle for Rimini: inverted crates were upholstered as seating and placed in a niche in the walling. Since they were moveable, this provided an opportunity to choose a

place to sit anywhere in the room. We covered the floor with a worn-out Persian rug welded into PVC for use in the outdoors. A few of the residents of Schwarzacher Hof modelled reliefs which we poured into the crates as transparent plastic sculptures (the residents' own contribution of reliefs was intended to make it easier for them to identify with the crate house).

At first we used only brown crates *(Kastenhaus 424.8)*. In a further development, the walls were enlivened with crates in other colors as well *(Kastenhaus 232.8)* and the structure was equipped for use in public exterior space with an ash tray and lighting for night-time visitors.

Traffic Flow

Münster: there are a lot of churches here, clothing stores too. Through the window of a fish restaurant we watch the people hurrying through the pedestrian zone; the main current carries us along Salzstraße to the Karstadt building, where the narrow street broadens. A measuring tape is laid out, someone stumbles over it; the concavity of the square facilitates rainwater runoff. Through this concavity the Dominikanerkirche (unfortunately closed), a department house with spoilers, and the Karstadt building sit in a hole and make room for five steel flags, a work of art lolling limply and opportunistically over the leftover space.

(In a constantly changing urban landscape, it no longer seems possible to establish clear spatial/architectural relationships, as for example in a classicistic square with a space-defining equestrian statue. With the disappearance of the monument or the mausoleum, a traditional field of activity for the sculptor has also been lost, as has the concrete justification for placing a monument.

As a rule, other artistic manifestations in the city, normally only valued by connoisseurs and sought after by collectors, are of public interest only when the artist is famous and thus in a certain way a figure of state. Popular sculptures in outdoor public space are generally perceived not in their quality as sculpture, but as bizarre, amusing fringe phenomena. As the example of the Neue Wache in Berlin shows, the intentions of the artist – for example with respect to size relationships – obviously no longer play a role when sculptures are employed for political purposes. The attractive patina of the bronze sculpture comes to a standstill at the display of pathos and dismisses the participant into the void…)

Back to Münster: user-friendly urban space presupposes the existence of certain conveniences. The concept of the "handy" city implies, for example, that airports and freeways are as accessible as the theater or concert hall. The striving for frictionless, rapid passage unfortu-

nately also results in a standardization of the urban interior, in which regional peculiarities vanish in a homogeneous urban image. (In the course of electronic networking, the concepts of place and path are being redefined. While at the moment we still generally follow a path with our bodies, the media are making it increasingly possible to go anywhere at all without actually having to travel there. Publicness can now be experienced on the screen from the comfort of one's own chair. The familiar real, existing outdoor public spaces – the meeting point, the plateau for events, the playground, the park as a place for strolling and people-watching – fall into disuse, while at night the bluish, shimmering windows with the flickering of television screens bear witness to the activity of the residents.)

The enterable building fence of FTK: here the attempt is made to transform an urbanistically designed leftover space into a construction site with a fence transporting the urbanites over an (imaginary) building zone. Option: to tunnel a distance of ca. 30 m over a space/time axis. An apse, likewise accessible, pushes itself between the flags and offers an interior space for relaxing. Punkers gamble with senior citizens for beer; on March 21, 1997 the tabloid Bild reported: "In Münster wird oft 'gesexelt'" (second place, Bielefeld only placed fifteenth).

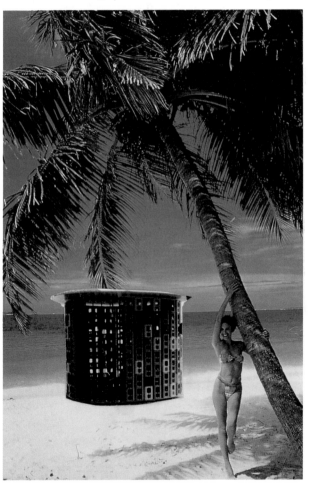

Wolfgang Winter/Berthold Hörbelt: *Kastenhaus 232.8*, 1996, photomontage

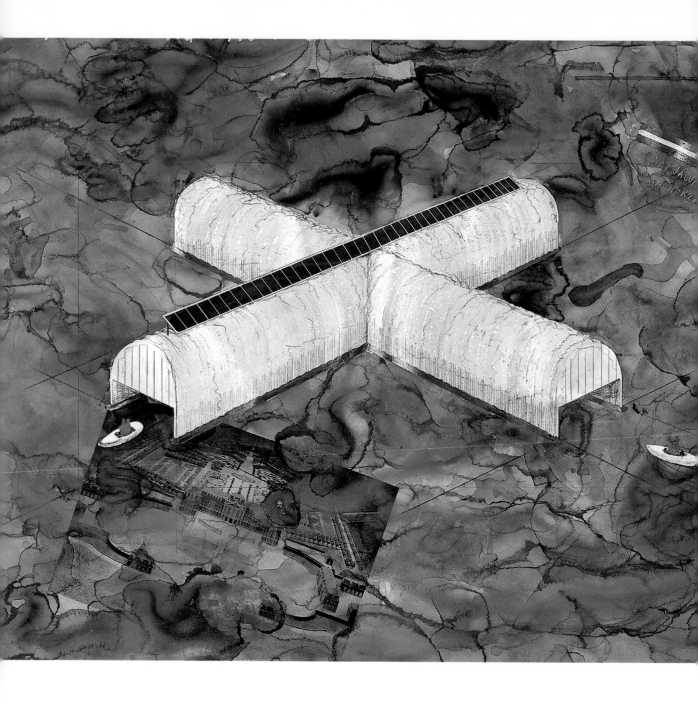

Jeffrey Wisniewski: View of installation *The Digital Island of Aa*, sketch (detail), watercolor, 1.51x1.94 cm

JEFFREY WISNIEWSKI

The Digital Island of Aa. Natural Aquatic Projector
Installation (pontoon, sheet steel, sun light collectors, four video projectors, 5 x 25 x 5 m, projected area 3 x 3,6 m)
North part of the Aasee
Not realized, presentation of the project in the old section of Westfälisches Landesmuseum

Born 1964 in Elmhorst, Illinois,
lives in New York

For information about the artist and additional bibliography see: Nutopi, Rooseum, Center for Contemporary Art, Malmö 1995; Pour un Couteau, Centre d'Art Contemporain, Thiers 1995; Ripple across the Water, The Watari Museum, Tokyo 1995; Jeffrey Wisniewski, Centre d'Art Contemporain, Thiers 1991.

Jeffrey Wisniewski:
The Digital Island of Aa
Natural Aquatic Projector

"Contrary to what we might believe, the experience of ghosts is not tied to a bygone historical period, like the landscape of Scottish manors, etc., but on the contrary, is accentuated, accelerated by modern technologies like film, television, the telephone. These technologies inhabit, as it were, a phantom structure ... When the very *first* perception of an image is linked to a structure of reproduction, then we are dealing with the realm of phantoms."[1]

The sun is a violent gaseous mass producing electromagnetic radiation, it is far greater than anything with which we are familiar. Weighing in at 300,000 Earths and with an expected life of ten billion years, it sends billions of photos – packages of energy with no mass, traveling at the speed of light – crashing into our atmosphere and to the outermost parts of the solar atmosphere beyond the orbit of the Earth.

"Over the years, experiments have shown that electromagnetic radiation is a type of energy that moves at the velocity of light from one place to another. Radiation carries information, enabling us to find clues to the nature of the objects that emit it; thus radiation is the principal way that information travels in our Universe."[2]

The focus of the sculpture will be to collect, store and reproduce the sun's radiation, turn-

ing natural radiation (light) into digital information (laser disc), then back into light.

The main structure of the sculpture consists of four silver steel-galvanum arches, 12 m high, connected in the center with intersecting barrel vaults, making the form of an addition sign or the positive pole of a battery, 29 m along each axis. This structure is secured to pontoons 80 cm wide, so that it floats. Attached slightly above one axis of the intersecting chambers is a long row of solar panels creating a blue line, harnessing the sun's energy to power four LCD video projectors (natural light into electrical information to digital information, back to light). The front of each chamber is closed off to a height of a meter and a half above the water line, allowing for the passage of small boats. This closure also functions as a light shield, preventing most of the exterior light from entering, keeping the interior dark. Inside are four LCD projectors mounted to the ceiling at the end of each chamber, near the center of the sculpture.

Stefan Jörden: views of installation, construction drawing, 59.4 x 84.1 cm (above), model of center of Münster, destroyed during Second World War (opposite above); Jeffrey Wisniewski and Mauro Fiore producing the video for the projections (opposite below)

"In our interpretation we shall not try to examine and paraphrase a structure of the work from the outside. Rather, we shall place ourselves within the structure itself in order to discover something of its framework and to gain the standpoint for viewing the whole."[3]

When a boat enters the sculpture, motion detectors will turn on the LCD projectors and the video footage will be projected onto the water of the Aasee. The images on the surface of the water will be approximately 4 x 4.5 m. The image sits approximately 10 to 12 cm into the water and appears to be floating. Cinematographer Mauro Fiore used a combination of filters and high-contrast compositions to increase the cinematic stability of the image when projected on the lake. The video light also refracts and will send light shining onto the ceiling and walls. The aesthetic appearance of the moving image on the water makes reference, through abstraction, to the conceptual and spiritual interests of the French Impressionists and the late nineteenth century American Luminist School. With the aquatic projection the watercolors of William T. Richards and John Frederick Kensett that transcribed light and color into a liquidity of form, converge with the contemporary alchemical abstract pours of Sigmar Polke. The video generates an expressionist, almost hallucinatory image creating a unique atmosphere offering the opportunity "to leave oneself, to remove oneself from one's customary equilibrium and condition, and to pass over into a new condition..."[4] When the boat and the viewer float through, the video will

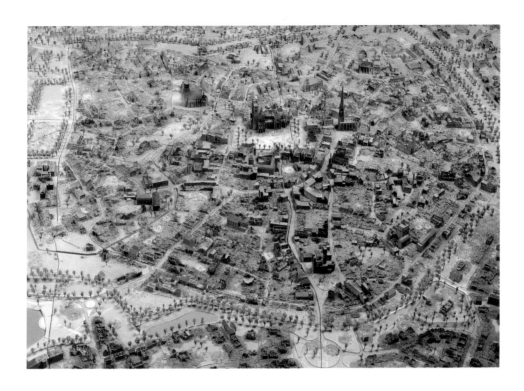

be projected onto them. The boat will also create a wake in the water which will change the way the light refracts. While floating through, the projections on each side of the boat and in front of the boat will be visible to the viewer. From the center of the sculpture, one is surrounded.

"Earth is constantly bombarded by cosmic rays, which despite the name are subatomic particles such as protons and helium nuclei that cruise through space at very high speeds – speeds approaching that of light and therefore termed relativistic. Discovered early in this century, cosmic rays provided the first hints that the Universe is not a quiescent collection of stars and planets, but, rather, the scene of violent events in which particles are accelerated to relativistic energies."[5]

The short video consists of contemporary and historical footage of Münster. It examines the historical growth, and the social violence of destruction and reconstruction, focusing on both the architectural and archival elements. It symbolically displays the powers of both European and American social, religious, and military beliefs and their effects on the town. A visual montage explores the conflict of the aerial and ground level, the real and the unrealized, the energy of creation and the violence of destruction right up to recent times, ending with panoramic helicopter shots of contemporary Münster.

So, montage is conflict.
The basis of every art is conflict (and "imagist" transformation of the dialectical principle). The shot appears as the *cell* of montage. Therefore it must also be considered from the viewpoint of *conflict*.
Conflict within the shot is potential montage, which in the development of its intensity shat-

ters the quadrilateral cage of the shot and explodes its conflict into montage impulses *between* montage pieces. As, in a zigzag of mimicry, the *mise en scène* splashes out into a spatial zigzag with the *same* shattering. As the slogan "All obstacles are vain before Russians" bursts out in the multitude of incident of *War and Peace*.
"If montage is to be compared with something, then a phalanx of montage pieces, of shots, should be compared to the series of explosions of an internal combustion engine driving forward its automobile or tractor; for, similarly, the dynamics of montage serve as impulses driving forward the total film…"[6]

*"The Saudi desert bloomed with oil pipe lines
To push the auto industry it's yours and it's mine
L. A. and Osaka got a habit on gas
In a bullet-proof Caddie you can really move your ass
From a Mickey-Mouse war on cocaine & crack
We dropped a million bombs on the kids in Iraq
How many we killed nobody wants to tell
It'd give a lousy picture of a war they gotta sell."*[7]

"The way contemporary history is told is like a huge concert where they present all of Beethoven's one hundred thirty-eight opuses one after the other, but actually play just the first eight bars of each. If the same concert were given again in ten years, only the first note of each piece would be played, thus one hundred thirty-eight notes for the whole concert, presented as one continuous melody. And in twenty years, the whole of Beethoven's music would be summed up in a single very long buzzing tone, like the endless sound he heard the first day of his deafness."[8]

Using a special univision lens, ten different historical models were filmed at the Stadtmuseum

Münster. Starting around the year 750, when Charlemagne sent the Friesian priest Liudger to found a mission called Monasterium, which later developed into Münster, continuing through to 1661 (after the end of the Thirty Years' War), the last model being the entire city after the bombing of World War II. It appears as if the viewer is flying in the space shuttle over the city in the year 1535; walking through a bishop's castle and garden that were never built, but were planned in 1769; sailing around the tops of cathedrals that appear to have just been bombed, narrowly missing the architectural debris. This is cut in with footage of present day streets, the interior and exterior of late-Gothic cathedrals, shots of a thirteenth-century clock that will run until the year 2007, shots of the entire city from the spires of the cathedrals, and finally, helicopter shots of Münster as it is today. The viewer will appear to be panoptic and omniscient, floating through the deconstructive montage of historical and contemporary forms.

"Now the concept of deconstruction itself resembles an architectural metaphor. It is often said to have a negative attitude. Something has been constructed, a philosophical system, a tradition, a culture, and along comes a de-constructor and destroys it stone by stone, analyses the structure and dissolves it. Often enough, this is the case. One looks at a system – Platonic/Hegelian – and examines how it was built, which keystone, which angle of vision supports the authority of the system. It seems to me, however, that this is not the essence of deconstruction. It is not simply the technique of an architect who knows how to de-construct

The Aasee in Münster; pedal boat on the Aasee, photos 1996

Jeffrey Wisniewski: Bird's-eye view of Münster, still from video for projections, 1997

what has been constructed, but a probing which touches upon the technique itself, upon the authority of the architectural metaphor, and thereby constitutes its own architectural rhetoric. Deconstruction is not simply – as its name seems to indicate – the technique of a reversed construction when it is able to conceive for itself the idea of construction. One could say that there is nothing more architectural than deconstruction, but also nothing less architectural."[9]

"The necessity for artistry that is laid upon us by the desire to be civilized, is not a matter only of appearances. Human *necessity,* however machine-made or mechanically met, carries within itself the secret of the beauty we must have to keep us fit to live or to live with. We need it to live in or to live on. That new beauty should be something to live *for*. The 'picture', never fear, will take care of itself. In any organic architecture the picture will be a natural result, a significant consequence, not a perverse cause of pose and sham."[10]

The idea of the project is to construct a large-scale solar projector, a digital island powered by the sun, the fundamental source of all energy, that disburses a historical montage aesthetic, disclosing its context for the last 1,000 years on its inside, while its exterior appears to be a strange silvery craft that has landed or emerged from the water itself – arguably the birthplace of life. Displaying past societies and the creative energies that it took to build and destroy and rebuild them. The moats around Münster, a town that once used the river Aa for its defensive survival, are now made into a lake for its pleasure. The destructive forces never came from the ground but from the air. The moats are now a promenade for bicycles and pedestrians. The cathedrals have all been reconstructed, an idea that in the United States is continually demonstrated with a Disney-like sensibility. This will be made visible through a form of public sculpture, a form that serves the development of the blurring of a conceptual art and pop art combination, high and low culture, within a minimal art form, a form the viewer can investigate and then participate in through nature, technology and history.

"To all appearances, the artist acts like a mediumistic being who, from the labyrinth beyond time and space, seeks his way out to a clearing … yet art history has consistently decided upon the virtues of a work of art through considerations completely divorced from the rationalized explanations of the artist … All in all, the creative act is not performed by the artist alone. The spectator brings the work in contact with the external world by deciphering and interpreting its inner qualifications and thus adds his contribution to the creative act."[11]

1 Jacques Derrida: The Ghost Dance. An Interview with Jacques Derrida by Mark Lewis and Andreas Payne, trans. Jean-Luc Svoboda, in: Mark Wigley: The Architecture of Deconstruction: Derrida's Haunt, Cambridge, Mass. 1993, p. 61.
2 George B. Field and Eric J. Chaisson: The Invisible Universe, 2nd ed., New York 1987, p. 2.
3 Martin Heidegger: What is a Thing? trans. W. B. Barton and Vera Deutch, Chicago 1967, p. 123.
4 Ibid., p. 167.
5 George B. Field and Eric J. Chaisson: The Invisible Universe, 2nd ed., New York 1987, p. 100.
6 Sergej Eisenstein: Film Form, New York and London 1949, p. 38.
7 Allen Ginsberg: Cosmopolitan Greetings; Poems 1986 – 1992, New York 1994, pp. 60 – 61.
8 Milan Kundera: Slowness, trans. Linda Asher, New York 1996, pp. 92 – 93.
9 Jacques Derrida: Architecture Where Desire May Live, in: Mark Wigley: The Architecture of Deconstruction. Derrida's Haunt Cambridge, Mass. 1993, p. 18.
10 Frank Lloyd Wright: The Future Of Architecture, 2d ed., New York 1963, p. 196.
1 Calvin Tomkins: Duchamp. A Biography, New York 1996, pp. 196 - 197.

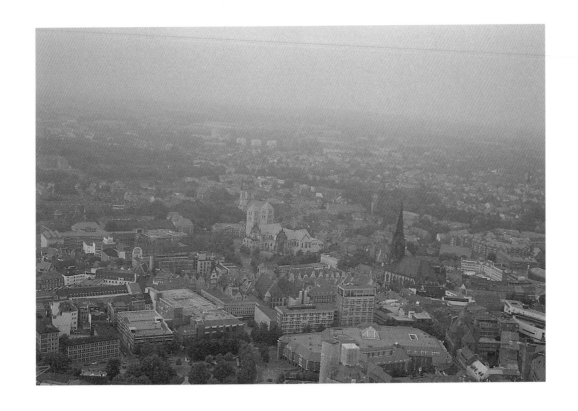

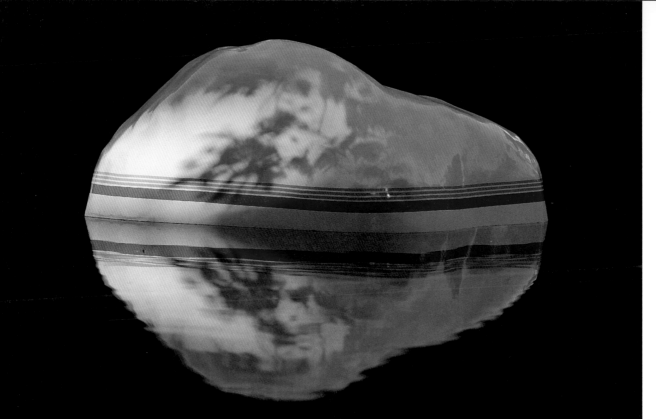

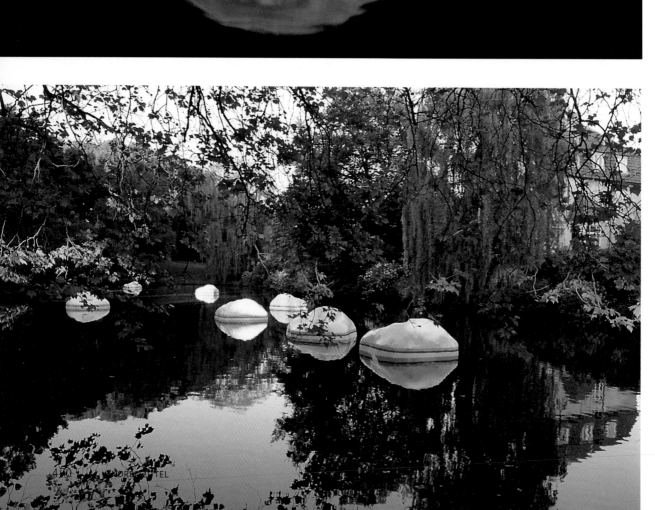

ANDREA ZITTEL

A–Z Deserted Islands
Ten fiberglass islands
Kanonengraben

Born 1965 in Escondido, California,
lives in New York

Andrea Zittel: *A–Z Deserted Islands*

The idea of the deserted island represents both
our biggest fear and our biggest fantasy.
For the past six years my work has almost
exclusively dealt with aspects of private space
and personal experience. When I began to think
about translating these interests to public
space I found myself drawn to issues of terri-
tory; the need for personal identity or auton-
omy; and then to our simultaneous and often
conflicting desire for the security and intimacy
of "community".
My ideas about individuality and community as
they relate to territory are distinctly American
in the sense that Americans are more specifi-
cally sensitized to physical, rather than cultural,
boundaries. The American pioneering spirit has
created within us a real drive towards the pos-
session and protection of a definable territory.
This territory may be identified by a green lawn
and a chain link fence, by our desire to ride to

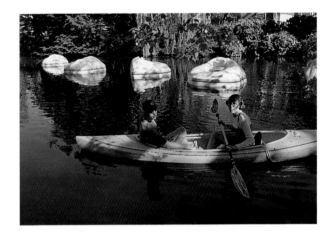

For information about the artist and additional bibliography
see: Andrea Zittel. Living Units, Museum für Gegenwartskunst
Basel, Basel 1996; nach weimar, Kunstsammlungen zu Weimar,
Ostfildern 1996; About Place: Recent Art of the Americas,
The Art Institute of Chicago, Chicago 1995; Whitney Biennial
Exhibition, The Whitney Museum of American Art, New York
1995.

work within the isolation of our own private
vehicles, or by our reluctance to share a restau-
rant table with strangers.
Perhaps this is why I respond to the physicality
of the early European moated city – which I
can't help but view as an island and a ship. I
find these images comforting as self-contained
entities (much like a familiar planet floating in

American desire for isolation (and isolationism), the image of the deserted island comes to mind. I love the way that the "deserted island" is used to represent both our biggest fear and our greatest fantasy. This attraction/repulsion plays itself out in popular culture, vis-a-vis in representations such as the cartoon of the overworked insurance salesman marooned on a deserted island with two beautiful bikini-clad women, or the story of the Robinson Crusoe destined to struggle alone on his island against the odds of nature.

In Münster, I am placing several *A–Z Deserted Islands* in a little body of water – a recollected fragment of the old city moat. The structures reference a cross between an artificial land formation and a recreational fiberglass boat. The *A–Z Deserted Islands* can work as a prototype for a mass-reproducible recreational vehicle that could conceivably be marketed for the purpose of "an individualised experience of isolation within a safe and comfortable environment". I find it rather ironic that most often it is the mass-reproduced product that best mediates our (often contradictory) desires and craving for individual experience, with the accompanying need to maintain oneself within a safe and predictable environment.

Andrea Zittel: *Prototype for A to Z Pit Bed*, 1995, wood, carpet, foam, rubber, 0.46x2.44x3.66 m (below); and *A–Z Deserted Islands*, sketch, 1996 (opposite)

472

A-Z deserted IS

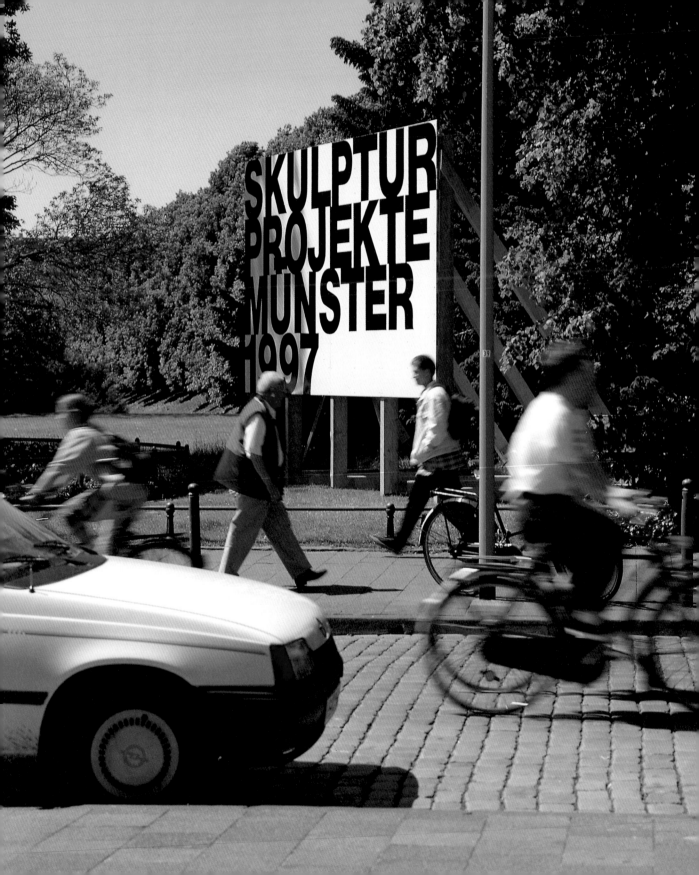

HEIMO ZOBERNIG

Untitled
Two-part work
Six billboards at six intersections of main
access streets to the Promenade: Neutor,
Mauritztor, Salzstraße, Windthorststraße,
Ludgeriplatz, Aegidiitor

Stage in the atrium in old section of
Westfälisches Landesmuseum

Born 1958 in Mauthen, lives in Vienna

Heimo Zobernig, *Untitled,* 1997

(1)
A large revolving billboard on the Ludgeriplatz
with the lettering SKULPTUR PROJEKTE
MÜNSTER 1997. Due to its geographical loca-
tion within the urban traffic system, this square
is considered the gate to the city. (For reasons
of traffic safety the work was not approved by
the Münster municipal authorities.)

1
Six billboards, placed at the intersections of the
six principal access streets to the promenade
belt of the city, showing the lettering SKULP-
TUR PROJEKTE MÜNSTER 1997 in the typeface
Helvetica Black, black on a white ground.

2
A stage across from the entrance to the atrium
of the Landesmuseum, with chairs from the lec-
ture hall of the museum in front of it. The rear
wall of the stage bears the lettering *SKULPTUR
PROJEKTE MÜNSTER 1997* in the typeface Hel-
vetica Black, white on a black ground.

For information about the artist and additional bibliography
see: Farbenlehre, Ferdinand Schmatz, Heimo Zobernig,
Vienna/New York 1995; Heimo Zobernig, Kunsthalle Bern, Bern
1994; Heimo Zobernig, Neue Galerie Graz, Graz 1993.

Christian Höller: Public Relations

Heimo Zobernig's works in public spaces function as complex interfaces. Though at first glance they may seem to convey the flair of the trivial, the commercially clichéd, even the tautological, upon closer examination they condense within themselves the most diverse systematics. In so doing they achieve nothing less than the opening up of connections and perspectives between a number of areas of jurisdiction: the significative, the spectacular, the appellative, the public, the power-invested. The work *Skulptur Projekte Münster 1997*, consisting of six billboards in public space and a stage in museum space, localizes itself at a number of such interfaces – places where, proceeding from a sequence of words, the convoluted relations between these five areas are made manifest.

This applies first of all to that interchange where textual and visual systems of representa-

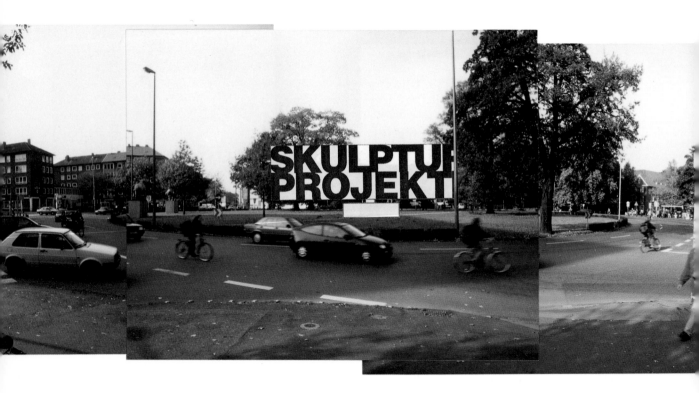

Heimo Zobernig: 1st project: *Drehende Plakatwand* (Revolving Billboard), location: Ludgerikreisel, 1996, 4.5x18x0.5 m, photomontage

tion collide, in such a way that their mutual inseparability becomes literally apparent. Images of writing are *per se* representational hybrids with both visual and linguistic components. Zobernig's work for the Skulptur Projekte Münster illustrates in an economically compressed way this level of interference between image and text, a level at which both components are subsumed into a common third, an *image-text*.[1] At the same time, the lettering *Skulptur/Projekte/Münster/1997* has a practical value of its own, hardly to be surpassed in functionality: public relations on the most important access streets of the city, the *logo*-like attribution of identity and distinction to a major project, the parading of cultural responsibility, and finally the transposition of the embedding context back into the space of the museum through the lettering – white on black, i.e. reversed – on the rear wall of the stage in the Landesmuseum.

The billboards fill, as it were, the space of the outward-directed, public-oriented self-representation of the Skulptur Projekte. Textually, they refer to a major project of which they themselves are elements. But the hybrid image-text of the lettering opens up a perspective on another interface as well. The *appeal* the viewer experiences through the oversized chain of signs that is aimed at him reveals an abstract apparatus which – building on the image/text system – is erected between artwork, individual appeal, institution, and public. Placed within public space, a second level of interference is thus superimposed on the indistinguishable hybridity of the textual and the visual, introducing as it were an ideological disturbance and corrective factor into the purely semantic representational problem of the first superimposition.

Zobernig's stage and billboards in fact occupy places in which, in addition to the medial indeterminacy (what is textual, what is pictorial?),

the referential and significative function of the lettering likewise comes into view. It is the *public function* of the means of representation that is thereby called into question: what can be rendered visible at all in the sign-glutted public sphere? Who or what possesses the power to assert for itself a freely accessible visibility? How does a sculpture function in the field of tension between sign and spectacle? That the message on the billboards corresponds *ex negativo* to the lettering on the stage[2] already reveals at the formal level how advertisement/signification and performance/presence – whose classic location is the stage – begin to dissolve into one another. Zobernig's sculpture project thus establishes a network of signification in which the sculptural oscillates ambiguously between pure sign function and the "empty" promise of public presence.

The power of artistic institutions and events to draw attention to themselves is commonly dictated both by the competitive considerations of market economy and, of course, by the imperative to present only their well-functioning surface structure. For the *Skulptur. Projekte in Münster 1997*, Zobernig exposes this principle of spectacular ostentation for places of artistic exhibition. At the same time, however, he exaggerates and sabotages the principle by in fact staging nothing more than its mere designation – and not, for example, spectacular attributions or promises of content. Instead, however, this is achieved through a *formal* exaggeration that intensifies and transforms only the indexical reference to the exhibition into the sculptural and monumental, leaving its thematic orientation entirely unconsidered. In the self-referential affirmation of the project name, in which pictorial and linguistic aspects are blurred into a logo, it is precisely its functionality and instrumentality that is elevated to the subject of art. Just as the traditional hierarchy of the spheres of linguistic and artistic production (in which

the image is always already subordinated to the *logos*) is here eradicated, so the contentual definitions of institutions and large-scale programs begin to dissolve into the pure formality of their signification.

Finally, in these complex superimpositions there becomes apparent yet another, a third level: in this way the word-sculptures become self-referential theoretical diagrams that parade their own function as image-text (representation) and as ideologem of publicness or of the making-public. Nevertheless, this display has as little transparency as the spheres of the significative and the public always possess a minimum of opacity or in other words: these areas can never actually be the supposedly free places for the exchange of goods and information that the liberal-bourgeois ideology once saw them as. To the extent that the boundaries between language, writing, image, and sculpture become indeterminate (i.e. indefinable), and to the extent that indexical, referential functions can no longer be separated from aspects of power, to precisely this degree a signposting reduced to the literal becomes the core of a hybrid theory of representation that can no longer view *image-texts* apart from ideologies.[3]

Zobernig's reductionistic reworking of representational patterns thus effectively analyzes the "relay mechanisms in the exchange of power, value, and publicness."[4] But precisely this visual manifestation of a theoretical context must in the final analysis itself remain *opaque:* if images (or texts or ideologies) were to be conclusively theorized, it would have be in radical abstraction from all imagery. Yet images recur stubbornly in the sediment of any theory, even image theory. Zobernig's work accepts this symptomatic by itself allowing image and text, signification and presence, representation and institution to flow indeterminately into one another, by weaving them into a reciprocal and unending play of puzzle and masquerade. The black typography of the billboards becomes the stencil for the white lettering on the stage (and vice versa); the place of performance becomes a sculptural "imitation" of the advertisement (and vice versa). Continual superimpositions of the simplest elements – like the billboard that turns and turns, and still never reveals more than one side to the gaze.[5]

1 Cf. W. J. T. Mitchell: Picture Theory, Chicago 1994, pp. 83 ff.
2 Only the dimensions are different: the 3 x 4 m billboard message contrasts with the 4 x 8 m lettering on the stage.
3 Cf. the theory of representation in Mitchell 1994, p. 420.
4 Ibid.
5 Zobernig's original project called for a revolving billboard on the traffic island of Ludgeriplatz. The one side would have born the lettering SKULPTUR PROJEKTE, the other the message MÜNSTER 1997. In the end the design was not approved by the municipal authorities of Münster.

Heimo Zobernig: Stage, location: atrium in old section of Westfälisches Landesmuseum, wood, 20x8x4 m, computer drawing, 1996 (left) and silkscreen, 1996, 80x60 cm

Can art get down from its pedestal and rise to street level?

DANIEL BUREN # Can art get down from its pedestal and rise to street level?

The word "Sculpture"

I would like to use the opportunity given me on the occasion of the twentieth anniversary and third edition of the Münster Skulptur Projekte to put down a few random thoughts on this very singular activity which consists in placing in urban space that is open to all and usually outdoors – although indoor spaces may also meet the same criteria – objects generally known as "sculptures".

It will be noted for a start that the word "sculpture", if not redefined, will cause a fair amount of confusion, with many who expect to see a three-dimensional object coming up against an inscription written on a wall or on the ground (Lawrence Weiner, Joseph Kosuth, Matt Mullican), or perhaps a photograph, a painting or a text glued to an advertising billboard (Raymond Hains, Barbara Kruger, Thomas Huber)!

Are these objects of a specific type which can be distinguished from other objects in the urban landscape?

What meanings do these objects have? If a similar object is placed in the museum, is its significance identical? Who allows them into the city? Where are they placed? Who chooses the site?

These few questions and dozens of others which interest me – primarily in the sphere of exclusively urban work undertaken outside specialist venues for some thirty years now, which I will try to discuss succinctly here – need to be understood as a mixture: of thoughts on a highly specific practice that I pursue in a variety of ways both official and unofficial, of commentaries on these experiences, of analyses concerning the incredible importance of the urban environment and how it differs from the specific space constituted by the museum and what each of them allows and refuses – their specific limits, and, lastly, of critiques of institutions, of the deciphering of political factors.

These few paragraphs should be read with a view to the visual work that has been undertaken, as an indication of what is to be seen, as a clarification of what I am trying to do in space, by what means and how, and not as some theory for use by anyone else.

Nor should what some of us are trying to do when we work outside – as is the case with my own work which is mainly what I'm going to talk about – be confused with the kind of figurative or abstract sculpture (or statuary) that, in accordance with the level of culture of those who compose them, is put outdoors by municipal councils who "stick" around the place, and with varying degrees of success, a Rodin, a Bartholdi, a Henry Moore or a Calder, or perhaps a Raymond Mason, some Maillols or a Thomas Vinçotte, a Louis Jéhotte or a Guillaume Charlier.

Whatever interest these scattered thoughts may have depends on accepting this limitation.

The constraints I aspire to impose on myself, before starting a piece of work, can of course be criticized, but only if one is well aware that this discipline, this way of analyzing, can be applied only to my work and is not a map for the route to be taken by another type of work. If it is taken, it is at this risk of those who take it.

Lastly, the criticisms I formulate here or there always name the works and the authors with regard to whom they are articulated and enable me to clarify my ideas without leaving that rather common and cowardly vagueness which

leaves the reader to guess what and who is being talked about.

These criticisms are of course not exhaustive nor directed exclusively at the work mentioned, which is considered only by way of example.

These analyses are not personal attacks and I believe, naively no doubt, that they shouldn't upset anyone, given that anyone who has the courage or the foolhardiness to show what they have done to others, and in public on top of that, opens the door to analyses, to commentaries, to criticisms and to praise.

Not to say anything about a public artwork is no doubt the worst thing that could happen to it: after not being looked at.

Public art

Why, when talking about a work in the open air or, more exactly, in the street, in urban settings, is the word "art" coupled with the term "public"?

What is implied by this pairing?

For example, does it mean, by the same token, that art exhibited in museums is not public? That it doesn't need or care about the public?

Or, again, is art in the museum so un-public that it would be somehow incongruous to use this word? And yet, given that museum institutions – certainly the majority of European museums, anyway – are not only open to all publics but are also financed by public money, the art in the museums is well and truly public or, at least, becomes public when it enters them and is shown there.

Can we then put forward the argument that if the word "public" is stated in one case and ignored in the other, it is for the following reasons: that, in the case of the museum, art is – necessarily and undoubtedly – public, an assertion that is so obvious that it hardly needs underlining, whereas in the street, this is so far from being obvious that this particular aspect does need to be emphasized!

I don't think that this interpretation holds water because while one can quibble about the museum-going public, I don't see who could call into question, be indignant or pleased about, the public in the street, or who could be unaware of its existence!

Art in the street cannot therefore be anything but public.

If there is a question that arises from this difference between art without an adjective, or to put it another way, art in the museum, and public art – apart from wondering why the pairing of art and public is only used when it comes to art in an urban setting, which seems to say no more than that a rose is a rose – it is about whether, in the street, we are still talking about art and if it is indeed the same art as the kind found in the museum.

Or, to put it another way, the same as all the things that are exhibited in the museum and defined – ipso facto – by the museum itself as art, in keeping with the unique power that it has arrogated, a power that can certainly be questioned and which is no longer what it was some thirty years ago, but which is still real enough for it to be clear that the street is totally devoid of it in this domain.

In this regard, there is something droll about the need to insist on this public character when talking about what is exhibited in the street insofar as, of all the aspects of an extramural work, this one is the most obvious whereas this is not always the case with the term "art", taken in the widest sense.

A girl of the streets

While, in the tandem formed by the two labels, "public art" and "art in the museum", the adjective may provide some information, the noun "art", the common denominator, is a long way from explaining anything.

Let us take it as axiomatic for a moment that, in the museum and in the street, what we are talk-

ing about is indeed art and let us make bold to use this word in spite of its lack of precision and the incredible mishmash it covers up.

In their mode of utterance, then, art in the museum and art in the street are distinguished in two different ways. One is generally named "art" without any adjective and the other "public art".

Or, another denomination is used: "art in the museum space" and "art in public space".

In this case there is an attempt to cover up the fact that the museum space is also a "public space" and, in the attempt to be more precise, the dichotomy between the two is strengthened by increasing the importance of the word "public" on one side to the detriment of the other.

Why this insistence on the word "public" on one side only, when we know that in an urban setting as in a museum one, in open as well as in closed spaces, what distinguishes them is not the meaning of the word "public"?

Could it be that the object set up in the street is always frequented by all kinds of publics and put before the eyes of all-comers whereas, in the museum, which is frequented mainly by a more specialist public or, a priori, a public that is more sensitive to painting or sculpture, i.e., interested in visual forms, this limited public does not have the right to be referred to as a public.

This would mean that exhibitions in museums would be – but this they don't say – for "professionals" only, and the exhibition in the street for the general public, just as agricultural , machine tool or prêt à porter shows have some days exclusively for professionals only and others open to everybody and anybody.

The very designation "public art" suggests a kind of contempt. Do we not in the same way call a prostitute a *fille publique*, a girl of the streets.

Is public art, contrary to art for museums, art that prostitutes itself?

In the museum

If we except the part of the museum for which the expression in which the word "public" is used, that is to say, in the sense of "public collection" (which, to be clear, means that it was paid for with public money), could we say that common parlance, by distinguishing between art in the museums, known as "exhibition of…" or "exhibition on", from which the word "public" is always excluded (and yet the museum was invented precisely for the public!) and art outside the museum, known as "public art" – that common parlance, as I was saying, whether unconsciously or not – tends to deny the very existence of this public, or at least its importance in relation to the museum whereas outside, in contrast, its existence appears to be considered essential.

Can we deduce that, in the museum, we have works made for a few, well defined individuals, or for ourselves or for some other abstract and, a priori, nonexistent, virtual person, whereas in the street, the work would always be made in direct relation to the public, and what's more a very sizeable one?

In the first case, the opinion of the public would be considered negligible, in the second, crucial.

In one case, art for a specialist public would appear to be unnameable, in the other, unavoidable.

In the first case we are up in the ether, in the second, in everyday reality.

Common parlance

Perhaps there is some truth in this common parlance, in this coupled, guaranteed label. Let's try to see what's behind it.

To be invited to make a work (or present it) in a museum is called: having an exhibition.

To be invited to make a work (or present it) in the street or to win a competition for a public space is called: getting a public commission.

Having just seen that in one case the word pub-

lic is essential to the label, we now see that the word "exhibition" disappears when in the street, in public space, and seems to be accepted only in the museum!

Just as it seems difficult to cancel the existence of the public and its role in the museum, even if we deny it, so it is difficult to admit that a work in the street is not exhibited there, even if no one talks about it.

The idea of the public commission corresponds to an artwork in a public setting. One does not exhibit, one responds to an order.

The idea of exhibition corresponds to an artwork in the museum. In an exhibition it is agreed that expression is free, uncommanded.

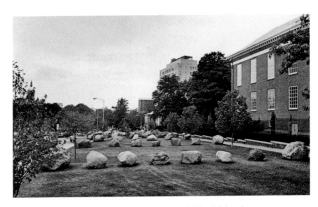

Carl Andre: *Stone Field Sculpture*, 1977, 36 (glacial) boulders, 7.25x1.33 m, Hartford, Connecticut

Public commissions

What we can say about commissions?

What can we say about exhibitions?

Here, too, words give us pause for thought.

The word commission implies an order, a task. A public work or commission would thus be the result of a formulated order!

If this was true when art in the city was mainly a matter of producing a work that was either a symbol of something (war, peace, philosophy, a war memorial, a river) or the glorious representation of an event (the Declaration of the Rights of Man, the Republic) or, more often, of a person (a scientist, a soldier, a politician, a writer), it is much less so today, since public commissions are back in favor and affect – and this is quite new – artists who had never or only rarely been called upon to undertake this kind of exercise.

In fact, nowadays it would be more appropriate to speak of public "demand" than "commissions".

This demand is generally precise only about the site where the work could be placed. Not about its content.

That said, this brings it much closer to the exhibiting of works in the museum.

But let's briefly reconsider the usual term which, when we are talking about a work in an urban setting, says that it is a public commission.

It will be noted that this term "commission" is totally absent from the different ways of naming an exhibition in a museum. Just as the word "public" seems not to suit the museum, so the word "commission" seems even more alien to the ideology of the museum.

This implies that an artist exhibiting there would under no circumstances have to respond to an order. Or, at least, that is what is generally believed, and what the dominant ideology maintains.

In the museum, we exhibit, create, without constraints. The twentieth-century Western artist exhibits there with complete freedom.

He cannot, therefore, be ordered to do anything.

The myth of the free artist could not allow anyone to imagine that he or she might dare to adapt, however little, to some commission. Of course, there's a lot that could be said about that particular kind of liberty.

It would be more appropriate to speak of liberty under surveillance.

Obligatory constraints

As for the ban on using the word "commission" from the usual parlance for exhibitions in the museum, what it signifies is above all a desire to hide the ideological and commercial obligations created by the museum, which elicits the creation of "commissions" out of nothing other than letting unexpected works blossom.

The fact that the world commission is not used for the museum also signifies that there are no constraints in such a setting. This is the foundation of the universal ideology of museums. Just because the constraints are not apparent at first glance it doesn't mean they don't exist.

A large part of the work I have been doing these last thirty years is an attempt to reveal them.

On the other hand, just as the word "public" seems superfluous when one is talking about artistic work in an urban setting, so is the word commission.

This inevitability of the commission, or demand, as I prefer to say, implies, if not an order, at least one or several explicit constraints.

Squares and streets

As for the word "exhibition", which disappears from the label of work done in an urban setting, it corroborates what I have just said and its "omission" is also very revealing. So, what is made in a public space is not exhibited? In other words, is the ambition "commissioned" from such a work to merge, to adapt, in fact ultimately to disappear into the surroundings? It must be said in this respect that most so-called public works succeed very well in meeting this demand, leading one to believe that they are indeed impeccable responses to a command.

There are several ways a public work can melt into its surroundings. One is to use the everyday furniture of the town and to stand out so little that no one can spot the difference, either of content or of container, as Jenny Holzer does, for example, when she presents her statements on electric billboards on Times Square. Or you can produce a work so banal that it looks like the ambient statuary to be found in squares in towns all over the world. This is the degree zero of public art. There are myriad examples of this category: from Venet to Pomodoro, from Ipoustéguy to Martial Raysse, via César or Pistoletto and other makers of memorials.

There are two main styles producing this banal punctuation of squares and streets: one is figurative and age-old, the other – a more recent vein – is abstract and generally polite, and seems to thrive outside the entrances of banks. Just like their figurative twins, these abstract works that sprout up around the place from Bamako to Singapore via New York and Tel Aviv could just as well all bear the same signature, in that their lack of inspiration and quality seems to constitute a style in itself, the distinguishing sign of their conformity.

We all know about the mediocrity of the works planted in the Tuileries in Paris at the beginning of the 1980s: they were so insignificant that the day after their inauguration nobody could say where they were situated or remember the name of their creators.

But since I have a good memory I shall name a few names to remind readers of the figurative banality signed Sandro Chia and the insipid abstract piece by Kirili.

Either one of them could have signed all the other works in their category, and not only in the Tuileries!

Commemorative plaques

Then there is the almost unanimous praise heaped on the work of Jan Dibbets by the members of the institution (curators, critics, etc.). Scattered over the pavements of Paris in homage to Arago, the great merit of this piece is that it upsets absolutely no one: hence its success with the institution. Even those who take

the time to read what is written on each of the 135 medallions are not put out by its identity as an "artwork" because these inscriptions are just like those used to indicate directions or sites of the kind always appreciated by tourists. You have to be pretty smart to realize straight out that this an artwork!

In this instance the artwork – since that's what we're talking about – actually hides and, moreover, passes itself off as on object of a totally different sort which, in the street, in contrast to the ambiguity that may exist in the museum, becomes unequivocal: a commemorative plaque with no particular qualities among other such plaques, and that's it.

It is no more or less than another little signal amidst the thousands of others dotted around the city.

Regarding the first examples (unfortunately the commonest), the kind of mediocrity that is put in place is no more worthy of attention than if there were nothing there at all.

In the last example, a sophisticated work strictly for the happy few capable of grasping what the medallion is (like tourists) and what its author represents (an artist with an international reputation).

Either way, whether the style is absolute mediocrity or discreet sophistication, the result is the same: the "works" in question are "invisible", aseptic.

They melt into the surroundings, do not challenge or transform them in the slightest way.

They respect the status quo to the point of nausea.

Of course, one could imagine works which, although discreet, perturb and disturb in the positive sense of those terms.

Discreet but remarkable, as is the work by Carl Andre in Hartford, Connecticut, or the one by Mario Merz in Strasbourg, or Jochen Gerz's invisible monument: *2146 Stones*, in Saarbrucken, or, again, discreet and remarkable while paradoxically very big, like Richard Serra's sculpture on Placa de la Palmera, Barcelona. And so on.

If the work is exhibited, if it tends to make an exhibition of itself, either by its formal ambition or because of the site it disrupts, or for both these reasons at once, you can be sure of a great outcry from the public, the media and politicians (cf. Richard Serra's *Tilted Arc* in New York, or my own work, *Les deux plateaux*, in the Palais-Royal, Paris).

Official vandalism

This public explosion may even lead to the destruction of the artwork by anonymous vandalism or even by that of the authorities themselves (in March 1996, the mayor of Toulon, one of the four French towns now governed by neofascists, ordered in the bulldozers to raze a sculpture by René Ghiffey. Christian Lapie's piece in Reims was censored following a complaint made by the widow of a Nazi general! A sculpture by Bruno Hadjadj was removed from its site because it constituted "an invitation to debauchery" etc.).

These instances of "official" vandalism, which up to now have been rare, seem to be increasing at the present moment, a fact which certainly doesn't say much for the tolerance or the health of the societies in which these cases of official, authoritarian vandalism occur.

As for graffiti, which is more frequent, it seems to be a part of everyday, public vandalism and is aimed undiscriminatingly at anything. It may cause damage but this is rarely irremediable. Graffiti can always be cleaned up.

Looking at the situation in France, where the idea of public commissioning came back into favor in the early 1980s (State, Regions, Municipalities and, especially, a combination of all three or, even better, with the support of the European Community), it seems that real out-and-out vandalism is actually quite rare.

What is more common, and can, using a much more insidious method, produce exactly the same effects, is lack of care, of maintenance. That of course is another serious matter touching on public art, its preservation and legibility.

Since official or state vandalism is relatively unusual, you would expect to rejoice at the relative lack of anonymous vandalism.

Unfortunately, the reason for this is not, as one might hope, the respect inspired by these significant works of art. Quite the contrary.

Most of these works are so insignificant that nobody, not even vandals, is interested in them. In fact, it has to be admitted that the reason for this mediocrity, which is so uniformly shared by cities around the world, is to be found further upstream.

Politicians

It rests first and foremost with politicians, who on the one hand give their patronage to mediocre artists (yes, these do exist!) and on the other work doggedly away to ensure that what should have been otherwise turns out mediocre.

For no one is more sensitive to majority opinion than a politician.

Since the public (i.e., his potential electors, his clientele) knows that - should there be disagreement - the politician can be hold responsible for putting up the execrated work, it is he, and he alone, whom they will punish for their distaste.

Knowing this, the politician does all he can either to ensure that such a work that could undermine him electorally will not be seen on his territory, or, failing that, to "mediocrify" the project until it is completely without interest.

The method is very simple. All you have to do is ask the opinion of your fellow town counselors without consulting a specialist on the subject or, even more demagogically, put the question to the people!

This method never fails: the vote always goes to the direst work of all.

What's more, you can also point out that you have chosen an exemplary democratic method. But this method is ill adapted to the subject in question and, in the end, contrary to appearances, antidemocratic, all the more so since it doesn't take into account the population's overall lack of artistic education, which ignorance is certainly not its fault and can't be considered blameworthy. Further, while the kind of insipid art I mentioned earlier is in most cases made independently of the site and can therefore be "judged" as a finished object, you cannot form an opinion in the same way about a work in progress. When all you have to go on is a plan or a few sketches, it is no easy exercise to imagine as exactly as possible what the work will really be like in space. Few people are capable of imagining what the finished work will be like on the basis of the project. This diffi-

Jochen Gerz: *2146 Steine – Mahnmal gegen Rassismus*, 1991-1993, Saarbrücken, cobblestones in front of Saarbrücker Schloß, undersides engraved with the names of all German Jewish cemeteries existing before the Second World War.

culty is something the artist experiences, too. The final result of the work always comes as a surprise.

The detractors of a project can go on forever arguing their case against its defenders, and vice versa.

Furthermore, whichever group wins this kind of battle, there are no means of determining who is right, especially if the one that wins is the one that prevents the project from existing! If several projects are involved in the discussion, the most mediocre one will always have the best chance of coming out on top.

Conversely, for every new or even difficult work, it can be said that there is a responsible politician who was bold enough to argue its corner.

This is why – and it is one of the main difficulties with urban art – the works that are brought into being in cities are rarely works of the first magnitude.

This is also why works in public places, or at least most of them, are generally not exhibited but hidden, literally "merging" with the existing scenery, entering into osmosis with the general mediocrity by adding their own, and why the word "exhibition" is consequently excluded, in common parlance, from the vocabulary concerning works commissioned through public channels.

Labels of origin

Indeed, you could have a lot of fun, not inventing new terms but using the ones that already exist and inverting them, transforming these labels of origin by making hybrids.

For example, instead of talking about "public commissions", to say: "permanent exhibition in the street", and make sure that that's what it really was.

Instead of "one man exhibition in a museum", to say: "ephemeral public commission in a museum", so that people would at last realize how harmful it is to believe in freedom of expression where creation is concerned, as a kind of taboo.

With this inversion, everything suddenly becomes clear and the ground rules that these two contexts impose on everything that enters them – while camouflaging them, as we have seen from common parlance – are clearly stated.

In fact, the meaning of the words that are used is only really manifest not, as one might expect, when you have understood what they mean, but when they are contrasted with what they hide or, even better, when they are replaced by the words in place of which they are used.

Obstruction

Our two little examples have shown us how, whether deliberately or not, words can clarify or obscure what they are applied to.

Aside from the manifest ambiguity of everyday speech when it comes to naming art in the street and art in the museum, these ambiguities already make it clear, whatever interpretation we put on this, that art on one side and art on the other are not exactly the same thing!

If you overlook this truism you will run into tiresome misunderstandings and monumental errors, inevitable and always harmful conflicts. One of these, the one between Richard Serra and the City of New York strikes me as the perfect example of exactly what not to do, both for the commissioning body and for the artist.

As far as the commissioning body, first of all, in the first place it can be reproached for having accepted Richard Serra's project without giving any more thought to its reality and the negative effect it could have on the users of the site, given the obstruction it would cause.

Not having concerned itself with this aspect, the commissioning body of course didn't bother to inform these users of its decision to accept the work in question and the reasons for its choice.

The users of the site, whom some will call the public, therefore found themselves face to face

with a fait accompli that disrupted their habits and their movements.

Of course, apart from the fact that it obstructed their usual route, the work, because of its intrinsic visual qualities, was even more disruptive with regard to their capacity for accepting such a form of art.

The last and, in my opinion, the most serious reproach concerning the commissioning body, given the general hullabaloo, is that, instead of meeting the criticism head on and explaining, however tardily, what the idea was and having the courage to stand by its choice, the commissioning body decided to beat a retreat and move the work, that is to say, to remove it from the site for which it had been designed and, previously, accepted.

We see here how the politician – for this was a political matter – who at first seems to have demonstrated lucidity and courage in accepting a strong and dominating contemporary project – a fact rare enough to be worth mentioning – suddenly withdraws under pressure from a part of the public amplified by the media, going so far as to despoil both the work and its author.

Public places

As regards the artist, now, note that to begin with he presented what he undoubtedly considered the best possible project and was accepted.

It is fully consistent with his usual approach, except for the fact that he says that this work is made specifically for the site in question, which is something new in his work but also proves that he has not gone all the way to meeting the requirements of site specific work because it would seem that he has not studied the ways and customs of the site in question, no more than the commissioning body had before him.

Were it not for this oversight, he would have noticed that the work obliged the habitués of the site to make a detour and that this would no doubt give rise to debate.

The installation, in a public place, of a steel obstacle that obliges people to walk around it, ran the risk of raising another obstacle, a public one which would be much more difficult, if not impossible, to get around. If, on the other hand, Richard Serra had noted this phenomenon and had continued regardless, then we could say that his work was also a provocation.

But, since it was accepted by the authorities as it was, we can say that he had won his bet – to begin with, anyway – and, once the work had gained acceptance from the authorities, it cannot be said that he was in the wrong in any way. Where he was in the wrong, I think, is at the next stage of the debate. To sum up the line he took during the trial that followed, he maintained that the artist is right and everyone else is wrong. In addition to the fact that it destroyed any chances of coming to an arrangement and will weaken the desire of other authorities in the United States to erect difficult works in urban settings, this position provides a striking demonstration of the penalty that comes with thinking that the artist in the museum and the artist in the street can and should behave in the same way.

This could not be further from the truth, even if it is difficult to show what kind of implication is necessary in each case.

I think that Richard Serra, in a rather extreme but at the same time traditional way, behaved rather as he could and should have done in similar conditions toward the director of a museum who had invited him to exhibit and then decided he didn't want his work any more.

For, in such a scenario, once invited it is up to the artist, and the artist alone, to assert their work.

They do so at their own risk and, when they succeed, this even adds to their stature.

Going back a little, I would say very quickly that this exigency on the part of the artist is based on a long struggle and is founded on a history that goes back a good hundred years, to when the Western artist was confronted with only one kind of venue: the gallery and its extension, the museum.

Leaving the museum

These privileged, unique exhibition places ended up creating not only a certain kind of

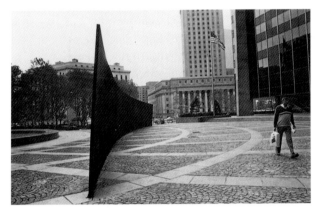

Richard Serra: *Tilted Arc*, 1981, Corten steel, 3.66x36.58x6.5 m, New York, destroyed

work but also a certain number of habits and reflexes that the street will not accept.

Indeed, in the twentieth century, it has been extremely rare for artists to have been given a chance to work in urban, public space.

We also know that many of them dreamed of doing so, from Léger to Matisse, including Picasso and of course Malevich, Mondrian and others, and that none of them ever had a proper chance to exercise their talents there.

In the last twenty years or so attitudes have changed a bit and the idea of inviting an artist to think about transforming a square or putting up a work in the street is part of this new reality, of this new field of exploration that was so

long denied to artists and offered almost exclusively to architects.

The mentality of architects – who have generally been very hostile to the visual arts throughout our century – has also changed a great deal in this respect over the last twenty years. After a century of sequestration it has again been possible to invite the artist to leave the museum.

This intramural imprisonment which was at first extremely positive – allowing the avant-garde to take form, acquire a relative freedom, enabling the development of a specific market for the exchange of works, establishing a dialogue between artists and art lovers, etc. – began, from about World War II, to produce more defects than advantages: the avant-garde gradually, and then blatantly, became institutionalized, fossilized, and freedom of invention was slowly replaced by a frantic hunt for cheap tricks, while the dialogue even with the specialist public has narrowed to become, at best, a dialogue between artists and art magazine specialists, and so on.

I hope readers will forgive me if I do not go further into the advantages and perversities of the museum, but what I am trying to say is that the habit artists have got into over more than a hundred years, of working, consciously or not, for a specific and sometimes and enlightened public, that of the museum, has caused it to become drastically cut off from a public that could be just as enlightened but is not specialist, and which, above all, has never received any artistic education.

Stating a truism

In the street, the artist suddenly finds himself confronted with this reality. This reality changes everything.

It is not a joyous state of affairs and there is no way that, when the work is put up, this education which has never taken place can suddenly happen overnight because of it.

Education, whether in art or anything else, has nothing to do with spontaneous revelations of miracles.

It may be a shame but that's the way it is!

It's a question of means. Often, the modern work of art is too far down the road to be accurately perceived by all.

These are the facts. However sad and difficult this reality, it does not allow us to draw hasty conclusions of the kind to be heard here and there, like saying that the answer is to go back to an easier, more - wait for it - figurative form of art, one more likely to please the "general public". That is a total misinterpretation of my analysis. To note the failings of an educational system does not mean - except for the demagogues - that you have to regress a bit more in order to satisfy the majority or take your cue from the general mediocrity.

The growing illiteracy observed in the developed world cannot be remedied by going back to the Stone Age on the grounds that, since no one can read or write, the shift would make everyone feel better.

Apart from being a truism, stating that artistic explorations are not in synch with the general public certainly doesn't mean that, to bring the two closer together, we should put "skill" back at the heart of our concerns, as eminent intellectual reactionaries such as the sinister Jean Clair declared we should. He, in fact, is one of those learned characters who are incapable of recognizing the real talent and incredible know-how of most of today's modern and contemporary artists, who have no reason to feel inadequate and have no need to be told what to do.

What he and his sidekicks want - and will never get - is a return to the status quo ante.

In other words, the future they promote is just nostalgia.

However, this total lack of public visual education, in the widest sense, is not only a rather grim fact but can also become a burden and a negative force which is often difficult to avoid and oscillates between totally paralyzing inertia and the most extreme violence with regard to all visual undertakings that are in some way innovative, whenever they try to express themselves in public.

The street is not home territory

That is why the original, marginal and solitary attitude developed by Western artists as a result of a more than century-old tradition needs to be called into question by the artists themselves, if they really do want to take to the streets.

The things an artist can do in a system of complicity (the Museum) - even when the environment is hostile - become much less simple in an unprepared system (the street), even if there are those who may provide support.

To take works out of the museum and set them up in public space, in a place they weren't made for or, even worse, to take the same liberties in the street as are allowed in the museum, under its protection, is in my opinion to court immediate failure and, on top of that, to show an artistic attitude that is completely regressive, incoherent and pathological.

The street is not home territory. At best, it is a territory to be tamed, to do which you need other weapons than those forged over the century in the sometimes complacent habits of the museum.

Revisions and reorientations

It is, in my opinion, precisely because he failed to understand the nature of the leap to be made between the logic that makes it possible to work in the museum and the completely different logic that controls the street, that Richard Serra was unable to preserve his work as and where it was in New York.

Only if he makes a considerable effort can the artist overleap this major contradiction which

consists in not letting himself down in the outdoor arena while being aware that the experiments undertaken in the indoor world, especially the best ones, cannot be reproduced as such outside.

The artistic history of our century, however rich and innovative, is at one with the history of museums and the great private collections.

It cannot be perpetuated or take root, just like that, extramurally.

For lack of opportunity, work in public space has been unable to establish itself, or to set up any kind of dialog with the public, or with its own history.

The current vogue for it – while it can be compared to periods when it was common for the architect and artist (who were often the same person) to work together on the urban environment – is wholly a contemporary phenomenon.

New parameters call for new solutions, new approaches. Art in the street? Why not?! But only if it is totally rethought, revised and re-oriented.

In other words, if it keeps taking to the street, can art at last get down from its pedestal and rise to street level and show itself there?

It would be a mistake to suggest that there is a kind of equality between the museum and the street.

They have little in common. And a lot of differences.

Habits and attitudes

These opposing terms can help us understand in a relevant way what in fact characterizes both of them.

What is it that allows one thing to be done in the first situation and something completely different in the second? The two are diametrically opposed. The search for greater freedom continually pushes back the limits in the museum, whereas it faces the most Draconian constraints in the street.

This simple example alone should suffice to make us realize what a change of habits and attitudes the artist needs to undergo if he wants to create art worthy of that name, i.e., something that is both innovative and uncompromising, in a public place.

On the one hand, this work will be judged by its rightness and talent and the vigor with which it makes use of its freedom in order to reveal to the beholder a new form, a new way of thinking about painting or sculpture, and the way it carries out its struggle against the elements.

On the other hand, the gifts that must be utilized to be worthy of this freedom allowed only after a great struggle, are suddenly no longer good for much besides leading you to make the stupidest mistakes.

Even though in the first case this attitude allows you to achieve excellent results and even though it is hardly applicable at all in the second, still there can be no question of giving up and employing these gifts in the service of mediocrity, or what's worse, demagogy, which would be all that would be allowed in public places!

The history of Western art for the last century has been characterized by a swarm of questions coming from all directions, including questions concerning art itself, its meaning, its aims, its necessity.

The question of the object has also often been posed.

Finally, among these rather diverse questions there is one that is particularly insistent and that pushes the limits further and further (or less and less far, depending on one's views), and that is the question of beauty.

Some people think that twentieth-century art has denied this concern.

When they talk about it, they express a certain aggressiveness towards the art in question, and at the same time, a certain nostalgia for the art of previous centuries that they find

more appetizing, or, in a word, more beautiful, because it is more in tune with their conception of beauty.

An inventive, attentive, active way of seeing

Of course there's an enormous amount that could be said about these questions.

I'd just like to say that there is certainly as much beauty in twentieth-century art as in that of previous centuries, but that with all the various schools and the differences between individual artists there has been not only a certain drift but even a scattering in terms of the criteria by which it is judged.

The initial result of this explosion has been a sense of disorientation and especially a loss of the canons that enabled people to find their bearings more easily in previous centuries.

In those days everyone followed those canons and so your talent could be judged almost objectively.

If someone did depart from them, the rightness or wrongness of that could also be judged.

Nothing like this is possible in our time. The viewer is at a loss.

In judging what they see, viewers can no longer use the yardstick of a more or less well-defined and respected set of rules. All they have is their own unique and direct way of relating their own consciousness, their own conception of beauty, their own culture, their own knowledge, on the one hand, and on the other, the corresponding attributes of the person who does the painting, who produces the artwork, their approach, their qualities and their situation in the context of their times. There is no explicit rule that can help.

At the same time, the viewer's intuition is not enough. Neither is their knowledge.

Viewers have to invent, to grope their way forward. They have to invent their own road just as the artist also seeks to find his or her own way. This quest on the part of both the viewer and the artist is doubtless one of the main lessons of twentieth-century art.

More than ever it requires an inventive, attentive, active way of looking. If they are armed with these qualities, even viewers who are not well educated and not specialists can begin to see clearly.

I believe it indisputable that even if beauty is no longer the primary aim of art, beauty certainly continues to exist. I even think that in this century's best work its presence is more strongly felt than ever before, just because it is unexpected.

It can also be present for lack of explicit intention. Startlingly present as if it had broken in.

The concept of beauty

In this regard, we could ask what it is that defines this beauty, assuming that is what we perceive.

If for more than a hundred years artists have called beauty into question by pretending to avoid it, or proudly to overlook it, to a large extent this is because they have been in a position to skip this question in a formal sense. For in fact it has been posed by the very structure of the museum itself. After all it is the museum that houses the artwork and that for centuries has had as its principal function the collection of beauty in all its forms.

When you see all those crazy collections stuck away in museums, the pell-mell piles of objects from all over, all kinds, from every century and every civilization, then you realize that the only thing that links together all this deluxe bric-a-brac, all these eclectic objects, is a diffuse but profound concept of beauty.

When the art of the twentieth century – that some people pejoratively call incoherent formal bric-a-brac – is added to that of previous centuries and civilizations, when it's stuck in the same receptacles, the same museums, how could we imagine for a minute that these insti-

tutions have suddenly lost their principal function, that of showing us, via successive selections and judicious choices, fragments and even complete ensembles of beauty?

No matter what, modern art cannot get away from this programmed beauty, especially because more than any previous art it is inseparably linked to the concept of the museum.

And therefore to the concept of beauty, even though, ironically no doubt, it has never ceased to deny that concept's importance.

This is exactly why certain artists, throughout the course of the twentieth century, thanks to that freedom I mentioned before, have never hesitated, and still do not hesitate, to wage open warfare against beauty precisely insofar as it is recognized and accepted.

In fact, while the majority of artists, including some of this century's most important, do not seem to have considered beauty one of their main concerns, others, also including some of the best, have sought to decapitate it.

So we can see that for most artists, whether they have proclaimed their indifference to beauty or declared war against it, consciously or unconsciously beauty remains a core concern.

Intrinsic ugliness

Aren't these two attitudes usually formulated differently, though with exactly the same meaning, when it is said that the twentieth century has been marked by two camps, the proponents of art and the proponents of anti-art?

Isn't "the death of art" or painting just a short-cut way of referring to, without naming it, the death of the question of beauty in art?

When people talk about the death of art, aren't they in fact speaking about the death of beauty as a goal?

However that may be, my point here is not to take one side or the other, especially since very often it is impossible to tell the difference between the intrinsic quality and even the beauty of work done by artists indifferent to the idea of beauty, and the work done by others whose attitude toward that concept is more aggressive.

What I find interesting here is the one-upmanship with regard to non-beauty that museums have allowed, exactly because of these two implicit concepts on which their ideology is in part founded and which I discussed before, namely freedom (the freedom of those who are invited) and beauty (of that which is exhibited).

The freedom granted those who are invited allows them to take their questioning as far as possible.

When it comes to things that are shown in a place called a "museum", the concept of beauty is so powerful that it allows artists to constantly kick against its limits, knowing full well, of course, that if these limits are pushed too far then sooner or later the offender will be ejected.

If that doesn't happen, that only means that the artist has been able to prove that the limits of the acceptable and the surprises of beauty can be pushed even further, and that once again the museum has played its role of defining new criteria, and even new canons.

As part of this little game, they started allowing intrinsic ugliness into the museum years ago. What does this mean? It's very simple.

In bad taste

If you want to be able to develop a discourse about beauty, you have to be able to do the same about ugliness.

Thus the museum is the vehicle of both, the one clarifying the other, or if you like, rejecting the other.

In general museums only keep things that are beautiful, or, to be more exact, things that through being in a museum become so.

The museum rejects that which resists it and

which it cannot assimilate or transform and thus sends it back to whence it came, the domain of ugliness, which is also the domain of oblivion.

If the museum accepts only beauty, the opposition artist says to himself, let's feed them kitsch and see how that goes down. If artists can force kitsch on the museum – and we all know that kitsch is exactly what an awful lot of artworks are – that is in a way an affirmation of their freedom in the face of the tyranny of beauty, and even more in the face of the tyranny of good taste, which is even more clearly in power. So let's not only do kitsch, let's do bad taste.

If the museum preaches refinement, obscenity and scatology must be forced on it immediately as an antidote.

If the museum preaches high culture, then it must made to throw it up by forcing pulp fiction and urinal graffiti down its throat. Ladies and gentlemen, Art Brut.

If the museum exalts the sublime, let's respond immediately with the anecdotal.

If the museum seeks meaning, let's spatter it with vacuous works.

If it preaches the art of reason, let's force the art of madness on it.

In a museum, you can not only challenge beauty with another beauty; you can also challenge it by ignoring it. You can also make a conscious attempt to bring it into being, as was done in the past, and finally you can challenge it with ugliness.

All these means are possible, all are ready for battle and all are employed, and there are others that have been or will be.

Here we have a discourse that, even if it is now extremely well known, can as a system still lead to positions being taken, to very fruitful investigations and to positive polemics.

Some of these polemics shed light on the state of society at a given moment, and others are

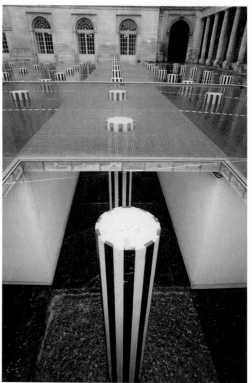

Daniel Buren: *Les deux plateaux*, June 1986, cour d'honneur of Palais-Royal, Paris

even more fascinating because of the master-pieces they make it possible to produce through the process of contradiction.

Exposed images

This rather short excursion through the concept of beauty in the realm of the museum is an attempt to show that this concept is at the core of the system. The uninterrupted discourse that it allows – including the rejection of beauty – even if not always cause for enthusiasm, is intrinsic to the very existence of the museum and would have no real role without it.

This means that while there is a certain legitimacy to bringing "indifference to beauty" or even "intrinsic ugliness" into the museum, and while these attitudes constantly resuscitate the debate on beauty in art, like a series of electric shocks to the heart, there is reason to doubt that there would be much point to pursuing such a debate in the wider world.

Earlier I said that if the discourse on beauty is still a part of the museum, even in the twentieth century, despite the fact that this concept does not seem to have always been at the heart of the concerns of the artists who have marked this century, it is because the museum is the depository of the beautiful and the very site where it is judged, defined and endlessly redefined.

Would any other context allow a similar discourse, and, for starters, would the public square or the street allow it?

One may certainly not like it but today at any rate the only answer is a categorical no. Especially when it comes to twentieth-century cities where, with the exception of a handful of neighborhoods and other places, the most arrogant ugliness predominates.

Of course this does not mean that these same cities do not exercise an unrivaled fascination.

You could almost go so far as to say that especially in this second half of the twentieth century, what's happening in the streets is an omnipresent discourse on ugliness.

Deliberately piling ugliness on top of ugliness

The ugliness of consumer culture that little by little is conquering the entire planet and imposing its laws, the ugliness of advertising whose images have become our daily bread, the ugliness of housing and other buildings, the ugliness of urban furnishings in general, the ugliness of the endless, soulless, stereotypical suburbs that stretch from Seoul to Paris to New York to Bangkok to Johannesburg by way of Tokyo, Hamburg, Athens, Istanbul, Rome and London.

In this context, dominated by vulgarity, gigantism, kitsch, filth, disharmony, chaos, pollution and stress, should we add yet more kitsch or gigantism or ugliness to this ugliness, with the excuse of continuing, this time outdoors, the same old discourse that we referred to before, that began in the museum?

Would this discourse that was so richly meaningful in the museum still make any sense at all in the street? Can the artist, outdoors, consciously pile ugliness on top of ugliness?

My answer is no. Categorically no.

Further, as we know all too well, this discourse of ugliness is already being taken up with great enthusiasm by dozens of other constituents of life in the city.

Above all by the architecture, almost all of it, and the other elements that make up the backdrop of daily life (street lights, benches, trash cans), as well as all the various kinds of advertising (neon signs, billboards both stationary and moving, advertising pictures and slogans, etc.) and the automobile traffic (polluting, noisy, dangerous, etc.). Their excesses make the city more and more unliveable and soon will make it completely unmanageable.

Garden gnomes on parade

The other side of this description which, though certainly not very attractive, does absolutely need to be mentioned and understood, is that it has inspired and continues to inspire a good number of artists, of no mean stature, and that with the aid of these artists and their discourse on beauty, whole fragments of urban objects such as those cited above have already entered the museum in the form of artworks.

As said before, these objects challenge the museum's ability to integrate them, and play on their characteristics as both familiar and vulgar objects in order to try and elevate themselves to the status of artworks. We should keep in mind that they also suggest a critique of the society that produces such objects.

Ever since Marcel Duchamp the examples of this have been so numerous that they would more than fill all the pages in this catalog.

So we can understand why it makes sense that these urban objects, whether they be banal, beautiful, vulgar, big, little, eye-catching or hideous, should be in the museum, exactly because they possess these characteristics, and why the museum sometimes endows them with a certain sacred quality even though they make the city uglier. But it would be a very safe bet that if they were "set loose" in their place of origin, the "beauty" conferred on them by the museum, a beauty that is very often associated with critical inquiry, would suddenly vanish.

If it was relatively easy to give meaning to these objects and signs by extracting them from their context and to validate them by exhibiting them completely separated from their original functions in the context of a museum, we already know for sure that the reverse situation would have no effect whatsoever except to reproduce the original effect. It would obliterate all their previous meanings, including, as a start, their critical meaning.

For example, why not display lawn jockeys in a museum? The gesture would certainly not go unnoticed.

A whole discourse about them could be elaborated and it could be recognized that such a presentation would amount to a critique of society, its good or bad taste.

These lawn jockeys could unleash all sorts of disputes and leave no one indifferent.

There would be a certain pedagogy in this kind of approach.

But if they were put on exhibition now, following a public commission, for example, in a public park or garden, the analysis that would be made of all this would certainly be less ambiguous.

At first a few visitors, the most sophisticated, would find such an exhibition in rather bad taste, or even a bit naive, since lawn jockeys are known to represent the heights of a kind of bad taste that is considered stupid.

Afterwards, especially if it were known that these pieces were the work of an artist (which would not be self-evident), as a purely demagogic gesture this would promote the placing of lawn jockeys on all the world's lawns as a the *ne plus ultra* of art in the home environment.

It would be a safe bet that such an "artwork" would attract even more support and backing from the broad public than any work by Richard Serra or Brancusi ever could.

In the street, that which in the museum had represented the establishment of a dialog with other works of art, a tolerable curiosity or even a necessity, would become unacceptable and degrading. There would be no ambiguity because it would demagogically flatter a poorly educated majority that has already flocked to such ornaments with the greatest satisfaction.

If such an approach would make the politicians who took it up intolerable and dangerous for democracy, it becomes certainly less dangerous when promoted by artists in the domain of art but is still completely odious.

The history of art in the city

What I am saying is that the habits associated with showing artworks and producing them for the museum and its public for more than a hundred years have created a tradition, knee-jerk reactions and a set of games in a very particular context, and at the same time created an unparalleled stretch of art history, especially in the first three-quarters of the twentieth century, but it would be wrong to believe that all this could be perpetuated in an urban setting, in the streets, without being called completely into question.

To work for the street is to challenge more than a hundred years of the production of art for the museum. It also means the artist coming down from his pedestal.

For the artist, it means daring to take this risk and to accept being humble.

It means learning how to think and work all over again.

When before I emphasized the example of the concept of beauty, I sought to show that since this concept is physically and culturally omnipresent in the museum, we can afford the luxury – as artists – of not bothering with it.

Is this luxury possible in the streets? I don't think so because this problem cannot be seriously dealt with in the streets.

In the museum, we are immediately and automatically confronted, spiritually, culturally and palpably, with beauty.

In the street, ugliness lurks at every step.

If that were the only difference between a work of art in the museum and a work of art in the street, it would still be enough to make those who are involved in these two domains understand that the same attitude be the same effect in both situations.

While it is true that there was once a time when the artist who worked in the street was in perfect accord with his environment, his culture, his public and his epoch, today that time is long gone.

This is above all because for the last several hundred years the artist has been excluded from the city.

The history of art in the city has been brought to a complete halt and replaced by another, hegemonic history, that of the museum.

A kitsch and even banal object

By separating genres and activities into little ghettoes or interest groups, by specializing the whole world to the point of insanity, we have succeeded in creating architects who are hardly ever artists, artists who are never architects anymore, painters who are not sculptors and sculptors who don't know anything about painting!

To introduce into the street that which developed in the museum and gallery and flows from that specific history would be ridiculous.

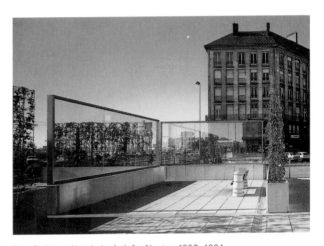

Dan Graham: *New Labyrinth for Nantes*, 1992–1994, wooden bridges and stairs, glass and one-way mirror glass, aluminum frame, concrete slabs and tubs, ivy, wooden trellis for climbing plants, dimensions of square 32 x 64 m

Yet with the recent reappearance of public commissions, this approach has become a daily occurrence. It goes along with what I was talking about before, this juxtaposing of a mediocre piece with a mediocre environment.

At various sites a kitsch or even banal object or one that is well executed in a deliberately ugly way is left to melt into the ambient ugliness.

In any case, things that might still be astonishing in a museum are no longer astonishing at all in the street. It is no longer a question of added value but of added ugliness, and like value it should be taxed.

The "new town" style

When an artist like Dan Graham, a student of vernacular architectures and an attentive reader of Venturi, becomes interested in the repetitive architecture of the greater New York suburbs or the bus stop shelters that inspire some of his work, when Dan Graham, as I was saying, introduces work of this type into a museum or gallery, he has a lot to say about our environment and emphasizes its outdatedness by, for example, letting grass grow in the Marian Goodman Gallery in New York.

But when Graham uses the same reasoning, the same approach, for something like his piece entitled *Nouveau labyrinthe pour Nantes* in that city's Place du Commandant Lherminier, what does this contribute? The work is neat and clean and we can be sure when the ivy ensconced between two sheets of glass grows in completely, the walls will be even more reflective than they are today.

The materials used, the arrangements of the orthogonal glass/ivy walls and their relationships to one another, the material used for the clamp that holds the walls to the ground and its design, the materials of which the ground itself is made, the urban objects that seem out of place in the work but are strewn throughout it, the immediate environment with its insipid buildings that are half imitations of older styles and half neutral and soulless postmodernism – all make up an ensemble that turns out to be almost identical to what we see flourishing all over France and that constitutes the general style, interchangeable and international from North to South and from East to West, that we could call "new town".

So when you know that Graham is fascinated by this phenomenon of the "new town" in the US, Japan and Europe, you could think that this site in Nantes is the ideal environment for his work.

That would amount to believing that something that is interesting in a spite specific to art could be equally so, without the slightest change, in the site that inspired it!

The discourse about banality and mediocrity that is sustained in an art gallery or museum, if it is well done, as is the case with Graham, is sharp, disturbing and even critical in regard to this mediocrity. When it is transposed into the streets, and what's more, into an environment where mediocrity is the currency and cannot be challenged with the mediocrity-versus-mediocrity strategy, then that critical discourse breaks down because it fits neatly into its model and is thus destroyed.

Further, an aesthetic that is deliberately borrowed from our daily environment, materials and all, can no longer play off against the contrasting gleaming ambience of the gallery and the museum.

The result is that it is a safe bet that no one would notice the slightest difference between Graham's *Nouveau labyrinthe pour Nantes* and the standard Decaux company bus stop shelters seen everywhere in France.

Graham himself recognized this problem when in the course of an interview he was giving to *Libération* (March 8, 1994) he wondered if his works in public places "lose their edge".

A work that is amazing in a museum can become invisible in the streets. What stands out from everything around it in one context is indistinguishable from everything else in another.

Visual interference

This brings us to another, crucial argument that should be added to those I have already laid out about the irreconcilable differences that make it impossible to go from the field of the museum to the urban field as if they constituted the same single terrain, and that is an argument concerning the physical and formal environment.

By this I mean the architectural envelope, the physical and formal framework in which the artwork – any artwork – is presented, installed, set up, hung, insinuated, displayed, deployed, admired, criticized, contemplated, exhibited, etc.

In a museum it can be said – in a shorthand sense – that in most cases the object is shown by itself and is the focus of everyone's attention.

For more than thirty years and in dozens of texts and above all in hundreds of particular works, I have developed a comprehensive understanding of such venues (museums, galleries) and their pseudo-neutrality as sites for receiving art.

That said, unless architects decide to use it as a way of permanently exhibiting their own architecture, which is happening more and more, the museum's principal architectural function is to make every effort to facilitate the reading of the artwork, by itself, to allow it to pontificate in majestic solitude, free of any visual interference that could disturb it, as if the physical, worldly envelope of the museum had suddenly disappeared.

The museum's duty is to offer the ideal framework for reading art, so ideal that some people find it easy to claim that the museum is cut off from real life, and that consequently artworks shown there are profoundly detached from it too.

Visual polluters

In the streets the change of scenery is radical.

It could be said, also in a shorthand sense, that visual pollution is at full blast.

There is nothing either in the conception of these new towns or in the environment that they provide that is conducive to the reception of art.

Under these conditions, to attract attention to a specific object becomes a high-wire act!

It becomes easier to understand why some people decide to place their work at the limits of the visible and the noticeable so as to escape that unacceptable visual pollution.

This is how they preserve appearances. In other words, the appearances of their own work that remains unseen, much to the benefit of the visual polluters of the environment who thus no longer have anyone in the way of their hegemonic projects.

Further, the only ones able to notice the "discreet presence" of these artworks are the same kind of people who already frequent museums and are thus able to distinguish themselves from the vulgar pedestrian who doesn't see anything there at all.

In this way the visual appearance of the city continues to be constructed and constituted without artists, and the omnipresent mediocrity of architecture, accompanied by aggressive advertising, continues to promote consumer culture and its invasive vulgarity.

What the museum allows art, the street refuses. The visual competition is brisk.

Whereas in the museum an artwork can assert itself by its mere presence, freed of all excessive interference, outdoors it is faced with the problem of how to assert itself amid an extreme visual interference.

In the streets this visual interference exists under any conceivable circumstances. It can be of varying intensity, and encompasses a spectrum that goes from the most attractive archi-

tectural jewel-box to the postmodernist, international style billboard-covered disaster that is now all too common.

The autonomy of the artwork

This differentiation between the museum and the street as venues for art brings us to a question that has interested me for quite some time, that of the autonomy of the artwork.

These two contradictory environments very clearly indicate what the real deal is as far as the autonomy of artworks is concerned.

While the dominant discourse in the West regarding the defense and the excellence of the autonomy of artworks can occasionally be defended in the museum, which is almost exclusively where the history of art has unfolded in the twentieth century (an autonomy I have tried to challenge since 1967, when I first realized the fundamental importance of the exhibition site), there is one place where such a philosophy becomes totally absurd; the urban environment.

The autonomy of the museum is completely artificial, thanks to the isolation that surrounds each artwork.

This artificiality is what I'm trying to expose. I want to explain what exactly is the deal with the reality of the museum as a space, to demonstrate step by step why the museum is not neutral, and how, for example, its architectural artificiality expresses and reinforces the dominant discourse regarding the defense of the autonomy of the artwork.

My analysis of this thinking has allowed me to take a position and do the work that people know, by stating that – as far as I'm concerned, of course – the autonomy of the artwork is an illusion and does not exist as far as my own work is concerned.

Of course I believe that no artwork can ever be autonomous anywhere, but I won't go into that subject today!

I'd add that when the museum does its work perfectly – which is very rare – it can achieve the illusion that the artworks exhibited really are autonomous.

No artwork is autonomous

This problem does not even come up in the streets.

No artwork is autonomous.

Everything that is exhibited in the open air is dependent on that air, all the more so when, in the city, that air is polluted in many ways.

What I find interesting about this concept of autonomy is that the people who defend it could obviously find fault with my work as long as they remain in the museum.

But on the other hand if they were try to leave it, they would have to at least revise their position, or else they would never show their work outside.

In my view, one of the merits of public places is that they completely wipe out all the shibboleths about any autonomy of the artworks that are shown there.

With the end of the isolation of the artwork, the heterogeneity of any whole must be accepted.

At best, the museum promotes the masterpiece of pure beauty.

At best, in the streets, in the public squares, the most beautiful artwork cannot be anything more than a mongrel masterpiece.

Also for this same reason, when it comes to public space a new history must be written.

In any case, we have to take up and try to resolve the problems posed by the existing (or destined to exist) architectural environment in relation to a given artwork that is to be integrated into it.

No matter what the artwork in itself may be like, now it is part of a whole; no longer is it above the whole thing as it was in the museum.

Further, the study of this environment and the state it is in forces us to take up once again –

and this time in a totally conscious way and not a posteriori – the question and the meaning of the concept of beauty, today, in public places.

The worn-out eye

Finally, the study of this environment makes us conscious of the wear and tear suffered by our gaze, a fatigue that affects all artworks in an urban setting.

This wear is beyond anything that could be compared to its equivalent in the museum.

Curators are quite familiar with this problem and to alleviate it, they often decide to move the artworks in a museum's permanent collection from room to room every year, precisely in order to avoid a situation in which the display becomes tiresomely familiar to frequent visitors.

The situation is completely different in the streets.

First of all, the averagely pedestrian pays far less attention to his surroundings than what is expected of the average attentive museum visitor. When someone is walking down the street it is not usually for the purpose of gazing around but rather to get from A to B as quickly as possible.

Further, if the pedestrian in question passes by the same places every day on his way to work, for example, then even aside from the question of his normal degree of attentiveness, by dint of following exactly the same route every day his attitude towards the things that mark it will certainly be one of indifference.

But don't museum guards also fall victim to this wearing down of the eye, just because they are used to always seeing the same works in the same position hundreds of times every day?

That said, this fatigue clearly occurs much more quickly in the street, where it is accentuated by the eclectic visual bombardment that constantly assails the pedestrian. In order not to completely lose sight of his reason for being there in the first place, he must make a neces-sary selection from among the visual demands placed on him, so that a host of objects, signals, architectures and other urban objects that are not absolutely necessary to finding his way disappear – out of his mind and thus out of his sight.

One measure of the degree to which our gaze becomes inured to things we see every day and sometimes many times a day is what happens when among all these urban objects one thing, such as an artwork, for example, or a street-light, disappears, or is removed.

We notice that something familiar isn't there anymore, but few people, among the thousands that pass by that place every day, could tell you what disappeared and still less could they describe it to you.

We know that there used to be something there, with a certain form, but what did it look like? Its content has disappeared.

This is a sign of a worn-out eye.

It is because of this same extremely pernicious wear that we get used to the worst kinds of ugliness and the other visual incongruities that are invading the city and the countryside.

It is this visual wear that entails a laziness of thought and a getting used to mediocrity and even vulgarity. It is the driving force behind the fury of those who react violently every time a new intrusion of art into the city is suggested.

Perhaps they are afraid that it might wake them up?

Worse yet, perhaps what they really fear is that it might wake up exactly those people whom it is their job to keep asleep!

The site specific work

Another point that some people may have already guessed, and that to my mind is even more interesting in the street than it is in the context of the museum, is the following: should public places allow only those artworks that were conceived for an exact spot and that link

up very particularly with this specific environment, either positively or negatively?

I am referring, of course, to site specific works.

The characteristics of the site specific work as I understand them are fundamental here and they are the only thing that offers some hope of success to the placement of artworks in an urban space.

Site specific work is the only kind where all the existing parameters can be taken into account and the work can be planned on the basis of that analysis.

Only site specific work can allow the constraints inherent in every venue to be intelligently surmounted.

Finally, it is the condition sine qua non for being able to show that by studying and working for a specific available place, the site specific work and only the site specific work make it possible to transform that place.

The question avoided

How can the surrounding visual pollution be incorporated into a work commissioned for a particular urban setting? What would it cost the artwork in question to accept this challenge? What is there of beauty in those surroundings? How can be it accessed? How can it be shared? This question so long avoided thanks to a context propitious for its omission – the omnipresence of the museum as the sole venue for art in the West – is suddenly and urgently reemerging at this turn of the century.

This question brings with it all the others.

Whom are we addressing in the street? What can we allow ourselves to do? What will the street allow us to do? What is being asked for? Is it necessary? Under what conditions should such a commission be accepted? To do what? When is it too late?

The *Skulptur. Projekte in Münster*

After having insisted on the differences, which to my way of thinking are fatal, between art for the museum and art for the city, and what this implies in terms of the artist's obligations, which above all means a profound change of attitude, I'd like to end with a few observations on the current exhibition in the city of Münster that may seem to partially contradict everything I've just said!

Actually, here in Münster we are in a paradoxical situation in regard to art in public places in general and this is why there is a contradiction between what I've just said and what is going on right now in the streets of Münster.

To see this contradiction in perspective, first of all we must realize that what we are talking about here is an exhibition organized by museum people who are considered by others in their profession to be eminent specialists, experienced in designing major·solo and group shows.

The essential difference between this exhibition and all other museum exhibitions lies in the fact that instead of being intramural, i.e., taking place within the confines of the museum, it is taking place extramurally, throughout the city of Münster.

The other difference between this and the usual "public commission" is that the works done here are ephemeral by definition.

This difference alone indicates that this is not at all the usual situation of the artwork that is made to be erected in public space.

In fact, a great many of the serious and sometimes insurmountable problems that face artworks done for public places are rooted in the fact that these works are to be permanent and not ephemeral. Ironically, that permanence is not reassuring but threatening.

When an ephemeral work is placed in the streets, even the most skeptical can let themselves be convinced.

All you have to do is to tell them that their suffering won't last for long – just as long as it takes for one exhibition!

This restriction alone is surely what has made it possible to erect more than three-quarters of the pieces included in this third Skulptur Projekte.

At the beginning of this text, I tried to redefine the designations used for intramural and extramural art exhibitions. For example, for a public commission, I would say, "Permanent exhibition in the street".

For a solo exhibition, I would say, "Ephemeral public commission in a museum".

I'd add the following designation for the Münster show: "Ephemeral exhibition in the streets commissioned by a museum. "

In vivo

This is why my analysis might seem to be contradicted by a number of the works this exhibition makes possible.

This contradiction disappears when you realize that this exhibition is not about "public commissions" but rather a group exhibition bringing together the work of some 70 contemporary artists.

This is why I suggest that we pay close attention to the context. To all contexts. To what they allow, what they don't allow, what they hide and what they bring out.

The highly unusual context of the Münster show makes it possible to carry out, with the kind of freedom usually available only in a museum, that is, without any direct untoward consequences, a number of live, full scale and site specific experiments in the streets. During the three months of this exhibition the city of Münster will become an enormous open-air museum, open to contemporary art and, as far as possible, to all kinds of fantasies and experiments.

This does not mean that such an exhibition can be organized in the same way as the usual exhibition within the walls of a museum.

Even though it is the organizers of this show, museum officials, who do the advance work, still the possibility of carrying out these projects, in other words, getting the necessary permission for these artworks, does not depend exclusively on them.

There must also be a go-ahead given by government and the other authorities that run the city. We have already seen that this "detail" makes a big difference in comparison with usual workings of an exhibition in a museum, where the director holds uncontested sway.

Usually the director doesn't need the agreement of the political authorities for the artists who are invited to be able to carry out their projects.

In fact, here we find ourselves between two stools, between the ephemeral exhibition in a museum where everything or nearly everything is permitted, and a permanent exhibition in the street where almost nothing is possible!

So we can consider Münster a proving ground where some experiments that could be considered "museum" can go beyond the bounds of the museum and express themselves in the public space insofar as the whole city has become a temporary museum.

Everyone in town knows about it and no one will be caught unaware.

Such an exhibition on a city-wide scale makes it possible to experiment and measure the reactions of the inhabitants and their degree of tolerance (insofar as the necessary data is gathered).

Insofar as this is now the third time in twenty years that this experiment has been carried out in this city, it would also be interesting to evaluate the population's understanding of contemporary art and the evolution of that understanding as a result of the education provided by the last two experiments. It could also be said that

a broad dialog has been established, making it possible for subtle and very discreet works to receive attention, even though here they are not reserved for a chosen few (as is the case with a permanent public commission).

Clearly, the degree of tolerance with regard to contemporary art manifested by the authorities and the majority of the population has made great progress in the last twenty years.

It can be said that here a broad public has seen contemporary art because contemporary art has been shown publicly.

So the Skulptur Projekte is an unusual experience that has made it possible to raise a great number of people's awareness of contemporary artworks in public places.

At the same time, this exhibition is taking place in conditions far different than what art usually encounters when it tries to get into the city.

Here we are not talking about a public commission in the literal sense.

The point is

The point throughout this text is that getting art into public places is something that interests me greatly.

The point is also that it is not so easy to produce a work of art under the physical, political and economic conditions in which most cities find themselves today.

The point is also that there are very tight constraints and we can neither ignore them nor give in to them slavishly!

The point is that the unlimited freedom given the artist in the museum no longer obtains in the street.

The point is that anyone who wants to do art for the streets should shed their arrogance and replace it with humility.

The point is also that the artist should leave solitude behind, get together with other competent people and accept them in order to carry out his or her projects.

The point is that artists who work for public spaces will often have to share their skill and the validation of the artwork.

The point is that more than a hundred years of experience in museums all over the world cannot be fully repeated in public spaces, nor can it be simply continued there without a profound change in our habits of thinking and acting.

The point is that public space is now a disaster area and we can't ask artists worthy of the name to try and paint over the cracks, repaint the peeling walls, hide a hideous architecture or glue it all back together again.

The point is that in some cases it is too late.

The point is that the great humility I spoke of before should go hand in hand with a great responsibility, not only in terms of artists accepting that responsibility but also in terms of greater confidence being placed in them.

The point is that artists cannot be used to contribute a tiny bit of the necessary awareness of today's disastrous and totally dehumanized urban conditions when that awareness is totally lacking.

The point is that on the contrary what artists can contribute to the city is an extra drop of soul, if they are given substantial projects.

The point is that if the enterprise of modern art is being asphyxiated in the museum, it can find the air it needs in the streets.

The point is that the lack of maintenance for public art is an act of disguised official vandalism. The point is that with public commissions the concept of site specific work as I understand it becomes fully meaningful.

The point is that when it comes to art in public space there is work to do before, during and after, long after!

The point is that in the city politics and economics are involved in everything.

The point is that without a doubt doing a successful artwork for a public place is like successfully squaring a circle.

The point is that for public art to regain its rightful title and flourish, the return of the concept of beauty must be on the agenda.

Finally, the point is that the public art today that I'm talking about and that I'm interested in has nothing to do with setting up, here and there around the planet, according to the desiderata of a handful of people, and under the cover of contemporary art in all its forms, except for humor, the 357,000th *Manneken Piss*.

Finished at Procida, March 1, 1997

Contributions to *Skulptur Ausstellung in Münster 1977*
and to *Skulptur Projekte in Münster 1987*

Skulptur Ausstellung in Münster 1977

1. Museum
2. Carl Andre
 Michael Asher, 19 positions
1. Joseph Beuys
3. **Donald Judd**
4. Richard Long
 Bruce Nauman, not realized
5. Claes Oldenburg
6. Ulrich Rückriem
7. Richard Serra

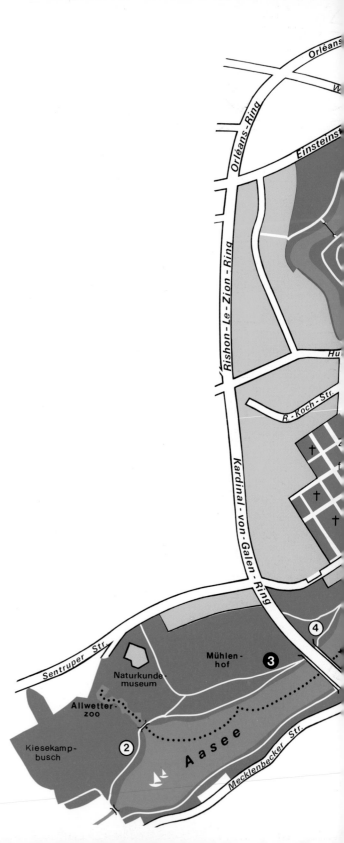

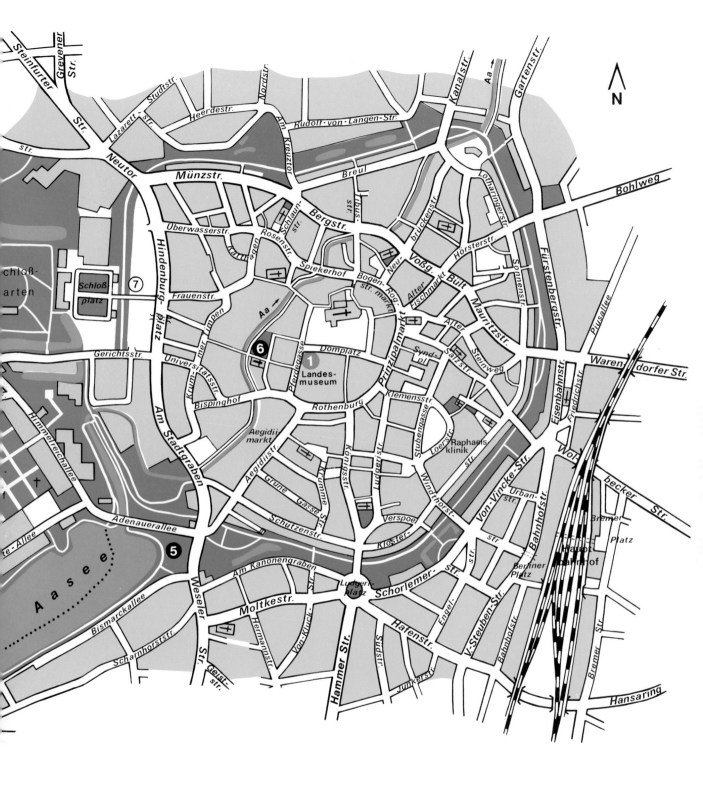

July 3 – November 13, 1977

Michael Asher
Born 1943 in Los Angeles, lives there
Installation Münster
Caravan in changing locations
19 different sites in and around Münster
Temporary installation during the
exhibition
See contributions to *Skulptur Projekte in
Münster 1987* and *Skulptur. Projekte in
Münster 1997*

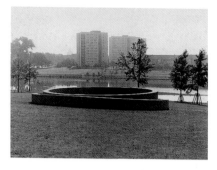

Donald Judd
Born 1928 in Exelsior Springs, Missouri,
died 1994 in New York
Ohne Titel
Two rings, nested
Concrete, outer ring 0.9 x 0.6 m, diameter
15 m; inner ring rising from 0.9 to 2.1 m,
thickness 0.6 m, diameter 13.5 m
Southwest lawn of Aasee,
below Mühlenhof
Permanent installation
Acquired 1977 by city of Münster
See contribution to *Skulptur Projekte in
Münster 1987*

Carl Andre
Born 1935 in Quincy, Massachusetts,
lives in New York
Steel Line for Professor Landois
Ground sculpture with 97 individual plates
Steel, 0.005 x 48.5 x 0.5 m
Hill at southwest end of Aasee
Temporary installation during the
exhibition
See contributions to *Skulptur Projekte in
Münster 1987* and *Skulptur. Projekte in
Münster 1997*

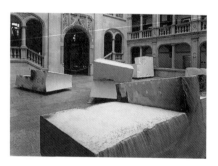

Joseph Beuys
Born 1921 in Kleve, died 1986 in
Düsseldorf
Radikal
Transmitter
Platform of west tower of
Überwasserkirche, Überwasserkirchplatz
Not realized
Unschlitt/Tallow
Warmth sculpture, temporary
Tallow, Chromel-Alumel thermo-elements
with compensating circuit, digital
millivoltmeter, alternating current
transformer, wedge

9.55 x 3.06 x 1.95 m
Hollow space between pedestrian ramp of
lecture hall and pedestrian tunnel on
Hindenbergplatz (model for cast)
Atrium of old section of Westfälisches
Landesmuseum
Temporary installation during the exhibition
See contribution to *Skulptur Projekte in
Münster 1987*

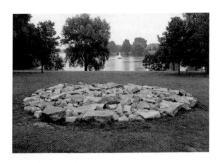

Richard Long
Born 1945 in Bristol, lives there
Stone Cairn
Arrangement of stones
Ibbenbüren sandstone, height ca. 0.5 m,
diameter 13.5 m
West lawn of Aasee, south of Annette-
Allee
Temporary installation during the
exhibition

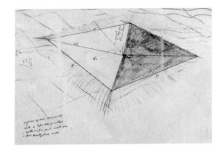

Bruce Nauman
Born 1941 in Fort Wayne, Indiana,
lives in Pecos, New Mexico
Square Depression
Ground sculpture
Poured concrete, 2.3 x 25 x 5 m
Naturwissenschaftliches Zentrum of the
university
Not realized
Square Depression, 1976, sketch, pencil,
56 x 73 cm
See contributions to *Skulptur Projekte in
Münster 1987* and *Skulptur. Projekte in
Münster 1997*

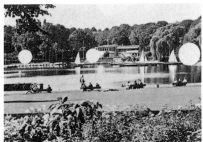

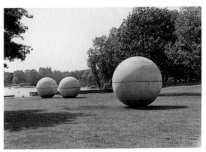

Claes Oldenburg
Born 1929 in Stockholm, lives in New York
Projekt für Münster I & II
I. Photomontage, drawing, watercolor
Imaginary: located at an unlimited number
of sites in the city
II. Concrete, 3 balls, diameter 3.5 m
Aasee terraces, south of Adenauerallee
Permanent installation
Acquired 1987 by city of Münster
See contributions to *Skulptur Projekte in
Münster 1987* and *Skulptur. Projekte in
Münster 1997*

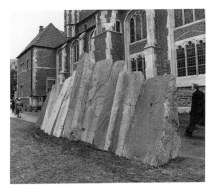

Ulrich Rückriem
Born 1938 in Düsseldorf, lives in Ireland
and Normandy
Dolomit zugeschnitten
Nine-part sculpture
Anröchte dolomite, 3.3 x 7.2 x 1.2 m
North side of Petri-Kirche
Temporary installation from January 5, 1977,
to January 5, 1981
1986 permanent installation for *Skulptur
Projekte in Münster 1987*
Permanent loan from the artist
See contributions to *Skulptur Projekte in
Münster 1987* and *Skulptur. Projekte in
Münster 1997*

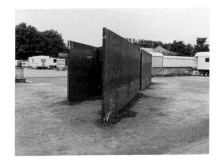

Richard Serra
Born 1939 in San Francisco,
lives in New York
Ohne Titel
Two-part sculpture
Steel, 3 x 13.4 x 2.08 m
Hindenburgplatz
Temporary installation during the
exhibition
See contributions to *Skulptur Projekte in
Münster 1987* and *Skulptur. Projekte in
Münster 1997*

Skulpture Projects in Münster 1987

1. Museum
2. Dennis Adams
3. Carl Andre
4. Giovanni Anselmo
5. Siah Armajani
6. Richard Artschwager, moved
 Michael Asher, 17 positions
7. Stephan Balkenhol
8. Lothar Baumgarten
 Josef Beuys, not realized
9. George Brecht
10. Daniel Buren, partly existent
11. Scott Burton, moved
12. Eduardo Chillida, work from 1993
 Thierry de Cordier, not realized
13. Richard Deacon
14. Luciano Fabro
15. Robert Filliou
16. Ian H. Finlay
17. Peter Fischli/David Weiss
18. Katharina Fritsch
19. Isa Genzken
20. Ludger Gerdes
21. Dan Graham, reinstalled
 Rodney Graham, 16 positions
 Hans Haacke, not realized
22. Keith Haring
 1. Ernst Hermanns
 1. Georg Herold
23. Jenny Holzer, partly existent
24. Rebecca Horn, reinstalled
25. Shirazeh Houshiary
26. Thomas Huber
 Donald Judd, not realized
27. Hubert Kiecol
28. Per Kirkeby
29. Harald Klingelhöller
30. Jeff Koons
 Raimund Kummer, not realized
31. Ange Leccia
32. Sol LeWitt
33. Mario Merz
34. Olaf Metzel
35. François Morellet
 Reinhard Mucha, not realized
36. Matt Mullican
 Bruce Nauman, not realized
 Maria Nordman, not realized
 Claes Oldenburg, not realized

37. Nam June Paik
38. A. R. Penck
39. Giuseppe Penone
40. Hermann Pitz
 Fritz Rahmann, not realized
41. Ulrich Rückriem
 1. Reiner Ruthenbeck
42. Thomas Schütte
43. Richard Serra
44. Susana Solano
45. Ettore Spaletti
 Thomas Struth, 7 positions
46. Richard Tuttle
47. Franz West
48. Rémy Zaugg

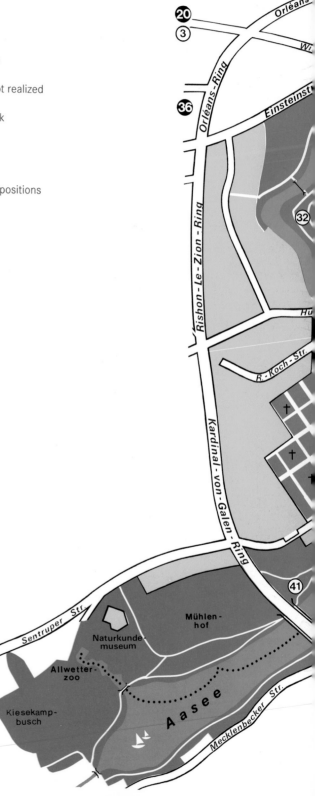

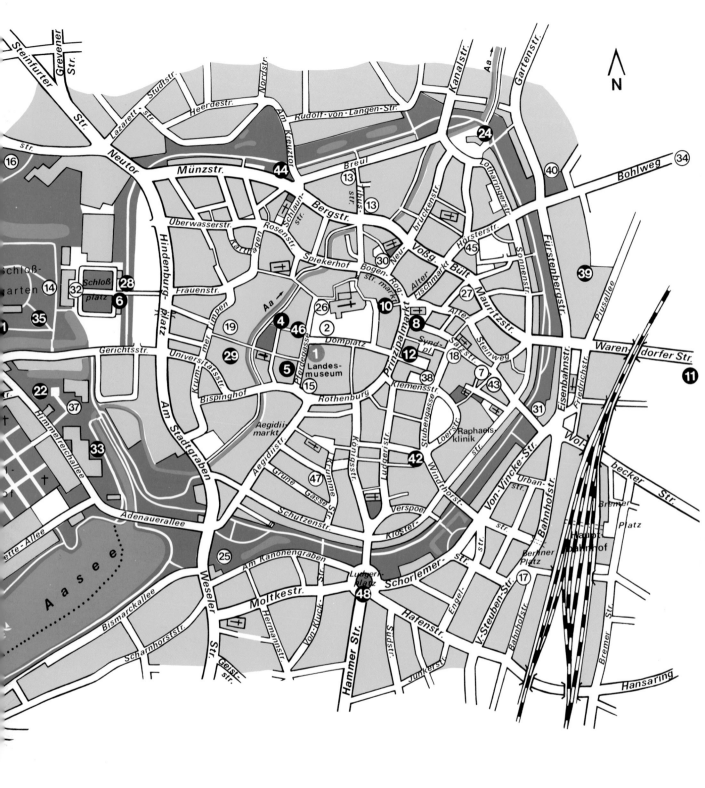

Münster and Gievenbeck
Not realized
See contributions to *Skulptur Ausstellung in Münster 1977* and *Skulptur. Projekte in Münster 1997*

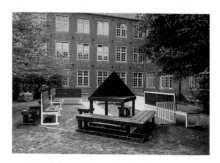

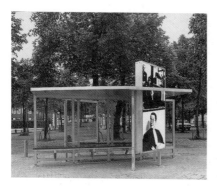

Dennis Adams
Born 1948 in Des Moines, Iowa,
lives in New York
Bus Shelter IV
Bus stop
Aluminum, plexiglas, wood, two-way
mirror glass, photographs,
3 x 4.65 x 3.1 m
Domplatz, in front of Westfälisches
Landesmuseum
Temporary installation to 1992

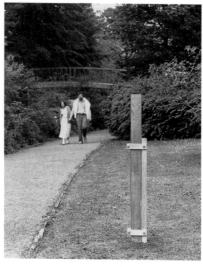

Giovanni Anselmo
Born 1934 in Borgofranco d'Ivrea, Italy,
lives in Turin
Verkürzter Himmel
Stainless steel, engraved inscription
"CIELO ACCORCIATO", 1.4 x 0.1 x 0.1 m
Lawn next to Theologische Fakultät,
Aa Promenade
Permanent exhibition
Permanent loan from the artist

Siah Armajani
Born 1934 in Tehran, Iran, lives in St. Paul,
Minnesota
Study Garden
Two-part seating group with two corner
benches, two benches, four stools,
and table
Wood, steel, 1.0 x 5.8 x 7.8 m and
1.8 x 1.3 x 1.3 m
Garden of Geologisches Museum,
Pferdegasse 3
Partially realized
Acquired 1988 by Westfälisches
Landesmuseum
Pedestrian Bridge
Pedestrian bridge from Bäckergasse to
Hindenburgplatz
Not realized
Pedestrian Bridge, 1986, structural
drawing, felt pen, 76 x 98 cm

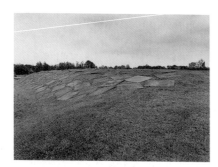

Carl Andre
Born 1935 in Quincy, Massachusetts,
lives in New York
Gras und Stahl, 4. Juni '87
Ground sculpture with 207 individual plates
Steel, 0.005 x 1.0 x 1.0 m each
Busso-Peus-Straße/Gievenbecker Weg
Temporary installation during the exhibition
Ohne Titel
Various found materials
Fallow terrain, Busso-Peus-Straße between

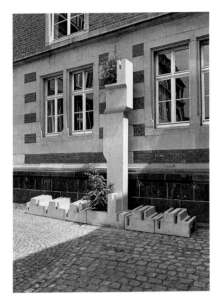

Richard Artschwager

Born 1924 in Washington, D.C.,
lives in Stottville, New York
Zwei Fahrradständermonumente
Ohne Titel, Monument A
Not realized
Ohne Titel, Monument B
Concrete, 2.82 x 0.75 x 0.5 m
Pädagogisches Institut, Bispinghof 2
(to 1997)
May 1997 moved to front of Schloß,
at AStA building (south guardhouse)
Permanent installation
Acquired 1987 by Westfälisches
Landesmuseum

Michael Asher

Born 1943 in Los Angeles, lives there
Installation Münster (Caravan)
Caravan in changing locations
19 different sites in and around Münster
Temporary installation during the
exhibition
See contributions to *Skulptur Ausstellung
in Münster 1977* and *Skulptur. Projekte in
Münster 1997*

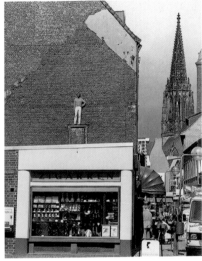

Stephan Balkenhol

Born 1957 in Fritzlar, lives in Alsace
Mann mit grünem Hemd und weißer Hose
Colored concrete, height 2 m
Façade on Salzstraße/Loergasse
Temporary installation to June 20, 1989

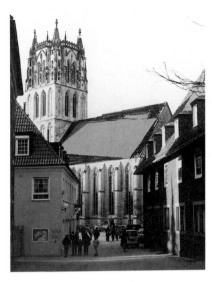

Lothar Baumgarten

Born 1944 in Rheinsberg, lives in Berlin
and New York
Das gestürzte Kreuz
Replacement of roof tiles
Dark red roof tiles, dimensions of roof:
ridge 36.76 m, incline 19.92 m, eaves
38.04 m
Roof of Überwasserkirche,
Überwasserkirchplatz
Not realized
Das gestürzte Kreuz, 1986, retouched
photograph

Drei Irrlichter
Three incandescent lamps in the
Anabaptist cages
Tower of Lamberti-Kirche, Lamberti-
Kirchplatz
Permanent installation
Acquired 1987 by Westfälisches
Landesmuseum

Joseph Beuys

Born 1921 in Kleve, died 1986 in
Düsseldorf
Rieselfelder
Tree planting
Rieselfelder
Not realized
See contributions to *Skulptur Ausstellung
in Münster 1977*

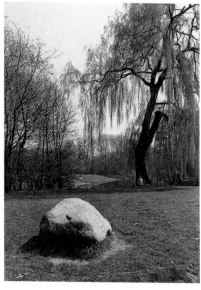

George Brecht

Born 1925 in Halfway, Oregon, lives in
Cologne
Three VOID-Stones
Three boulders with chiseled inscription
"VOID"
1. Einsteinstraße, between Edith-Stein-
Straße and Am Schloßgraben
2. Pädagogisches Institut, Bispinghof 2
3. Bogenstraße/Neubrückenstraße
Partially realized (1.)
Permanent installation
Acquired 1987 by Westfälisches
Landesmuseum

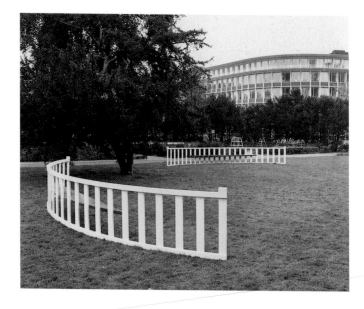

Daniel Buren

Born 1938 in Boulogne-Billancourt,
France, lives in Paris
4 Tore
Aluminum, painted, 4.41 x 4.41 x 1.05 m
1. Geisbergweg, 2. Domgasse, 3. Spiegel-
turm, 4. Jesuitengang
Temporary installation during the
exhibition
Permanent installation of *Tor* on
Domgasse
Permanent loan from the artist
See contribution to *Skulptur. Projekte in
Münster 1997*

Scott Burton

Born 1939 in Greensboro, Alabama,
died 1989 in New York
Pair of Park Benches
Two benches
Painted wood, 1.02 x 8.78 m each,
seating area 0.51 x 5.17 m
Engelenschanze
Temporary installation during the
exhibition
Later permanent installation in interior
courtyard of administrative building of
Landschaftsverband Westfalen-Lippe,
Warendorfer Str. 24
Acquired by Landschaftsverband
Westfalen-Lippe
Sandstone Furniture (A Set of Prototypes)
Seating group
Red sandstone, table 0.72 x 1.42 x 1.42 m,
Two armchairs 0.86 x 0.59 x 0.99 m each,
bench 5.15 x 0.99 x 0.60 m
Foyer of Westfälisches Landesmuseum
Temporary installation during the
exhibition
Later permanent installation in interior
courtyard of Westfälisches
Landesmuseum
Permanent loan from the artist
Public Art Proposal
Red granite
Salzstraße
Not realized

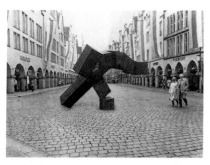

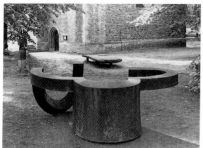

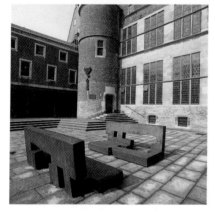

Servatii-Kirchplatz
Temporary installation during the exhibition
Toleranz durch Dialog, 1993
Steel, 1.14 x 2.85 x 1.22 m each, thickness 0.25 m, backrest 0.89 m, seat depth 0.98 m
Interior courtyard of Rathaus
Permanent installation
Acquired 1993 by city of Münster

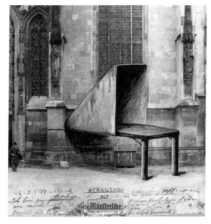

Thierry de Cordier
Born 1954 in Oudenaarde, Belgium, lives in Ghent
Die Münstersche. Die letzte Berghütte
Sculpture
South side of Lamberti-Kirche, Lamberti-Kirchplatz
Not realized
Die Münstersche, 1987, overpainted photograph and collage, 32.3 x 30.4 cm

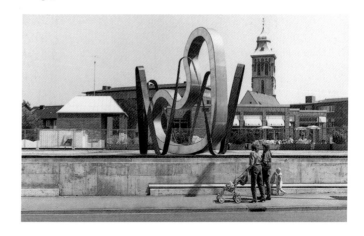

Richard Deacon
Born 1949 in Bangor, Wales, lives in London
Like a Snail (A)
Hard fiber, wood, galvanized steel, 5.6 x 6.8 x 5.2 m
Tibusstraße/Breul
Like a Snail (B)
Wood, galvanized steel, 4.65 x 5.26 x 4.5 m
Tibusstraße/An der Apostelkirche
Temporary installation during the exhibition
See contribution to *Skulptur. Projekte in Münster 1997*

Eduardo Chillida
Born 1924 in San Sebastián, Spain, lives there
Versetzung des "Monuments" auf den Prinzipalmarkt
Monument, 1970–71, steel, 3.59 x 4.3 x 4.99 m
Prinzipalmarkt
Not realized
Tolérance I, 1985
Steel, 9.4 x 2.64. x 2.2 m
Servatii-Kirchplatz
Temporary installation during the exhibition
Hommage à Luca Paccioli, 1986
Steel, 7 x 6 x 1.7 m

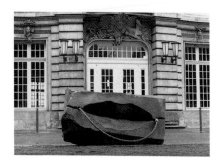

Luciano Fabro
Born 1936 in Turin, Italy, lives in Milan
Demetra/Demeter
Volcanic rock, wire rope, 1 x 2 x 0.7 m
In front of garden portal of Schloß
Temporary installation during the
exhibition

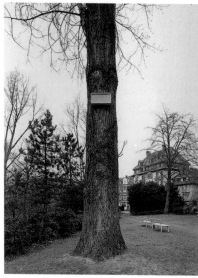

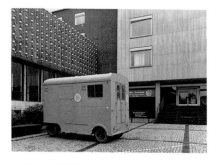

Robert Filliou
Born 1925 in Saure, France, died 1987 in
Les-Eyzies-de-Tayac-Sireuil
Permanent Creation – Tool Shed
Construction shed with neon installation
Square in front of Museum für
Archäologie, Rothenburg
Temporary installation during the
exhibition

Ian Hamilton Finlay
Born 1925 in Nassau, Bahamas,
lives in Dunsyre, Scotland
A Remembrance of Annette
Epitaph for Annette von Droste-Hülshoff
Sandstone, 35 x 75 x 20 cm
Old Überwasser cemetery, Wilhelmstraße
Temporary installation until theft in late
July 1987, recovered 1992
Acquired 1993 by Westfälisches
Landesmuseum
Rüschhaus Proposal
Four sandstone panels
Moat around Rüschhaus
Not realized
Eine Erinnerung an Annette
Accordion-folded booklet with text by
Finlay, offset, 86.5 x 13.4 cm
The Rüschhaus Proposal
Accordion-folded booklet, offset,
111.2 x 13.5 cm

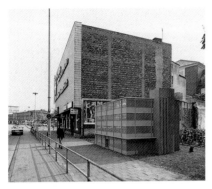

Peter Fischli/David Weiss

Born 1953/1946 in Zurich, Switzerland,
live there
Haus
Wood, plexiglas, painted,
3.5 x 5.7 x 4.1 m, scale 1:5
Von-Steuben-Straße
Temporary installation during the
exhibition
See contribution to *Skulptur. Projekte in
Münster 1997*

Katharina Fritsch

Born 1956 in Essen, lives in Düsseldorf
Madonna
Duroplast, replaced with cast stone after
being twice damaged, 1.7 x 0.4 x 0.34 m
Salzstraße
Temporary installation during the
exhibition (repeatedly vandalized and
stolen)
Pappeloval
Tree planting
80 poplars
1. Grüner Grund
Not realized
2. Thomas-Morus-Weg
Not realized
Rasenplatz mit Rasen (Pappeln)
Model, wood, plastic, 0.16 x 0.8 x 0.8 m
Tennisplatz
Münster-Kinderhaus
Project not intended for realization,
presented by the artist as topic for
discussion
Tennisplatz
Model, wood, wire 0.26 x 1.5 x 1.25 m

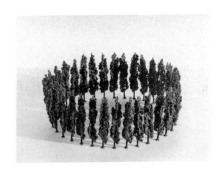

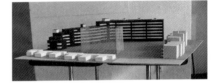

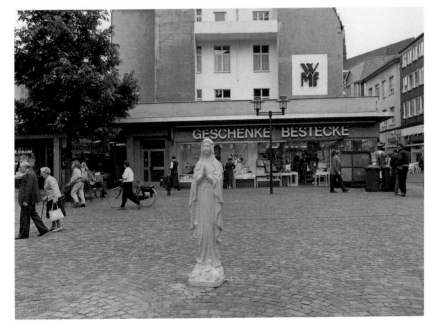

Isa Genzken

Born 1948 in Bad Oldesloe, lives in Berlin
ABC
Concrete, refined steel,
14.85 x 11.2 x 0.4 m
University library
Temporary installation until 1988
See contribution to *Skulptur. Projekte in
Münster 1997*

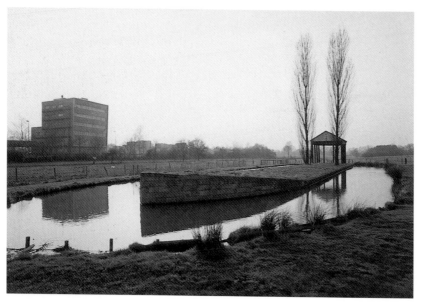

Ludger Gerdes

Born 1954 in Lastrup near Lindern,
lives in Düsseldorf and Munich
Schiff für Münster
Sandstone, wood, two poplars,
length 43 m, width 5 m, trench depth 4 m,
hut 4.6 x 4.2 x 7.4 m
Lawn west of Horstmarer Landweg
Permanent installation
Acquired 1987 by city of Münster,
gift of the artist

Rodney Graham

Born 1948 in Vancouver, lives there
Cyclamen
24 books with copy of title page of
Die Gattung Cyclamen by Dr. Friedrich
Hildebrand (Jena 1898), otherwise empty
pages, paper
Display windows of various bookstores
Temporary installation during the
exhibition

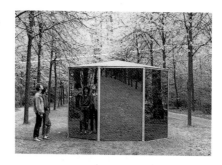

Dan Graham

Born 1942 in Urbana, Illinois,
lives in New York
Oktogon für Münster
Pavilion
Two-way mirror glass, metal, wood,
height 2.4 m, diameter 3.65 m
South Schloßgarten
Temporary installation during the
exhibition
May 1997 permanent installation on
original site
Acquired 1988 by the Westfälisches
Landesmuseum
See contribution to *Skulptur. Projekte in
Münster 1997*

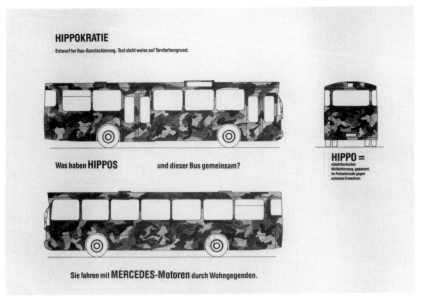

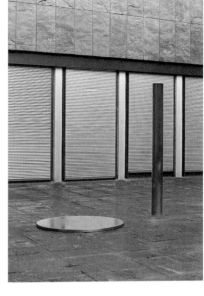

Hans Haacke
Born 1936 in Bad Godesberg,
lives in New York
Hippokratie
Bus design
Transit bus without fixed location
Not realized
Hippokratie, 1987, drawing, ink, felt pen,
typography, 25 x 33.8cm
See contribution to *Skulptur. Projekte in
Münster 1997*

Ernst Hermanns
Born 1914 in Münster, lives in Munich
Skulptur (ohne Titel)
Refined steel, column: height 2.28 m,
diameter 0.2 m, disk: height 0.035 m,
diameter 1.4 m
Interior courtyard of Westfälisches
Landesmuseum
Temporary installation during the
exhibition

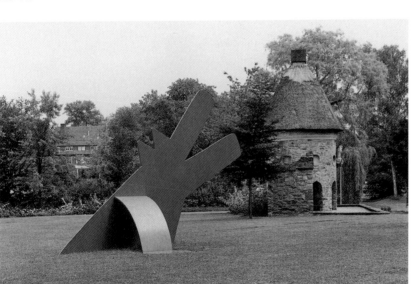

Keith Haring
Born 1958 in Kutztown, Pennsylvania,
died 1990 in New York
Red Dog for Landois
Corten steel, painted,
9.45 x 12.43 x 10.67 m
Alter Zoo/Himmelreichallee
Permanent installation
Permanent loan from Galerie Hans Meyer,
Düsseldorf

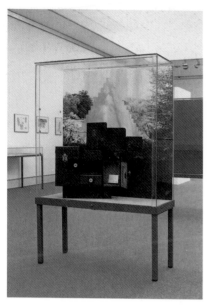 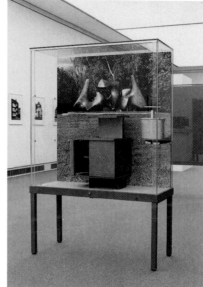 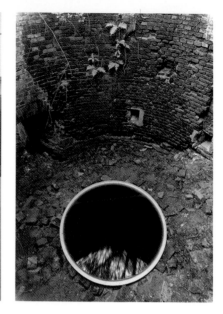

Georg Herold
Born 1947 in Jena, lives in Cologne
Wir richten uns ein
Two display cases, equipped with small furniture items, photos
exhibition in Westfälisches Landesmuseum

Temporary installation during the exhibition
Acquired 1988 by Westfälisches Landesmuseum
See contribution to *Skulptur. Projekte in Münster 1997*

Rebecca Horn
Born 1944 in Michelstadt, lives in Berlin, New York, and Paris
Das gegenläufige Konzert
Plexiglas funnel, height 0.60 m, thickness 0.01 m, diameter 1.2 m, steel funnel, height 5 m, diameter 1.8 m,
40 steel hammers, 40 candles, glass terrarium with two snakes, goose egg, two steel rods
Zwinger, on the Promenade
Temporary installation during the exhibition
Acquired 1993 by city of Münster
1997 permanent installation, altered
See contribution to *Skulptur. Projekte in Münster 1997*

Jenny Holzer
Born 1950 in Gallipolis, Ohio, lives in New York
Bänke
Five sandstone benches,
0.35 x 1.52 x 0.5 m each
Schloßgarten
Temporary installation during the exhibition
Later permanent installation of two casts of original benches
Acquired 1996 by Westfälisches Landesmuseum Münster, gift of the artist
Laufschriftinstallation
Nine colored electronic LED signs
Discothek Odeon, wall near dance floor
Temporary installation during the exhibition
TV-Spots
Advertising spots
WDR television
Not realized

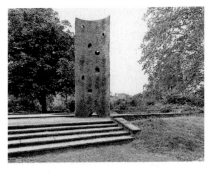

Shirazeh Houshiary
Born 1955 in Shiraz, Iran, lives in London
Temple of Dawn
Wood, wicker, straw, clay, 6 x 2 x 0.8 m
Embankment on Kanonengraben, on the
promenade
Temporary installation until collapse
during a storm in March 1992

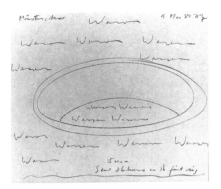

Donald Judd
Born 1928 in E x elsior Springs, Missouri,
died 1994 in New York
Loch im Aasee
Not realized
See contribution to *Skulptur Ausstellung
in Münster 1977*

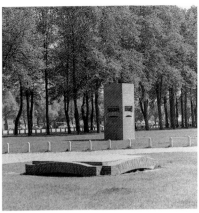

Per Kirkeby
Born 1938 in Copenhagen, lives there and
in Frankfurt am Main
Backstein-Skulptur
Brick, 4.92 x 2.06 x 2.06 m and
0.5 x 4.03 x 4.03 m
North side of Hindenburgplatz
Permanent installation
Acquired 1986 by city of Münster
See contribution to *Skulptur. Projekte in
Münster 1997*

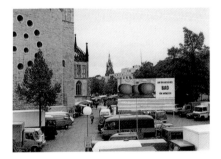

Thomas Huber
Born 1955 in Zürich, lives in Düsseldorf
Ein öffentliches Bad für Münster
Billboard
Aluminum, painted, 3.3 x 6 m
Westside Domplatz
Temporary installation during the
exhibition

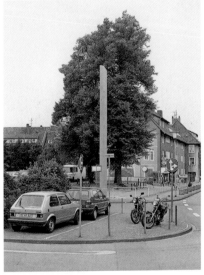

Hubert Kiecol
Born 1950 in Bremen, lives in Cologne
Hohe Treppe
Concrete, 11.2 x 0.5 x 0.4 m
Bült / Asche
Temporary installation until December 5,
1990

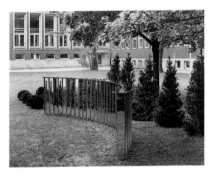

Harald Klingelhöller
Born 1954 in Düsseldorf, lives there
*Die Wiese lacht oder das Gesicht in der
Wand*
Mirror glass, metal construction, 21 yew
trees (Taxus baccata), 1.5 x 4 x 0.2 m
Interior courtyard of Juridicum
(Rechtswissenschaftliche Fakultät),
Universitätsstraße 14–16
Permanent installation
Acquired 1987 by Westfälische Wilhelms-
Universität Münster

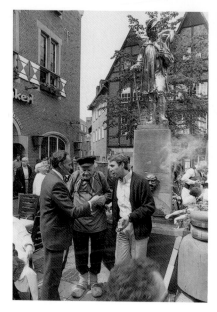 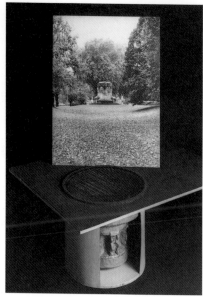

Jeff Koons
Born 1955 in York, Pennsylvania,
lives in New York
Der Kiepenkerl in Edelstahl
Stainless steel replica of bronze sculpture
Spiekerhof/Bergstraße
Temporary installation during the
exhibition
See contribution to *Skulptur. Projekte in
Münster 1997*

Raimund Kummer
Born 1954 in Kassel, lives in Berlin
*Ehrenmal an die Kriege und Siege 1864,
1866, 1870/71*
Bronze, concrete, steel
Promenade/Fürstenbergstraße
Not realized
*Versenkung eines Negativabgusses der
Ehrenmale von Bernhard Frydag*
Model, wood, plastic, hight 38 cm,
diameter 43 cm, plate 75 x 100 cm

Ange Leccia
Born 1952 in Minerviù, Corsica, lives in
Paris
Zwei Fußballtore/Zwei Mähdrescher
Two-part installation
Football goals
1. Servatiiplatz
Temporary installation during the
exhibition
Combines
2. Schloßplatz
Installation for two weeks during the
exhibition

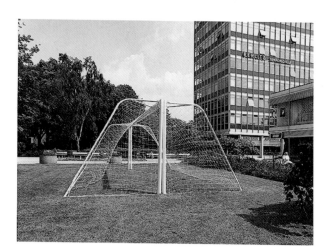 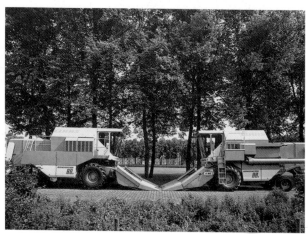

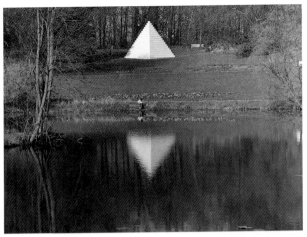

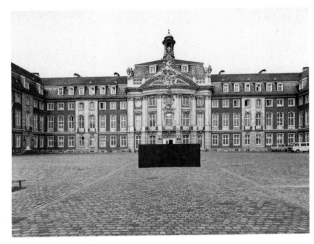

Sol LeWitt
Born 1928 in Hartford, Connecticut,
lives in Chester,
Connecticut
White Pyramid
Cellular concrete, painted white,
5.1 x 5.1 x 5.1 m
Botanical garden
Temporary installation until April 1988

*Black Form – Dedicated to the Missing
Jews*
Cellular concrete, painted black,
1.75 x 5.2 x 1.75 m
In front of Schloß
Temporary installation until February 24,
1988
See contribution to *Skulptur. Projekte in
Münster 1997*

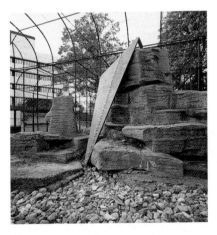

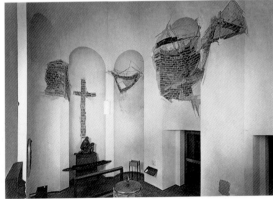

Mario Merz
Born 1925 in Milan, lives in Turin
Die optische Ebene
Steel, painted, 21 glasses, 6.4 x 1.4 x 0.5 m
Large aviary of Alter Zoo, at the present
Landesbausparkasse, Himmelreichallee
Permanent installation
1989 permanent loan from the artist

Olaf Metzel
Born 1952 in Berlin, lives in Munich
Taufkapelle St. Erpho
Wall installation
Interior of St. Erpho-Kirche,
Ostmarkstraße
Temporary installation until renovation of
church in 1989
See contribution to *Skulptur. Projekte in
Münster 1997*

François Morellet

Born 1926 in Cholet, France, lives there
A la française (encore une fois):
Kreis, Quadrat und Dreieck
Ground marking with brick
Schloßgarten
Permanent installation
Acquired 1988 by Westfälisches
Landesmuseum

Reinhard Mucha

Born 1950 in Düsseldorf, lives there
Vitrine
Duplication of existing display case
Square in front of Westfälisches
Landesmuseum
Not realized
Idee für Münster, Vitrine
Watercolor, ink, xeroxcopie, 75 x 82.5 cm

See contribution to *Skulptur. Projekte in Münster 1997*

Matt Mullican

Born 1951 in Santa Monica, California,
lives in New York
Bodenrelief für die Chemischen Institute
Granite, sandblasted, 10.5 x 7.5 m
Naturwissenschaftliches
Zentrum / Chemisches Institut,
Corrensstraße 36
Permanent installation
Acquired 1996 by Westfälisches
Landesmuseum

Bruce Nauman

Born 1941 in Fort Wayne, Indiana,
lives in Pecos, New Mexico
Truncated Pyramid Room
Room installation
Concrete or wood, height ca. 10 m
Tibusstraße/An der Apostelkirche
Not realized
Truncated Pyramid Room
sketch, pencil and watercolor,
96.7 x 98.5 cm
See contributions to *Skulptur Ausstellung
in Münster 1977* and *Skulptur. Projekte in
Münster 1997*

Maria Nordman

Born 1943 in Görlitz, lives in Santa
Monica, California
"Cheir" — Farben der Hände
Performance
Schloßgarten
Performance on October 7, 1986,
and July 3, 1987
"Phoné" — Farben der Stimme
Performance
Schloßgarten
Performance on October 7, 1986,
and July 3, 1987
"Pneûma" — Farben des Atems
Performance
Lawn on Kanalstraße
Performance on November 23, 1986
Wiese an der Kanalstraße
Ground depression with stepped seating
areas and birch planting
Lawn on Kanalstraße
Not realized
Projekt Kanalstraße 1986, 1986, sketch,
pencil, 62.3 x 88.6 cm
See contribution to *Skulptur. Projekte in
Münster 1997*

Claes Oldenburg

Born 1929 in Stockholm, lives in New York
Münster – The 4th Ball Becomes the 4th and 5th Expansion of project *Giant Pool Balls* from 1977
2 concrete balls, diameter 3.5 m
Aasee terraces, south of Adenauerallee
Not realized
Münster – The 4th Ball Becomes the 4th and 5th, 1987, sketch, pencil,
18.5 x 26.3 cm
See contributions to *Skulptur Ausstellung in Münster 1977* and
Skulptur. Projekte in Münster 1997

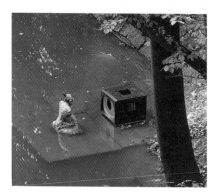

Nam June Paik

Born 1932 in Seoul, lives in New York
TV-Buddha für Enten
Installation
Various materials: bronze Buddha,
63 x 51 x 37 cm, television (Admiral),
bakelite, plexiglas, 46.5 x 46.5 x 51.5 cm
Philosophenweg on the Aa river
Temporary installation during the
exhibition
See contribution to *Skulptur. Projekte in Münster 1997*

A. R. Penck

Born 1939 in Dresden, lives in Berlin
Konzept für Münster: Eine Kleinplastik – Frau mit ausgebreiteten Armen
Bronze, 39 x 38 x 7 cm
Office of the then mayor Dr. Jörg Twenhöven
Temporary installation during the
exhibition

Giuseppe Penone

Born 1947 in Garessio, Italy, lives in Turin
Progetto Pozzo di Münster
Bronze, length 7.0 m
Alter Hörster Friedhof, Karlstraße
Temporary installation during the
exhibition
Since 1996 permanent installation
Acquired 1995 by Westfälisches
Landesmuseum

Hermann Pitz
Born 1956 in Oldenburg, lives in Düsseldorf
Uhr im Treppenhaus
Parabolic mirror, diameter 1.6 m, depth 0.23 m
Landesstraßenbauamt, Hörsterplatz
Temporary installation during the exhibition
See contribution to *Skulptur. Projekte in Münster 1997*

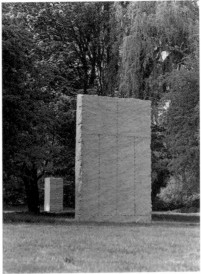

Ulrich Rückriem
Born 1938 in Düsseldorf, lives in Ireland and Normandy
Finnischer Granit gespalten
Three-part sculpture
Finnish granite, 3.51 x 2.34 x 0.5 m and 2.2 x 1.1 x 1.1 m each
Lawn of Aasee
Temporary installation until 1992
See contributions to *Skulptur Ausstellung in Münster 1977* and *Skulptur. Projekte in Münster 1997*

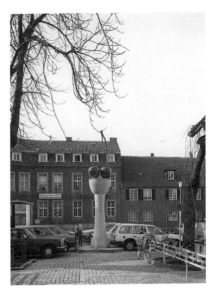

Thomas Schütte
Born 1954 in Oldenburg, lives in Düsseldorf
Kirschensäule
Sandstone, aluminum, painted, height 6 m
Harsewinkelplatz
Permanent installation
Acquired 1987 by city of Münster
See contribution to *Skulptur. Projekte in Münster 1997*

Fritz Rahmann
Born 1936 in Wuppertal, lives in Berlin
Schaltung der Leuchtkörper
Bahnhofspassage
Underground passage between Berliner Platz and Bremer Platz
Not realized

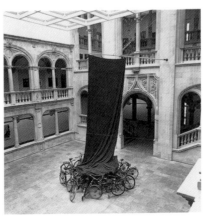

Reiner Ruthenbeck
Born 1937 in Velbert, lives in Düsseldorf
Lodenfahne
Wool fabric, 14 x 2.4 m, flagpole, length 5.61 m, bicycles
Atrium of old section of Westfälisches Landesmuseum
Temporary installation during the exhibition
See contribution to *Skulptur. Projekte in Münster 1997*

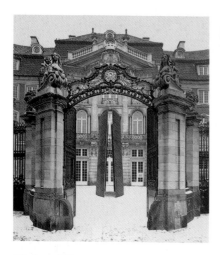

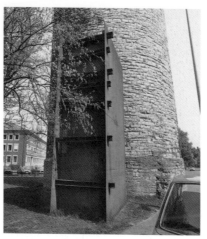

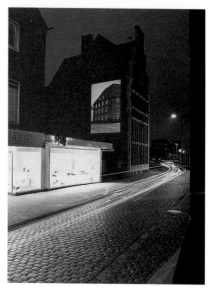

Richard Serra
Born 1939 in San Francisco,
lives in New York
Trunk, J. Conrad Schlaun Recomposed
Two-part sculpture
Corten steel, 5.9 x 4.25 x 2 m
Forecourt of Erbdrostenhof, Salzstraße
Temporary installation during the
exhibition
See contribution to *Skulptur. Projekte in
Münster 1997*

Susana Solano
Born 1946 in Barcelona, Spain, lives there
*Muralla transitable/Wandelbarer
Zündfaden*
Galvanized iron, height 4-6 m, length 31 m
Buddenturm, Münzstraße
Partially realized
Permanent installation
Permanent loan from the artist

Thomas Struth
Born 1954 in Geldern, lives in Düsseldorf
Nacht-Projektionen
Eight slide projections
Eight slide projectors, black and white
photographic views of Münster
1. Horsteberg, 2. Domgasse,
3. Alter Steinweg, 4. Prinzipalmarkt,
5. Rothenburg, 6. Geisbergweg,
7. Michaelisplatz
Temporary installation during the
exhibition

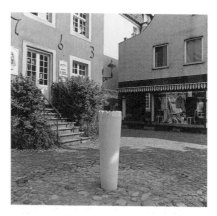

Ettore Spalletti
Born 1940 in Capelle sul Tavo, Italy,
lives there
Fonte
White marble, height 1.2 m,
diameter 0.4 m
Hörsterstraße
Temporary installation until 1988

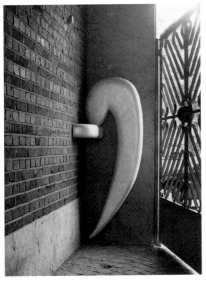 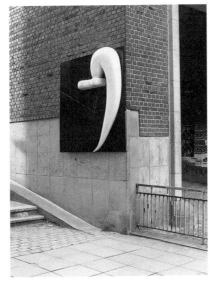 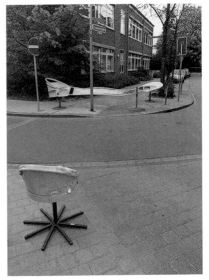

Richard Tuttle
Born 1941 in Rahway, New Jersey,
lives in New York
Art and Music I
Wood, 2 x 0.73 x 0.75 m
Art and Music II
Steel, wood, 2 x 2 x 0.3 m
Fürstenberghaus, Domplatz
Permanent installation
Permanent loan from the artist

Franz West
Born 1946 in Vienna, lives there
EO IPSO
Two-part seating group
Iron, painted, 1.18 x 5.46 x 1.15 m and
0.83 x 0.57 x 0.52 m
Breite Gasse/Krumme Straße
Temporary installation during the
exhibition
See contribution to *Skulptur. Projekte in
Münster 1997*

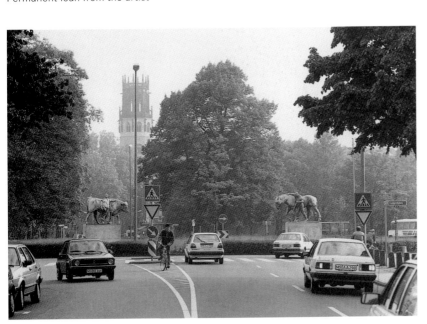

Rémy Zaugg
Born 1943 in Courgenay, Switzerland,
lives in Basel
*Versetzung der Skulpturen "Knecht mit
Pferd" und "Magd mit Stier" auf neue
Sockel*
Ludgeriplatz
Permanent installation
Acquired by city of Münster

Acknowledgments

Skulptur. Projekte in Münster 1997 and the accompanying publications are supported by the exclusive patronage of:

KULTUR-STIFTUNG

Deutsche Bank Gruppe

Additional primary sponsors of *Skulptur. Projekte in Münster 1997* are:

Samsung Foundation of Art and Culture, Seoul
Ministry of Urban Development, Recreation, and Culture of the state of North-Rhine/Westphalia, Düsseldorf

The silk-screen edition published on the occasion of the exhibition in the Landesmuseum Münster was supported by Deutsche Bauspar AG, Frankfurt/M., and produced by Atelier Limited, Münster

We thank the Stadtwerke Münster GmbH or the generous support in municipal services (water, energy, public transports)

The production and realization of projects by the following artists were generously supported by:

Kim Adams
Canada Council and Canadian Embassy, Bonn
Westeel, Winnipeg
Hoogovens Aluminium Sidal GmbH, Rutesheim
Antonius Witte, Düsseldorf
Taxiunternehmen Schlömer & Co., Münster
Feuerwehr Münster
Technisches Hilfswerk, Münster
Firma Kappel, Münster
Stadtwerke Münster GmbH

Michael Asher
Ludwig Peltzer, Münster

Christine Borland
The Henry Moore Foundation, Hertfordshire
INTECU GmbH, Gera
Glatz Engineering, Olpe
Lisson Gallery, London
Bookworks, London
Prof. Dr. med. Reinhard Hildebrand, Münster

Janet Cardiff
Canada Council and Canadian Embassy, Bonn
Franz-Josef Giesbert, Münster

Maurizio Cattelan
Francesco Bonami, New York
Anton Flügge and Johann König

Stephen Craig
Dr. Harald Falckenberg, Hamburg
The Henry Moore Foundation, Hertfordshire
Planning: Stefan Jörden, Münster
Realization: Werner Schlüter GmbH, Drensteinfurt
Firma Gehringhoff Zimmerei, Münster

Mark Dion
Allwetterzoo, Münster
Ms. Grimm, London/Münster

Stan Douglas
Praktijkbureau Beeldende Kunstopdrachten/ Mondriaan Stichting, Amsterdam

Maria Eichhorn
Real Estate Office of the city of Münster
Cornelius Creutzfeldt, Berlin

Ayşe Erkmen
IG Metall, Frankfurt/M.

Peter Fischli/David Weiss
Fondation Nestlé pour l'Art, Lausanne
Elisabeth Richter-Bünning, Münster

Isa Genzken
Planning: Stefan Jörden, Münster
Realization: Das Lichthaus, Gedike und Döpper, Lüdinghausen

Jef Geys
Barbara van der Linden, Brüssel

Douglas Gordon
Kulturstiftung der Stadtsparkasse Münster
Lisson Gallery, London
Barbara Flynn
Kay C. Pallister
Christine Van Assche
Marente Bloemheuvel

Dan Graham
Helge Achenbach Art Consulting, Düsseldorf

Marie-Ange Guilleminot
La Caisse des Dépôts et Consignations, Paris

Raymond Hains
Société Dauphin, Paris
Robert Fleck, La Bouillie-Fréhel

Thomas Hirschhorn
Pro Helvetia, Schweizer Kulturstiftung, Zürich
Murielle Zio, Paris

Rebecca Horn
Work acquired 1995 by the city of Münster

Huang Yong Ping
Hans-Ulrich Obrist, Paris

Fabrice Hybert
Galerie Arndt & Partner, Berlin

Ilya Kabakov
Work acquired 1997 by Landschaftsverband Westfalen-Lippe with the support of Ministry of Urban Development, Recreation, and Culture of the state of North-Rhine/Westphalia, Düsseldorf
Verein der Kaufmannschaft, Münster
Planning: Stefan Jörden, Münster

Realization: Firma Wohlhorn Metallbau, Münster-Wolbeck
Das Lichthaus, Gedike und Döpper, Lüdinghausen

Tadashi Kawamata
Brijderstichting, Alkmaar
Praktijkbureau Beeldende Kunstopdrachten/ Mondriaan
Stichting, Amsterdam
Fritz-Jürgen Gillkötter, Münster

Martin Kippenberger
Anna and Thomas Grässlin, St. Georgen
Lukas Baumewerd, Cologne
Galerie Gisela Capitain, Cologne

Per Kirkeby
Ministry of Urban Development, Recreation, and Culture of
the state of North-Rhine/Westphalia, Düsseldorf
Structural Engineering Office of the city of Münster
Janinhoff GmbH & Co., Ziegel- und Klinkerwerke, Münster

Jeff Koons
Fondazione Prada
Jeffrey Deitch Projects, New York
Anthony d'Offay, London
Max Hetzler, Berlin
Hans J. Baumgart, Daimler Benz AG

Atelier van Lieshout
Rotterdamse Kunststichting, Rotterdam
Mondriaan Stichting, Amsterdam

Olaf Metzel
BMW AG, München
Mr. and Mrs. Klett, München
Dieter Sitzmann, München
Steffen Werner, München
Westfälische Bauindustrie GmbH, Münster

Bruce Nauman
Dr. Friedrich-Christian Flick

Maria Nordman
Work acquired 1995 by the city of Münster with the support
of numerous privat donators
as well as Hartmut Tauchnitz, Gail Kirkpatrick, Rudolph
Koolway, Heinrich Westarp

Gabriel Orozco
Marion Goodman Gallery, New York
Dr. Ernst Scheneen, Chemag AG

Nam June Paik
Samsung Foundation of Art and Culture, Seoul
Carl Solway Gallery, Cincinnati, Ohio

Jorge Pardo
K. A. Tauber Spezialbau GmbH & Co. KG, Münster
Planning: Stefan Jörden, Münster
Static: Mr. Lippert, Ingenieurbüro Würzer & Partner,
Düsseldorf

Hermann Pitz
Sabine Kammerl, Münster
Employees of the Weigert Stahlprägewerk company, Neu-
burg/Donau

Marjetica Potrč
Ministry of Culture, Slovenia
Fresko: Taylor Spence

Tobias Rehberger
Westfälische Wilhelms-Universität Münster
Dockland, Münster
Daniel Haaksmann, Frankfurt/M.
Konzertbüro Schoneberg, Münster

Allen Ruppersberg
Kulturstiftung der Deutschen Bank, Frankfurt/M.
Amateurbühne Münster
Städtische Bühnen Münster
First Reisebüro Lückertz, Münster
Reisecenter alltours
as well as all interview partners and interested citizens of
Münster

Ulrich Rückriem
Heinrich Ehrhardt, Frankfurt/M.

Karin Sander
Dr.-Ing. Dieter Grünebaum
Olaf Lenzmann
Prof. Dr.-Ing. Lothar Lenzmann

Richard Serra
Work acquired 1996 by Landschaftsverband Westfalen-
Lippe (LWL) with the support of
City of Münster
Ministry of Urban Development, Recreation, and Culture of
the state of North-Rhine/Westphalia, Düsseldorf
Lions Club Münster, Johann Conrad Schlaun
Volksbank Münster
as well as numerous private donators

Roman Signer
Pro Helvetia, Schweizer Kulturstiftung, Zürich
Feuerwehr Münster
Galerie Barbara Weiss, Berlin

Andreas Slominski
Stadtwerke Münster GmbH
ZDF Mainz, Aspekte-Redaktion

Yutaka Sone
The Japan Foundation, Tokyo
Panasonic
Fritz König, Margret von Allwörden, Walther König, Tissi
Muhle-König

Diana Thater
Kulturstiftung der Stadtsparkasse Münster
David Zwirner Gallery, New York
Rolf Jungenblut GmbH, Münster

Bert Theis
Fonds Culturel, Luxembourg
Ministère de la Culture, Luxembourg
GAMO, Luxembourg
Robert Engel, Ralph Rippinger

Rirkrit Tiravanija
Gymnasium Paulinum (Dr. Manfred Derpmann), Münster
Abendgesellschaft des Westfälischen
Zoologischen Gartens (Richard Schmieding), Münster
Stempel & Telenga, Bau- und Möbeltischlerei, Münster
Dorit Köhler, Münster

Eulàlia Valldosera
Karstadt AG, Münster
Rolf Jungenblut GmbH, Münster

herman de vries
Work acquired 1997 by Landschaftsverband Westfalen-
Lippe (LWL) with the support of Ministry of Urban Develop-
ment, Recreation, and Culture of the state of North-
Rhine/Westphalia, Düsseldorf
Planning: Stefan Jörden, Münster
Realization: Firma Kappel, Münster
Werner Schlüter, Drensteinfurt
Advising: Hermann Czech, Vienna

Franz West
Österreichisches Bundesministerium für Wissenschaft,
Kunst und Verkehr, Vienna
Österreichisches Bundeskanzleramt, Staatssekretariat für
Kunst, Europa und Sport, Vienna
David Zwirner Gallery, New York

Elin Wikström/Anna Brag
Schwedische Botschaft, Bonn
MOELVEN Töreboda Limträ AB, Töreboda
Mixxon AB, Göteborg
Moderna Museet International Programme, Stockholm
Architekt Diplomingenieur Sigurd Brag,
Karlskrona
Elit Fönster, Vetlanda
FOCUS NEON AB
Hägersten, Göteborg/Malmö/Jönköping
FOCUS NEON GmbH
Hilpoltstein, Dresden

Jeffrey Wisniewski
Prof. Dr. K. von Wild, Münster
Planning: Stefan Jörden, Münster
Alyson Baker, Mauro Fiore, Udo Westbrook

Wolfgang Winter/Berthold Hörbelt
Gesellschaft Deutscher Brunnen, Bonn
Deutsche Telekom, Dortmund
Deutsche Bahn AG, Münster
Koch Ingenieure, Vellmar
as well as Catharina, Lea, Marie-Theres, Monica and Sophia

Andrea Zittel
Andrea Rosen Gallery, New York
Coutts Contemporary Art Foundation, Zürich
The San Francisco Museum of Modern Art, San Francisco

Heimo Zobernig
Österreichisches Bundesministerium für Wissenschaft,
Kunst und Verkehr, Vienna
Österreichisches Bundeskanzleramt. Staatssekretariat für
Kunst, Europa und Sport, Vienna

More over our thanks go to
British Council, London
Siemens Kulturprogramm, Michael Roßnagl,
Dr. Matthias Winzen
Association Française d'Action Artistique, Paris
Generali, Dr. Sabine Breitwieser, Dr. Dietrich Karner
Stadtklang, Münster
Lars Nittve, Louisiana
Dr. Nastansky, DAAD, Berlin
Dr. Friedrich Meschede, DAAD, Berlin
Hermann Janssen, Münster
Dr. Jörg Twenhöven, District President, Münster
Bart Cassiman, Gent
José Lebrero Stals, Barcelona
Roman Soukop, Wolfhagen
Hortensia Völckers, documenta X, Kassel
Seung-Duk Kim, Paris
David Elliott, Moderna Museet, Stockholm
Judy Adam, London

The project as a whole could not have been realized without
the conceptual and intellectual support of Elizabeth Duke of
Bakersfield Spirit.

The renovation of permanently installed works from the
sculpture exhibitions of 1977 and 1987 was supported by
Josef Bogatzki GmbH & Co KG, civil engineering, Münster
Rolf Jungenblut GmbH, Münster
Ralf Pohlmann, Malermeister, Münster
Schimanski GmbH, Garten- und Landschaftsbau, Münster
Werner Stempel, Tischlerei, Münster

Technical Committee

Westfälisches Landesmuseum (Landschaftsverband
Westfalen-Lippe)
Kasper König, curator
Florian Matzner, project director
Ulrike Groos, exhibition office manager

City of Münster
Bernadette Spinnen, Office of Culture
Gerhard Löhr, Ludwig Peltzer, Structural Engineering Office
Rainer Karliczek, Marion Philipp, Urban Planning Office
Christian Schowe, Michael Kappel, Gunnar Pick, Subsidiary
Preservation Authority
Rudolf Schabbing, Rudolf Grawe, Civil Engineering Office
Bernhard Roth, Andreas Tschöpe, Ralf Riedel, Martina Köller,
Real Estate Office
Hartmut Tauchnitz, Franz-Josef Gövert, Ulrich Kleine-Bösing,
Klaus-Dieter Helmchen, Office of Parks and Natural
Conservation
Siegfried Thielen, Rolf Fiene, Office of Building Regulations
Gerd Meier, Gerhard Dittmer, Security Office
Hubert Mischke, Survey and Cadaster Office
Hans Geukes, Werner Laumanns, Office of Publicity
and Tourism

Westfälische Wilhelms-Universität Münster
Robert Bretschneider, Reinhard Greshake, Real Estate and
Building Office

District government Münster
Kordula Attermeyer-Steinkühler, Department 15 (Real Estate)

Lenders

Georg Baselitz
Galerie Michael Werner, Cologne
Pace Wildenstein, New York

Alighiero Boetti
Collezione Caterina Boetti, Rom

Maurizio Cattelan
Collezione Leggeri

Fabrice Hybert
Galerie Arndt & Partner, Berlin

Atelier van Lieshout
Kröller-Müller Museum, Otterlo
CAST, Tilburg

Thomas Schütte
No. 4 and 5 Christian Stein Gallery, Milan
No. 6 Galerie Fischer, Düsseldorf
No. 7 Galerie Philip Nelson, Centre Pompidou,
Paris
No. 8 Thomas Schütte

Franz West
FRAC, Reims

Andrea Zittel
Andrea Rosen Gallery, New York

Photo credit

Unless otherwise indicated, all photographs are the copyright of Roman Mensing

Abendgesellschaft Zoologischer Garten, Münster p. 420, 421 left
Thorsten Arendt, Münster p. 52, 54
Argosfotobüro (Leo van der Kleij) p. 244
Galerie Arndt & Partner, Berlin p. 230, 233
Dirk Bleicker, Berlin p. 356 bottom
Douglas Boez p. 331 bottom
Peter de Bryne p. 361
Daniel Buren, Paris p. 80
Klaus Bußmann, Münster p. 269 top
Stephen Craig, Hamburg p. 112
Richard Davis p. 331 top
Christina Dilger, Münster p. 70, 71 bottom, 130, 240, 282, 284, 285, 323, 397–399
Mark Dion, New York p. 120, 122, 123
Stan Douglas, Vancouver p. 126, 129
Todd Eberle p. 294 bottom
Maria Eichhorn, Berlin p. 139–141
Peter Fischli /David Weiss, Zürich p. 150, 151, 155–157
Christian Geißler, Münster p. 287
Georg Herold, Köln p. 359
David Kalef p. 48 top
Gerd Kittel p. 293
Svetlana Kopystiansky, Berlin p. 266, 267
Miki Krarzman p. 193
Guy L'Heureux p. 48 bottom
Martin Lauffer, Stuttgart p. 364, 377
Pierre Leguillon p. 190, 214, 215
Atelier van Lieshout, Rotterdam p. 272, 273, 275
Paul Litherland p. 50
Friedrich Meschede, Berlin p. 383
Metropolitan Museum of Art, New York p. 450
Olaf Metzel, München p. 278–281
Reinhard Mucha, Düsseldorf p. 283
Peron Muscato, Los Angeles p. 472
National Gallery, London p. 116
Wolfgang Neeb p. 356 top
Gallery Anthony d'Offay, New York p. 448
Matija Pavlovec p. 331 middle
Hermann Pitz, Düsseldorf p. 320
Marjetica Potrč p. 325
Elisabeth Richter-Bünning, Münster p. 153
Walther Rohdich, Münster p. 78
Daniel Rückert p. 231
Karin Sander, Stuttgart p. 379
Galerie Schneider, Luxemburg p. 224 right
Elfie Semotan, Wien p. 248–250
Andreas Slominski, Hamburg p. 396, 400
Zmago Smitek p. 324

Staatliche Museen zu Berlin – Preußischer Kulturbesitz, Nationalgalerie p. 160
Stadtarchiv Münster p. 423
Stadtmuseum Münster (Thomas Samek) p. 318, 465 top
Vermessungs- and Katasteramt, Münster (Hubert Mischke) p. 44, 45, 82, 162, 226, 348
Galerie Michael Werner, Köln p. 66
Westfälisches Amt für Denkmalpflege, Münster p. 68, 144, 1445 left, 366, 408
Westfälisches Landesmuseum Münster (Rudolf Wakonigg and Christiane Förster) p. 21–25, 27–31, 33, 34, 55, 56 bottom, 59–65 left and middle, p. 81, 117, 124, 148, 154, 161, 184, 208, 221 top, 254, 261, 263, 269, 288–290, 294 top, 295 bottom, 309 top, 338 bottom, 345, 357, 388, 389, 444, 511–535
Wolfgang Winter /Berthold Hörbelt p. 458
Jeffrey Wisniewski, Berlin p. 467
Antonius Witte, Düsseldorf p. 49 bottom
Donald Young Gallery, Seattle p. 334 right

Translation credit

Unless otherwise indicated, all texts were translated by Melissa Thorson Hause

Heather Eastes and Stephen Reader p. 7–41
Ruth Koenig p. 241–245
Cynthia Martin p. 235–238
Charles Penwarden and L.-S. Torgoff 79–81, 482
Allison Plath-Moseley and Nils Plath p. 207–208

This book is published on the occasion of the exhibition *Skulptur. Projekte in Münster 1997*

Exhibition

Director, Landesmuseum
Klaus Bußmann

Curator
Kasper König

Managing director
Florian Matzner

Exhibition office
Ulrike Groos (manager)
Claudia Büttner, Barbara Engelbach, Martina Ward

Interns
Bergit Arends, Monika Flocke, Barbara Förster, Karsten Grebe, Judith Kobus, Sonja Lehnert, Angelika Nollert, Jan-Hendrik Wentrup

Press and public relations
Markus Müller with assistance of Elke Althaus, Christa Kuchenbecker, Claudia Posca, Uta Ramme, Julia Schmidt, Kathrin Wolf

Museum education program and introductory film
Klaus Kösters, Landesbildstelle Westfalen

Photographic documentation
Roman Mensing with assistance of Thorsten Arendt and Christina Dilger

Installation
Students from the Kunstakademie Münster, the departments of architecture and design of the Fachhochschule Münster, and the art history department of the Kunstgeschichtliches Seminar der Westfälischen Wilhelms-Universität under the direction of Andreas Wissen (works in the city) and Manfred König (exhibition in the museum)

Secretarial office, transportation, insurance
Regina Binder (Frankfurt/M.), Harriet Groneuer, Petra Haufschild, Monika Kestermann, Ines Müller

Administration
Uwe Dutkiewitz, Dietmar Halemba, Ute Lassmann, Heike Woitzik

Cover illustration
after Ayşe Erkmen: *Sculptures on the Air*, computer simulation

ISBN 3-7757-0667-4 (English trade edition)
ISBN 3-7757-0649-6 (German trade edition)

Printed in Germany

Catalog

Editors
Klaus Bußmann, Kasper König, Florian Matzner

Editorial staff
Claudia Büttner, Barbara Engelbach, Ulrike Groos, Kasper König, Florian Matzner

Copy editor
Ian Connolly Hunt

Graphic design and production
Gerhard Brunner

Typeset in Corporate

Production
Dr. Cantz'sche Druckerei, Stuttgart

© 1997 Verlag Gerd Hatje, Stuttgart, editors and authors
© 1997 for works reproduced by the artists and their legal successors; for Carl Andre, Lothar Baumgarten, Joseph Beuys, Daniel Buren, Eduardo Chillida, Maria Eichhorn, Katharina Fritsch, Ludger Gerdes, Paul-Armand Gette, Marie-Ange Guilleminot, Dan Graham, Raymond Hains, Georg Herold, Rebecca Horn, Fabrice Hybert, Donald Judd, Ilya Kabakov, Raimund Kummer, Ange Leccia, Sol LeWitt, Olaf Metzel, François Morellet, Bruce Nauman, Hermann Pitz, Reiner Ruthenbeck, Karin Sander, Thomas Schütte, Richard Serra, Susana Solano, Eulàlia Valldosera, Lawrence Weiner, Heimo Zobernig at VG Bild-Kunst, Bonn 1997

Published by
Verlag Gerd Hatje, Senefelderstraße 12,
73760 Ostfildern-Ruit, Germany

Distribution in the US
DAP, Distributed Art Publishers
155 Avenue of the Americas, Second Floor
New York, N.Y. 10013
T. (001) 212 – 627 19 99, F. (001) 212 – 627 94 84

Distribution in Great Britain and British Commonwealth
Thames Hudson Ltd.
30–34 Bloomsbury Street, London WC1B 3QP
T. 0171 – 636 16 95, F. 0171 – 636 54 88

Internet and CD-Rom

Concept and production
Ralf Dank, Sebastian Bertalan, Susanne Boecker, Marcus Wolf, Köln
Redaktionsbüro Dank
Gladbacher Str. 18 – 20, 50672 Köln
Telefon 02 21 / 952 04 64, Telefax 02 21 / 952 04 63

Internet home page
http://www.artthing.de/muenster/

Editorial staff, Landesmuseum
Claudia Büttner, Barbara Engelbach, Ulrike Groos, Florian Matzner, Markus Müller